Félix Vallotton

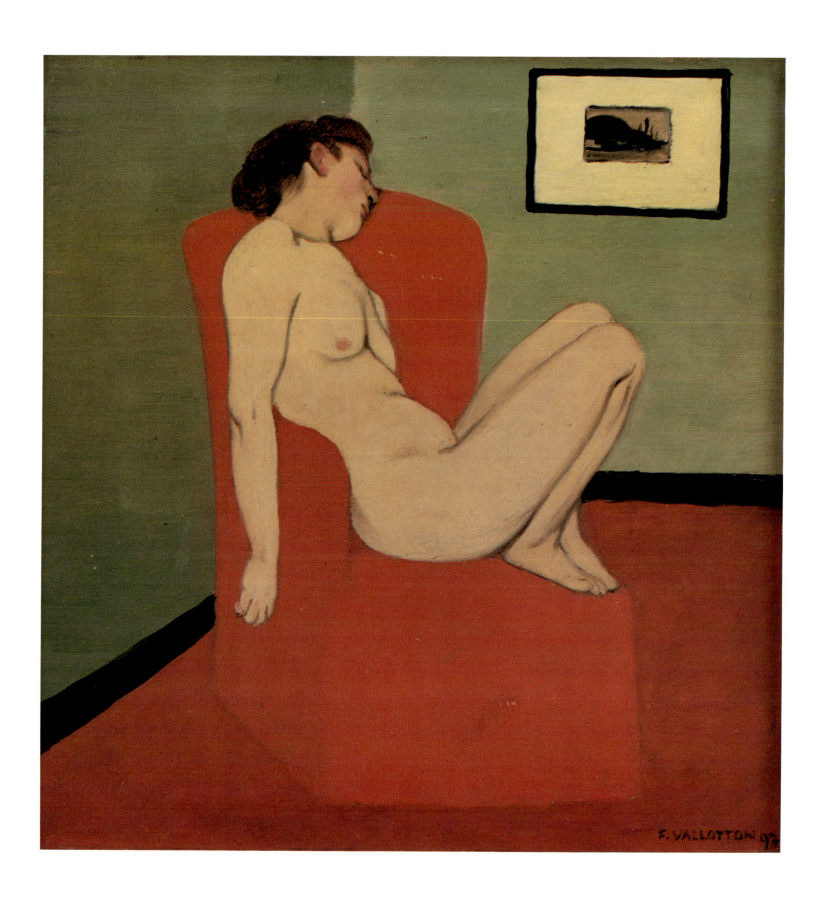

Félix Vallotton

Sasha M. Newman

With essays by: Marina Ducrey, Richard S. Field,
Deborah L. Goodman, Margrit Hahnloser-Ingold,
John Klein, and Rudolf Koella

Edited by Lesley K. Baier

Yale University Art Gallery, New Haven

Abbeville Press Publishers New York London Paris

This book is published in conjunction with the exhibition:

Félix Vallotton: A Retrospective

Yale University Art Gallery, New Haven
24 October 1991–5 January 1992

Museum of Fine Arts, Houston
31 January–29 March 1992

Indianapolis Museum of Art
25 April–21 June 1992

Van Gogh Museum, Amsterdam
27 August–1 November 1992

Musée cantonal des Beaux-Arts, Lausanne
21 November 1992–31 January 1993

This exhibition is supported by an indemnity from the Federal Council on the Arts and the Humanities and was made possible by grants from:

Fondation Pro Helvetia: Arts Council of Switzerland

The National Endowment for the Arts

The Barker Welfare Foundation

The Robert Lehman Exhibition and Publication Fund

Library of Congress Cataloging-in-Publication Data

Newman, Sasha M., 1955–
 Félix Vallotton / Sasha M. Newman ; with essays by Marina Ducrey . . . [et al.] ; edited by Lesley K. Baier.
 p. cm.
 "Published in conjunction with the exhibition Félix Vallotton: a retrospective, Yale University Art Gallery, New Haven, 24 October 1991–5 January 1992 . . . [et al.]"—T.p. verso.
 Includes bibliographical references (p.) and index.
 ISBN 1-55859-312-8 (acid-free hard)
— ISBN 0-89467-057-3 (acid-free pbk.)
 1. Vallotton, Félix, 1865–1925—Exhibitions. I. Vallotton, Félix, 1865–1925. II. Baier, Lesley K. III. Yale University. Art Gallery. IV. Title.
N6853.V24A4 1991
760′.092—dc20 91-66233
 CIP

Designer: Marc Zaref Design, New York, NY

Typesetter: Dix Type Inc., Syracuse, NY

Printer: The John D. Lucas Printing Company, Baltimore, MD

Front Cover/Jacket:
Detail of *The Lie*, 1898 (see plate 170)
The Baltimore Museum of Art, The Cone Collection, formed by Dr. Claribel Cone and Miss Etta Cone of Baltimore, Maryland, BMA 1950.298

Back Cover/Jacket:
The Demonstration (La Manifestation), 1893
Woodcut, 20.3 x 32 cm (block)
The Metropolitan Museum of Art, New York, Rogers Fund, 1922, 1922.82.1–9

Frontispiece:
Nude Seated in a Red Armchair, 1897
Oil on canvas, 30 x 29 cm
Musée de Grenoble

Contents

Director's Foreword

In recent years major exhibitions have begun to focus on the art of the Nabis, a group of young artists who, in one manifestation of the Symbolist aesthetic which prevailed in Paris at the turn of the century, banded together in the 1890s and named themselves for the Hebrew word prophet. Pierre Bonnard and Edouard Vuillard, artists who were among Félix Vallotton's closest companions in this "brotherhood," have been singled out for particular attention. Yet the Swiss-born Vallotton, long renowned as a graphic artist, has remained largely absent from these reevaluations. For although he focused in the 1890s on the same quotidian subject matter as his Nabi brethren—the street and the domestic interior—his strange and acerbic vision marked him even then as "le Nabi étranger" (the foreign Nabi). Rooted in the traditions of both French classicism and Northern realism, Vallotton's personal and often "perverse" vision grew increasingly evident in the figural landscapes and in the nudes to which he seemed obsessively drawn after the turn of the century. In exploring the particulars of that unsettling vision and the degree to which it informs his work in various genres, media, and periods, this exhibition and publication have undertaken a reappraisal of Vallotton's individual achievement as well as his significance in the subsequent development of European art.

A university art museum like the Yale University Art Gallery, which is especially strong in late-nineteenth-century art, is uniquely suited for such a reappraisal. Sasha Newman, the Seymour H. Knox, Jr. Associate Curator of European and Contemporary Art, who is a specialist in Bonnard in particular and the Nabis in general, initiated the idea of the first major Vallotton exhibition in North America and the first comprehensive publication on Vallotton's life and art in the English language. Her boundless energy enabled the Yale Art Gallery to realize a venture of considerable magnitude; and her acute mind guaranteed its scholarly achievement.

This project, however, would never have achieved fruition without the

assistance of several key individuals. Mme Marina Ducrey, author of the forth-coming catalogue raisonné of Vallotton's painted oeuvre; Dr. Margrit Hahnloser-Ingold; and Dr. Rudolf Koella, former Director of the Kunstmuseum Winterthur and a preeminent Vallotton scholar, devoted themselves generously and enthusi-astically to this endeavor, contributing their expertise to the exhibition's realiza-tion as well as essays to the publication. Members of the curatorial staff at the Yale University Art Gallery were equally valuable participants. Richard Field, Curator of Prints, Drawings, and Photographs, assumed responsibility for the graphic art section of the exhibition and contributed a masterful essay; Deborah Goodman, Assistant Curator of European and Contemporary Art, participated in every aspect of the project's organization and wrote an essay as well as the artist's chronology; and John Klein, former Curatorial Assistant in European and Contemporary Art, furnished an essay. The publication benefitted greatly from the extraordinary editorial skills of Lesley Baier.

Ultimately, the generosity of lenders and those who provided financial support have made this exhibition a reality. I would like to thank the many institutions and private collectors who helped in the preparation of the exhibition and parted with cherished works for a significant period of time. We owe a special debt of gratitude to Luc Boissonnas and Christoph Eggenberger of the Fondation Pro Helvetia for their magnanimity from the inception of this project; and to Lukas Gloor, Consul at the Consulate General of Switzerland in New York, for his enthusiasm and help. Major funding was provided by the Fondation Pro Helvetia, the National Endowment for the Arts, The Barker Welfare Foundation, the Robert Lehman Exhibition and Publication Fund, and the Federal Council on the Arts and the Humanities.

Finally, we are especially pleased to share the brilliance of Félix Vallotton's art with the Museum of Fine Arts, Houston; the Indianapolis Museum of Art; the Van Gogh Museum, Amsterdam; and the Musée cantonal des Beaux-Arts, Lausanne. In this regard we are deeply grateful to Peter Marzio, Bret Waller, Ronald de Leeuw, and Jörg Zutter, the respective directors of these museums, whose keen interest has enabled us to bring Vallotton's work to a national and international audience.

Mary Gardner Neill
The Henry J. Heinz II Director

Acknowledgments

Any exhibition is like an orchestral collaboration, with each part absolutely essential to the realization of the whole. This retrospective of the work of Félix Vallotton, the first in North America, has been especially so: the generosity of colleagues and lenders both here and abroad has been overwhelming. We are greatly indebted to the cooperation of Swiss organizations and their representatives, in particular to Luc Boissonnas and Christoph Eggenberger of the Fondation Pro Helvetia; Hans Lüthy of the Swiss Institute for Art Research; Lukas Gloor and his predecessor J. F. Guerry of the Consulate General of Switzerland in New York; François Barras of the United States Swiss Embassy; and Livio Hürzeler of the Swiss Embassy in London.

Our deepest thanks go to the many lenders who have shared their own or their institutions' treasures. The Galerie Vallotton and the Vallotton family must be singled out for their many essential contributions. The generosity of the Hahnloser and Josefowitz families, who provided support from the outset, has also been crucial. Others to whom we owe sincere gratitude are Arthur and Diana Altschul, Felix Baumann, François Bergot, Erika Billeter, Elizabeth and Walter F. Brown, Françoise Cachin, Riva Castelman, Phillip Dennis Cate, Philippe Chabert, Catherine Chevillot, Malcolm Cormack, Douglas Druick, Marianne and Walter Feilchenfeldt, Jay Fisher, Suzanne Folds-McCullagh, Christian Geelhaar, Oscar Ghez, Charles Goerg, Sabine Helms, John and Paul Herring, Michal and Renata Hornstein, Colta Ives, André Kamber, Larry Kantor, Christian Klemm, Georg W. Költzsch, Albert Kostenevich, Catherine Legrand, Marceline McKee, Jean-François Méjanès, Charles Moffett, Michael Pantazzi, C. Petry, Jean-Pierre Reverseau, Brenda Richardson, Andrew Robison, John Sebastian Sattentau, Dieter Schwarz, Emmanuel Starkey, Dr. Erich Steingraber, Tony Stooss, Charles Stuckey, Béatrice Tabah, Jan van der Marck, Hans Christoph von Tavel, Françoise Viatte, Roberta Waddell, Beat Wismer, Deborah Wye, and those lenders who wish to remain anonymous.

Vital assistance and encouragement were offered by Ay Whang-Hsia, Elizabeth Childs, Anne Dumas, Romy Golan, Trudy Hanson, Mary Laing, Martha Parrish, Ashley St. James, David Schaff, and Kenneth Silver. I would also like to thank Ellen Lee of the Indianapolis Museum of Art; George Shackelford of the Museum of Fine Arts, Houston; Stefan van Raay of the Van Gogh Museum, Amsterdam; and Jörg Zutter of the Musée cantonal des Beaux-Arts, Lausanne.

Although their contributions have been acknowledged in the Foreword, I would like to add my personal thanks to the authors whose perceptive essays constitute a significant contribution to the literature: Mme Marina Ducrey, Dr. Rudolf Koella, Dr. Margrit Hahnloser-Ingold, John Klein, and my colleagues at the Yale Art Gallery, Richard Field and Deborah Goodman. The editing of this book was accomplished with great skill by Lesley Baier; all of the authors are in her debt. Ms. Goodman unflaggingly managed every phase of the exhibition and the publication. I am grateful to them both, as I am to Mary Gardner Neill, the Henry J. Heinz II Director of the Yale University Art Gallery, for her support throughout the project.

Many other members of the Art Gallery staff contributed to the success of this endeavor. I would like to thank each of them for their patient and tireless efforts, in particular Kristin Hoermann, Paintings Conservator; Susan Frankenbach, Registrar, and Diane Hart, Associate Registrar; Louisa Cunningham, Business Manager; Richard Moore, Operations Manager; and Marie Weltzien, Public Relations Coordinator. Invaluable assistance was also offered by Fatiha Ahmed, Mark Aronson, Howard el-Yasin, Carolyn Fitzgerald, Burrus Harlow, Anthony Hirschel, Richard Johnson, Elizabeth Marsh, Brigitte Meshako, Bernice Parent, Robert C. Soule, and Patricia Zandy. In the department of European and Contemporary Art, special thanks go to the many assistants and student interns who worked on this project: Alvin L. Clark, Jr., who handled reproduction rights; CarrieLyn Donigan; Kimberly Davenport; Victoria Kostadinova; Elizabeth Peyton; Gayle Velardi; and especially Jessica Dobratz, who must be singled out for her exceptional dedication during key moments of this project's preparation.

This book was masterfully designed by Marc Zaref, Alison Jones, Alice Kang, and Lisa Sloane of Marc Zaref Design. Its production was organized and expedited by Myrna Smoot, Nancy Grubb, and Dana Cole at Abbeville Press. Adriane Fabio and Elizabeth Gemming compiled the Index. For photographs and reproduction rights we thank Joe Szaszfai and Michael Agee at Yale, Liane and Martin Atlas, Laure Barbizet, Cécile Brunner, Starr Figura, Wayne Furman, Friedrich Kessler, Calman A. Levin, Ulla Lundgren, Carmela Marner, Nancy Boyle Press, Samar Qandil, Aileen Silverman, Sylvia Slifka, Hélène Strub, Richard L. Tooke, Barbara Trelstad, Verena Villiger, and Patricia Willis. And for their able assistance with translations, we wish to acknowledge Celene Abramson, Eric de Chassey, Philippe Hunt, Yasmina Mobarek, and Maria Watroba.

Sasha M. Newman
The Seymour H. Knox, Jr. Associate Curator of European and Contemporary Art

Sasha M. Newman

Introduction

Artist and author, anarchist rebel and solid bourgeois, Félix Vallotton eludes characterization as he eludes the more Paris-centric views of Post-Impressionism. His oppressive, even hostile interiors, unprecedented in the late nineteenth century, firmly reject the sumptuous organic vision of Nabi intimates like Edouard Vuillard and Pierre Bonnard, artists in whose milieu Vallotton nonetheless participated. He painted portraits with a primitivist vigor that rivaled Le Douanier Rousseau, yet was equally capable of producing a society formula for money. A powerful graphic artist, he manifested in his extraordinary woodcuts of the 1890s an overwhelming disdain for the attitudes and aspirations of the *haute bourgeoisie*, yet he embraced that class through his marriage in 1899 to Gabrielle Rodrigues-Henriques. Ultimately he painted monumental nudes with an insistence and force that belied the classical heritage he so often expressed a desire to embrace.

The greatest challenge in addressing Vallotton's work is the reconciliation of these persistent oppositions. If a consistent vision can be said to exist, it is in the way this artist emphatically privileged his position as spectator or voyeur—whether of the physiognomic details of social agitation and political injustice, or of marital discord and a woman's naked body. Such a recognition and exploitation of the power of a visual record seem particularly significant in an era that witnessed the explosion of the mass media and its concomitant specters of sensationalism, commercialism, and greed. In producing these visual records, Vallotton remained always the detached observer purposefully unimplicated in their substance. Such an attitude was shared by any number of his contemporaries who considered themselves essential witnesses to this very particular fin de siècle age of anxiety and appetite.[1] Victor Joze, a colleague and kindred spirit at *La Revue blanche* and other literary reviews to which Vallotton contributed perhaps best expressed this stance: "I am only a spectator, a passerby who travels the highway of life and interests himself in the battle of the human insect. I observe the diverse

1. Detail of *Interior with Woman in Red Seen from Behind*, 1903 (see plate 36)

manifestations of the social movement, I am philosophically incapable of hating. I do not curse. I record."[2]

When Félix Vallotton left Lausanne for Paris in February of 1882, he fulfilled a destiny that by then had become a novelistic cliché: an idealistic young provincial, generally with artistic aspirations, quits the protected world of his birthplace and seeks his fortune in one of the great capitals of the industrialized West.[3] Only seventeen, Vallotton was a recent graduate from secondary school, where he had pursued a standard classical course of study, interspersed with advanced drawing classes and repeated visits to the local museum. With an insistent ambition to be a painter but very little money, he left behind a bourgeois and resolutely Protestant upbringing in a bustling but isolated Swiss canton to come to Paris. There he joined the legion of foreign artists who flooded the city between the two international exhibitions of 1878 and 1889 to study, exhibit, or simply assimilate the tremendous activity of the French art world.[4] Vallotton distinguished himself from many of these foreigners in that French—though the French of the Vaudois, not of Paris—was his native language.

So one might express the central dichotomy of Vallotton's career: the artist who would be French (and in fact did become a French citizen in 1900), but whose art was rooted in local traditions.[5] Yet how can one specify or define these "local traditions"? Switzerland was, after all, a country of four languages and

2
Edouard Vuillard (1868–1940)
Félix Vallotton, ca. 1900
Distemper on board, 63 x 49.5 cm
Musée d'Orsay, Paris

3
Vallotton and Misia in the Dining Room, rue Saint-Florentin, 1899
Oil on board, 67.7 x 50.6 cm
William Kelly Simpson Collection

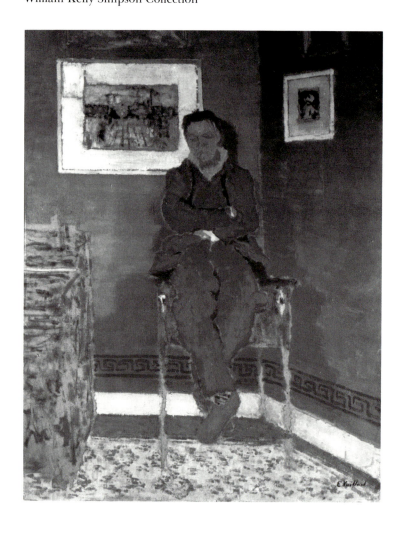

4
Self-Portrait, 1897
Oil on board, 58 x 47 cm
Private Collection

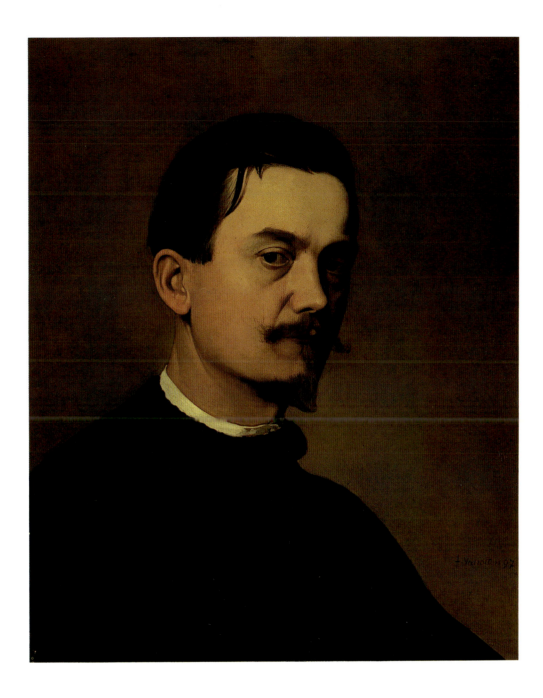

consequent regional and cultural differences that directly inhibited the development of a single national artistic identity.[6] The one exception was the Alpine landscape, upon which nearly every text on nineteenth-century Swiss painting focused as a source of both artistic inspiration and nationalism. Yet Vallotton's own forays into this terrain were limited.[7] Unlike his peer Ferdinand Hodler, he preferred the particulars of France's regional landscapes over the well-known peaks of his homeland. Perhaps this can be attributed to the fact that Hodler remained in Switzerland for his artistic studies while Vallotton, like the majority of his compatriots, went abroad.[8] Switzerland had not developed its own academies, nor any specific professional training programs for artists except in the application of art to craft and industry. There were few collections open to public view and even fewer exhibition possibilities available to young artists. All artistic

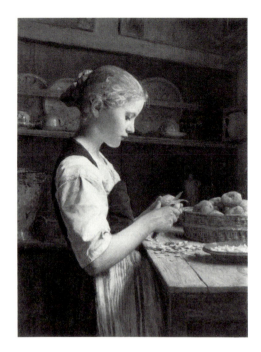

5
Albert Anker (1831–1910)
Girl Peeling Potatoes, 1886
Oil on canvas, 70.5 x 52.2 cm
Private Collection

activity was intimately related to the Swiss bourgeois image and social structure; the prevailing attitude was that education in art was important for the general acculturation of man and society but not for the foundation of a career.

Vallotton's move to Paris was thus an escape from the circumscribed limits of a Swiss artistic career; but the attitudes he had absorbed as a young man were not so easily or even so willingly shed. It is poignant to read of his father's concern about Vallotton's career and to recognize in the letter of response from Félix's art school professor, Jules Lefebvre, the anxieties of a parent who wished his child to be economically well-situated in the world. Lefebvre reassuringly suggested that Vallotton needed only his parents' encouragement and confidence to achieve his potential.[9] The artist himself would oscillate throughout his life between goals of financial security and artistic autonomy.[10] As a result, his graphic work could include within the same six months acerbic prints for pro-Dreyfus journals as well as portrait commissions of figures notorious for their anti-Dreyfus stance.[11] In later years he would balance his production of disruptive and uncanny large-scale nudes with that of society portraiture.

Nor did Vallotton wholly abandon the visual models that he had so assiduously studied as a young man. Swiss painting at mid-century that was not devoted to landscape motifs was generally trapped within the confines of genre realism, as practiced by painters like Albert Anker.[12] Trained in Paris, Anker returned every summer to his native village of Anet, near Bern, where he devoted himself to such meticulously detailed, if sentimentalized, rural themes as *Girl Peeling Potatoes* of 1886 (plate 5). Vallotton himself responded to this Swiss genre tradition in such paintings as *The Kitchen* (LRZ 122; plate 6) or *The Sick Girl* (plate

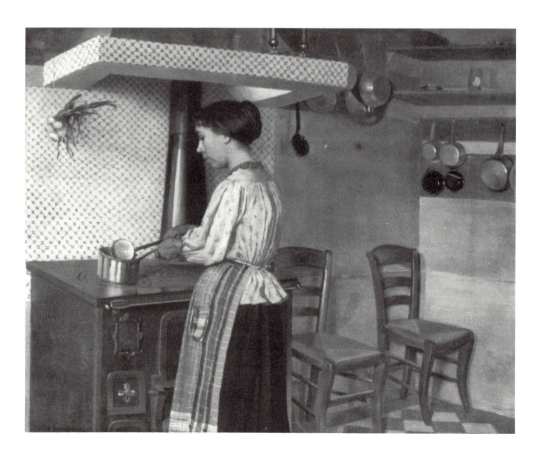

6
The Kitchen, 1892
Oil on wood, 33 x 41 cm
Private Collection

8), both of 1892. The latter, painted after a ten-year residence in Paris, also makes a specific nod to a more historical Swiss source, Jean-Etienne Liotard's *Breakfast* of 1754 (plate 7). Within a few years, Vallotton's genre treatment had metamorphosed into the strange dislocations and caricatural acidity of his interiors of the 1890s, a trajectory that exposes both the roots and the shocking originality of his conception.

Other Swiss painters, particularly Charles Gleyre and Arnold Böcklin (plate 224) were also essential to Vallotton's formation, although both lived and worked outside the country. Gleyre, arguably the most celebrated Swiss painter of the nineteenth century, was the model of academic success: having studied with Ingres, his fame rivaled that of any of the other *pompiers*, and his private atelier in Paris trained huge numbers of students.[13] Initially the young Vallotton aspired to such successes. Yet in 1893 he submitted *Bathers on a Summer Evening* (plate 148) to the Salon des Indépendants, a painting that parodied the well-established formula of the academic nude staunchly evinced by Gleyre himself. With later mythological nudes like *The Rape of Europa* (plate 38), Vallotton engaged in a reinvention of the traditions of history painting. While such works alluded to earlier academic ambitions, their perverse, acerbic, even cartoon-like quality was closer to Böcklin—a painter in whom Vallotton seems to have found a kindred spirit—than to the neo-Grec Gleyre. Vallotton's review of the Böcklin retrospective in Basel in 1897—published in *La Revue blanche*—reveals his close study of Böcklin's production, as well as his admiration for the older Swiss painter's treatment of the figure and the silhouette, which Vallotton described as bitter, passionate, and original.[14]

When Vallotton arrived in Paris in the late winter of 1882, France had had a decade to recover from the humiliating defeat of the Franco-Prussian War and the brutal massacre of the leftist Paris Commune. Paris itself was resolutely embracing its role as a vibrant center of consumer culture, as department stores, theatrical spectacles, sporting events, and leisure travel multiplied with ever-increasing ferocity. This rollercoaster ride of material consumption was parallelled in the political arena. Life in the city was marked by a persistent insecurity, provoked by the feeling that the country was weaving from one crisis to another. Hence, there were as many *nouveautés* in the political spectrum as there were in the Bon Marché. Since 1870 social and socialist agitation had been on the rise. Equally evident, however, were anti-parliamentary forces eager for a return to monarchic traditions and military glory. Moreover, shifts between these extremes of left and right were enacted with a blinding rapidity, leaving little chance for continuity or consistency. Nationalism existed side by side with Social Marxism and anti-Semitism; and while the election of 1877 registered a failure of the monarchist right, the newly elected Republican concentration headed by Jules Grevy was ultimately a choice that satisfied neither the clericals and the reactionary monarchists nor the workers. It was, however, during this initial establishment of the Republican regime that the Freedom of the Press Law of 1881 was passed. The elimination of government censors contributed significantly to the rapid increase in the number of popular dailies as well as to the onslaught of reviews specializing in political and social satire. And the rise of sloganry and campaign bandstanding caused election battles to be fought with a sensationalism recognizable today. Technical advances in lithographic and photomechanical reproduction contributed to this expansion; whether financial scandal or fashion item,

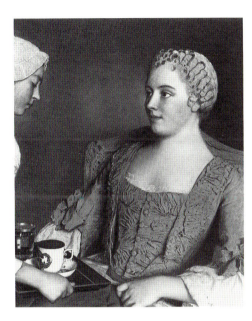

7
Etienne Liotard (1702–1789)
Breakfast, 1754
Pastel, 34 x 19 cm
Bayerische Staatsgemäldesammlungen,
Alte Pinakothek, Munich

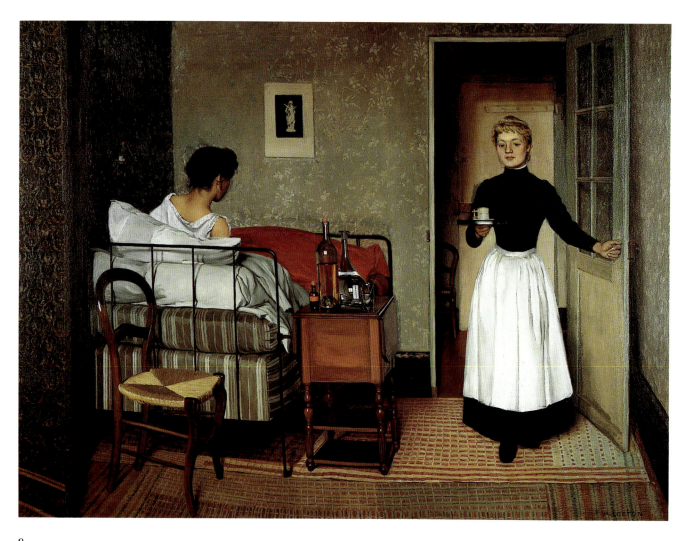

8

The Sick Girl, 1892

Oil on canvas, 74 x 100 cm

Galerie Vallotton, Lausanne, Private Collection

information and illustration were disseminated with the same intensity and theatricality. The golden age of a popular press greedy for news and rarely restrained by libel laws had begun.[15]

Vallotton, who in the decade of the 1890s would become one of the most important artists of this graphic phenomenon, actually entered this milieu rather slowly. From 1882 until 1885, when his *Portrait of Monsieur Ursenbach* (plate 114) appeared at the Salon des Artistes français, Vallotton focused exclusively on his work at the Académie Julian, having chosen to attend this alternative academy rather than the Ecole des Beaux-Arts to which he was also accepted. Initially opened by Rodolphe Julian in 1868, the Académie Julian accommodated the myriad foreign students not accepted at the Ecole des Beaux-Arts because of the language exam required for entrance; it was so successful that a number of franchises were opened throughout Paris between 1878 and 1892.[16] Four of the best-known and most well-connected professors from the Ecole des Beaux-Arts —Jules Lefebvre, Gustave Boulanger, Tony Robert-Fleury, and Jean-Paul Laurens—visited the ateliers on a weekly basis and through their considerable influence helped favorite students get admitted to the salons, as Lefebvre did for Vallotton in 1885.[17] The essential guiding principles of the Académie Julian did not differ acutely from those of the Ecole. Drawing was considered the corner-

stone of art, Ingres was preeminent, and work from the model was the focus of study. Yet the Julian also offered courses in the "minor arts" of lithography and printmaking: a timely response to the media explosion, which increased the economic opportunities of many aspiring artists. And students were allowed to pursue their work with little interference. Such freedom from professional standards, from a rigorous and increasingly meaningless curriculum, combined with the students' right to choose and pose their own models, encouraged many who could have or did attend the Ecole des Beaux-Arts—Vallotton in the former case, Pierre Bonnard and Edouard Vuillard in the latter—to enroll at the Julian.

While Bonnard and Vuillard were to become Vallotton's Nabi "brothers" as well as his colleagues at *La Revue blanche* during the subsequent decade, he did not know them at the Julian.[18] It was the French painter Charles Maurin, who had been a student there in the 1870s and became a professor in 1885, who took Vallotton under his wing and introduced him to bohemian life. Their correspondence in the years between 1884 and 1892 is extensive and revealing.[19] Ten years older than Vallotton and of a more irrepressible temperament, Maurin—whose letters all begin tongue-in-cheek, "my dear Wallotton,"—reproaches the younger,

9
The Ball, 1899
Oil on board on wood, 48 x 61 cm
Musée d'Orsay, Paris, Legs. Carle Dreyfus

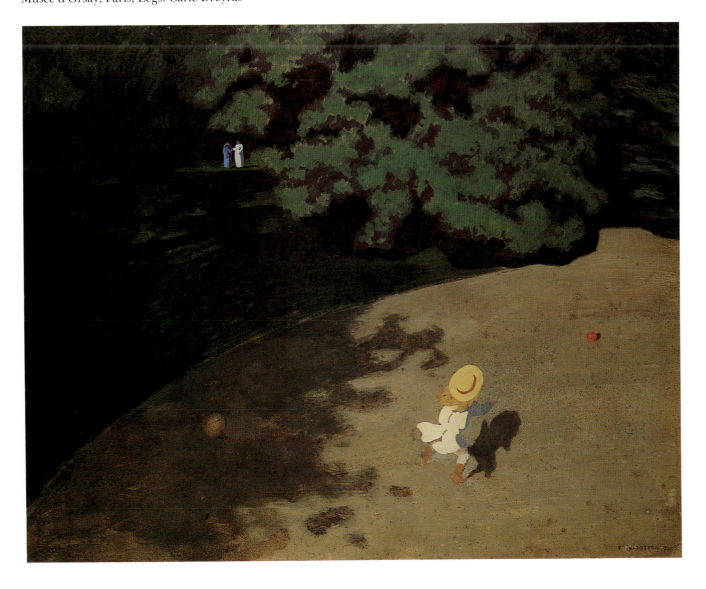

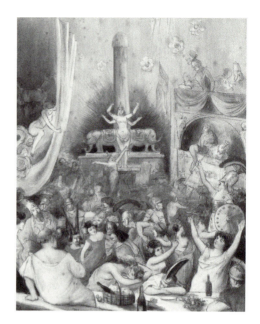

10

Charles Maurin (1856–1914)

Ball at the Quat'z'Arts, ca. 1894

Pastel, 61.5 x 48.5 cm

The Jane Voorhees Zimmerli Art Museum, Rutgers, The State University of New Jersey, Gift of Carleton A. Holstrom

more cautious artist for his reserve, his financial concerns, his lack of independence, his order. And indeed, as Vallotton would later confess in a letter to Vuillard, he did have a taste for measured calm, for a harmonious life "without history."[20] Moreover he shared his father's concern about his ability to achieve economic security as a professional artist. Maurin, who clearly admired Vallotton's talent, disrupted this world view, which he considered to be a holdover from Vallotton's stolidly bourgeois Swiss upbringing. As he wrote the artist in 1886: "Your letter disturbs me, it seems to me that you do not enjoy your profession, which alone can raise your spirits; I have already written to you that one must not expect to make a fortune in painting, as commerce or anything else would be more profitable."[21] Certainly Maurin understood Vallotton's need to support himself; he helped him get the commissions for the copies, conservation, and portraits that allowed Vallotton to remain in Paris.[22] Yet he counseled him again and again to embrace painting as more than a metier, urging him to forge a new way of seeing by discovering and exploiting the primitive within himself: "in spite of all the masterpieces that I see in a museum I tell myself without pretension that I don't see nature like all these other artists, and my way alone if I can ever discover it will be interesting, it is this way of seeing that is new despite painting's oldness, it is you who can be new, but it is first necessary to rediscover one's virginity, to have personal impressions."[23]

In teaching Vallotton to discover himself Maurin also introduced him to the cafés and cabarets of Montmartre, which had become the center of avant-garde artistic activity in Paris in the early 1880s.[24] Le Chat Noir, run by Emile Goudeau and Rodolphe Salis, was perhaps the most notorious of these cabarets (plate 11). A frequent visitor, Vallotton experienced there that spirit of *fumisme* so characteristic of the French artists and writers of his generation who, despite their different political attitudes—and these were many—shared a refusal to treat the official world with seriousness and respect. Although bourgeois patrons were

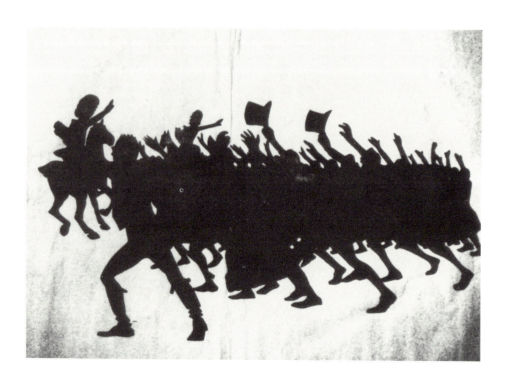

11

Caran d'ache (1859–1909)

The Epopee, silhouette for the shadow theater at the Chat Noir Cabaret, 1888

Zinc cutout, 31 x 64.5 cm

Geneviève Noufflard/Mrs. H. Guy Loé

12
Pierre Bonnard (1867–1947)
The Street in Winter, 1894
Oil on wood panel, 26.7 x 34.9 cm
Dallas Museum of Art, The Wendy and
Emery Reves Collection

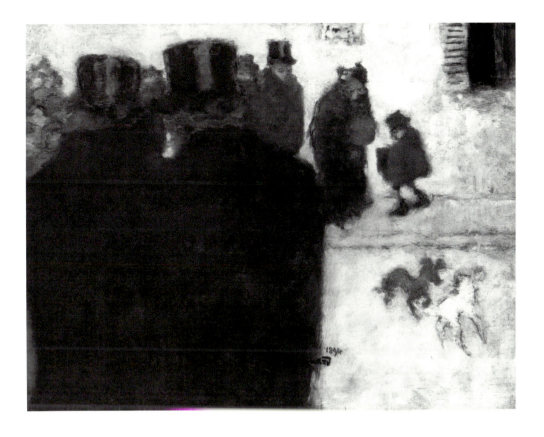

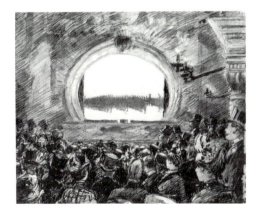

13
Henri Rivière (1864–1951)
**The Shadow Theater at the Chat Noir
Cabaret,** ca. 1888
Pen and ink and gouache on Gilot paper,
19.5 x 19 cm
The Jane Voorhees Zimmerli Art Museum,
Rutgers, The State University of New Jersey,
Mindy and Ramon Tublitz Purchase Fund

served with exaggerated consideration, Le Chat Noir—and the newspaper of the same name edited by Salis—in fact treated everyone and everything with the ironic disdain of a practical joke. There Vallotton could rub shoulders with a bizarre parade of visitors who ranged from Maupassant to Edmond de Goncourt, from Toulouse-Lautrec to General Boulanger and the Prince of Wales. There he saw the brilliant silhouettes of Henri Rivière's shadow theater (plate 13) and participated in the bacchanalian rituals of the art students' Bal des Quat'z'Arts (plate 12). And it was certainly in such a milieu that he evolved the distinctive caricatural vision apparent not only in his graphic work but also in the cold and satirical eroticism of such paintings as *Bathers on a Summer Evening*, which so shocked the conservative critical public when it was exhibited at the 1893 Salon des Indépendants.

Maurin's role in Vallotton's life and art was not, however, limited to the simple revelation of the secrets of Montmartre. He was also responsible for introducing the younger artist to the woodcut, the medium which Vallotton would go on to exploit with such brilliant and innovative intensity throughout the 1890s. Having been received into the highly charged social and political mix of Montmartre café society, Vallotton was increasingly avid for a vehicle of expression that would not only allow him to engage in the myriad illustrational possibilities available in the burgeoning popular press, but would effectively express the blunt, unmodulated, primitive voice Maurin had been encouraging.

Ironically Maurin, who first began experimenting with the woodcut between 1890 and 1891, never fully connected with the power of the medium, achieving instead a surprisingly lyrical, even traditional, lithographic effect.[25] It was Vallotton whose first attempt—the portrait of Verlaine reproduced in Octave

14
The Bistro, ca. 1895
Oil on canvas, 22 x 27 cm
Mr. and Mrs. Arthur G. Altschul

15

To Paul Verlaine *(A Paul Verlaine),* 1891

Woodcut, 13.1 x 10.7 cm

Yale University Art Gallery, Gift of Eric Gustave Carlson, B.A. 1962, in honor of Professor Robert L. Herbert, 1974.9.5

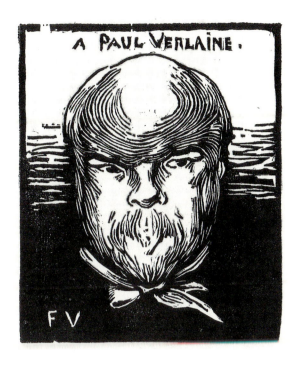

Uzanne's article on Vallotton in the 20 February 1892 issue of *L'Art et l'idée* (VG 80; plage 15)—literally blew away previous technical traditions. Between 1891 and 1894, the same years that he would begin to participate in the exhibitions of the Impressionists and Symbolists at the Barc de Boutteville, as well as in the Salon de la Rose + Croix and the Salon des Indépendants, his woodcuts appeared in a huge number of literary and political journals.[26] *L'Escarmouche, Le Rire, Le Courrier français, La Revue blanche, Le Mercure de France, L'Assiette au beurre, Les Temps nouveaux,* and *L'Ymagier*—not to mention foreign publications like *The Chap Book* in Chicago, *Scribner's* in New York, and *Die Jugend* in Munich—all solicited work from Vallotton frequently and continually throughout the 1890s.

The early 1890s also seem to have been the period of Vallotton's most explicit political engagement, despite his self-conscious and fashionably cultivated stance of non-partisan recorder. It is impossible to establish with absolute certainty the nature of Vallotton's political views, or the extent of his political involvement, largely because the contemporary French political spectrum was so volatile and so ambiguous. Of the artists with whom he was most often linked, only Alexandre Steinlen, Henri Ibels, and Maximilian Luce were actually positioned to the left as anti-military anarchist-socialists. Jean Forain and Caran d'ache were pro-military and reactionary as well as anti-Semitic; and Toulouse-Lautrec was notoriously apolitical.[27] Yet Vallotton's strongest links in these years were with the Steinlen, Ibels, Luce crowd. He did a number of illustrations for specifically anarchist journals, some commissioned, others submitted: *Le Père peinard* and *Les Temps nouveaux* as well as *La Revue anarchiste,* founded by Ibels' brother André in 1891. It is important to remember, however, that French anarchism was often more a matter of sensibility than of doctrine, despite the fact that the division between the anarchist agitators and the socialist left was clear. The latter wanted to remake the state for the oppressed; the former, whose ideologues were Pëtr Kropotkin and Jean Grave, wanted to abolish the state.[28] The deep pessimism

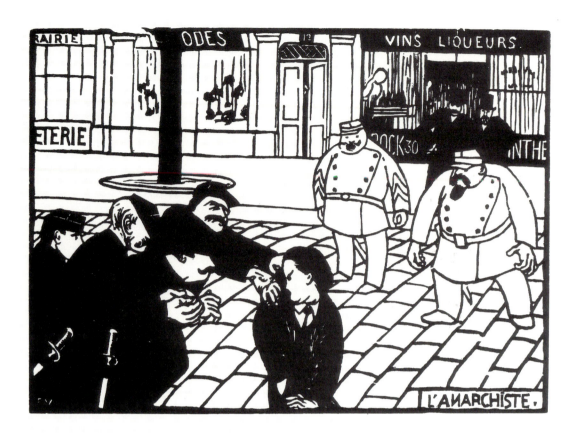

16

The Anarchist *(L'Anarchiste)*, 1892
Woodcut, 17.1 x 25 cm
Galerie Vallotton, Lausanne

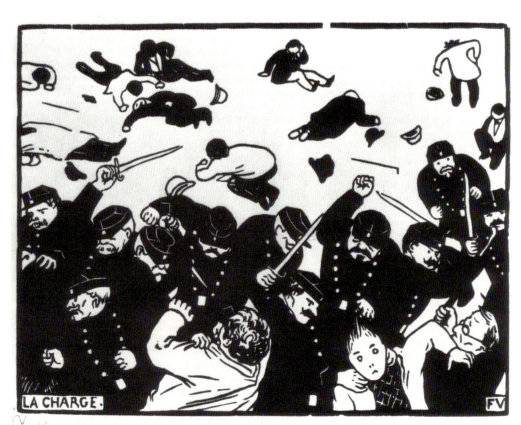

17

The Charge *(La Charge)*, 1893
Woodcut, 20 x 26 cm

Print Collection, Miriam and Ira D. Wallach
Division of Art, Prints and Photographs,
The New York Public Library; Astor, Lenox
and Tilden Foundations

18

The Demonstration (*La Manifestation*), 1893
Study for the woodcut, "The Demonstration"
India ink, lead pencil, and scraping on cream
wove paper, 20.3 x 32.5 cm (image)
Galerie Vallotton, Lausanne

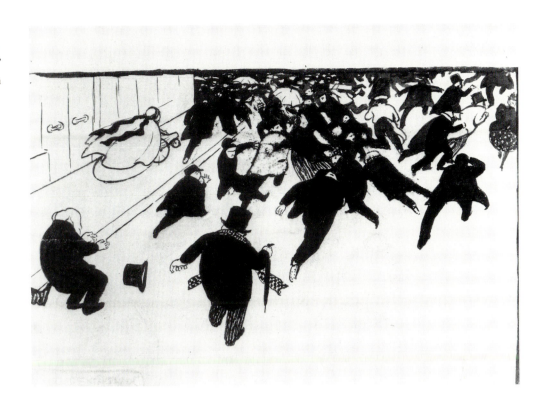

espoused by Grave as to man's ability to live in harmonious social accord certainly reflects Vallotton's own attitudes. As reformers inevitably become oppressors, any new form of government is ultimately futile.

Anarchists were activists. Their deeds were those of insurrection, with all the attendant theatricality of today's terrorism and agit-prop. They lived the life of the raw street, a subject that itself was insistently felt throughout Vallotton's work of the 1890s in both prints and paintings.[29] Many of Vallotton's most provocative graphic works, among them *The Anarchist* and *The Charge* of 1892, and *The Demonstration* of 1893 (plates 16–18, 56), parallel the period of real anarchist frenzy in Paris beginnning with the riots of 1 May 1891 and ending with the fatal stabbing of Sadi Carnot, president of the Third Republic, on 24 June 1894.[30] Each bears witness to Vallotton's ability to classify and to identify the social types of rigorously stratified Parisian society. Certain figures like the well-turned-out portly bourgeois in his checked coat and top hat appear again and again in the prints and paintings of these years. In *The Anarchist* a vulnerable young man shrinks from the grip of a fat policeman; in *The Charge* brutal police methods are made even more explicit as figures fly through the air from the force of the policemen's clubs; and *The Demonstration* is an extraordinary shorthand presentation of a crowd—as if Seurat's *La Grand Jatte* had suddenly been animated. Such woodcuts and others executed in the same years indicted, as did the anarchist activities themselves, private property, governmental injustice, police brutality, and compulsory military service.

Through these years one has the sense of an increasingly assimilated Vallotton who comfortably rubbed shoulders with his Parisian colleagues and was rapidly gaining stature as an artistic personality. Yet for all of his attributed Frenchness, the strange density of Vallotton's graphic vision had strong Nordic

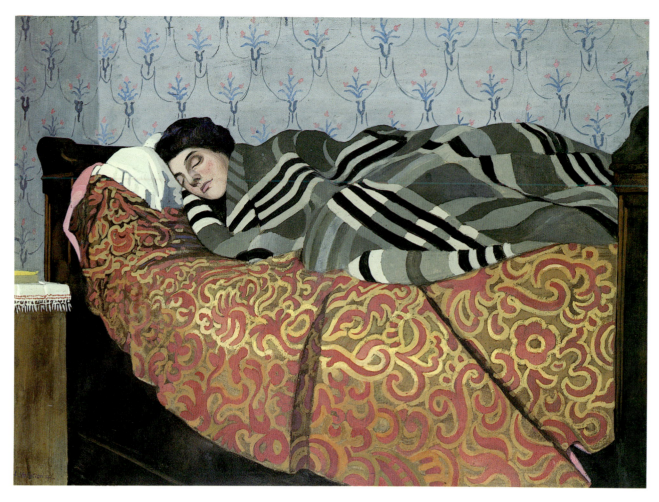

19
Sleeping Woman, 1899
Oil on board, 56.5 x 76 cm
Private Collection

and German ties. The correspondence between Maurin and Vallotton includes many references to the fifteenth-century Flemish and German painters both artists revered, as in the following letter written during Maurin's trip to the Netherlands and Belgium in the early fall of 1888:

> I'm back from Holland—Visited Brussels, Antwerp, the Hague—Scheveningen, Haarlem, Zandcoort, Leiden, Rotterdam, Amsterdam,—and all that in eight days, you see it here at a jog from the train station to the Museums—Struck by the country, and by the primitives I saw here and there, nothing of Bruges, and I regret it,—Matsys [sic], Cranach, Jean Stein [sic], Peter [sic] de Hooch, and Raveinstein [sic], Franz Hals, and Albert [sic] Dürer are some of the admirable unknown masters—The Adam and Eve of Van Eyck and the Christ of Matsys [sic] are again strongest.—Rembrandt ? Rubens,—disappointing, but Jordaens on the other hand, Oh! Ah! . . . we'll talk of that—Saw a proof by Dürer (the Adam and Eve), its will is unprecedented—I adore this master he is truly an engraver and I've abandoned Schongauer—My hatred of Italian painting has increased, also of our French painting—Saw some very curious, very personal Liotard pastels in Amsterdam—long live the North and to hell with Italy.[31]

Two years later, during his first major trip since his move to Paris, Vallotton stopped at many of the same museums while visiting Germany, Austria, and Eastern Europe. He also met the German art historian Julius Meier-Graefe, who would author the first monograph on the artist in 1898. Moreover, among con-

20
Ernst Ludwig Kirchner (1880–1938)
Nude on a Patterned Bed Cover, ca. 1904
Woodcut
Collection Unknown

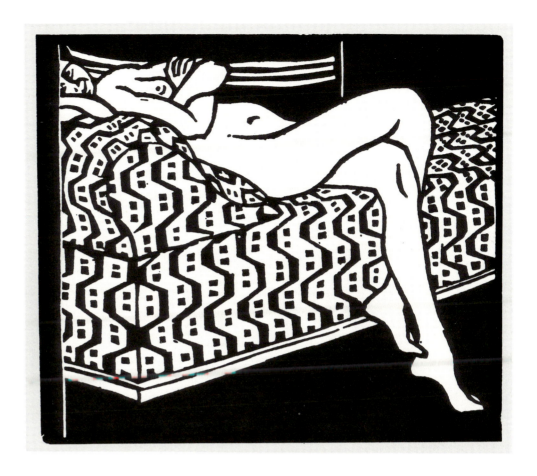

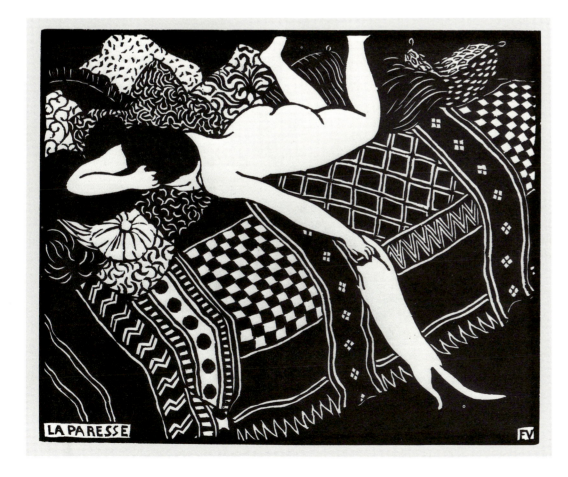

21
Laziness *(La Paresse),* 1898
Woodcut, 17.9 x 22.4 cm
Josefowitz Collection

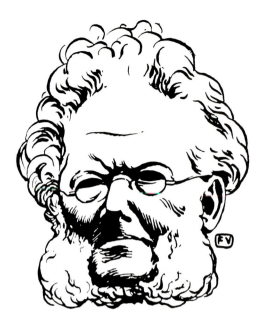

22

Portrait of Ibsen, from Prospectus Program for the Théâtre de l'Oeuvre, 1895–96

Woodcut

The Atlas Foundation

temporary graphic artists, Edvard Munch was clearly an accessible stimulus.[32] And both Munch and Vallotton in turn would become tremendously influential in the woodcut revival initiated around 1905 by the young German artists of the Dresden Die Brücke group—specifically Erich Heckel and Ludwig Kirchner (plates 20, 21). In many ways Vallotton felt himself to be an artist of northern climes. He never embraced the sinuous arabesque and neo-aristocratic rococo traditions of French Art Nouveau despite the fact that he so often worked in the heart of this milieu: the offices of *La Revue blanche* on the rue Laffitte.[33]

La Revue blanche was certainly the most brilliant literary and artistic review of its era. As its title was meant to suggest—white being the synthesis of all the colors of the spectrum—it purposefully denied partisanship and propaganda at a moment when both seemed to reign preeminent. Félix Fénéon would later reminisce: "This review . . . is perhaps even better known today than when, twice a month, its appearance provoked animated discussion. What other publication is still a topic of conversation twenty years after its disappearance? *La Revue blanche* was unique in that, far from playing to the public, each issue offered a salty surprise to its readers, for it was free of moral and social suspicions."[34] Fénéon himself was literary counselor and editorial secretary of the magazine beginning in 1895; his brilliant iconoclastic presence, his elitist views which nonetheless embraced proletarian interests, gave the publication its continued edge.

Founded and managed by the three Natanson brothers, Alexandre, Alfred, and Thadée (plate 125), *La Revue blanche* hosted all of the luminaries of the age. Mallarmé, Jarry, Debussy, Valéry, Proust, Jules Renard, and Romain Coolus all graced its pages and frequented its offices. Lucien Muhlfeld, Léon Blum, and André Gide were, successively, its literary critics. It was as much a home to theater as it was to advanced French and foreign literature. Alfred

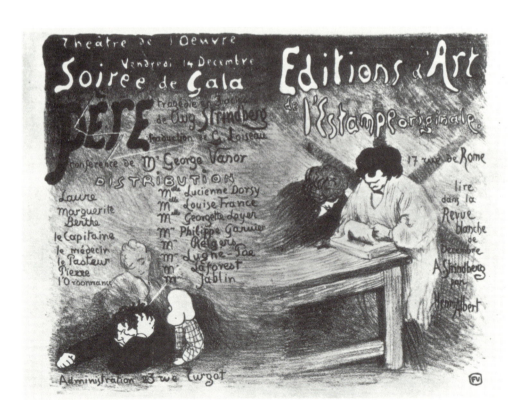

23

Program for Strindberg's "The Father," Théâtre de l'Oeuvre, 1894

Lithograph, 24.4 x 31.8 cm

Yale University Art Gallery, Gift of Eric Gustave Carlson, B.A. 1962, in honor of Professor Robert L. Herbert, 1974.9.3

Natanson was married to the actress Marthe Mellot (plate 124); and Thadée and Misia Natanson went on a pilgrimage to Norway with Lugné-Poe during the summer of 1894 to meet Ibsen and see his plays performed. Productions at André Antoine's Théâtre Libre, which championed dramas of social significance, at Paul Fort's Théâtre d'Art, which introduced audiences to Ibsen, Strindberg, Gerhart Hauptmann, Maeterlinck, Brieux, and Jarry, as well as at Lugné-Poe's well-known Théâtre de l'Oeuvre, were all reviewed in its pages.[35] Vallotton did the lithographed program for Strindberg's *The Father* in 1894 as well as a woodcut portrait of Ibsen which was circulated to promote his plays (plates 22, 23).[36]

24
Edvard Munch (1863–1944)
Portrait of Ibsen, 1895
Oil on canvas, 73 x 101 cm
Private Collection

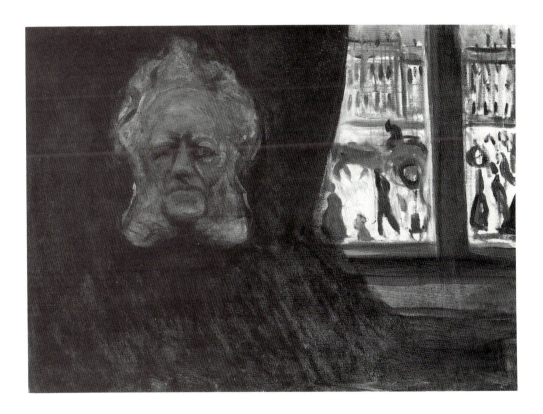

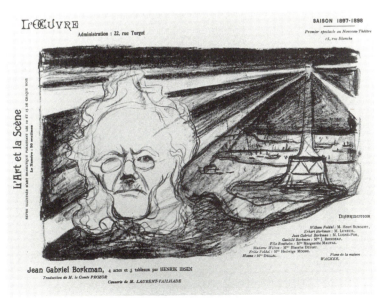

25
Edvard Munch (1863–1944)
Program for "Jean Gabriel Borkman," by Henrik Ibsen, 1897
Lithograph, 28.3 x 38.1 cm
The Atlas Foundation

Vallotton's essentialized style produced a portrait with the economic immediacy of a product or advertising logo. It so instantly became the paradigmatic image of Ibsen that even an artist as insistently interpretive as Edvard Munch used it in a seemingly symbolist portrait of the revered dramatist (plates 24, 25).

Perhaps most importantly, Vallotton's presentation of the interior in the woodcut series *Intimités* of 1898 and the subsequent paintings of 1899, as well as in works like *Dinner by Lamplight* (plate 136), is overwhelmingly theatrical. These figures in their box-like spaces manifest a terrifying sense of entrapment. They are not only fixed in the sinister banality of their recorded activity—whether it be eating dinner or exchanging a duplicitous kiss—but paralyzed by the merciless observation of the viewer. Scenes of supposed intimacy become as public as the life of the street. Despite this concentrated silence, however, this is not only the realm of Symbolist suggestion, for it also incorporates the formal innovations of Rivière's shadow theater into a vaudevillian catalogue of uninflected types, for example "the bourgeois" and "the mistress."

Although over forty artists worked for *La Revue blanche*, it was known

26

The Visit, 1899
Oil on board on wood, 81 x 111.5 cm
Kunstmuseum Winterthur

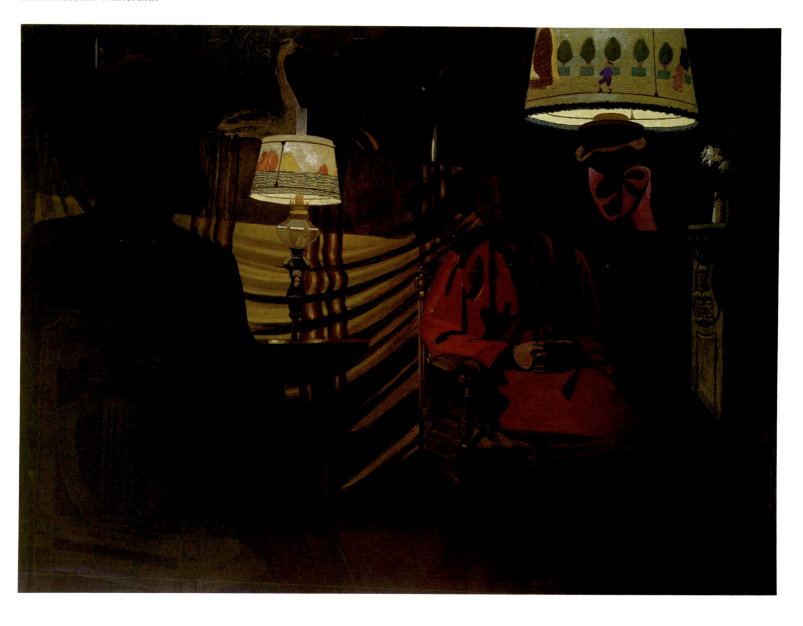

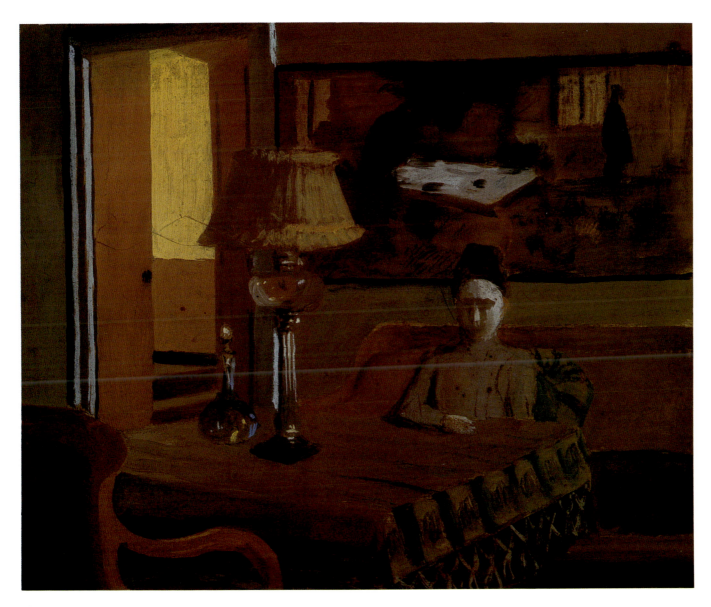

27

Woman in a Purple Dress by Lamplight,
1898

Gouache on board, 29.5 x 36 cm

Private Collection

throughout its fifteen-year run as a journal devoted to the art of the Nabis and their circle, with a particular emphasis on Toulouse-Lautrec, Vallotton, Bonnard, and Vuillard. The latter two developed their decorative style in response to the Natansons' commissions, but Vallotton's participation was primarily that of a graphic artist.[37] Thadée Natanson, the magazine's principal art critic, remembered Vallotton's initial arrival at his offices:

> He arrived here very young and very thin, blonde, with a slightly asymmetrical oval face, a very small moustache and a mere nothing of a goatee. He walked sideways, careful of his steps. If his clothing showed a little thread it wasn't from not having been carefully brushed. He had the air of being constantly on his guard . . .[38]

He also remembered Vallotton's distance and reserve, which only Vuillard or Fénéon could penetrate, as well as his absolute independence in terms of his preferences in painting.[39]

While *La Revue blanche* exemplified the chic liberal and Jewish world of

**Box Seats at the Theater, The Gentleman
and the Lady,** 1909
Oil on canvas, 46 x 38 cm
Private Collection, Switzerland

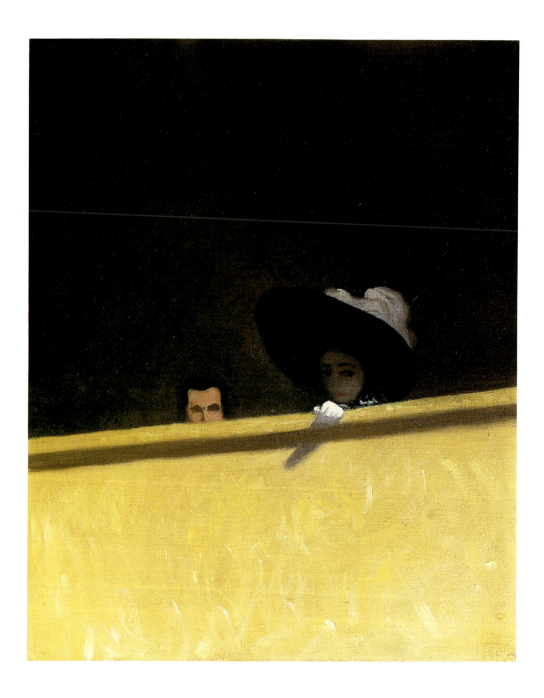

art, politics, and letters, it never displayed any profound political engagement until the notorious Dreyfus Affair.[40] It was among the first to publish articles exposing the irregularities of Captain Dreyfus' 1894 court-martial for treason. And with its sister periodical *Le Cri de Paris*, founded by the Natansons exclusively for the purpose of publishing opinions about Dreyfus, *La Revue blanche* was an essential voice in the clamor for a retrial.[41] While not all of the affiliated artists were active Dreyfusards—Lautrec and Bonnard for example were deliberately non-partisan—Vallotton was an adamant member of the pro-Dreyfus camp. His *The Age of Paper* (plate 32), published one month after "J'accuse," Zola's defense of Dreyfus, appeared in *L'Aurore*, is not only a representation of the Dreyfus Affair as a battle of the journalistic word but a recognition of the overwhelming power of the mass media. Each top-hatted individual hides behind the opinions of his chosen paper, which only reinforces his preexisting prejudices. Yet Vallot-

ton for once did not conceal his personal view. The mastheads are of notoriously pro-Dreyfus papers, subtly inverting the media's own variably propagandizing role. Hence the print itself functions with the decisiveness of advertising or political sloganry.[42] Vallotton remained passionately engaged in the trajectory of the Dreyfus affair, marking its culmination with *The Debacle* of ca. 1906 (plate 33), in which the evil triad of Church, Army and courts has succumbed to the hand of justice, despite their efforts to suppress it.[43]

Although thematically significant, *The Debacle* was in many ways a footnote to Vallotton's career as an illustrational journalist. By 1906, he had already abandoned the graphic arts as his primary mode of expression, refocusing his attention on the medium that first drew him to Paris and continued to compel him most: painting. Only the upheaval of World War I would activate these impulses

29

At the Français, 3rd Gallery, Theater Impression, 1909
Oil on canvas, 45.7 x 37.9 cm
Musée des Beaux-Arts, Rouen

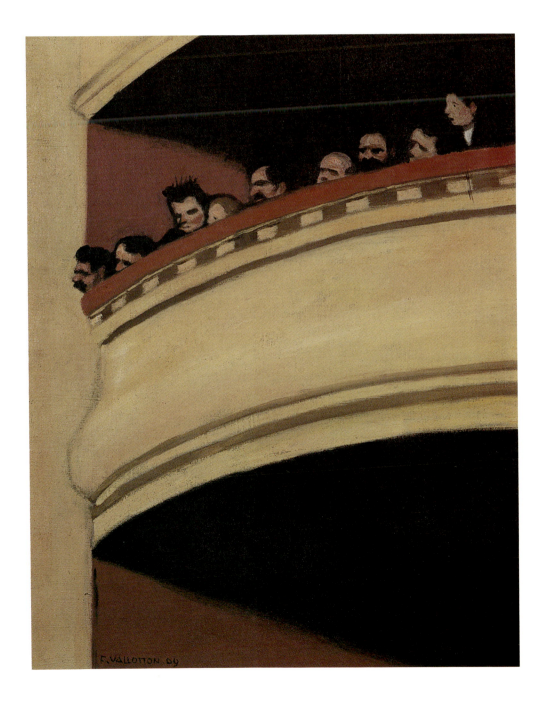

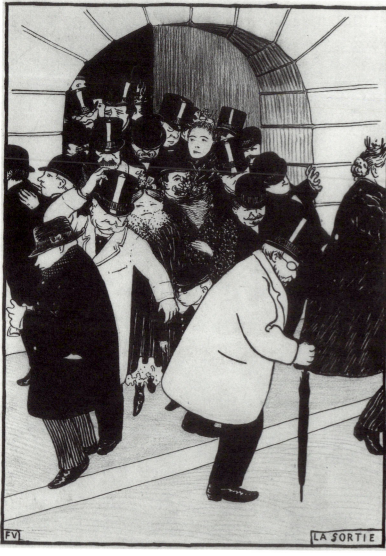

30

The Exit (*La Sortie*), 1894

India ink, pencil, and crayon on paper,
31.7 x 22.9 cm (sheet)

Published in *Le Courrier français*,
13 May 1894

Mr. and Mrs. Arthur G. Altschul

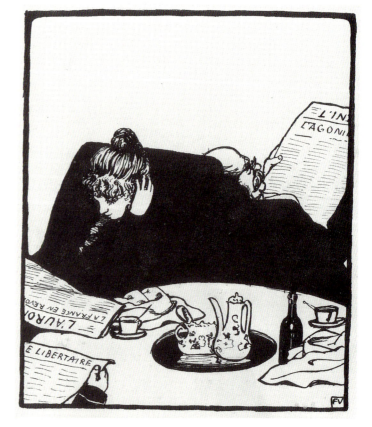

31

At Home, 1898

India ink on paper, 23 x 19 cm (sheet)

Published in *Le Cri de Paris*, 18 December
1898

Private Collection, Zurich

32

The Age of Paper, 1898

Published on the cover of *Le Cri de Paris*,
23 January 1898

Galerie Vallotton, Lausanne

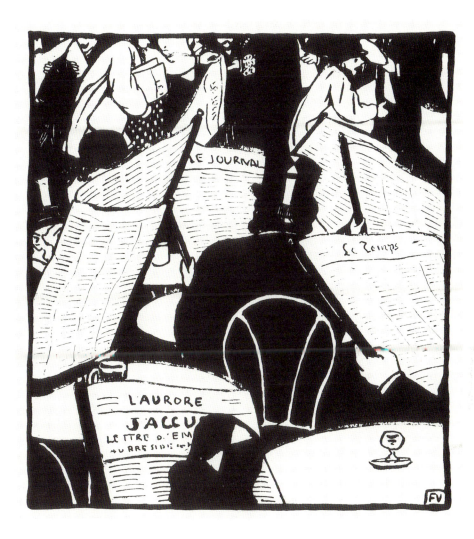

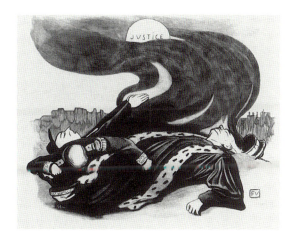

33

The Debacle, ca. 1905

Lithograph (executed by Berger?) after a
drawing by Vallotton

Galerie Vallotton, Lausanne

once again. Yet why did Vallotton, one of the most successful and most innovative of those swept up in the turn-of-the-century print revival, purposefully relinquish the mode of expression for which he had such an extraordinary facility and with which he first achieved fame? Certainly he had always privileged paint as the principle medium of "high" artistic expression, and he often considered his woodcuts a throwaway craft with which he seems to have had a deeply ambiguous relationship.[44] And despite Maurin's earlier insistence, Vallotton did not consider originality, which many contemporaries felt he had attained in his woodcuts, a quality intrinsic or essential to the artistic process. As he wrote in 1905 in response to an "inquiry into recent tendencies in the plastic arts" published in the *Mercure de France*: "I don't believe that art ever takes new directions, its goals are perpetual, immutable, and have been so forever."[45]

The actual event that seems to have made possible this sea change, and that in fact transformed Vallotton's life in all respects, was his marriage in 1899 to Gabrielle Rodrigues-Henriques. Rich, Jewish, a widow with three children, Gabrielle belonged to the same social milieu as the Natansons. She was also the daughter of Alexandre Bernheim, "a great picture dealer" as Vallotton described him to his brother in a letter announcing his marriage.[46] He was in fact one of the most important promoters of Impressionism and Post-Impressionism in pre-

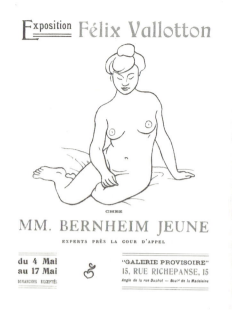

34

"Exposition Félix Vallotton," catalogue cover, Galerie Bernheim-Jeune, 1906
Bernheim-Jeune Archives

World War I France; Fénéon worked for him after the dissolution of *La Revue blanche*, and Vuillard and Bonnard showed with the Bernheim-Jeune gallery until their deaths (plate 34). In this bourgeois marriage in which the ties that bind seem to have been as much those of property and status as those of affection, Vallotton embraced all of the things he had professed to despise—women, children, society, and money—all of the things he had so acidly and effectively parodied in his most acclaimed print series, *Intimités*, ironically published only one year before his nuptials. As a result of his forthcoming marriage, Vallotton's friendship with Maurin—who felt he had sold out to the bourgeoisie—cooled substantially. And Vuillard wrote to Vallotton in response to the news: "There seems to have been a revolution."[47]

In allying his life with Gabrielle's, Vallotton not only renounced the independence he had always guarded so jealously, but also left Hélène Chatenay, the working-class seamstress with whom he had lived since 1892 and who had provided significant emotional support through his early, difficult years in Paris.[48] Friends and family were clearly concerned about Hélène's fate, and Vallotton uncharacteristically felt compelled to explain his actions:

> That which touches me most is that which concerns *la petite*. Since I have known her I have had, and despite everything, will maintain a complete and total affection for her; in acting as I have, I have caused her grief, and I feel it perhaps

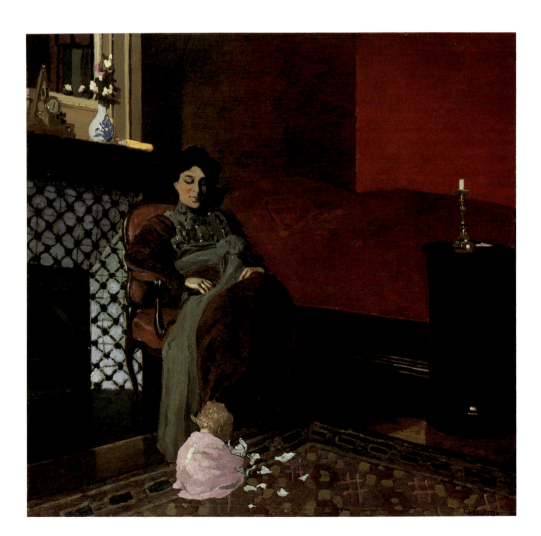

35

Interior, Red Room with Woman and Young Child (Mme. Vallotton and her Niece Germaine Aghion), 1899

Oil on board, 49.2 x 51.3 cm

The Art Institute of Chicago, Bequest from the Estate of Mary Runnells, 1977.606

36
Interior with Woman in Red Seen from Behind, 1903
Oil on canvas, 92.5 x 70.5 cm
Private Collection

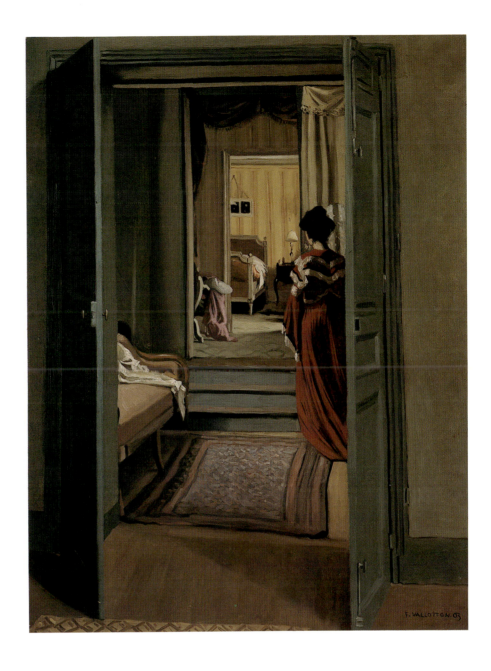

even more than she does, she knows it, she understands my sentiments.—I always told her that I would marry, for several years our relations have been purely amicable; hence I can continue them; my fiancée knows everything, she wants me to stay in touch with her, to help her, to be her best friend and counselor . . . Actually I see her little enough, the form of our relations had changed at any rate, because it is essentially intact, I love her very much and she knows it, my marriage will not change anything.—I tell you this to calm the worry you have over my conduct: I will do all that I am able.[49]

Vallotton's abandonment of Hélène Chatenay for Gabrielle, his departure from his old lodgings on the rue Jacob on the left bank for the distinctly more fashionable and substantially bourgeois rue de Milan on the right—a shift in address well-documented in the paintings of these years (plates 35, 36)—was clearly not effected without conflict. The aversion and hostility that he continued to feel toward a world he had willingly entered found its most overt expression

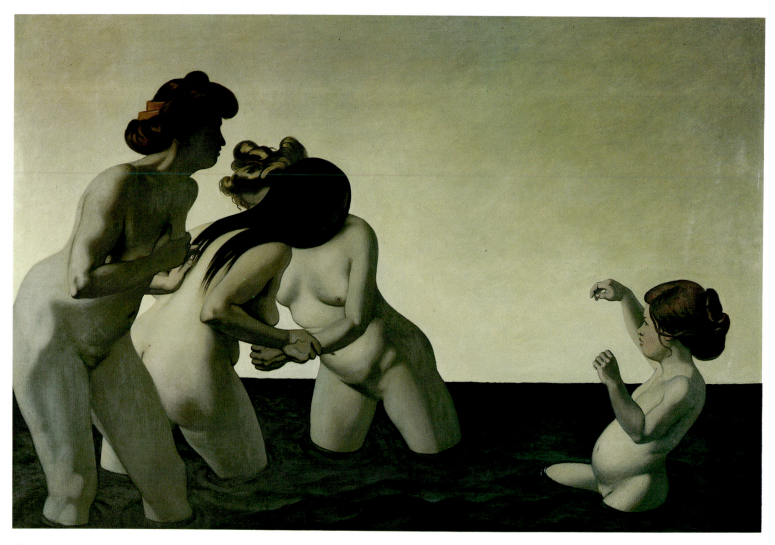

37

Three Women and a Young Girl Playing in the Water, 1907

Oil on canvas, 130.5 x 195.5 cm

Oeffentliche Kunstsammlung, Kunstmuseum, Basel

in the fiction-writing that he pursued avidly in the early years of his marriage.[50] Certainly the guilt and confusion he felt toward Hélène Chatenay were most explicit in his first published novel, *La Vie meurtrière* (The Murderous Life). Begun in 1907, the year Hélène was seriously injured by a passing car, *La Vie meurtrière* was half biography, half fiction. Although Hélène rallied, the accident was greatly debilitating, and she died impoverished and alone in the spring of 1910. Wrote Vallotton to his brother: "I've just learned such sad news, the death of *la petite* Hélène Chatenay which her friend came to tell me. She died quickly of a stroke and I don't think she had time to suffer or even to question what was happening. I feel such grief because although her life was often so hard she had a heart of gold and a good nature. I hadn't seen her for a long time, as she was so capricious, but we received postcards each time she moved. With her died an entire past and a great part of my youth."[51]

Thus, in the first decade of the twentieth century, three of Vallotton's most important youthful contacts were abruptly disrupted: Charles Maurin, Hélène Chatenay, and *La Revue blanche* itself in 1903. In their stead were the complexities of domestic life with Gabrielle—children, apartments, vacations—and, ironically, renewed ties to Switzerland through the patronage of Arthur and

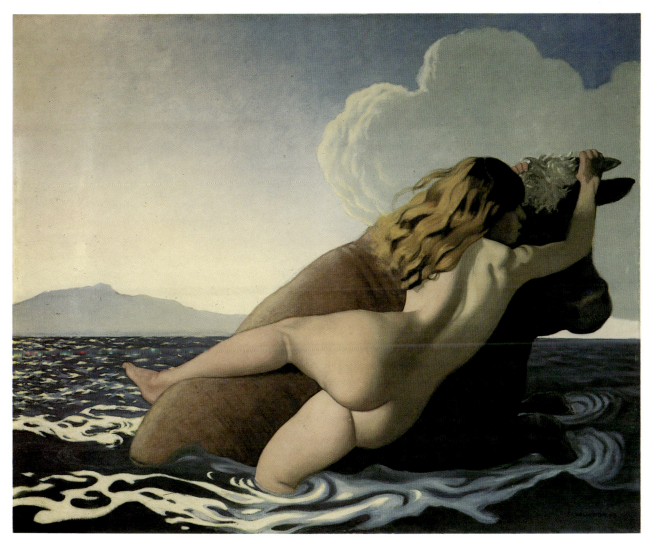

38

The Rape of Europa, 1908
Oil on canvas, 130 x 162 cm
Kunstmuseum Bern

Hedy Hahnloser, whom Vallotton met in 1908. Through the Hahnlosers, Vallotton rediscovered his homeland, a Switzerland no longer characterized by dismal vacations with his family, but rather by a growing recognition of his achievement.[52] In many ways Vallotton's 1902–03 portrait of the Nabis, *The Five Painters* (plate 130), was a *memento mori*—a memory portrait of a brotherhood and a community of artistic aspiration that were coming to an end. By 1903 each artist had begun to pursue his own vision, implicit perhaps but unacknowledged in their earlier work. Maurice Denis and Pierre Bonnard represented the two extremes: the dry academicism of Denis' late style and his commitment to the notorious conservatism and nationalism of *L'Action française*, versus Bonnard's infinitely nuanced exploration of subjective deformation and his purposeful disregard of political strategizing.

And where does Vallotton's post-Nabi work fit into this conundrum? As the essays in this catalogue reveal, the focus of Vallotton's painting began to shift in the period between 1899 and 1903. Beginning with his submission of *Three Women and a Young Girl Playing in the Water* (plate 37) to the Salon d'Automne in 1906, the first in a succession of ambitious submissions through World War I that included *The Rape of Europa, Perseus,* and *Hatred* (plates 38, 195, 193)—one can

39
Chaste Suzanne, 1922
Oil on canvas, 54 x 73 cm
Private Collection

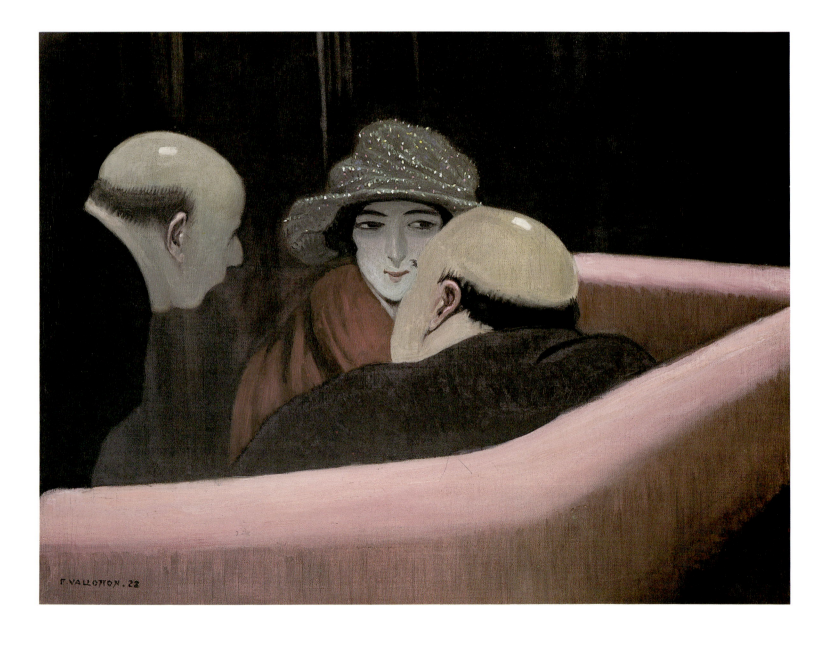

identify the resolution of Vallotton's mature painterly vision. However dramatic this shift may seem, it is in fact one of subject rather than attitude. These nudes collectively embody an approach consistent with, even predetermined by, such early paintings as *Bathers on a Summer Evening* and the suite of six interiors that followed the publication of *Intimités*. As Vallotton categorically rejected Impressionism's disintegration of form, so he also refused the utopianism of the humanist tradition. In his privileging of the nude—a subject replete with historical implications of classicism, hedonism, sensuality, and optimism—Vallotton systematically disrupted traditional expectations with the insistent objectivity of a disenfranchised voyeur.

Although Vallotton's marriage to Gabrielle Rodrigues-Henriques, for whom he seems to have felt a very real affection, gave him the freedom to pursue the painting he wished to investigate, it also reminded him again and again of his refusal—and the failure implicit in that refusal—to explore those French traditions apotheosized in the exhibition policies and attitudes of the Bernheims.[53] As the penultimate choice in a life long characterized by conflict—of place, Switzer-

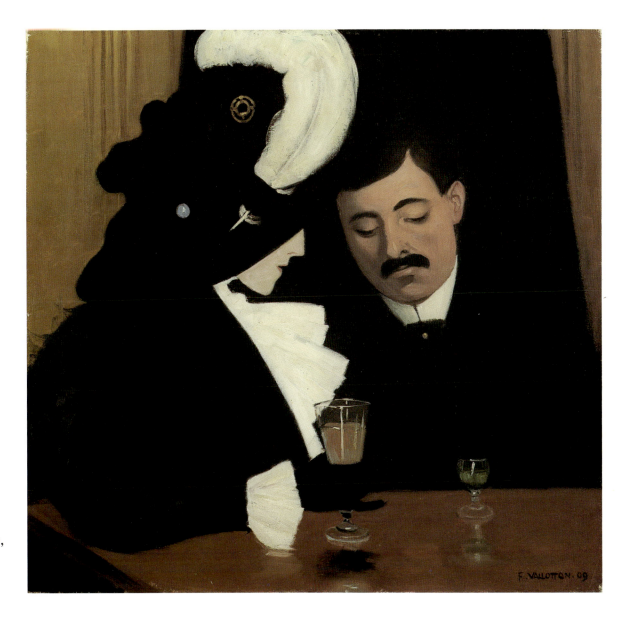

40
At the Café (The Provincial),
1909
Oil on canvas, 50 x 53 cm
Private Collection

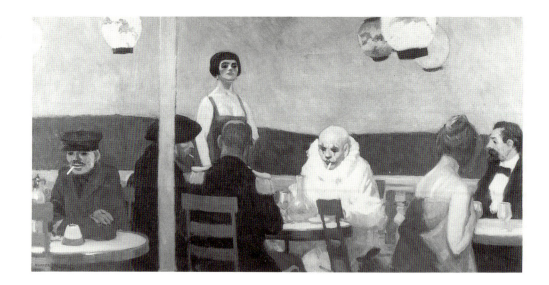

land versus France; of class, bourgeois comfort versus anarchist independence; even of ambition, personal motivation versus public perception—it represents the essential tension so evident in Vallotton's most successful late paintings. In the most aridly terrifying of these works, narrative and sexual elements are so rigidly controlled that the refusal of emotion is itself a position.

Vallotton's post-1900 production necessarily changes the way we view the fate of figurative art in the twentieth century. His late paintings, particularly the nudes, cannot merely be categorized as a conservative retreat from radical abstraction. He does not participate in that nationalistic embrace of the classical tradition so embedded in the Italianate pastorals of Emile Bernard or the lugubrious religious subjects of Maurice Denis, contemporaries whose work did shift significantly from strong Symbolist beginnings. Instead Vallotton must be located in that developing tradition of hyperrealism evident in artists as diverse as Christian Schad and Edward Hopper (plate 41). His realism is predicated upon the potent gap between technical precision and emotional objectivity—a gap made explicit by the omnipresence of photography and the journalistic media. Vallotton's visual record is by no means as uninflected as it initially seems. Also rooted in the unsentimental realism and the airless, crystalline precision of Northern painting, it achieved both a combination of stillness and dislocation as well as a provocative tension between the familiar and the strange. Like the later realists of Weimar Germany, Vallotton exposed the lie of the bourgeois dream. Whereas bourgeois naturalism is warm and ingratiating, Vallotton's art is repressed, rigid, and bleak. While keeping the lexicon of figurative painting intact, he suppressed the individual organic qualities of nude, landscape, or still life into rigorously structured geometric orthodoxies whose formal autonomy denied the human presence that had traditionally been the very center of their meaning.

42

Nude Young Woman on Yellow-Orange
Velvet Background, 1921
Oil on canvas, 100 x 81 cm
Mr. and Mrs. Michal Hornstein, Montreal

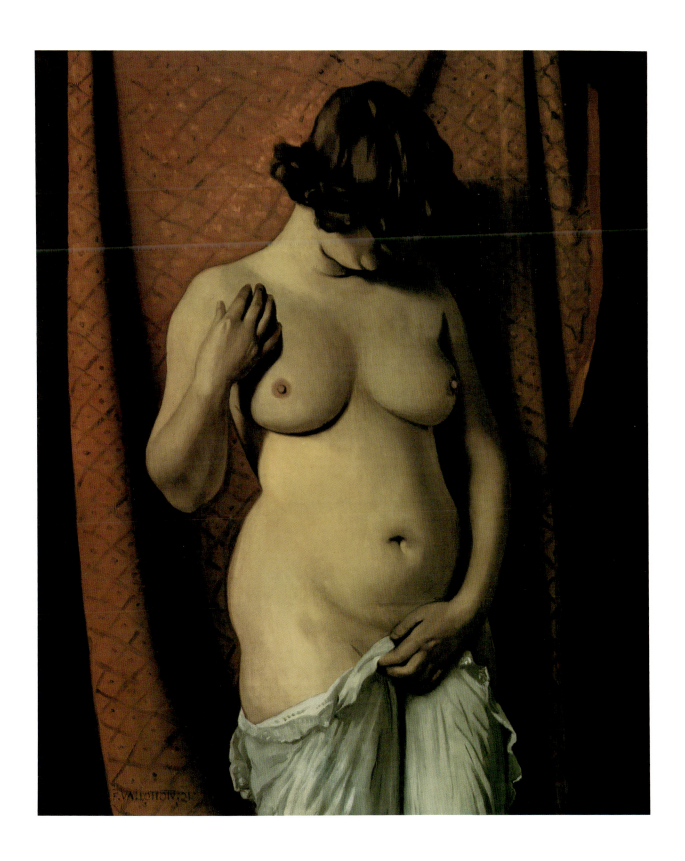

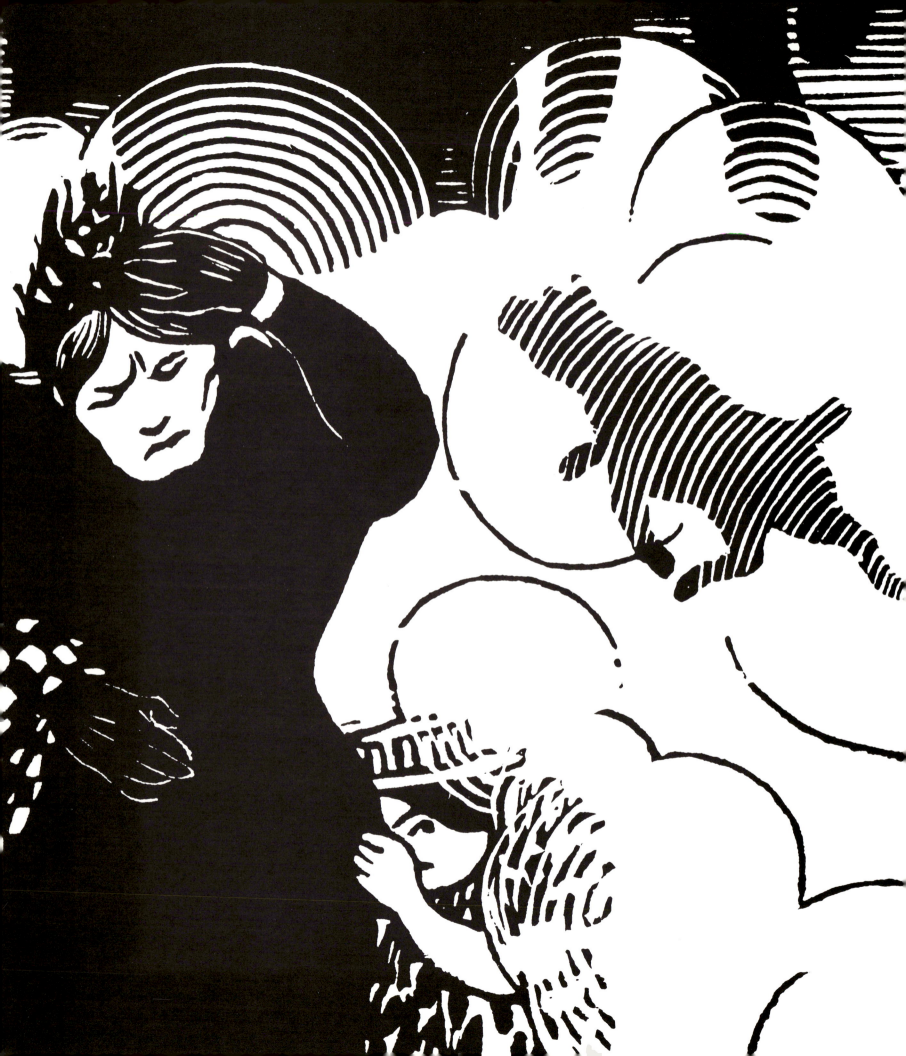

Richard S. Field

Exteriors and Interiors
Vallotton's Printed Oeuvre

Vallotton keeps on the surface; his humor and irony are, so to say,
an armor that prevents him from becoming too deeply involved
in things and at the same time allows him to approach them
without sentimentality.

JULIUS MEIER-GRAEFE, 1898 [1]

Vallotton is usually credited with being one of the initiators of the great woodcut revival that occurred at the end of the nineteenth century. While hardly the first to experiment with the Japanese method of working *with* rather than *across* the grain of the wood—Emile Bernard, Auguste Lepère, Charles Maurin, and Henri Rivière had already adopted this technique—he very quickly exploited the planar and, for him, black qualities naturally inherent in this process to develop a radically reductive idiom.[2] Vallotton has also been recognized for his uncanny ability to fuse a graphic wit with an acerbic if not ironic humor. Yet the particular originality of his social commentaries has not been so clearly perceived. Recent collectors and historians have emphasized the Japanese and the decorative in his work, regarding political and psychological content as secondary to formal innovation. Even the words of one of Vallotton's earliest champions, Julius Meier-Graefe, suggest that such privileging of form and decoration was part of the artist's intentions. Not surprisingly then, the two woodcuts that are now regarded as his masterworks, *The Bath* of 1894 (VG 148) and *Laziness* of 1896 (VG 196; plate 21), are marvelously playful emblems of female vanity and seductivity, in which the artist invented graphically sophisticated equivalents for a pampered and sensual bourgeois existence. But despite their formal cleverness and humor, they are not nearly as central to Vallotton's preoccupations and meanings as are the images that focus on the behavior of crowds and the relationships between man and woman, themes upon which this essay will concentrate.

Nevertheless, it was indeed Vallotton's strategy to keep his viewers on the surface. Although it is inconceivable that his sophisticated compositions of elided black planes and gleaming whites would have been possible without the example of the Japanese woodcut, he was not remotely tempted by the ingratiating color-printing techniques also adopted from the Japanese by Rivière and Lepère.[3] Equally eschewing the entire range of painterly and coloristic subtleties explored

43. Detail of *The Gust of Wind*, 1894 (see plate 76)

by artists as diverse as Whistler, Degas, Gauguin, and Munch, Vallotton had no interest in subtle manipulation of his printing surfaces. They yield unnuanced images, each impression identical to the next: there are virtually no states, no experiments, no different inkings, and little sensitivity to the wide range of papers available for printing. Vallotton also avoided the new "primitivism" practiced by such artists as Bernard: that hacking away of an image from the materials of art in order to reach beyond the veneers of sophisticated technique to what was regarded as a simpler and more universally understood language. Vallotton's process hence mirrored subject; he was far more fascinated by the portrayal of types than he was committed to the sounding of the torments of individual psyches.

It is not surprising, then, to find that a large part of Vallotton's graphic art was geared to a wide audience. In their flatness, his graphics altered the traditional language of caricature, but in their obliteration of all unnecessary detail, they were very much a part of that popularized tradition. Immediately apprehensible through their mastery of space and shape, and through their rendering of typical gesture and expression as well as individual motion and posture, they possessed something of the quality of the instantaneous photograph. And to a greater degree than such contemporaries as Toulouse-Lautrec, Pierre Bonnard, or Théophile-Alexandre Steinlen, Vallotton was able to formulate his images in accordance with a variety of fin de siècle pictorial tastes: those of the mass readership of the popular press, the literati of the small publications, and the *amateurs d'estampes* (print lovers) with their fastidious expectations of printmaking. During the mid-1890s alone, his illustrations appeared in over a dozen periodicals, from the avant-garde *La Revue blanche* to the popular *L'Escarmouche*.[4]

While Vallotton's popular illustrations and portraits were generally anecdotal, depending more often upon distortion and graphic cleverness than upon the subtle draftsmanship that emphasized movement in space, the best of these woodcuts raised caricature to a level of ironic social commentary on a par with Daumier's work. Yet, where individual character and gesture were most successfully isolated, the image often remained more emblematic than realistic—as the short, declarative titles that were inscribed *inside* the picture affirm. Critics have, therefore, widely felt that even the best works possess an aura of the sanitized and formulaic. Such consistently encountered factors of distance are important hallmarks of Vallotton's art. One senses in him a constitutional reluctance to commit himself to the full spectrum of the artistic endeavor—the stylistic intricacies of his era, the materials and processes of his craft, the subjects of his daily observations, or the burning social issues of his time. His impenetrable blacks are very much a personal metaphor for denied access—one simply cannot "see" shades of meaning, or confidently establish the artist's own feelings and politics. And it was particularly easy for Vallotton to allow his woodcuts to slip into the realms of the formulaic, the decorative, and the caricatural, offering an immediate and incisive "take" and little more. Nevertheless, the ironic detachment occasioned by his visual devices suited two groups of his prints admirably: the crowds and the interiors. In these works, subtle and succinct understatement masked an ongoing dialogue with major contemporary emotional issues about the nature of crowds and the roles of women, issues unsuspected by those who have valued Vallotton for his formal inventiveness. How is it that these works, whose language was so close to that of the popular press, could articulate the fears and fantasies of a generation, the collective malaise of the fin de siècle?

The Crowds

The simplicity and exaggeration of the sentiments of crowds have
for a result that a throng knows neither doubt nor uncertainty.
Like women, it goes at once to extremes.
GUSTAVE LE BON, 1895[5]

One would never guess from Vallotton's modest remarks in letters of the early 1890s to his brother Paul, how remarkable it must have felt to have become one of the leading illustrators of his day. His uncommon reserve aside, it is likely that he both desperately needed the income and quietly regretted that it was his graphic production rather than his painting that had won him recognition. But it was clearly the woodcut in particular that led him not only to radical formal innovations, but also to his early and famed adoption of the theme of the crowds, a subject he would later treat in a few paintings, such as *The Crowd* of 1894 and *Passersby (Street Scene)* of 1897 (plates 44, 59). For it was in the collective blacks of the woodcut that Vallotton located and explored the crowd's collective character.

44
The Crowd, 1894
Oil on panel, 26.8 x 34.9 cm
Allen Memorial Art Museum, Oberlin College, Elisabeth Lotte Franzos Bequest, 1958

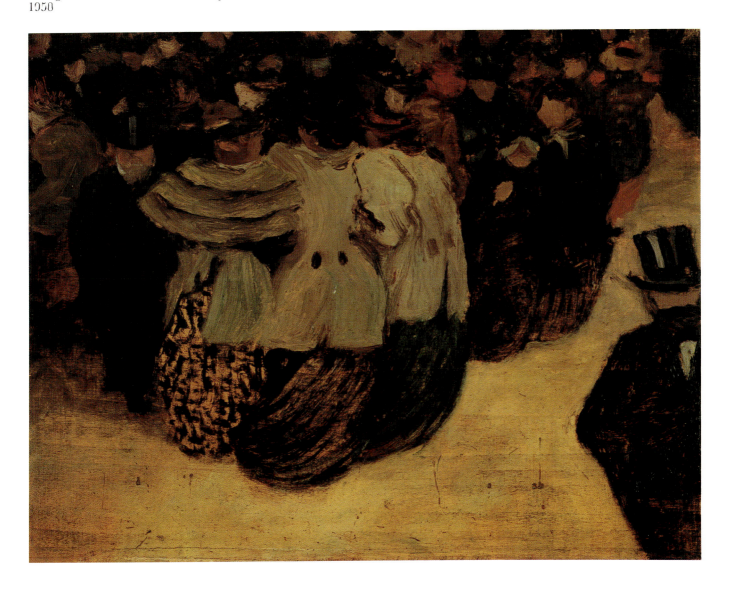

45
Charles Maurin (1856–1914)
Head of a Woman, ca. 1891
Woodcut, 24.3 x 21.8 cm
The Jane Voorhees Zimmerli Art Museum,
Rutgers, The State University of New Jersey,
New Brunswick

46
Head of an Old Woman, 1891
Woodcut, 13.1 x 10.8 cm
Galerie Vallotton, Lausanne

Vallotton's woodcut style emerged almost full-blown at the end of 1891. His initial inspiration came from his closest friend, Charles Maurin, who had begun to experiment with the woodcut around 1890. Comparison of the latter's *Head of a Woman* of ca. 1891 (plate 45), and Vallotton's *Head of an Old Woman* of 1891 (VG 79; plate 46), for example, confirms this indebtedness.[6] Vallotton soon modified Maurin's rough-hewn, linear technique, however, for flatter, blacker, far more curvilinear and synthetic effects. Unlike Bernard's deliberately crude and experimental woodcuts of peasants dating from the late 1880s, Vallotton's sophisticated, smooth, unvarying surfaces seemed far better suited to urban subjects.[7] It was, in fact, his specific genius to combine character studies—the sketches of Parisian types (so-called *physiologies de la rue*) and street happenings, which must have filled his sketchbooks and memory—with his new interest in the woodcut. Although Symbolism and Neo-Impressionism occupied center stage at the time, many of those who would be major contributors to the art of the 1890s —Lautrec, Bonnard, Vuillard, Anquétin—were, in the late 1880s, intimately involved with the more public arts that celebrated the boulevards and cabarets of

47
Kitagawa Utamaro (1754–1806)
Banquet on a Snowy Night
Color woodcut, 25.4 x 36.9 cm
Yale University Art Gallery, 1950.591

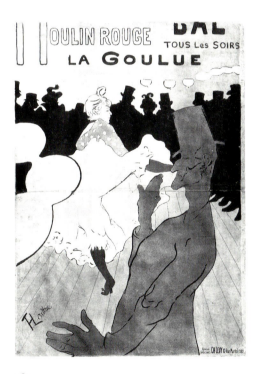

48
Henri de Toulouse-Lautrec (1864–1901)
Moulin Rouge, La Goulue, 1891
Color lithograph, 168 x 118.8 cm
Philadelphia Museum of Art, Gift of Mr. and
Mrs. R. Sturgis Ingersoll, 40–45–1

Paris. The sentimental structures of such urban vignettes—visual, verbal, or literary—derived from earlier explorations of this genre by Daumier, Gavarni, Guys, Forain, and Steinlen, among others. The new images adorned the various editions of Aristide Bruant's *Dans la rue* (1888–) and *Le Mirliton* (1885–96), decorated countless sheet music covers, informed the irreverent cartoons of *Les Incohérents*, and appeared in the novel, silhouetted projections of the many *théâtre de l'ombres* (shadow theaters) that had sprung up in Paris during the eighties.[8]

Probably the most dramatic and influential incorporation of the forms of the shadow theater was Toulouse-Lautrec's first major poster, *Moulin Rouge, La Goulue* of 1891 (plate 48). The play of foreground performers in deep space against the continuous black frieze of spectators was of stunning originality and, along with similar experiments by the Nabis, must have revealed an entirely new idiom to Vallotton. There is certainly no doubt that among the Nabis, he especially was deeply impressed by Henri Rivière's elaborate shadow theater performances at the Cabaret du Chat Noir from 1885 to 1898 (plate 13).[9] Not only did Vallotton's flat, black shapes clearly reflect the shadow theater's condensation of two and three dimensions, but his choice of subjects, his proclivity toward the rendering of motion, and his fascination with crowds must have been greatly influenced by the clever perspectives and massing of figures in the cutouts prepared for the shadow theater. These cutouts may themselves have drawn inspiration from such nineteenth-century Japanese woodcuts as Utamaro's (plate 47), which represented the play of shadows projected onto the paper walls of indigenous dwellings.[10]

Included within the circle of the Chat Noir was a group of artists far more central to its ambience than any of the young Nabis: illustrators such as Willette, Steinlen, Hermann-Paul, Ibels, and Toulouse-Lautrec, whom Vallotton eventually would join as a contributor to magazines like *L'Escarmouche*, *Le Rire*, and *Le Courrier français*. This affiliation exposed him to an art that not only critiqued

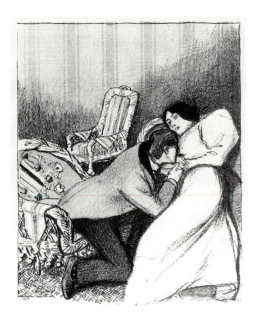

49

Théodore-Alexandre Steinlen (1859–1923)

The Triumph of the Heart, 1895

Published in *Gil Blas*, 9 June 1895

The Beinecke Rare Book and Manuscript Library, Yale University

contemporary society, but often clearly espoused social causes by means of a caricatural mode of draftsmanship descended from Daumier (who had died only a decade previously). One wonders if Vallotton harbored any particular feelings for Steinlen, a fellow expatriate from Lausanne working in Paris. Whether the two were more than casual acquaintances seems doubtful, but the elder artist's work clearly contained numerous sources for Vallotton's own images: compare, for example, Steinlen's *The Triumph of the Heart* of 1895—illustrating a novel on adultery—with Vallotton's *A Trusting Man* (plates 49, 50).[11] Conversely, there is an abrupt change in Steinlen's work around 1892–93 that may be ascribed in large part to the power and success of Vallotton's woodcuts.

Although such multiple influences helped propel Vallotton into a career of graphic illustration, he was born to make woodcuts. He stamped the medium with his own sensibilities almost immediately. His gift for immediacy and clarity of action, and his love of decoration informed most of his graphic art throughout the 1890s. Even in *The Funeral* of 1891 (VG 84; plate 51), Vallotton instinctively compared the shapes and rhythms of the gravediggers' genuine, individualized work with the massed, bent, stupefied postures of the mourners. The poor widower and his son are relegated to the background of this play, timid and silent; only the child, peering at us, seems to wonder, to be conscious! In the far background a screen of disorderly cypresses mocks the sobriety of the scene, and a heavy iron gate closes the space with the absolute finality of its silhouetted cross. Like many gifted illustrators, Vallotton drew his cast of characters from dimly familiar sources: the father from Maurice Denis' effete types, the struggling worker from Steinlen or Vuillard,[12] and the *pleurants* from medieval French tra-

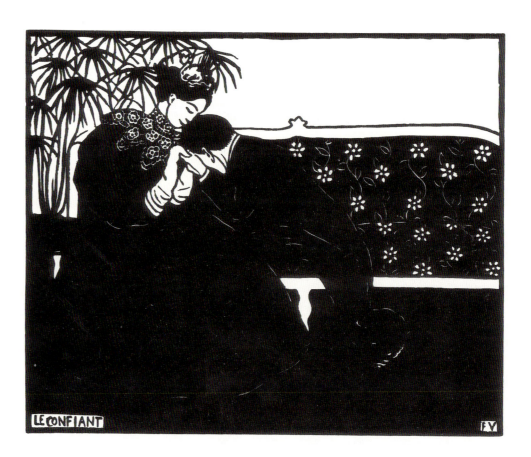

50

A Trusting Man (*Le Confiant*), 1895

Woodcut, 17.8 x 22.4 cm

Galerie Vallotton, Lausanne

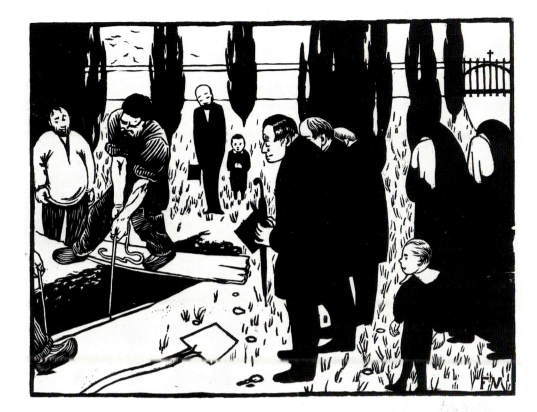

51

The Funeral, 1891

Woodcut, 26 x 35.3 cm

Collection, The Museum of Modern Art,
New York, Gift of William S. Rubin, 389.62

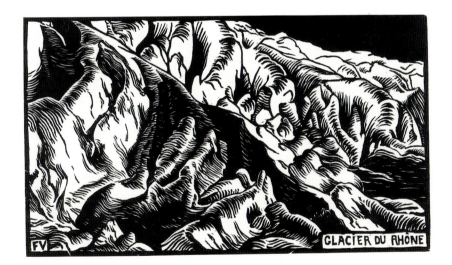

52

Rhône Glacier *(Glacier du Rhône)*, 1892

Woodcut, 14.5 x 25.5 cm

Galerie Vallotton, Lausanne

dition through Gustave Courbet himself.

In 1892, Vallotton retrieved earlier oil studies of Swiss mountains for a breathtakingly calligraphic use of the wood. He discovered in himself an uncanny ability to devise precise methods of cutting that evoked the optical character of a surface seen at a specific distance, without ever abandoning the literal textures of the woodblock itself. Each of the cuts—of the Breithorn, Matterhorn, Mont Blanc, Rhône Glacier (plate 52), Jungfrau, and Monte Rosa (VG 85–90, 105)—varies its techniques: irregular flicks of white in a black ground to suggest the lower forests; wave-form patterns of white to evoke the dark rocky masses below

the glacier; similar patterns of black (reversing values) to render the brightly lit, high snow fields; and convoluted parallels of black line flowing into nearly impenetrable black masses (barely articulated with a few flecks of ordered light) to portray the turgid, massive, and slow-moving glaciers and crevasses. Unique among the woodcut artists of the 1890s, Vallotton consciously endowed each scene with its own visual and graphic character, with its own "sound" (not unlike the woodcuts of *Musical Instruments*, which would appear in 1896). Strangely little recognition has been accorded these Swiss mountainscapes, although they are probably the most radical experiments in the medium since the few, calligraphic essays by Titian and his entourage in Venice, Jan Lievens in Amsterdam, and Christoffel Jegher in Antwerp.[13] Vallotton himself did not further exploit the textural and expressive skills he had evolved in these woodcuts (one could imagine him developing a kind of equivalency to Vuillard's painted surfaces). They did, however, prepare the way for the deft but readily apprehended forms of his street scenes and interiors.

By 1892, the language Vallotton was developing in the woodcut was already conjoined to extraordinarily topical and pertinent subjects, namely those of the Parisian crowd. The aptness of his figures derives from his adoption and construction of a vocabulary of Parisian types that seems consonant with what one knows of the imagistic worlds of fin de siècle music halls, cabarets, literary cafes, and boulevards.[14] Vallotton's characters appear almost as if they were stamped from similar patterns—the colorful humanity that populated the boulevards and gave rise to so much of the sentimental realism of contemporary literature. But Vallotton's woodcut manner revivified Baudelaire's exultation of the anonymous black of contemporary dress as a cloak that both hides and unifies.[15] For Baudelaire (and, of course, for Manet), the black forms of the boulevard stroller (*flâneur*) evoked the detached, anonymous observer. For Vallotton, it was

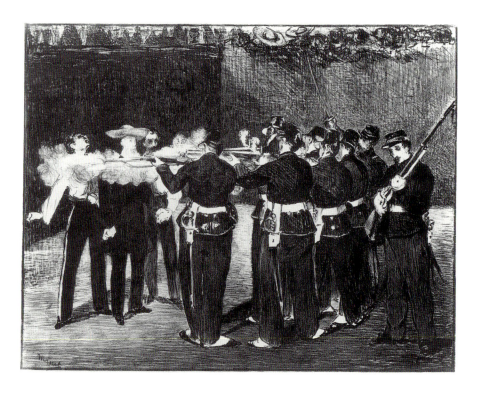

53

Edouard Manet (1832–1883)

The Execution of Maximilian, 1867

Lithograph on chine appliqué, 33.2 x 43.2 cm

Smith College Museum of Art, Northampton, Massachusetts, Purchased 1980

54

The Paris Crowd, 1892

Woodcut, 13.9 x 19.5 cm

The Metropolitan Museum of Art, New York, Gift of Mary Turley Robinson, 50.522.2

quite otherwise: the engulfing blacks suggested the orchestrated, often humorous, movement of the crowd. Where Manet had worked his blacks in order to characterize the individual, Vallotton proceeded, as his drawings attest, by a progressive masking of detail and a synthesizing of form. What the two artists shared —see, for example, Manet's lithograph *The Execution of Maximilian* (plate 53)— was an ability to maintain an air of utter detachment in their most horrific scenes, a stance Vallotton ascribed as well to the hero of his quasi-autobiographical novel, *La Vie meurtrière* (The Murderous Life). Yet even in this, their motives were diametrically opposed; whereas Manet and such artists as Daumier, Degas, and Gauguin had sought myth and tragedy in the individual, Vallotton would find hidden danger in the collective. But through his masterful elisions of individual and type, Vallotton cloaked his fears with a wit and irony that effectively masked his deep pessimisms about human nature.

In his next figurative woodcut, *The Paris Crowd* (VG 91; plate 54), Vallotton raised his point of view, organizing his perspective on a diagonal in order to play out the ironic juxtaposition of the crowd, herded by the policeman, and the lone, radically truncated figure plodding the empty cobblestones. To what spectacle could such a mass of varied humanity be so forcefully attracted? While the policeman appears to contain the crowd with little effort, it is the singleness and cohesiveness of this group of highly compacted individuals that fascinates the artist. The emptiness of the street and the unseen event that draws the people together heighten the viewer's identification with the crowd. But just as crowds are conglomerates of disparate elements, so they are always in Vallotton's works in danger of decomposing. In this first woodcut of the Paris streets, a jumbled disorder is clearly evoked by the multiplicity of irregular shapes and textures.

In *The Brawl* (VG 101; plate 55), Vallotton explored the potential energy of the unified crowd by massing his figures into one solid black shape driven by a single purpose. Compelled to differentiate the inner workings of this fracas, the spectator becomes involved, empathetically adjusting his or her body to the perceived forms of the participants. Typical of Vallotton's woodcut language, the black mass is punctuated by hands that thrust, threaten, and grasp in futile attempts to stay the blow of the raised water decanter; even the distant bartender lunges over the counter toward the raised weapon, mimicking the astounding spatial movements evoked by the compacted forms of the shadow theater. The plunging perspective of the table (on which lie, almost peripheral to the present moment, the playing cards that provoked the argument), and the strong diagonals that move in and out of the lower corners articulate and focus the drama of the foreground. Providing a comic foil, two decoratively adorned female bystanders—the one on the left a cousin of the poor widower standing at graveside —act as frivolous parentheses to the uncontrolled energies of the massed figures.

While certainly a confused and unresolved composition, *The Brawl* nonetheless embodies the essential disorder of such an emotional outburst. Another threatening confrontation is evoked in the woodcut *The Anarchist* (VG 104; plate 16), also of 1892. Four policemen rush out of the lower left corner to seize a young, scowling anarchist, who reaches ominously into his pocket. Two overstuffed policemen in white stand watch—behind them, two top-hatted gentlemen in black are equally intrigued by the action—ready to join the black forces if needed, but otherwise content to enjoy the spectacle unfolding against the comfortable backdrop of neighborhood shops. So normally quotidian is their decorative and parallel disposition—a trope of breaking the idyllic peace of Paris—

55
The Brawl, 1892
Woodcut, 17 x 25 cm

Print Collection, Miriam and Ira D. Wallach Division of Art, Prints and Photographs, The New York Public Library; Astor, Lenox and Tilden Foundations

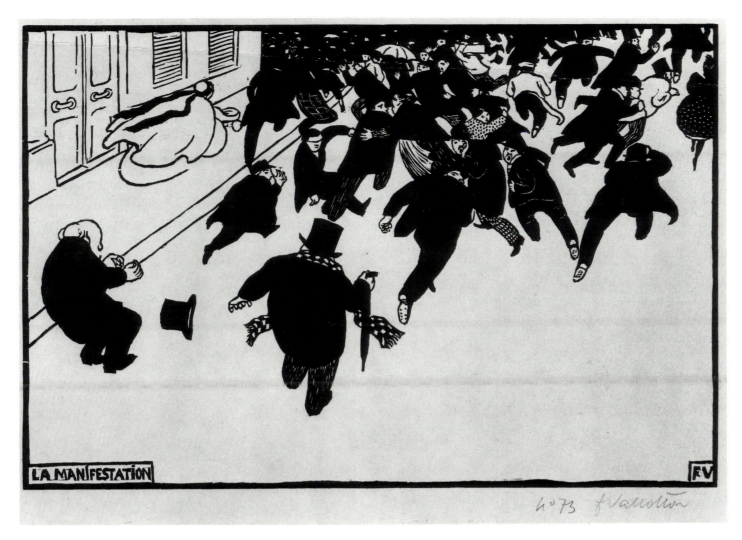

LA MANIFESTATION

FV

56

The Demonstration *(La Manifestation)*, 1893

Woodcut, 20.3 x 32 cm

The Metropolitan Museum of Art, New York, Rogers Fund, 1922, 22.82.1–9

that the violence is felt as a brief and minor intrusion. Order has been preserved; for now, hostility has been confined to the margins.

By the winter of 1892–93, Vallotton had mastered the manipulation of shape and space, most assuredly aided by the study of his contemporaries' works. Like Lautrec's, Vallotton's forms never fail to amuse by their vacillation between abstractly expressive surface ornament and deeply recessional spatial markers descriptive of motion and gesture. In no single image is this more successfully embodied than in *The Demonstration* (VG 110; plate 56), published in the first number of André Marty's *L'Estampe originale*.[16] In a tour-de-force of economical forms, a huge crowd runs pellmell into the distance, not drawn toward some distant event, but in headlong flight away from some agent of fear signaled by the masks of terror of those who look over their shoulders. Such panic is evoked through the implied movement of forms and the shaping of the whites (depth) of the paper. The good nanny, with her billowing white mantles and perambulator, the dumbfounded old man knocked backwards by the rushing crowd, and the more slowly lumbering figure in the center all accentuate the rush into space. One must return to the late 1860s for a comparable scene, to Edouard Manet's lithograph of the race track at Longchamps with its rush of black horses (as well

57

The Patriotic Ditty
(Le Couplet patriotique), 1893

Woodcut, 17.6 x 27.3 cm

The Metropolitan Museum of Art, New York, Gift of Mary Turley Robinson, 1950, 50.522.1

as the rhythms of the crayon) down the track toward the viewer. Manet, of course, was preoccupied with the autographic use of line as an equivalent for the excitement of the crowd, and as a disguise for his own. Vallotton, on the other hand, constructs his reserve by pulling back from the center, raising his point of view, and avoiding any suggestion of his own hand. His vantage—cool, detached, and superior—is much more appropriate to the woodcut.

Other images of the crowd abound in Vallotton's graphics. *The Patriotic Ditty* (VG 127; plate 57), perpetuating a theme common to the entire run of nineteenth-century art, gives it a very specific, psychological twist. No longer is it Daumier's crowd, articulated by the outbursts of a few picturesque characters, but a mass of humanity mesmerized and unified by a single event.[17] With two or three exceptions, each individual is transformed by the patriotic song, caught up in a jingoism manufactured by those out-of-sight manipulators of the sentiments of crowds. One senses in Vallotton's suggestions of excess just how such a crowd might quickly generate uncontrollable energies, drawing upon the crueler instincts of the individuals who compose it. Such a notion is continually underscored in Vallotton's scenes of police brutality, such as *The Charge* (VG 128; plate 17). Here again the artist contrives to match the physical brutality of the woodcut with the solid black mass of policemen that compresses its victims into the extreme foreground. There is no escape from this destructive force, which has left the detritus of urban repression strewn across the open spaces of the white ground.

Such pure, naked aggression is so rarely represented in art that one is startled to realize how essential an ingredient of Vallotton's printed imagery it is. Yet what, we might ask, is the viewer's part in these images of open hostility? Does an occasional spectral glance directed outward suffice to restructure the artist's otherwise rather distant psychic remove? Or is there some covert message in their

cleverness? Their economy—the very soul of graphic wit—provides a kind of fascinating distraction, like the women in *The Brawl*, ironically hinting at some perverse enjoyment the viewer might derive from such brutal representations. May we be confident, as some have maintained, that these images encode strong protestations against the repressive nature of the French government? I know of little in the published correspondence to corroborate such an interpretation, and so cannot believe there is a partisan, political text to be read in Vallotton's images. Rather, they may embody something of Vallotton's own fear of any loss of order or emotional control, and a corresponding need to mask his own aggressive impulses. It is possible that such meanings also account for the artist's apparent obsession with funerals and their attendant repetitive blacks. Among a surprising number of images, none is more lugubrious than the static mass of black-frocked men attending *The Burial Service* of 1894 (VG 146).[18] Seen from behind—yet another device for masking the artist's feelings—the mourners form a massive and slightly disordered group that fails to fully share the piety of the priest or the sorrow of the family.

Not all of Vallotton's crowds behave violently or lugubriously, though they do act collectively. In *The Print Fanciers* (VG 107; plate 58), customers flock to view the irresistible offerings of Edmond Sagot's print shop; only the most modest indications of pattern, girth, posture, and gesture distinguish the individuals from the crowd, so convincing is Vallotton's portrayal of communal interest.[19] Distraction, on the other hand, might be the central theme of *The Bon Marché* (VG 116; plate 165), where a gentler, flowing, black crowd of women and their fawning salesmen push through curvilinear masses of draperies and fabrics.[20] Telling gestures and soft swathes of cloth indicate an atmosphere of persuasive

58
The Print Fanciers, 1892
Woodcut, 18.5 x 25.3 cm
Yale University Art Gallery, Everett V. Meeks, B.A. 1901, Fund, 1984.16

59
Passersby (Street Scene), 1897
Tempera on board, 33.2 x 46 cm
Private Collection

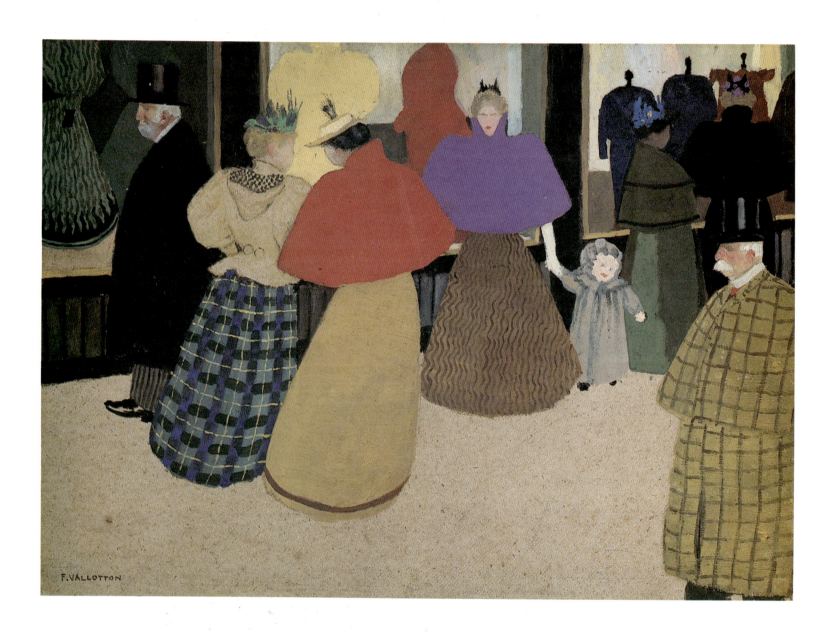

60

A Street (Street Corner), 1895

Gouache on board, 35.9 x 29.9 cm

The Metropolitan Museum of Art, New York, The Robert Lehman Collection, 1975, 1975.1.736

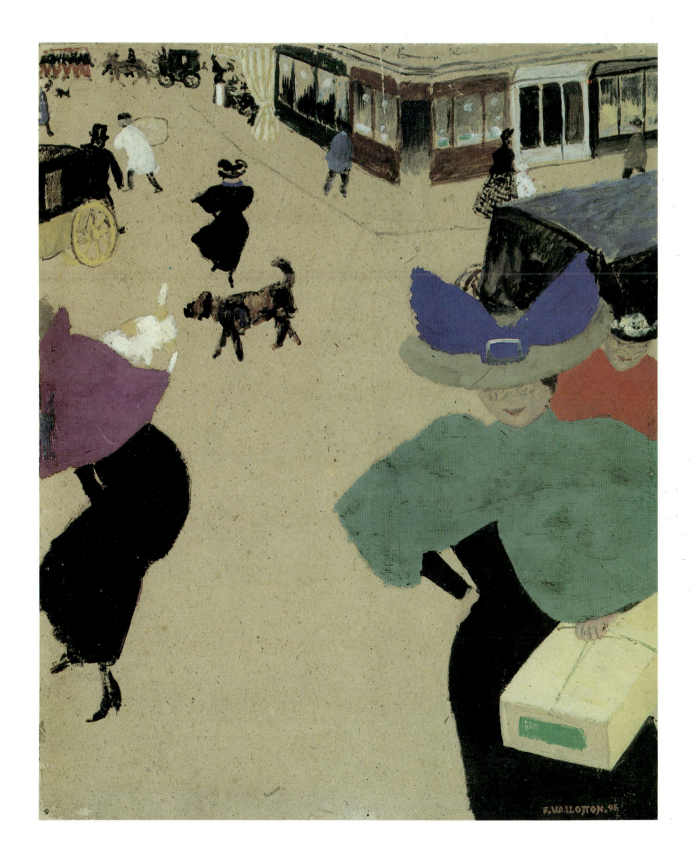

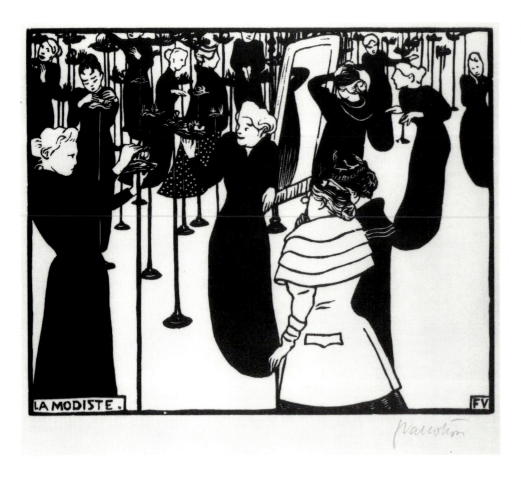

61

The Milliner (*La Modiste*), 1894

Woodcut, 18 x 22.6 cm

National Gallery of Art, Washington, Ailsa Mellon Bruce Fund, 1983.90.1

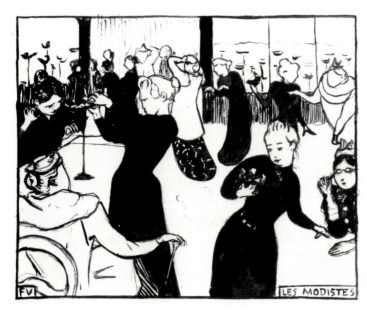

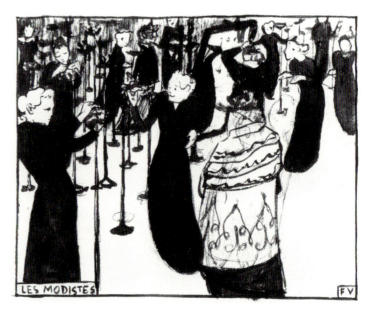

62

The Milliners (*Les Modistes*), 1894

Study for "The Milliner"

India ink, charcoal, and lead pencil on glazed cream wove paper, 18.1 x 22.6 cm (image)

Galerie Vallotton, Lausanne

63

The Milliners (*Les Modistes*), 1894

Study for "The Milliner"

India ink, charcoal, and scraping on glazed cream wove paper, 18.2 x 22.7 cm (image)

Galerie Vallotton, Lausanne

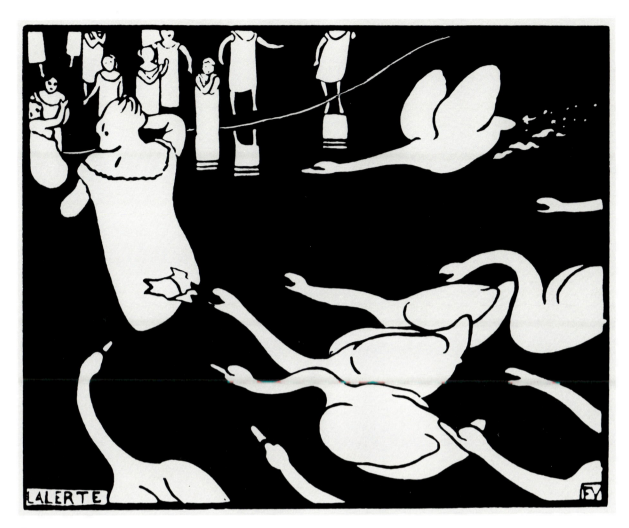

LALERTE

64

The Alarm *(L'Alerte)*, 1895
Woodcut, 17.9 x 22.4 cm
Galerie Vallotton, Lausanne

solicitude. Even more orchestrated and graphically original is *The Milliner* (VG 138; plate 61), for which two preparatory drawings (plates 62, 63) hint at Vallotton's careful editorial process. A rectilinear, centralized space gives way to one that gradually attenuates along a diagonal, playing the concentrated patterns of the crowd against the more individualized figures in the foreground. No words can aptly substitute for Vallotton's keen sense of physical comportment; empathy identifies the viewer with the serious absorption, modest suggestion, or fey enthusiasm of the three saleswomen who delimit the main diagonal. But as he worked on this print, Vallotton uncovered in this veritable forest of narcissism a far more devastating outlet for his wit: the slavish solicitude toward hats—birds tethered to lone, phallic stanchions—suggests other, more sardonic or fetishistic meanings.

The aggressive component of Vallotton's art emerges once more, in an unexpected subject: the bathing scenes of 1893–94. Even so innocent appearing an image as the *Three Bathers* (VG 133; plate 158), published in the February 1894 issue of *La Revue blanche*, disguises—under the ruse of graphic playfulness—peculiar fracturings of the female body that result in a perverted equivalence of back and front: a thinly veiled hostility toward women. This subtle suggestion surfaces explicitly in Vallotton's images of swans, especially in *The Alarm* (VG 166; plate 64) of 1895. There, in a barely disguised phallic fantasy, a covey of swans have not only exposed a woman's backside, but are in hot pursuit. Such construc-

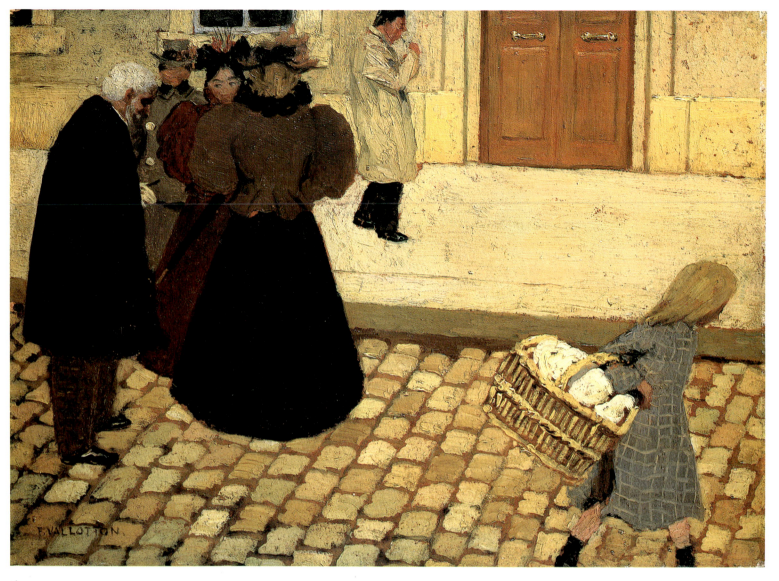

65

Street Scene, 1895
Oil on board, 26 x 34 cm
Private Collection

tions might still be perceived as good-humored, but, as Eugene Glynn has pointed out, they are clearly aggressive and, I would add, deeply misogynist.[21]

Vallotton's withheld and secretive character—his long, but almost undetailed affair with Hélène Chatenay, his surprising engagement to the moneyed widow, Gabrielle Rodrigues-Henriques, his reluctance to participate fully in the groups to which he had access, and his apparent free-ranging bitterness (as Jules Renard wrote in his journal)[22]—cannot help but cast a cynical aura over one's perception of the artist's meanings. Even an image as seemingly playful as the interrupted sexual escapade, *In a Flutter* (VG 135), may be regarded as encoding a male fear of women (the vagina dentata), though in typical fashion Vallotton scrupulously avoids any manifestation of psychological dread. How careful is this artist to disguise his own feelings from himself!

In all probability, here lies a major reason for Vallotton's almost immediate affinity with the Japanese woodcut. Its smooth surfaces are aloof from the personal struggle that the chisel, gouge, and more direct methods of cutting would have recorded. Additionally, while the steep, diagonal perspectives of Jap-

66

Paris Intense, 1894
Frontispiece from *Paris Intense*
Zincograph, 22 x 31.5 cm
The Baltimore Museum of Art,
Unknown donor, BMA 1956.162.1

67

Study for "Paris Intense," 1894
India ink, charcoal, and graphite on cream
wove paper, 21.3 x 31.2 cm (image)
Galerie Vallotton, Lausanne

anese space lent greater diversity and furnished a more dynamic stage for his crowds, they also removed the artist/viewer from the scene, constructing an observer rather than a participant. Intuitively, Vallotton had adopted the same stance as those who wrote about the dangers posed by crowds. Their constructs, too, were not based on participation and measurement but rather on historical accounts and political and psychological motives.

Vallotton systematically explored his distance from the Parisian crowd in a series of seven lithographs entitled *Paris Intense* (VG 45–51; plates 66–73), published by L. Joly in 1894. Though obviously drawn, rather than cut, they

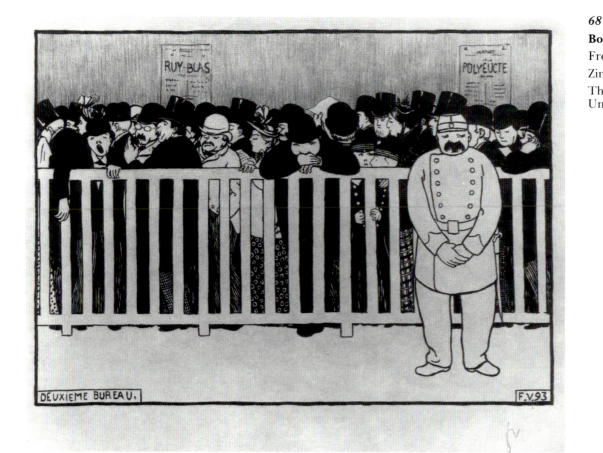

68

Box Office *(Deuxième bureau)*, 1893
From *Paris Intense*
Zincograph, 21.7 x 31.2 cm
The Baltimore Museum of Art,
Unknown donor, BMA 1956.162.2

69

Off to the Jug *(Au violon)*, 1893
From *Paris Intense*
Zincograph, 21.8 x 31.4 cm
The Baltimore Museum of Art,
Unknown donor, BMA 1956.162.4

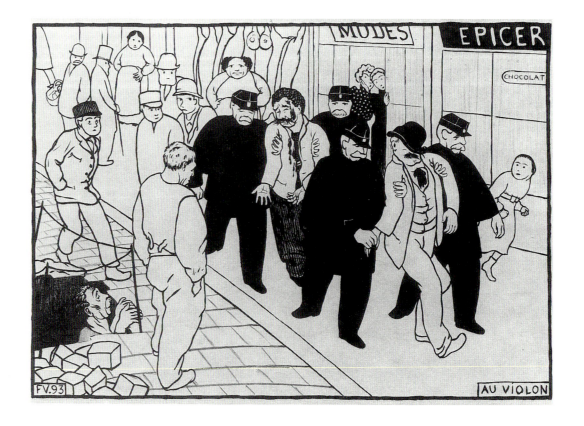

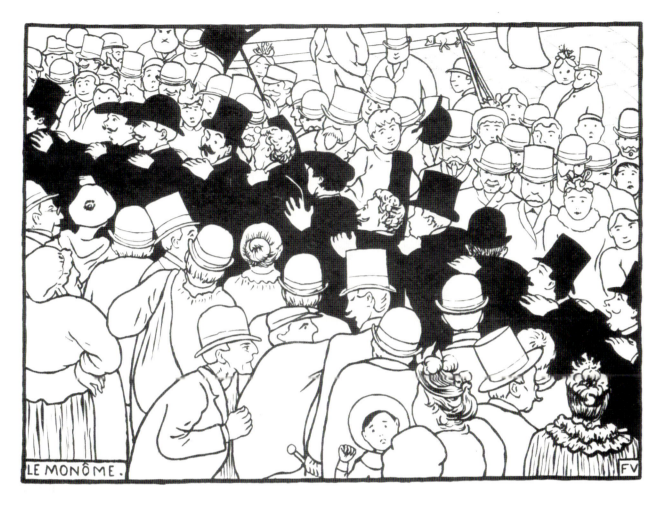

70

Parading through the Streets in Single File (*Le Monôme*), 1893

From *Paris Intense*

Zincograph on saffron yellow paper,
22.2 x 31.1 cm

National Gallery of Art, Washington,
Rosenwald Collection, 1952.8.483

reveal the profound influence of the woodcuts. The frontispiece, often printed on a light yellow or green paper, is suitably flat, the actors displayed frontally as in a police line-up (plate 66). A sharply receding pavement doubles as the wall against which boxed names of the series and its author are drawn. A more insistent flatness herds those who wait for tickets in *Box Office* (plate 68) behind the police-enforced barricade. *Off to the Jug* (plate 69) is articulated by the diagonal of the street, along which two arrested brawlers are briskly moved, pausing only to appeal to the street laborer. *Parading through the Streets in Single File* (plate 70) raises the point of view to show as many as possible of the spectators who sandwich the black line of "students" rallying in support of the censured "Bal des Quat'z'Arts": an orderly, jocular crowd, a nearly benign procession of hats, hands, and shoulders. As in *The Brawl*, the decorative device of a woman's blouse and hair is used to close and siphon off the charge of the composition. If *Parading* depicts an organic crowd, *The Accident* (plate 71) appropriately does the opposite. Here the blank stage of the aerial view is punctuated by a non-crowd—a few emotionally laden figures absorbed in their individual reactions: curiosity, shock, indifference, and ignorance. A similar inorganic involvement characterizes those who actually attend the poor woman who has fallen under the majestically frightened horse. And an analogous dispersal of the crowd has been effected by the driving rain of *The Shower* (plate 73). People huddle themselves into compact

71

The Accident (*L'Accident*), 1893

From *Paris Intense*

Zincograph, 22.4 x 31.2 cm

National Gallery of Art, Washington, Rosenwald Collection, 1952.8.485

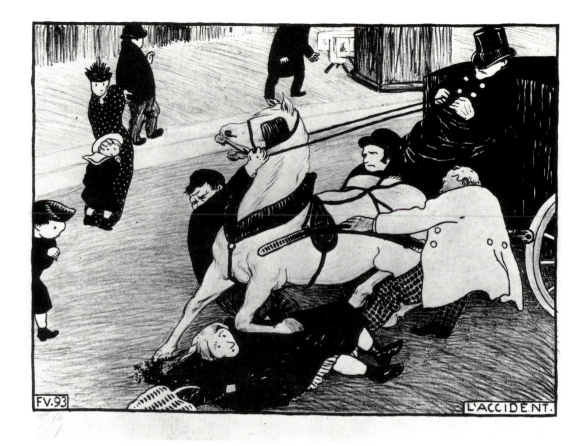

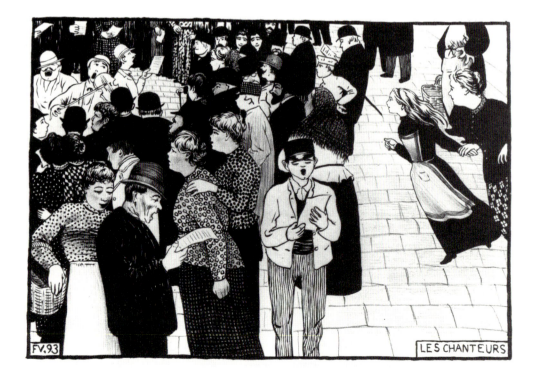

72

The Singers (*Les Chanteurs*), 1893

From *Paris Intense*

Zincograph, 21.5 x 31.5 cm

The Baltimore Museum of Art, Unknown donor, BMA 1956.162.3

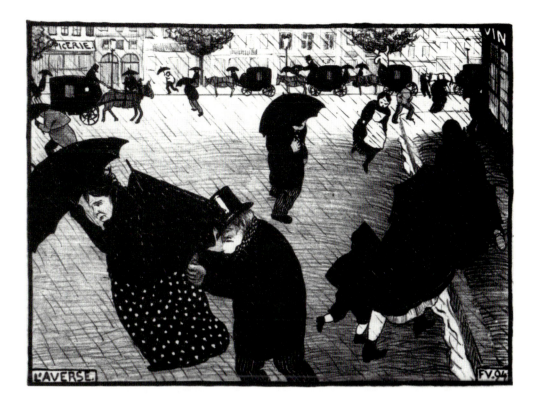

73

The Shower (*L'Averse*), 1894

From *Paris Intense*

Zincograph, 22.7 x 31.3 cm

National Gallery of Art, Washington, Rosenwald Collection, 1952.8.484

shapes as they seek to escape both the downpour and the exposed openness of the square. Discomfort is only momentary, however: the contrasting diagonals and receding curb are reassuringly closed and stabilized by the facades and line of *fiacres* in the background.

In forsaking the economy and synthesis of the woodcut, *Paris Intense* gave way to the descriptive and atmospheric details so natural to lithography. Consequently closer to their preparatory drawings (plate 67), the lithographs are generally not as successful as Vallotton's woodcuts.[23] Like most of the drawings he executed for reproduction in contemporary magazines, they are less abstract, less detached, and therefore far less ambiguous. Comparison with the nearly contemporaneous woodcut version of *The Shower* (VG 149; plate 74) demonstrates how the woodcut inverts the premises of the lithograph. The descriptive space of the latter becomes the undifferentiated crowd of the former. No longer is the artist tempted to draw the textures of the pavement, the streaking of the rain, or the variety of individuals; rather, all are fused in a jumble of black arcs punctuated by a few hands, faces, and textures. It is not wetness (which can be described with the litho crayon) but an entangled blindness, an organic confusion of pierced black forms that meanders across the picture plane. Again, one must return to the preparatory drawing (plate 75) to discern how the slight flecks and cracks of white provide the barest of clues necessary to structure the crowd. A very similar conception informs another woodcut of 1894, *The Gust of Wind* (VG 145; plate 76). In a typically Vallottonian trope borrowed from Japanese prints, the forces are offstage, billowing in from the right, affecting and even invading the very forms of the crowd.[24] Gestures, circular rhythms, and incipient instabilities all combine in an instant to impart the overwhelming sensation of a gust of wind. The image is thus analogous to "le mot juste," the word that is the perfect

74

The Shower *(L'Averse),* 1894

Woodcut, 18.2 x 22.5 cm

The Metropolitan Museum of Art, New York, Mary Martin Fund and The Elisha Whittelsey Collection, The Elisha Whittelsey Fund, 1984, 1984.1071.1

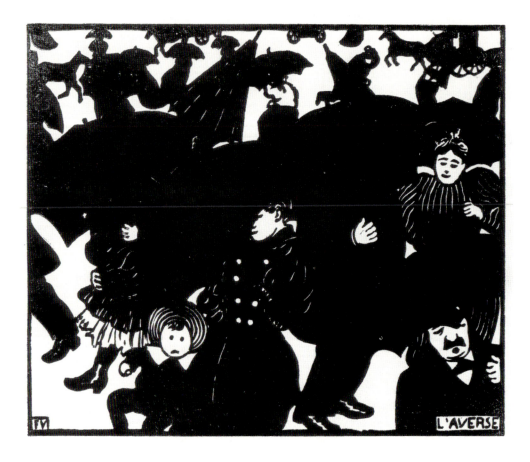

75

Study for "The Shower," 1894

India ink, charcoal, and scraping on white wove paper, 18.3 x 22.6 cm (image)

Galerie Vallotton, Lausanne

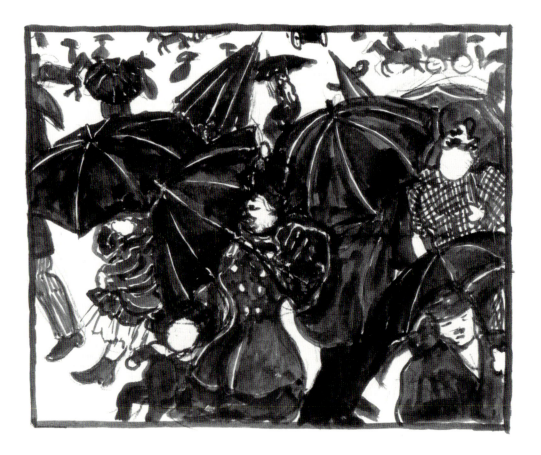

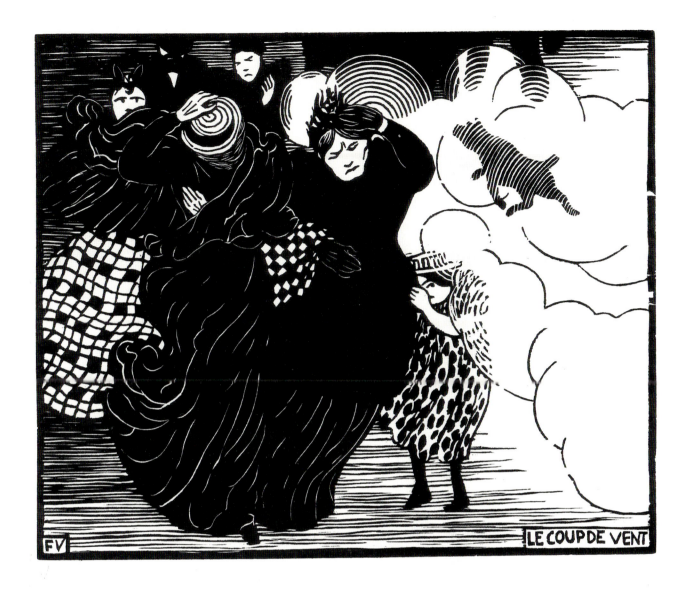

76

The Gust of Wind (*Le Coup de vent*), 1894
Woodcut, 18 x 22.4 cm
Collection, The Museum of Modern Art,
New York, Gift of Mrs. Bertha M. Slattery,
184.51

equivalent of some small incident, which resides more clearly in memory than in actuality.

Vallotton's study of the crowd was in some ways simply part of the traditional Parisian fascination with the "psychology of the street." Nothing better attests to the artist's literary sympathies than his collaboration on Octave Uzanne's *Les Rassemblements* (Gatherings) of 1896. In a totally unorthodox move, Uzanne determined that the fifteen contributing authors should initiate their short texts in response to the thirty illustrations Vallotton had already executed, rather than the other way around.[25] Thus each text was evolved from the substance of one drawing. Such an unusual literary gambit permitted one first to grasp the author's initial image and then to witness his verbal elaboration. And so synthetic were the blacks of the reproductions that it has been suggested they are in fact original woodcuts (see plates 77–83).[26] Virtually all of Vallotton's scenes concern the events of the streets of Paris, witnessed alike by the *flâneurs*—connoisseurs of

77
Cover, *Les Rassemblements,* 1896
Galerie Vallotton, Lausanne

Parisian life—and the *badauds*—the gawkers and idlers who gather to watch any kind of event, or non-event: the jugglers and acrobats, the dentists, the poster-hangers, the anglers, the accidents, the arguments, funerals, drownings, marriages, parades, the actions and dress of women, the hawkers and speakers, the roadworkers, the drunkards, arrests, fires, and, of course, the crowds themselves. And, in the spirit of these observers, Vallotton portrayed all this without calling upon the personal involvement of the viewer or the reader, who had long before cultivated the ability "'to gaze on the greatest farce impassively.'"[27]

What characterizes the drawings of *Les Rassemblements*—and so many others for Parisian magazines of the later 1890s—is the directness with which Vallotton depicted both crowds and spectacles, in a distinct departure from his earlier woodcuts, where the motivating event so often remained out of sight in order to privilege the crowd. In anticipation of a more popular audience, Vallotton shifted his focus from the collective psyche of the crowd to the narration of a single spectacle, from the abstract to the specific. Depictions without comment, these ingratiating illustrations were ideally suited for Uzanne's authors, for whom they were but starting points for their own reveries.

Vallotton's concern with the crowd, however, did not merely perpetuate visual and literary traditions. It was a highly original formulation that also par-

78

The Drunk, for *Les Rassemblements*, 1895
India ink and blue pencil on cream paper,
26.5 x 20.3 cm
Galerie Vallotton, Lausanne, 966863

79

The Drunk, from *Les Rassemblements*, 1896
Galerie Vallotton, Lausanne

took of the intense focus on the nature of crowds sweeping through the professional and popular psychological press of the day. In fact, it was precisely during the early and mid-1890s that several famous treatises on the crowd by Gabriel Tarde, Scipio Sighele, and Gustave Le Bon appeared.[28] As early as 1882, Guy de Maupassant had spoken of the special being that was the crowd and had cited the popular saying, "the crowd does not reason." Referring specifically to the theater, he observed how individuals lost their identities in crowds, which were a function of "the mysterious influence of number."[29] It was Le Bon's *La Psychologie des foules* (The Psychology of Crowds) of 1895, however, that captured the popular imagination and is still regarded as a classic by sociologists today. Grounded in an almost hysterical old-guard nationalism, Le Bon's ideas about the elemental nature of the crowd served as vivid descriptions of the dangers besetting all that was most valued in French society.[30] For Le Bon and his sympathizers, the crowd was the embodiment of the "other," sociologically as well as psychologically. Hence it represented what was alien to the order of both the state and the self. Vallotton's crowds may be viewed as social and personal explorations, if not reflections, of those same sentiments.

Basic to both artist and sociologist as well was the thesis that the character of a crowd differs radically from the individuals of which it is composed. The

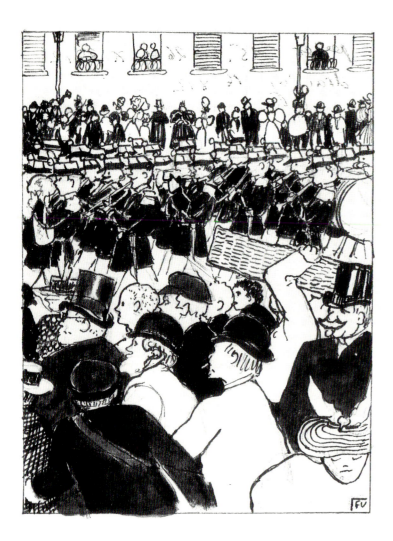

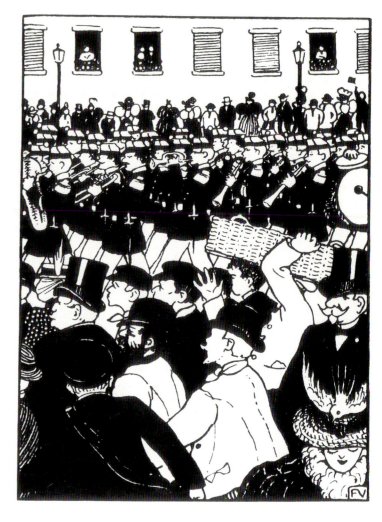

8o

Military Music, for *Les Rassemblements,* 1895

India ink and blue pencil on cream paper,
25.5 x 20.3 cm

Galerie Vallotton, Lausanne, 966862

81

Military Music, from *Les Rassemblements,*
1896

Galerie Vallotton, Lausanne

artist's synthesis, his all-embracing blacks, his but slightly variegated types, all instinctively repeat Le Bon's assertions about the mass-behavior of crowds as a living organism driven by its own collective psyche: "The substitution of the unconscious action of crowds for the conscious activity of individuals is one of the principal characteristics of the present age."[31] Also encoded in Le Bon's formulation was the dangerous idea that the crowd's mind regresses to a more primitive mentality, one that is both culturally and psychologically uncivilized. According to Le Bon, "reason is more recent than the processes of the unconscious."[32] Such views of the crowd must have informed Vallotton's imagery: how often his crowds seem swept along by single ideas or preoccupations; even the shoppers at *The Bon Marché* are rendered as if caught up in some irresistible flow.

The crowd is the great leveler. It is driven by "contagion" and suggestibility, and it is emboldened by a sense of collective power, the blinding conviction that everyone is imbued with the same thoughts and desires—a state that Le Bon very acutely likened to that of the hypnotized subject.[33] Thus there is little mental room between the thought and the act; crowds act without reflection:

> Moreover, by the mere fact that he forms part of an organized crowd, a man descends several rungs in the ladder of civilization . . . It will be remarked that

82

The Wedding, for *Les Rassemblements,* 1895

India ink and graphite on cream paper,
25.8 x 20.4 cm

Galerie Vallotton, Lausanne, 966864

83

The Wedding, from *Les Rassemblements,*
1896

Galerie Vallotton, Lausanne

among the special characteristics of crowds there are several—such as impulsiveness, irritability, incapacity to reason, the absence of judgment and of the critical spirit, the exaggeration of the sentiments . . . which are almost always observed in beings belonging to inferior forms of evolution—in women, savages, and children, for instance.[34]

Even more striking are Le Bon's proposals concerning the form of the ideas that motivate the crowd. He stresses the idea of simplicity in a manner that sounds like a prescription for Vallotton's imagery. Uncannily, then, Vallotton had absorbed into his art the most trenchant of contemporary attitudes:

> Whatever be the ideas suggested to crowds they can only exercise effective influence on condition that they assume a very absolute, uncompromising, and simple shape. They present themselves then in the guise of images, and are only accessible to the masses under this form . . . Whatever strikes the imagination of crowds presents itself under the shape of a startling and very clear image, freed from all accessory explanation, or merely having as accompaniment a few marvelous or mysterious facts.[35]

Of course, what lay behind Le Bon's thinking was the fear that the old guard was being supplanted by the masses, the socialists, and anarchists, in short,

84

Cover, *Le Rire,* 8 January 1898
The Jane Voorhees Zimmerli Art Museum,
Rutgers, The State University of New Jersey,
Museum Purchase

85

Cover, *Le Rire,* 1 December 1894
The Jane Voorhees Zimmerli Art Museum,
Rutgers, The State University of New Jersey,
Museum Purchase

by those whose values were based on inferior sentiments and quite assuredly less civilized mental processes. That crowds were likened to women and children who were held to think and act like "barbarians" or "savages" is a multiply compounded misfortune, which, alas, also finds an echo in the unruly and capricious children in Vallotton's two representations, *Little Girls* of 1893 (VG 129) and *Little Angels* of 1894 (VG 139). In Le Bon's case, such deprecations also reflected the intense opposition to and fear of the feminist movement and all it sought in terms of political and sexual equality.

We do not know how deeply Vallotton sided with these political outcasts in his daily politics, though all his biographers assume he harbored some sympathy for the socialists and anarchists. After all, he worked at *La Revue blanche* for—and painted a portrait of—Félix Fénéon, a declared anarchist. He also negotiated for some illustrations with Jean Grave, a publisher of anarchist literature; and in the late nineties he was a confirmed Dreyfusard.[36] Vallotton's sympathies certainly were with the victims of political repression and very likely with all who were systematically exploited by the upper classes and harassed by the police. Yet while all Paris was very much aware of the dangers of the crowds, so dramatically evidenced by the frequent and often violent manifestations of the early 1890s, Vallotton's images of crowds are free of a strong *parti pris.* Their detachment conveys a greater interest in what comprises and informs the crowd than in identification with the causes of their existence. Vallotton's device of locating the centers of interest beyond the borders of his images is a most telling metaphor: it is not the idea that drives the crowd that is central, but the nature of the crowd's behavior. By composing his images with simple, elided forms; by painstakingly eliminating all but the most necessary clues to characterological, social, and spatial distinctions; and by compressing the essence of feeling into a simple shape or posture, Vallotton created images that might be regarded as worthy of the imagination of the crowd. It is this engagement with one of the more urgent concerns of his time that renders his images—most especially the highly synthesized woodcuts—so rich with significance and so memorable. As Le Bon's skilled leader might evoke images to fire up the crowd's imagination, so Vallotton does for us.

Quite a number of Le Bon's ideas were challenged during the early 1890s, and I believe that those touching upon the relationship of the individual to the crowd actually shed light on Vallotton's ambivalent formulations of the individual —both as a member of the crowd and as the single subject of the artist's justly famous printed portraits. One of Le Bon's more disputed notions was his claim that the idea was prior to the act, that crowds and the individuals within them were indeed motivated. In a review of Le Bon's text, Georges Sorel contrarily argued that the *act* frequently gave rise to the idea (a postmodernist notion!): "movements provoked by artificial means actually give rise to conscious feelings of their cause."[37] One could argue, in fact, that many of the faces in Vallotton's crowds show little if any expression, as if they were mindlessly abandoning themselves to the physical emotions of the throng. Another crowd psychologist, Maurice Spronck, touched upon another sensitive issue for the already precarious psyche of the late nineteenth century when he spoke of the loss of individualism engendered by crowd phenomena, indeed by all collective behaviors. In a lecture reported in the *Revue bleue,* Spronck concluded that the real danger of his day lay in the excessive individualism that had been spawned by the perceived loss of identity associated with "the age of the crowd."[38] As a result, the nineteenth

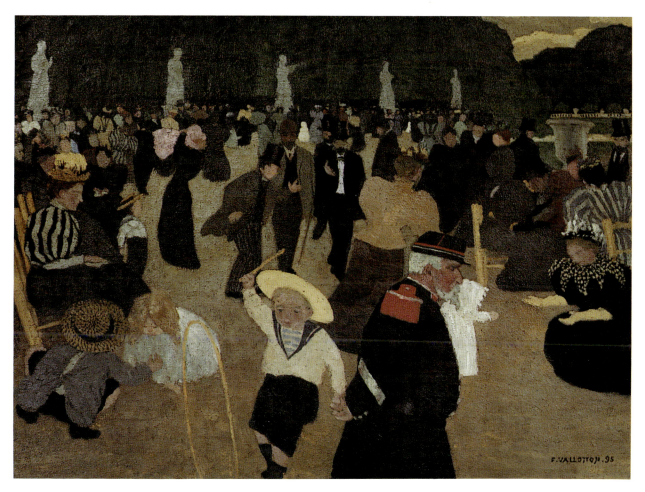

86

The Luxembourg Gardens, 1895
Oil on canvas, 54 x 73 cm
Private Collection

century had progressively destroyed its collective roots, its willingness to "follow one's masters" and to "imitate one's models."[39] As with Le Bon, such concern over the loss of traditional values led directly to discussions of the virtues of nationalism (one thinks of Vallotton's *The Patriotic Ditty*). It was Vallotton's genius to be able to exploit, in his rather detached, sometimes satiric, sometimes ironic manner, a fundamental modernist ambivalence concerning the loss of individuality to the crowd and the compensatory hyperindividualism to which the crowd then gave indirect impetus.

Inevitably such reflections require a brief consideration of Vallotton's portraits, for these too are often like faces from the crowd, albeit a cultural one.[40] Despite their unique formulations of individual physiognomy (some from well-known photographs—the portraits of Baudelaire and Poe [plate 121], for example), Vallotton's drawn and woodcut likenesses were more like emblems of the press than portraits. Although they are brilliant and totally memorable syntheses, they forbid any deeper look into the complexities of character, rather like Andy Warhol's formulations of the 1960s, which were also based on photographs. Thus even Vallotton's most individualized work subsumes the cult of personality (Spronck's excessive individualism) into the psychology of the crowd. Indeed, Vallotton's black-and-white portraits are rather like masks fashioned by the same maker (plates 15, 22). Their very popularity attests to the fact that they too straddled conflicting sensibilities of the 1890s.

The Interiors

What great evil has man committed that he deserves this terrifying partner called woman? It seems to me that with such violently contradictory thoughts and so clearly opposed impulses, the only possible relationship between the sexes is that of victor and vanquished.

FÉLIX VALLOTTON, 1918[41]

It is naturally tempting to polarize characterizations of Vallotton's exteriors and interiors: the crowd scenes preoccupied with public behavior, the interiors obsessed by unspoken emotional conflicts between individuals. Nevertheless, both were linked by underlying fears of the irrational; and as I shall conclude, that irrationality was in both cases associated with a pervasive mistrust of the female and the feminine. With his first woodcuts, Vallotton had abandoned literal description of the external world in favor of his witty vocabulary of human action. For a while, from 1891 until 1895 or so, the woodcut evolved so that it increasingly privileged the crowd over the individual. First, there was a noticeable loss of individualism among the members of the crowd, as Christian Brinton had already remarked as early as 1903.[42] And second, this melding of types was accompanied by a growing black manner that progressively eliminated line and increasingly relied on the isolation of the whites of the paper. It was this latter effect that Vallotton transposed from the out-of-doors into the dimly or artificially lit interior, where action gave way to uneasy stasis. As he moved into the hothouse settings of his interior encounters, Vallotton's images gained sonority and somberness.[43] Each image was couched in unique but simple decorative principles (always derived from the domestic world, never from abstract invention), whose repeated textures are both analogues for music itself and unfailingly apt accompaniments to the main motifs. Music, after all, was an important aspect of all Symbolist undertakings, especially those of the Nabis and the circle of *La Revue blanche*: the artists Bonnard, Denis, Roussel, Lautrec, and Vuillard, the director Thadée Natanson and his wife Misia, and various writers.

The Symphony of 1897 (VG 186; plate 87) portrays Misia at the piano and, sequestered at some distance, five absorbed listeners (who surely include Vuillard, standing, and Alfred Cortot, with glasses).[44] The shape of the piano, the patterns of the background, and the title itself suggest a musical, but one wonders why Vallotton chose the word "symphony." Was he slyly commenting upon Misia's charisma, setting her off in pure white as spiritual orchestrator of both her music and her admirers? They are indeed held spellbound, almost disembodied, in the blackness that emanates like sound from her piano. Surely no other Symbolist painter managed to capture so completely the mesmerizing powers of a performer and her music. But such a reading, if just, intimates that music exerted a mysterious, seductive power not unlike that held by women over men, a theme that had been brewing in Vallotton's painted and graphic work since the middle of the decade.

In 1896 and 1897, Vallotton had completed a suite of six woodcuts, which he laconically entitled *Musical Instruments* (VG 171–76; plates 88, 89, 91). Each one, however, is also a portrait of a musician—Joseph Holmann, cellist; Eugène

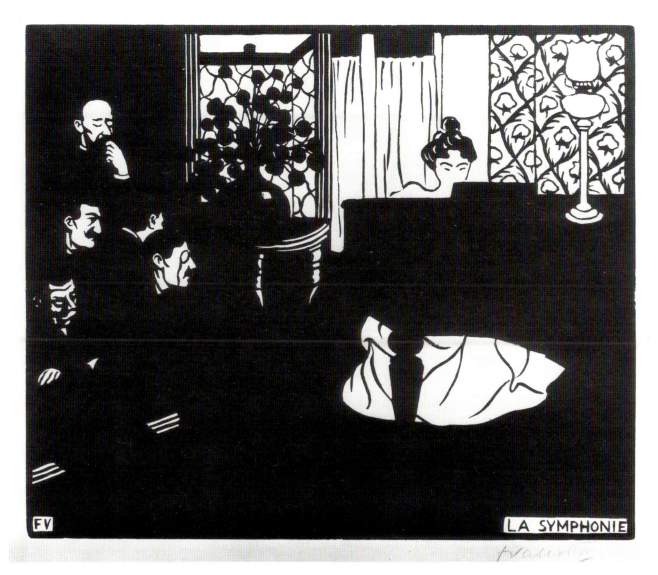

8₇

The Symphony *(La Symphonie)*, 1897
Woodcut, 21.8 x 26.8 cm
Josefowitz Collection

Ysaïe, violinist; Raoul Pugno, pianist; Louis Schopfer, guitarist; and an unidentified flautist and cornetist—performing privately, engulfed in deep shadows, surrounded by a few isolated, personal effects.[45] The images themselves are overwhelmed by deep blacks, into which one may read—especially through the preparatory drawings (plates 90, 92)—the space of a room, the shape of a man, the texture or separateness of an object. Full of suggestiveness, the shadows are alive and sensitive, and seem to conjoin performer, instrument, setting, and music in a wholly mysterious manner. At the absolute height of his understanding of black and white, Vallotton wielded remarkable powers of differentiation. Yet, I do not believe he was attempting to find formal or abstract equivalents (*correspondances*) for the sounds of individual instruments.[46] Rather he was able to so individualize the scenes that each feels as if it embodied a distinct timbre. Psychoanalyst Glynn, on the other hand, interpreted the six plates of the *Musical Instruments* very differently, as solitary, masturbatory fantasies: an idea not at all in conflict with their deliberate sensual overtones and solo performances. Even if one resists accepting the explicit sexuality of Glynn's reading, there is a related view that

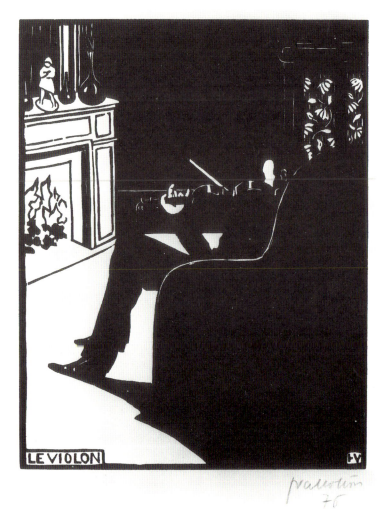

88
The Violin (*Le Violon*), 1896
From *Musical Instruments*
Woodcut, 22.5 x 17.9 cm
Josefowitz Collection

89
The Flute (*La Flûte*), 1896
From *Musical Instruments*
Woodcut, 22.4 x 17.7 cm
Collection, The Museum of Modern Art,
New York, Gift of Victor S. Riesenfeld,
371.48

seems more generally appropriate. Allowing that for Vallotton the highest expression of musicality was the merging of the individual identities of musician, instrument, and setting, it could be argued that the woodcuts of *Musical Instruments* embody fantasies of self-sufficiency and refuge, of men without women, of retreat from the problematic relationships that would soon surface in Vallotton's *Intimités*.

This second album of interiors was Vallotton's most sophisticated graphic undertaking. Yet the ten blocks of *Intimités* were published by *La Revue blanche* in 1898 in an edition of only thirty before they were destroyed. And they have only once been accorded the attention they deserve, and then in an unpublished Master's thesis by Lise Marie Holst, who basically regarded the set as a critique of bourgeois marriage, its hypocrisies, its false promises, and its inevitable rendezvous with failure.[17] As Holst points out, the series signals an unusual joining of the obsessions and ominous psychological themes of Gauguin, Munch, and other

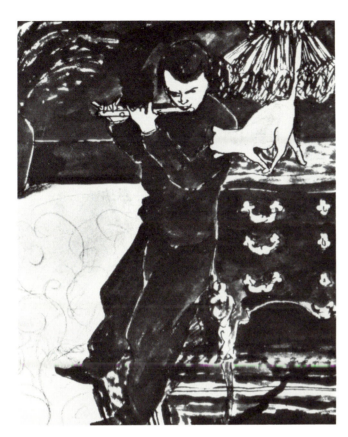

90

The Flute (*La Flûte*), 1896

Study for "The Flute"

India ink and blue crayon on white wove paper, 27.2 x 22.6 cm

Cabinet des estampes, Musée d'Art et d'Histoire, Geneva

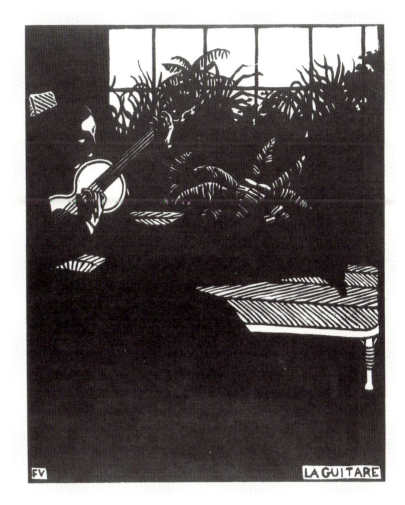

91

The Guitar (*La Guitare*), 1897

From *Musical Instruments*

Woodcut, 22.5 x 18 cm

Collection, The Museum of Modern Art, New York, Gift of Ludwig Charell, 131.55

92

The Guitar (*La Guitare*), 1897

Study for "The Guitar"

India ink and lead pencil on white laid paper, 26.4 x 20.7 cm

Cabinet des estampes, Musée d'Art et d'Histoire, Geneva

Symbolists, with the stuffy interiors of the Nabis. Just as the crowd scenes reflected nearly hysterical ideas about the unpredictable, primitive, emotional surges of the masses, so the interiors reflected late-nineteenth-century preoccupations with the primitive nature of women and their hidden, uncontrollable instincts.

As a whole, the *Intimités* seem to evoke a text, so linked are they to the themes that prevailed in the theater, literature, the popular press, and contemporary psychology: specifically, the relationships between men and women. Each of Vallotton's woodcuts suggests a staged event, a vignette, a short story—very much, for example, in the manner of the short episodes of Jules Renard's *La Maîtresse* (The Mistress), for which Vallotton had provided drawings in 1896, or the short sketches by Victor Joze and countless other authors of the period.[48] Each scene narrates a specific emotional encounter between a man and a woman, set in a domestic interior. Yet *Intimités* is not a tale of "a marriage," for the characters are sufficiently varied to avoid any hint of a continuous text. Just as the series does not tell a story, so each scene may only be subjected to partial interpretation. While every nuance of contour is at once a descriptive, decorative, and spatial event, there is a mysterious refractiveness to these images that returns to the observer an even greater responsibility for the construction of meaning than was the case with the images of crowds. Much of this inaccessibility can be traced to Vallotton's threatening, obliterating blacks. Associated with the Germanic tradition of woodcuts of death (from the anonymous masters of the fifteenth century through Dürer, Baldung, Holbein, Friedrich, and Rethel), Vallotton's opaque blacks are not only full of foreboding, but uncomfortably obstructive, impeding the viewer's access to that which he or she assumes to exist within the murky shadows—and *is* there to be seen in the less synthesized preparatory drawings (plates 94, 96, 97, 100, 101, 104, 107, 110). Vallotton's blacks become more than mere abstractions; they extend into space and suggest volume, but in so doing are also a vehicle through which the author's own opacity inscribes itself in the work. In other words, in the *Intimités* the blacks both set a mood and are a metaphor for restrained interpretation. What is more, Vallotton underscores his ambiguity in the titles, whose meanings and applications are often deliciously unclear.

Holst traces Vallotton's inspiration for the *Intimités* specifically to Vuillard's painting, *The Conjugal Life* of ca. 1894, an interior whose space disquietingly separates man and wife. It was during the following year that Vallotton broached the theme of the relations between the sexes with the woodcut *A Trusting Man* (VG 161; plate 50), succeeded in 1897 by *The Fine Pin* (VG 187) and *The Lie* (VG 188; plate 93), all of which positioned the lovers on a bench or couch whose breadth could express the short distance between intimacy and separation. Only *The Lie* would find its way into the final portfolio of *Intimités*. Even the next two woodcuts, *The Outburst* and *Emotion* (VG 199 and 198) were eventually rejected from the series.[49] From their order of execution (set forth in the artist's *Livre de raison*), it would appear that Vallotton was groping for a specific, understated tone, one whose balance would not be perturbed by anything as obvious as the open strife of *The Outburst* or as superficially anecdotal as the first version of *The Fine Pin*. The ambiguity of *The Lie* was far preferable: two lovers embracing, his eyes closed, her face buried against his, their legs intimately entwined, all subverted by the title, which—as in all of Vallotton's woodcuts—forms part of the

93

The Lie *(Le Mensonge)*, 1897

From *Intimités*

Woodcut, 18 x 22.5 cm

The Art Institute of Chicago, Gift of the
Print and Drawing Club, 1948.3.1

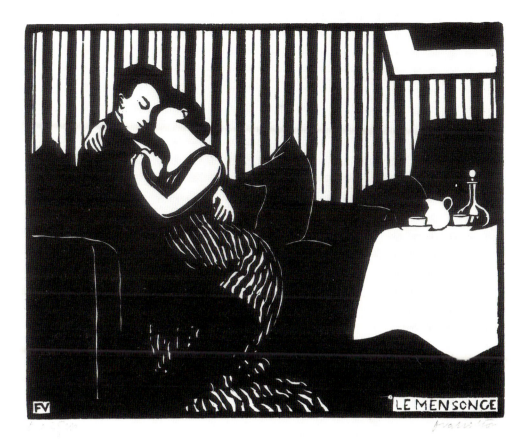

94

The Lie *(Le Mensonge)*, 1897

Study for "The Lie"

India ink, lead pencil, and white gouache on
white laid paper with watermark, 18.2 x 22.8
cm (image)

Musée du Louvre, Département des Arts
Graphiques (Fonds Musée d'Orsay), Paris

95

The Triumph *(Le Triomphe)*, 1898
From *Intimités*
Woodcut, 17.8 x 22.5 cm

The Art Institute of Chicago, Gift of the
Print and Drawing Club, 1948.3.2

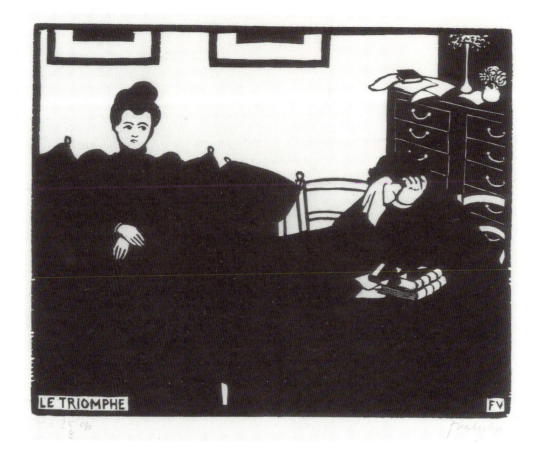

image.[50] Who is dissembling in this blissful interior disrupted only by the harsh pattern of the striped wallpaper? Is it intimacy itself that is the lie? Is it the man who feigns love only in order to conquer? Or is it the woman who, in the next scene, *The Triumph* (VG 189; plate 95), sits almost rigidly frontal and glances virtually unmoved at the spectacle of her weeping lover seated at his work table, his head now buried in his own handkerchief? Here she is firmly ensconced beneath two precisely squared picture frames; he, in contrast, slumps amid the subtle disorder of books and papers. Sphinx-like and triumphant, she very much recalls the many images of jealousy painted and printed by Edvard Munch in the mid-nineties.[51] From this point in the series, it remains open to question whether Vallotton had thrown in his lot with the popular medieval theme that celebrated the domination of man by woman, or was continuing to equivocate about the nature of intimate relationships.[52]

The second version of *The Fine Pin* (VG 190; plate 98) is far more open to interpretation than its predecessor. The couple embraces by the side of a bed, whose decorative footboard and jaunty white pillows gleam cozily and invitingly. The protectiveness of the interior is indicated by the partly closed, gracefully cordoned drapes. The woman, all innocence in white, gestures as if to examine (or remove?) a "fine stickpin" from the man's shirt. Is this a scene of affectionate or of unequal exchange, that is, of love for money (the late-medieval motif of "unequal lovers")?[53] Should one attribute such exchanges to avarice rather than tender affection? Such ambiguities pervade the *Intimités* and at first appear to be the very heart of their Symbolist content.

Ruby (*Rubis*), 1898

Study for "The Fine Pin"

India ink, lead pencil, sepia, and white gouache on white laid paper watermarked Hallines, 18.3 x 19.6 cm (image)

Musée du Louvre, Département des Arts Graphiques (Fonds Musée d'Orsay), Paris

96

The Triumph (*Le Triomphe*), 1898

Study for "The Triumph"

India ink, lead pencil, sepia, white gouache, and scraping on white laid paper with watermark, 18.1 x 22.7 cm (image)

Musée du Louvre, Département des Arts Graphiques (Fonds Musée d'Orsay), Paris

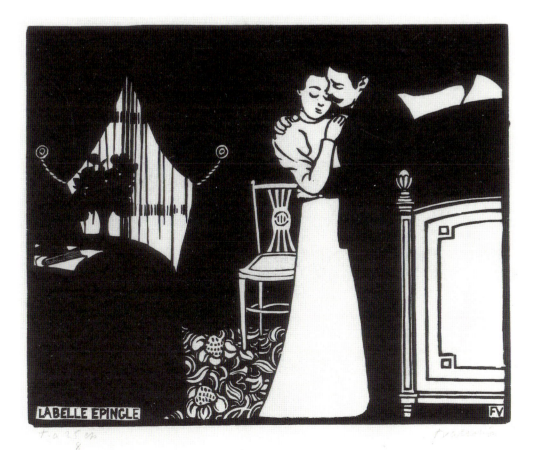

98

The Fine Pin (*La Belle épingle*), 1898

From *Intimités*

Woodcut, 17.9 x 22.5 cm

The Art Institute of Chicago, Gift of the Print and Drawing Club, 1948.3.3

© The Art Institute of Chicago. All Rights Reserved.

99

The Cogent Reason
(La Raison probante), 1898

From *Intimités*

Woodcut, 17.8 x 22.3 cm

The Art Institute of Chicago, Gift of the
Print and Drawing Club, 1948.3.4

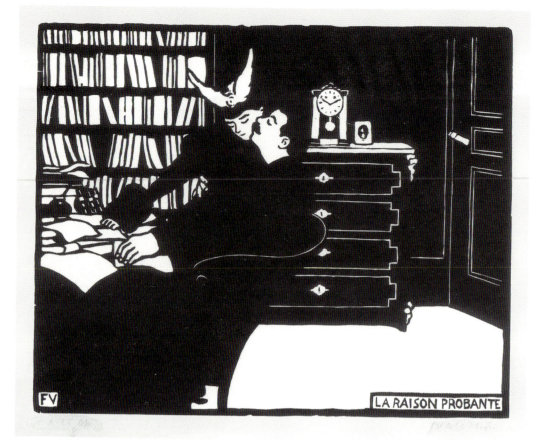

100

The Pressing Errand
(La Course pressée), 1898

Study for "The Cogent Reason"

India ink on white laid paper watermarked
Hallines, 17.7 x 22.3 cm (image)

Musée du Louvre, Département des Arts
Graphiques (Fonds Musée d'Orsay), Paris

101

The Temptation *(La Tentation),* 1898

Study for "Money"

India ink, lead pencil, white gouache, and
sepia on white laid paper watermarked
Hallines, 18.3 x 24.7 cm (image)

Musée du Louvre, Département des Arts
Graphiques (Fonds Musée d'Orsay), Paris

102

Money *(L'Argent)*, 1898
From *Intimités*
Woodcut, 17.9 x 22.5 cm

The Art Institute of Chicago, Gift of the
Print and Drawing Club, 1948.3.5

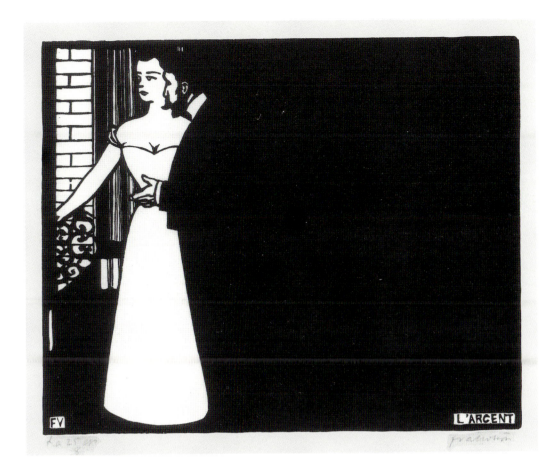

The Cogent Reason (VG 191; plate 99) again permits readings at odds with
each other: a woman departing offers either affectionate reassurance or a decep-
tive rationale. Yet, might she not be arriving, making some urgent excuse for an
unexpected visit? The first preparatory drawing makes clear that she is not
merely bending over to be pecked, but has actually seated herself in the man's
lap. Vallotton pondered this himself as he debated titles, wavering between "The
Pressing Errand," with which he inscribed both preparatory drawings (plate 100),
and "The Cogent Reason," which he finally cut into the block. The latter title is
far more ambiguous than "pressing errand," and it seems to me that this greater
suggestiveness was precisely what Vallotton desired. How innocently the man
exposes his neck and closes his eyes in the act of kissing; how feminine is her hat
with its motif of the winged dove, a rather obvious but again ambivalent emblem.
Does it suggest feminine flightiness or calculated flight? Carefully composed, the
work supplies no clues of deceit; the trusting man has simply been interrupted in
his comfortable study.

If deception lurks in the shadows of the affectionate interchanges of *The
Fine Pin* and *The Cogent Reason*, a dark cynicism takes center stage in *Money* (VG
192; plate 102). Modern viewers might assume that the man is initiating the
exchange; he appears distinguished, reserved, and controlling, while the woman,
bathed in light, is surely the object of his desire. Her glance is averted here; it is
she who looks away through the open window, as if longing for something un-
known, while accommodating the male gaze with her generous body. Does her
look conceal wistfulness or deceit? On the other hand, his gesture, though gentle

103

Extreme Measure (*Le Grand moyen*), 1898
From *Intimités*
Woodcut, 17.7 x 22.3 cm
The Art Institute of Chicago, Gift of the
Print and Drawing Club, 1948.3.6
© The Art Institute of Chicago. All Rights
Reserved.

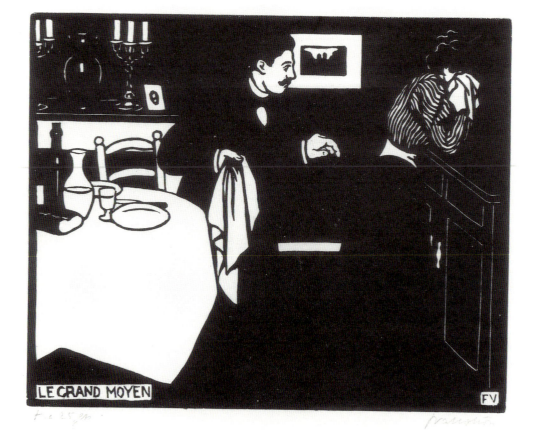

and confident, is not necessarily that of an importuning lover. Even Vallotton's provisional title for the preparatory drawing, *The Temptation*, leaves matters unclear as to who is using money as barter for affection. Without doubt, *Money* is the most subtle of the *Intimités*. The silhouette of the man, which so perfectly defines the woman (or is it the other way around?), conjoins him as well to the impenetrable flatness and darkness of the remainder of the image. It is in this expanse of black that Holst locates her most pessimistic interpretation of the *Intimités*: "The black, as it merges the figure of the man with the darkness of the surrounding room, makes a strong statement, central to the meaning of the set, as it represents the void that is at the heart of the relationship between the two people portrayed . . . a metaphor for the nature of the intimacy we are invited to examine."[54] Is the title, which gleams from the impenetrable black of the right half, part of his world or hers? Is his gesture one of polite offering or of desire? If she indeed is being tempted, is she hesitant or alluring, or perhaps as inaccessible as the blank wall of the exterior or as inscrutable as the murkiness of the interior? To see *Money* as the portrait of a manipulative woman, as Holst, Godefroy, Thérive, and others seem to have concluded, is to limit the possibilities of that which Vallotton has so masterfully crafted.[55]

Similarly, one could claim that *Extreme Measure* (VG 193; plate 103) is a brazen depiction of feminine wiles. A dinner has been interrupted by some emotional stress; the man rises, concernedly distracted—he still holds onto his napkin. A telling separation between the two is made more emphatic by the picture on the wall and the white strip of dado. The woman's motion is away from the

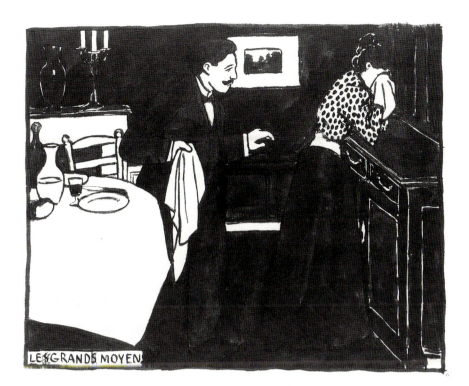

104

Extreme Measure (*Le Grand moyen*), 1898

Study for "Extreme Measure"

India ink, lead pencil, and scraping on white laid paper watermarked Hallines, 18 x 22.7 cm (image)

Musée du Louvre, Département des Arts Graphiques (Fonds Musée d'Orsay), Paris

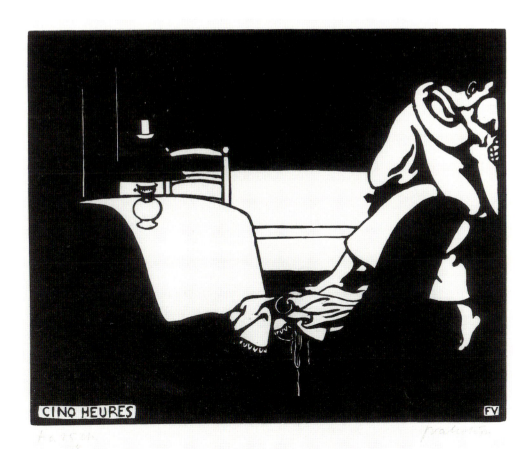

105

Five O'Clock (*Cinq heures*), 1898

From *Intimités*

Woodcut, 17.7 x 22.3 cm

The Art Institute of Chicago, Gift of the Print and Drawing Club, 1948.3.7

© The Art Institute of Chicago. All Rights Reserved.

domestic order and tranquility of the dinner table. What the man has declared, confessed, or accused, however, the viewer cannot know. Only Vallotton's title suggests that her tears are something other than those of shame or guilt, betrayal or despair, that they are manipulative; the image itself remains neutral, as does that of the next woodcut, *Five O'Clock* (VG 194; plate 105). Again the table, bare except for a tablecloth and a lamp, acts as a foil for the lovers, who embrace hastily, impatiently, even bestially. Their awkwardly fused, peculiarly organic shapes crowd and disappear into the right margin, not unlike the feline-featured servant who is decidedly "marginalized" in Vallotton's woodcut *The Bath* of 1894.[56] Is this a furtive love affair, the illicit "five o'clock" rendezvous forced to the margins by hypocrisy (or morality!)? Should we assume that *Five O'Clock* represents a betrayal of one partner more than of the other?

Despite my efforts to underscore the ambiguities of Vallotton's images, there is a somber air that hovers over these simple, stately, artificially illumined scenes. One senses a desperation, a silence, and a distance between the lovers, one that seems to expand ineluctably as one ponders successive images. A growing, nagging suspicion arises that despite the fair-mindedness of the viewer, the woman has indeed been cast as the deceiver all along—especially by a society that had denied her freedom and sexual identity. She, rather than the hypocritical society that romanticizes intimate relationships, is the root cause of the disintegration of the intimacies of love and marriage. She is made responsible for man's insecure phallicism, his desperate need to control and domesticate the dangerous female he must also idolize. There can be little questioning of Vallotton's intent

106

Getting Ready for a Visit
(Apprêts de visite), 1898

From *Intimités*

Woodcut, 17.7 x 22.3 cm

The Art Institute of Chicago, Gift of the Print and Drawing Club, 1948.3.8

© The Art Institute of Chicago. All Rights Reserved.

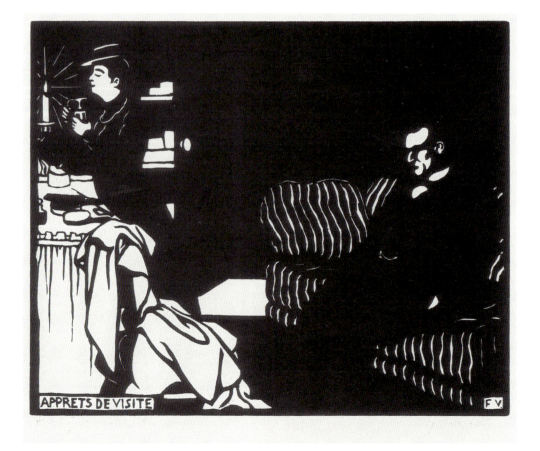

in *Getting Ready for a Visit* (VG 195; plate 106), in which he contrasts the man, eyes averted, hands in pockets, to the woman's bustling preparations before going out, presumably by herself (she is already wearing her hat). More obviously narrative, the hardly differentiated shape of the man is craftily absorbed into the striped sofa, while the woman's form and her cologne are illumined by the nearby candle. Vallotton's first titles, scribbled in the lower margin of the preparatory drawing, leave little doubt about the cause of the man's downcast disposition: "getting ready for a visit," "getting ready to go out," "disquieting outing," "the pressing errand," "gloomy forebodings," "suspicion," and "the pressing errand." The fact that the artist again considered using "the pressing errand" to excuse the departure of the woman casts an even more sinister aura over the scene he eventually titled *The Cogent Reason*.

The Other's Health (VG 196; plate 108), as Holst points out, must be paired with *Five O'Clock*. Not only is it again set in a rather bare room, but it once more portrays something of genuine intimacy and affection. And as in *Five O'Clock* (as well as *The Lie*), Vallotton deliberately occluded the woman's features. In so doing he not only emphasized her generic selflessness and generosity, but also her facelessness—an undifferentiated object of male desire and servitude. Is man only in love with the idea of woman, but never the individual? Is affection an illusion, only attained by illicit means? Or is man forced to seek affection from the bodies of those who do not matter because his spouse concerns herself only with material rather than emotional exchanges? So pervasively misogynist is the literature of the late nineteenth century—it even informed Le Bon's invidious

107

Dressing Up to Go Out (*Toilette de sortie*), 1898

Study for "Getting Ready for a Visit"

India ink, lead pencil, sepia, and white gouache on white laid paper watermarked Hallines, 18.1 x 22.7 cm (image)

Musée du Louvre, Département des Arts Graphiques (Fonds Musée d'Orsay), Paris

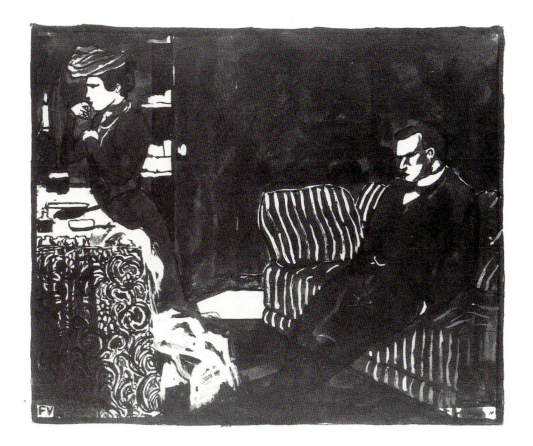

108

The Other's Health
(*La Santé de l'autre*), 1898
From *Intimités*
Woodcut, 17.7 x 22.3 cm
The Art Institute of Chicago, Gift of the
Print and Drawing Club, 1948.3.9

comparison between crowds and women—so fearful were men of the politically
and sexually emancipated woman, that only with great effort could one fail to
read an underlying misogyny in the *Intimités*. Holst, citing Vallotton's words of
1918 with which this section begins, maintains that the artist was attacking the
institution of marriage, its false promises of happiness, and its certain degenera-
tion into a struggle for power in which women emerged as the ultimate victors.[57]
Is this not the scenario of *Intimités'* final scene, *The Irreparable* (VG 197; plate 109)?
The couple sits side by side, conjoined but irreparably separate: she, as in *The
Triumph*, frontal, unmoving, and content; he distraught, hands and glance totally
distracted, comforted only by the natural world of the sheltering, weeping plant.
Man's isolation from woman is as politically final but not as psychologically shat-
tering as in Munch's images of *Jealousy* (plate 111). The declarative legend, lurk-
ing in the darkness that embraces the couple, fuses its meaning with the image,
fixing forever the unbridgeable gulf between man and woman.

110

The Irreparable *(L'Irréparable)*, 1898
Study for "The Irreparable"
India ink, lead pencil, sepia, and white
gouache on white laid paper watermarked
Hallines, 18.1 x 22.8 cm (image)
Musée du Louvre, Département des Arts
Graphiques (Fonds Musée d'Orsay), Paris

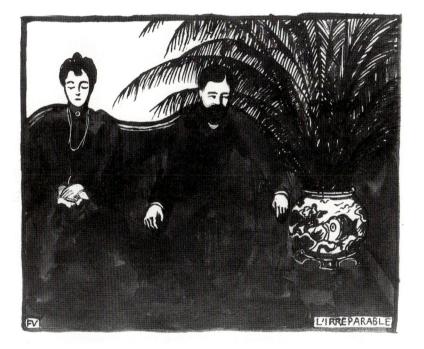

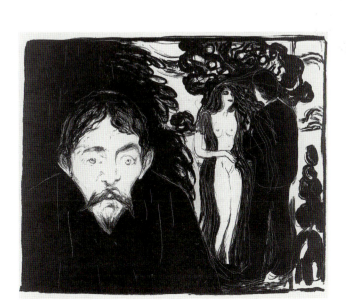

111

Edvard Munch (1863–1944)
Jealousy, 1896
Lithograph, 47.7 x 57.5 cm
Private Collection

112
Cancellation proof, *Intimités,* 1898
Woodcut, printed from 10 blocks
Galerie Vallotton, Lausanne

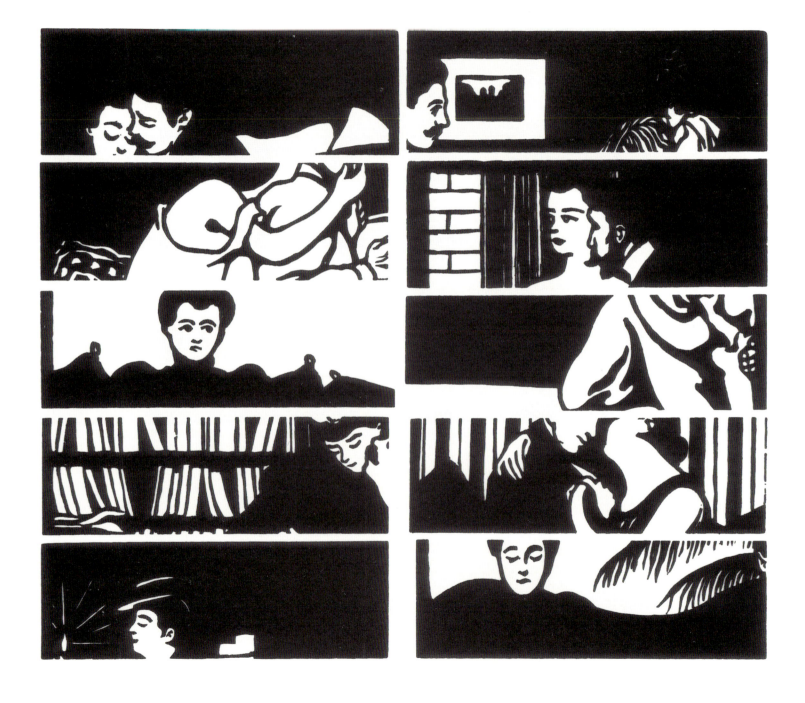

Vallotton's remarkable feat is to have infiltrated so much gloom and bit-terness into a series of simple scenes, at least half of which resist definitive narra-tive interpretation. There is no doubt that the process is very much akin to the structure of Renard's *La Maîtresse* or Strindberg's volume of short stories, *Mar-riage*, both of which consist of short chapters or cameos—bits and pieces of dia-logue or events that operate not metaphorically but metonymously. Vallotton's woodcuts work similarly: the suggestive blacks of single works imply a much more elaborate whole, while the insistent repetition of ambiguity produces meanings consonant with life itself.

Intimités is thus very much greater than the sum of its parts. While most of the images maintain a level of benign ambiguity, the morbid content of the whole is being constructed. It overtakes the reader almost without conscious realization, like the slow disillusionment that may undermine a marriage. Even Vallotton's most unusual "cancellation proof," appended to each portfolio and consisting of one telling section excised from each destroyed block (plate 112), was itself a compendium of final destruction, both physically and metaphorically. Such insidious accumulation of evidence lends a power and originality to *Intimités* very different from the hauntingly psychological images of Edvard Munch's *Frieze of Life*, which was so obsessed with the inevitable cycle of the woman's life and with the voracious female's infiltration and domination of man's consciousness.

Perhaps incapable of fully examining his own feelings, Vallotton found a way to inflict his bitterness and mistrust on scenes of the everyday world. A pessimistic community of interests was shared by his major subjects, the crowds and the interiors: both were stages on which were played out the instinctive, irrational, and aggressive behaviors that threatened the established order of things. Only Vallotton's wit, cleverness, distance, and ambiguity succeeded in deflecting and delaying recognition of this pervasive pessimism. His images cap-ture the essence of the "gay nineties," the "Belle Epoque" under whose glitter and extroversion seethed the most deeply conflicted attitudes and emotions.

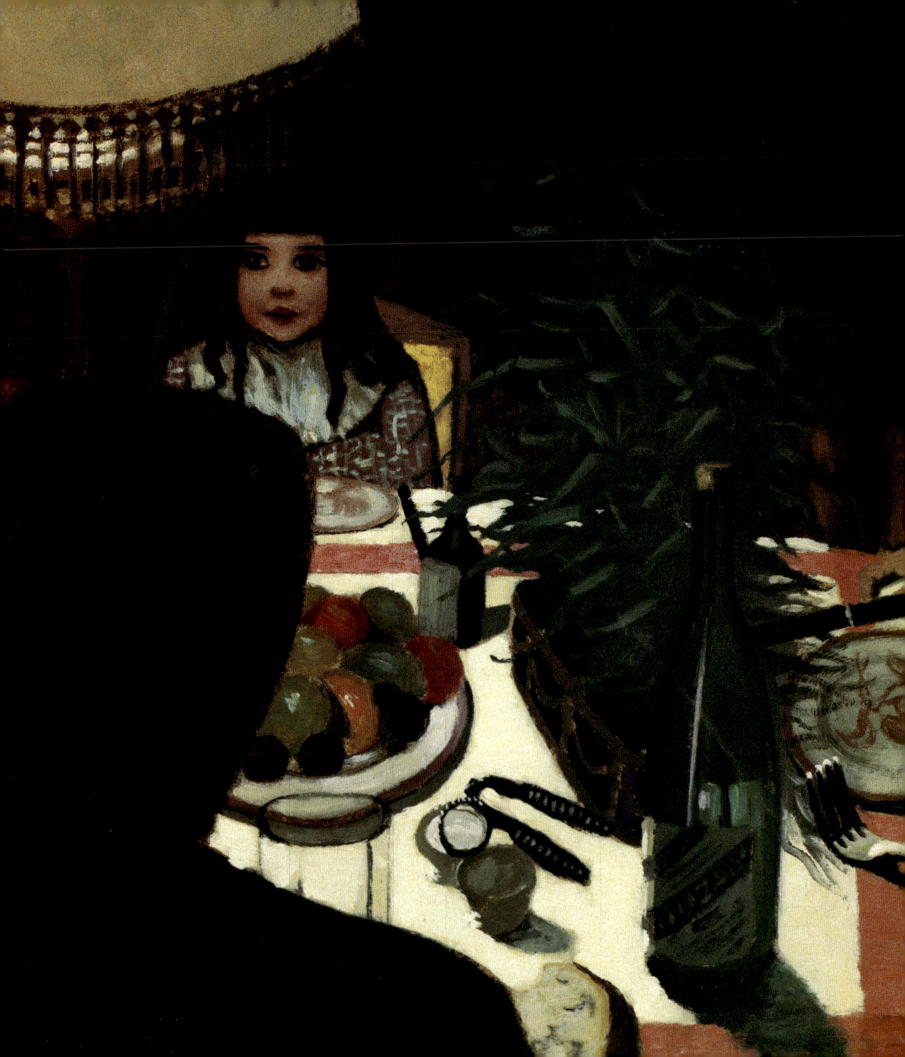

John Klein

Portraiture and Assimilation of the "very singular Vallotton"

Félix Vallotton's distinctive woodcuts and genre paintings of the 1890s, the decade of his close association with the Nabis, have largely determined his status within the avant-garde. And the particular renown, both critical and popular, of his portrait prints has assured his reputation to the present day. By comparison, however, the career-long significance of the *painted* portrait in Vallotton's art has been obscured. Such disregard is hardly surprising. Portraiture in general occupied a subdued position in advanced European art at the end of the nineteenth century and the beginning of the twentieth. Its decline was in large part attributable to the growing popularity of photography, which had made greater incursions into the territory of the painted portrait than into other genres. Nevertheless, many ambitious painters were drawn to portraiture as a means of exploring the reciprocity between social and psychological meaning. Some, including Cézanne, Vuillard, Beckmann, and Matisse, took on the challenge of one or more of the portrait's traditional rhetorical concerns, such as resemblance, positive revelation of character, or the expression of the sitter's values. Other artists, for example Schiele, Gauguin, Picasso, and Picabia, transgressed such attributes of the sitter to devise a more conceptual representation.[1]

Vallotton belonged to the first category, but his extensive portrait practice set him apart from most of his contemporaries in the avant-garde in several respects. Portraiture was the key to Vallotton's early reputation and increasing success. It was through his portraits that, as a young Swiss artist in Paris, he gained entrance to the annual Salon and to the opportunities that followed from this exposure. And nowhere in Vallotton's painting is his desire to align himself with the realist tradition in European art more evident. In the portrait he found the ideal vehicle for his devotion to the kind of crisp, static, and graphically sophisticated realism that he admired in the work of old master artists, particularly those of the "severe schools in the grand manner"; at the Louvre he copied portraits by

Antonello da Messina, Leonardo, Dürer, and Holbein, a fellow Swiss native for whom he expressed the keenest regard.[2] Vallotton's effort to reconcile his esteem for these painters with his desire for originality and personal expression was a typical dilemma for the modern artist who sought a place alongside the achievements of the past.

Artistic assimilation was not Vallotton's sole concern as a portraitist, however. He solicited portrait commissions throughout most of his career and was particularly mindful of the potential value of the encounter between sitter and artist. Yet his success was not merely a question of sales and public acclaim, but was even more intimately and concretely linked to changes in his own position within French society. I wish to propose that Vallotton had an active interest in this process of social mobility and that he discovered in the portrait a means to define social worlds—those to which he belonged and those to which he aspired. In other words, the portrait was a tool of social as well as artistic assimilation. Early in his career, he used portraiture to bridge the gap between the conservative Swiss society of his origins and the literary and artistic avant-garde of Paris. From this platform he ultimately gained access to a position in the French upper-middle class that transcended his more modest origins in French-speaking Lausanne. His outsider's quest for inclusion thus functioned within levels of French culture as well as levels of class.

More than any other genre in which he worked, the portrait operated as an agent of Vallotton's social ambitions. Yet between the expression of a desire and its satisfaction, ambivalence may arise. Assimilation is rarely a seamless process, and the effort to remake oneself can leave mixed emotions. Vallotton's many portraits of others throw light on his own self-image, revealing both the aspirations and the misgivings that attended his rise in French art and society.

Even as a member of the Nabis Vallotton remained apart, "the foreign Nabi."[3] Stylistically his portraits of this period retained the cool edge of his earliest manner, which was rooted in academic tradition and specifically in the heritage of Ingres. Vallotton preferred the tangibility of represented surfaces and the integrity of their contours to the dissolving and embedding fluidity of the interiors of Bonnard or Vuillard: his work is more allied in this respect with that of Maurice Denis. Bodily integrity in Vallotton's representation of his sitters was a sign of their self-sufficient identity; with Bonnard and Vuillard, a more atmospheric and undifferentiated rendering of figure and environment stood for the mutability and contingency of identity in a field of relationships. The dominance of this essentially Mallarméan idea in Vallotton's circle did not seem to affect him. Stylistic assimilation was not strictly necessary to social assimilation, and throughout his career he exercised a determined independence that earned him an assessment as "the very singular Vallotton."[4]

Conceptually, however, Vallotton's portraiture fluctuated between the romantic ideal of the heroic autonomy of the individual and a more contemporary realist concern with contextual identity. The isolated figure carries a different psychological charge, and a different index of identity, than does the figure integrated in a domestic or professional interior. There is no apparent pattern to Vallotton's employment of these two basic premises for the portrait, no sense of his work developing from one view of the individual to the other. Circumstances no doubt played some part, but it is worth speculating that the variance results from his uncertainty about whether an individual's identity was lodged in the self

or others, in nurture or society, in what you were or what you could become.

Two early portraits, each with a prominent place at the beginning of Vallotton's career, already exhibit this dialectic between autonomy and environment. The *Portrait of Monsieur Ursenbach* of 1885 (plate 114) was the first work the young artist recorded in his *Livre de raison*, the compulsive personal account of his production he began to keep that year.[5] *The Painter at 20* (plate 115), also painted in 1885, is Vallotton's earliest self-portrait. Together the two paintings reveal Vallotton's sensitivity to the appropriateness of a given context.

The Painter at 20 is the first of Vallotton's nine painted self-portraits, a restrained total for such a demonstrably self-conscious artist coming of age in the late nineteenth century. A smaller and undetermined number of drawings and prints after his own image completes a limited and fairly homogeneous group.[6] Vallotton did not make self-portraits with the confessional compulsiveness of Van Gogh or Hodler, or the more somber role-playing of Beckmann or Corinth; nor with the allusiveness of de Chirico or the authorial declamation of Picasso. But the muted rhetoric of his self-images is telling, for it discloses a substantial tension between self-assertion and doubt.

As in all his early self-portrait paintings, Vallotton presents himself in isolation, here against a background of steely blue, a pure atmosphere of paint. Body in profile, face turned three-quarters, the young artist seems barely to meet his own gaze in the mirror. Vallotton's relationship to his image, at once bold and hesitant, betrays a young artist in possession of masterful technique but not yet in command of himself. When he exhibited this work in the Salon des Artistes français in 1886, he gave it the dissociating title *Portrait of a Young Man*. Diffidence and directness mingle at an early point in an oeuvre notable for simultaneous acknowledgment and suppression of passion.

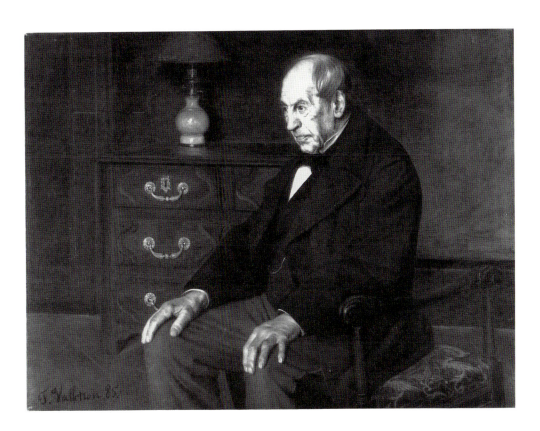

114
Portrait of Monsieur Ursenbach, 1885
Oil on canvas, 97 x 131 cm
Kunsthaus Zürich

In contrast, *Portrait of Monsieur Ursenbach* neither expresses a dynamic psychology nor indeed seems even to interrogate the character of the sitter. But when Vallotton exhibited this painting at the Salon des Artistes français in 1885, it did much to launch his career as a portraitist. Its sober style, betokening bourgeois solidity and respect for tradition, provoked a critical response of archetypal importance for Vallotton's subsequent reputation. The writer for the newspaper *Le Gaulois* characterized the picture as "a bold portrait, honest and interesting, although a little dry."[7] With minor variations critics would apply this set of attributes to Vallotton's portraiture throughout his career.

The awkwardness and placidity of Ursenbach's presentation are a far cry from the image of worldly power in the picture's likely prototype, Ingres' portrait of the press lord Louis-François Bertin (plate 141). Yet in its emphasis on draftsmanship—the basis of the curriculum at the Académie Julian, where Vallotton had been studying for three years—the portrait provides one of the earliest indices of Vallotton's continuing affinity with Ingres' graphic treatment of the human figure.[8]

Portrait of Monsieur Ursenbach also depicts a man in a room, but a room

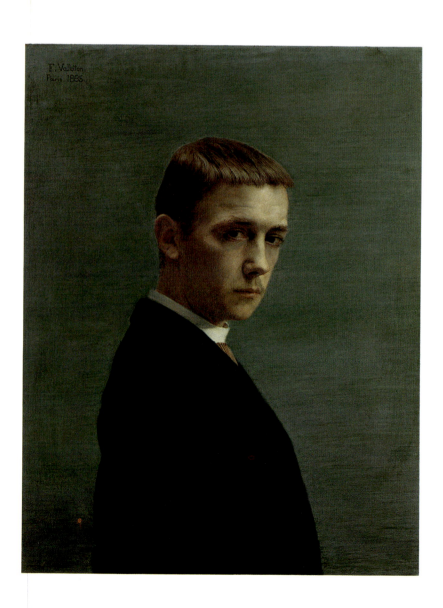

115
The Painter at 20, 1885
Oil on canvas, 70 x 55.2 cm
Musée cantonal des Beaux-Arts, Lausanne

manifestly not his own. Ursenbach's attitude of self-conscious unease may result from the demands of posing. But his uncomfortable, upright position, as if he is on the verge of leaving, suggests another order of displacement as well. Like Vallotton, Ursenbach was an outsider in Paris, an American and a Mormon who shared with the artist an interest in mathematics.[9] As appropriate as this tasteful, well-maintained interior may seem to this avuncular figure, he does not inhabit this place, in which he is literally decentered and skewed. Vallotton himself was acutely sensitive to such dislocation; by 1885 he had been on his own in Paris for three years. Long visits home, concern for parental approval, and an ample correspondence—especially with his older brother Paul—testify both to the strength of his family attachments and to his need to reaffirm them.[10] While the suppression of environment in *The Painter at 20* asserts Vallotton's independence of any social context, the uncertainty and obliqueness of his self-presentation convey a full measure of his ambivalence about his situation away from home.

During visits to Lausanne in the latter half of the 1880s, Vallotton painted several portraits of his parents and siblings that likewise reveal a great deal about the contested territory of the self. It seems the most natural thing for a young artist to paint portraits of family members. Not only are the sitters held by compelling ties, but such portraiture extends the self of the artist into a larger human realm, one that reciprocally locates and qualifies his or her formation. A family portrait is both a demonstration of achievement and worth and an acknowledgment of shared values, as the maturing artist discovers—in a family long taken for granted—individuals who have their own claims for recognition. In these works Vallotton gave his family members their due, through grand conceptions and respectful, masterly technique. *The Artist's Parents* of 1886 (plate 116), a majestic double portrait that evokes the early family groups of Degas, depicts his mother and father seated on a divan.[11] Behind them a neutral background is enlivened by subtle, elegantly patterned wallpaper. The Vallottons exemplify middle-class solidity. In contrast to Ursenbach's discomfort, they easily and securely inhabit their surroundings, taking a firm but unforced place in the domestic environment.

While Vallotton's parents here inhabit a muffled, measured world, his older brother Paul is figured quite differently in two portraits that convey the artist's frank admiration. A successful businessman who would become the director of the Cailler chocolate concern, Paul Vallotton was eventually the principal dealer for Vallotton's work through a gallery bearing his own name. In the first portrait (plate 117), from 1886, Vallotton invested his brother with the aura of a self-absorbed romantic hero. At the same time, his casual, assured bearing and steady gaze seem the natural attributes of a man of ways and means. In contrast to the artist's shrinking posture in *The Painter at 20*, Paul Vallotton's solid, axially placed figure nearly fills its indefinite space. The red glow of a cigarette held nonchalantly in his right hand anchors and echoes other daring touches of color.[12] This is one of Vallotton's most full-blooded portraits, the most compelling mix of the informal and the sensual he ever achieved in this genre. There is nothing dry here; but as in his more astringent self-portrait, Vallotton located the individual in a hermetic isolation.

Two years later, he gave his brother a distinct social valence in a second portrait resonant with hints of worldly success (plate 118). With the same gesture and placement, Paul's hand now cradles a top hat, bourgeois emblem supreme.

The Artist's Parents, 1886
Oil on canvas, 102 x 126 cm
Musée cantonal des Beaux-Arts, Lausanne

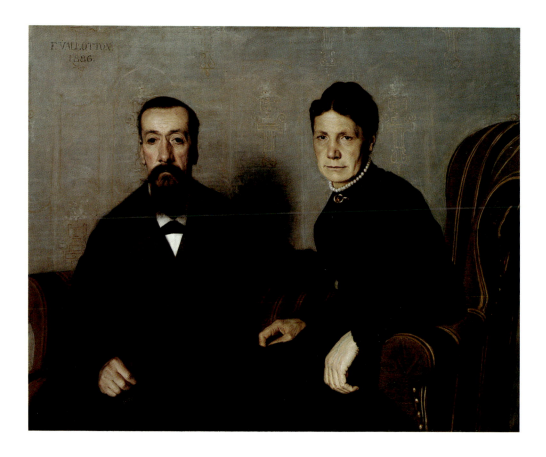

His grooming and dress are crisper, and the apparently thoughtful gesture of hand to chin suggests studied informality. Here Vallotton's decentering of the figure has an effect opposite from that of the dislocated Ursenbach; Paul Vallotton takes full command of his space through the subtle dynamism generated by such asymmetry. The space itself is lightly but tellingly marked by a Greek key decoration, a pretentious embellishment echoed in the artist's exacting signature and balanced by the inscription at the upper left. As if chiseled or engraved, this lettering reinforces the impression of solid good taste conveyed by Vallotton's portrait of his parents. And to the degree that Vallotton's portraits of others were self-referential, these decorative flourishes were signs of his own desire as well as of his brother's material attainments.

In the honorific language of these family portraits we see Vallotton's effort to reach a synthesis of his origins and his ambitions. There is also reason to believe that by making these portraits he sought a more distant social horizon than the edge of his family circle. Advertisements of his skill, they led to portrait commissions from other relatives: aunt and uncle, cousins, and others more distant. Such networking within his own family closely shaped Vallotton's early career. Assiduous at cultivating such commissions, he recognized that portraiture was his path to prosperity and acclaim.[13] Thus although it is clear that the process of making a portrait could be a source of great satisfaction to him, he was nevertheless alert to the chance for a potboiler. So essentially mercenary a practice is integral to portrait traditions and does not detract from Vallotton's achievement. He could, for example, be sufficiently distanced from the interactive process to paint a portrait after a photograph, as he did on several occasions for relatives

and friends of his family.[14] In such cases, he was effectively upgrading portraits his subjects already had, giving them a better image of themselves through a better class of image.

Vallotton was equally aware of the portrait's value as a medium of exchange. In trade for painting his portrait, a friend of Vallotton's parents offered the artist some new suits from his son-in-law's clothing store. In 1889 Vallotton accepted a chair in a similar arrangement; and several years later, his portraits of a certain Madame de Broutelle led to commissions for drawings for her fashion magazine. The artist's willingness to consider the portrait as a commodity is also reflected in his occasional replication of portraits he had already done for certain clients.[15] Should transactions such as these appear to compromise the social values inscribed in portraiture, it should be remembered that the very process of making a portrait is a form of exchange. As the tangible result of a transaction between artist and sitter, the portrait inevitably incorporates values brought to the table by each party. The material emphasis of Vallotton's early use of portraits in fact recapitulated in concrete terms these more abstract social transactions.

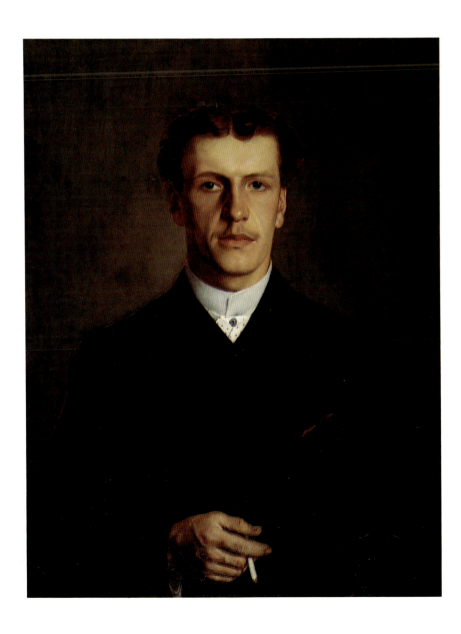

117
Paul Vallotton, the Artist's Brother, 1886
Oil on canvas, 76 x 61 cm
Galerie Vallotton, Lausanne, Private
Collection

Portrait of my Brother with his Hat, 1888
Oil on canvas, 76 x 61 cm
Galerie Vallotton, Lausanne, Private
Collection

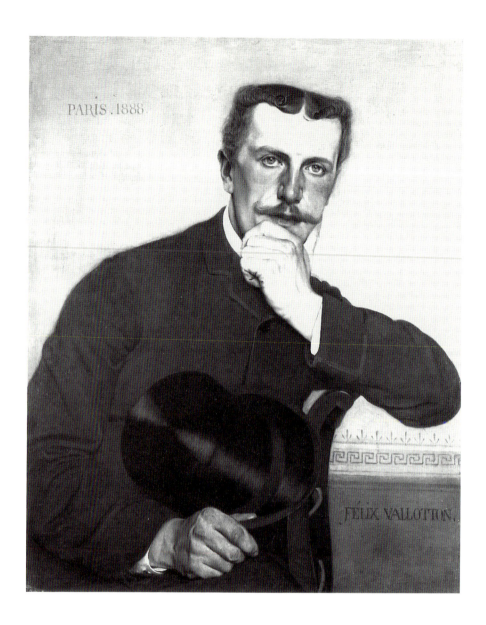

Several of Vallotton's early portraits reveal his sheer pleasure in repre-
senting an individual with whom he felt sympathy independent of family ties.
Prominent among these was his friend and fellow artist, Félix Jasinski. A for-
eigner like Vallotton, Jasinski came from an expatriate Polish family. The two
young artists were bound as well by their penury and their tendency to melan-
choly. In two portraits of Jasinski, both of 1887, Vallotton explored the same
conceptual opposition of autonomy and contextualization that characterized his
portraits of Paul. He first located Jasinski's identity in his work as a reproductive
engraver, a profession that gained him a modest reputation but a meager living
(plate 119). Jasinski studies intently the work he will translate into another me-
dium. His silhouetted profile, and such details as his radically foreshortened but
almost hidden right arm and his sharply flexed little finger emphasize his anxious
concentration. If, as in most of Vallotton's early portraits, the colorful variety of
the world is damped down into a narrow range, the usual sobriety is here relieved
by the prominently featured interior: busy, even cheerful, it clearly communicates
a sense of purpose. And the objects gathered—several framed pictures, a plaster

cast, a portfolio—suggest that Jasinski's activity has a more artistic purpose than mere reproduction.

In this portrait of the artist at work, Vallotton made an image of focused occupation that is surely reflexive, expressing his own commitment to his art. Here the decentering of the sitter activates the space, allowing for a profusion of attributes that reinforce his identity. A different Degas comes to mind now, the Degas whose portraits of the musician Désiré Dihau, and the writer Edmond Duranty, defined the sitters through their work. Vallotton's interest in situating a figure in a characteristic milieu also looks forward to one of the dominant themes of Nabi portraiture.

In his second portrait of Jasinski (plate 120), the intent artist has been supplanted by a cold, hard man, a ruthless counterpart to Paul Vallotton's more benign bourgeois. It is a remarkable portrait of a close friend, one that mythologizes the struggling Jasinski as a man of great success, proud and dapper. As in the portrait of Paul Vallotton, the silk top hat is more emblematic than descriptive, and its prominence helps to drive an even more dynamic asymmetrical composition. Here a species of wishful thinking and projection of status may reveal Vallotton's own social and economic aspirations, which were about to improve considerably. Jasinski's career, by contrast, would suffer a continual decline. Ironically, the tool that occasionally abetted Vallotton's artistic practice— the photograph—made Jasinski's profession obsolete.[16]

In the early 1890s printmaking became Vallotton's dominant means of expression, and portraiture assumed a new prominence within his graphic production. The massive concentration of portrait paintings in his earlier work thinned rapidly, as portrait prints took over the provision of exposure and livelihood that these paintings had formerly guaranteed. Under commission from publishers, Vallotton made several series of portrait prints, characteristically issued for sale singly or in small groups, then gathered into an album for publication.[17] His portraits were also published in popular reviews, sometimes in special supplements in a uniform format.

Whereas Vallotton's portrait paintings of the 1880s and early 1890s derived from family relation and personal acquaintance, his portrait prints from these years formed a pantheon of notable public figures, few of whom he knew; indeed, many were dead. Enshrinement was the explicit premise of these series, beginning with *Immortels passés, présents ou futurs* (Immortals past, present or future), sixteen lithographic portraits mostly in the manner of Daumier's full-figure *portraits charges*. Contextualization was rarely necessary for these well-known personages; their identities could be fully and suggestively located in their effigies alone. Then, in the woodcut, and in a "masque" format consisting of the face only, Vallotton found the combination through which he made a distinctive contribution to printmaking and to portraiture.

Many of these prints are mildly caricatural, underlining the processes of selection and distillation that define the relationship between the portrait and the caricature. What made these works most striking—their bold contrast of black and white—also rendered them ideal for mass reproduction. They were thus highly commodified images whose proliferation reiterated on a public scale the procedures of exchange and duplication that had often characterized Vallotton's private portrait commissions of the previous decade. And this mechanism of celebrity increased Vallotton's own renown, as he became widely admired for

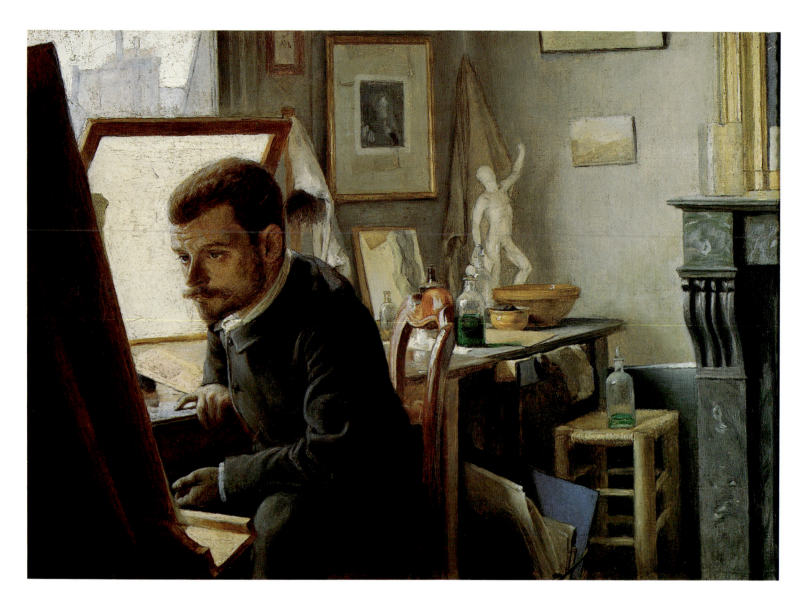

119
Félix Jasinski in his Printmaking Studio,
1887
Oil on canvas, 26 x 37.5 cm
Sabine Helms, Munich

what was perceived as his ability to capture the essential character of the luminaries whose faces he consecrated.[18]

Vallotton's woodcut portrait of Edgar Allan Poe of 1894 is exemplary (plate 121). The image is simple and readily comprehended. With clean contours, large unmodulated areas of black and white, and little modeling, the portrait nevertheless suggests individualized detail in a field of generalization. The background seems arbitrary, but it actually directs our attention subtly to Poe's shadowed eyes. The ease with which we grasp the image leads us to believe that the portrait emerged naturally from Vallotton's insight into the great poet's dark character. In fact, a formula for synopsis paradoxically produced this sense of individuality and vitality. Often working after photographs—in this particular instance probably after a reproductive engraving of a daguerreotype—Vallotton exaggerated even further their matrix of tonal contrasts, eliminating all intermediate grays.[19] The resulting concentrations of black and white produced an arresting effect when the portrait was isolated on a sheet and equally held their own superbly when faced with blocks of printed type.

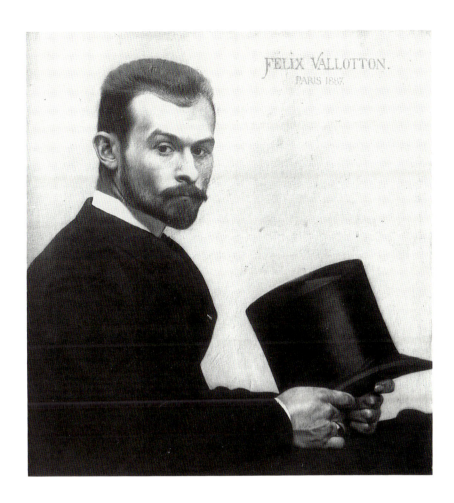

120
Félix Jasinski Holding his Hat, 1887
Oil on canvas, 65.5 x 60.5 cm
Ateneum, Helsinki

121
To Edgar Poe (*A Edgar Poe*), 1894
Woodcut, 16 x 12.5 cm
Galerie Vallotton, Lausanne

The success of these portraits widened Vallotton's social and professional world tremendously, initiating his contact with the Nabis and introducing him to the writers and artists of *La Revue blanche*, founded in 1891 by Thadée Natanson and his brothers, Alfred and Alexandre. From 1894 to 1897, Vallotton's prints, especially his woodcut portraits, appeared regularly in this journal, whose extended publishing family in turn became the source for most of his portrait paintings of the period. So narrow a scope is worth noting. For despite Vallotton's increased contacts in the Paris art world, his devotion to a small group of friends —centered around Thadée Natanson and his charismatic wife Misia—testifies to his need to anchor himself in a substitute family (plate 122).

Although Vallotton's assimilation into French society would be fairly thorough, his art remained stubbornly resistant to the orthodoxies of the avant-garde with which he was associated. Few of the portraits he made within this circle convey the informality and intimacy so characteristic of the portraiture of Vuillard, Bonnard, Roussel, and other Nabis. There is nothing in Vallotton's portraiture comparable, for instance, to Bonnard's touching and amusing portraits of his sister and her children, or to Vuillard's many studies of odd moments and relationships in the domestic life of the Natansons. Vallotton continued to work almost exclusively in the honorific mode he had honed in the previous decade, posing his sitters in formal *mise en scène* carried out with exacting technique, as in his portraits of Stéphane Natanson (1897; plate 123), the actress Marthe Mellot (1898; plate 124), and Alexandre Natanson (1899).[20]

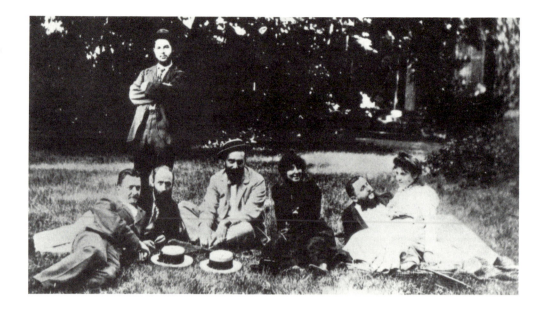

Félix Fénéon at the Revue blanche (1896; plate 261) is one of the few portraits of the 1890s in which Vallotton embraced the Nabi aesthetic of integration, embedding the sitter in his environment and creating a more decorative ensemble. Fénéon, the art critic, anarchist, and editor of the journal, works at close quarters in his office, where stacks of paper suggest Sisyphean labors. This trope of unposed absorption, which we have already seen in Vallotton's portrait of Jasinski in his studio, may indicate how closely the writer's identity was tied to his journalistic work. Similar images of professional dedication characterize the portrayals of other members of the *Revue blanche* circle as well, as in Vuillard's portraits of the playwright Lugné-Poe (1891) and his own later portrait of Fénéon (1901).[21] But Vallotton's treatment is more clarified and balanced, the figure more the object of focus. And the directness of his angle of view admits none of the voyeurism suggested by Vuillard's oblique vantage point in many of his portraits of people deeply engaged in their work.

Thadée Natanson is also identified with a particular environment in Vallotton's portrait of 1897 (plate 125). Yet his is not a working environment but rather a possession; Vallotton imputes to Thadée mastery over the Natansons' newly acquired country house, where the artist spent so many pleasant days in the company of stimulating friends. But Natanson's thematic and compositional dominance is perilous; reflecting the impact of Vallotton's portrait prints, this painting comes as close to caricature as do any of his portraits of these years. Witty correspondences between the molding on a wooden chest, the wrought iron window bar, and the sitter's carefully tended mustache create a kind of brute visual punning that was foreign to the more subtle elisions found in Vuillard's and Bonnard's portraiture.

This combination of visual wit and mock gravity instead calls to mind something else entirely—the portraits of Henri Rousseau. His *Portrait of Pierre Loti* (plate 126) of about 1891 shares with Vallotton's Natanson a slightly comic mix of firmly set features, drifting eyes, and distinctive mustache; clever visual rhyming (Loti's fingers holding a cigarette echo four factory stacks, one smoking); and an ostentatious signature. The artists' common interest in early Renaissance

123
Portrait of Stéphane Natanson, 1897
Oil on canvas, 46 x 55 cm
National Gallery of Canada, Ottawa

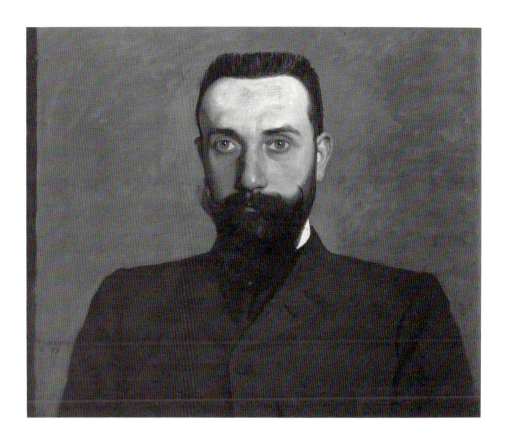

124
Portrait of Marthe Mellot, 1898
Oil on canvas, 73 x 60 cm
Kunsthaus Zürich, Vereinigung Zürcher
Kunstfreunde

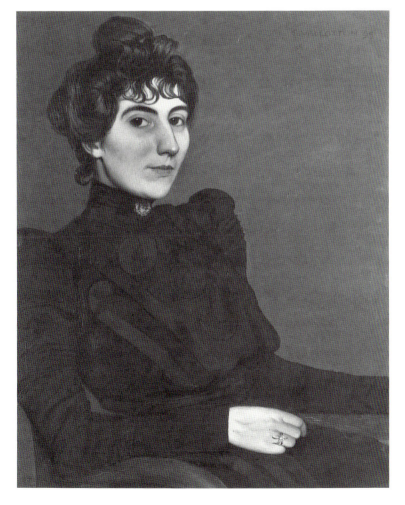

125

Portrait of Thadée Natanson, 1897

Oil on board, 66.5 x 48 cm

Musée du Petit Palais, Geneva

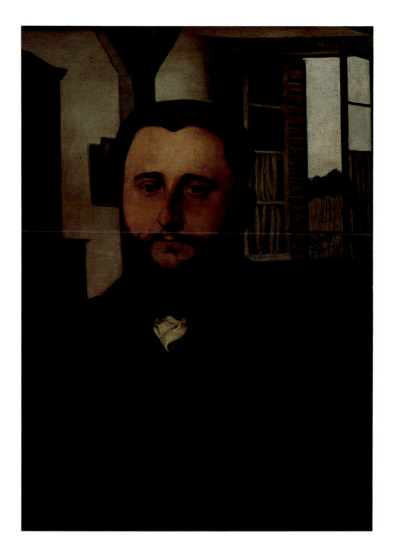

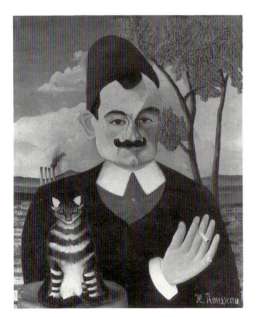

126

Henri Rousseau (1844–1910)

Portrait of Pierre Loti, ca. 1891

Oil on canvas, 62 x 50 cm

Kunsthaus Zürich

portraiture should not obscure their more directly shared intention to represent the individual with a clarified directness, an intention that firmly places both within the primitivizing tendencies of their age.[22]

Vallotton had been an early admirer of Rousseau's painting, writing knowledgeably about his landscapes in 1891.[23] Nor was he alone in this estimation; shortly before he sat for his portrait, Natanson himself had written a warm appreciation of the "implacable naiveté" of Rousseau's style.[24] Vallotton's portrait thus expresses a communion of interest between artist and sitter. Natanson may have recognized the same qualities in the methodical, highly trained painter as he did in the methodical, self-taught one. Certainly Rousseau did; standing in front of Vallotton's *Bathers on a Summer Evening* (plate 148) at Vollard's gallery, the Douanier had declared his affinity: "Well now, Vallotton, let us walk together."[25]

Within the circle of his new associates, Vallotton was closest to Thadée and Misia Natanson. They exerted the strongest pull on his imagination and his desire to give image to his society. Attractive and coquettish, with a penchant for self-display, Misia offered a breathless contrast to Vallotton's taciturnity (one cannot imagine anyone else calling him "my little Vallo").[26] Vallotton expressed his fascination with her in several portraits painted in stronger, flatter colors than those he customarily used. In *Misia at her Dressing Table* (1898; plate 127), for

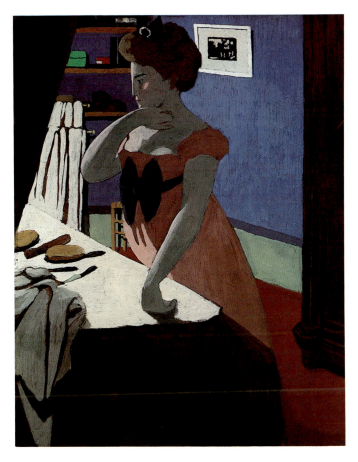

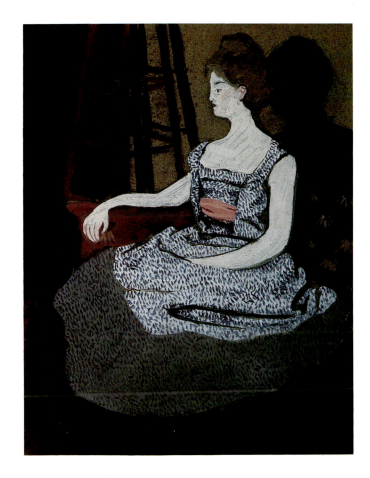

127
Misia at her Dressing Table, 1898
Tempera on board, 35 x 27 cm
Private Collection

128
Misia Godebska, 1898
Gouache on board, 35.9 x 29 cm
Bayerische Staatsgemäldesammlungen, Neue
Pinakothek, Munich

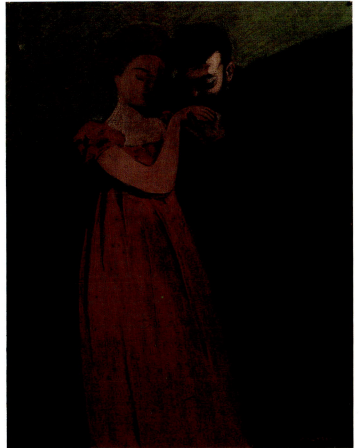

129
The Hand Kiss (The Lovers)
(Thadée and Misia), 1898
Tempera on board, 30 x 37.5 cm
Private Collection

example, we are witness to a private act of intense self-regard. Severe and sculptural, Misia leans against the marble top of her dressing table, her absolute absorption heightened by the gestures of her impossibly bent right arm and her contrarily elongated left arm: the first self-referential, the latter a barrier to our access.

With similar emphatic hues applied across broad areas he painted Misia and Thadée together in *The Hand Kiss* (plate 129), one of a group of small studies of 1898. Sharing in the informality and narrative flavor of that group, it is quite unlike any other portraits he had made, and really seems to be both portrait and genre subject. The formal and thematic similarities between these small paintings and his *Intimités* of 1897–98 suggest that Vallotton had the couple in mind when making this series of woodcuts on the troubled state of affairs between men and women. The blurring of strict genre categories in *The Hand Kiss* would have important consequences for Vallotton's portaiture later in his career, as he would blend the portrait and the study of a model in a hybrid he called a "similiportrait." And in a larger context his mixture of genres fit into more general trends toward breaking down traditional categories in response to demands for institutional change and personal expression.[27]

Considering Vallotton's many portraits of members of the *Revue blanche* circle, it is conspicuous that he so rarely portrayed his fellow Nabis—the notable exceptions being a few images of Vuillard, his closest friend among these painters.[28] But in 1902–03 Vallotton made one of his most remarkable portraits, *The Five Painters* (plate 130). Gathered around a desk are Bonnard, Vuillard, Charles Cottet, and Ker-Xavier Roussel; Vallotton himself, standing at the left, completes the group. As one of Vallotton's largest easel paintings, and his only group portrait, it is a statement of manifesto-like dimensions: but what the painting says is unexpected, in light of whom it represents.

Vallotton was probably responding to Maurice Denis' *Homage to Cézanne* of 1900 (plate 131), in which a substantial gathering of Nabi artists—nearly all *but* Vallotton, in fact, so perhaps Vallotton's portrait was as much riposte as response —pays tribute to a shared source of inspiration. Denis had exhibited the painting in the Salon of the Société nationale des Beaux-Arts in 1901; Vallotton showed his there in 1903, under the more neutral title *Group of Portraits*, recalling the similarly distanced title he had given to *The Painter at 20*. But in contrast to Denis, Vallotton did not refer to any common ground unifying the artists portrayed; rather he stressed the individuality—the singularity—of each. To a degree such an about-face reflected actual conditions. By 1903 the Nabis had effectively disbanded, and the *Revue blanche*, their sanctuary and vehicle, was at the end of its run. Yet any sentiment of nostalgia is dispelled by Vallotton's style: cold, abstract, confrontational. Even the artists' physical proximity is paradoxically tension-ridden, for it accentuates the stylized alienation in their gazes and in their overwrought, non-communicative gestures. By contrast, Vallotton's detached restraint sets him apart from the group on yet another level.

This puzzling portrait indicates just how tenuous the connection between Vallotton and a Nabi group aesthetic was. *The Five Painters* was a self-consciously anti-Nabi statement, Vallotton's assertion of his own, and his colleagues', individuality. Always more attentive to physiognomy, bearing, and presentation than to psychological exploration and the complexity of human relationships—themes central to the portraiture of Bonnard, Vuillard, and Roussel—his portraits char-

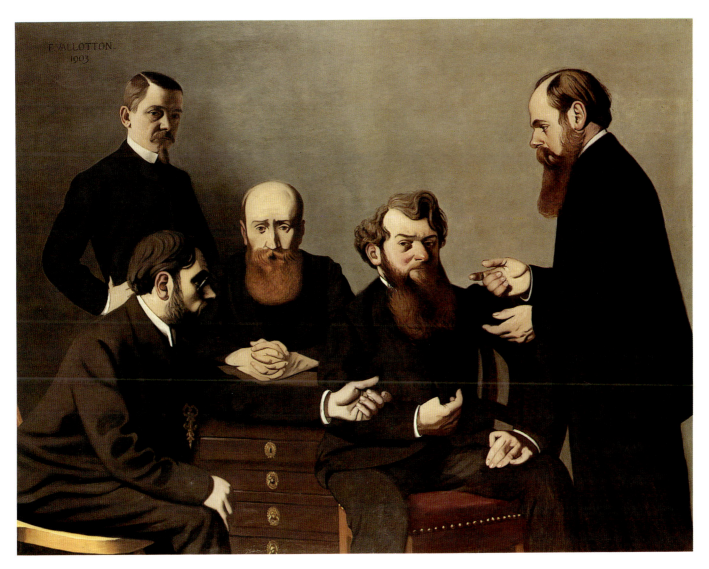

130
The Five Painters, 1902–03
Oil on canvas, 145 x 187 cm
Kunstmuseum Winterthur

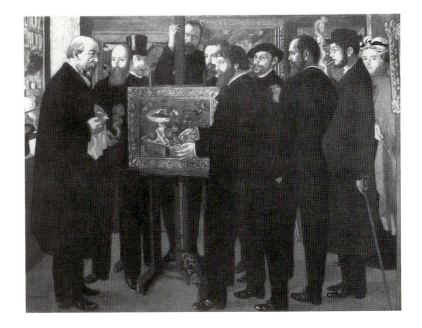

131
Maurice Denis (1870–1943)
Homage to Cézanne, 1900
Oil on canvas, 180 x 240 cm
Musée d'Orsay, Paris

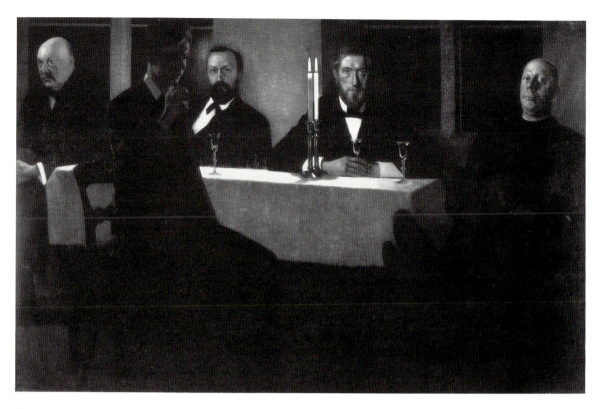

132
Vilhelm Hammershøi (1864–1916)
Five Portraits, 1901
Oil on canvas, 190 x 340 cm
Thielska Galleriet, Stockholm

acteristically ran against the Nabi grain.[29] In its strenuous muteness *The Five Painters* epitomized his role as an outsider in this community.

Estranged from the French portrait tradition, this painting presents the kind of stylized, awkward melodrama long found in northern European art.[30] In this connection it is worth noting the striking similarity between *The Five Painters* and the Danish artist Vilhelm Hammershøi's *Five Portraits* of 1901 (plate 132). Reinforced by a tonal palette and dramatic lighting, the moody aloofness of these five prominent figures in the Danish avant-garde asserts their individualism. Although Vallotton was probably unaware of this particular painting, general parallels between the two artists' work indicate a shared sensibility for heightened, stylized realism.[31]

Closely related in style and gravity is an earlier series of eight portraits from 1901 and 1902, each representing a great nineteenth-century writer or, in one case, musician. In his *Livre de raison* Vallotton characterized these essentially iconic portraits as either "portrait décoratif" or "peinture décorative," although they bear little relation to the unified fields and atmospheric integration that inform the Nabi concept of the decorative. His idiosyncratic use of the term may represent another attempt to distinguish himself from his peers. In their predominantly bust-length format and abstract, synoptic quality, these works have usually been related to Vallotton's portrait woodcuts of the previous decade.[32] Certainly the organizing principle of a pantheon similarly informs the portraits as a group despite differences in size and proportion: squat for the hunkering figure of Paul Verlaine (plate 133), more vertical for the gaunt Hector Berlioz. But these paintings are at once removed from any particular literary context and suffused with an idea of literature in general. Memorials to prominent figures of the Romantic, Realist, and Symbolist movements, each was conspicuously inscribed with a dedi-

cation to the memory of its source of inspiration.[33] Although Vallotton exhibited them widely at the time—in Paris, Lausanne, Vienna—he kept the paintings in his own apartment in Paris, displayed as a gallery of personal heroes.[34] It is surely no coincidence that while engaged in these works, the well-known painter and graphic artist was also trying to make a mark as a novelist and playwright.[35] His determination to widen the scope of his activity undoubtedly underlay his desire to associate himself with such a distinguished group of creators, not one of them a painter.

In these paintings, as in the portraits of his associates from the *Revue blanche*, Vallotton was marking the coordinates of the world of creativity and enterprise that had assumed such importance in his life. While each paid tribute to an individual within this world, as a group they contributed to Vallotton's definition of himself. In his own self-portraits, however—such as the intense *Self-Portrait* of 1897 (plate 4)—he resolutely isolated himself from any context. This finely crafted painting acknowledged neither his growing success nor the society that came increasingly to inflect his life. Vallotton may have been split between two ways of asserting his identity. Like most of his self-portraits, this image at once projects and withholds.

Despite such studied neutrality, Vallotton's professional ambitions seem to have exercised a greater role in determining his social ones. After living for many years with one of his early models, Hélène Chatenay, Vallotton left her to marry Gabrielle Rodrigues-Henriques in 1899. To his brother Paul, Vallotton professed to have been looking forward to marriage for some time, but there was

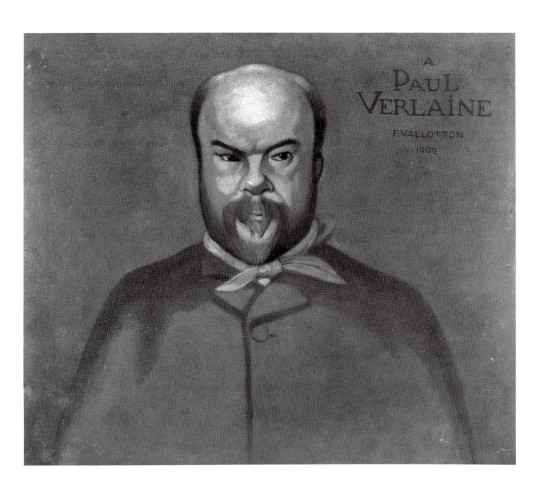

133
Decorative Portrait of Verlaine, 1902
Oil on board, 73 x 82 cm
Private Collection

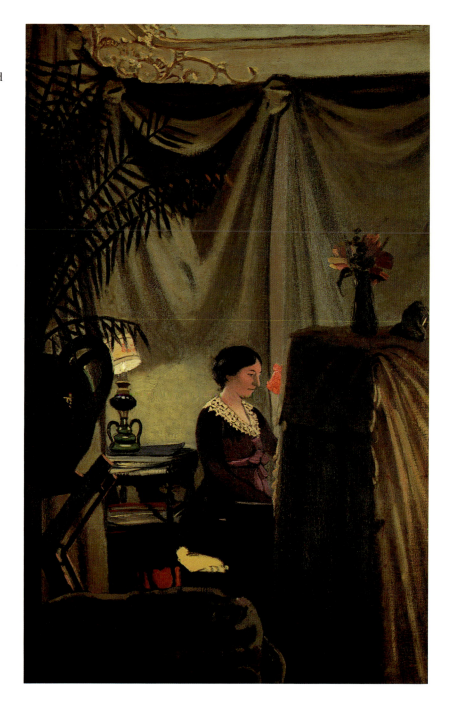

134
Gabrielle Vallotton at the Piano, 1904
Oil on canvas, 77 x 49 cm
Private Collection, Geneva, Switzerland

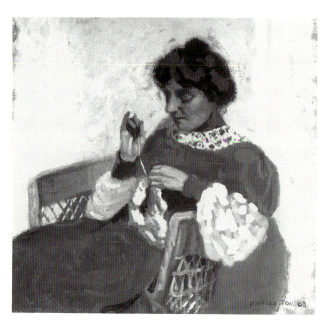

135
Gabrielle Vallotton Sewing, 1903
Oil on board, 25.1 x 25.2 cm
Private Collection

never any question that it would be to someone other than his lower-class consort.[36] His new wife, a widow with three children, was the daughter of the successful Paris art dealer Alexandre Bernheim. Vallotton's portraits of Gabrielle usually figure her engaged in everyday domestic activities, as if to validate his remark to Paul that the couple wanted to "live without any, or little, change in our habits, I with my work, she at home; it will be very sensible."[37] This was certainly what he hoped for from a new situation that seemed to fulfill his aspirations perfectly. With the stability and companionship that normally attend marriage, he also gained an experienced wife and homemaker, children already "élevés" (he did not like the thought of infants), an enormous boost to his social position, and an

instant alliance with some of the most influential art dealers in Paris (the Bern-heim-Jeune gallery immediately began to show his work). It was an excellent union of convenience and opportunity.

In the early years of their marriage, Gabrielle's identity is so completely keyed to her domesticity in Vallotton's portraits of her that the artist approached Vuillard's and Bonnard's thematics of domestic space. *Sleeping Woman* of 1899 (plate 19) must certainly be a depiction of Gabrielle embraced by gorgeous surging patterns that overwhelm the vulnerable face of the unconscious woman—pure Vuillard except for Vallotton's snappy graphic sense. In another portrait of 1904 Gabrielle plays the piano amid a profusion of sensual attractions and comforts (plate 134); in others she sews or reads (plate 135). These tender evocations of quiet life at home echo the sense of satisfaction evident in Vallotton's paintings from a decade earlier, showing Hélène Chatenay engaged in domestic tasks.[38] In his paintings of both women, Vallotton tended to subordinate the identity of each to defining circumstances and activities, the obvious difference being that while Hélène Chatenay had been shown at work, Gabrielle Vallotton enjoys the privileges of the mistress of the house.[39]

Vallotton's new situation also brought tensions and compromises.[40] In *Dinner by Lamplight* of 1899, a work which he copied in 1900 (plate 136), his own

136
Dinner by Lamplight, 1900
Oil on board, 55.3 x 87 cm
Kirov Art Museum, Kirov, USSR

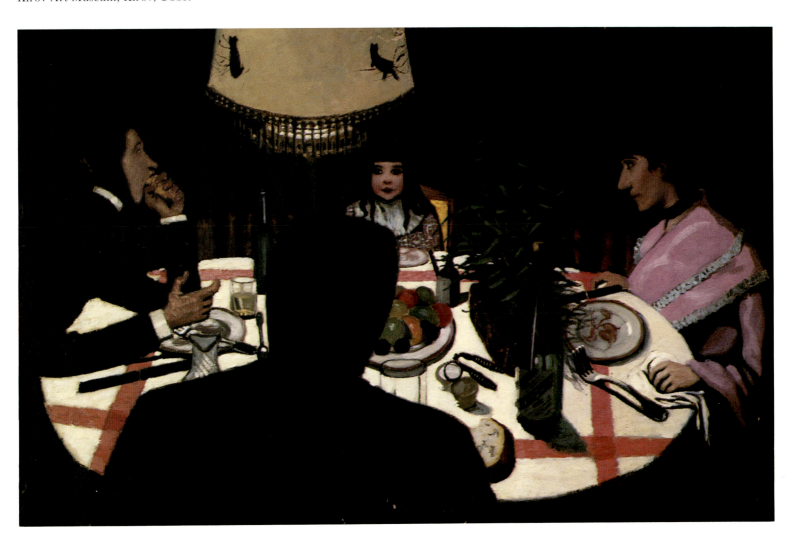

silhouette looms as an oblique presence in this disconcerting tableau of family life: stepson Max stifling boredom, stepdaughter Madeleine staring aggressively, Gabrielle solicitous.[41] Vallotton's alienation also extended to the rest of the Bernheims, as expressed in his voyeuristic studies of their amusements, *Billiards* and *The Poker Game* (plates 137, 138), both of 1902: in each a gulf of space, an empty chair, an aggressive obstacle. These remarkably candid signs of Vallotton's discomfort transmit their ambiguous messages through distortion of space and extravagant attention to furnishings and appointments.[42]

Vallotton's portrait of his brothers-in-law shares this voyeuristic flavor and inscribes the connection between family and business (plate 264). The dapper Josse and Gaston Bernheim, the "jeunes" of Bernheim-Jeune, consult in their elegantly appointed office. A conspicuous telephone, key instrument of their business, is close at hand. The spaciousness and unruffled calm of their affairs present a striking contrast to Fénéon's absorption and Jasinski's attentive labors. Business at the Bernheim establishment is conducted on a more social level, with aplomb; editing is solitary and devotional (Fénéon looks like a scribe). Vallotton makes art dealing look easy and clearly upper-class, unencumbered by financial negotiations; such was the substance of his aspirations with regard to the sale of his own work.[43] These portraits of the Bernheims in their domestic and professional settings would seem to indicate another phase in Vallotton's interest in the realist, Zola-esque model of comprehending the individual as a product of social and environmental factors. But really the reverse is true: these individuals are understood to have *produced* their environment, which operates in their portraits as an expression of their success and status.

With his marriage, Vallotton not only formed an alliance with powerful and successful art dealers, he married into a prominent French Jewish family. What was the attitude of the Swiss Protestant to this milieu? Although there are hints that his alienation from the Bernheims may have had a component of latent prejudice, he was not anti-Semitic in a public or political sense.[44] He was, after all, a committed Dreyfusard and an intimate member of the largely Jewish circle of the *Revue blanche*. Vallotton's domestic situation was more complicated than opposing cultural traditions alone would suggest. It must be remembered, after all, that as an outsider in France, he very likely identified with other groups not of the *pays*, even though he became a naturalized French citizen in 1900. The successful Bernheim family was powerfully attractive to his own ambitions to rise in French society.[45] It was a long way from Jasinski's attic studio to the generous office on the fashionable rue Laffitte, but this was a trajectory that Vallotton had realized in the course of fifteen years. Jasinski with his silk hat might have belonged here; Vallotton does not seem to be certain that he himself does, despite the material evidence that this was now his world.

The studied contextualization of the Bernheim portraits is essential to Vallotton's view of them as indivisible from their material circumstances. In the same year (1902) that he painted domestic portraits of his wife and his mother-in-law (plate 269), as well as *Billiards* and *The Poker Game*, he also made a double portrait of his parents, as if to coordinate the new poles of his expanded social universe.[46] The minimized environment in this work implies his parents' relative autonomy in simple and stark contrast to the Bernheims. And when his domestic life was under particular strain in 1905, he longed to escape to his parents' home and paint their portraits, which he would do the following year (in the meantime

137
Billiards, 1902
Oil on board, 67 x 52 cm
Private Collection

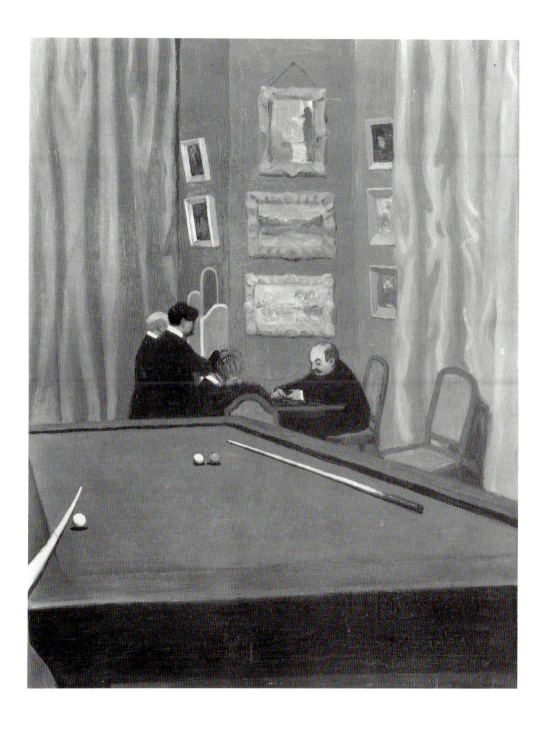

he painted another stiff, isolating self-portrait). The simplicity and the dignity with which he endowed his mother and father in his portrait of 1906 elevated them above the increasing cares of his life in Paris, which were inextricably bound to the Bernheim environment.[47]

As the decade elapsed, portraiture gradually moved further from the center of Vallotton's concerns; after 1910 the making of a portrait was for him a rare occasion. But in the space of a few years he painted several commanding images of new patrons, including one of the most discerning Americans then collecting modern art, and a young Swiss woman who would take a leading role in the advancement of Vallotton's reputation.

138
The Poker Game, 1902
Oil on board, 52.5 x 67.5 cm
Musée d'Orsay, Paris, Gift of David Weill

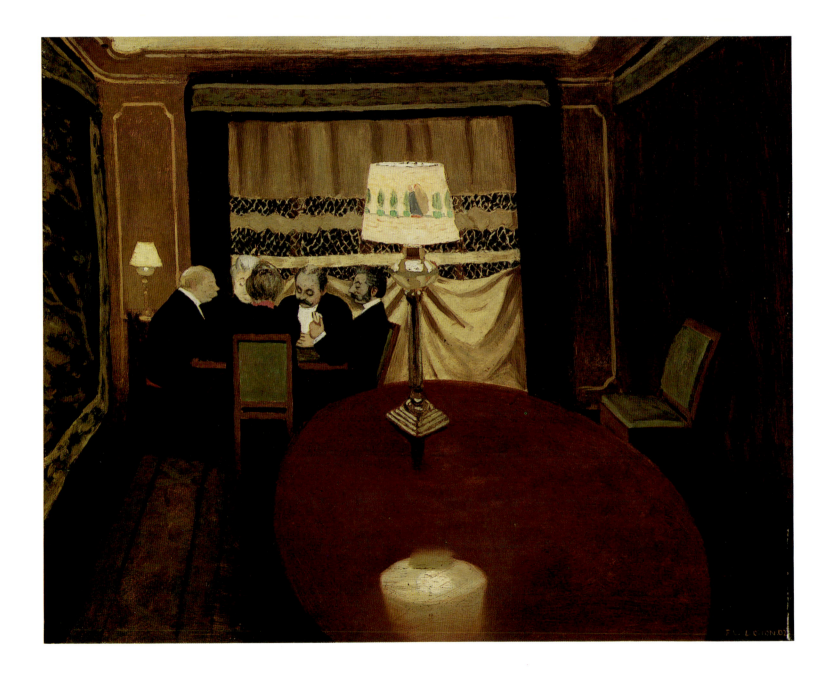

139

Portrait of Gertrude Stein, 1907

Oil on canvas, 100.3 x 81.2 cm

The Baltimore Museum of Art, The Cone
Collection, formed by Dr. Claribel Cone and
Miss Etta Cone of Baltimore, Maryland,
BMA 1950.300

140

Pablo Picasso (1881–1973)

Portrait of Gertrude Stein, 1906

Oil on canvas, 100 x 81.3 cm

The Metropolitan Museum of Art,
New York, Bequest of Gertrude Stein,
1946.47.106

In *The Autobiography of Alice B. Toklas*, Gertrude Stein related how Vallotton came to paint her portrait in 1907 (plate 139), the year after she sat for Picasso:

> [Vallotton] asked Gertrude Stein to pose for him . . . She often described the strange sensation she had as a result of the way in which Valloton [sic] painted . . . When he painted a portrait he made a crayon sketch and then began painting at the top of the canvas straight across. Gertrude Stein said it was like pulling down a curtain as slowly moving as one of his swiss glaciers. Slowly he pulled the curtain down and by the time he was at the bottom of the canvas, there you were. The whole operation took about two weeks and then he gave the canvas to you. First however he exhibited it in the autumn salon and it had considerable notice and everybody was pleased.[48]

We learn several things from Stein's account. She did not commission the portrait; Vallotton approached her with the idea. And his method of painting it was

141

Jean-Auguste-Dominique Ingres
(1780–1867)

Louis-François Bertin, 1832

Oil on canvas, 116 x 95 cm

Musée du Louvre, Paris

extremely methodical, not apparently conforming to Stein's idea of how artists should proceed. He made no preliminary drawing, preferring to sketch the composition directly on the canvas, as if he knew from the outset what the final result would look like.[49]

There can be little doubt that Vallotton undertook this portrait of Stein in response to Picasso's portrait of the same sitter from the previous year (plate 140).[50] Countering Picasso's assault on portrait traditions—he had substituted for Stein's face a primitivist mask based on ancient Iberian stone sculpture—Vallotton figured Stein in the mode of Ingres' portrait of Louis-François Bertin, one of the icons of French portraiture and among the best-known paintings in the Louvre.[51] Stein sits in the opposite direction from Bertin, but Vallotton has practically transposed the latter's fleshy, predatory hands into a new encircling position that emphasizes the unitary bulk of Stein's figure. While she lacks Bertin's wound-spring look of potential energy, she more than compensates with a gaze of forbidding endurance.

Vallotton's reference was immediately recognized. Vuillard is said to have exclaimed: "That's Madame Bertin!"; and several critics made less witty but no less percipient comments about the painting's heritage.[52] By 1907, Vallotton's work had been regularly connected to Ingres in more general terms, in a lineage of idealizing form and noble content.[53] With the otherness of his primitivizing, Picasso (who had probably also responded to Ingres' *Bertin*) violated this canon; Vallotton sought in it a place for himself, referring instead to a long tradition of primitivizing in the service of the ideal. Having flirted in his portrait of Natanson with the abstraction of the naive, he now declared his devotion to the abstraction of the classical. In fact the primitivism of the outsider and the primitivism of the insider could be disarmingly close to one another, as Guillaume Apollinaire would recognize in 1912: "[Vallotton] pretends to draw his inspiration from Ingres, while, in fact, he imitates one of the most astonishing modern painters . . . the Douanier Rousseau."[54] But the extreme earnestness of Vallotton's portrait of Stein conveys his intention, at least, to assert his affinity with the earlier master of abstract linearity.

Gertrude Stein fell far shy of becoming Vallotton's next great patron, but shortly thereafter the Swiss collectors Arthur and Hedy Hahnloser began their ardent support of the artist.[55] Vallotton's portrait of Hedy Hahnloser casts her in an open-minded and sympathetic light (plate 298). The portrait of Arthur Hahnloser (1909) figures him in a more professional mode, with a full emphasis on the hands with which he practiced his profession of eye surgery. Clearly Vallotton felt Hedy to be the stronger and more self-sufficient. The sense of frankness and confidence expressed in her portrait aligns her with the aristocratic sitters of Ingres, reasserting Vallotton's almost career-long dialogue with the artist who in his own time had been a singular voice of an abstract and modern realism.

Over the last fifteen years of his career, Vallotton painted few portraits that initiated a social transaction of the kind that had been so compelling earlier. Possibly few opportunities for commissions came his way; but strangely, he painted no portraits among his family, and scant few of his friends. Portraiture had ceased to be a meaningful tool of social and professional mobility. In a sense he no longer needed it as a means of expressing his values and proclaiming his aspirations. Financially secure, comfortably if not altogether happily married, he enjoyed a stable life with little cause for further change.

He displayed this certainty, with perhaps a twinge of regret, in a self-portrait painted in 1914 as France prepared to go to war (plate 142). Vallotton wanted to serve but did not qualify, and his ambivalence about his situation is revealed in a letter to his brother Paul, in which he wryly characterized this portrait as a "statue of the Commander."[56] Writing in his own journal, he discerned "the air of a stuffy bureaucrat" in this image of palette-wielding self-protection, but allowed that it was "not bad otherwise."[57] Despite the reassurance of a technical facility that never left him, he was ironically discomfited by the comfortable image of himself he had constructed: a muffled, battened, cosseted man consigned to sitting on the sidelines of a world in turmoil.

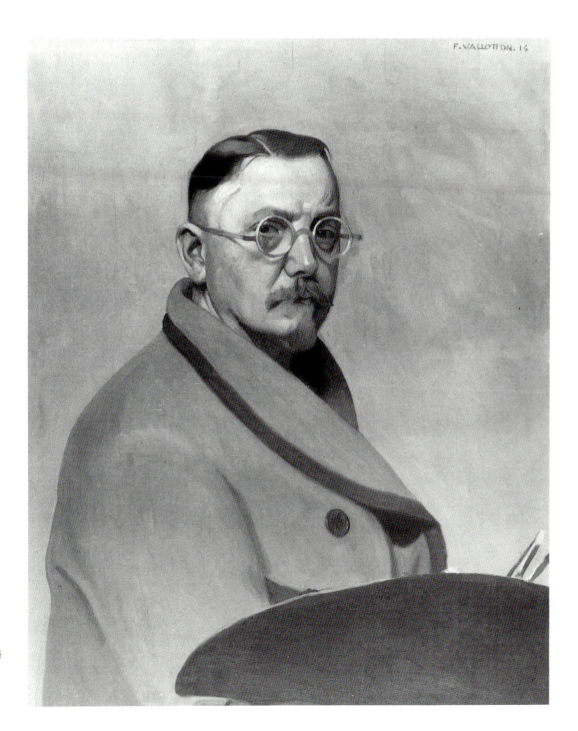

142
Self-Portrait in a Dressing Gown, 1914
Oil on canvas, 81 x 65 cm
Musée cantonal des Beaux-Arts,
Lausanne

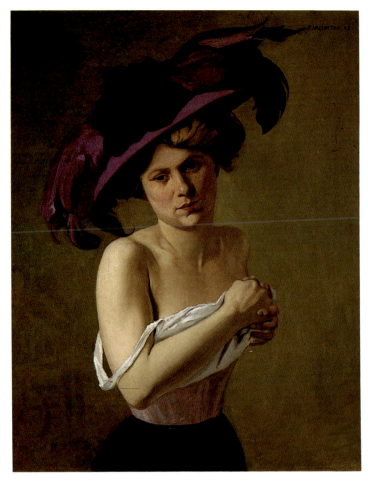

143
The Purple Hat, 1907
Oil on canvas, 80 x 65 cm
Private Collection

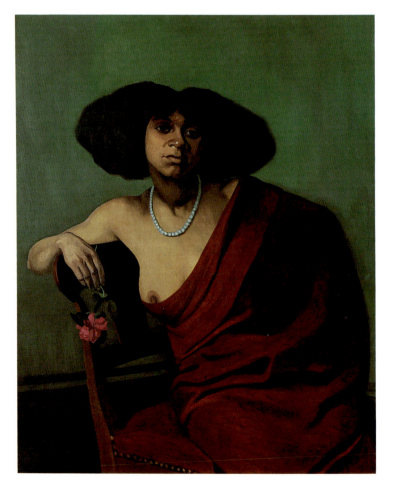

144
Mulatto in a Red Shawl, 1913
Oil on canvas, 100 x 81 cm
Kunstmuseum Winterthur

As Vallotton staked out new territories in still life, landscape, and the female nude, he had less need to affirm the link between his values and those of his sitters. In place of the portrait that expressed a social relationship (if not always a personal one) between artist and sitter, he had already begun to make a type of figure painting that simulated the conditions of portraiture while lacking the measure of social content and context that gives a portrait its deepest meaning. For this he hired models, always female, whom he then posed in portrait-like attitudes. He called such pictures "simili-portraits" in recognition of their hybrid nature.[58] Although they were too anonymous to be portraits, their construction nevertheless transcended the mere study of a model's body. These paintings sometimes showed women engaged in such activities as nonchalant nail-filing, or in other attitudes of vanity, posing improbably in hat but out of chemise.[59] Others covertly distilled national and ethnic identities into typology: *The Purple Hat* of 1907 (plate 143); *African Woman* of 1910 (plate 197); *Mulatto in a Red Shawl* of 1913 (plate 144). One senses in each Vallotton's absolute control over these situations, a control that had not been possible in his earlier efforts to locate the individual within a changing social constellation.

The best of Vallotton's portraits offer a mixture of graphic clarity and inventiveness, technical sophistication, respect for the integrity of the sitter, and psychological tension resulting from the artist's—and perhaps the sitter's—uncertainty about the nature of his or her identity. In the "simili-portraits" and other later studies of the clothed or nude female figure, Vallotton's graphic vision and impressive technique are rarely absent. But the ethic of these images of partly draped women, and of the sexual and cultural stereotypes they often rehearse, was far removed from the social intersection—of the sitter's individuality and status with Vallotton's own evolving identity—that gives his strongest portraits such disturbing appeal.

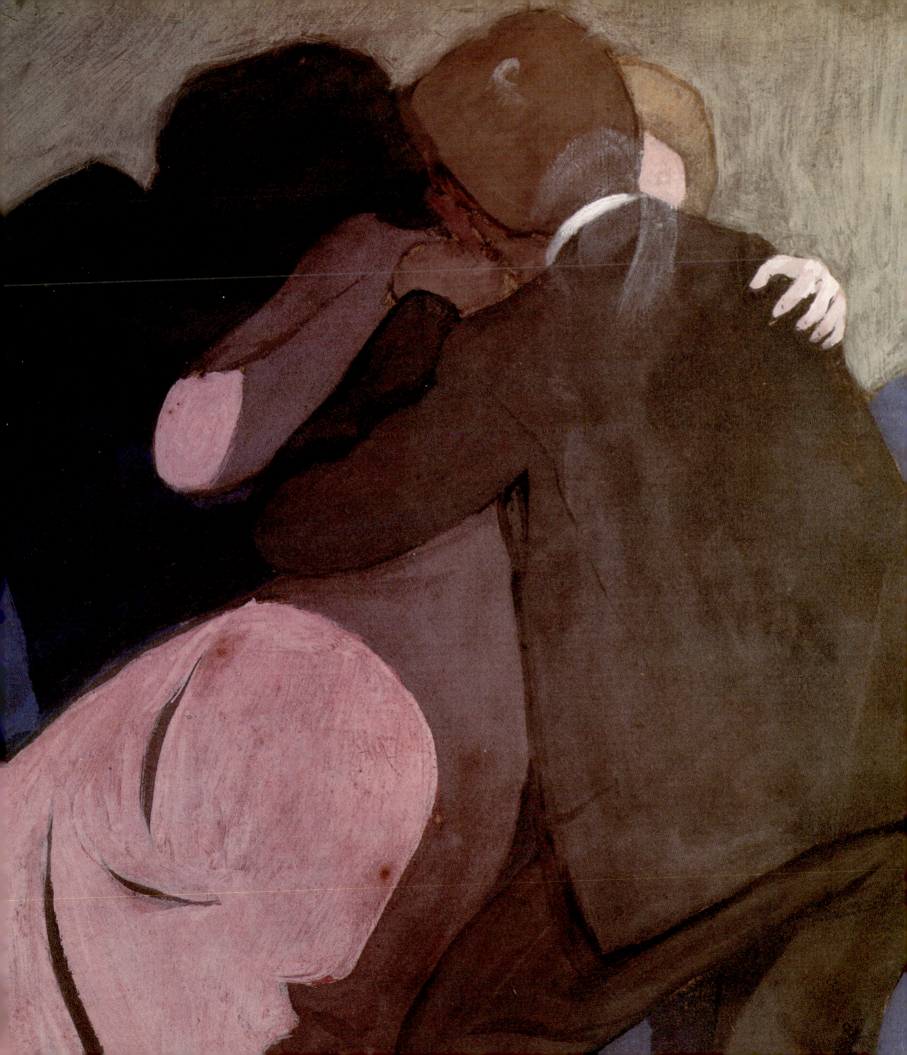

Sasha M. Newman

"Stages of Sentimental Life"
The Nudes and the Interiors

*What great evil has man committed that he deserves this terrifying
partner called woman? It seems to me that with such violently
contradictory thoughts and so clearly opposed impulses, the only
possible relationship between the sexes is that of victor and
vanquished.*

FÉLIX VALLOTTON, 1918[1]

Between January of 1907 and January of 1908 Vallotton completed his first and most enigmatic novel, *La Vie meurtrière* (The Murderous Life). Having attempted unsuccessfully to publish it in 1909, he entrusted its future to André Thérive in 1925: "I am not well, I'm growing old, I would really like to leave behind this trace."[2] Although the work obviously held tremendous personal significance for Vallotton, his journal makes but one reference to this literary effort, mentioning it in 1921 in relation to some drawings intended to illustrate the text: "I'm doing very little painting, some innocent still lifes, some drawings for my novel 'A Murder,' making it now fourteen years since I decided to bring the novel to light. I have gone over it with a fine-toothed comb. It is what it is, no better or worse than any other, perhaps even a little better than many others."[3]

Such offhand circumspection, combined with the ironic tone of a prologue written well after the book's completion and clearly intended to distance the author from the novel's overwhelming sense of personal revelation, signal the very centrality of *La Vie meurtrière* to an understanding of Vallotton's sense of his own ambition, as both painter and author. The first-person narrative contains many pointed references to his own history, disguised in the experiences of Jacques Verdier, a young provincial who became an artist in worldly Parisian society. Ultimately, however, the degree to which the novel's protagonist is Vallotton's alter ego is purposefully ambiguous. Part autobiographical record and part fictional posturing, the novel explores the binary oppositions at the core of the artist's obsessions: love and murder, victor and vanquished, man and woman. And it is woman who will serve as the preferred vehicle for the expression of these oppressive dualities. For in the same year in which the novel was completed, Vallotton turned to the female nude as the primary focus of his painting, beginning with an important series of bathers and studies of women at their toilette and culminating in the grand allegorical compositions of later years.

145. Detail of *The Kiss*, 1898 (see plate 172)

Victim and Executioner

A smooth brow. A pale eye, well placed, but without brilliance
under sickly eyelids, a short aquiline nose, a prominent upper lip
where the beginnings of a retiring mustache could be detected, a
thick-lipped mouth purposefully half-opened over quite beautiful
teeth, but separated, and then, suddenly, the failure of everything
in the weak little chin, a haphazard little chin which blemished the
ensemble and spoiled it with its weakness.

FÉLIX VALLOTTON, *LA VIE MEURTRIÈRE* [4]

So begins the second chapter of *La Vie meurtrière*, establishing the two poles of scientific discourse and personal confession that structure the novel through its conclusion. The text shifts back and forth between such passages of acute detail —detail often explicitly related to Vallotton himself (one has only to compare this description with Vallotton's earliest self-portraits [plate 115])—and scenes imbued with a disjunctive and pre-Surrealist iconicity, scenes rendered magisterial through the authority of unconscious desire. Moreover, the reader is never allowed to forget that the shadow of Vallotton the artist might be as embedded in each of Verdier's actions as it is in every detail of Verdier's self-description.[5] And so the reader is encouraged to speculate as to the relative truth of the novel's principle melodramatic events: three accidental deaths for which Verdier feels himself responsible.[6]

Whether fantasy or distant memory transformed, these lurid deaths punctuate a narrative otherwise distinguished by its dry and uninflected manner. Convinced that he is possessed of a corrosive and malevolent power, Verdier/Vallotton describes each death, be the victim male or female, with a vocabulary of sexual violence that reverberates with a deep fear of female sexuality.[7] And it is the gaze of the "pale eye"—the artist's eye—that catalyzes his capacity both to generate evil and to describe it in that moment of reciprocity of vision between subject and object, executioner and victim, victor and vanquished.[8]

Such instances of visual reciprocity are portrayed with an astonishing lucidity in *La Vie meurtrière*. Startling his first "victim," the engraver Hubertin, when he opens his studio door unexpectedly, Verdier causes him to embed the point of a burin in his finger. Under the surveillance of Verdier's gaze, the reader witnesses each stage of Hubertin's death as his system is poisoned by the trace of copper left on the burin's point (plate 146). It is a slow process of decomposition. When gangrene develops, the amputation of the putrefied flesh of the finger and finally the arm contributes to the progressive violation of the victim's body in a vain attempt to halt it.

The death of Jeanne Bargueil, an artist's model and Verdier's most significant victim, also occurs through maiming. Again entering a room unannounced, this time a sculptor's atelier where Jeanne is posed on an elevated table, Verdier fixes his eyes upon her, recording and cataloguing every detail of her appearance. Observing from the young girl's stance that she is discomfited by his unrelenting stare, he extends his hand to help her descend from her platform. Jeanne meets his gaze and loses her grip, falling onto the lit stove below and burning herself terribly. The full extent of her injuries is revealed when Verdier, making love to

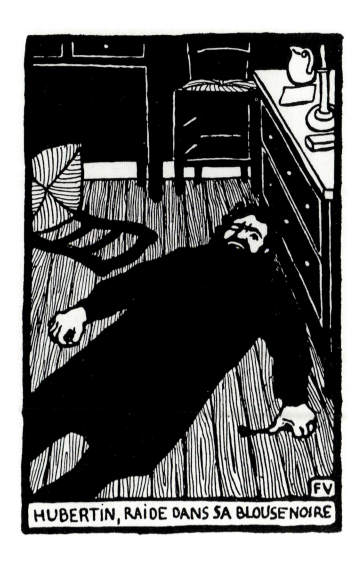

146
Hubertin, Stiff in his Black Smock
(Hubertin, Raide dans sa blouse noire), from
La Vie meurtrière, ca. 1921

Jeanne in response to her advances, discovers that her breast had been consumed by the fire. "Already my hand was at the opening of her bodice, breaking down her defenses, when a cry escaped me, a cry of disgust and horror. Instead of the soft hoped-for thing, my fingers felt some lumpy and withered residue! . . . I leaped to my feet away from her. The poor girl, practically thrown to the ground, could scarcely regain her equilibrium."[9] Verdier recoils in revulsion from the dismembered female body; Jeanne flees and dies soon after. His lament at her death is a perversely erotic elegy to an idealized image untainted by the bestiality of the flesh: "Dead! . . . the sweet Jeanne of the clear laugh was dead! . . . Dead her smile! . . . dead her hair! . . . dead her perfume!"[10]

Such repellent images of female sexuality, in which man is transfixed by his obsession with the filth of woman's animal nature, and in which woman's desire is manifested as a state of progressive decay, are central to much of the literature of the period: from Zola's description of Nana's corpse to Huysman's descriptions of putrefied flesh in *A Rebours* (Against Nature).[11] What is unique to Vallotton, however, is the curious relationship between the rhetoric of this literary confession, a rhetoric simultaneously voluptuous and clinical, and his artistic production. Described as the "confessions of the inner man," *La Vie meurtrière* is a

147
Nude Lying in the Grass, 1897(?)
Oil on board, 26 x 28 cm
Josefowitz Collection

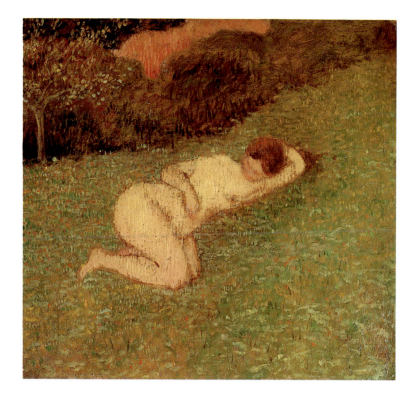

compulsive personal record of pain and pleasure. Yet paralleling this theme of subjective revelation is a system of objective scientific classification expressed in the same deadpan syle as the author's painstaking codification of Verdier's physiognomy.[12]

From his works of the 1890s, particularly *Bathers on a Summer Evening* (plate 148), the *Intimités* woodcuts, and the subsequent suite of painted interiors, through the large-scale nudes that increasingly preoccupied him until his death in 1925, Vallotton developed a schematic, even semiotic language that classed and ordered objects within the framed field of the canvas. In the work of the 1890s, reflecting aspirations similiar to those of literary realism, this language is generally externalized, often parodic, and specifically concerned with the representation of current social attitudes and sexual mores. After 1905, however, such incidents of positivist description are suppressed within a rigorously limited and traditional range of so-called neutral subject matter, with a particular and insistent concentration on the nude.[13] Increasingly determined to encapsulate the otherness of objects (especially women), Vallotton devised in these later works a personal voluptuary of the ugly, the abbreviated, and the distilled. Although these paintings may seem to share with his earlier works an underlying motivation of detached observation, they are enigmatically confessional. In fact, the way in which the artist figures and disfigures the female body can be read, like the text of *La Vie meurtrière,* as the confusion of two intentions. Albeit consciously constructed, these paintings function also as a representational unconscious revealed through the very process of their making. The hard-edged pictorial strategies that Vallotton explored so completely in his paintings of nudes avoid any specificity of place, movement, or detail. Indeed the artist's gaze petrifies his subject. It is ultimately the gaze of the male voyeur whose penetrating stare violates and humiliates the object of its focus.[14]

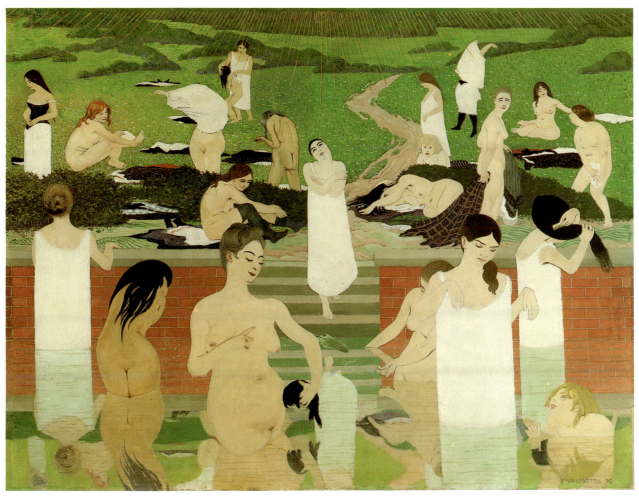

148
Bathers on a Summer Evening, 1892–93
Oil on canvas, 97 x 131 cm
Gottfried Keller-Stiftung, on loan to the
Kunsthaus Zürich

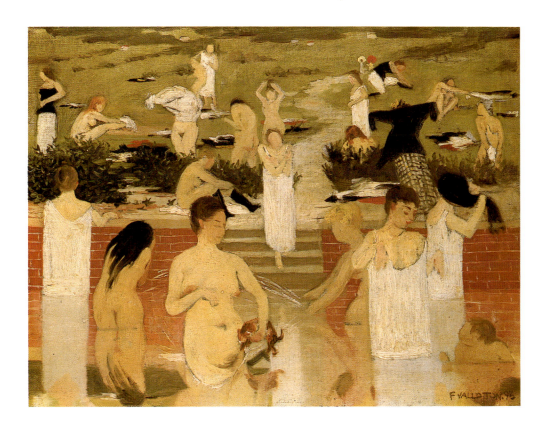

149
Study for "Bathers on a Summer Evening,"
1892
Oil on board, 24.8 x 32.5 cm
Private Collection

Bathers on a Summer Evening

Bathers on a Summer Evening of 1892–93 is a carefully prepared and ambitious work that could be considered a palimpsest of the artist's strategies and concerns, many of which he would not fully explore until after 1900.[15] It is equally a sophisticated summation of the decorative impulse, and the artistic sources for this impulse, that had begun to preoccupy Vallotton's new Nabi colleagues.[16] Its meticulous surface and facture are consistent with his earliest works, manifesting a primitivism or provincialism that would become essential to Vallotton's self-consciously cultivated style. It was in his choice of subject that Vallotton made a clear break with his past work, addressing for the first time the nude outside of the context of academic rendering. As Félix Fénéon described it: "One who really gives the needle to the gawkers is Vallotton; he shows us a bunch of women taking a swim, both young and old, some in the buff, others in their chemise, it will tickle you silly."[17] Certainly *Bathers* provoked laughter and consternation all around when Vallotton exhibited it at the Salon des Indépendants in the spring of 1893.

As Fénéon noted, *Bathers* is a curious and disturbing exegesis on the naked and the clothed. Clearly Vallotton had in mind Manet's *Luncheon on the Grass*, which had caused a stir in the first Salon des Refusés of 1863, when he constructed his own controversial painting thirty years later. Yet while the presence of discarded clothing in Manet's work problematizes the status of the female body as nude—and hence safe and idealized—by revealing the immediacy of the naked female body, Vallotton's *Bathers* undermines the possibility raised by that situation: that is, that these women might indeed be gendered flesh.[18] Instead, he uses a caricatural language in concert with episodes from high art to create a dictionary of contemporary female types: prostitute in black stockings, courtesan bathing a lap dog, young girl rising from sleep. Holding the painting in the realm of the gesturally parodic, Vallotton orchestrates the activity as an interplay of social and sexual signs: woman is at all times fleshless, and at all times fetish.

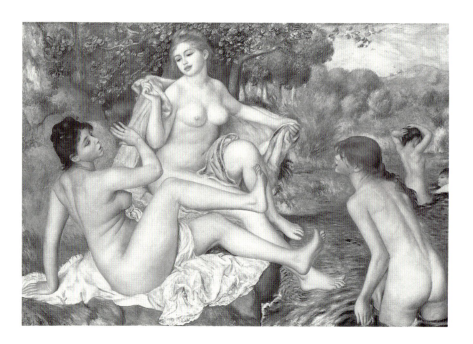

150

Auguste Renoir (1841–1919)

The Large Bathers, 1885–87

Oil on canvas, 115 x 170 cm

Philadelphia Museum of Art, The Mr. and Mrs. Carroll S. Tyson Collection, 63–116–13

151
Ferdinand Hodler (1853–1918)
Night, 1889–90
Oil on canvas, 116 x 299 cm
Kunstmuseum Bern

152
Lucas Cranach (1472–1553)
The Fountain of Youth, 1546
Limewood panel, 121 x 184 cm
Staatliche Museen Preussischer Kulturbesitz,
Gemäldegalerie, Berlin

Created at a moment when the topography of the sexualized female was in tremendous flux, *Bathers* can be understood as a parable of fin de siècle mythologies of the feminine.[19] In the upper quadrant of the composition women of all body types and ages dress and undress, comb their hair, and dry their feet in a series of iconic poses, readily identifiable parodies of recently exhibited paintings that would have been well-known to Vallotton's contemporaries. A bather from Renoir's *The Large Bathers* (plate 150) coexists with figures from Lautrec, Degas, Puvis de Chavannes, and Manet, even from Cranach's *The Fountain of Youth* (plate 152), the allegory upon which the painting is based.[20] Like little poster versions of the originals, in which individual touch or brushstroke is subsumed under a mechanically glacial surface, these replicas are montaged onto the rigorously orchestrated surface plane. The study for *Bathers* (plate 149) is both less specific and more modeled. Most significantly, the figure in a black jacket and checked skirt, silhouetted in the middle ground like a refugee from a Vuillard

interior, was ultimately eliminated. Perhaps her resolute contemporaneity disrupted the decorative balance Vallotton sought. Certainly her fully clothed state undermined the privileged position of discarded clothing in the final version.[21]

Similar groups of women appear in the contemporary allegories of Ferdinand Hodler's *Night* (plate 151) and Charles Maurin's *Dawn* (plate 153), decorative murals that were Vallotton's most immediate sources. And the lineage established between *Bathers* and the sexual and historical ambiguity of a later surrealist work, Paul Delvaux's *Antinoüs* of 1958 (plate 154), is undeniable. In Delvaux's painting women also pose in various states of dress—in clothing whose sixteenth- and nineteenth-century associations recall both the mannered classicism of Jean Fouquet and the cool commentary of Vallotton himself. Where Delvaux orchestrated his composition around the male presence of Antinoüs, however, Vallotton deliberately rejected so central a focus, choosing instead to scatter his bathers across the surface in an implicit evocation of male absence. Yet

153
Charles Maurin (1856–1914)
Dawn, ca. 1899
Oil on canvas, 79 x 148 cm
Musée Municipal de Saint-Etienne

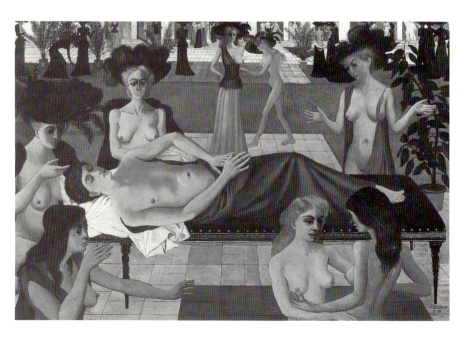

154
Paul Delvaux (b. 1897)
Antinoüs, 1958
Oil on canvas, 124.8 x 190.8 cm
North Carolina Museum of Art, Raleigh,
Gift of John Loeb

155
Paul Baudry (1828–1886)
The Pearl and the Wave, 1862
Oil on canvas, 83 x 175 cm
Museo del Prado, Madrid

closer scrutiny reveals that the severed torsos and headless figures in Vallotton's work also manifest a morphological ambiguity on the brink of metamorphosis. The buttocks of the brown-skinned figure on the right, for example, could double as a phallus or a face.[22] Indeed, so stylized are the bathers' poses and faces that, in contradiction to the uncompromising clarity of brushstroke and compositional structure, they seem hardly understandable as figures. Instead, one reads in them a multiplicity of phallic symbols—Freud's Medusa's head—whereby the woman herself becomes phallic through her powers of violent mutilation.[23] Reflections in the water compound the impression of unrelated or unattached body parts, any or all of which have the same relative importance as the discarded chemises, stockings, bustiers, and corsets.

These various items of private apparel—cultural signs of the feminine—are the locus of the sexual fascination generated through Vallotton's elaborately conceived system of displacement and substitution. Both fragmented body parts and female appurtenances achieve the status of fetishistic commodities.[24] As abstract sign and fetish, they suppress the organic integrity and the specificity of the complete and hence sexualized woman. Through emphatically linear outlines and hardened breaks between bodies and their reflections, Vallotton revised the syntax of the female body, creating a physiognomic type simultaneously mutilated and whole. That the superficial rendering of these "new" bodies borrowed the smooth touch of Salon painting—one thinks of contemporaneous works like Paul Baudry's *The Pearl and the Wave* (plate 155)—made his treatment all the more astonishing (that is, ugly) to contemporary audiences.[25]

Nevertheless, this new type of fragmented bather would soon proliferate in the work of such artists as Hermann-Paul, whose harsh depiction of women in lithographs like *Three Nude Women Bathing* (plate 156) owes much to Vallotton. In comparison to the disturbing, extreme fragmentation of the female body in Vallotton's *Bathers* or later woodcuts like *Three Bathers* (plate 158), where dismembered arms, heads, and torsos float above the water's surface, Hermann-Paul's work is more traditionally illustrative. And Vallotton's next large-scale painting of bathers, to which the title *The Mistress and the Servant* (plate 157) was appended by contemporary critics, is in turn far closer to the anecdotalism of Hermann-Paul. Less fetishized object than cartoon of social and racial relationships, it juxtaposes dark skin to light, stocky build to stylized and refined. The "servant,"

156

Hermann-Paul (1864–1940)

Three Nude Women Bathing, ca. 1894–95

Color lithograph, 21.9 x 34.7 cm

The Jane Voorhees Zimmerli Art Museum, Rutgers, The State University of New Jersey, Herbert Littman Purchase Fund

157

The Mistress and the Servant, 1896

Oil on board, 52 x 66 cm

Private Collection, Switzerland

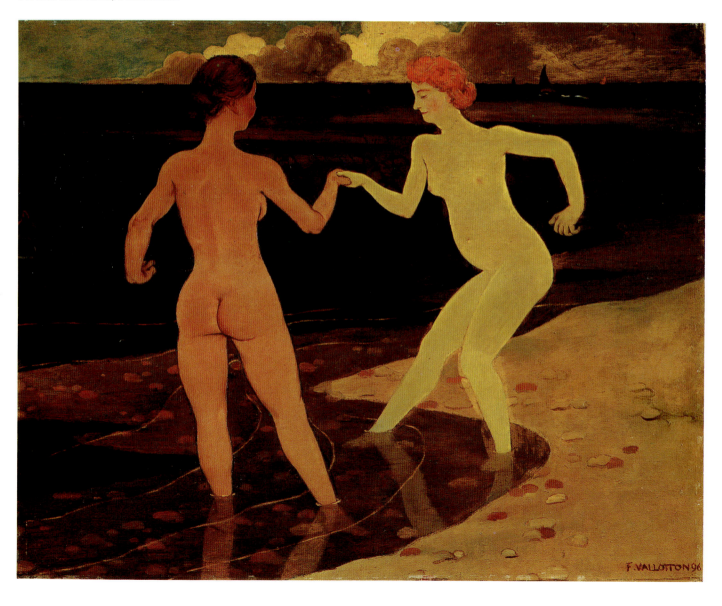

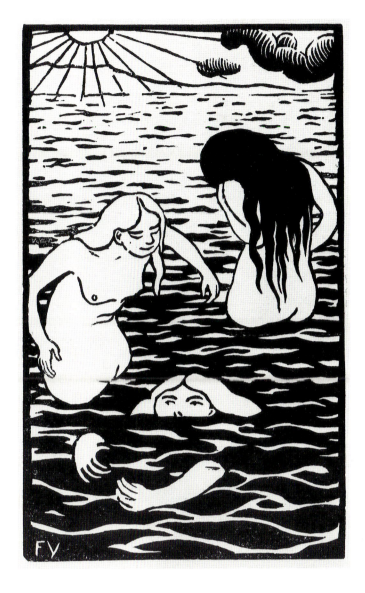

158
Three Bathers, 1894
Woodcut, 18.2 x 11.2 cm
Collection, The Museum of Modern Art,
New York, Gift of Heinz Berggruen, 163.51

159
Woman in the Bathroom Fixing her Hair,
ca. 1895
Tempera on board, 59 x 36 cm
Private Collection, Switzerland

whose body was described by Julius Meier-Graefe as "proletarian," is observed from the rear, standing sturdily on well-formed legs as she helps her mincing mistress, a caricature of neurasthenic vanity, enter the sea.[26]

Like many of the most provocative works of this period, *Bathers* operates simultaneously as historical reference and present-day parable. It is a modern trepidarium, a penetrating caricature of "woman" who, with the elaborate accessories of fashion and leisure, dominated contemporary society. As that inveterate chronicler of Parisian life Octave Uzanne wrote: "Art and literature have never before been so profoundly absorbed by the consideration of woman as at this present day, with the culture of her body, the study of her nerves, of her caprices, her desires. Woman does not simply inspire the artist of today: she dominates him. She is no longer merely the Muse, she is the Succubus. She has ceased to pose with a halo of splendour and perfection; rather she invites her votaries to an orgy of the senses; she lives and palpitates as if possessed with a demon of luxury."[27] And as trepidarium its nod to Ingres is unmistakable: an homage intensified by Vallotton's uninflected style and sinuous line. In later works, like *Women at their Toilette* (plate 161) and *Nude in the Red Room* (plate 162), Vallotton's

160
Nude Standing in front of Bed with Little Dog, 1898
Oil on canvas, 33 x 22 cm
Private Collection

161
Women at their Toilette, 1897
Oil on board, 48 x 58 cm
Private Collection, Switzerland

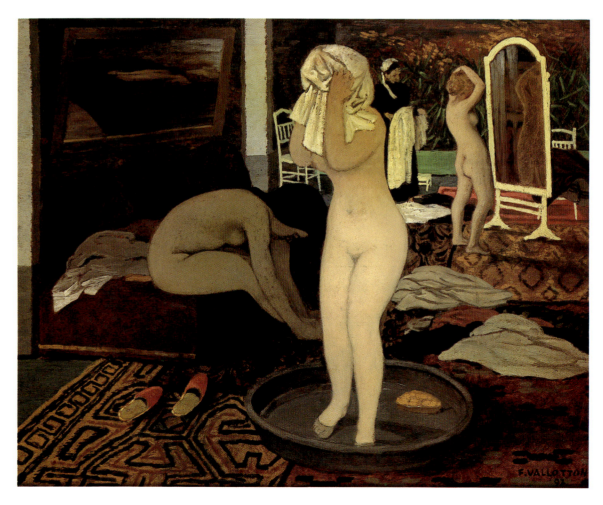

162

Nude in the Red Room, 1897
Oil on board, 43 x 60 cm
Private Collection

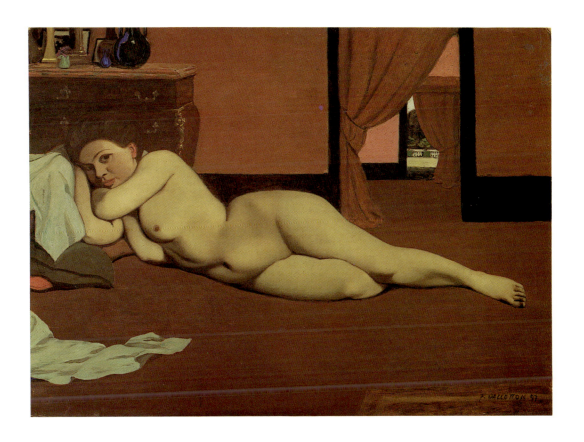

163

Woman Reclining on Cushions, 1897
Oil on board, 23 x 40 cm
Josefowitz Collection

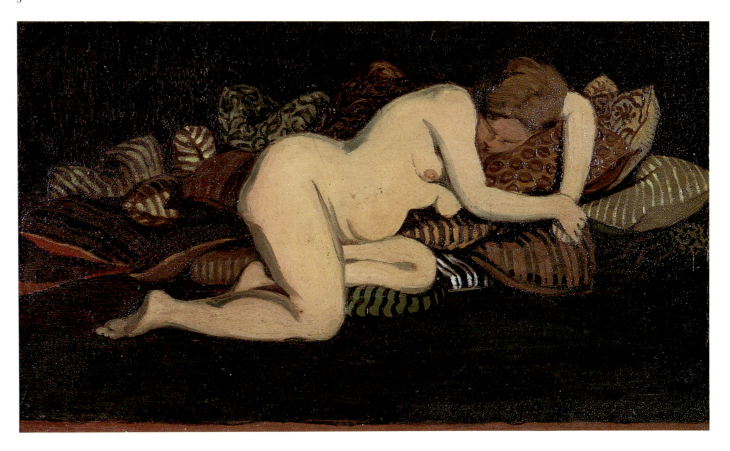

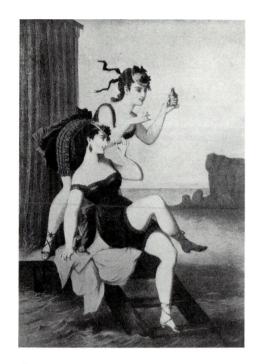

164

Bettanier, after Charles Vernier (1831–1887)

Girls at the Sea

Color lithograph, 23.8 x 16.8 cm

Published in *L'Histoire, la vie, les moeurs et la curiosité par l'image 1830–1900*, 1928

Paul Prouté Collection

quotations of Ingres become more explicit, his attempts at contemporary parody less so. Yet his embrace of Ingres' capacity for expressive distortion is upended by his extension of its effects into the realm of cartoon and caricature rather than aestheticized form. The opulent interior display of *Women at their Toilette* is in certain ways a pendant to the exterior location of *Bathers*. An earlier small bather (plate 159) mediates between the two. The physical distortions first elaborated in *Bathers* unite with the extremes of northern realism rather than those of Ingres. *Women at their Toilette* is considerably more lush—one woman dries her hair (again a faceless form), another her feet, and another coifs her hair before a standing mirror while an attendant holds a towel. Decorating the walls are mural-sized paintings replete with associations to, but not specifically identifiable as, the works of Vallotton's contemporaries: his own interpretations of Monet or Vuillard.[28] Both artist's studio and domestic living room, this interior is neither public nor private.

 Bathers on a Summer Evening is situated in an equally ambiguous region, one simultaneously Arcadian and contemporary. Certainly its exhibition in the Pavillon de la Vie de Paris intensified the potential contemporaneity of its setting. Here in this pavilion of urban living the site of Vallotton's baignade could not simply be dismissed as strange or problematic. Neither winding river nor pastoral seascape, this artificial pool of viscous fluid eschews the soothing classicism of Puvis de Chavannes as violently as it does the luminosity of impressionist immediacy. Yet one cannot but recall the craze for swimming and bathing that figured so prominently in Impressionist painting. By the 1880s everyone was learning to swim (plate 164): "swimming was practiced in the Seine and in all the rivers during the summer. This is where the pools are."[29] In 1885 Oller's Piscine Rochouart, Paris' first indoor swimming pool, opened to a public that was increasingly female. Here, as in the city's new exhibition halls and large department

165

The Bon Marché (*Le Bon Marché*), 1893

Woodcut, 20.2 x 26.1 cm

Galerie Vallotton, Lausanne

The Bon Marché (*Le Bon Marché*), 1898
Triptych, oil on board, 70 x 50,
70 x 50, 70 x 100 cm
Private Collection

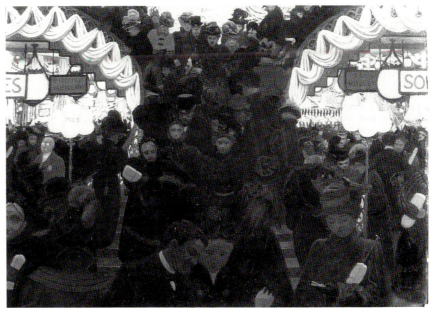

stores—the setting for Vallotton's next ambitious public statement, *The Bon Marché* (plate 166)—women of all rank and status rubbed against one another, engaging in the conspicuous leisure that might be considered an adjunct of conspicuous consumption.

As both object of consumption and ostentatious consumer, women in public places resonated powerfully in the male imagination, eliding with the popular notion that French society was headed toward universal prostitution and completing the equation often drawn between venal woman and national degeneration.[30] Vallotton's disdain for the flesh is as consistent with this social commentary as it is with his fetishizing treatment. Said the collector Louis Rouart to Francis Jourdain: "How well he has realized all of the uglinesses of women."[31] And, in the parlance of Vallotton and his contemporaries all equally vain, equally venal, and equally falsely idolized.

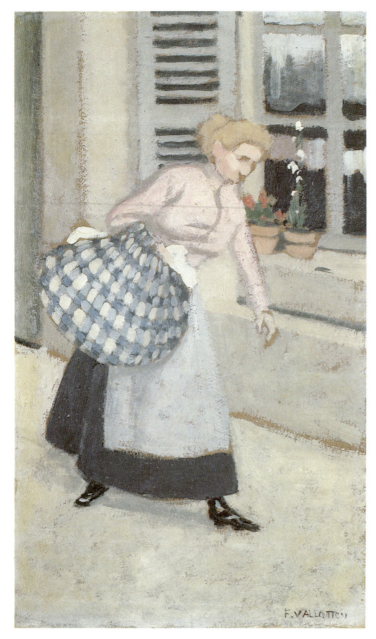

167
The Laundress, 1895
Oil on board, 36 x 21 cm
Private Collection

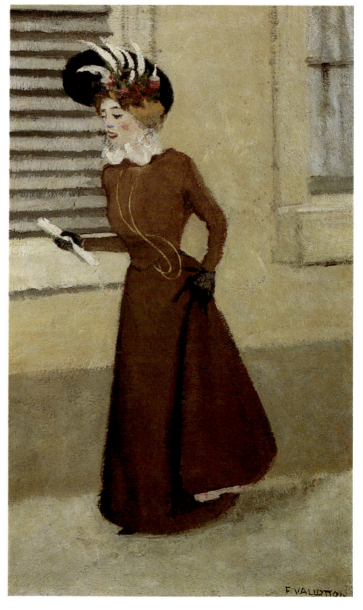

168
Woman with a Plumed Hat, 1895
Oil on board, 48 x 29 cm
Private Collection, Zurich

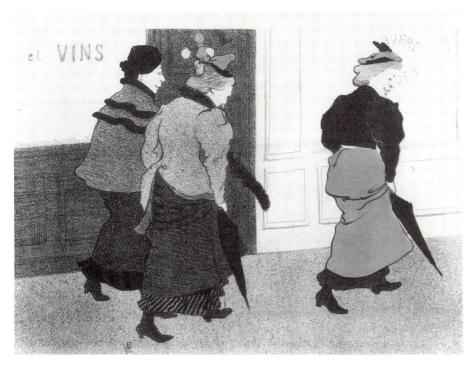

169

Hermann-Paul (1864–1940)

Three Women Walking (The Milliners),
1894

Color lithograph, 24.4 x 35.2 cm

The Jane Voorhees Zimmerli Art Museum,
Rutgers, The State University of New Jersey,
Herbert Littmann Purchase Fund

A Story of Passion and Vallotton's *Intimités*

With *Bathers*, which identified Vallotton as a social satirist preoccupied with the "woman question," Vallotton achieved the critical attention that fostered his assimilation into the circle of *La Revue blanche*. Throughout the 1890s, the writers and critics loosely attached to this magazine would exercise an essential influence on Vallotton's work and attitudes. A review of the table of contents of *La Revue blanche*—one of the most advanced literary, artistic, and socio-political publications of its day—reveals a journal concerned with the form and function of gendered social rituals and anxious to define the problematic of the relationship between men and women: considered, not incidentally, to be an exclusively male predicament.[32] It is fitting that Vallotton did not make his February 1894 debut in its pages with the caricatural portrait drawings that were then the mainstay of his existence, but with the full-page woodcut entitled *Three Bathers*. And it is equally fitting that his greatest success both with the magazine's public and critics was *Intimités*, a series of ten woodcuts that deliberately, even crudely, delineates the hypocrisies, guilt, and perversions of bourgeois marital and sexual life.[33]

Variations on the theme of wifely betrayal enjoyed tremendous popularity in literature and the arts throughout the last quarter of the nineteenth century. Similar anecdotes were published in all journals, newspapers, and reviews—whatever their different socio-political agendas—from *La Revue des deux mondes* to *La Revue blanche*, from *L'Illustration* to *L'Escarmouche*.[34] And related illustrations appeared frequently in the popular press. Adultery was a common focus of novels, dramas, vaudevilles, farce, and dinner party conversation. Dumas fils wrote play after play about it. Zola contributed an article on its proliferation to *Le Figaro* in 1881; entitled "L'Adultère dans la bourgeoisie" (Adultery among the bourgeoisie), it would form the basis for his novel *Pot Bouillé*. *La Gazette des Tribunaux*, a journal of legal judgments, published records of adulterous accusations that read

like the erotic society novels of Paul Bourget, the most popular novelist of the day.[35] A topic uncircumscribed by distinctions between high and low, it elicited so much interest that it could almost be considered a form of bourgeois popular amusement. And while the editorial stance of *La Revue blanche* was expressed in more enlightened terms by such favored writers as Henrik Ibsen—who proselytized the merits of equal unions between men and women based on liberty, will, and knowledge—the journal also gave preeminence to such texts as Strindberg's "On the Inferiority of Woman" and such anecdotes as the following tale, which as it happens immediately preceded Vallotton's *Three Bathers* in the magazine's February 1894 issue and which has much in common with the attitudes that spawned his *Intimités*.[36]

Entitled "A Story of Passion," with the provocative epigram "Actual Tales," and confirming the late-nineteenth-century fascination with the story of Robinson Crusoe, this vignette by Pierre Veber describes Crusoe's fate after visiting Europe to choose an appropriate wife: "He chose her from amongst the most chaste and the most beautiful little 'Eves' who were at the disposition of acquirers."[37] Promptly setting sail on a seafaring honeymoon, Crusoe and his wife are shipwrecked exactly as before, returning to the desolate island of Defoe's novel.[38] Here they set up their *ménage* as the prototypical bourgeois couple, at least according to the expectations of the readership of *La Revue blanche*. Installed in splendid isolation, Mme. Crusoe seems initially delighted to have her husband all to herself, insisting that she will not miss the public distractions of the city— stores, balls, operas—that figured so prominently in her previous life. Crusoe, in turn, is overwhelmed with pride that he has chosen so sensible and faithful a wife. Yet such marital bliss is not destined to continue. After only three years, Zoe Crusoe becomes enervated by her solitude. Oppressed by her assigned interior space—the domestic realm of chaste, moral, bourgeois women—she is no longer the proud "guardian of the hearth."[39] An increasingly lax housekeeper, she ceases even to play the piano or read novels, preferring to look dreamily at the stars. Crusoe, conditioned to be attentive to such classic signs of wifely disaffection, realizes that something is wrong. Yet their solitary circumstances prevent him from suspecting that malady of all modern marriages, adultery: "Oh, if I were in Europe or even Australia, it would be something else without question. Here, it's impossible, my wife can deceive me only with me."[40] So he suppresses his fears and continues to hunt, leaving his wife alone in the house for days at a time. When Zoe's listlessness suddenly ends and she begins leaving the house at odd hours for inhabitual errands on unreasonable pretexts, however, a jealous Crusoe arranges a modern husband's ruse: he leaves the house, informing his wife that he will be away for two days. Full of duplicitous concern she embraces him, admonishing him with a final fillip of domestic care to be mindful of the cold. But Crusoe returns home that very night to find the windows illuminated. Putting his ear to the door, he hears cries of sensual pleasure of a nature that he cannot misinterpret. Unable to imagine with whom his wife is enacting this ultimate deception, he forces the door open and discovers Zoe—so desperate was she to engage in the duplicity that is central to the female nature—making love with a dog-faced baboon.

With far greater subtlety, Vallotton's *Intimités* of 1897–98, and the series of related paintings he exhibited soon thereafter, address many of the same moral attitudes, insecurities, and obsessions as this "story of passion." While *Bathers* had

addressed the representation of "modern woman," it did so in the form of a diachronically frozen moment, suggesting a story that would never really be told. The woodcuts of *Intimités*, albeit episodic, are nonetheless cumulatively more explicit in proposing that deceitful, adulterous behavior is an inevitable and predetermined aspect of woman once her sensual nature has been awakened.[41] The perversion of woman expresses itself in adultery; she is, according to Dumas fils, a creature with "inverted ideals, weak dignity, elastic morals, an imagination troubled by bad examples, a curiosity for sensation disguised under the name of sentiment, a thirst for danger and for the pleasure of trickery, a need for the fall, for its vertiginous descent and all of its attendant duplicity."[42]

Born of the same milieu as Jules Renard's *L'Ecornifleur* (The Cadger), humorous if cynical stories of the disastrous consequences of a wife's reckless sexuality—not incidentally illustrated by Vallotton in 1894—*Intimités* gives visual form to the pervasive discourse that the failure of the relationship between the sexes is the failure of bourgeois society in general.[43] Each image reinforces a shared refrain: there is no truth in the emotional ties that bind man and woman, no redemption in the conventions of marriage. Neither storyteller nor moralist, Vallotton situates himself as the revealer of the ugly truths—amorous, marital, material—lying hidden beneath the accepted rituals of daily life. As Jean Schopfer would write of the series soon after its publication: "Félix Vallotton holds us by the arm as it were, to show us actions and grimaces that have become by habit familiar and inoffensive—a new image wherein the ugliness of hidden motives appears to us suddenly and in its dry truth."[44]

This "ugliness of hidden motives"—those of greed and power—is paraded with some candor and attention to detail. In each woodcut, the archetypal couple is surrounded by the damning material attributes of their class: furniture, flowers, clothes, books, the accretion of which has trapped them in this space from which they cannot escape.[45] Women seduce and wheedle, avid for the gratification of luxury goods (*The Fine Pin* [plate 98]); married couples quarrel (*Extreme Measure* [plate 103]); assignations occur with a grotesque lack of poetry or romance (*Five O'Clock* [plate 105]) and conclude like a successful business negotiation—with the smug satisfaction of one partner and the disillusionment of the other (*The Irreparable* [plate 109]). If a wife's adultery, and hence his own emasculation, is the ultimate fear of the bourgeois husband, then the interior is the arena in which such anxieties are enacted. In each scene, intimacy is revealed as a farce, as a theatrical spectacle:

> Ten times a man and a woman meet in all of the attitudes in which the mishaps, the stages of sentimental life are fixed. They express every imaginable aspect, the naive and the ridiculous, the hypocrisy and the lies, the cruelty and the taste for death that is in all of our conception of love. One laughs, one trembles, one is moved, one is shocked, one shudders. The delicious, disquieting spectacle.[46]

Yet for all its lubricious subject matter and for all its attention to "la bête humaine," *Intimités* is elegant and ingratiating. The elements of troubling disquiet that Natanson so lyrically catalogued remain "delicious" because of Vallotton's refined orchestration of blacks and whites, solids and voids. Such formal harmonies allow the initiated and sophisticated viewer to luxuriate in the spectacle of marriage and of infidelity as simply that, spectacle. Mitigating the anxiety produced by real emotional engagement, Vallotton allows male viewers to be titillated by their sexual predicament rather than overwhelmed or indicted by it. Anecdotal

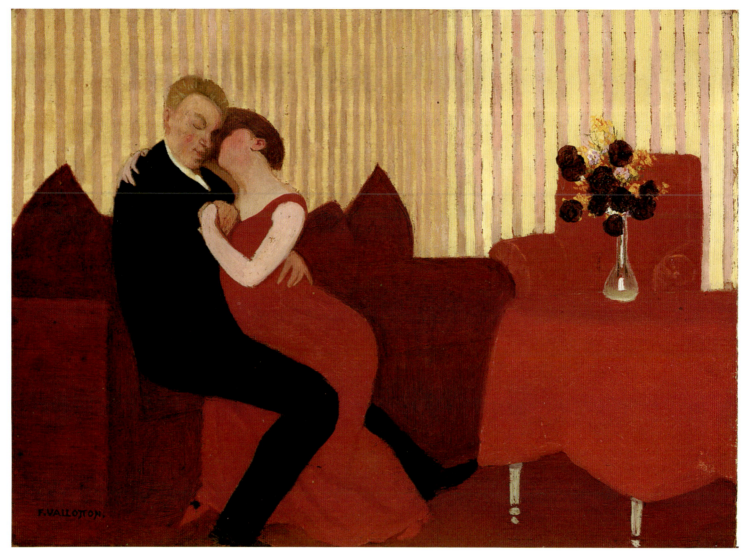

170

The Lie, 1898

Oil on board, 23.5 x 33 cm

The Baltimore Museum of Art, The Cone
Collection, formed by Dr. Claribel Cone and
Miss Etta Cone of Baltimore, Maryland,
BMA 1950.298

and sentimentalizing, these woodcuts describing the artificial burlesque of bour-
geois life are the antithesis of Edvard Munch's examination in the same medium
of the biological struggle between the sexes.[47] Only the first print of the series,
The Lie (plate 93), in which a couple is locked in an embrace (one directly related
to Munch's *The Kiss* [plate 171]), suggests the possibility of a more fundamental
moral message. Yet, as always, there is ambiguity in Vallotton's stance. Does this
work refer to that lie of social convention—*le mensonge vital*—which is the essential
condition of contemporary life and which violates any possibility for an honest
relationship between man and woman? Or is its title simply a modish reference to
all of those popular publications, smugly and superficially preoccupied with the
deceitful nature of woman?[48]

It is no surprise, then, that *Intimités* was Vallotton's most enthusiastically
received work. In his review of the series Thadée Natanson welcomed Vallotton
into the inner sanctum of *La Revue blanche*, noting that despite the continued
resonance of Vallotton's foreign origins, *Intimités* revealed his assimilation of
things French: "His thorough study of the French masters, of Ingres in particu-
lar, nationalizes him a Frenchman."[49]

171
Edvard Munch (1863–1944)
The Kiss, 1892
Oil on canvas, 72 x 90.8 cm
Nasjonalgalleriet, Oslo

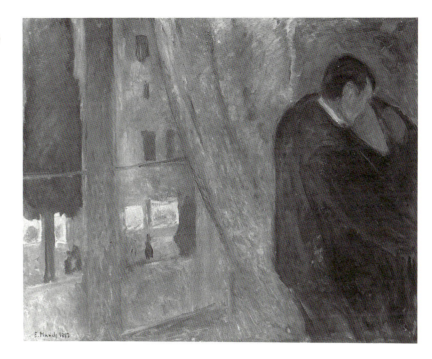

172
The Kiss, 1898
Tempera on board, 30 x 37.5 cm
Private Collection

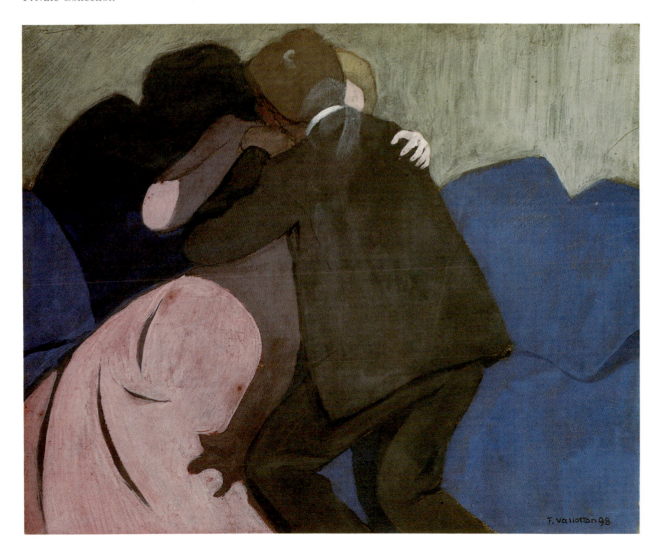

The Interiors

It was to be a short-lived welcome, despite Vallotton's marriage and subsequent patriation. While *Intimités* was considered by most critics to be the artist's masterpiece, the thematically related paintings that he exhibited soon after its publication did not elicit the same enthusiasm.[50] The woodcuts had been spare but intelligible, suggesting if not articulating a world order where physical and psychological detail could be understood. No such ease of access informs the intensely colored paintings, whose brash palette was rendered considerably more disruptive by virtue of the potential comparison with the black and white patterning of the woodcuts. Oriented toward large surface contrasts, they are disturbingly more enigmatic in their elaboration of artificiality.

As in *Intimités*, the drama of the relationship between the sexes is here played out against interior settings. These painted rooms are harsh and cold places filled with silent tensions and conflicts. And the sexual encounters enacted therein, ranging from the passionate to the estranged, reflect the same capacity for ugliness and sordidness as the physical details of the spaces themselves.[51] Eyes are closed and heads often averted, as even embracing couples refuse to look at each other. So deliberate a device contributes not to a sense of intensity, but to an inarticulate and dull muteness. The terror of the reciprocal gaze, and the recognition it initiates, have been completely diffused. However, we the audience are clearly implicated as voyeurs, uncomfortable witnesses to these "forbidden spectacles" of unspecified emotional violence. Singularly disquieting and alienating, these paintings disallow that element of the "delicious," of titillating equilibrium, that had rendered the woodcuts so felicitous.

The Lie (plate 170), the first of these interiors to be listed in Vallotton's *Livre de raison*, took its inspiration directly from the woodcut of the same title. In the painting, the tyranny of the unreal reds and stark blacks lends a lethal almost vampirish quality to the couple's embrace. The palette is fashionable, but menacing, as is the couple's posture. While the woman seems to swoon into the man between his black trousered legs, a rigid image of sexual difference is imposed by the abrubt color contrasts and the precise contours. As in *La Vie meurtrière* there is tremendous aggression, even violence, implicit in this binary oppression. Who is victor and who is vanquished? We have crossed the threshold into a world where manipulations and flirtations have the potential for real devastation. Misogyny is expressed through vampirism, so common an inversion in this period that it had actually become a pictorial convention.

Vallotton continues to examine the all-consuming embrace in *The Kiss* (plate 172). Here the man and the shadow engulf the woman; only her claw-like hand on his shoulder escapes, as he forces her back against the same blue couch that reappears, like a cast-off from a stage set, in later interiors. This is one of Vallotton's most organic images, where the sexual encounter is not mediated by social ritual. Generally he portrays a world where the most ominous possibility is not the *femme fatale*—for it is woman's power that Vallotton refuses to acknowledge and that he imagistically dismantles or disrupts—but rather the bitter dissatisfaction implicit in all conjugal or sexual unions. And when the kiss is of a more courtly sort (plate 129), the impression is overwhelmingly that of ritual posturing with no profundity of feeling, no hope of emotional redemption.

Vallotton's subsequent interiors—*Interior with Couple and Screen, The Red*

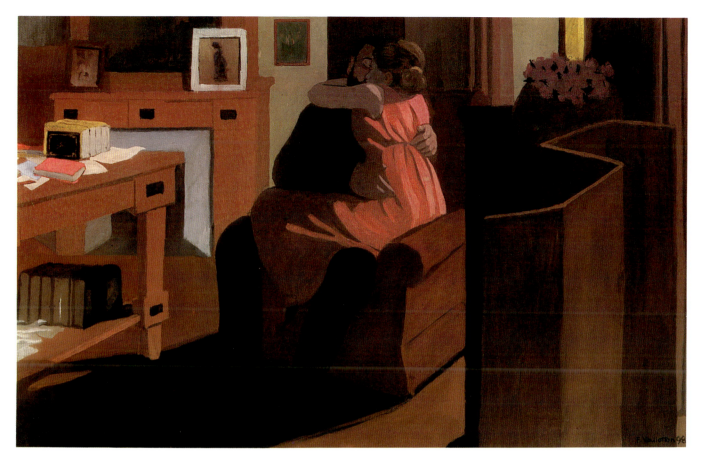

173
Intimacy (Interior with couple and screen),
1898
Tempera on board, 35 x 57 cm
Josefowitz Collection

Room, Private Conversation, The Visit, and *Interior with Red Armchair and Figures* (plates 173–77)—compose a distinctly interrelated group of psychological dramas. Abandoning the close-up for a more inclusive view of the setting, he nevertheless maintained the claustrophobic character of the three previous works. In *Interior with Couple and Screen,* a man and woman embrace in the red armchair that appears in six of the eight interiors. Strongly illuminated from the left, they cast a heavy shadow across the floor that contributes to their entrapment within a maze of demonstrably unappealing furniture. The next three paintings create a catalogue of amorous arrivals and departures. In *The Visit,* a man ushers a woman into an uninviting, non-intimate, sitting room furnished with the rote banality of the apartment described in Jules Renard's *La Maîtresse* (The Mistress).[52] Vallotton had completed his illustrations for this unsentimentalized record of the affair between a young man and an older woman in 1896 (plate 178). The uninflected dialogue and distinct lack of romantic poetry in the vignettes describing this relationship were certainly a touchstone for the artist's own skepticism in the face of romantic clichés and stereotypes. The perfunctorily furnished space in *The Visit* is clearly a room for assignations, whose dénouement is literally specified by the open door leading into the bedroom beyond. Yet there is no joy or anticipation in this pre-coital state. The couple's demeanor suggests a gestural codex of prescribed manners. One feels an overwhelming sense of insidious claustrophobia, even boredom, in their interaction.

Private Conversation implies a similar narrative, only here the woman in

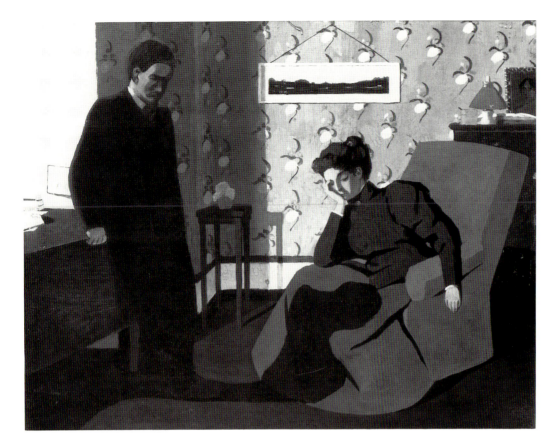

174
Interior, Red Armchair and Figures, 1899
Gouache on board, 46.5 x 59.5 cm
Kunsthaus Zürich, Donation Ms. O.
Röderstein

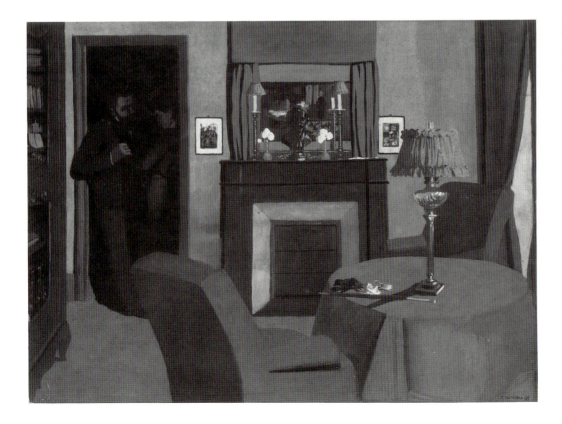

175
The Red Room, 1898
Tempera on board, 79.5 x 58.5 cm
Musée cantonal des Beaux-Arts, Lausanne

176

Private Conversation, 1898
Pastel and gouache on paper reinforced
with board, 45.5 x 64.5 cm
Musée d'Art et d'Histoire, Geneva

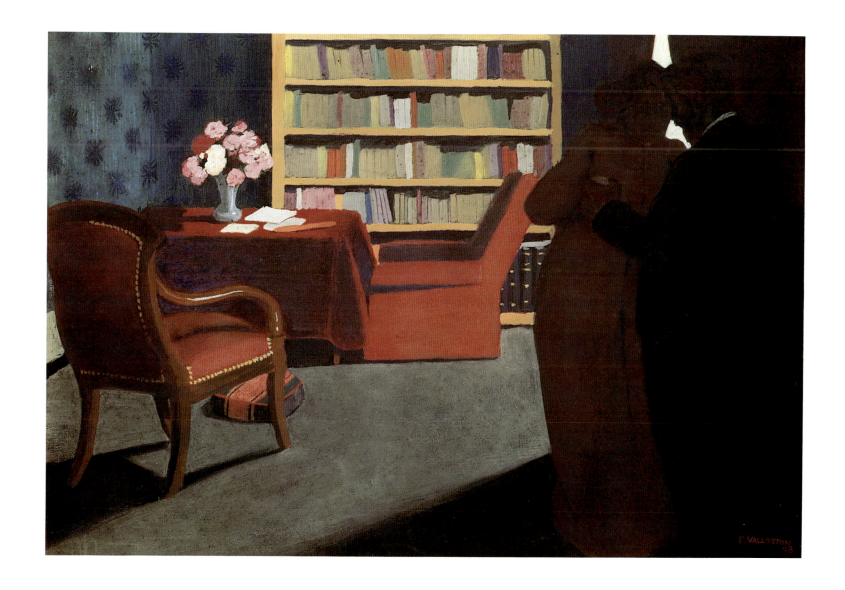

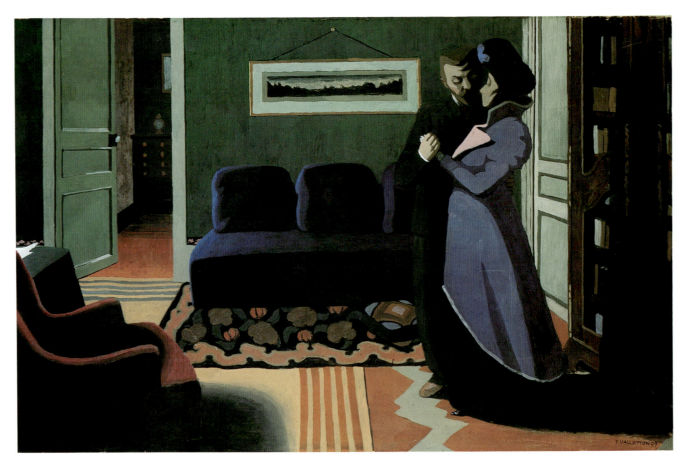

177
The Visit, 1899
Gouache on board, 55 x 87 cm
Kunsthaus Zürich

her "at home dress" awaits the man. In both this image and *The Red Room*, the couple is cast in dark shadows that obscure the details of their greeting. In the latter, in particular, they seem engaged in an elusive test of wills, though it is impossible to determine whether we are witness to a scene of reluctance and persuasion, mere passivity and dominance, or some even more subtle contre-temps. Their personal drama is reinforced by, but subordinate to that of the interior space, which is illuminated by a lurid and portentous red glow. Vallotton uses physical details like clues. The intense red of the table top compels the viewer's eyes to its surface where the woman's accessorial and fetishistic attributes lie scattered—a purple parasol, black gloves, a yellow purse, a linen handkerchief —accidentally left behind like blood on a murderer's glove, telltale signs of her menacing sexuality.

Nothing is potentially more sordid or more expressive in these interiors than the furniture included in each painting. Vallotton's hyper-conscious atten-tion to the details of decor can be seen in his early work from the 1880s. Such paintings as *The Kitchen* and *The Sick Girl* (plates 6, 8) reveal his roots in traditions of northern realism. Yet they do not share the potential for artificiality, deceit, or disguise that characterizes the realm of appearances in the interiors of 1898 and 1899. In these later works, Vallotton no longer belabors the details of an exqui-sitely rendered cane chair or striped bed ticking. Instead, furniture is depicted synthetically and non-specifically: bed, clock, armoire, mantelpiece, commode, and sofa have a symbolic function, not a descriptive one.

As Zola frequently attested in his various exegeses of naturalism, houses

178
Vignette, from *La Maîtresse*, 1896

and their decor were metaphorical reflections of the moral life within them: one might even speak of the moralized interior. *Pot Bouillé*, a bitter burlesque of bourgeois life enacted in the overwhelmingly detailed, walled-in house of the Rougon-Maquart family, was caricatured upon publication in *La Caricature* as a series of rooms in comic-book style.[53] Vallotton's interiors of 1898–99 likewise caricature this material self-importance brilliantly. As Octave Mirbeau noted on first viewing these paintings: "Not only do the people play their roles marvelously, but so does the furniture, in a comic fashion singularized by its fabrics, its placement, its essential simplification."[54] The lack of grace and poetry, which so distinguishes the material attributes of these interiors, is clearly reflected in the moral or spiritual life of the inhabitants. The viewer is not seduced by the spectacle of merchandise in these paintings, but instead is repelled by it.

Other works by Vallotton certainly reflect his awareness of the contemporary mania for collecting furniture and bibelots, as well as his general lack of sympathy for opulent bourgeois luxury. Woodcuts like *The Milliner* (plate 61) or paintings like *The Bon Marché* chronicle this bourgeois fascination with consumption. Sharing the thematic concerns of the Realists, *The Bon Marché* could even be understood as a pictorial comment on Zola's *Au Bonheur des Dames* (At the Bonheur des Dames). Published in 1883, this important novel described the grandiose and theatrical architecture and atmosphere of France's first department store in Darwinian terms, as a gigantic living organism that swallows up the small shops around it.[55] Vallotton's triptych, which portrays the hollow immensity of this same store, is also a cynical paean to woman's material avariciousness. Here, in opposition to the sexual transactions of the interiors, men sell and women buy; but each situation concludes with the material goods that the woman desires.

Those contemporary critics who were as disturbed by Vallotton's painted interiors as they were pleased by his woodcuts for *Intimités* could not accept his unflinching records of the small but persistent uglinesses of daily life. "Rich looking and in bad taste, chairs stuffed with horse hair and covered with heavy fabric, this synthetic and simplified place of banal loves," wrote Henri Gheon in 1899.[56] Artificial and inhuman, Vallotton's world is stripped of the refinement, the nuanced harmony, and the tenderness of the French spirit, so apparent and so beloved in interiors by Vuillard and Bonnard.[57] The obsessive dryness and lack of insinuating grace in these works were particularly shocking to an audience who, in the face of encroaching industrialism, valued the ingratiating, aristocratic nervosity of the French eighteenth century. As Edmond de Goncourt complained in his journal: "Passion for the art object and the industrially produced art object has killed for me the seductiveness of woman."[58]

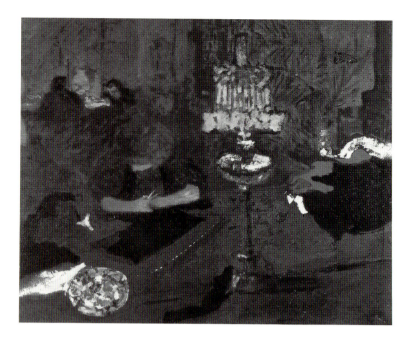

179
Edouard Vuillard (1868–1940)
The Natanson Brothers, Misia, and Léon Blum, ca. 1898–1900
Oil on board, 43.2 x 50.8 cm
Private Collection

180
Pierre Bonnard (1867–1947)
Lamplight, 1898
Oil on board, 61.5 x 75 cm
Kunstmuseum Bern

The lethal frigidity of Vallotton's interiors disrupts the organic warmth of the Art Nouveau interior so essential to the intimate visions of Bonnard and Vuillard, artists with whom Vallotton was often compared and with whom he often exhibited. In their small paintings of interiors as well as their large-scale decorative ensembles, these Nabi artists proposed a unified neo-rococo vision of internal harmony that did much to neutralize the discordant social reality of the epoch.[59] Vallotton, however, confronted this reality headlong. Rejecting the mania for collecting, the sumptuous build-up of pattern, color, and object that delights and soothes the mind in paintings by Vuillard or in related literary descriptions by the Goncourts, Vallotton's interiors function not as organic ensembles but as theatrical stage sets.

A lack of faith in appearances was one of the distinguishing aspects of the Nabi vision. In Vuillard and Bonnard this translated into an urge to find subjects in everyday life that would liberate the development of their inner being or subconscious, allowing them to find a visual expression that would mediate between the reality of matter and the reality of the spirit. Vallotton, on the other hand, sought to reveal the essential lie of life, not through an expression of the ephemerality of appearances but through an increasingly intense focus on the sordid actuality of the here and now.[60] His is a mute and heavy vision, without organic vitality.

In interiors like *Woman in a Purple Dress by Lamplight* of 1898 (plate 27) or *Woman Searching through a Cupboard* of 1901 (plate 181), Vallotton engaged a motival convention—the effects of lamplight—that predominated in Bonnard's and Vuillard's work of the late 1890s as a way of visualizing the Bergsonian integration of mind and matter (plates 179, 180). According to Bergson, perception was always subjective and always in flux.[61] For Bonnard and Vuillard, integration of figure and ground, of perceiver and perceived, would be the means by which they sought to convey this symbolic relationship between interior psychological states and the objects of perception. Aware of these models of psychologi-

181

Woman Searching through a Cupboard,
1900–01

Oil on canvas, 78 x 49.5 cm

Private Collection, Basel, Switzerland

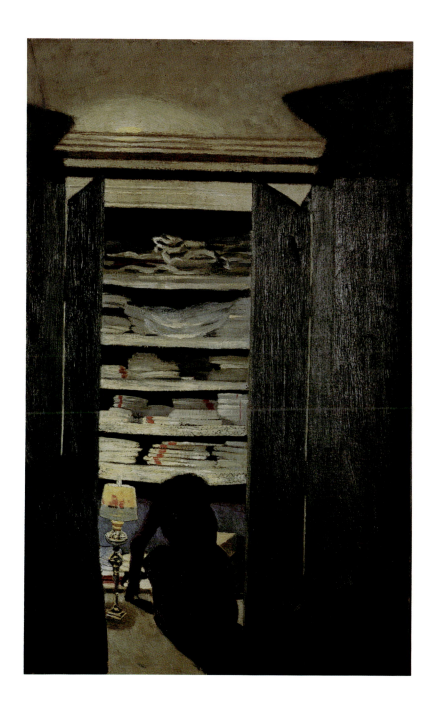

cal perception, Vallotton nonetheless inverted them: his lamplight separates, it does not unify. The oppositions so seminal to Vallotton's late work, where figure and ground are utterly distinct, are identifiable even at his moment of greatest proximity with the Nabi intimists. Initially, of course, they had all shared a stylistic interest in the broad brushstroke and flat areas of uninflected color advanced by Sérusier and Gauguin. Among the Nabis, Bonnard and Vuillard were the first to shift to a more impressionistic brushstroke, though in service of emotional resonance rather than atmospheric study. As Bonnard said of Impressionism: "it came as a new enthusiasm, a sense of revelation and liberation . . . Impressionism brought us freedom."[62] It was an enthusiasm Vallotton never shared, an aspect of the French tradition he never pursued.

The Genre Interiors

In 1899 Vallotton married Gabrielle Rodrigues-Henriques, daughter of the Bernheim art dealer. A wealthy Jewish widow, she was accustomed to the luxury and society that, paradoxically, Vallotton had disdained in his room interiors of the 1890s. With the marriage Vallotton was forced to change his habits, to give up his simple housing in the Latin Quarter and his working-class mistress, for a large modern apartment on the rue de Milan in the sixteenth arrondissement. Ironically, the Vallottons established residence in just that area of Paris that catered to the new upper-middle class, and their new apartments were furnished with just those decorative manifestations of bourgeois consumerism that Vallotton had recently parodied. As he gradually took possession of his new surroundings and his new wife, Vallotton produced a series of room interiors that record the first happiness of his marriage. In direct opposition to the suite of moralized, male-dominated interiors of the 1890s, these new interiors are distinctly feminized— not only because Gabrielle is so often in evidence in her negligée, at her toilette, or quietly pursuing domestic tasks of sewing and embroidery—but because Vallotton portrays the private spaces of his home, not the public reception rooms that had figured so prominently in the earlier works. Here Gabrielle fulfilled her role of "dressing" the house, of making it a pleasant nest. Here she harmonized her own apparel with the decor of her surroundings, joining the battalions of women of her social class in their purchase of household accessories.[63]

Interior with Woman in Red Seen from Behind of 1903 (plate 36) and *Interior, Bedroom with Two Women* of 1904 (plate 183) are among Vallotton's most accomplished evocations of domesticity. In the former, an overwhelming sense of light and airiness contrasts with the inverted claustrophobia of the earlier interiors.

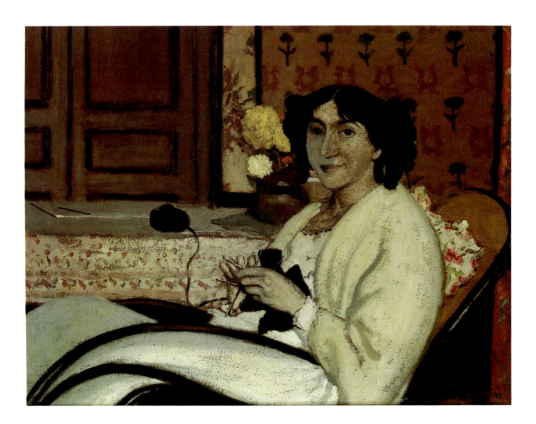

182
Portrait of Gabrielle Vallotton Sitting in a Rocking Chair, 1902
Oil on board, laid on panel, 45 x 65 cm
Josefowitz Collection

183
Interior, Bedroom with Two Women, 1904
Oil on board, 61.5 x 56 cm
State Hermitage Museum, Leningrad

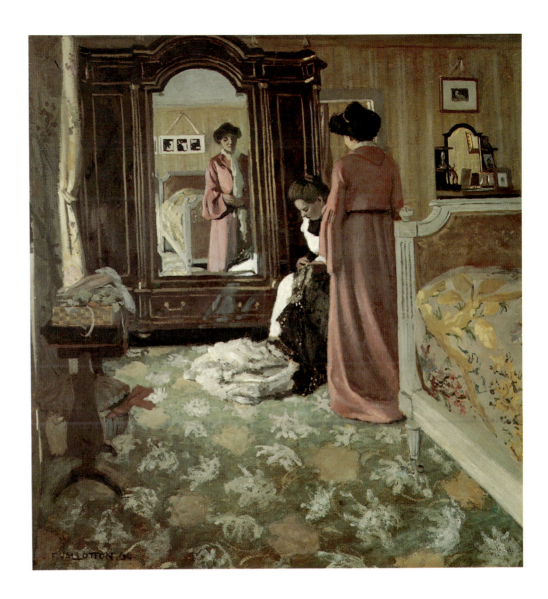

Tall doors open to a generous suite of rooms where articles of clothing lie on the sofas, chairs, and bed. The palette of pale greens and cool reds is clear and harmoniously balanced. In the latter painting, we have also penetrated into woman's private realm; and despite the close-up view, one has the sense of expanding rather than contracting space. Gabrielle stands in pink, reflected in the mirror, as her maid sews a hem. In this archetypal scene of bourgeois domesticity, mirrors, patterns, clothes, embroidery, even the maid, establish Gabrielle's role as mistress of the hearth.[64] In *Interior with Woman in Pink* (plate 185) and *Interior, Vestibule by Lamplight* (plate 186), Gabrielle's figure is less prominent, positioned as she is in the public spaces of her home, rather than in her private sanctum. Yet in both, she is a more integral part of her surroundings than in any other painted interior. In all of these genre interiors of his wife, Vallotton detailed in an astonishing reversal the softness and sumptuousness of woman's realm. The intensity of focus and lethal gaze of his earlier interiors would find their ultimate expression not in these paintings but in Vallotton's treatment of the nude.

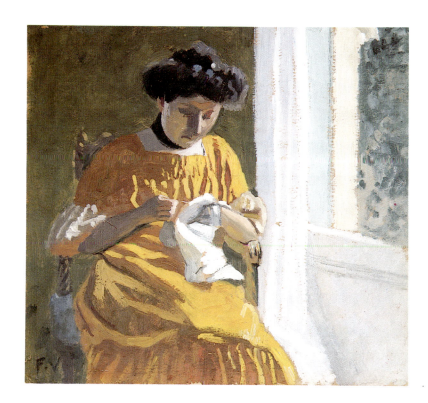

184
Woman Hemming, 1900
Oil on board, 26.5 x 24.5 cm
Private Collection

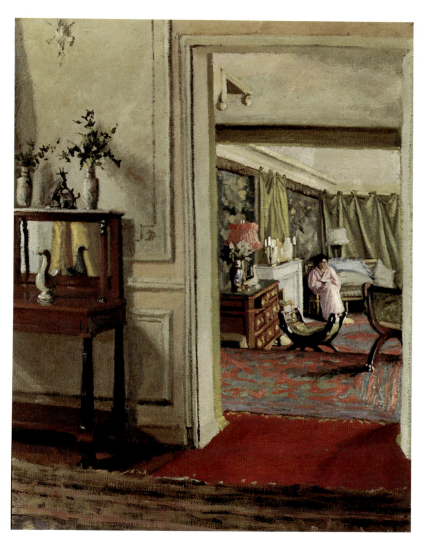

185
Interior with Woman in Pink, 1903–04
Oil on canvas, 67 x 54 cm
Private Collection

186

Interior, Vestibule by Lamplight, 1904

Oil on board, 61.5 x 63 cm

Virginia Museum of Fine Arts, Richmond;
The Collection of Mr. and Mrs. Paul Mellon

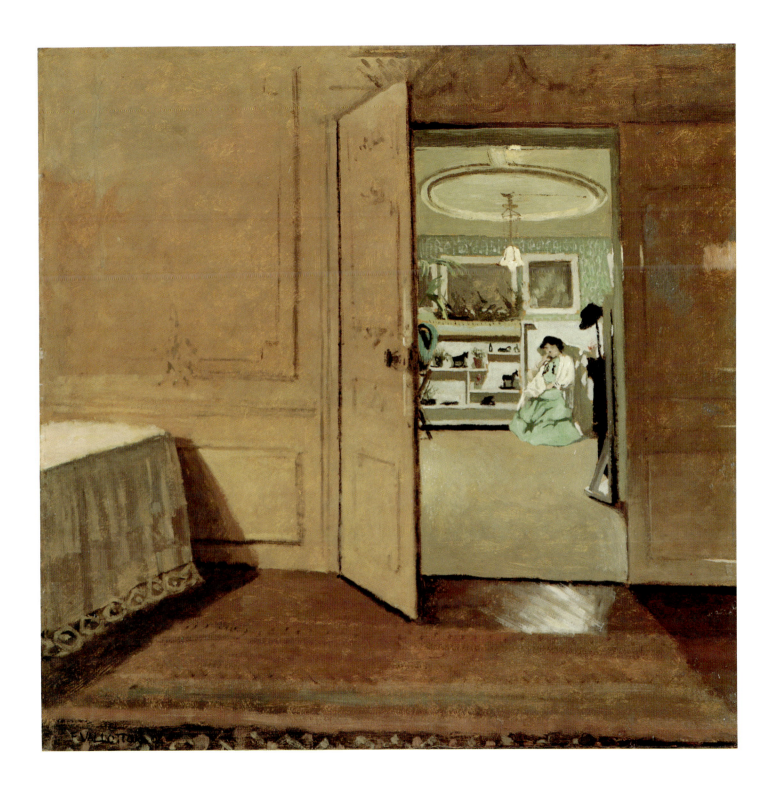

The Nudes

After 1904 the nude emerged at the forefront of Vallotton's artistic production and became the subject through which he defined himself as an artist. His winter studio life in Paris was preoccupied with work from the model, and his notebook is filled with a strange and staccato commentary about models and their distinguishing physical characteristics.[65] On the basis of their adherence to certain conventions one might divide the nudes into three categories: allegorical or historical subject paintings, physiognomic portraits, and works that recall *Bathers* and can perhaps best be described as parodic masquerade, wherein anecdotal incident does not posit thematic closure but encourages a sense of displacement or disorientation.[66] It is in this latter category that Vallotton made a signature contribution to the tradition of the nude in French art.

Between 1900 and 1904, the nude and the interior briefly seemed to merge in works that often review Vallotton's earlier achievements. Turned away from the viewer, the figure in *Nude at the Stove* of 1900 (plate 187) recalls the earlier *Women at their Toilette* and includes specific furnishings that figure repeatedly in Vallotton's interiors and nudes: the fireplace, the cupboard, the red chair, the patterned rug. The strong outline of the nude's partially shadowed, legless torso dominates the field. Again one witnesses in Vallotton's willed transforma-

187
Nude at the Stove, 1900
Gouache on board, 80 x 110 cm
Private Collection

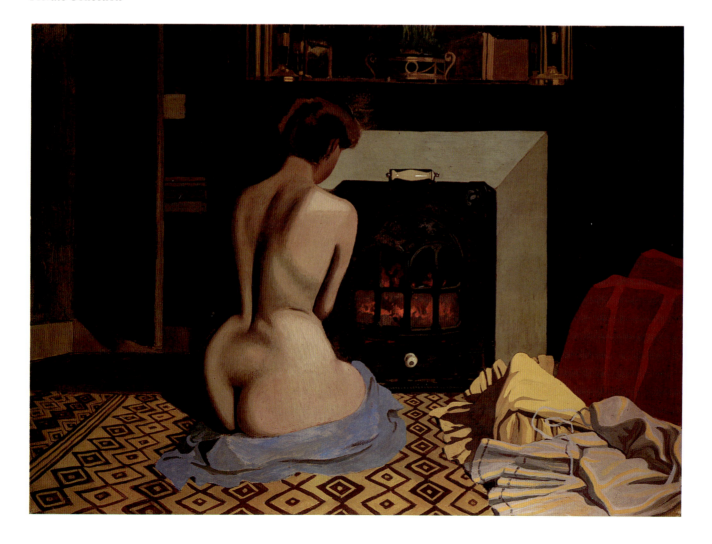

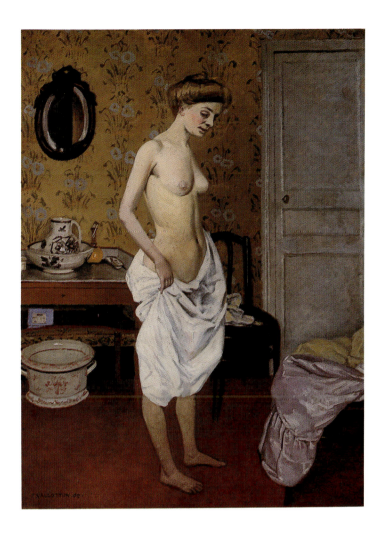

188
The Toilette, 1905
Oil on board, 87 x 65 cm
Collection Ellen Melas Kyriazi

tion of the female body—torso/phallus/torso—the morphological inversions that will not reappear with any consistency until the advent of Surrealist photography.[67] Entirely vulnerable to the painter's gaze, the red embers of the fireplace whose Art Nouveau curves echo the outlines of the woman's body, imply the interior heat that the cool uninflected surface of her skin denies. Her back also to the viewer, the nude in the earlier but related *Nude Seated in a Red Armchair* of 1897 (*frontispiece*) is boneless, collapsed in a chair of the same violent red as the dress and tablecloth in *The Lie*; and with its green walls, the work manifests the same tension through coloristic oppositions.

While the nude had become a subject of increasing interest among all of Vallotton's peers—for some like Emile Bernard or Maurice Denis because of its expression of traditional, classical values; for others like Bonnard because it was a subject whose multiplicity of associations allowed an exploration of the subconscious, what Bergson called *intuition*—Vallotton's treatment of the subject in such works as these shares little with his contemporaries. Other more traditional studio studies like *The Black Stocking* (plate 189) or *The Toilette* (plate 188) do parallel the work of Bonnard and Vuillard. The former, more than any other work, conflates Vallotton's interests with theirs: the model even appears simultaneously in both artists' works.[68] The anatomical and interior details of *The Toilette*, however, could only be Vallotton.

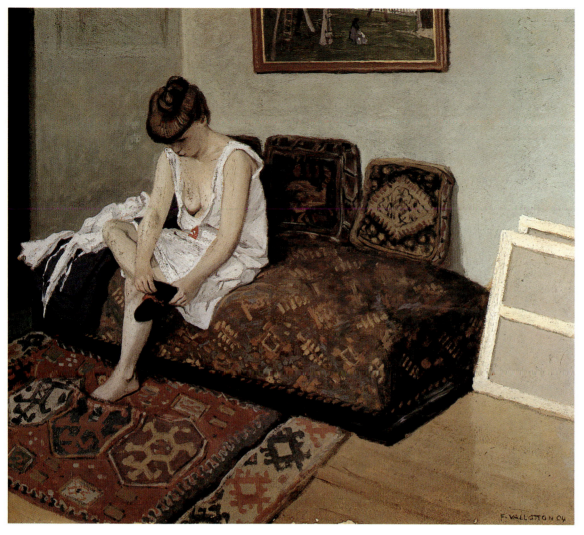

189
The Black Stocking, 1904
Oil on canvas, 62 x 71 cm
Private Collection

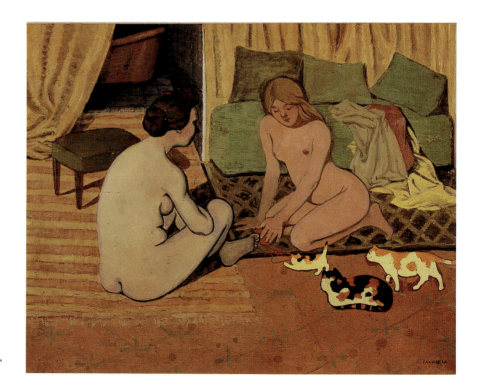

190
Nudes with Cats, 1898(?)
Oil on board, 41 x 52 cm
Galerie Vallotton, Lausanne,
Private Collection

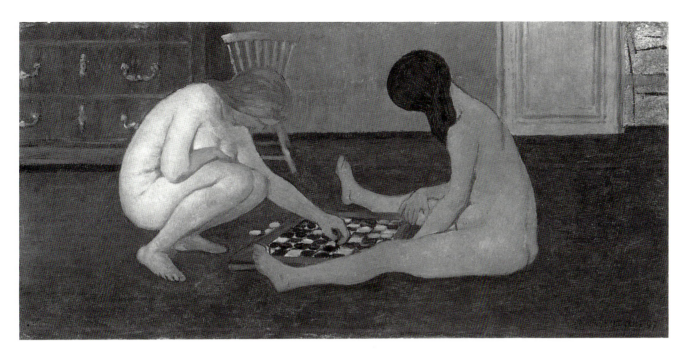

191

Nudes Playing Checkers, 1897

Oil on panel, 25.5 x 52.5 cm

Musée d'Art et d'Histoire, Geneva

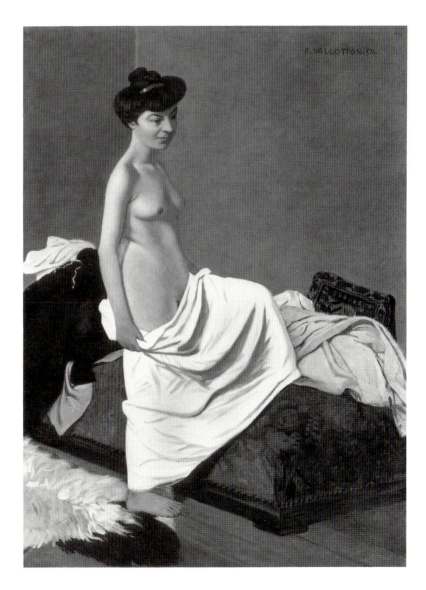

192

Standing Nude Holding her Gown at her Knee, 1904

Oil on canvas, 134 x 101.3 cm

The Detroit Institute of Arts, Founders Society Purchase, Robert H. Tannahill Foundation Fund

As Vallotton's public exhibitions focused increasingly on the nude, Ingres became the leitmotif of critical commentary. The two names had been paired as early as 1896, when Vallotton completed the woodcut, *Roger and Angelica* (plate 194).[69] References to Ingres proliferate as well in the artist's own journals and letters, especially from 1904 to 1915 when he summarily described most of his non-mythological submissions to the Salon d'Automne as "bathers."[70] Indeed, while the poses and subjects of these nudes may have had their genesis in the classical nude or in "*pompier*" theatrics, the specific thematic references of a subject like *The Turkish Bath* (plate 274), the figural disposition of *Rest* (plate 292), or the overall uninflected facture and "probity of line" are Ingres. Or are they? In fact Vallotton was ultimately not described as a "pure Ingres," as he was at the beginning of the critical trajectory, but as a "dark Ingres" or a "perverted Ingres."[71] His summoning up of this master of the exaggerated linear arabesque is in fact an elaborate persiflage, disguising his own ironic and artificial reformation of reality. Vallotton derails Ingres' aestheticization of the female nude, his cultivated eroticism of form.

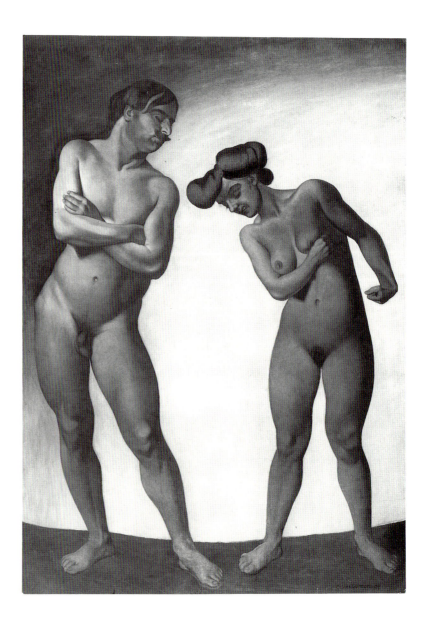

193
Hatred, 1908
Oil on canvas, 205 x 146 cm
Galerie Vallotton, Lausanne

194
Roger and Angelica (*Roger et Angelique*),
1896
Woodcut, 17.9 x 22.4 cm
Galerie Vallotton, Lausanne

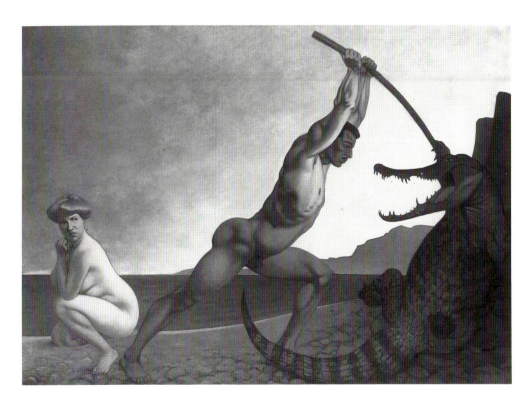

195
Perseus Slaying the Dragon, 1910
Oil on canvas, 160 x 225 cm
Musée d'Art et d'Histoire, Geneva

In *The White and the Black* (plate 196) exotic conventions that reached their apogee in Ingres are wholly upended.[72] Whereas Vallotton had previously used line to disembody (in *Bathers* or *Mistress and Servant*) here he uses it to objectify. A white model reclines on a white-draped divan, eyes closed, head thrown back, body exposed. Yet the delectation is not the viewer's, but that of the seated black model, casually smoking a cigarette. Such an intrusion of temporal incident, so very rare in Vallotton's work, mediates between viewer and image, deflecting focus from the nude model to her counterpart, who both fixes and directs our gaze.[73] Vallotton permits no obvious access to their relationship, elaborating instead a "catalogue" of oppositions: the white model is recumbent, naked, passive,

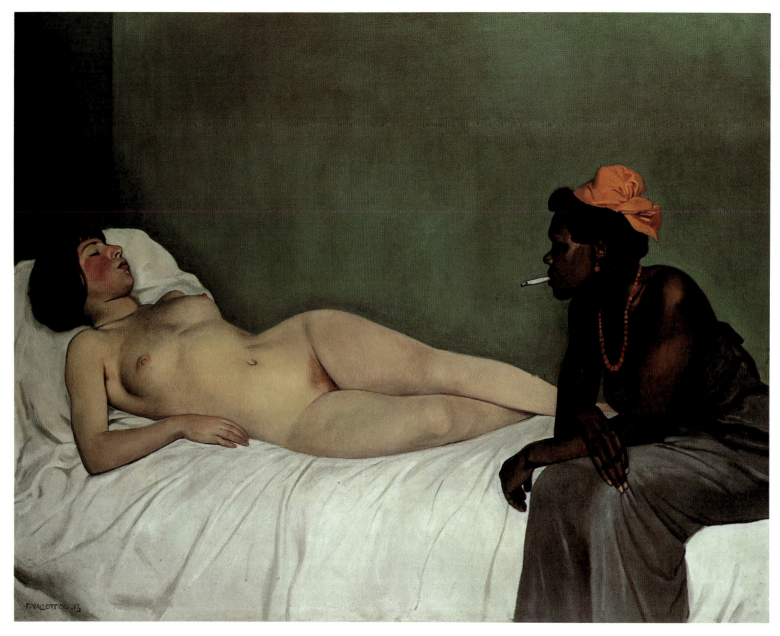

196

The White and the Black, 1913
Oil on canvas, 114 x 147 cm
Private Collection

and unaware; the black model is seated, draped, active, sentient in her role as posed object; one can almost hear Vallotton's studio clock ticking away the minutes of her hired time. The former is traditionally compliant, the latter defiant, but resigned.

The nineteenth century luxuriated in portrayals of the black other.[74] Yet nowhere in the previous lexicon of images is such a willfully banal attitude toward the "dark continent" expressed. Vallotton not only subverts Ingres' Orientalism, but he sidesteps all of the romantic attitudes toward the primitive, from Jean Jacques Rousseau's romantic primitivism to Paul Gauguin's Tahitian idylls. This depiction of the African serves neither stylistic nor sensual liberation. Vallotton's anarchist affiliations must have made him acutely aware of the public scandals that rocked France as revelations about colonialism and the systematic destruction of tribal life were increasingly publicized.[75] Moreover, throughout the preceding

two decades there had been a proliferation of exhibitions that had insistently portrayed the tribal black "in context"—for example, the Jardin d'Acclimatation in the Bois de Bologne exhibited human beings in designed habitats. Racial contempt was as much a part of French bourgeois life as was gender stereotyping. Certainly cultural attitudes sexualized the black, particularly the black female who, as a white woman's companion both revealed her mistress's charms and signified her sexual availability. Vallotton's portraits of black women, among them *Mulatto in a Red Shawl* (plate 144) or *African Woman* (plate 197), have a sensual aura, a fleshly presence, that is absent from his far more petrified white nudes.

No series of nudes in Vallotton's repertoire is more lethal than that represented by *Solitaire (Nude Playing Cards)* of 1912 (plate 198). Superimposed on an interior with absolutely no relief or ingratiating detail, the nude faces away

197
African Woman, 1910
Oil on canvas, 100 x 81 cm
Musée d'Art moderne de Troyes

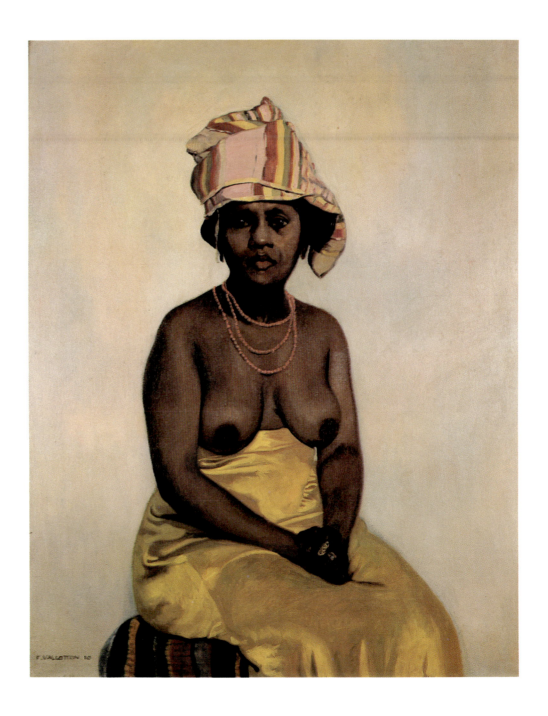

198
Solitaire (Nude Playing Cards), 1912
Oil on canvas, 89.5 x 117 cm
Kunsthaus Zürich

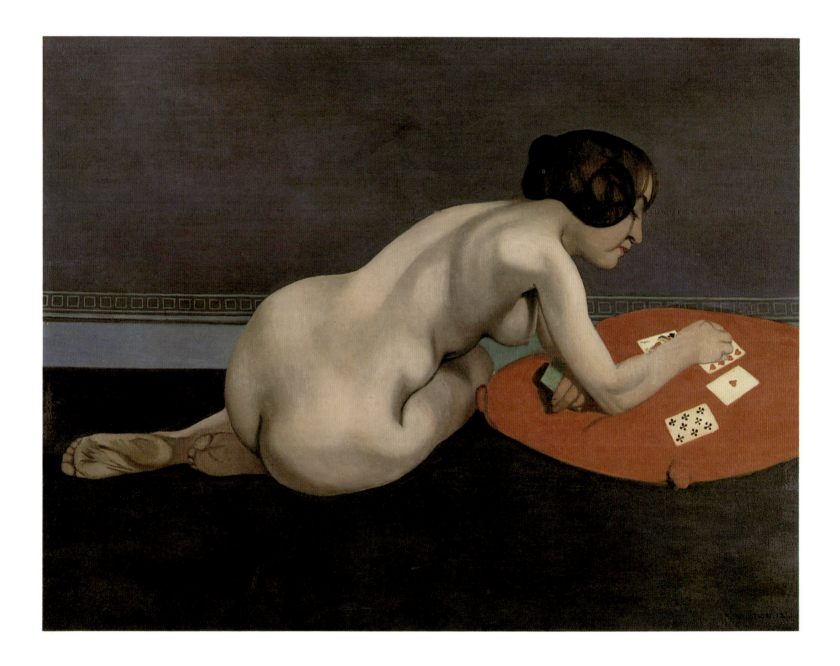

199
Felice Casorati (1886–1963)
Noon, 1922
Oil on wood, 119.5 x 130 cm
Civico Museo Revoltella, Galleria d'Arte
Moderna, Trieste

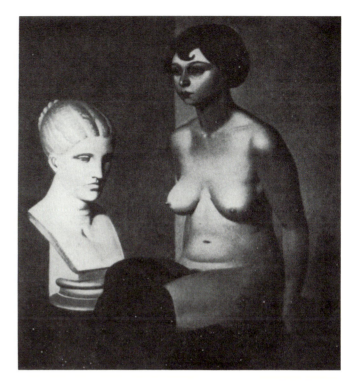

200
Georg Scholz (1890–1945)
Seated Nude with Antique Bust, 1927
Oil on canvas, 65 x 55 cm
Frau Friedel Scholz, Waldkirch

from the viewer as she plays her game of solitaire. The intensifying fetishism of woman's body in this painting and in such later nudes as *Nude Young Woman on Yellow-Orange Velvet Background* (plate 42) where the face covered with hair doubles for the hidden pubic area, seems clearly related to the proliferation and dissemination of erotic and pornographic photography. The camera fragments and abstracts the living subject, emphasizing the presentation of parts of her body for scopic consumption.[76] Yet unlike his colleagues Bonnard and Vuillard, Vallotton never mentions photography. In contrast to their enthusiasm and attachment to their "petit kodaks" in the 1890s, Vallotton's perverse insistence on detailed pencil studies has a resonance akin to subterfuge. Ingrisme becomes for Vallotton almost an excuse for formal manipulations, exercised behind the guise of academic classicism but with an entirely different result. As Vallotton's principle critic Paul Budry noted, in a brilliant riposte to all of those who tried to marry Vallotton's work to the French tradition:

> Vallotton, like Ingres, tries to form a simple line around a form that continues like a lasso to render it immobile without violence by calming its movement, to represent its rest. But the drawing then becomes too tight and chokes the movement instead of stopping it, enclosing the model in such a rigid and definite attitude that it appears temporary. All of Vallotton's figures have this quality of being wrongly placed or laid out—they are like trapped animals with a broken paw, stiff, awkward and miserable, and full of desire to escape.[77]

Like Ingres, Vallotton controls the form with his line. But unlike Ingres, Vallotton's linear gesture serves neither formal unity nor repose. Instead it strangles the movement, suffocates the form, and traps the model who is transformed into an animal desperate to escape. The metaphor suggested by Vallotton's contemporaries of the artist as scientific vivisectionist is fully realized; he traps and restrains the animal (the scopic object) before dissecting it on the table. Paralleling the scene of horror in *La vie meurtrière* when Jacques Verdier puts his hand on Jeanne's breast after her accident, the revelation of form is not a perceptual discovery of organic completeness, but of clinically described dismemberment.

So Vallotton situates his science of the nude, retaining it as a field of formal exploration disrupted by incidents of reality that link his vision to the disruptions of photography and to those haunting dislocations of banal "present-ness" (Freud's *unheimlichkeit*—strangeness in the most familiar things) so apparent in post-war *Neue Sachlichkeit* expression (plates 199, 200).[78] The obsessive fantasies that pervade Vallotton's representations of women seem a fitting conclusion to a century of fetishism of the female body. His world, like that of his contemporaries, is seen dichotomously through the portrayal of insistent dualisms. Unique to

201

Sleep, 1908
Oil on canvas, 113.5 x 162.5 cm
Musée d'Art et d'Histoire, Geneva

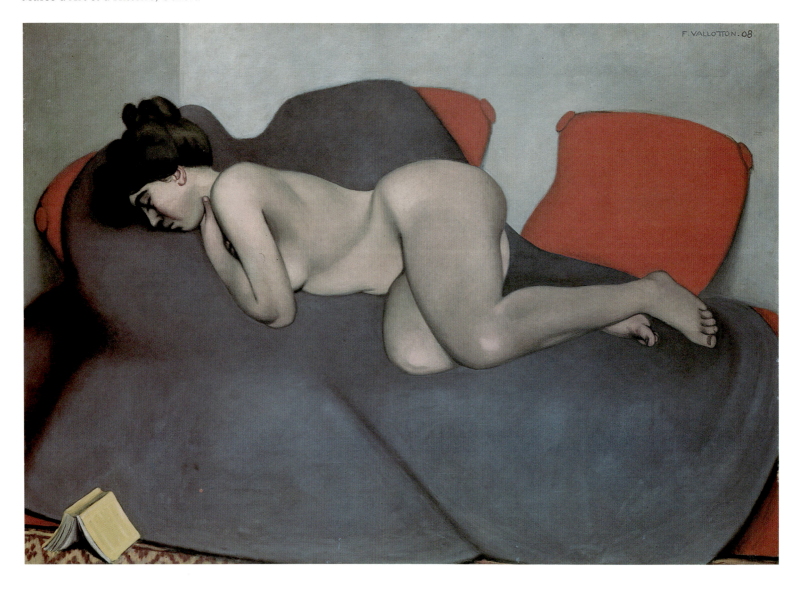

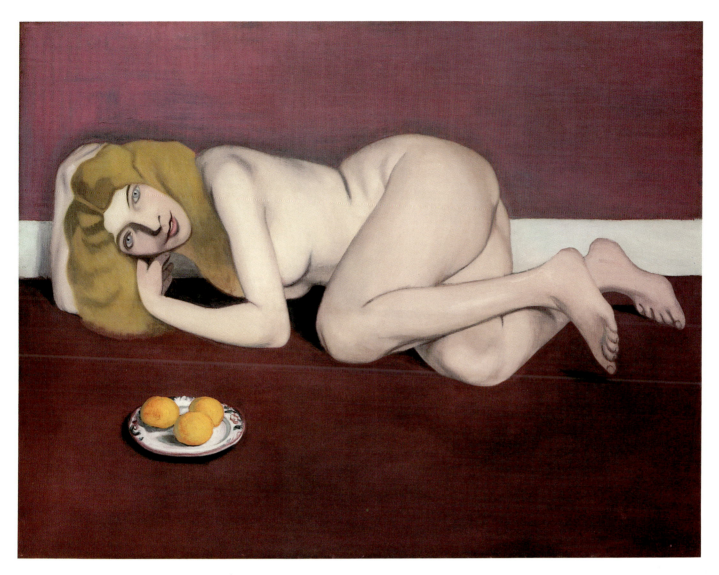

202

Nude Blonde Woman with Tangerines, 1913

Oil on canvas, 89.5 x 116.5 cm

The Walter F. Brown Collection, Texas

Vallotton, however, is the direct, even brutal expression of the dualism of sexual difference: of inside vs. outside, object vs. subject, watched vs. watcher, victim vs. aggressor. Hence the unease produced by the stern geometry, the unbroken contours, and the airless ambience of such works as *Solitaire* and *The White and the Black*. For all of Vallotton's authorial insistence on scrupulous recording and completeness, the relationships and activities portrayed here are deeply ambiguous, disrupted, and fragmented. Despite his often insistent historical references of pose or subject, these paintings are not about classical harmony. Rather, they are willfully aggressive, alienated, and alienating.

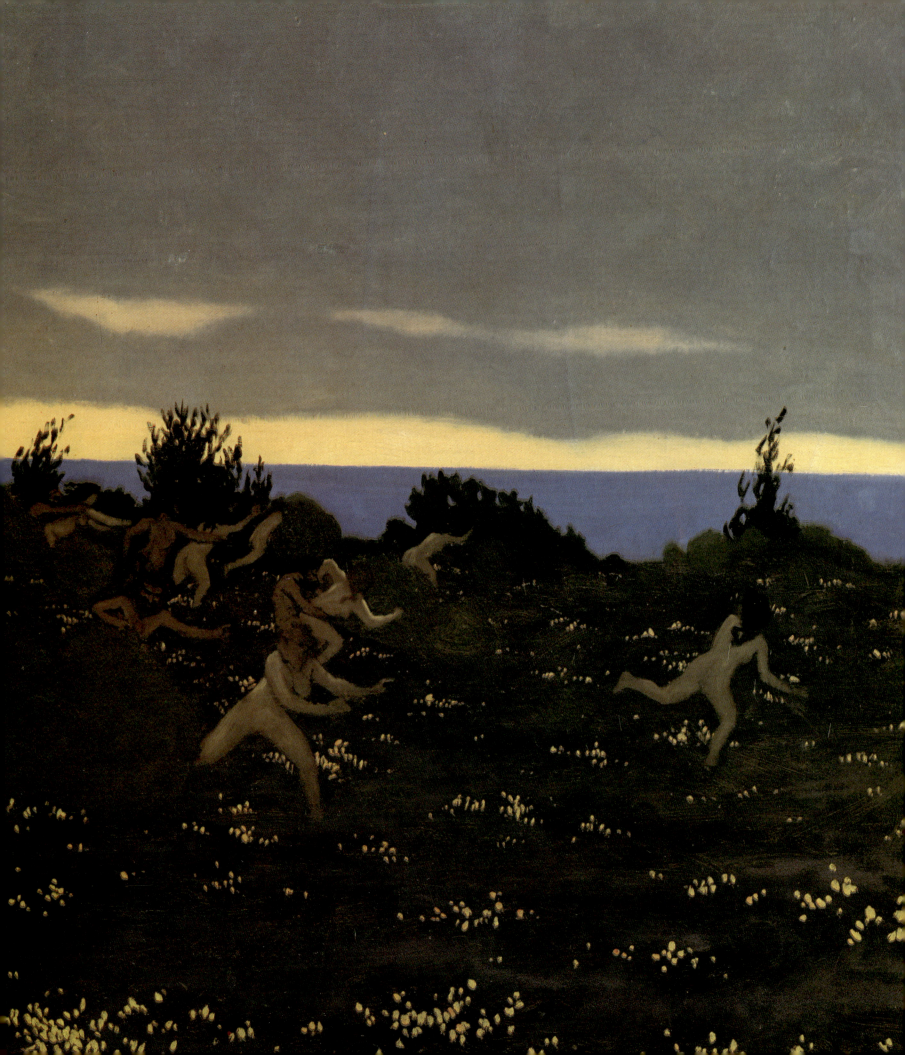

Rudolf Koella

Vallotton's Rediscovery of the Classical Landscape

Landscape painting occupies a special position within Félix Vallotton's oeuvre. Practiced during every stage of his artistic development, it became increasingly important after 1900 and achieved particular significance between 1909 and 1925, when up to forty landscapes per year were recorded in his *Livre de raison*. However, the significance of Vallotton's landscapes is not merely quantitative. If in the 1890s his revolutionary woodcuts had brought him almost immediate international fame and had influenced the work of such eminent artists as Ernst Ludwig Kirchner, Edvard Munch, and Wassily Kandinsky, after 1900 his landscape paintings assumed a comparable—although less frequently acknowledged—role in his painted work.[1] Critically well received by his contemporaries, they displayed not only his indebtedness to the French landscape tradition but also his contribution to its evolution. The neorealistic landscapes that André Derain produced in the south of France between 1910 and 1920, for example, are unthinkable without the example of Vallotton. Even Picasso's early landscapes of La-Rue-des-Bois, painted in 1908, partake of the parameters of Vallotton's form and color, as Marcel Duchamp recognized.[2] Of even greater consequence was Vallotton's impact on Northern art. In 1936 his first biographer, Hedy Hahnloser, recorded that Alexander Kanoldt, then considered the best magic realist landscape painter in Germany, had not only spoken with great admiration of Vallotton, but was convinced that Vallotton had strongly influenced the members of his circle.[3] How important Vallotton was to the Swiss art scene between the two World Wars has been documented in the 1979 Winterthur exhibition "Neue Sachlichkeit und Surrealismus in der Schweiz."[4]

As opposed to his mature work, Vallotton's early landscapes were quite influenced by late-nineteenth-century Swiss art. In the 1880s and early 1890s, he painted some delightful plein-air pictures of the area around Lake Geneva, where he regularly vacationed after having settled in Paris in 1882, including *The Lake at Chexbres* (1892; plate 204). In the mid-1890s, he attempted a few synthesized

203. Detail of *Twilight*, 1904 (see plate 223)

204
The Lake at Chexbres, 1892
Oil on panel, 35 x 27 cm
Musée cantonal des Beaux-Arts, Lausanne

landscapes according to Nabi principles. But it was not until the turn of the century that landscape painting began to rival Vallotton's portraits and interiors, assuming a central role in his art. When the Nabis slowly disbanded after 1900, Vallotton, who had always been a loner within the group, particularly struggled for greater artistic independence. The early years of the century witnessed several shifts within his new focus on landscape painting, the genre in which his development toward an austere neorealistic style first became evident.

In 1900, when Vallotton for the first time produced a larger number of landscapes, the principles of the Nabis' decorative and abstracted style were still operative. Indeed, Vallotton himself referred to these works as "*paysages décoratifs.*"[5] Painting in the summer next to each other in Romanel, high above Lausanne, Vallotton and Vuillard each produced several small pictures of Lake Geneva (plates 205, 206). The astonishing similarity of style in these works overshadows even their shared content. In most, one looks across a panorama of flat land, articulated through small round trees and narrow rippling fields, toward the lake or the blue silhouette of the Jura mountains. There is, however, no illusion of depth. As in their paintings of the 1890s, large flat surfaces are distinctly, even harshly juxtaposed, resulting in an emphasis on decorative pattern

205

Edouard Vuillard (1868–1940)
The Blue Hills, 1900
Oil on board, 42.5 x 68 cm
Kunsthaus Zürich

206

Autumn Crocuses, 1900
Oil on board, 33.5 x 55 cm
Musée cantonal des Beaux-Arts, Lausanne

that is reinforced by the heightened coloration. We know, in fact, that Vallotton painted some of these works not in front of the actual motif, but instead in his Paris studio with the help of studies that he had made in Switzerland.[6]

A series of vivid but parched looking views of Paris executed the following year announced a first step toward a more realistic exploration of the landscape. Thematically, these pictures—including *Seine Embankment with Red Sand*, *Place Clichy*, *The Pont Neuf*, *Yellow Sand and the Eiffel Tower*, and *Dawn* (plates 207–211) —still belong to the tradition of the impressionistic urban landscape, especially as it was cultivated by Camille Pissarro. Vallotton, however, avoided Paris' well-known centers of sophisticated activity, choosing instead to represent the outlying areas where city and industry met: on the banks of the western bend of the Seine between the Champ-de-Mars and the Point-du-Jour, where barges rather than pleasure boats plied the waters. Abandoning the strictly horizontal and layered construction of his previous year's work, Vallotton exploited the unfamiliarity of these sites to create a more complex but playful dialogue between the decorative

207

Seine Embankment with Red Sand, 1901
Oil on board, 46 x 65 cm
Museum Folkwang, Essen

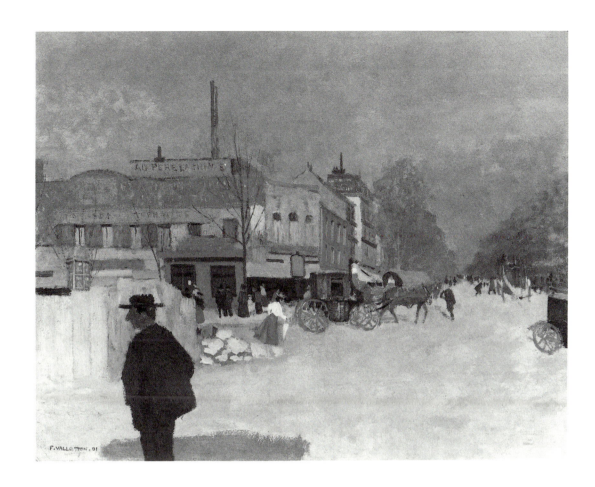

209
Yellow Sand and the Eiffel Tower,
1901
Oil on canvas, 49.5 x 65 cm
Private Collection, Switzerland

210
The Pont Neuf, 1901
Oil on board, 39 x 58 cm
Kunstmuseum Winterthur

and the realistic. Exaggerated diagonals and a repoussoir-like succession of sand-piles, wheelbarrows, or horsecarts are set against the horizon or the far bank of the river, making witty reference to traditional means of spatial illusion. Although hints of anecdotal incident or detail combine to draw the eye "into" the scene, the surface ultimately prevails as Vallotton maintains the decorative power of unmod-ulated color. In their particular rejection of impressionist perception, such paint-ings most likely had an influence on contemporary art—not only on the Fauvist Albert Marquet, who painted his first Parisian views in the same year, but also on Edward Hopper, who could easily have seen Vallotton's pictures during his 1906–07 stay in Paris (plate 212).[7]

These landscapes had an obvious impact on Vallotton's own efforts in this genre, which would increasingly occupy him over the next two years. But far more prescient was the series of landscapes of Arques-la-Bataille that he pro-duced in the summer of 1903 while vacationing in Normandy.[8] Here one finds the first instance of a specific pictorial type that Vallotton would fully develop only between 1909 and 1925: the *paysage composé*, or landscape reconstructed from memory. This type of landscape is differentiated from the artist's previous efforts in his choice of motifs, composition, and color, and even in such secondary

211
Dawn, 1901
Oil on canvas, 46 x 65 cm
National Gallery of Victoria, Melbourne

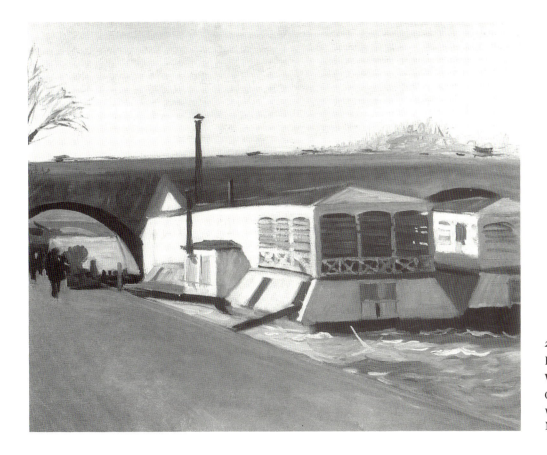

212
Edward Hopper (1882–1967)
Wash Houses at the Pont-Royal, 1907
Oil on canvas, 59 x 72.4 cm
Whitney Museum of American Art,
New York

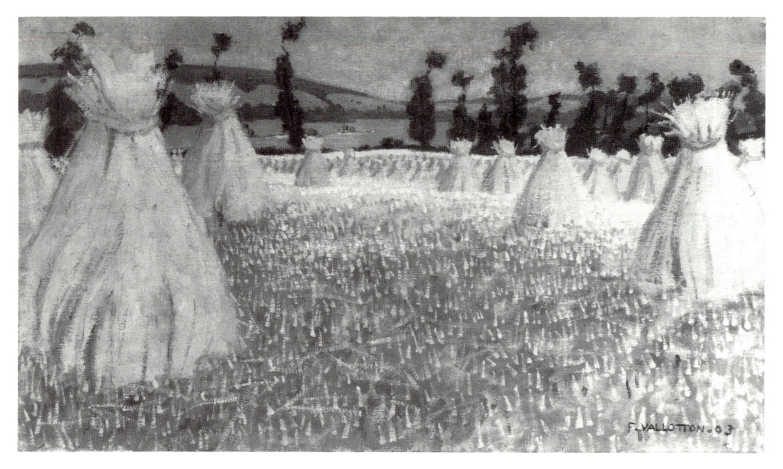

213
Landscape at Arques-la-Bataille, 1903
Oil on canvas, 66 x 102 cm
Private Collection

points as medium and size. Noticeably larger, the pictures are no longer painted on cardboard, but rather on canvas. Two of the seventeen pictures listed in Vallotton's *Livre de raison* as "landscapes executed at Arques-la-Bataille" are reproduced here: a river landscape and a stubble-field heaped with piles of cut wheat (plates 216, 213). In these paintings, the geometrical articulation of Vallotton's urban landscapes has disappeared in favor of curving and undulating contours that contribute to a new sense of spatial complexity. Perspective space becomes tangible space: a space of individually modeled forms and dynamically projecting and receding planes exposed to a cold, hard light that throws dark shadows and creates sharp color contrasts. The very strangeness of this light—at its strongest unmerciful, at its weakest discomfiting—would be a characteristic feature of Vallotton's entire late work.

In these landscape paintings, the representation of a particular topographical setting is no longer of primary importance, nor did it seem essential for the artist to capture a momentary impression. Although based upon an exact observation of nature, they do not aim to reproduce nature as it presents itself at a certain time or place. Rather, their goal is to depict nature in its immutability, as it always had been and would always continue to be: as an idealized abstraction of reality.

Unlike Vallotton's earlier works, each of these 1903 landscapes derived from small, precise pencil sketches executed at the site (plates 214, 215).[9] Intended to serve only as technical tools for the artistic imagination, these drawings

were prepared without any aesthetic pretensions; nor do they make any claims for autonomy. Instead, Vallotton's focus was on a compositional whole that would serve as a memory aid, informing him of certain given facts when he later turned to oil and canvas in the studio. Such sketches usually included color notes, which were replaced after 1909 by a numerical system corresponding to an appended legend.

Vallotton's concept of the *paysage composé* refers quite literally to this new working method, which would henceforth characterize most of his work.[10] It comprises, under a single term, those landscapes that are based on an actual observation of nature, but were painted in the studio from memory, with the help of a small preparatory sketch. Vallotton's faithfulness to nature varied considerably among these pictures; they encompass stylized representations, arbitrary combinations of excerpted details, and wholly imaginary fantasy landscapes. If the works painted in 1903 in Arques-la-Bataille remain, on the basis of the sketches, fairly faithful to the actual landscape, those also listed in that year in the *Livre de raison* (531) as "small paintings Bois de Boulogne"—particularly *The Satyr in the Bois de Boulogne*, in which the artist represented himself amidst a forest of bushes—seem like an utterly free mixing of various landscape elements. Even when the landscape is topographically identifiable, the objective reality is only secondary. The artist was free to condense different aspects and varied perspectives into a single work to accommodate the demands of the pictorial order. Freed from all such accidental and temporal features, these paintings appear clarified and pure. As Guillaume Apollinaire claimed, in regard to the Cubists, they aspire not to an art of imitation but to an art of conception, an art whose credo is "after the study, forgetfulness."[11] Or, as Antonin Artaud stated in 1920, "Vallotton's landscapes are not interpretations but equivalences."[12]

With these works, Vallotton was obviously determined to establish his own place within the French landscape tradition, embracing the dramatic resurgence

214
Study for "Landscape at Arques-la-Bataille," 1903
Pencil on paper, 10.7 x 16.1 cm
Private Collection, Paris

215
Study for "Landscape at Arques-la-Bataille," 1903
Pencil on paper, 10.7 x 16.1 cm
Private Collection, Paris

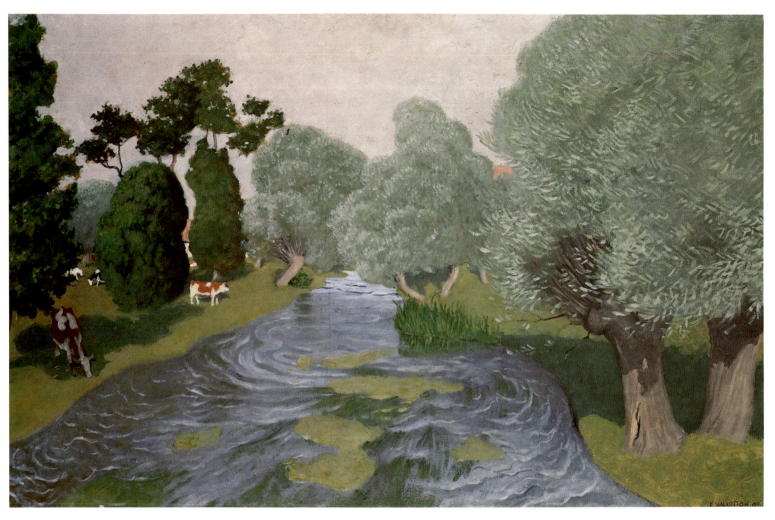

216
Landscape at Arques-la-Bataille, 1903
Oil on board, 67 x 103.5 cm
State Hermitage Museum, Leningrad

217
Nicolas Poussin (1594–1665)
Spring, ca. 1660–64
Oil on canvas, 117 x 160 cm
Musée du Louvre, Paris

of classicism that was currently sweeping French art. Grounded in the seventeenth century and echoed throughout the eighteenth and nineteenth centuries, the French classical tradition had found its foremost practitioner in Nicolas Poussin, whose idealized Arcadian landscapes—in such works as *Spring* (plate 217)—depicted man and nature in absolute harmony. Vallotton's focus on this tradition distinguished him fundamentally from such fellow Nabis as Bonnard and Vuillard, whose identification with a more visual and sensual, hence "irrational," expression ultimately established them as heirs to the French rococo and to such romantic masters as Delacroix. Yet in an age justifiably described as a "renaissance of classical feeling," it is not surprising that after 1900 even they opened their art to certain principles of the classical tradition.[13]

In the Nabis' circle, the idea of this renaissance had been present before 1900. In 1890, Maurice Denis had vaguely formulated the concept of *néo-traditionnisme*, for which he substituted the terser expression *néo-classicisme* after a stay in Rome with André Gide in 1897. Denis defined as classical those works "that address themselves more to our judgment than to our senses; that are not at all sentimental; that only slowly create an emotional impact." He further elaborated:

In the notion of classical art, what prevails is the idea of synthesis. There is no classical art that is not sparing in its means, that does not subordinate the elegance

218

Evening on the Loire, 1923
Oil on canvas, 72 x 93 cm
Private Collection, Switzerland

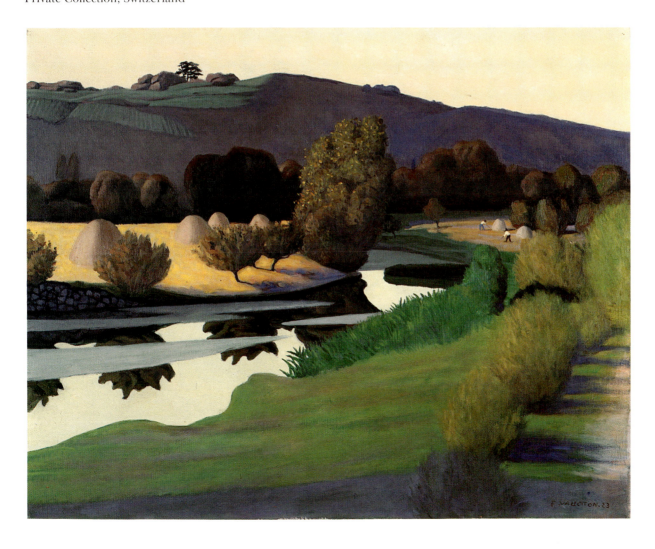

of details to the beauty of the whole, that does not attain greatness through concision. But classical art still implies the belief in necessary connections, in mathematical proportions, in a normative concept of beauty either in the subject of the work of art (human laws) or in the economy of the work itself (laws of composition). Classical art establishes a just equilibrium between nature and style, between expression and harmony. The classical artist creates synthesis, style, and beauty not only when he sculpts or paints but when he uses his eyes and looks at nature. Any object he considers is recreated as an object that maintains its essential logic but is transformed by his own talent.[14]

Such an expression of the classical was most perfectly realized in the mature work of Cézanne, whom Denis called "a rather severe master" and "the Poussin of still lifes and green landscapes."[15] This latter reference demonstrates even more clearly how Denis and the Nabis understood the concept of the classical: not as a designation of an actual style and certainly not as the designation of an historical epoch, but solely as an objective "term of value."[16] Rather than imitating a former style, they sought to predicate their work on the model of the old masters while still forging new and original modes of expression, as Cézanne had done. The latter's own similar definition of the classical was reported by Gasquet: "Imagine Poussin's work recreated from nature, and you'll see what I mean by classicism. What I cannot accept is the type of classicism that limits your horizon. I expect the frequentation of a master to give myself back to me. Everytime I leave Poussin, I know better who I am."[17]

Through his connection with the dealer Ambroise Vollard, Vallotton must have had a fairly precise idea of Cézanne's art. Around the turn of the century he had even acquired in a trade with Vollard a small painting by Cézanne, *Departure by Water* of 1879–82 (plate 219), which henceforth occupied a place of honor in his small collection.[18] But aside from the congruence in aim, their art seems to exhibit few common features. What they shared was their high regard for Poussin, which led them both to self-reflection, to a critical appraisal of their means and possibilities.[19] Hence, when in September 1916 Vallotton defined his own conception of "classical" landscape painting in his journal, he was fundamentally defending the same ideas as Cézanne:

219
Paul Cézanne (1839–1906)
Departure by Water, ca. 1879–82
Oil on canvas, 25.5 x 33 cm
Private Collection [Ex-collection Félix Vallotton]

220
Sandbanks on the Loire, 1923
Oil on canvas, 73 x 100 cm
Kunsthaus Zürich

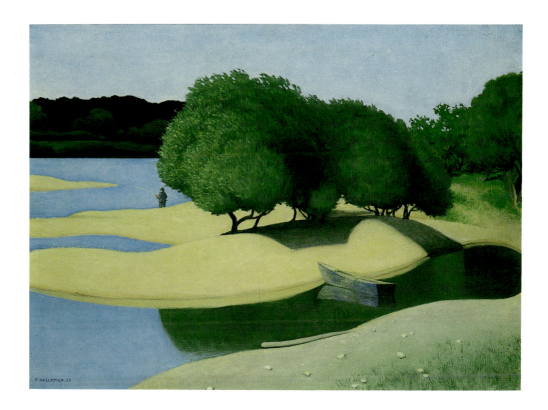

I dream of a painting free from any *literal* respect for nature. I would like to be able to recreate landscapes only with the help of the emotion they have provoked in me, a few large and evocative lines, one or two details chosen with no thought for the exact time or light. It would be like going back to the famous *historical landscape;* and why not? And who knows if from the landscape I will not go back to the figure? There seem to be open and unlimited directions.[20]

What Vallotton furthermore could have learned from Cézanne was to rely on himself alone, to perfect himself through constant work, to leave nothing to habit, and to exclude chance from the creative process. And indeed, all this characterizes Vallotton's art. In his constant pursuit of a condensed and composed image, he not only rejected the impressionist evocation of the momentary, but eschewed as well any hint of improvisation in the act of painting. Like Poussin, he regarded the actual process of painting as a mechanical act, which rested entirely on skill and served only to translate an already given idea into the correct pictorial form. "I recite my painting," he said, "because I voluntarily neglect what cannot be foreseen, not in the street or among others, but in the matters of my art."[21] Vallotton's method could not be more aptly described; he recited his pictures, just as one recites a text that one has memorized. A more sober approach to painting can scarcely be imagined.

Maurice Denis already recognized in 1907 that Vallotton was one of the very few artists of his generation who was not influenced by Cézanne, but rather continued the synthesism and cloisonnism of Anquetin, Gauguin, and Bernard.[22] This can be seen not only in Vallotton's preference for ornamental elements in his pictures, and in his even, flat distribution of color, but also in his embrace of certain abbreviations of form. The manner in which he represents the moving water in *Landscape at Arques-la-Bataille*, for example, recalls the graphic stylizations

in such works as Gauguin's *The Wave* of 1888, as well as in similar paintings by his pupils and followers.[23]

But the importance of the art of Gauguin and his circle to Vallotton's early *paysages composés* extended beyond such formal considerations to include method as well. By the late 1880s, Gauguin had already led his students away from "objective" representation, advising them to work solely from memory:

> As you work I will propose a method of contradiction, if one may call it that. To fight the most general principles, to do whatever was forbidden, and to rebuild with more or less success without fear of excess, indeed with excess. To learn anew, and once you know, to learn again. Overcome your shyness no matter how ridiculous you might appear. In front of his easel, the painter is neither the slave of the present, nor of nature, nor of public opinion. He is himself for now and always.[24]

Gauguin was not alone in teaching this "subjective deformation." It largely corresponded to Anquetin's ideas; and Emile Bernard similarly emphasized the significance of memory to the artistic process:

> The artist should not describe the object—or the landscape, or whatever he is painting—but should, in representing the object, present its essence and the sensations of the artist while perceiving it. This is only possible if the artist does not see the object in front of him while painting, if he works from memory. Memory clarifies the perception of the object; it does not retain the inessential features, but only those fundamental characteristics, on the basis of which the artist feels an inner relationship to the object . . . The problem of the artist consists, therefore, in simplifying form and color such that they no longer describe the object but are capable of representing its necessarily concentrated and suggestive form of appearance.[25]

221
Pierre Bonnard (1867–1947)
The Faun, ca. 1905
Oil on canvas, 128 x 146 cm
Private Collection, Switzerland

222
Pantheus, 1904
Oil on canvas, 93 x 142 cm
Private Collection, Zurich

This doctrine did not pass unnoticed, as we can witness by the example of the young Nabis. However, the classical method practiced by Nicolas Poussin and Claude Lorrain, which does not rely only on memory but employs the aid of small sketches in composing the picture, was much more extensively used by Vallotton after the turn of the century than by any other Nabi colleague. And no one changed his style so radically as he did. After 1900 most of the Nabis made greater allowances for color, light, and spatial conditions in their work and, at the same time, embraced more conventional literary and symbolic subjects. While Denis and Bernard attempted to rejuvenate religious art, Maillol and Roussel turned toward the world of ancient myths, the former creating figural works in a classic balance, the latter picturesque Arcadian landscapes. And other Nabis also pursued classical mythology in connection with landscape painting. Between 1900 and 1905 Bonnard painted some amorous bucolic scenes, such as *The Faun* (plate 221), that are closely related to those of Roussel; and in 1904 Vallotton himself borrowed from classical mythology in two very original and unique works.[26] *Pantheus* (plate 222) depicts the pursuit of Pantheus by crazed maenads, while *Twilight* (plate 223) shows a herd of fauns attacking a group of naked women.[27] Yet in Vallotton there is nothing of the gay, playful mood and the spring-like colors that Roussel or Bonnard present in their mythological paintings. There is only a world of strange dimness, enigmatic and uncanny.

In these two paintings, Vallotton presents, in a rather ironic manner, a primordial theme of human existence: the battle between the sexes, that is to say the irresolvable conflict between man and woman. It is a theme that he had already addressed in his interiors of the late 1890s; and after 1907 it would

223
Twilight, 1904
Oil on canvas, 92 x 142 cm
Private Collection

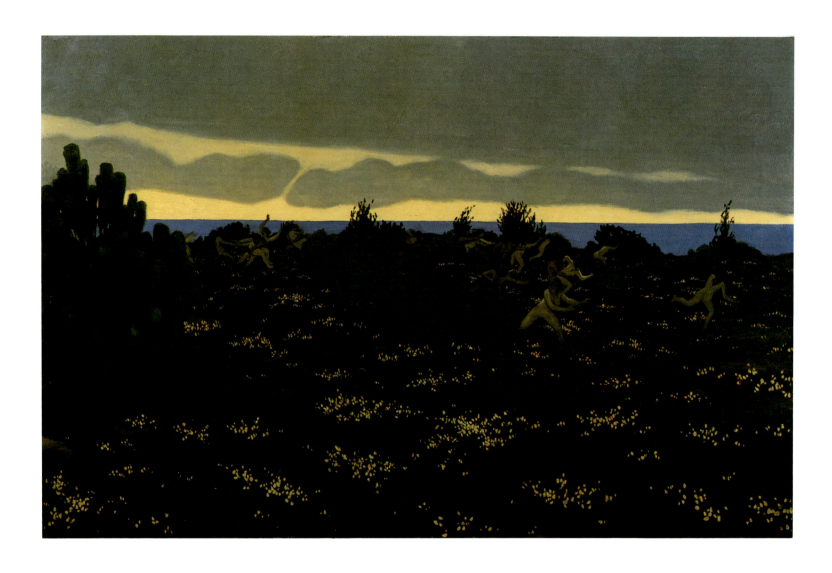

reappear in a very sarcastic manner in his figural allegories, such as *Hatred* of 1908 (plate 193).[28] No Arcadian comfort is apparent in either picture. The attack of the fauns is not an attempt at seduction but instead brutal rape. And the maenads do not chase Pantheus for the sake of some game; they want to tear him apart in their wild rage. These horrific acts are, paradoxically, in harmony with the landscape. Although its expanse and opulence seem to indicate a location in the south of France—newly identified with the pastoral ideal in French art—the shimmer of southern light is missing. Instead, an uncanny glimmer fills the sky, like a hidden fire. The ground, however, remains wrapped in shady darkness, dominated by cold and fractured colors: the cold green of the vegetation and the muted violet of the naked earth.

Despite their mythological themes, these two landscapes seem wholly unprecedented in mood and subject. It is hardly to Poussin, or to any of Vallotton's Nabi colleagues, but rather to the work of the famous late Romantic master, Arnold Böcklin, that one must look to find an obvious context for them (plate 224). Vallotton's gloomy and portentous atmosphere recalls the master from Basel, as does the very conception of the landscape as a decoratively styled southern Arcadia. Furthermore, mythology plays a similar role in both these artists' creations: that of masking or repressing an unconquered sexuality.[29] Vallotton himself made allusion to this idea when in 1897 he described Böcklin as "a bitter artist, tortured by Baudelairian dreams and realizations beyond his means."[30]

But Böcklin was also one of the most important rejuvenators of the "heroic" landscape genre, which again goes back to Nicolas Poussin and in which landscape was conceived as a backdrop for historical and mythical events, or

224
Arnold Böcklin (1827–1901)
The Hunt of Diana, 1862
Oil on canvas, 188.5 x 345 cm
Kuntsmuseum, Basel

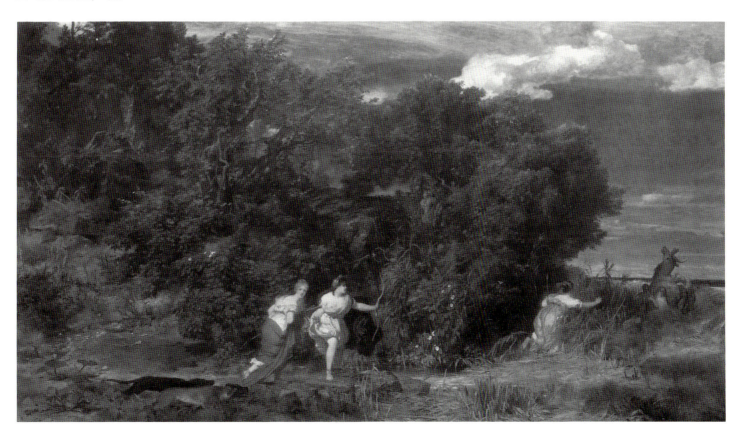

225

Clouds, 1902
Oil on canvas, 64 x 52 cm
Schweizerische Volksbank, Bern

simply as a "stage for a human tragedy."[31] Clearly, Vallotton's *Pantheus* and *Twilight*, like Böcklin's *The Hunt of Diana*, are heroic landscapes in this most essential, most extreme mode. Although Vallotton listed the former in his register of works as "landscapes with antique figures," he could have equally used the term "historical landscape," which in French most often designates the heroic landscape genre.[32]

However, these two paintings remained an exception within Vallotton's landscape work. Generally he did not idealize his *paysages composés* in terms of a dreamlike Arcadia; rather, he attempted to actualize the traditional genre by representing localities that he himself had seen and experienced. And he usually peopled these landscapes not with mythological heroes, but with anonymous figures from everyday life—for example, a woman collecting wood, a mailman, a vagabond—whose small and insignificant scale in relation to the setting emphasizes the powerful and dramatic nature of the landscape itself. Even when he placed nude women in his pictures, as in a 1905 *Landscape with Figures* that shows bathers in a stylized river landscape, there is no sense of pantheistic release—of

the integration of figure into landscape—as in such Cézanne bathers as those in *Departure by Water*. Rather, the unnaturalness of their poses and their fashionable coiffures parallels the cool artificiality of the landscape, which is as freely invented as the figures placed within it.

In a certain sense, *Pantheus* and *Twilight* represent Vallotton's final attempt to follow the lead of the Nabis in interpreting the contemporary value of the classical tradition. However, a more individual artistic direction is mirrored more purely and with greater consequence in other works: not only in the landscapes of Arques-la-Bataille of 1903, but also in the painting *Clouds* of 1902 (plate 225), in which a thunderstorm looms above the still sea. The ominence of the clouds is made even more powerful by the setting sun, which heightens their corporeality and wraps them in fantastic colors. Although there are no figures here, this work may also be considered a heroic landscape, for this term also embraces landscapes that represent nature not in the multitude of its appearances, but as an elemental and primeval force striving toward the dramatic and the heroic.[33] Landscapes that are heroic in such an extended sense can be found

226
A Corner of the Lake in the Bois de Boulogne, 1920
Oil on canvas, 81 x 65 cm
Private Collection, Zollikon

227
Sunset, 1910
Oil on canvas, 78 x 100 cm
Private Collection

228
Sunset, Gray-Blue High Tide, 1911
Oil on canvas, 54 x 81 cm
Private Collection

229

Sunset, 1918
Oil on canvas, 54 x 73 cm
Private Collection, Switzerland

The Wind, 1910

Oil on canvas, 89 x 116.2 cm

National Gallery of Art, Washington,
Collection of Mr. and Mrs. Paul Mellon

231
The Andelys, 1924
Oil on canvas, 73 x 60 cm
Private Collection

repeatedly in Vallotton's late work. The 1910 pictures, whipped by wind and rain (plate 230), belong to this category, as do the strikingly conceived fantastic sunsets that without doubt are among the artist's most astounding achievements: among them *Sunset* of 1910, *Sunset, Gray-Blue High Tide* of 1911, *Sunset* of 1918, and *The Andelys* of 1924 (plates 227–229, 231).

Such accomplishments did not go unnoticed in France. Even Guillaume Apollinaire, Cubism's staunch defender, commented repeatedly on Vallotton's new art. In 1910, Apollinaire claimed a personal taste for the more ambitious artists who "sought to represent the sublime in painting and who were not deterred by the danger of stumbling from pursuing such an exalted form of art."[34] Among such artists he recognized not only Picasso and Derain, but also the outsider Vallotton, and affirmed that if the former had already been justified by their success, one day too "the purity of a Vallotton must be recognized."[35]

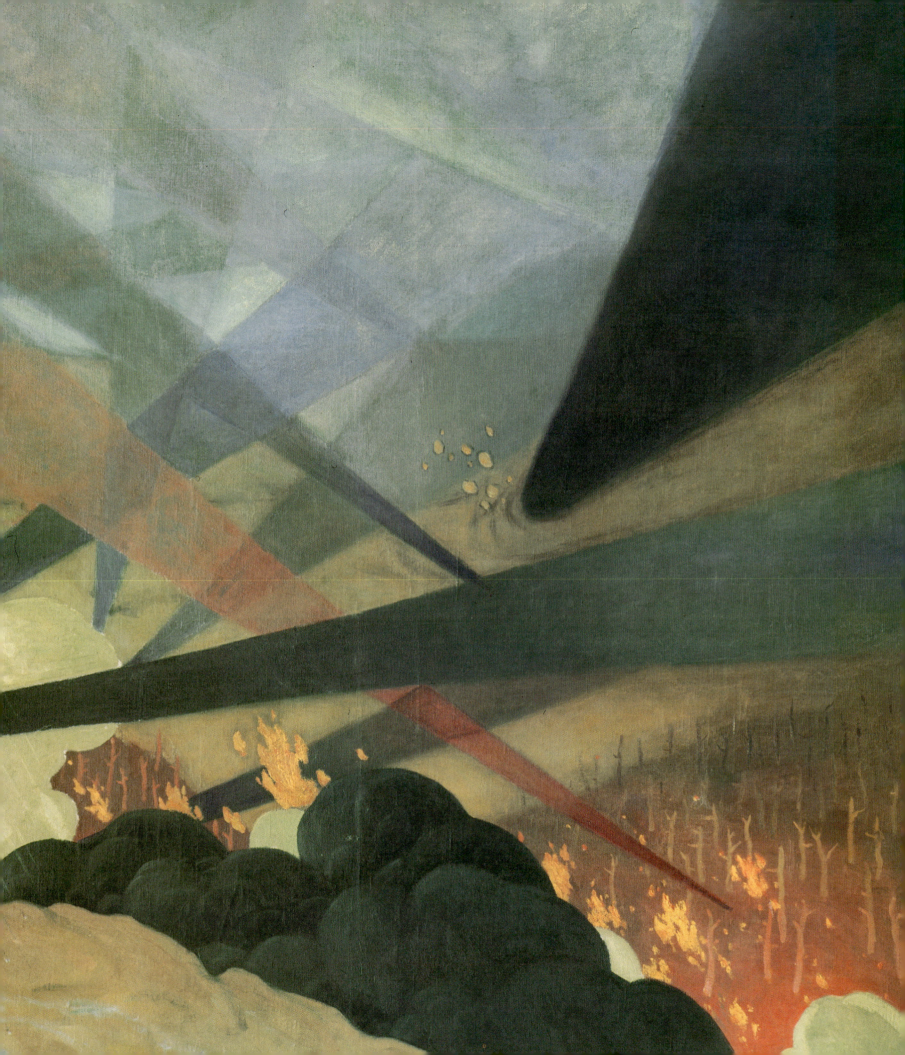

Deborah L. Goodman

Vallotton and the Great War

*War! . . . The word is magnificent, it is evocative, it clearly rings
with the most fearsome resonances; no qualification can possibly
augment or diminish it, and the day I saw those letters thickly
scrawled across the walls, I really believe I felt the most powerful
emotion of my life.*

FÉLIX VALLOTTON, DECEMBER 1917[1]

When the First World War—the Great War, to the French—exploded
in Europe in July and August of 1914, Vallotton was summering at
the northern seaside resort of Honfleur with his wife Gabrielle. In the
private journal he kept from mid-1914 through 1921, he commented
bluntly and with some excitement: "Order for general mobilization! It is all over
and France will play its great game."[2] For Vallotton, the war years would prove
difficult from a personal as well as creative perspective. Overcome by the pres-
sures of being a non-combatant, struggling with an artistic impasse and an in-
creasingly disinterested audience, he would search for a way to contribute to the
French cause as a man and to win public approval as an artist.[3] This odyssey
carried him in several directions. At first Vallotton responded to the war as a
graphic artist, issuing an album of woodcuts intended to suggest the horrors of
war for the soldier on the front line and the civilian left behind. Failing to achieve
the recognition he sought for this effort, he turned to the larger patriotic con-
cerns of the moment and embraced the iconography of French nationalism in
several paintings of the ruined monuments of Gallic civilization. Vallotton ulti-
mately abandoned this borrowed symbolism when, challenged to look beyond
mere transcription by a war whose unprecedented death and devastation would
redefine the very idea of combat, he executed a painting of Verdun that realized
his ambition to convey the internal forces of modern warfare.[4]

So nationalistic were Vallotton's feelings for his adopted country, and so
absolute was his disdain for the Germans, that he volunteered to join the army at
the outbreak of the war.[5] Refused admission due to his age—forty-nine—he had
to settle for work as a stretcher bearer in nearby Le Havre until his return to Paris
in the fall.[6] Exposing Vallotton as a member of the elder generation, the army's
rejection echoed the position in which he found himself as an artist. The distinc-
tion between soldier and non-combatant reinforced a generational hierarchy
among artists of the time. Vallotton's art, like that of his contemporaries Pierre

232. Detail of *Verdun*, 1917 (see plate 250)

233

Luc-Albert Moreau (1882–1948)

The Masked Gunner, ca. 1916

Published in *Le Crapouillot*, no. 10, July 1916(?)

Print Collection, Miriam and Ira D. Wallach Division of Art, Prints and Photographs, The New York Public Library; Astor, Lenox and Tilden Foundations

Bonnard, Edouard Vuillard, Ker-Xavier Roussel, and Maurice Denis, essentially represented an extension of nineteenth-century French pictorial investigations. In contrast, such new movements as Fauvism, Cubism, and Futurism broke more obviously with tradition and forged a more purposefully avant-garde art. Many of the younger members of this current Parisian avant-garde, including Georges Braque, Jean Metzinger, Othon Friesz, Fernand Léger, and Roger de la Fresnaye, fought at the front and hence served their country physically as well as artistically. Particularly for Vallotton, whose letters had long revealed feelings of inadequacy and a predilection toward depression, the war triggered a dual crisis, invalidating his manhood and confirming the irrelevance of his art.[7]

It was not easy to be a civilian in Paris during the war. With the front less than seventy-five miles away, the city swarmed with soldiers, and a man without uniform was subject to verbal accusations of cowardice and internal feelings of guilt.[8] Experiencing tremendous pangs of futility, boredom, and despair, Vallotton bitterly feigned indifference at the end of 1914:

> I can almost say that I no longer suffer from my inaction, let us say my uselessness; I'm resigned to the inevitable; since all admit that this war only concerns those who wage it, those in power and the shrewd, I am unemployed. Businessmen find a way to earn a living, the crafty manage well on their feet and collect honors, the brave get themselves killed. As for me, I remain here, without money, and therefore useless to the poor; practicing a profession whose utterance alone invites laughter under the circumstances; too old for the service and so perfectly stripped of all ambition that the idea of making a spectacle of myself and attempting the indispensable military drills sends a chill up my spine. I am perfectly useless, it is grievous because I believed I had some value.[9]

The impotence expressed here left him uninspired to paint, a predicament exacerbated by lagging sales of his work.[10]

Despite Vallotton's pessimism, the war did not drive art underground. Although many private galleries curtailed their exhibition schedules and maintained a low profile, some continued to organize small shows, often consisting of work sent back from the front, with proceeds donated to a worthy cause. Furthermore, the government expanded its patronage of the arts and recognized a significant political and documentary role for artists of all ages.[11] Artists who were mobilized were encouraged not only to depict their experiences at the front, but also to exhibit and sell their works at such government-sponsored exhibitions as the Salon des armées.[12] And the commission on the "Missions artistiques aux armées," established in 1916, allowed artists too old to enlist to visit the front as envoys of the Ministry of Fine Arts.[13]

Nevertheless, as the horrors of modern combat shocked the world, some art critics called for a departure from the heroicizing paintings that flaunted French victories in the military gallery at Versailles.[14] Even right-wing critic Robert de la Sizeranne, who shunned modern art, complained that French artists had learned nothing from the modern battle.[15] And André Salmon argued that the traditional glorification of single, "picturesque" battles was anachronistic. The conclusive battle of the past had been replaced by numerous uncertain confrontations.[16] Salmon further remarked that the best art from the front was not on canvas but in *Le Crapouillot*, the trench journal of the *poilu* or French foot soldier (plate 233). Founded by artist Jean Galtier-Boissière, with its first issue appearing in August 1915, *Le Crapouillot* [Série de guerre] was one of several such news-

papers. Committed to the portrayal of the realism of life at the front, it published artists' sketches, short articles, and regular columns about the soldier's life there: for instance "Fashion at the Front," "The Vocabulary of the Poilu," "Theater at the Front," "Art and the War," and "The Notebook of an Officer at Verdun." Rejecting the government's propagandistic glorification of battle, the newspaper was often the victim of censorship.[17]

Vallotton's determination to achieve an art evocative of this new kind of warfare led, in the winter of 1915–16, to his execution and publication of an album of six woodcuts titled *C'est la guerre!* (This is War).[18] Both the popular success of the trench journal and the renewed interest in the *Images d'Epinal*—a type of crude and primitive broadside in woodcut (and later lithography) that had enjoyed wide popularity in France since the sixteenth century—must have encouraged his hope of recapturing the critical and commercial acclaim accorded his woodcuts in the 1890s.[19] But it was most likely his collaboration on *La Grande guerre par les artistes* (The Great War by Artists), a bi-monthly album produced by such artist-illustrators as Hermann-Paul, Ibels, and Steinlen, that directly inspired Vallotton's brief return to a medium he had abandoned at the turn of the century. As fellow members of Toulouse-Lautrec's circle, Vallotton and the three illustrators had been close friends in the 1890s; and all four had submitted socially engaged drawings to several illustrated reviews, including *Le Rire* and *Le Courrier français*.[20] The politicized, anarchist bias of their work from that decade found a new outlet in war-related images. Ironically, these artists who had once damned the French military bureaucracy—in such works as Vallotton's woodcut of 1894, *At the Age of Twenty*, which commented on France's mandatory military conscription—were now lending that very institution their support.[21] Beginning in 1915, Vallotton would periodically contribute drawings that emulated the crudeness of woodcuts and whose subjects—a trench scene, caricatures of the Germans, and portraits of military leaders—were very much in keeping with *La Grand guerre*'s anti-German and often satirical tone (plate 237).

On the front cover of Vallotton's album of woodcuts, the title in black is accented by a striking splatter of blood-red ink (plate 235); and the woodcuts themselves combine tragic subject matter with comical representation. Only the tiny helmets and bayonets of soldiers huddled in a trench are visible as a bomb explodes nearby (plate 236); under a starry sky, the bloated cartoon-like bodies of dead soldiers sprawl across a tangled arabesque of barbed wire fencing; a family cringes from the rifles of an unseen enemy firing through the window of their home. Despite Vallotton's obvious intention to convey the horrific brutality of war, however, these images are curiously generalized. They lack the immediacy and conviction of illustrations in *Le Crapouillot* and exhibit none of the dark caricatural intensity of Vallotton's earlier graphic work. Only in *The Orgy*, in which German soldiers pillage a French home at night, does one find a similarly unsettling ambiguity of meaning. The album sold poorly, and a disappointed Vallotton wrote rather defensively in his journal: "It is true that this is war! . . . and that pockets are not easily opened for something that is not a work of solidarity—And yet this is one."[22]

At about the time he first submitted work to *La Grande guerre par les artistes* in 1915, Vallotton also contributed a drawing to the *Album national de la guerre* (National Album of the War). Published by the *Comité de la fraternité des artistes*, of which the venerable portrait and history painter Léon Bonnat (1833–1922) was

234
Revival, October 1914
Published in *Album national de la guerre*, 1915
General Research Division, The New York Public Library; Astor, Lenox and Tilden Foundations

235
This is War! *(C'est la guerre!)*, 1915–16
Album cover, 26.9 x 34.8 cm
Galerie Vallotton, Lausanne

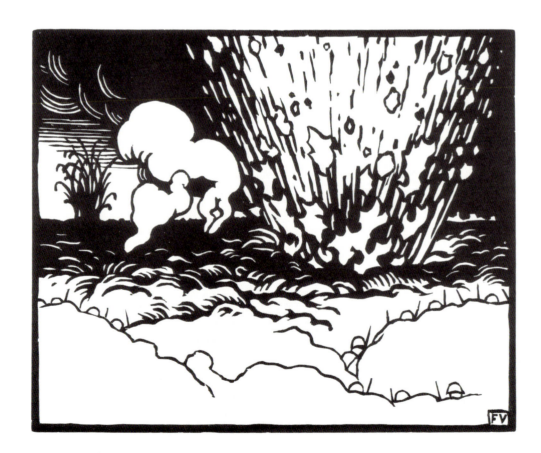

236
The Trench, 1915
From *This is War!*
Woodcut, 17.6 x 22.2 cm
Collection, The Museum of Modern Art,
New York, Abby Aldrich Rockefeller Fund

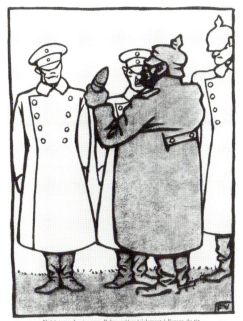

237

German Science (*"This is our latest shell model, created especially to fire on nursery schools"*), ca. 1915

Published in *La Grande guerre par les artistes*, no. 15, 1915?

General Research Division, The New York Public Library; Astor, Lenox and Tilden Foundations

president, the album was edited by Vallotton's brothers-in-law, Josse and Gaston Bernheim-Jeune. It reproduced works by the gallery's own artists, including Bonnard, Vuillard, Roussel, and Denis; as well as works by well-known nineteenth-century artists Degas and Renoir and even their more conservative contemporaries, for example Fernand Cormon (1845–1924) and Albert Besnard (1849–1934). Vallotton's drawing, *Revival*, was of the head of a woman depicted as a Roman (plate 234).[23]

The introductions to both the *Album national de la guerre* and *La Grande guerre par les artistes* disclosed a shared desire to promote French patriotism and more specifically, to exalt the great French tradition in art. Although the contents of the two differed—the album representing high art, the journal filled with more popular illustrations—their message was the same: France's humanitarian culture, so deeply rooted in Mediterranean classicism, was vastly superior to that of the Germans. Such zealous nationalistic sentiment had been brewing since the French defeat in 1870 in the Franco-Prussian War and through colonial conflicts of the first decade of the twentieth century. Rampant by the outbreak of World War I, it would thrive in France well into the 1930s. In his introduction to the *Album national*, Bonnat made two points: that the artists involved—all French—had collaborated toward fulfilling the same ideal, "to put art at the service of charity," with proceeds from the sale of the album donated to the families of mobilized artists; and, more pointedly, that the French school had once again proved its "fertility and unflagging generosity." Employing the imagery of warfare, he further asserted that France and French art, "exalted by victory would burst forth once again with a brilliant and splendid explosion."[24] A similar message was echoed in the introduction to *La Grande guerre*: the French artists who honored the journal with their collaboration would elaborate in their art "the justice, beauty, and goodness of the [French] cause."[25]

Far more than merely recording the war, the arts were clearly motivated by nationalistic sentiment, extending the struggle between two opposing nations to one of culture—French versus German. This competition invaded not merely the visual arts but literature as well. In order to assert their superiority over the barbarous Germans, or the "Boches" as they were consistently labeled, the French excavated their Latin roots to reinforce their enduring classical foundations.[26] Vallotton's references to a classical heritage in *Revival* and in his paintings of French ruins from his trip to the front in 1917 were certainly invoked in this spirit.

On 8 November 1916, the Minister of Fine Arts and the Minister of War had agreed to send a number of officially chosen painters on artistic missions to the front with a mandate to "seize the atmosphere . . . recording events there with sensitivity and emotion," and with the understanding that their drawings and paintings would be purchased by the government and exhibited in the Musée de Versailles.[27] Vallotton, who claimed he had applied not out of a zealous passion to visit the front but out of a need to alleviate the stigma of having "seen nothing" of the war, was perhaps also attracted to this opportunity by a perverse desire to witness the death and devastation firsthand, having as he did a predilection for images of death, despair, and suicide.[28] He received his letter of mission on 5 June 1917 and left two days later for a three-week tour of the front in the region of Champagne accompanied by two painters of his generation, Henri Lebasque and René Piot.[29] On the fringe of the avant-garde, they too felt that as

peintres aux armées (army painters) they would assume a legitimate role in the drama that was unfolding (plates 238–240).[30]

Vallotton recorded his impressions of the front in his journal and made sketches that would later serve as studies for full-scale paintings.[31] Clearly, this official trip had a profound impact on his state of mind, both validating his profession and directly inspiring a group of four paintings he would begin upon his return to Honfleur in July. Invigorated, he worked rapidly to complete several of these for the "Peintres aux armées" exhibition at the Musée du Luxembourg in October.[32] The small village of Souain, home before the war to fewer than 500 inhabitants and cruelly devastated during the battle of the Marne, became the focus of his attention. Describing this town in his journal, Vallotton emphasized not the horror of its destruction but the ironically picturesque quality of its ruined state: "An entire day in Souain in this heap of antique ruins sprinkled with rose petals . . . From all sides the Boche or French fuses answer each other, creating an air of celebration in this desolate landscape." He likewise characterized his paintings of Souain as "more or less ruined landscapes."[33]

238
Vallotton, Lebasque, and Piot at the front, Argonne, June 1917
Vallotton Archives

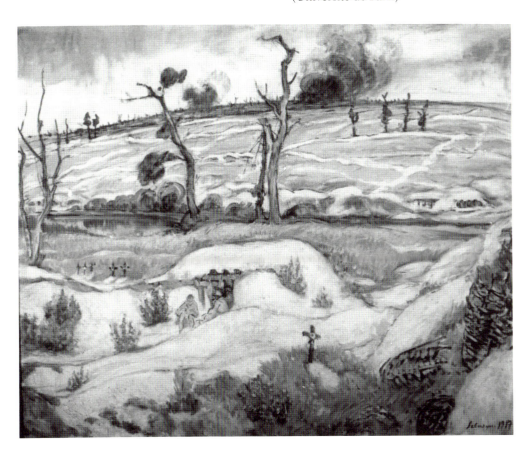

Such ruins were an all too common sight in France during the war, as new military technology made it possible to bear destruction upon a landscape as never before. Ruins became both monuments of the war's desolation and of France's cultural heritage—powerful symbols of Germany's barbarism. In *L'Art pendant la guerre*, critic La Sizeranne despaired at their abundance:

> Certainly this is not the first war that created ruins, all of them have. But this is the first, at least in modern times, that they have been this complete and this precious. Cities have not been razed for centuries, nor have masterpieces been destroyed . . . now, there are landscapes of ruins . . . The horror of these destructions is such that it ends up appearing grandiose, almost equal to the great convulsions of the globe.[34]

And he further noted that artists had never before dedicated entire paintings to the depiction of the vestiges of battle, which he called portraits of ruins.[35] Recalling France's long and proud classical tradition, such portraits were emblematic of her devastated civilization and served as a metaphor for the eternal ruins of Rome (plates 241, 242).[36] The wreckage of a bombarded town was equally popular among authors, photographers, and illustrators; and such images of "martyred" towns even sold well as postcards.[37]

241

Ruins of the Church at Souain, 1915

Published in *Album de la Guerre,* 1 November 1915

Sterling Memorial Library, Yale University

242

Joseph Quesnel (1897–1931)

In Front of the Ruins of the Coliseum, 1915

Cover lithograph, *Le Pêle-Mêle,* 14 November 1915

In Vallotton's *Ruins at Souain* of 1917 (plate 243), the remains of a building stand in the midst of rubble. In the foreground, gabions—large cylindrical wicker baskets usually filled with earth for use as fortification in the trenches—are filled instead with the stones of blasted walls. Perhaps Vallotton was calling attention to the inefficacy of man-made shelters in the face of a war that seemed to assume a life and power of its own. That the basketed stones resemble eggs in a nest, and that the scene is bathed under a blue sky, ironically reinforces the message of man's fragility, to which nature is profoundly indifferent. And although Vallotton's art was distinctly nonsecular, the hollow wicker spikes of the gabions nevertheless suggest the most poignant symbol of Christian martyrdom, Christ's crown of thorns.

If the depiction of ruins struck a deep emotional chord in the French sensibility, reaction to the ruined church was the most impassioned. Usually the oldest building in town, its destruction represented German disdain for French Gothic (Catholic) architectural symbols as well as for the *Union sacrée* (sacred union), the patriotic faith that bound the French ideologically during the war.[38] Hence the theme of the devastated church was a war motif much favored by artists, photographers, and writers; and Reims Cathedral, bombed in September 1914, served as the major symbol of France's Catholic martyrdom at the hands of the philistine Protestant Germans.[39] Vallotton strategically drew upon this iconographical tradition in a second work, *The Church of Souain in Silhouette* (plate 246), in which only the church's gothic window is intact. The overall style is passionless and decorative. Responding to the scene as if it were a still life or a theatrical backdrop, Vallotton eschewed emotional significance in favor of style and effect.

The caricatural economy and dry, colorful surfaces of these paintings suggest a conscious emulation of the visionary jungle landscapes of Henri Rousseau. The critic Guillaume Apollinaire was the first to notice the similarities in the work of these artists, an influence that was not surprising given their mutual admiration.[40] Vallotton was among Rousseau's earliest advocates; and the latter,

243
Ruins at Souain, 1917
Oil on canvas, 82 x 88 cm
Collection Ellen Melas Kyriazi

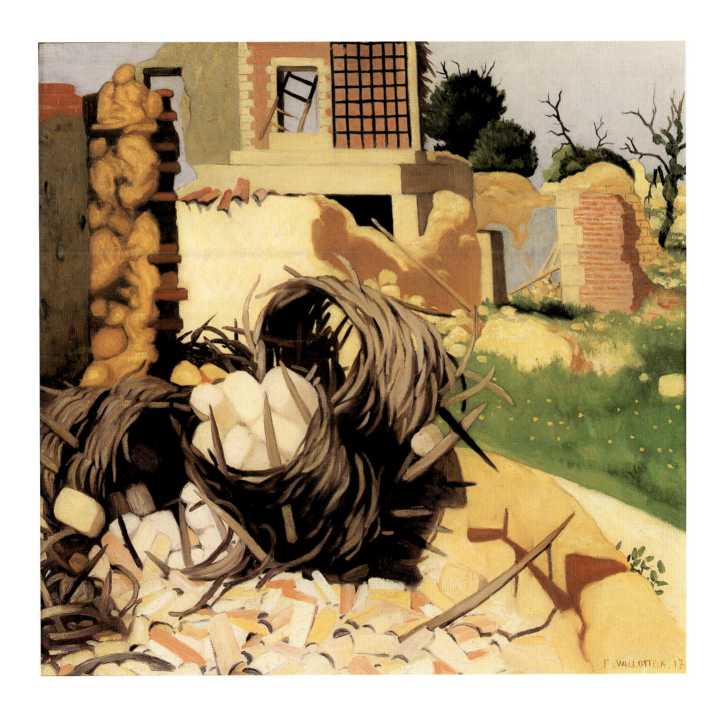

upon viewing Vallotton's *Bathers* (plate 148), took the former's arm and exclaimed, "Vallotton, let's walk together."[41] Undoubtedly aware of Rousseau's allegorical painting of the Franco-Prussian War, which he had exhibited in 1894 at the Salon des Indépendants (plate 245), Vallotton perhaps had it in mind when in 1915 he painted his own allegorical triptych of the war: *Hope, Crime Punished*, and *Mourning* (plate 244).

The very stillness in Vallotton's Souain paintings—their odd mix of destruction and continuity—can best be understood in relation to an observation the artist would make in his journal the following year:

> Indeed, as deformed as they are, the attacked objects return to a new steadiness in the instant following the shock. What was a house is nothing but a shaky ruin, but on this ruin the sun plays and distributes its rays; the contours are different, the materials differ, the surfaces and the angles are modified; a stone is here that wasn't before; a wall has disappeared, suddenly replaced by a balancing of trees; the decor is transformed, but it is still and always a *decor*.[42]

And although he admitted that such an interpretation would not reveal "The War," he nevertheless had captured one true aspect of war's aftermath: nature's indifference to the violence of man.[43] In fact, his depiction of Souain recalls in part the 1916 account by Monseigneur Tissier, the bishop of Châlons, of the destruction of several churches in the region, including that of Souain:

244
Hope, Crime Punished, Mourning, 1915
Oil on canvas, each 250 x 200 cm
Musée cantonal des Beaux-Arts, Lausanne

245
Henri Rousseau (1844–1910)
War, 1894
Oil on canvas, 114 x 195 cm
Musée d'Orsay, Paris

The Church of Souain in Silhouette, 1917
Oil on canvas, 96 x 130 cm
National Gallery of Art, Washington, The
Chester Dale Fund

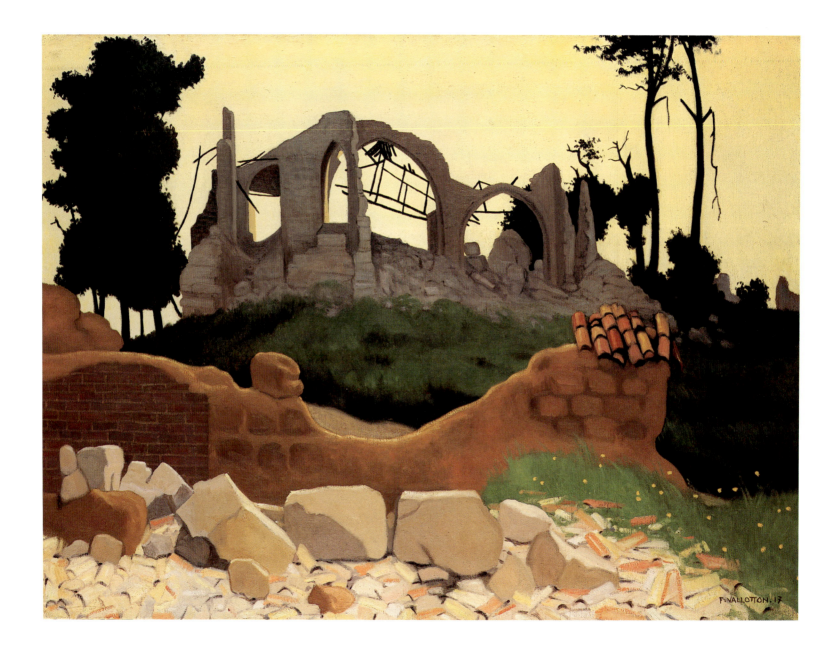

The church [of Souain] situated in the center of town seems to have been their [the Germans] preferred goal since the beginning. It was only too late that they thought of saving the furniture—the sacristy had been demolished by a shell at the beginning. The rest of the church followed little by little the same fate, especially in May, when a soldier thought he had made a great coup in replacing the cock with a French flag. This did not last long—the shells soon demolished the steeple whose debris still supports the bell lying at this moment in the street in front of the grand portal. There is not a square meter of roof left intact, and on the damp stones, most in the middle of the demolished pews, wild grasses are beginning to grow. Only some statues, spared by the hail of bullets and returned by the benevolent officers or soldiers in Suippes are the stones awaiting future resurrection.[44]

Finally, Vallotton's unpopulated, rigorously ordered landscapes of Souain —for they can be more rightly called landscapes than images of the war—have a purposeful affinity with the historical landscapes of the seventeenth century. A student of classical studies in Switzerland in the early 1880s, Vallotton had visited Rome on a near annual basis since 1906 and was particularly impressed by its imposing ruins.[45] Only a year before the outbreak of the war, he had made a series of tourist-view paintings of Rome, including the *Roman Forum*—a pastiche of the Roman Forum, the Meta Sudans fountain, the Arch of Constantine, and the ruins of the Temple of Venus—a twentieth-century recapitulation of a seventeenth-century model.[46] And as an ardent admirer of Poussin, he had written in October 1916 that he was dreaming of a return to the classically inspired historical landscape.[47] Surely his images of Souain represent one stage in Vallotton's personal interpretation of the historical landscape—his "*paysages composés*" —which, reconstructed from memory, were disengaged from any literal representation of a specific site.

Although Vallotton continued to draw from memory and paint scenes inspired by his visit to the front, his persistent dissatisfaction with his work led him to publish in December of 1917 an essay entitled "Art et guerre" (Art and War) in *Les Ecrits nouveaux*, a new literary journal edited by Paul Budry.[48] Expressing the frustration of his search for a means to portray the true "forces" of war, it began:

> Many artists, having seen it all, returned from the lines, their pockets stuffed with sketches made on location, in the trench at rest, or by candlelight in the somber boredom of the tents; their success was large and justified, but however interesting these notations and their still unexhausted abundance, their meaning did not surpass that of cheerful illustrations. One took pleasure in them for lack of anything better. But for all those whom "the word" gripped, the payment was meager and "the war" was still searching for its plastic expression.[49]

Even before his visit to the front, Vallotton believed the drama of war demanded a synthetic personal expression: "The idea of the war is an interior idea; the spectacle of the images it brings forth would satisfy my curiosity, but would not augment the amplitude of the drama that I feel."[50] He was now determined to avoid the picturesque or the documentary.[51] And yet the question remained,

> What to represent in all this? Not the object of course, it would be simplistic, although it can't be helped, and nevertheless an art with no specific representation of an object—is it possible? Who knows! . . . Maybe the still embryonic theories of cubism can yet be fruitfully applied? To draw or paint "forces" will be more

247

Fernand Léger (1881–1955)

Verdun: The Trench Diggers, 1916

Watercolor on paper, 35.9 x 65.4 cm

Collection, The Museum of Modern Art, New York, Frank Crowinshield Fund

profoundly truthful than reproducing material effects, but these "forces" have no form, and even less color.[52]

Vallotton ultimately attempted to resolve this quandary in *Verdun* of 1917 (plate 250), in which he experimented with the Cubist-Futurist idiom that thrived among such avant-garde artists at the front as Léger, answering their need for a visual language that, like modern combat, was dissociated from the past.[53]

If ruins stood as the major symbol of France's cultural heritage during the war, the battle of Verdun came to symbolize her military might. On the 21st of February 1916 the Germans initiated a massive offensive at Verdun, firing over one million shells on the French soldiers, concealed in their trenches. So began an eight-month long bloody conflict of bombardment, machine gunning, and poison gas that would nearly break the spirit of the French army as they struggled to recover Fort Douaumont from the Germans. With over half a million casualties on both sides, Verdun became the ultimate symbol of the war's dramatic destruction and carnage. As the only exclusively French campaign, with no British troops involved, it also evolved into a competition of "race"—French versus German, classicism versus barbarism.[54] Victorious in the end, the French remember Verdun as the paramount battle of the war. It was certainly among the most publicized campaigns in France, and Vallotton followed it with the concern of most citizens, monitoring its progress in his daily journal entries. By 10 March, he wrote: "Out of all of this horror rises a perfect nobility; we are becoming truly proud to be on this side of humanity, and whatever happens, the French name is made young again with a luster unknown until now."[55] Although Vallotton was deeply moved by the gravity of this conflict, his experience was a far cry from that of Léger and Luc-Albert Moreau, who witnessed the battle firsthand as

248

1914 . . . Landscape with Scorched Ruins, 1915

Oil on canvas, 115 x 147 cm

Kunstmuseum Bern, Emil Bretschger Collection

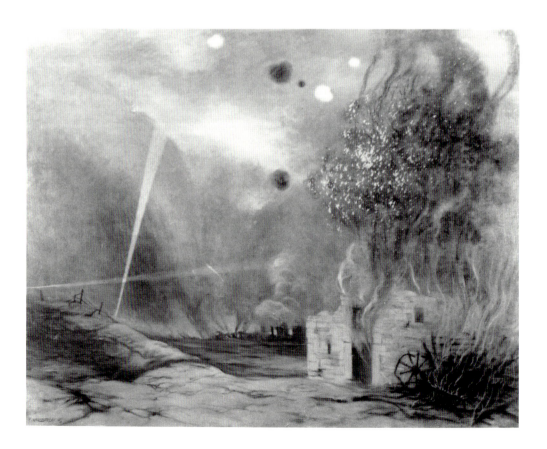

249
Gino Severini (1883–1966)
Plastic Synthesis of the Idea: "War," 1915
Oil on canvas, 92 x 70 cm
Private Collection

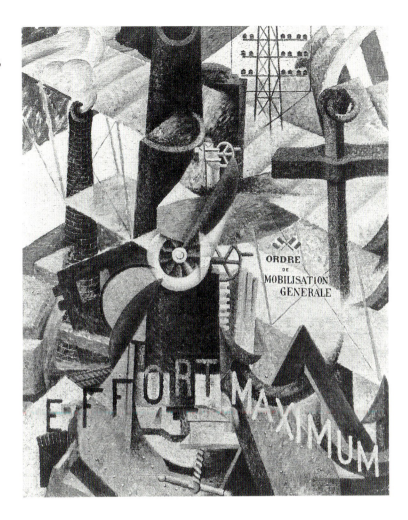

soldiers in the trenches and made sketches of the ruined town they sacrificed their lives to defend (plate 247).[56]

Vallotton's painting, descriptively titled *Verdun. Interpretive depiction of the war, blue-black colored projections and ruined red terrain, clouds of gas* in his *Livre de raison,* is an abstraction of the modern battle.[57] It actually derives in part from the first painting he made directly relating to the war, wherein he had hoped to depict the "nightmare of the war" without resorting to facile romanticism. In *1914 . . . Landscape with Scorched Ruins and Burning Tree* of 1915 (plate 248), a burning farmhouse on an empty field is dominated by a colorful nocturnal sky illuminated by a beam of light from a projector. *Verdun,* a further abstraction of this work, can perhaps best be described as a visual counterpart to a statement Vallotton made in "Art et guerre": "A shell that explodes on an embankment and whose shrapnel carries death to its surroundings, presents nothing tragic visually. In the abstraction made by the sound, one only notices a large bubbling of smoke and variously nuanced dust clouds whose curls link gracefully, unwind, then dissipate according to the usual laws."[58] Void of human form, as were all but one of his war paintings, its only identifiable objects the burnt skeletons of trees, *Verdun* masterfully evokes the dehumanization and mechanization of the war. Whereas the images of Souain look back on the French tradition with nostalgia, this painting, with its overlapping beams of colored light and its purple-black and yellow clouds of gas and roaring flames, has a far more visceral immediacy.

250
Verdun, 1917
Oil on canvas, 115 x 146 cm
© Musée de l'Armée, Paris

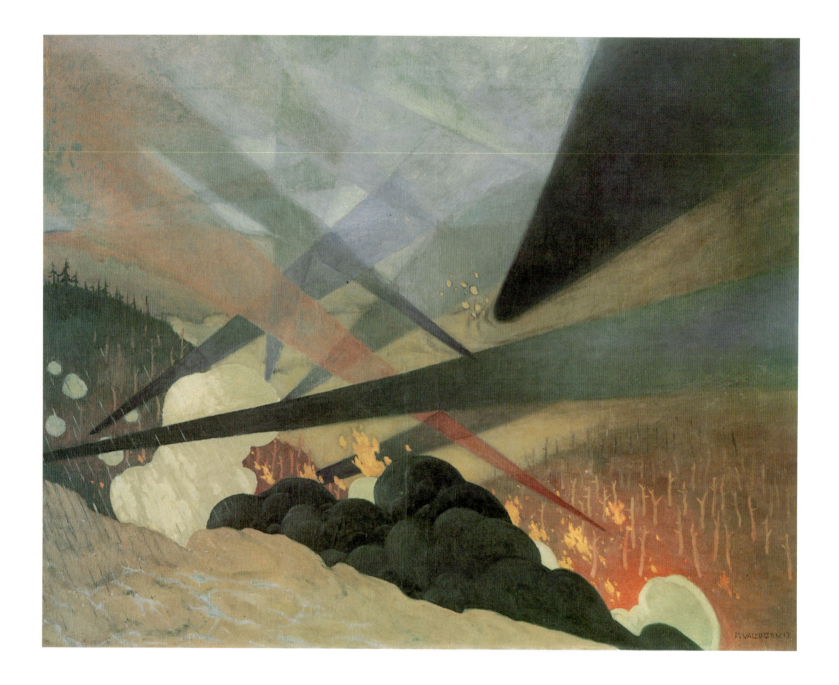

251
Anonymous, French
Nocturnal Bombardment, 1916
Published in *Illustration*, 8 April 1916
Sterling Memorial Library, Yale University

252
Guy Arnoux (d. 1951)
The Zeppelins, ca. 1917
Color woodcut, published in *Carnet d'un permissionnaire,* text by Roger Boutet de Monvel
Seeley G. Mudd Library, Yale University

Verdun recalls the recent work of the Italian Futurist Gino Severini, an expatriate living in Paris during the war. Vallotton may have seen Severini's three paintings, *Plastic Synthesis of the Idea: "War"* (plate 249), which flaunted the machinery of the war, on exhibition in 1916 at the Galerie Boutet de Monvel in Paris.[59] Futurist works aggressively celebrated such new technology as mass-produced weaponry and electric light, the latter exploited during the war in projectors capable of illuminating the night sky.[60] Vallotton's *Verdun* was equally dependent on such technology. Beacons searching for zeppelins (and later airplanes) dropping bombs were a familiar nocturnal sight for the inhabitants of Paris, and were a popular subject in the illustrated journals (plates 251, 252).[61] Despite the formal links between Vallotton's and Severini's work, however, the

emotional content of *Verdun* hardly shared the Futurist artist's enthusiasm for the war's eradication of the old order.

Coincidentally, the journal and war images of Paul Klee, a Swiss expatriate in Germany, share the mix of fascination and horror with which Vallotton viewed the war. On 17 November 1916, Klee wrote from Cologne: "The sharp beams of four wily searchlights. Far above the towers of the cathedral, the bright little bar of a Zeppelin maneuvering gracefully, speared by one of the beams. I had never seen any city put on such a nocturnal spectacle, truly a solemn festival of evil."[62] Seeing Klee's *The Idea of Firs* of 1917 (plate 253)—a luminous watercolor in which geometric beams of color emanate from a dark and jagged, off-center alpine motif that resembles an explosion—one is immediately struck by its affinity with Vallotton's *Verdun*.

The only precedents for Cubist-Futurist abstraction in Vallotton's oeuvre are the four synthetic war drawings he made in 1915, following a visit to the studio of the Cubist artist Henry Valensi.[63] The latter's mechanical, abstracted works, based on his expedition with General Gourand to paint the war in the

253
Paul Klee (1879–1940)
The Idea of Firs, 1917
Watercolor on paper mounted on board,
24 x 16 cm
Solomon R. Guggenheim Museum,
New York

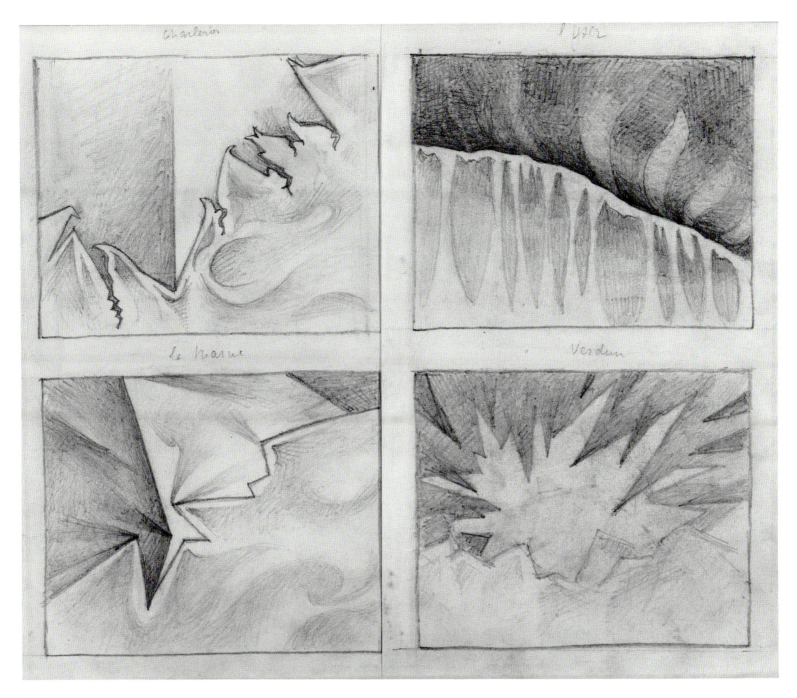

254
Charleroi, Yser, The Marne, Verdun, 1916
Black pencil, each 11 x 13.5 cm
Private Collection

Turkish Dardanelles, inspired Vallotton to experiment with the cubist idiom in making these "geometric drawings" of Charleroi, the Battle of the Marne, L'Yser, and Verdun (plate 254).[64] Vallotton probably exhibited *Verdun* with two less experimental landscapes of major battles fought on French soil—the early *1914 . . . Landscape with Scorched Ruins* and *Yser* of 1918—as an informal triptych in March 1919 at the Galerie Druet. This exhibition, Vallotton's first one-man show since the war began, was well-received. Wrote one enthusiastic critic in *Le Crapouillot*: "Here [the triptych] is the war of the machine and science without the picturesque elements so dear to past military painting."[65] After four years of trials and errors in a struggle to define his place in a society at war, Vallotton could not have hoped for a more perceptive tribute from a worthier critical source.

260
Study for "Félix Fénéon at the Revue blanche," ca. 1896
Sketchbook leaf, graphite, 7.2 x 12.6 cm
Private Collection

261
Félix Fénéon at the Revue blanche, 1896
Oil on board, 52 x 65 cm
Josefowitz Collection

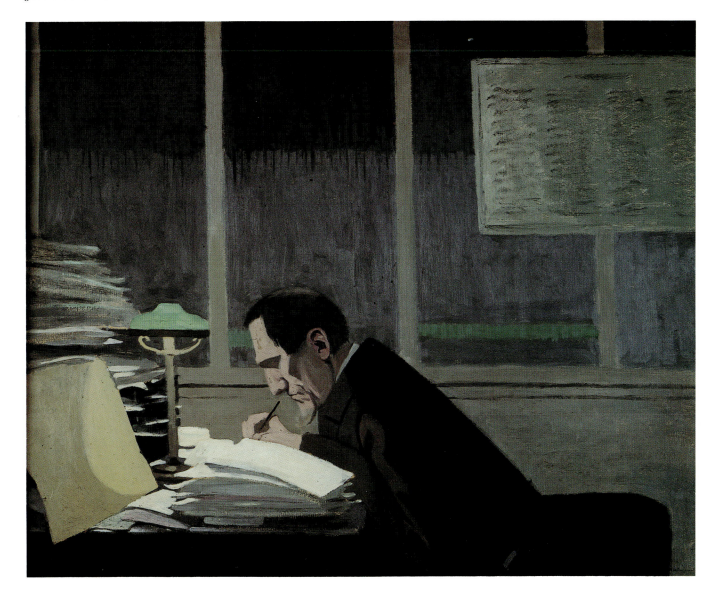

thought that Vallotton composed most of his paintings directly on the cardboard that was then his most common support, the former appears to anticipate both technically and stylistically the sketches for the "composed landscapes" of Vallotton's maturity.[11] Like them it includes a numbered code for color notations and is executed in a soft pencil that allows a flexible, vigorous line, one that the artist has strengthened in places so as to emphasize powerfully lit areas or to sum up the outline of forms. In the transfer from drawing to painting, the work's centering undergoes a significant transformation. This phenomenon, in part due to the lack of room on the sketchbook leaf, here affects the geometry and the meaning of the painting. Raising the top edge of the composition by about one-third, Vallotton transforms an eye-level view of the main motif into a view from above. This favorite device of the Nabis results in a flattening of the image, here intensified by the vertical separations of the depicted partition wall. But it also affects the image's expressiveness; although reduced in proportion to the whole, the lit part of the desk and the angular profile of the critic paradoxically gain more presence in the painting, as if to emphasize the fact that at this late hour, Fénéon is the only person still working in the offices of the *Revue blanche*.

Vallotton experimented with yet a third type of preparatory portrait drawing when he had no recourse to a full-time sitter or model. Although some portraits were painted from photographs, various documents reveal that for many the artist prepared extremely precise aides-mémoire. These were usually elaborate drawings done with a rather hard pencil on loose sheets notably larger than sketchbook size. The artist intended them to contain what he described as "the whole character" of the person.[12] This type of preparatory drawing, which in some respects recalls Vallotton's single-sheet studies of nudes as well as the drawings for his drypoints of 1891–93, almost exclusively concerns paintings done soon after the turn of the century: for example, the portrait of the art merchant Ambroise Vollard, dated 1902 but probably executed in 1901 (plates 262, 263); *The Five Painters* of 1902–03 (plate 130); or the 1902 portrait of Julius Meier-Graefe, of which only the drawing survives.[13]

In contrast to the varied sketches for Vallotton's portrait paintings, there are but few sketches pertaining to his painted interiors. As far as we know, not one exists for the pure interiors of his Nabi period, despite their thematic link to the woodcuts of the *Intimités*, all of which derived from preparatory drawings. Essentially creating works of the imagination with a universal significance, Vallotton did not aim to reproduce a specific place, but rather to suggest a social environment. His tendency to furnish these interiors with pieces from his own lodgings made sketches superfluous: the object was always within sight should he need to check a detail. *Large Interior*, for example—a gift from Vuillard in 1897—appears in two paintings of 1898: *Woman in a Purple Dress by Lamplight* and *The Red Room* (plates 27, 175).[14] Among other depicted furnishings known to have belonged to the artist are a brass-based lamp with gathered shade, two small cruet-shaped vases, and a studded mahogany armchair. As for the glazed cupboard on the right in *The Visit* (1899; plate 26), and on the left in *The Red Room*, it figures repeatedly in works from all periods.

From the time of his marriage in 1899 until 1906, Vallotton's interiors evidence a new concern with specificity of place. He staged the overwhelming majority of these in his permanent lodgings, first on the rue de Milan, then the rue des Belles-Feuilles, as well as in various houses the couple rented for the

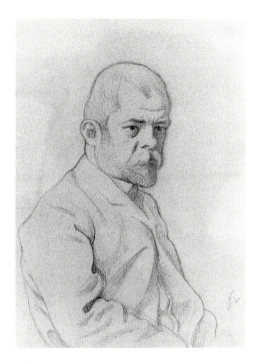

262
Study for "Portrait of Ambroise Vollard," 1901
Graphite, 20.5 x 22 cm
Private Collection

holidays. As with the details of his Nabi interiors, however, physical access to the motif seems to have obviated the need for sketches: Vallotton continued to work directly on the support.

In the same few years, however, the artist also painted six interiors of the homes and offices of his in-laws.[15] As a recently discovered sketchbook reveals, he occasionally made sketches for future reference when it would be difficult to check details of these settings at whim.[16] In 1901, Vallotton embarked upon a portrait of his brothers-in-law, Josse and Gaston Bernheim-Jeune, in their offices on the rue Laffitte (plate 264).[17] As he placed great hopes on the support of the Galerie Bernheim-Jeune, where he had begun exhibiting with the Nabis the year before, Vallotton was undoubtedly anxious that the painting be well received. Although he certainly had numerous occasions to observe his models socially, it

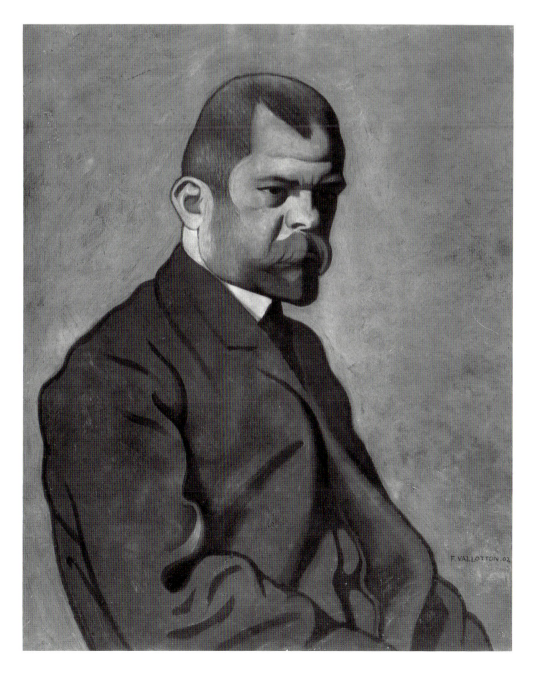

263
Portrait of Ambroise Vollard, 1901–02
Oil on board, 78.8 x 63 cm
Museum Boymans-van Beuningen, Rotterdam

264

Gaston and Josse Bernheim-Jeune in their Office, 1901

Oil on board, 80 x 75 cm

Galerie Bernheim-Jeune, Paris

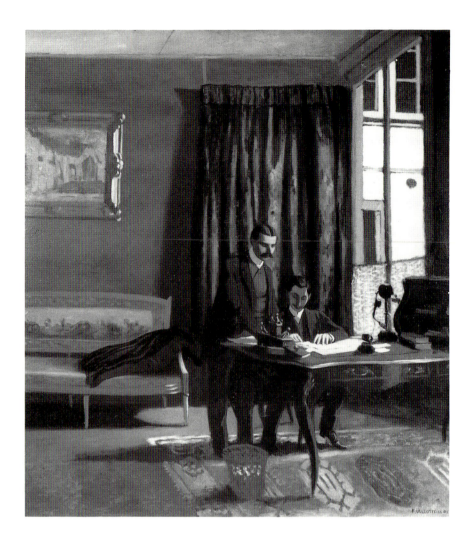

is nonetheless striking how meager his portrait documents were: tiny sketches of the head of each brother (plates 265, 266) and a cursory study of their poses, which he later modified in the painting. Despite the scale, Vallotton readily captured the characteristic features of the two: hairline, shape of the face, style of the mustache.[18] As for the interior itself, there seems to have been no overall study defining the space or situating the protagonists amidst the other elements of the composition. Rather, Vallotton executed an almost puzzle-like series of six sketches, each providing exhaustive information on the shape and color of the various luxurious furnishings while emphasizing details made prominent by the light. A single sketch noting the vanishing lines of the ceiling and floor indicates the room's dimensions, while detailing in heavier strokes the sculptured moldings and bronze ornaments of the desk (plate 267). Vallotton also described the outside wall visible through the window, thereby widening the space in what was to become a characteristic feature of the works that broke with the confinement of the artist's Nabi paintings. The other sketches for this double portrait-interior take up, in detail, various particulars of the wallpaper, the carpet, the furnishings. Finally, in the sole reference to the sitters' profession, Vallotton identifies the painting hanging on the wall (plate 268): "Sisley church pale blue sky reddish gr[ay] roofs."[19] A seventh leaf on the opposite page of the sketchbook contains only color notations.

265
Josse Bernheim-Jeune, 1901
Study for "Gaston and Josse Bernheim-Jeune in their Office," 1901
Sketchbook leaf, graphite, 12.1 x 8.1 cm
Private Collection

266
Gaston Bernheim-Jeune, 1901
Study for "Gaston and Josse Bernheim-Jeune in their Office," 1901
Sketchbook leaf, graphite, 12.1 x 8.1 cm
Private Collection

267
Study for "Gaston and Josse Bernheim-Jeune in their Office," 1901
Sketchbook leaf, graphite, 12.1 x 8.1 cm
Private Collection

268
Study for "Gaston and Josse Bernheim-Jeune in their Office," 1901
Sketchbook leaf, graphite, 8.1 x 12.1 cm
Private Collection

Preparatory work for *The Poker Game* (plate 138) and *Billiards* (plate 137) of 1902 was much the same, although the artist made fewer sketches and was even more summary in his description of details. A different method informs the portrait-interior of Vallotton's mother-in-law, *Portrait of Madame Bernheim de Villers*, probably painted toward the end of 1902 (plate 269). Two sketches, each from a different sketchbook, articulate the space of the entire room when they are placed side-by-side (plates 270, 271). A mirror on the left widens the perspective, and the complex arrangement of the furniture contributes to an illusion of depth. As there are no known sketches of Madame Bernheim herself, one may perhaps conclude that Vallotton painted her from life after preparing the background.

When Arthur and Hedy Hahnloser acquired Vallotton's large painting of 1912, *The Models at Rest* (see plate 300), they asked the artist for the preliminary studies as well. To their surprise, there were only two: on separate sheets, each of the nudes was drawn in relation to its immediate setting.[20] Dozens of preparatory drawings executed most often on loose sheets confirm that this was Vallotton's usual method for studying the nude, as evident for example in two preparatory drawings for *The Turkish Bath* of 1907 (LRZ 625; plates 272–74). Typically, light strokes detail the contour of the body, and shadows are often already reduced to the simplified shapes they would assume in the paintings. Most of these nudes were sketched from life: the pages of Vallotton's journal make frequent reference

269

Portrait of Madame Bernheim de Villers,
1902

Oil on canvas, 48 x 67.5 cm

Musée d'Orsay, Paris

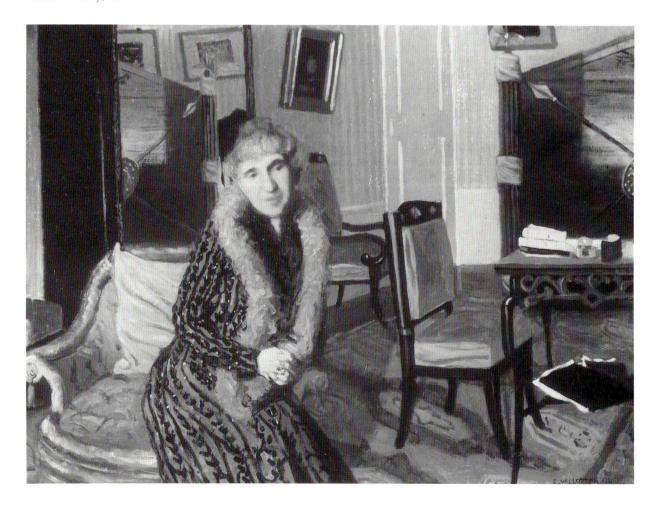

270
Study for "Portrait of Madame Bernheim de Villers," 1902
Sketchbook leaf, graphite, 11 x 17 cm
Galerie Vallotton, Lausanne

271
Study for "Portrait of Madame Bernheim de Villers," 1902
Sketchbook leaf, graphite, 11 x 16.5 cm
Private Collection

to models, whether in anticipation of a sitting or irritation at a missed appointment. Like many of his contemporaries, however, Vallotton occasionally made use of photographs. In the case of *Three Women and a Young Girl Playing in the Water* (plate 37), he even clearly admitted having done so for the central figure, for which he wanted a strong woman.[21] Yet a photographic source did not preclude an intermediate preparatory stage, as the existence of preparatory drawings for all four figures demonstrates.

Vallotton sometimes concluded his preparatory studies with a basic outline drawing of the composition, particularly for certain multiple-figure landscapes and for the large allegorical or mythological compositions that he intended for the salons. Among the six sketches for *The Rape of Europa* of 1908 (plate 38), for example, the fifth presents the selected motif as it was squared and transferred to the canvas, while the sixth is an elaborate figure study of Europa herself.[22] He seems to have had greater difficulty resolving the composition of *Orpheus Torn Apart by Maenads* of 1914.[23] Two drawings, one in graphite, the other in blue pencil (plate 275), vary significantly from the final motif, assembling seven

273
Study for "The Turkish Bath," 1907
Graphite, 19 x 25.5 cm
Private Collection

272
Study for "The Turkish Bath," 1907
Graphite, 18 x 24 cm
Galerie Vallotton, Lausanne

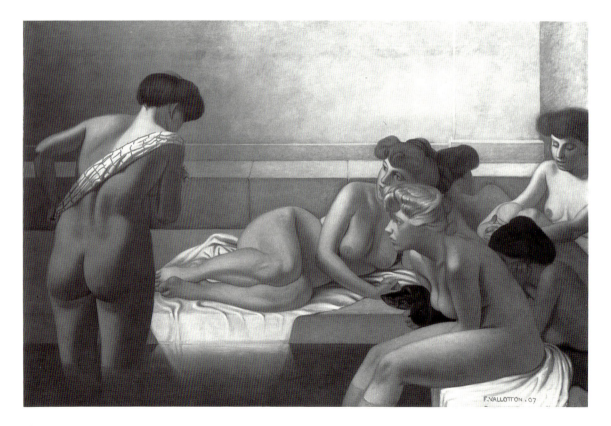

274
The Turkish Bath, 1907
Oil on canvas, 130.5 x 195.5 cm
Musée d'Art et d'Histoire, Geneva

women rather than six and altering the attitudes of the figures, including that of Orpheus. The most anomalous feature of his preparatory process for this work, however, followed his completion of the squared drawing, when he executed a painted study on canvas, probably to test the strange harmony of the pink and pale green tones that he planned to use.[24] Five years later, in a shift from horrific mythology to a strangely unsettling domesticity, Vallotton used the figure on the left in these studies—shown digging her nails into Orpheus' back—as the model for *Crouching Woman Offering Milk to a Cat* (plate 276).

In the majority of Vallotton's landscapes with figures, be they mythological scenes or bathers, the landscape itself—consisting mostly of a bare shore, the sea, and the sky—does not represent an identifiable location. Rather, it is a setting whose function is to reinforce either the decorative effect of the composition or the unusual angle chosen to describe the main figural subject.[25] It is therefore striking that both *Summer* of 1912 (LRZ 861) and *Landscape with Bathers* of the following year, Vallotton's largest figural landscapes, likely found their primary inspiration in landscape sketches executed not in the studio but in front of the

275
Study for "Orpheus Torn Apart by Maenads," 1914
Graphite and blue pencil, 49 x 39.5 cm
Galerie Vallotton, Lausanne

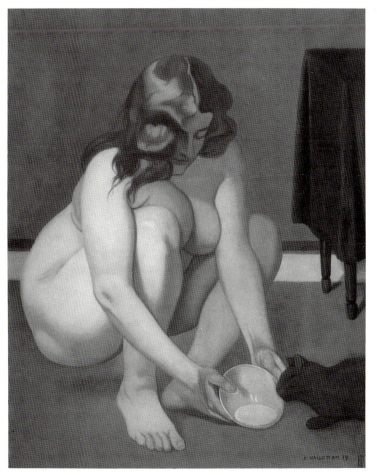

276
Crouching Woman Offering Milk to a Cat,
1919
Oil on canvas, 100 x 81 cm
Galerie Vallotton, Lausanne

actual motif.[26] In both, the distinctive shape of a central tree articulates the composition. *Summer* was based on a small painting on wood depicting the view onto the estuary of the Seine, as Vallotton could see it from the Villa Beaulieu, on the hills above Honfleur (plate 278).[27] Three successive sketches study in a few strokes the web of vegetation, varying the figures' placement in it. The last drawing is squared for transfer to the canvas, and Vallotton even noted the composition on a letter to Hahnloser (plates 277, 278). *Landscape with Bathers* was likewise based on a simple sketch from a sketchbook filled largely with landscapes of Honfleur and Houlgate from 1913. While there are individual drawings of each of the bathers as well, no known study integrates them into the landscape.

277
Study for "Summer," 1912
Ink and blue pencil, 19.5 x 24.5 cm
Galerie Vallotton, Lausanne

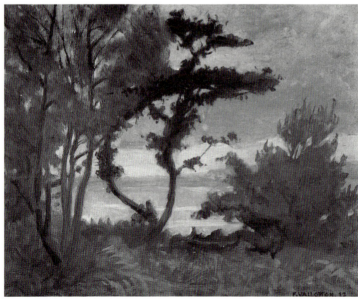

278
Honfleur, ca. 1910
Oil on wood, 22 x 26 cm
Private Collection

279
Letter, Félix Vallotton to Hedy Hahnloser,
with sketch for "Summer," ca. 1912
Hahnloser Archives

Although only a few examples of Vallotton's sketches have been detailed here, it should be apparent that they enrich in various ways our understanding of the artist's approach to painting. Perhaps their most valuable contribution is their qualification of the hitherto strongly held perception that in any given period, Vallotton's working methods were absolutely discrete and inflexible. Yet as the 1896 sketch for *Félix Fénéon at the Revue blanche* demonstrates, Vallotton had conceived the method for composing his mature landscapes several years before the turn of the century. Inversely, his recourse in 1912 to a tiny *pochade* as a model for *Summer* recalls his use of painted studies for certain landscapes before 1900.[28] Likewise, his execution of rough oil sketches for works of pure imagination, or pencil layouts for large multiple-figure compositions, indicates that Vallotton did not hesitate to vary his preparatory process in response to the particular features of the work concerned.

In addition to refining our perception of Vallotton's creative process, his sketchbooks offer precious insights into the purely chronological development of the artist's painted oeuvre—a contribution clearly worthy of far more systematic study than it has hitherto been accorded. In this sense, the sketchbooks augment the information provided in the two most commonly used sources for identifying or dating works the artist left unsigned: his *Livre de raison*, which unfortunately is not all-inclusive, and his *Livre de comptes*, in which Vallotton recorded the sums collected for works sold.[29]

When signing his works for sale or exhibition, Vallotton typically referred

to the detailed records he kept in his *Livre de raison*, in order to add to his signature the exact date of a work's execution.[30] After his death in 1925, his heirs affixed a stamp adapted from his signature to unsigned paintings. Although they often added a date as well, they did not necessarily consult the artist's own records and hence made occasional errors that have led to persistent misidentifications and incorrect assumptions about the artist's working methods and chronology.

Gossip of 1902 (plate 280) provides a typical example of the many problematic cases the sketchbooks have helped to resolve. After Vallotton's death, the painting was stamped and dated "99" on the presumption that it was a pure Nabi work. And indeed, it does exhibit the characteristics of the artist's Nabi period: the composition is evocative of a theater stage; the figures recall the flat cutouts of silhouettes; a certain irony underlies the representation of the faces; and the technique—gouache on board, juxtaposed in flat tints—counters any impression of relief. Only one incongruous feature hints at a post-Nabi date for the painting: the bench in the foreground, rendered in perspective, leads the eye toward the

280

Gossip, 1902
Gouache on board, 38 x 51 cm
Mr. and Mrs. Arthur G. Altschul

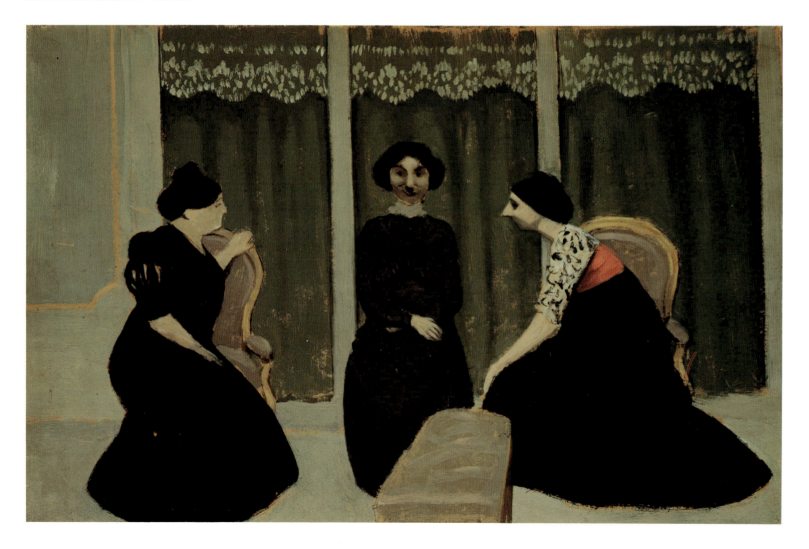

281

Three Women in an Interior, 1901–02
Study for "Gossip," 1902
Sketchbook leaf, graphite, 8.1 x 12.1 cm
Private Collection

group of women and creates an illusion of depth. As the *Livre de raison* mentions no painting of 1899 whose description fits *Gossip*, it has always been assumed that it is one of the over 150 works the artist, despite his scrupulousness, neglected to include. The same sketchbook with drawings for Vallotton's several interiors and portrait-interiors of his in-laws, however, contains an obvious preliminary sketch for *Gossip* (plate 281), located between those for *The Poker Game* and *Billiards*, two paintings signed and dated "02." Accordingly, Vallotton's reference in his *Livre de raison* (477) to a hitherto unidentified *Interior with Three Women* of 1902, immediately following those citations for the Bernheim interiors, most certainly describes *Gossip*.[31]

A similar case occurs with *The Balloons* (plate 282), stamped with Vallotton's signature but left undated. This representation of a parade on the rue Royale, in front of the church of the Madeleine, has always been identified as *Street Scene* of 1897, number 323 in the *Livre de raison*.[32] And yet obvious differences distinguish this composition from *Passersby (Street Scene)* (plate 59), a pure Nabi work undoubtedly executed in 1897.[33] The street in *The Balloons* is no longer confined to a closed backdrop of shop windows, in front of which only the disposition of figures creates an illusion of space. Rather, it recedes in space along the defining perspectival line of the buildings. The light value of the Madeleine's last column, juxtaposed to the darker value of the house, indicates the continuation of the street between both buildings. And unlike the various street scenes of 1895 to 1897, in which the horizon is claustrophobically insistent, *The Balloons* opens out toward the sky.

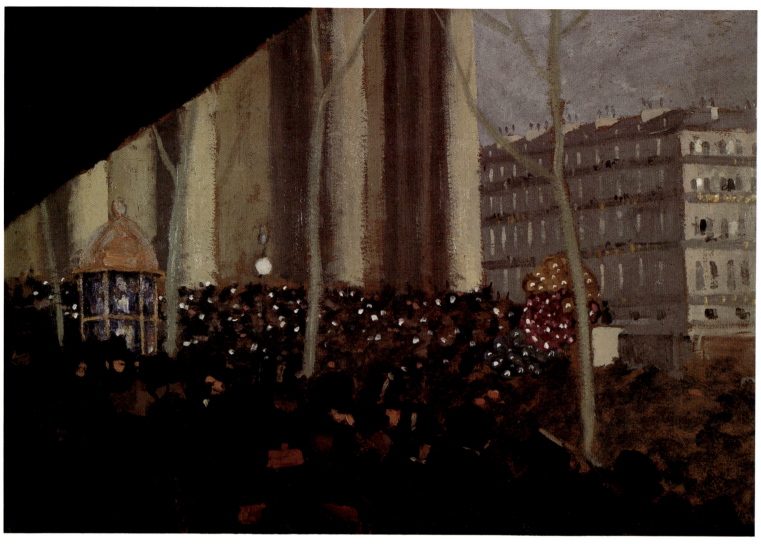

282

The Balloons, 1900–02

Oil on board, 39 x 57 cm

Aargauer Kunsthaus, Aarau, on loan from
the Gottfried Keller-Stiftung

283

Study for "The Balloons," ca. 1900-02

Sketchbook leaf, graphite, 8 x 12.6 cm

Galerie Vallotton, Lausanne

The recent discovery of the sketchbook containing a preliminary sketch for *The Balloons* resolves this discrepancy between chronology and style (plate 283). The earliest sketches therein relate to two Swiss landscapes entitled *The Dent d'Oche*, both signed and dated "00."[34] But it is largely given over to a series of sketches for the landscapes of Locquirec and Villerville, painted in 1902, next to which are small drawings of "Coquelin in *The Bourgeois Gentilhomme*, for London," also executed in 1902.[35] Clearly *The Balloons* was painted between 1900 and 1902, and most likely in 1902, although there is no corresponding description to be found in Vallotton's *Livre de raison* after 1900. Such discoveries not only rectify previous errors, but also encourage us to qualify our perception of the transitional period in Vallotton's oeuvre. The painter's turn-of-the-century efforts toward new formulations of space and volume apparently coexisted harmoniously for a while with his earlier, more decorative style.

Documentation of the landscapes of Vallotton's maturity is far more extensive.[36] As with the cases above, sketches for a series of paintings often follow, in a single sketchbook, the order in which the finished paintings were recorded in the *Livre de raison*. Simple crosschecking allows us to resolve discrepancies of both date and title. This sometimes leads to a leap in time and geography of several years and hundreds of miles. A *Bois de Boulogne* dated 1925 and exhibited many times under that title is, in fact, an undergrowth painted near Cagnes in 1921, as revealed in a drawing from a sketchbook the artist used during his stay in the south of France that winter. Similarly, no mention will be found in the

284

Landscape: Beets, Wheat, and Cabbage,
1914

Oil on canvas, 56 x 96 cm
Private Collection, Switzerland

285

**Study for "Landscape: Beets, Wheat, and
Cabbage,"** 1914
2 sketchbook leaves, graphite, each
9.3 x 16 cm
Galerie Vallotton, Lausanne

Livre de raison, under the year 1909, of the vibrant landscape entitled *Landscape: Beets, Wheat, and Cabbage* (plate 284; also known as *Fields, Croix-Rouge Plateau*), whose studio stamp precedes the date "09." A preparatory drawing with color notations on the opposite leaf (plate 285), however, appears in a sketchbook with sketches of Rome and Perugia of 1913, followed by landscape sketches of 1914 corresponding to numbers 1000 to 1010 in the *Livre de raison*. Among these, the description of number 1005 exactly matches the painting in question.

In addition to preparatory drawings that were notably few in number for any given painting, Vallotton produced literally thousands of independent drawings in ink, pencil, red chalk, colored pencil, charcoal, wash, or stump—both sketches and completed works of all sizes and genres. "Félix is constantly drawing," from a letter Gabrielle Vallotton wrote to her son Jacques Rodrigues in the 1920s, could well be evoked to describe a lifelong enthusiasm.[37] Furthermore, as has already been established, Vallotton clearly privileged the characteristics of the drawing media in his painted oeuvre. And yet he paradoxically made few public references to these works on paper. They rarely figure in his *Livre de raison* and were scarcely ever exhibited.[38] "Nice little *succès d'estime*, and some sales," the artist noted, as though surprised, in response to one of the few exhibitions of his drawings, presented by Druet in 1921.[39] That he valued them cannot be doubted: "My painting may be bad, but I do know that my drawings are good."[40] He was happy to show them to friends, but was adamant that they not be framed.[41] Executed with a profusion that remarkably did not undermine their quality or their intimate appeal, these drawings were, for the artist, a secret garden whose riches we have only begun to explore.

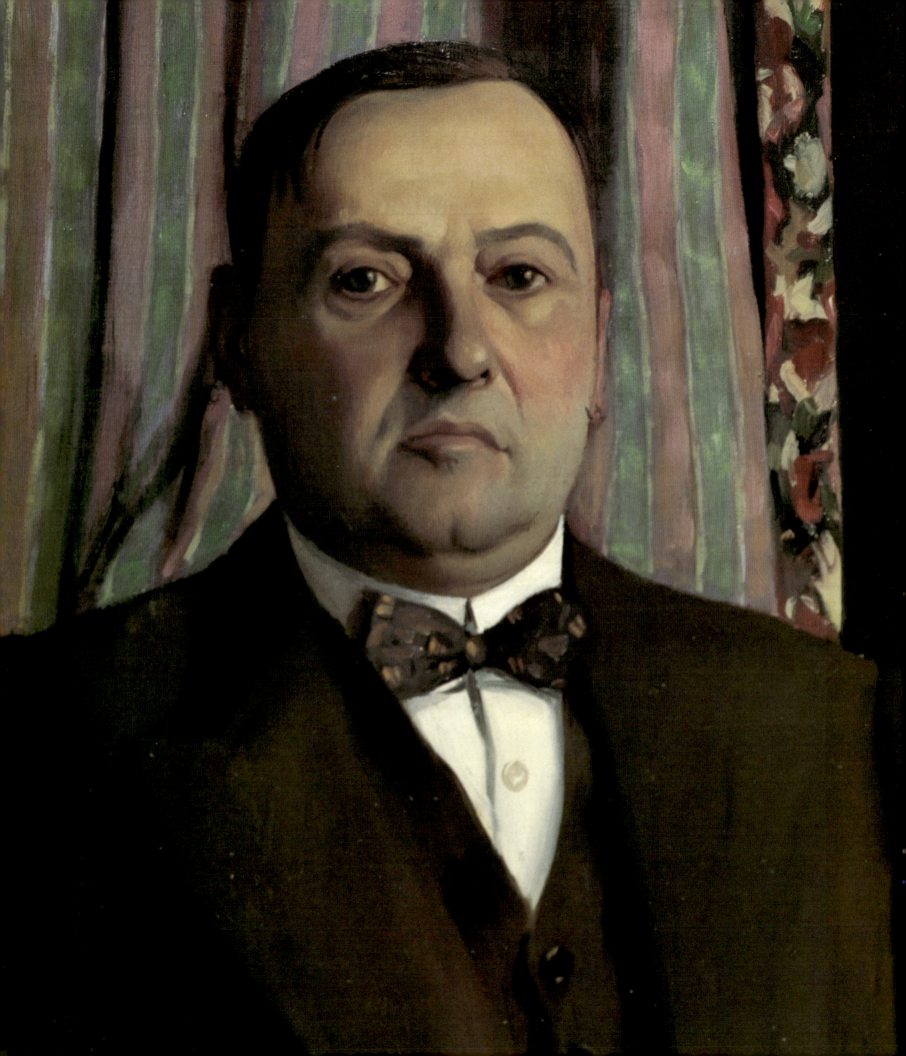

Margrit Hahnloser-Ingold

Affirmation and Debate
Vallotton's Critics and Collectors

So original an art is its own best defense and cannot help but be so.
RENÉ AUBERJONOIS ON FÉLIX VALLOTTON, 1931[1]

When Vallotton died in 1925 at the age of sixty, the world was little interested in his work. Yet in the 1890s and early 1900s, his epochal woodcuts, incomparable in their spareness of expression, and his impressive paintings of interiors and bathers had attracted the attention of an entire generation of artists. By 1893 his involvement with the inner circle of *La Revue blanche* firmly established his place in the French avant-garde and cemented his ties to a number of colleagues and critics—most notably Edouard Vuillard, Thadée Natanson, and Jules Renard—whose friendship and estimation of his work would continue to serve as touchstones long after the journal's demise.

Neither Vallotton's temperament nor his realistic, sober, and often overdrawn style, however, has ever been easily accommodated to this avant-garde status. Academy-trained and hence steeped in tradition, he hoped to be awarded the *Prix de Rome*, expected his art to provide him with bourgeois affluence and prestige, and admitted to feeling "a repulsion for everything bohemian or sloppy."[2] His work, like that of Vuillard and Maillol, was rooted in a classical vision of artistic creation, and it remained relatively untouched by the innovative and speculative spirit of abstraction. Rather, it explored the decorative possibilities of objective representation, developing a surprisingly modern monumentality and simplification of the subject. Although these latter qualities have contributed to the current reassessment of his achievement, Vallotton rarely met with widespread understanding in his own day, particularly after the First World War. Critics consistently described his work as "dry," "cold," "deliberately reductive," "without poetry," and "heavy."[3] In an equivocal review of Vallotton's 1910 independent exhibition at the Galerie Druet, for example, Louis Vauxcelles extolled "the forceful vigor of his Spanish studies; the sober realism of his nudes, the pragmatic virtuosity of details—flowers, fabrics, scarves . . . the decorative splendor of his vast and silent landscapes." And yet his overall, unfavorable impression was that the work was "chillingly austere."[4]

286. Detail of *Portrait of Mr. Hasen*, 1913 (see plate 302)

In reference to his Swiss origin, but also to his distanced, serious, and rather suspicious personality, Vallotton was revealingly nicknamed "the foreign Nabi" by his colleagues. The essential duality of this epithet, with its suggestion of underlying conflict, characterizes both descriptions of Vallotton and evaluations of his art. Thadée Natanson called him "the very singular Vallotton" and provided, in his memoirs, a delightful portrait of this gallant but obstinate and eccentric outsider. He described him as being both shy and impudent; as self-critical, evincing both ambition and cynicism; as fair-minded, yet frugal to the point of avarice; as appreciative of sensual passion—"none more than that of a woman's skin"—despite the willed passionlessness of his nudes.[5]

Straddling two centuries, two countries, two heritages, Vallotton was clearly not a simple man. Hence it is not surprising that critics reached little accord in assessing his work. Was his uncomfortable art to be ascribed to the artist's Swiss-Protestant background or was it, after all, part of the French tradition, which had produced such outsiders as Daumier or Rouault? French critics generally saw everything harsh, strict, or pedantic about Vallotton's work as a function of "his Calvinist inheritance,"[6] while their Swiss counterparts were more likely to focus on his place within a clearly French context. Vallotton's nudes, however cold and inexorable, were there granted the legacy of Ingres; and in his landscapes the Swiss recognized the influence of Gauguin or Puvis de Chavannes.[7] Seemingly antithetical, both points of view command a certain validity. Although his art grew in French soil, Vallotton could not wholly escape his Swiss roots. As his colleague René Auberjonois later affirmed: "At home in French Switzerland there is a certain rustic prudence, an arid self-analysis, a definite taste for sauntering about. Strolling under a pleasant blue sky, you will not find the silver light of the Ile de France or the prevailing hues of Italy or Spain."[8]

The reception and appraisal of Vallotton's work, never consistent even when the artist was most well-known, deteriorated after the First World War. Like Bonnard, Vuillard, or Rouault, who earned little favorable notice in the years between the wars, Vallotton lived a withdrawn life, absorbed in his work and only peripherally touched by the international buying boom in Paris. Even in his native French-speaking Switzerland, new collectors were increasingly drawn to the impressionism of a Monet landscape or to the sensual appeal of a Renoir nude. At the same time, those connoisseurs in German-speaking Switzerland whose interest in expressionism or abstraction had not led them to reject Vallotton altogether, variously contextualized his work either within his own Swiss or his adopted French tradition: as a successor to Holbein or Böcklin in the first instance, as an heir to Ingres in the second. Although Vallotton's death occasioned several memorial exhibitions in Switzerland—at the Kunstmuseum Winterthur and the Kunsthalle Basel in 1926, the Kunsthalle Bern in 1927, and the Kunsthaus Zürich in 1928—each failed to elicit any notable enthusiasm. Only in the late 1930s would an exhibition at the latter institution, as well as the publication of various articles and monographs, spark a more general Swiss reappraisal of Vallotton's work. Gotthard Jedlicka focused primarily on the artist's complex personality in an article of 1937. And in 1936 Hedy Hahnloser, a close friend and passionate supporter, published the still fundamental monograph on Vallotton. Intent on making his work more widely known, Hahnloser was equally determined to defend it against various attacks and misconceptions.[9]

In France, Vallotton's posthumous reputation was even more precarious.

Although there were several small gallery exhibitions in the late 1920s at Druet and Jacques Rodrigues-Henriques, and although the first monograph on the artist was published five years after his death by Charles Fegdal, it was not until the mid-1950s and 1960s that large retrospectives of Vallotton's work were organized in Paris—at the Maison de la Pensée française in 1955 and the Musée national d'Art moderne in 1966. Poorly received, however, these exhibitions did little to prompt a more intensive evaluation of Vallotton's position in earlier modern French art. Critics and viewers alike, echoing their early twentieth-century peers, deemed offensive such nudes as *Three Women and a Young Girl Playing in the Water* of 1907 (plate 37) and such allegorical representations as *Hatred* of 1908 (plate 193) and *Perseus Slaying the Dragon* of 1910 (plate 195).

By 1978, organizers exercised greater caution. Coordinating a Vallotton exhibition that traveled to Paris' Musée du Petit Palais, the Swiss foundation Pro Helvetia dispensed with the large allegorical paintings and emphasized "quality" as the primary criterion in selecting works. Although this tactic clearly accommodated French sensibilities, the majority of critics nevertheless seconded André Fermigier's dismissive assessment: "The room with the large nudes doesn't lack interest: the work is still very solid, very well painted, but even when the level of execution is high (*The White and the Black* [plate 196]), the feeling seems morose and heavily equivocal. It's no longer an unsettling manner of being simple, but too simple a manner of wanting to unsettle us." [10]

No other artist so prominently active in the French avant-garde has faced such persistent censure. Certainly one cannot cavalierly disregard almost a century of criticism, and yet a more nuanced and more generous impression of Vallotton's achievement is long overdue. Disaffected from his homeland, a stranger in his adopted country, he produced a stubbornly independent art characterized by a sense of separation and estrangement. It is an art that resists purely sensual or visual appreciation, demanding from its audience an attention that is both more intellectual and more empathetic.

France

In the early 1890s, with the publication of his first expressive woodcuts, Vallotton found himself in the spotlight of avant-garde activity in Paris. [11] Reviews of the 1893 Salon des Indépendants made positive note of his spectacular submission, *Bathers on a Summer Evening* (plate 148), which revealed a bold transposition onto canvas of his woodcut style. That same year, he began to contribute regularly to *La Revue blanche*, arguably the most liberal organ of its day for literature, music, and the visual arts. A popular member of its inner circle, which every Tuesday could be found grouped around Stéphane Mallarmé, Vallotton was particularly close to Vuillard and to Thadée Natanson and his much admired wife Misia, especially in the turbulent years at the turn of the century. Correspondence between the four indicates a mutual need and affection, as evidenced in Misia's letter of 1897: "Remember, my dear Vallo, the good friends you have here who are waiting for you with anticipation. They will make you happy again if you will listen to me and come spend the summer here. Please finish quickly what is keeping you in Paris. Don't behave like a child." To this, Thadée added: "I need you." [12] And in the fall of 1899 in a letter to Vallotton, Vuillard pleaded: "I would have liked very much to be able to talk to you for a while. Could you at least write

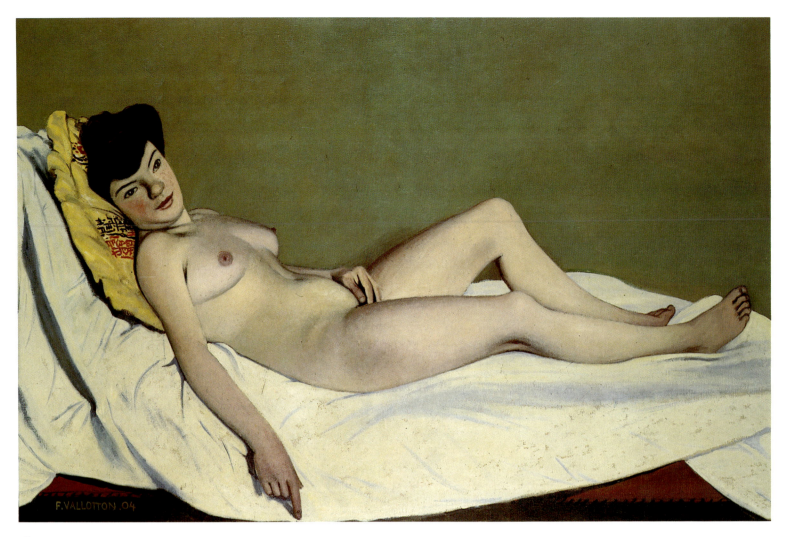

287
Nude Reclining on a Yellow Cushion, 1904
Oil on canvas, 98 x 146 cm
Private Collection

me a little note? It would be kind of you. Here one tends to believe that the world is limited to the surrounding slopes and to the ideas that one plays with. This is not very prudent and this is why I am asking you to shake me up a little until you can be here in person." [13]

In the summer of 1899 Vallotton married Gabrielle Rodrigues-Henriques, a widow from the wealthy Bernheim-Jeune family. He was accused by some of having abandoned his model and former companion Hélène Chatenay for financial security and ties to a prominent gallery; such an implicitly self-serving act has often been interpreted as alienating Vallotton from his circle of friends and as constituting his first step into isolation. [14] Yet in the years after the turn of the century, Vallotton was a respected, well-situated, and much discussed artist who did not shy from public notice. He participated in all the Nabi group exhibitions and regularly sent works to the annual salons. Certainly the deaths of Mallarmé and Toulouse-Lautrec, in 1898 and 1901 respectively, as well as the dissolution of *La Revue blanche* in 1903, threatened the Nabis' spontaneous exchange of ideas and forced them to reflect on their individual achievements, but their collaborative exhibitions actually grew in number.

In 1900, Vallotton contributed ten paintings to a group exhibition with Bonnard, Maillol, Ranson, Roussel, Sérusier, and Vuillard at the Galerie Bern-

heim-Jeune; three years later, sharing a showing there with Vuillard, he exhibited seventy-five works, a veritable festival of landscapes, to Vuillard's ten. At the first autumn salon in 1903, he introduced two new interiors. And although his submission to the 1904 Salon des Indépendants consisted of six landscapes, he surprised the 1905 Salon with the first public exhibition of one of his large, bold nudes. *Nude Reclining on a Yellow Cushion* (plate 287), which was unanimously seen as inspired by Manet's *Olympia*, drew considerable attention and controversy: "M. Vallotton has to face the terrible parallel between the *Maja desnuda* and the *Olympia*. His naked woman, lying with one hand resting where she draws her living, is the result of a skillful and honest draftsman. Her head is true and curious, expressing all the passivity of prostitutes."[15]

The painting was purchased by the American Leo Stein, who with his sister Gertrude established a superior collection of avant-garde art. For Vallotton, the sale initiated occasional visits to the Steins' increasingly influential salon, "Rue de Fleurus" (plate 288). Gertrude was far less impressed than her brother with the painting, noting in her autobiography that: "His big nude had all the hardness, the stillness and none of the quality of the Olympe [sic] of Manet," and more generally that "his portraits had the aridity but none of the elegance of David."[16] She did, however, agree to Vallotton's request that she sit for her portrait in 1907 (plate 139). Painted in a mere two weeks, this strong, impressive work depicts Gertrude's massive body even more voluminously than Picasso had a year before. Well aware of the painting's significance both in terms of Picasso's portrait and Stein's publicity value, Vallotton borrowed it from Leo for exhibition in that year's Salon d'Automne, assuring him that "it will be all the rage."[17]

Vallotton exhibited forty-four works in his first solo exhibition at the Galerie Bernheim-Jeune in 1906. Two years later he began to contribute to group shows at the Galerie Druet, where such younger artists as Van Dongen (1905),

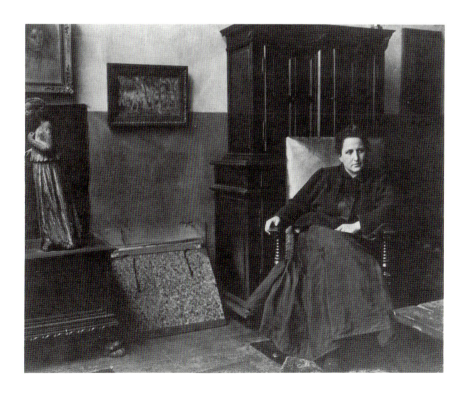

288
Gertrude Stein at 27, rue de Fleurus, ca. 1905
James Mathews, New York

Matisse (1906), and Marquet (1907) had preceded him. Late in 1909, he signed a contract with Druet and wrote enthusiastically to Hedy Hahnloser:

> I made a deal with Druet. I needed somebody in Paris and he is the best person . . . He paid a reasonable amount or should I say will pay—I hope—he did not bargain much. He wanted to take all the paintings from the workshop . . . and he will boost the prices. I shall give him the first choice for the next three years but as for the orders, portraits, decorations and so on, he will not touch them and I remain free to keep some things if I wish to do so.—Besides I only intend to sell to him if he pays in advance, if not entirely at least the major part. And everything I have at home until today (November 1st) belongs to me and he has no right to it. And there are still many left![18]

For the catalogue of Vallotton's first independent exhibition there in 1910, the author Octave Mirbeau, known for his scathingly sharp commentary and his enthusiastic defense of young artists, particularly the Nabis, contributed a lauda-

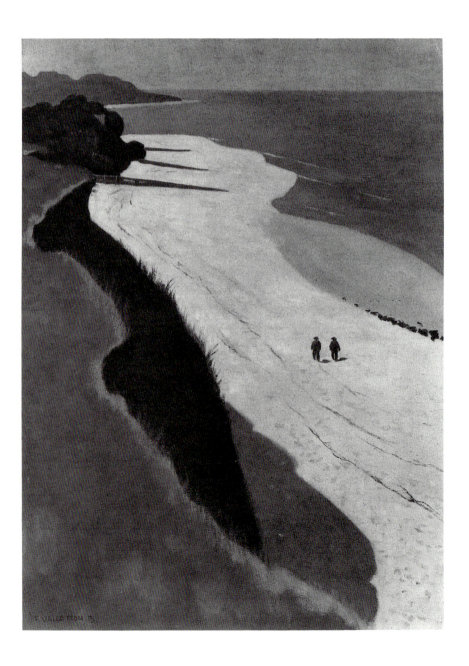

289
Cliff and White Shore, 1913
Oil on canvas, 73 x 54 cm
Private Collection

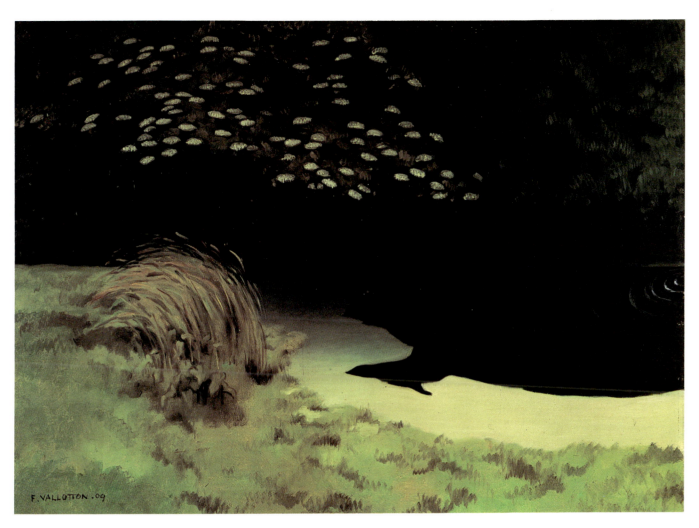

290

The Pond, Landscape at Honfleur, 1909
Oil on canvas, 73 x 100 cm
Private Collection, Switzerland

tory preface in which he singled out the landscapes—*The Pond, Landscape at Honfleur* of 1909 (plate 290) was among the works on view—for special praise:

> When I contemplate this magnificent exhibition where between poems of flesh and soul, I can see landscapes that are like havens for our emotions, the exceptional vision of this rare artist is confirmed. I admire the violent passion that moves him and shakes his whole art. And I like this absolute ideal whose quiet strength was never shattered by error or deception. I know very different painters. I know some who are more seductive perhaps, but none stronger.[19]

Although not all critics shared Mirbeau's high estimation—Louis Vauxcelles, who gave the young generation of Fauves its name, wrote that "whatever Mirbeau says, this art is chillingly austere"—Vallotton could nevertheless draw great satisfaction from the fact that this exhibition, which represented his biggest success to date, did not involve any members of the Bernheim-Jeune family.[20] As he reported to Hahnloser: "I have the pleasure of announcing to you that my exhibition at Druet's was a big success. He sold three paintings out of six and it is not over yet. But more than that it is the success of an artist, which is for me far more important."[21]

Additional individual exhibitions at Druet followed in 1912 and 1914, exposing French audiences to Vallotton's most recent works. While the former

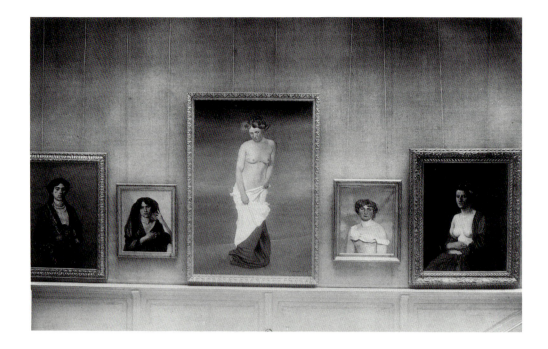

included many traditional landscapes, it also exhibited a number of Vallotton's nudes, among them *African Woman* (1910; plate 197), *Seated Black Woman, Front View* (1911; plate 293), and *Rest* (1911; plate 292). Indeed, one of the least expected results of the exhibitions at Druet is the degree to which Vallotton's nudes impressed many of the critics:

> He is almost always a powerful painter when dealing with female nudes. His vision seems then to find its natural application and become truly creative. Somehow like Ingres—despite making allowances for their differences, the comparison, though already drawn, is unavoidable—he casts his eyes on a woman's body with looks so sharp, obstinate, and devoid of prejudice that they apprehend the form at its most primitive and natural source. And from the tenacious, meticulous, and impartial observation of a singular model who might at times be vulgar or awkward, he precisely draws magnificent images of general beauty. It is because he submits himself to the real, contemplated without any other preoccupation, that he discovers the typical line, the pure structure, and the precise style. His approach, being neither conventional nor academic, acquires a certain classicism.[22]

Even Vauxcelles, who had expressed misgivings in the past, modified his criticism and suggested that a work be purchased for the permanent collections of the Musée du Luxembourg: "The colors on the palette are richer, more varied. Forms palpitate. The sap circulates. Flowers shine with a warmer glow. One breathes more freely. One feels a certain 'joie de vivre' inside the room. Why not acquire a painting by M. Vallotton for the Musée du Luxembourg?"[23]

It was with these nudes that Vallotton's problematic relationship to classical academic traditions was first acknowledged by his supporters as well as his detractors. Guillaume Apollinaire, together with several other critics of the day, related Vallotton's narrow academicism to *"les Pompiers"*—those later nineteenth-century academics and salon painters: "it appears that M. Félix Vallotton's true masters are 'the Pompiers.' "[24] However, the fact that Vallotton confronted the

viewers of the various salon exhibitions with such difficult, allegorical paintings as *Hatred* (Salon d'Automne, 1909), *Perseus Slaying the Dragon* (Salon d'Automne, 1910), and *Man and Woman* (LRZ 953; Salon d'Automne, 1913) contradicts Apollinaire's suggestion of ingratiating academicism. Moreover, these paintings so shocked and unsettled Vallotton's public that the achievement of his oft-declared goal of a new classical plasticity and monumentality was impeded. Hence André Salmon would write that "this artist's satanism grows each year; not long ago he waited for ugliness to seize a passage; now he creates it arbitrarily, setting up the falsest and most troublesome academicism."[25]

Despite the fact that his contract with Druet assured him of a modest income, Vallotton nonetheless continued to exhibit occasionally at the Galerie Bernheim-Jeune, where he put together such thematic groupings of his work as "Nudes" and "Fauna" in 1910, "Water" and "The Mountain" in 1911. Vallotton did not want to seem to be capitalizing on family connections—he insisted on handling his business affairs personally—yet he ultimately placed his art above such scrupulous concerns. Driven by his talent, he searched both for acknowledgment and a sense of individual identity, consciously pursuing success to a far greater extent than did either Vuillard or Bonnard: "Every single artist inflamed

292

Rest, 1911

Oil on canvas, 88.9 x 116.9 cm

The Art Institute of Chicago, Gift of Mr. and Mrs. Chester Dale, 1945.18

© The Art Institute of Chicago. All Rights Reserved.

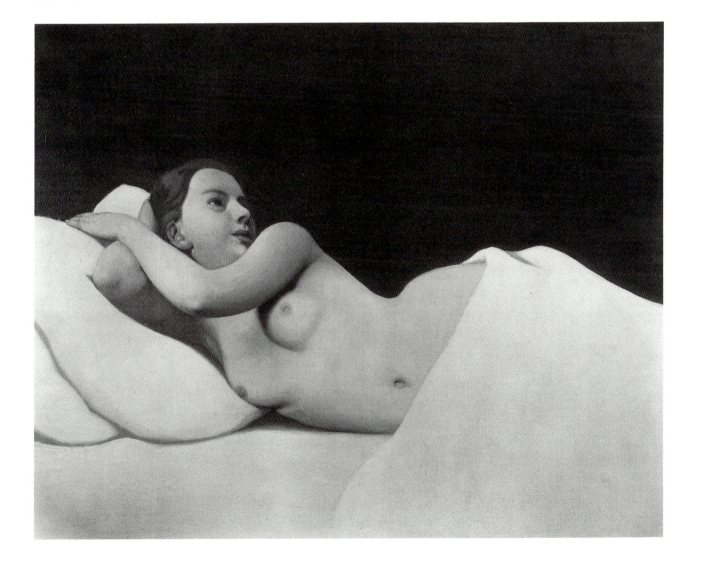

293
Seated Black Woman, Front View, 1911
Oil on canvas, 81 x 65 cm
Private Collection, Switzerland

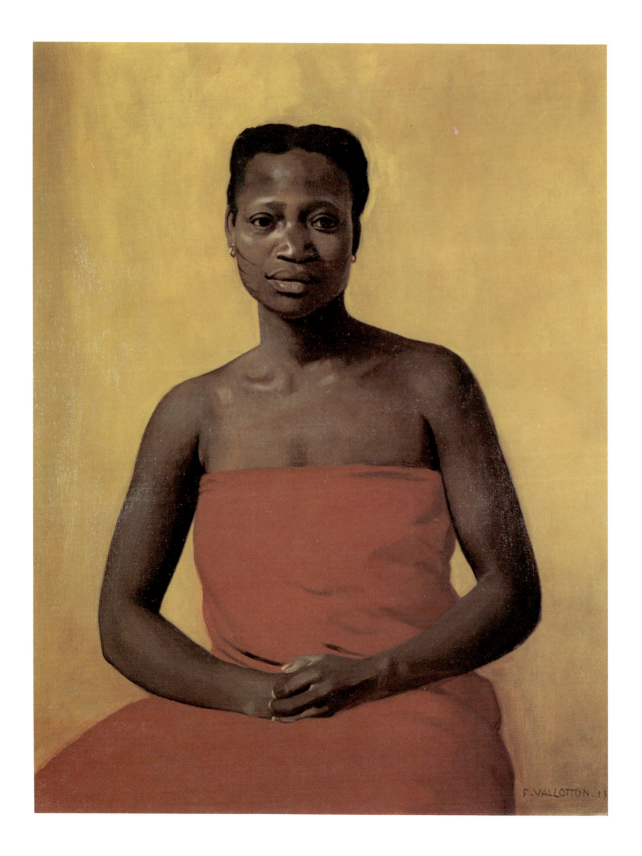

with a healthy desire aspires to a new ideal, an ideal that would be strictly his own, comparable to another's only in that they shared the same profession,—and even this rapport would become less and less distinct."[26]

Within the spectrum of quite diverse artistic trends coexisting on the threshold of the First World War, Vallotton secured a rather stable position for himself. He attracted a considerable number of buyers in Paris, some of whom belonged to the Bernheim family circle. Collectors Joachim Gasquet, Paul Gallimard, Charles Pacquement, Gaston Duché, and Pierre Goujon purchased his work. As Vallotton rather gleefully informed Hedy Hahnloser in 1909, Gasquet already owned *The Rape of Europa*, which had been exhibited in the Salon d'Automne of 1908: "Can you imagine that the first of my paintings sold by Druet (among the last group that he bought) was the naked figure you found so bad that you prevented me from exhibiting it (the young naked girl with a green bow in her hair which made you laugh). A poet bought it! . . . There is no accounting for taste."[27] When Pacquement's collection was auctioned at the Galerie Georges Petit in 1932, five major paintings by Vallotton were sold, including *Rest*, purchased by American collector Chester Dale.[28] Marcel Noréro, who particularly favored Vallotton's nudes, sold much of his collection at the Hôtel Drouot in 1927. Seven important paintings by Vallotton were among the works auctioned, including such bold nudes as *End of the Sitting* of 1902 (LRZ 482), which went to the Renand collection in Paris,[29] and *Solitaire (Nude Playing Cards)* of 1912 (plate 198), as well as the landscapes *The Pond, Landscape at Honfleur* and *The Hospital at Honfleur* (1912; LRZ 866). As trade in works of art increased in Paris just before the war, new collectors joined the ranks of those interested in Vallotton's work: Marcel Kapferer, Dr. Jacques Soubies, Bénard, Renand, and Roudinesco.

Nevertheless, incomes remained modest and sales fluctuated to a far greater extent than during the post-war art market boom of the 1920s. Hence in a single year, 1910, Vallotton could report both disappointments and successes to Hahnloser: "At Druet's group exhibition I have three landscapes and two still lifes; I am pleased but nothing has sold. The situation is not too good at the moment and everyone is tightening their purse strings. This is the general situation for everyone"; and "The exhibition is a major success and this will prove beneficial especially economically. Up to this day 14 paintings have been sold, at solid prices, because a Vallotton is worth more and more!!!"[30]

Switzerland

After moving to Paris in 1882, Vallotton never again lived in his native Switzerland. Yet ties to family and, in later years, friends and patrons, assured him an ongoing presence and recognition there. In the 1890s news of Vallotton and his work reached his homeland through reviews of the Parisian salons and critical notices in Swiss journals. Meier-Graefe's monograph, published in 1898, drew renewed attention to his woodcuts, which had already been favorably received in the Exposition fédérale des Beaux-Arts in Bern in 1892: "The manner in which M. Vallotton works has the attraction of something lifelike, robust, and bold. His drawings with their very primitive aspects announce a painter whose vision is both precise and ambitious."[31] Yet his paintings met with more resistance. Although he occasionally submitted work in the 1880s and 1890s to such exhibitions as the Salon suisse des Beaux-Arts in Geneva and the Exposition vaudoise des

Beaux-Arts, it was primarily through the art collecting of Arthur and Hedy Hahnloser in Winterthur and the exhibitions of the Kunsthaus Zürich (called Künstlerhaus Zürich until 1910) that Vallotton's paintings received their earliest dissemination in Switzerland.

In 1901, four oils and a series of woodcuts were shown in the exhibition "Swiss Artists in Paris" at the Künstlerhaus Zürich; and with Vallotton's first large-scale exhibition there in 1909, the audience was exposed to the full range of his work. Over seventy paintings from 1899 to 1909 were on view, among them *The Visit* and *The Ball* of 1899 (plates 177, 9); *Cloud at Romanel* and *Autumn Crocuses* of 1900 (plates 296, 206); *Twilight* of 1904 (plate 223); *The Beautiful Florence* of 1906 (plate 307); *Three Women and a Young Girl Playing in the Water* of 1907; and *Sleep* of 1908 (plate 201). In the accompanying catalogue, the young director Wilhelm Wartmann commented: "His color is cool, simple, at times almost hard; it is completely adjusted to his metallic forms. His figures are conceived sculpturally, his compositions seem to have sprung from stone. All his works of this kind show the development of a higher form that, as its final destination, must lead to monumentality."[32] Vallotton himself had organized the exhibition, with the help of Hedy Hahnloser in Winterthur, and hence was solely responsible for its arrangement. Despite Wartmann's praise, it had actually been postponed for several months, for fear that Vallotton's concentration on a selection of nudes would cause a scandal. The artist relayed the news to Hahnloser with some dismay:

> I have received today a rather astonishing letter from Kisling; he suggests that I delay my exhibition until fall or next year! . . . His reason being the fear that my

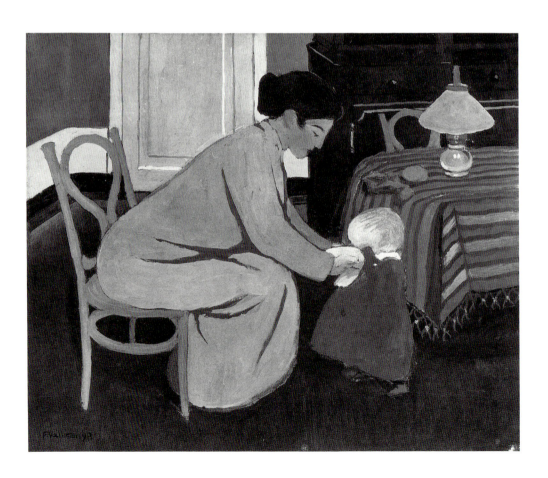

294
Mother and Child, 1898
Gouache on board, 27 x 34 cm
Private Collection

295

The Boardwalk at Etretat, 1899
Oil on board, 33 x 53 cm
Private Collection

nudes may be construed as a provocation to the public in Zurich; especially after those shown by Hodler which are said to have revolutionized public opinion.— He seems to think a delay of a few months will be necessary to restore the peace. —I must admit that I find myself in a rather awkward position and this is why I am asking if you will do me the favor of getting in touch with these gentlemen,— *immediately* and see exactly what it is all about.—I will not conceal the fact that so much fuss in order to submit my work to public opinion makes me weary.[33]

Soon after, he wrote again:

Personally I think it is better to be forward and to give one's opinion completely and unreservedly, but I am dealing with an ill-favored committee and a hostile public. Is this worth so much trouble, worries, and expenses? At any rate the way I imagine it, the exhibition could be important, even unique (76 works) including nudes, landscapes, and a few interiors.—I will certainly never begin it over again anywhere else.[34]

The majority of reviews, in fact, dealt positively with the exhibited nudes, although some letters arrived from scandalized visitors who believed themselves to have strayed into a "bar" or "bathing establishment." And one critic asked: "Why must the four ladies in Nr. 59 [*Three Women and a Young Girl Playing in the Water*] bathe in ink?"[35] The museum itself purchased the earliest work in the exhibition, *The Visit* of 1899, which in its stylistic relationship to Vallotton's woodcuts was far less controversial than his nudes.

296
Cloud at Romanel, 1900
Oil on board, 35 x 46 cm
Musée cantonal des Beaux-Arts, Lausanne

Although the title of this retrospective exhibition emphasized Vallotton's place in French art, his birth and increased presence in Switzerland made him, in the eyes of the public, a Swiss artist.[36] Because of his close ties with both family and friends there, many Swiss museums—particularly those of Winterthur, Zurich, and Lausanne—had early access to his work and acquired significant collections that reveal the various stages of his development. When the Kunstverein Winterthur hung an exhibition in 1911 of all the works of art owned privately in Winterthur, Vallotton's representation with fourteen paintings was second only to Ferdinand Hodler. In 1914, two years before the opening of the museum's new, privately funded building, Hahnloser was already making plans for a "Cabinet Vallotton":

We now need something fresh and jolly to bring some colors to the walls. For we shall see in sequence: the woman with the parrot, the landscape with the bathers, our black painting on death, the portrait of the old woman that we'll also provide, one of the early little gray landscapes from the series of paintings on wood (which

our brother-in-law will donate). There will be enough paintings with heavy and dark colors.[37]

When the building opened, seven works by Vallotton credited as "private depositions," in addition to three owned by the museum itself, were on view.[38] That same year, 1916, three works selected by Vallotton for the Kunstverein Winterthur's exhibition of French art all sold. Previously, in 1913, he exhibited three works in the Turnus-Exhibition of the Schweizer Kunstvereins, and the Sektion Glarus bought, with state funds, his *Old Fisherman* of 1910 (LRZ 735). Recognition of Vallotton's art reached a new peak that year with the exhibition of forty-three of his most recent works at the Kunsthaus Zürich. Primarily landscapes and still lifes, they fascinated visitors with their exquisite, shimmering color, "full of the piquant appeal of the corporeal."[39] Such works as *Flirtation* (LRZ 785 or 837) and *Autumn Fire* (LRZ 817) of 1911, and such details as the sunny turns of a path or the shiny surfaces of objects were particularly lauded. According to the records of the Galerie Druet, almost a third of the works exhibited were already privately owned; one painting, *Plate* of 1911 (LRZ 779?), sold.

297
Washerwomen at Etretat (Women Drying Laundry on the Beach), 1899
Oil on board, 39 x 50.5 cm
Marianne Feilchenfeldt, Zurich

298
Portrait of Hedy Hahnloser, 1908
Oil on canvas, 82 x 62 cm
Private Collection

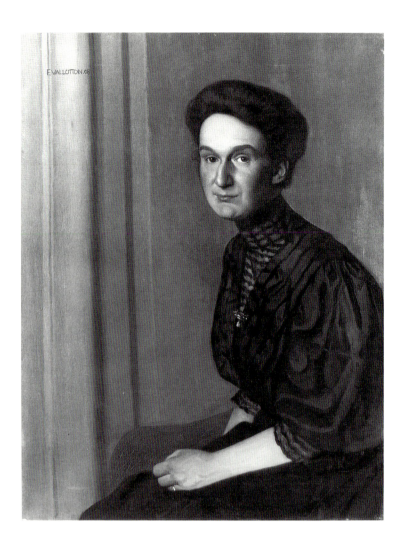

Despite such appreciation, Vallotton's French citizenship complicated his official recognition in Switzerland. In 1914, there were some negative reactions on the part of other Swiss artists to the possible purchase with state funds of Vallotton's *Woman with a Parrot* of 1909 (LRZ 674); and there were even attempts to prevent him from participating in the "Exposition Nationale." Vallotton wrote to his defenders: "I would never have thought it possible for my painting to cause so much stir, and to think I had to wait so long to run the risk of being rejected in Switzerland! This would not have been without a certain interest for posterity." [40] Richard Bühler, the Winterthur industrialist and Vallotton collector, defended the artist's inclusion in jury meetings while Vallotton himself stayed out of the fray; he, in fact, had to console his defender Hedy Hahnloser:

> I'd certainly rather have stayed at home and not sent anything there but it is obvious that fighting as much as you do without sparing anyone would get you into trouble. Consider the situation philosophically and in all this do not worry about me but of yourself alone and your own interests.—As for me, nothing in the work will shake me away from the route I have set and will untiringly follow. You cannot even imagine how much people who discuss, malign, or slander me leave me indifferent. They do not infuriate me any longer, and to be frank I save my energy for other worthy ideals and objectives rather than wasting my time in idle polemics. [41]

Vallotton found in Hedy and Arthur Hahnloser early and committed allies. They met in 1908 in Paris through a mutual friend, the Swiss painter Charles Montag, and they visited the Salon des Indépendants together. Presumably, it was Montag who encouraged the Hahnlosers to buy one of Vallotton's bathers. Although they were particularly enchanted by its colors against a gray wall and by the work's "unexpected spatiality," the painting occasioned much dismay among their friends, as Hedy Hahnloser reported to Montag: "By the way, the arrival of the 'Bather' created a great stir at the club, and very little enthusiasm."[42] Her extensive correspondence with Vallotton from 1908 to 1925 records their friendship, providing records of the artist's work, reports on events in Paris, and tales of his personal worries. The artist frequently stayed at the Hahnloser's home in Winterthur "Villa Flora" (plate 299)—where he painted Hedy's portrait in 1908 (plate 298), Arthur Hahnloser's in 1909, and their two children's in 1912. Vallotton described his relationship with Hedy Hahnloser as one of opposites: "[You are] an exuberant woman and I am a man who is a little bit disillusioned and doesn't believe much in the many things of which you are still passionately fond."[43] Nevertheless Hahnloser, who had briefly trained as a painter in Munich, found in Vallotton an untiring counselor and conversational partner. At first a teacher-student relationship characterized their friendship. And although her surviving letters suggest that she was fascinated by and perhaps infatuated with the artist, it is clear that for both their relationship was one of mutual affection and need: "You see then, my dear friend, that it is always the same thing that makes life precious to me. It is to feel connected to you and to your intentions both in your work and in your life"; "You still owe me so many answers to so many questions . . . I am happy to be, even in a small way, the confidante of your distress."[44]

299
"Villa Flora," Winterthur, ca. 1912
Hahnloser Archives

Vallotton certainly did not hesitate to burden Hahnloser with his worries, in letters that often sounded dark and pessimistic:

> Once again I must carry the burden of life and once again get accustomed to the strenuous conditions I have to face. It is painful and I need all the courage I have left. When I think of my life it is extremely solitary and disenchanted. This no doubt explains the acerbity and lack of joy in my painting. This will be my mark.[45]

Emphasizing that "the pleasure I find in talking and opening up a little to people exceeds any other," he even expressed some jealousy of the attention she paid such artists as Manguin and Bonnard, laying claim to a privileged bond with her —"Do not forget that I am your oldest and most faithful friend here, and write, won't you"—or simply requesting some news: "Send me some news and tell me what you are doing."[46]

From 1908 on, the Hahnlosers began to acquire many works by Vallotton each year, making their selections firsthand in Paris, or based on photographs sent by Druet or even on descriptions by the artist. Of the more than sixty works they owned when Vallotton died in 1925, their most daring purchases were certainly the painter's nudes: *The White and the Black, The Models at Rest* (1912; see plate 300), *The Rape of Europa*, and *Woman with a Parrot*.[47] In addition, Hahnloser tirelessly acted as Vallotton's intermediary and unofficial agent among her large circle of Swiss friends and acquaintances. She sought portrait commissions for him, accepting the risk that the models were, on occasion, so dissatisfied with the artist's interpretation that they destroyed the painting. Even rude comments about the nudes she had purchased did not intimidate her. So successful were

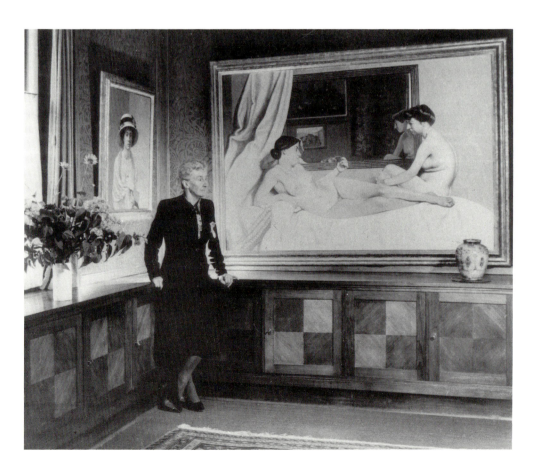

300
Hedy Hahnloser in the "Villa Flora,"
ca. 1942
With Vallotton's *The Models at Rest,* 1912
Hahnloser Archives

her efforts that prior to Paul Vallotton's establishment of his gallery in 1913, she often had to request another shipment of paintings from the artist.

One of Hahnloser's most eager converts was her cousin Richard Bühler, who owned *Mulatto in a Red Shawl* (1913; plate 144), *The Blue Shawl* (1912; LRZ 841b), *The Kremlin* (1913; LRZ 911), *Nude Holding her Gown* (1905; LRZ 539), *Pantheus* (1904; plate 222), and the beautiful late landscape *The Dordogne at Carrenac* (1925; LRZ 1565), among others. Industrialists Hans Schuler, Sydney Brown, and Friedrich Sulzer, all of whom had shown an early interest in the French Impressionists as well as van Gogh, Cézanne, and Gauguin, also made purchases through Hahnloser. Schuler bought his first Vallotton through her and his second, a still life, from the 1913 exhibition in Zurich. And in 1908, Brown dared to buy the controversial *The Turkish Bath* (1907; plate 274), which had been exhibited in the Salon des Indépendants as *Women Bathing*.

Hahnloser's efforts on Vallotton's behalf found their counterpart in the activities of Georges Hasen, one of the artist's most dedicated friends, collectors, and agents. A representative of the renowned Swiss chocolate firm Cailler, with which members of the Vallotton family were involved, Hasen had long lived in Russia. In 1908 he purchased Vallotton's *Interior, Bedroom with Two Women* (1904; plate 183); and *Woman Wearing a Black Scarf and a Black Hat* (1908; LRZ 637), one of six paintings by the artist included in the exhibition of French avant-garde art organized in Moscow that year by the newly founded art journal, *Zolotoe Rouno* (The Golden Fleece; plate 301). And in 1910, Hasen bought *Landscape at Arques-la-Bataille* of 1903 (plate 216), one of four Vallottons in a traveling exhibition of

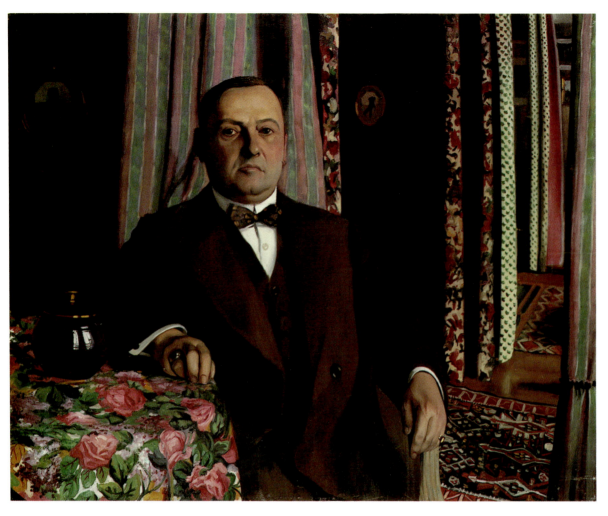

302

Portrait of Mr. Hasen, 1913

Oil on canvas, 81.5 x 100 cm

State Hermitage Museum, Leningrad

French art whose venues included St. Petersburg, Odessa, and Kiev. Hasen also commissioned a portrait of his wife in 1908, and one of himself in 1913 (plate 302). For the latter painting, Vallotton accepted his invitation to visit St. Petersburg. Letters to his brother Paul in Lausanne and to Hedy Hahnloser detail his enthusiasm for the Hermitage as well as his impressions of Moscow:

> I am interested in so many things here, not so much from the point of view of art but rather life and manners. The Kremlin is quite astonishing, savage and barbaric and also a bit comical. There you can find devotion which, although wretched, is quite moving; mud, pretty women, wonderful theaters. These are the clearest recollections of all.[48]

Upon his return to Paris, Vallotton completed five paintings—winter impressions of St. Petersburg and Moscow—based on rudimentary sketches. Betraying his sensitivity to color, they masterfully convey the cold, the northern light, the breadth of the architecture. His landscapes of St. Petersburg in particular exhibit a bold and unprecedented connection between strictly geometric architectural forms and atmospheric paint texture.

Nor did Vallotton lack for enthusiasts in Switzerland in the later half of the 1910s and the 1920s. In 1917, the young, impassioned collector Josef Müller, who would later become curator of the Kunstmuseum in Solothurn, bought his

303

Still Life, Red Peppers on a White Table,
1915

Oil on canvas, 46 x 55 cm

Kunstmuseum Solothurn, Dübi-Müller-
Stiftung

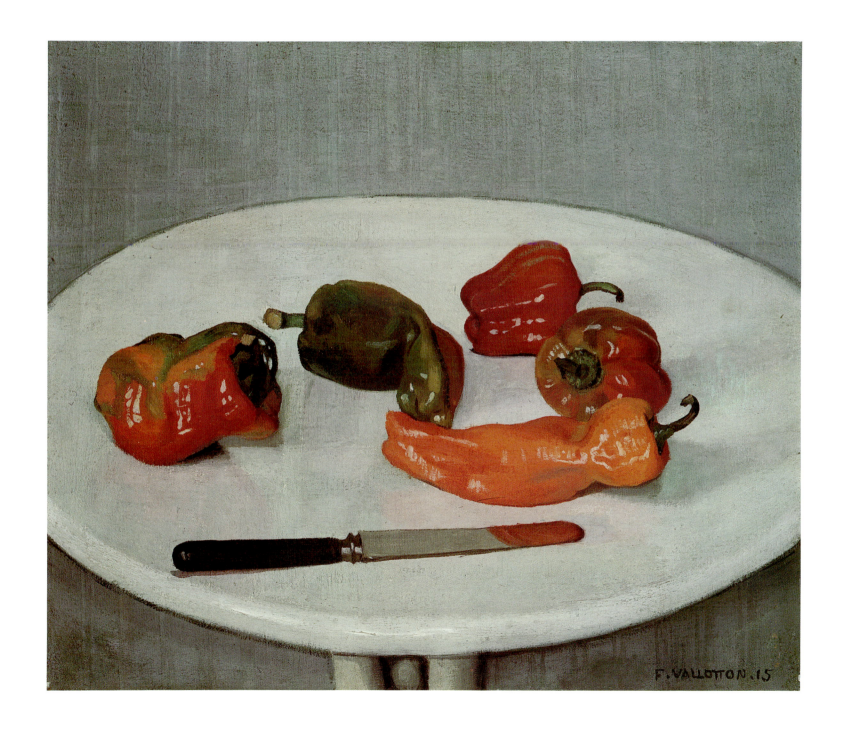

first paintings by Vallotton through Paul Vallotton: *Nude Lying on a Sandy Beach* (LRZ 658) and *Torso of a Young Woman Nude to Mid-Thigh* (LRZ 659?), both of 1908. A pioneering collector who bought works by artists from Renoir to Kandinsky, including Bonnard, Matisse, Picasso, Rouault, and Léger, Müller continued to collect paintings by young artists until his death in 1977. His appreciation for Vallotton's art continued unabated even after the war; in 1924 and 1926 in Paris he purchased, respectively, *Still Life, Red Peppers on a White Table* of 1915 at Jacques Rodrigues' (plate 303) and *Nude at the Stove* of 1900 at Alfred Vallotton's (plate 187); and as late as 1942 he purchased *The Turkish Bath* from Sydney Brown's collection. Willy Russ-Young, a chocolate manufacturer from Neuchâtel who like Müller had a penchant for the paintings of Ferdinand Hodler, discov-

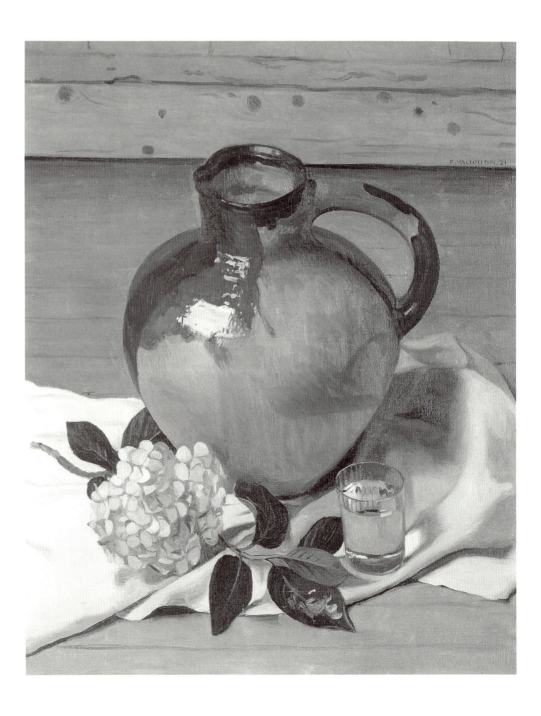

304
Jug and Hydrangea, 1921
Oil on canvas, 81 x 65 cm
Private Collection

ered Vallotton's work at Druet's while roaming through Paris. In 1912, he purchased *The Yellow Foulard* (1911; LRZ 776); four more works, selected with the help of Paul Vallotton, made their way into his collection, among them *Self-Portrait in a Dressing Gown* of 1914 (plate 142), now in the Musée cantonal des Beaux-Arts, Lausanne.

Paul Vallotton was also responsible in part for interesting Claribel and Etta Cone of Baltimore in collecting Vallotton's paintings. Financially supportive of Gertrude Stein, who introduced them to collecting before the war, the Cones purchased her portrait by Vallotton in 1926. And close contact with the family and the Galerie Paul Vallotton, especially between 1926 and 1929, led to their purchase of additional works, including the famous *The Lie* of 1898 (plate 170), three still lifes—*Still Life with Pitcher and Plate* (1887; LRZ 28), *Roses and Black Cup* (1918; LRZ 1160), and *Fish and Lemon* (1925; LRZ 1580)—one drawing, and four bronzes.[49]

Hahnloser continued to act as Vallotton's mediator even after Paul Vallotton's gallery opened in Lausanne; and it was only a month before his death that Vallotton ceased sending works to her, writing on 8 November 1925: "Thank you for the nice thought but I am determined not to send any paintings on deposit abroad."[50] His discouragement had already been evident in a letter sent several months earlier, in which he had asked her for a report on his affairs:

> Would you be so kind as to carefully sort out my affairs in Winterthur so that no difficulty ever occurs in any foreseeable circumstances . . . One complains here of the poor state of affairs. Rising expenses without an increase in business is a constant source of worry for me. I find life very difficult and the future rather alarming especially when old age is approaching and illusions vanish.[51]

Such despair in the final months of the artist's life perhaps contributed to Hahnloser's assertion, in her 1936 monograph, that "in Switzerland, no one has understood the importance of Vallotton's investigations."[52] For although such a claim could be made of his posthumous standing there, it did not fairly describe the appreciation and acclaim he was accorded in his lifetime. His participation in a 1910 exhibition at the recently opened Moderne Galerie of Heinrich Tannhauser in Munich, for example, earned him laudatory reviews in Swiss as well as German publications.[53] His landscapes in particular—*Cloud at Romanel* of 1900 was among those exhibited—were singled out as the most accessible, least problematic of his paintings:

> Vallotton has appeared collectively in Munich several times, but most impressively in the Secession exhibition. But nothing has yet made such a favorable impression as what can be seen in his present exhibition in the Moderne Galerie . . . Surely one can find much to appreciate in the figural works, which despite their objectivity of form and color possess something strangely stylized and appear cool and still like old frescoes. But I, your reporter, felt most drawn to the landscapes, and particularly to those that quite simply, almost factually sober and yet not without a romantic and personal intonation, recreate the impressions of nature.[54]

A second anonymous Swiss critic noted further:

> There are several figural representations among them. The forms are wonderful, but the manner of painting is strangely hard and dry. Vallotton represented himself quite differently as a painter of landscapes . . . How differently good French Impressionism affects us compared to that of the Germans! There, the feeling that we are confronted with something strange, something that has been

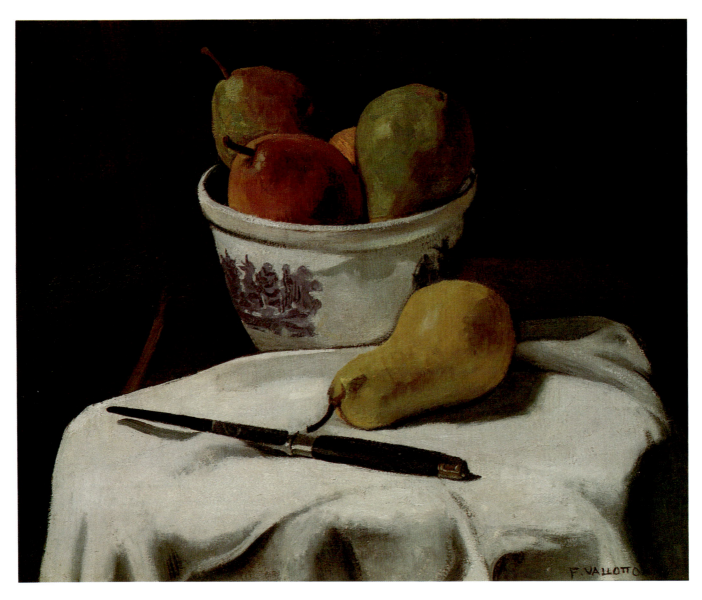

305
Still Life, Pears in a Japanese Bowl, 1914
Oil on canvas, 46 x 55 cm
Private Collection

taken over, often does not leave us; in front of paintings such as those of Vallotton, however, one truly has the impression that, as a local art critic expressed it, "an inner, physiological characteristic of race" is involved. Vallotton paints absolutely everything in nature; and for each new subject has a new form that does it justice. One can no longer speak of an intentional style or manner.[55]

In fact, Vallotton's significance in Switzerland extended beyond that of his own work. Serving not only as Hahnloser's adviser but as a tireless counselor to his brother when Paul became an important distributor of French art in Switzerland, he occupied a key role in the understanding and dissemination of avant-garde French art there. According to Marina Ducrey: "He gave copious advice on which painters to represent and how to determine prices, and reported interesting offers to his brother. He shared with Paul his long experience in the art trade."[56] Nevertheless, the Swiss had difficulty in accepting modern works of art. On the occasion of the first Vallotton exhibition organized by the artist's brother in 1914, Paul Budry, the young art critic from Lausanne commented: "Among all the methods of selling art—the surest being to flatter mediocrity—he has

Still Life with Large Jug, 1923
Oil on canvas, 81 x 65 cm
Galerie Vallotton, Lausanne, Private
Collection

chosen what I believe to be the most perilous and the most disinterested, intending to educate a new taste by forcing van Dongens and Félix Vallottons on a bourgeoisie that allows its art museum to die and sees no further than a print from Lory for ancient art, no further than the *Gazette du Bon Ton* for modern." Budry well understood the difficulty that Vallotton's work in particular raised: "Anyone who saw images by Renoir, Guérin, van Dongen, or Vuillard on these walls is scandalized by Vallotton's harsh methodism. It asks us not least of all to give up our love of Impressionism, which it aggressively insults."[57]

In his art as well as his life, distance and alienation were the means by which Vallotton gave shape to his emotions and his themes. Physically removed from his homeland, he was paradoxically more highly recognized there than in Paris, the scene of his work, the city where he felt he belonged. He clearly needed the inspiration it provided: "Paris is stimulating and invigorating; it's a core dispensing energy. I feel it myself."[58] And yet he complained repeatedly of loneliness in his closest surroundings. In his later years, distance from the new French avant-garde certainly contributed to this alienation, which by then had become professional as well as personal.

307
The Beautiful Florence, 1906
Oil on canvas, 81 x 65 cm
Private Collection, Basel, Switzerland

The stylistic sense of remove that increasingly characterizes Vallotton's work, with its spare expression of an impersonal and almost cosmic silence, must be in part attributed to the rigorous separation he maintained between his art and his life. After the war, he still wrote optimistically to Hedy Hahnloser:

> The show was a real success. The result was perfect. Mme. Druet who had sold almost all my paintings came back to get some more. It is going extremely well. One could even say that they are all the rage.—It is high time and I have waited long enough. All this makes me all the more happy that you have always encouraged me and never denied me your support.[59]

But in his private journal, even such successes were dismissed as insignificant, as he grew increasingly pessimistic about his achievements. Without embellishment and with a dark prescience, he noted there in 1920: "Already I see dust accumulating around me; I belong to a past whose dim light barely survives among the brass bands and the big drum of the modern. I consider this without melancholy, and there are days when I wish I could push on the wheel of time and hasten the end."[60]

What exactly is the meaning of Vallotton's disturbing works, so unsettled by what Maurice Besset has termed their "cold figuration" their "poetics of separation, of distance"?[61] Even Vallotton's contemporaries struggled with the definition of his artistic mission. In a 1914 collection of essays on young artists, including Cubists and Futurists, Gustave Coquiot formulated a precise judgment on the effect of Vallotton's art, one that is certainly a model for future considerations of the artist's work:

> He disdains artifice and trickery. He even ignores the skillful devices employed by so many of his colleagues. The form of his nude figures is austere and their sensuality carefully veiled. This sensuality yields itself only after a long meditation or remains otherwise hidden. Its aim is neither to catch the eye, nor to please. Its aim is to provoke thought. And yet M. Félix Vallotton's art is not the art of a preacher. It simply demands to be considered with reflection and slowly appreciated like a delicacy. It is not addressed to superficial minds easily captured by reds, blues, and yellows. It is addressed to the wise.
>
> It may be a Protestant art; but above all it is a Protestant art that has ceased to be rough or stern when in contact with Paris and other enviable countries visited by M. Félix Vallotton.[62]

Vallotton's aggressive pictorial formulations always captivated and challenged his audiences, whether the latter admired or rejected his art. The artist thereby achieved a great deal of attention, a good dose of irritation and, looking ahead, a surprising modernity. Although he worked within universally accepted and effective pictorial traditions whose underlying familiarity engaged the viewer, the extent of his stylization and deformation, as well as his reinterpretation of pictorial hierarchies, prevented a sentimental, emotional response to his works. Thus he realized in his art what Bertolt Brecht represented on the stage: the alienation from common patterns of sight and thought. It is in this achievement that Vallotton, whose work provoked the most violent reactions during his lifetime, clearly takes his place in the twentieth century.

Deborah L. Goodman

Chronology

1865
Born December 28 in Lausanne to a Protestant family. Son of Emma Roseng and Armand-Adrien Vallotton, a dry-goods store proprietor who, a few years after the birth of his sons, bought a chocolate factory. Félix was the third of four children: Henri, the oldest, died in childhood; Paul was born in 1864, Hélène, the youngest, in 1867.

1875
Enters Collège Cantonal in Lausanne. Receives a degree in classical studies in 1882.

1881
Makes his first known print, a drypoint (VG 221) after a portrait etching by Jean-Jacques de Boissieu (1736–1810).

1882
Moves to Paris; rents a 2-room apartment near the rue Jacob (6e arrondissement in the Saint-Germain-des-Près neighborhood). Enrolls in February at the Académie Julian, where he studies under Jules Lefebvre (1836–1911), a portraitist and genre painter, and Gustave Boulanger (1824–1888), a history painter. Vallotton's first friend in Paris is Dr. Moret, an oculist with whom he visits the Louvre on Sundays. He will henceforth return annually to Switzerland for vacation.

1883
Accepted 4th out of 70 to the Ecole des Beaux-Arts, but chooses to stay at the Julian. Begins friendships with Charles Maurin (1856–1914), a genre painter, portraitist, and printmaker (woodcuts) who had studied with Lefebvre and was teaching at the Julian; and Félix Jasinski (1862–1901), a Polish printmaker and painter.

1884
Moves in October to 18 bis, avenue Denfert-Rochereau (14e arrondissement, near Montparnasse).

1885
Begins his *Livre de raison* ("List of my works, paintings and prints, in chronological order from 1885"), a log of his artistic output.[1] Participates in first public exhibitions at the Salon des Artistes français (*Portrait of Monsieur Ursenbach* [plate 114]) and the Salon suisse des Beaux-Arts in Geneva (*Portrait of an Old Man*). He will continue to send paintings to Swiss exhibitions throughout his life.

1886
Receives an honorable mention at the Salon des Artistes français for his self-portrait (plate 115).

1887
Makes copies at the Louvre of works by Antonello da Messina, Leonardo da Vinci, and Albrecht Dürer. Exhibits *Félix Jasinski Holding his Hat* (plate 120) and *The Artist's Parents* (plate 116) at the Salon des Artistes français. Lefebvre, who had considered proposing Vallotton for the *Prix de Rome*, disapproves of the former painting and becomes less supportive. Vallotton distances himself from the Académie Julian. Begins association with Toulouse-Lautrec. Moves twice, to 27, rue Jacob in January, then to 32, rue de Vaugirard (near Montparnasse).

1888
Convalesces in Zermatt, Switzerland from an illness referred to as a nervous breakdown; is henceforth subject to a nervous condition. Contemplates moving to America to earn more money.

1889
Makes etchings after Rembrandt and Millet. Begins relationship with Hélène Chatenay, a working-class woman who appears in some of his paintings (*The Sick Girl*, *The Kitchen* [plates 8, 6]), and with whom he will live until 1899. Receives his first print commission, to make a photographic copperplate etching for the publisher Jourdan et Babot. Represents Switzerland with three portraits and one

etching at the Exposition universelle in Paris, receiving an honorable mention for his *Portrait of Monsieur Ursenbach*. Summers in Les Charbonnières and Lausanne; moves in October to 60, rue des Saints-Pères (6e arrondissement).

1890
Experiences financial difficulties; takes a job in conservation for art dealer Henri Haro. Writes his first art criticism for the *Gazette de Lausanne* (on the Exposition des Artistes Indépendants, Paris), where he discusses a painting by Toulouse-Lautrec, *At the Moulin Rouge, The Dance*: "I immediately discovered a notable painting by M. Lautrec. It is one of Degas' low-life figures, but the force or rather the understanding of the drawing grabs you."[2] Vallotton will write regularly for the *Gazette* until 1897. Visits Germany, Vienna, Trieste, and Prague with cousin and aunt Mathilde (September).

1891
Makes his first woodcuts; sells woodcuts to book and print dealers Edmond Sagot and L. Joly. Inspired by the exotic landscapes of the Douanier Rousseau at the Salon des Indépendants, Vallotton is one of the first to give this artist a favorable review: "In spite of those doubled up with stifled laughter . . . Rousseau becomes more and more astonishing each year, but he commands attention and, in any event, is earning a nice little reputation . . . In addition he is a terrible neighbor, as he crushes everything else. His tiger surprising its prey ought not be missed; it's the alpha and omega of painting and so disconcerting that the most firmly held convictions must be shaken and brought up short by such self-sufficiency and childlike naïveté."[3] Visits Epinay-sur-Orge (July).

1892
Increases his artistic activity, producing twice the number of prints as in 1891. Secures first commissions for his woodcuts: "It appears my woodcuts are making their small way in the world, and are making me well known. It is true that they don't earn me much; the agents refuse to give me a receipt and I am at their mercy."[4] Octave Uzanne's "La Renaissance de la gravure sur bois: un néo-xylographe, M. Félix Vallotton" appears in *L'Art et l'idée* (February). Sells woodcuts to Galerie Boussod et Valadon (April). Begins work on *Immortels passés, présents ou futurs* (Immortals past, present or future), a series of 16 lithographic portraits published by L. Joly from 1892 to 1894. Becomes affiliated with the Nabi brotherhood along with Charles Lacombe; Pierre Bonnard, Edouard Vuillard, Ker-Xavier Roussel, and Maurice Denis are already members. Visits Ballancourt with Hélène Chatenay; Jasinski is their neighbor (summer).

1893
Makes a woodcut, *The Demonstration* (plate 56) for *L'Estampe originale*, and woodcuts and lithographs for *L'Escarmouche*. Considers marrying Hélène Chatenay. Disputes with Jasinski over collaboration on an etching for the Société des Amis des Beaux-Arts of Cracow, a reproduction of *The Constitution of 3 May 1791* by the Polish artist Jan Matejko. The print was rejected by Matejko and the Society, and Jasinski refused to split the commission fairly. Exhibits *Bathers on a Summer Evening* (plate 148) at the Salon des Indépendants. Nine years later, the painting was purchased by the dealer Ambroise Vollard. Begins lifelong friendship with Edouard Vuillard (1868–1940); exhibits with the Nabis in the "Exposition des Artistes Impressionnistes et Symbolistes" at Le Barc de Boutteville and will continue to exhibit with them until 1903.

1894
Collaborates on *Le Courrier français* (January–May). Does illustrations for *Le Rire* and the *The Chap Book* (Chicago). Makes a stained glass design for Siegfried Bing: *Parisiennes* which was executed by Tiffany and exhibited first at the Salon de la Société nationale des Beaux-Arts in April 1895 and then at Bing's Salon de L'Art Nouveau in December 1895. Designs the lithographic program cover for a performance of August Strindberg's *The Father* at Lugné-Poe's Théâtre de l'Oeuvre (14 December). Joly publishes his set of 7 zincographs, *Paris Intense* (plates 66, 68–73). His woodcut *Three Bathers* (plate 158) appears in the February issue of *La Revue blanche*. Becomes friendly with that publication's circle: the Natanson brothers, Octave Mirbeau, Jules Renard, Remy de Gourmont, Félix Fénéon. Exhibits with the Nabis at the Paris offices of the newspaper *La Dépêche de Toulouse* (May). Travels to Belgium and Holland with the sculptors Rupert Carabin and Alexandre Charpentier, the architect Henri Sauvage, and the painter Francis Jourdain (February). Visits Chambly in June and spends the summer in Saint-Trojan, Ile d'Oléron.

1895
Moves to 11, rue Jacob (January). Becomes artistic director of the *Revue franco-américaine* of Prince André Poniatowski. Meets the art historian Julius Meier-Graefe. His prints appear for the first time in *Pan* (Berlin) and *Die Jugend* (Munich).

1896
Makes illustrations for Octave Uzanne's *Les Badauderies parisiennes: Rassemblements, Physiologies de la rue* (Parisian Curiosities: Gatherings, Physiologies of the Street; plates 77, 79, 81, 83). Illustrates Otto Julius Bierbaum's *Die Schlangendame* (The Serpent Woman; Berlin), his first important collaboration on a foreign publication; Jules Renard's *La Maîtresse* (The Mistress); and Remy de Gourmont's *Le Livre des masques* (Book of Masks). Meets Gabrielle Rodrigues-Henriques (b. 1864)—the daughter of the Paris art dealer Alexandre Bernheim, and a widow with three children— when she asks Vallotton to paint a portrait of her daughter. His

308. Roussel, Vuillard, Romain Coolus, and Vallotton, ca. 1896

woodcut, *To Fe. Dostoyevsky* (VG 163), is refused at the Salon du Champ-de-Mars, Paris. The critic Roger Marx criticizes this rejection in *Le Voltaire*: "The author [Vallotton] was one of the architects of the emancipation of the woodcut that we enjoy today; his decisive role in this liberating development merited being highlighted; he was excluded without consideration for his profound science, without taking note of the exquisite quality of his irony, and this, at the very moment when the Salon du Champ-de-Mars boasts of welcoming the humorists and satirists."[5] Participates in Bing's second Salon de L'Art Nouveau. Travels to Brittany. Visits Camaret (January–February), Locquirec (June–July), and the Natansons in Valvins (July). Vuillard and Bonnard visit him in Switzerland (August).

309. Vallotton with Hélène Chatenay (right) and Eugénie, the friend of Maurin (left), ca. 1897

1897

Begins a six-year collaboration on *Le Cri de Paris*, directed by Alexandre Natanson (February, until June 1902). Vallotton, Bonnard, and Vuillard become closer with Thadée and Misia Natanson, whom Vallotton and Toulouse-Lautrec visit at Villeneuve-sur-Yonne. Paints Thadée Natanson's portrait (plate 125). Writes final review for the *Gazette de Lausanne* on Holbein exhibition in Basel.

1898

Paints *The Bon Marché* (plate 166), which he exhibits at the Galerie Vollard. Meier-Graefe publishes the first monograph on Vallotton's graphic work, in French and German, in which he makes one of the first references to Vallotton's interest in Ingres: "In returning to Ingres, Vallotton seeks to reconquer the same elements of painting. But he does not return to Ingres' time, on the contrary, he seeks to remodel these elements, giving them a modern form and expression in order to make them the source of the artistic feelings that move us now."[6] Vallotton's series of 10 woodcuts, *Intimités*—published by *La Revue blanche* and exhibited at their offices—prompts Thadée

Natanson to describe him in that journal as "a poet who is at once discerning and gay, bitter and voluptuous."[7] He makes the cover image *The Age of Paper* for the pro-Dreyfus journal *Le Cri de Paris* (23 January 1898; plate 32) and illustrates Remy de Gourmont's second *Livre des masques*. Visits Saint-Gilles-sur-Vie (July). Decides to dedicate his time exclusively to painting.

1899

Exhibits six *Intimités* paintings at the Galerie Durand-Ruel. Vallotton marries Gabrielle Rodrigues-Henriques (May 10), writing to his brother: "[Her family is] among the most honorable, and wealthy. The two brothers run the business on rue Laffitte; the other sister is married to a Monsieur Aghion who is very wealthy but otherwise unimportant. She does not have a great fortune, but a pension that assures her and her children a living. Their future is guaranteed by the family. I will add the contribution of my work, which will increase, and I will be strongly supported you would think by her family, whose profession it is and who are very friendly toward me . . . I love her, which is the main reason for this marriage, and she does me; we know each other well and trust each other completely."[8] Vallotton visits Switzerland to introduce his wife to his family (May). Maurin considers the marriage a capitulation and ends their friendship. The Vallottons move in June to a large apartment with a studio above at 6, rue de Milan (9e arrondissement, in the Opéra neighborhood). They summer in Etretat, joined by Vuillard and the Natansons. Vallotton exhibits at the Vienna Secession. Contributes an illustration to Jean Grave's anarchist journal, *Les Temps nouveaux*.

310. Vallotton, ca. 1899, Vallotton Archives

1900

Becomes a naturalized French citizen (3 February). Receives two postage stamp commissions for Switzerland. Does illustrations for *Le Cri de Paris* and woodcuts for *Scribner's* (New York). Rents the Château de la Naz, at Romanel near Lausanne, where he is joined by his stepson Max Rodrigues; the art dealer Jos Hessel (Gabrielle's cousin), his wife Lucy, and his sister; Vuillard; and the actress Marthe Mellot (July–October). Visits his parents in Bex.

311. Félix and Gabrielle Vallotton, ca. 1900

1901

Visits Marseilles, Cannes, Nice, Honfleur; spends a few weeks with the Natansons in Croix-de-Garde above Cannes (January). Visits Vuillard and Roussel at l'Etang-la-Ville. Summers at the Villa Beaulieu in Equemauville near Honfleur.

1902

Visits Locquirec in Brittany, where he paints 24 landscapes (June–July). Visits Jos and Lucy Hessel with Vuillard, at Villa les Etincelles, Criqueboeuf (September).

1903

Moves to 59, rue des Belles-Feuilles (16e arrondissement, near Bois de Boulogne). *La Revue blanche* closes. Remains in contact with Bonnard, Roussel, and Denis over the years but maintains a close friendship only with Vuillard. Exhibits *The Five Painters* (plate 130) at the Salon du Champ-de-Mars. Exhibits at the Vienna Secession and receives a letter of congratulations from the founding members, among whom are Klimt and Hodler. Is one of the founding members, with Vuillard, of the Salon d'Automne, where he will exhibit annually. Has joint show with Vuillard at the Galerie Bernheim-Jeune. Visits Arques-la-Bataille in Normandy (summer).

1904

Makes group of four bronze statuettes. *Interior, Woman Fixing Her Hair* is acquired by the state (Musée des Beaux-Arts, Dijon). His one-act play, "Un Homme très fort" (A Very Strong Man) is presented at

the Théâtre de Grand Guignol (1 February); "La Part du feu" (The Sacrifice) is rejected by the Comédie française. Visits Brussels and Holland (April) and Varengeville (July–September).

1905

Friendships with Manguin, Marquet, Guérin, and Laprade. Ingres and Manet retrospectives at the Salon d'Automne. Exhibits *Nude Reclining on a Yellow Cushion* (plate 287) at the Salon des Indépendants; critiqued by Louis Vauxcelles—"Of all these nudes, the only laughable one is that of a beautiful creature reclining in a pose immortalized by Titian and the author of the *Maja desnuda*"[9]— the work is purchased that year by Leo and Gertrude Stein. Rents a chalet in Montbarry near Gruyère (June–September). Winters at Cimiez, near Nice.

1906

First purchases by the dealer Eugène Druet. Solo exhibition at the Galerie Bernheim-Jeune; critic C. F. Ramuz writes, "M. Vallotton proceeds from Ingres . . . There is no boldness that it [his painting] doesn't dare to make, so great is his art; it seems to take pleasure in the most formidable foreshortenings; however, it displays no feeling. On the contrary, it always maintains this maladroit, dare I say classical, appearance that comes from the subordination of the hand to the mind, the enemy of facile effects."[10] Summers in Cabourg. Visits Rome, Florence, and Pisa (August–October); henceforth makes nearly annual visits to Italy in the spring or fall.

1907

His one-act play "Un Rien" (A Nothing) is presented at the Théâtre de l'Oeuvre (18 May). Writes *Un Meurtre* (A Murder), a semi-autobiographical novel, published posthumously as *La Vie meurtrière* (The Murderous Life) in *Le Mercure de France* (1927). *Portrait of Gertrude Stein* (plate 139), exhibited at the Salon d'Automne, is noticed by Guillaume Apollinaire: "Much to our regret, M. Vallotton is not exhibiting the portrait of a wealthy Protestant lady from Switzerland who insisted on taking out her dentures during her sittings: 'It would not be honest to paint my teeth,' she said, 'In fact, I have none. The ones that are in my mouth are false, and I think that a painter should paint only what is real.'"[11] Visits Rome and Naples (May), Guernesey (August).

312. Vallotton with his parents in their home in Broc, 1907

1908

Meets Hedy and Dr. Arthur Hahnloser, who buy a *Half-length Bather* for 700 francs (May); visits them frequently at their home in Winterthur. Hedy Hanhloser, the artist's future biographer, and his brother Paul Vallotton, begin to circulate his work in Switzerland. Exhibits for the first time at the Galerie Druet, in a group show; submits *The Rape of Europa* (plate 38) to the Salon d'Automne, where it is hung in the same room as the works by Matisse. The critic Pierre Hepp writes: "It is clear that M. Vallotton obeys a hidden internal fatality and that his intelligence is not disposed to the guise of aptitudes that were granted to him in the cradle. He can only advance between the severe shafts in his implacable will. From where does this conviction, this mournful audacity that breathes in his vintage works, come? *The Rape of Europa* is a blunt affirmation that it clings to defiance."[12] Exhibits six paintings at the "Zolotoe Rouno" (Golden Fleece) exhibition in Moscow; sells a copy of *Dinner by Lamplight* of 1900 (plate 136). Visits Venice and Perugia (September).

1909

Signs contract with Druet and becomes associated with the *"premier groupe"* of the gallery: Albert André, Maurice Denis, Hermann-Paul, Pierre Laprade, Henri Lebasque, Aristide Maillol, Odilon Redon, Théo van Rysselberghe, Paul Sérusier, and Louis Valtat (January). Teaches at the Académie Ranson with Vuillard, Bonnard, Roussel, and Denis. Again rents the Villa Beaulieu in Honfleur, where he will spend summers henceforth. First solo museum exhibition, at the Künstlerhaus in Zurich, to which he sells *The Visit* (plate 177). Sales to Swiss collectors increase.

1910

Hélène Chatenay dies of a stroke. First one-man show at the Galerie Druet; Octave Mirbeau writes the preface to the catalogue: "M. Vallotton has a clear, precise, very informed, very cultivated, and very passionate mind. A sharp observer, sometimes a bit bitter because of his sensitivity to people and things, he enjoys playing among ideas, and he adds grace, force, wit, and profundity to this game."[13]

1911

Travels to Cologne, Berlin, Dresden, Munich (February). In Honfleur meets and begins close friendship with the painter and illustrator Paul-Elie Gernez (1888–1948).

1912

Offered, with Bonnard and Vuillard, the *Légion d'honneur;* all refuse it. Second solo exhibition at the Galerie Druet is well received by the critics. Apollinaire's review notes analogies between Vallotton's work and that of the Douanier Rousseau: "M. Vallotton imitates him lovingly, as is evident in his *Cart*, his *Poplars*, his *Ravine*, and many other canvases, not to mention the still lifes. Rousseau would have been delighted to have such a pupil, but I do not think he would have wanted to sign any of these paintings."[14]

1913

Travels to St. Petersburg and Moscow at the invitation of the St. Petersburg representative of the Cailler chocolate company, Georges Hasen, whose portrait he paints (plate 302). Travels to Rome and Perugia (fall). Paul Vallotton benefits from his brother's relationship to the Bernheim family and opens a branch of the Bernheim Gallery in Lausanne in the Galeries du Commerce, where he sells modern French and Swiss paintings (March). Exhibits three paintings at the Armory Show, New York (two in Chicago). Paints *The White and the Black* (plate 196).

313. Vallotton in his studio at rue des Belles-Feuilles, 1915

1914

Solo exhibitions at the Bernheim-Jeune Gallery, Lausanne and at the Galerie Druet. Begins a personal journal in May which he will keep until the end of 1921. The war breaks out while Vallotton is in Honfleur (August). Refused admittance to the army due to his age, he works briefly as a stretcher-bearer. By November both the Galerie Druet and the Galerie Bernheim have closed; Druet reopens in the spring of 1915. Vallotton experiences financial difficulties as sales of his paintings decrease.

1915

Executes first series of woodcuts since 1901, *C'est la guerre!* (This is War!), which he hopes to sell on his own. The war brings him closer to his wife, whose son Jacques is taken prisoner (January); her second son Max enters the army (April) and is injured in June. Vallotton attends a court-martial. He and Gabrielle visit Paul Vallotton in Lausanne (March).

1916

Eugène Druet dies. Vallotton meets the artist, illustrator, and critic Louise Hervieu, who becomes a good friend. Goes to Dax-les-Bains for a cure for sciatica. Visits Honfleur, Les Andelys.

1917

Second stay in Dax-les-Bains. Paul Budry publishes first important study on Vallotton in the Geneva journal, *Pages d'art* (April). Goes on an artistic mission to the front at Champagne. Publishes "Art et Guerre" in *Les Ecrits nouveaux* (December 1).

1919

Visits Switzerland and Brittany. Jacques Rodrigues begins to sell works by his stepfather in Paris. Four paintings, including *Portrait of Thadée Natanson* sell poorly at auction at the Hôtel Drouot (March 2). Rupture with Thadée: "I feel my art in complete disfavor among

art lovers, but I have certain sentimental support from the young who console me a bit for this brutal ostracism. Nevertheless I have a lump in my throat and anxieties. If I sell nothing it will be a catastrophe. Why all these hostilities?"[15] However, Vallotton can count on a circle of private collectors interested in his work: Charles Pacquement, Marcel Guérin, Paul Gallimard, and Pierre Goujon in Paris; the Hahnlosers and Richard Bühler in Winterthur; Joseph Müller in Solothurn. Solo exhibition at the Galerie Druet. Exhibits the triptych *Hope, Crime Punished, Mourning* (plate 244) at the Salon d'Automne. Visits Sierre, Saint-Malo, Dinan. Henri de Régnier, commissioned by Bernheim-Jeune to write poems about the gallery's artists, emphasized the various types who made up Vallotton's portrayal of Paris street life:

Cent masques, en leurs traits particuliers surpris,
Dont un livre fameux se commente et se pare
Et chacun avec sa ressemblance et sa tare
Sont là. Feuillette-les, Lecteur! Songe ou souris.

Puis voilà, jeunes, vieux, teints jaunes ou fleuris,
D'autres visages, l'un sinistre, l'autre hilare,
La Femme qui minaude et l'homme qui se carre,
Modernes Apollons et bourgeoises houris.

Devant vous gravement l'artiste que le vrai
Attire et persuade à son désir sacré
Se recueille et vous voit sans amour et sans haine.

Vous connaissez l'âpre plaisir, ô VALLOTTON,
Que le modèle soit Dulcinée ou Gothon,
De lire de la vie en toute face humaine.[16]

1920

Works in Avignon. Experiences extreme depression: "Attack of depression and gloom; I feel weary as I have never felt before, and of everything. I am indifferent to painting, people pester me and I avoid one after another, finding comfort nowhere."[17] Stays in Cagnes (November–April 1921) where he is happy, the first of many visits there until his death. Invited to exhibit at the Carnegie Institute International Exhibition in Pittsburgh, but receives notice from the organizer that the jury has rejected his submission, *The Library* (April). He writes a letter to the journal, *Bulletin de la vie artistique* criticizing this decision, which he claims was made not because of his painting but because the status-conscious committee had learned that he had no prestigious awards to put by his name in the catalogue. Paul organizes an exhibition at his gallery in Lausanne, which receives considerable attention. André Salmon writes of Vallotton in *L'Art Vivant*: "That which is most dramatic in this painter's experience is this: an artist, particularly sensitive to unspontaneous lyricism—the perfect illustrator of Jules Renard—he arrived there by defying the picturesque. Félix Vallotton's restlessness was the fruit of a slowly acquired wisdom."[18]

315. Félix and Paul Vallotton in Champéry, 1921

1921

Visits Tourcoing. Five days before his fifty-sixth birthday he writes: "Life is a vapor, one struggles, deludes oneself, hangs on to phantoms that slip from one's grasp, and death is there."[19]

1922

Works in Cagnes. Paul breaks with the Bernheim-Jeune Gallery and founds the Paul Vallotton Gallery (December 19).

1923

Visits the Loire, Cagnes, and Avallon. His stepson Jacques Rodrigues-Henriques organizes a retrospective of Vallotton's prints (with Hermann-Paul).

1924

Works in Cagnes, Vence, Les Andelys, Berville, Deauville, and Villeneuve-Loubet.

1925

Visits Dordogne. Summers in Honfleur. Takes care of his affairs and destroys numerous letters, documents, paintings, and wax sculptures before entering the hospital in Neuilly for cancer surgery. Dies December 29, the day after his sixtieth birthday, and is buried in the Montparnasse cemetery.

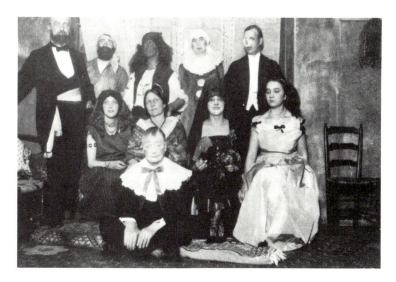

314. Vallotton (seated in front) as a clown, Cagnes, ca. 1920

Notes

The following abbreviated references for frequently cited works are used throughout the Notes:

DOCUMENTS 1, *DOCUMENTS 2*, or *JOURNAL*: Gilbert Guisan and Doris Jakubec, eds., *Félix Vallotton: Documents pour une biographie et pour l'histoire d'une oeuvre* 1, 1884–1899; 2, 1900–1914; 3, 1914–1921 (Paris-Lausanne: La Bibliothèque des Arts, 1973–75). All references are to page numbers.

DUCREY 1989: Marina Ducrey, *Félix Vallotton: La Vie, la technique, l'oeuvre peint* (Lausanne: Edita, 1989).

ETUDES DE LETTRES: Gilbert Guisan and Doris Jakubec, eds., "Félix Vallotton, Edouard Vuillard et leurs amis de La Revue blanche," *Etudes de lettres* (Lausanne), 3d series, vol. 8 (October–December 1975).

HAHNLOSER 1936: Hedy Hahnloser-Bühler, *Félix Vallotton et ses amis* (Paris: Editions A. Sedrowski, 1936).

LRZ: Félix Vallotton, *Livre de raison*; published in *Félix Vallotton. 1865–1925*, exh. cat. (Zurich: Kunsthaus, 1938).

MEIER-GRAEFE 1898: Julius Meier-Graefe, *Félix Vallotton: Biographie de cet artiste avec la partie la plus importante de son oeuvre editée et différentes gravures originales & nouvelles* (Berlin: J.-A. Stargardt; Paris: Sagot, 1898).

VG: Maxime Vallotton and Charles Goerg, *Félix Vallotton: Catalogue raisonné de l'oeuvre gravé et lithographié* (Geneva: Editions de Bonvent, 1972).

LA VIE MEURTRIÈRE: Félix Vallotton, *La Vie meurtrière*, 2d ed. (Geneva and Paris: Editions des Trois Collines, 1946).

Introduction

All translations, unless otherwise noted, are by the author.

1. For a good overview of French politics and culture at the turn of the century, see: Theodore Zeldin, *France 1848–1945*, 5 vols. (Oxford: Oxford University Press, 1973–81); Eugen Weber, *France: Fin de Siècle* (Cambridge: Harvard University Press, 1986); Jerrold Seigel, *Bohemian Paris: Culture, Politics, and the Boundaries of Bourgeois Life, 1830–1930* (New York: Penguin Books, 1986); and Charles Rearick, *Pleasures of the Belle Epoque: Entertainment & Festivity in Turn-of-the-Century France* (New Haven: Yale University Press, 1985).

2. *"Je ne suis qu'un spectateur, un passant qui se promène sur la grand'route de la vie s'intéressé aux batailles des insectes humains.*

J'observe les manifestations diverses du mouvement social, en philosophe incapable de haïr. Je ne mandais pas, je constate" (Victor Joze, *Les Rozenfelds, histoire d'une famille juive: La tribu d'Isidore* [Paris: Antony, 1897]; quoted in Phillip Dennis Cate, "The Paris Cry: Graphic Artists and the Dreyfus Affair" in *The Dreyfus Affair: Art, Truth & Justice*, ed. Norman L. Kleeblatt [Berkeley: University of California Press in cooperation with the Jewish Museum, 1987], 70–71). Written as the preface to a series of novels intended to chronicle the history of a modern "israelite family," this statement was intended to confirm Joze's stance of objective observer so as to deny any charge of anti-Semitism.

3. The model for this type is Gustave Flaubert's *L'Education sentimentale*, first published in 1869. See also Seigel, *Bohemian Paris*, 269 for a related discussion of the memoirs of Georges Jeanneret, a young Swiss from Neuchâtel, who lived in Paris from 1869 through the mid-1870s. Part fact, part fiction, these memoirs, published in 1879, chronicled the initiation of a young provincial into the pleasures of Paris, the cradle of bohemianism, and may even have served as a model for Vallotton's own semi-autobiographical novel, *La Vie meurtrière* (The Murderous Life).

4. A huge number of foreign painters exhibited at the Salon nationale des Beaux-Arts (from 1890 on called the Salon du Champ-de-Mars) in these years, among them the Germans Leibl, Trubner, and Liebermann; Vallotton and fellow Swiss artists Ferdinand Hodler and Arnold Böcklin; the American Whistler—to name just a few. A large and growing Nordic colony of painters (as well as writers and intellectuals) in the 1880s was also extremely well represented at the World Exhibitions of 1878 and 1889. See Kirk Varnedoe, ed., *Northern Light: Realism and Symbolism in Scandinavian Painting, 1880–1910*, exh. cat. (Brooklyn: The Brooklyn Museum, 1982) for a fuller discussion of the exhibition and reception of Scandinavian art and literature in Paris during this period.

5. Despite his well-known and frequently described reserve, Vallotton was quite expressive about his feelings for Paris and his adoption of France as his native country, as evident in excerpts from a letter he wrote to Vuillard from Lausanne in the fall of 1897, in response to Vuillard's letter of 23 October 1897: "My dear Vuillard, I am writing to you in Paris where I believe you are, and where I hope to be soon. I am beginning to become listless here and I miss many things. There is nothing to say, my roots are in Paris and I can only live here as a tourist

and for a limited time . . . I imagine that you have work and great hopes. I look forward to seeing you and Paris in order to have the same. Here the color of things and of the people portray me too much as a dismal failure. It is distressing and I must get away." "*Mon cher Vuillard, je vous écris à Paris où je vous suppose, et où je m'espère bientôt. Je commence à devenir languissant ici, et bien des choses m'y manquent. Il n'y pas à dire, mes racines sont à Paris et je ne puis vivre ici qu'en touriste et pour un temps donné . . . J'imagine que vous avez de la besogne et de grands espoirs. J'ai hâte de vous voir et de voir Paris pour en avoir aussi. Ici la couleur des choses et celle des gens me peint vraiment trop en raté lugubre. C'est affligeant et il faut que m'en aille*" (letter from a Private Collection).

A few months later, just before his marriage and subsequent nationalization, Vallotton wrote to his brother Paul: "My irregular situation here is becoming untenable, I must regularize it; I am thus going to ask for naturalization . . . I really must do it because as I am, I feel at the mercy of everything and without any possible help. It also paralyzes my plans and the foreign title is really beginning to disturb me." "*Ma situation irrégulière ici devient intenable, il est nécessaire que je la précise; je vais donc demander ma naturalisation . . . Je crois faisant cela, bien faire, car tel que je suis, je me sens trop à la merci de tout, et sans secours possible. Cela me paralyse aussi pour mes dessins et le titre d'étranger commence à devenir une gêne*" (3 February 1898, in *Documents 2*, 8).

6. The four languages are German, French, Italian, and Romantsch. See *From Liotard to Le Corbusier: 200 Years of Swiss Painting, 1730–1930*, ed. The Swiss Institute for Art Research, exh. cat. (Atlanta: The High Museum of Art, 1988).

7. The exceptions are Vallotton's seven woodcuts of the most famous Swiss peaks: see plate 52 and the essay by Richard S. Field in the present publication.

8. Ferdinand Hodler (1853–1918), the eldest son of a carpenter, received his first training in art with Ferdinand Sommer, a painter of tourist views; after studying in Geneva with Barthélemy Menn from 1872 to 1877, he made his first trip to Paris. The mural *Night*, exhibited at the 1891 Salon du Champ-de-Mars, was his first great public success: a work which Vallotton knew and to which his own *Bathers on a Summer Evening* of 1892 certainly referred. See *Ferdinand Hodler*, exh. cat. (Zurich: Kunsthaus, 1983).

9. "He is intelligent, hardworking, and well-bred. I have only one reproach to address to him, which is a bit of timidity in his work that sometimes paralyzes his efforts. I am convinced that this timidity will disappear, the day he feels that his family has confidence in him and encourages him." "*Il est intelligent, laborieux et bien élevé. Je n'ai qu'un seul reproche à lui adresser, c'est un peu de timidité dans le travail qui parfois paralyse ses efforts. Cette timidité disparaitra j'en ai la conviction, du jour où il sentira que sa famille a confiance en lui et l'encourage*" (Jules Lefebvre to Adrien Vallotton, 25 July 1884, in *Documents 1*, 28).

10. Vallotton's pecuniary concerns were notorious among his contemporaries; as Francis Jourdain sarcastically noted, he avoided all excesses—even those of conversation, as reported in Eugene Glynn, "The Violence within: The Woodcuts of Félix Vallotton," *Art News* 74 (March 1975): 36.

11. These are not satirical portraits but are undertaken in the same spirit as Vallotton's laudatory gallery of literary and artistic notables. See particularly his 1894 portrait of the vocal anti-Dreyfusard Edouard Drumont (VG 152). See also Theodore Zeldin, *France 1848–1945: Taste and Corruption* (Oxford: Oxford University Press, 1980), 153–55 for a discussion of the Dreyfus Affair and the publishing industry.

12. One also sees a profusion of such themes in the early work of Hodler. Anker (1831–1919), whose work was a model for Vallotton's early production, lived a double life as an artist. Having concluded, consistent with his middle-class upbringing, that it was a painter's first priority to provide for the material needs of his family, he supplemented his income as an "easel painter" with work painting porcelain plates for the Theodore Deck company.

13. Charles Gleyre (1806–1874) was born in Switzerland and raised in Lyon. Trained in Paris, he took over the studio of Paul Delaroche in 1838 and taught there for twenty-one years. Many Swiss artists were attracted to his atelier, and he was a stalwart supporter of Swiss patronage and the Swiss national art fairs.

14. "Sur la grande exposition Boecklin à Bâle," *La Revue blanche* 14 (15 November 1897): 280–81. See also Vallotton's letter to Vuillard, "I saw in Basel where I went a very interesting Holbein exhibition, which gave me great pleasure as did one of Böcklin, also interesting, but terrifying." "*J'ai vu à Bâle où je suis allé une très intéressante exposition de Holbein, ça m'a fait grand plaisir ainsi qu'une sur Böcklin, intéressante aussi, mais terrible*" (undated, Fall 1897, Private Collection).

15. See Zeldin, *Taste and Corruption*, 203; and Phillip Dennis Cate and Susan Gill, *The Graphic Arts and French Society, 1871–1914* (New Brunswick and London: Rutgers University Press and The Jane Voorhees Zimmerli Art Museum, 1988).

16. See Catherine Fehrer, "History of the Julian Academy," in *The Julian Academy, Paris, 1868–1939*, exh. cat. (New York: Shepherd Gallery, 1989); Colette Cosnier, *Marie Bashkirtseff: un portrait sans retouches* (Paris: P. Horay, 1985); and John Rewald, *Post-Impressionism: From van Gogh to Gauguin* (New York: The Museum of Modern Art, 1978), 250–51.

17. The Lefebvre-Boulanger team was quite famous and worked together until Boulanger's death in 1888. These seem to have been the professors with whom Vallotton primarily studied, especially as evinced by Lefebvre's particular interest in him.

18. In many ways the Académie Julian was the cradle of the Nabi movement, which then matured at the *Revue blanche*. The Nabis, whose name was coined by the critic Auguste Cazalis from the Hebrew word meaning prophet, first came together in early 1889 to explore the artistic and intellectual ideals symbolized by Paul Sérusier's *The Talisman*, an abstract landscape painted on the lid of a cigar box in Brittany in October 1888. The original brotherhood of Sérusier, Pierre Bonnard, Maurice Denis, Henri Ibels, René Piot, and Paul Ranson was joined the following spring by Ker-Xavier Roussel and Edouard Vuillard. The Dutch painter Jan Verkade and the Danish painter Mogens Ballin joined in 1891, followed by Vallotton and Georges Lacombe in 1892, the Hungarian József Rippl-Rónai and Scotsman James Pitcairn-Knowles in 1894, and Aristide Maillol in 1895. See George L. Mauner, *The Nabis: their History and their Art, 1888–1896* (New York: Garland, 1978); Agnès Humbert, *Les Nabis et leur époque, 1888–1900* (Geneva: Editions Pierre Cailler, 1954); and Patricia Eckert Boyer, ed., *The Nabis and the Parisian Avant-Garde*, exh. cat. (New Brunswick and London: Rutgers University Press and The Jane Voorhees Zimmerli Art Museum, 1988).

19. The complete correspondence is published in Hahnloser 1936, 38, 58–78, 109, 119, 149, 160, 241, and 204, although it is often incorrectly dated. See also *Documents 1*, 29–32, 36–37, 40–44, 53–60, 65, 68–73, 76–77, 83.

20. "*Le goût du calme et de la mesure, d'une vie harmonieuse et 'sans histoire'*" (see Gilbert Guisan and Doris Jakubec, "Préface," in *Documents 1*, 11).

21. "*Votre lettre me gêne il me semble que vous n'aimez pas votre métier, lui seul est capable de vous remonter le moral, je vous ai déjà écrit qu'il ne faut pas s'attendre à faire fortune dans la peinture, le commerce ou n'importe quoi serait plus profitable*" (18 October 1886, in *Documents 1*, 31).

22. See "Chronology" for the complete list of Vallotton's various occupations.

23. ". . . *malgré tous les chefs-d'oeuvre que je vois dans un musée sans prétention aucune je ne me dis je ne vois pas comme tous ces artistes la nature, et ma façon à moi si jamais je peux la découvrir sera intéressante, c'est cette façon de voir qui est nouvelle malgré toute la viellesse de la peinture, c'est vous qui pouvez être nouveau, mais il faut avant tout recouvrer sa virginité, avoir ses impressions personnelles*" (Maurin to Vallotton, 18 October 1886, in *Documents 1*, 32).

This idea of newness, of a visual *tabula rasa* where the artist's vision is the creator of a new artistic order, is fundamental to Nabi theorizing; see Filiz Eda Burhan, "Vision and Visionaries: Nineteenth-Century Psychological Theory. The Occult Sciences and the Formation of the Symbolist Aesthetic in France" (Ph.D. diss., Princeton University, 1979). For issues of originality and tradition see also Richard Shiff, *Cézanne and the End of Impressionism* (Chicago: University of Chicago Press, 1984); and Newman, "Pierre Bonnard: The Nudes and the Landscapes," in Colta Ives, Helen Giambruni, and Sasha M. Newman, *Pierre Bonnard: The Graphic Art*, exh. cat. (New York: The Metropolitan Museum of Art, 1989).

24. See Cate and Gill, *The Graphic Arts and French Society*. Unlike many of the other artists with whom he became associated—Ibels, Hermann-Paul, Anquetin, Steinlen, Lautrec—Vallotton did not actually live in Montmartre but rather in a series of ever-changing attic rooms in the 6th and 14th arrondissements. See also Phillip Dennis Cate and Patricia Eckert Boyer, *The Circle of Toulouse-Lautrec: An Exhibition of the Work of the Artist and of his Close Associates* (New Brunswick: The Jane Voorhees Zimmerli Art Museum, 1985); and Patricia Eckert Boyer, "The Nabis, the Parisian Vanguard Humorous Illustrators and the Circle of Le Chat Noir" (Master's thesis, University of California at Santa Barbara, 1982).

25. This is not to discredit Maurin's quite original style, which was characterized by a black line technique also manifested in Vallotton's efforts and which seemed clearly influenced by British experimentation as well as by the work of Emile Bernard. See Jacquelynn Baas and Richard S. Field, *The Artistic Revival of the Woodcut in France 1850–1900*, exh. cat. (Ann Arbor: The University of Michigan Museum of Art, 1984), 84–85; and the essay by Richard S. Field in the present publication.

26. It was not until 1893, when he was included in the exhibition of Impressionists and Symbolists at Le Barc de Boutteville, that Vallotton first exhibited with Bonnard, Vuillard, Sérusier et al. It is difficult to determine when and how Vallotton made the aquaintance of those future Nabis whom he would officially join in 1892. It is more than likely that he had already met a number of them in the cafés of Montmartre probably through Toulouse-Lautrec, to whom he was introduced by Maurin.

27. See Cate, "The Paris Cry: Graphic Artists and the Dreyfus Affair," 62–95. Vallotton was also very friendly with Lautrec although we have few specific details about this relationship. It seems that Lautrec first brought Vallotton into the orbit of the *Revue blanche*.

28. For the relationship between anarchism and socialism see Theodore Zeldin, *France 1848–1945: Politics and Anger* (Oxford: Oxford University Press, 1979), 411–14; Weber, *France: Fin de Siècle*, 115–20; and more generally Jean-Marie Mayeur and Madeleine Rebérieux, *The Third Republic from its Origins to the Great War, 1871–1914* (Cambridge: Harvard University Press, 1984), originally published in French as *Les Débuts de la troisième république 1871–1898* and *La République radicale? 1898–1914* (Paris, 1973 and 1975).

29. See Vallotton's illustrations in Octave Uzanne's *Rassemblements* of 1896 (plates 77, 79, 81, 83), as well as related paintings (plates 44, 59, 65), and the essay by Richard S. Field in the present publication.

30. There are remarkably few studies actually devoted to anarchism as a political activity; see Jean Maitron, *Histoire du mouvement anarchiste en France 1880–1914* (Paris: Société universitaire d'éditions et de librairie, 1951). What is significant is the tremendous interaction between anarchism as political activism and the goals and motivations of Symbolism in their respective insistence on individual liberation and freedom from the bonds of external, social forces. Many authors and artists wrote and illustrated for anarchist journals and many Symbolists were involved in anarchistic activities, among them Félix Fénéon, Paul Adam, and Gustave Kahn. See also Eugenia W. Herbert, *The Artist and Social Reform: France and Belgium, 1885–1898* (New Haven: Yale University Press, 1961); and Jacques Monferier, "Symbolisme et anarchie," *Revue d'Histoire littéraire de la France* 65 (1965): 231–43.

31. "*J'arrive de Hollande—Visité Bruxelles, Anvers, La Haye-Shevening̈ue, Harlem, Zandcoort, Leyde, Rotterdam, Amsterdam,—et cela en 8 jours, vous voyez ça d'ici des pas gymnastiques de la gare aux Musées—Epaté du pays, et des primitifs que j'ai vu ça et là, rien de Bruges je le regrette,—Matsys, Cranach, Jean Stein,—Peter de Hooch, et Raveinstein Franz Hals, et un Albert Dürer des maîtres inconnus admirables—*
l'Adam et Eve de Van-Eyck et le Christ de Matsys c'est encore ça de plus fort.—Rembrandt .? Rubens,—désapointé, mais en revanche Jordaens, Oh! Ah! . . . nous causerons de ça . . . Vu une épreuve de Dürer, (L'Adam et Eve) c'est inouï de volonté—J'adore ce patron c'est vraiment un graveur et je lâche Schongauer—Ma haine de la peinture Italienne s'est accru, aussi de notre peinture Française—Vu des pastels à Amsterdam de Liotard très curieux, très personnels—Vive le Nord! et merde pour l'Italie" (17 September 1888, in *Documents 1*, 44).

32. *La Revue blanche* provided an important forum for Scandinavian literature and art, whose psychological realism strongly appealed to those in the journal's circle. For an index and history of this publication see Fritz Hermann, *Die Revue blanche und die Nabis* (Munich: Mikrokopie G.m.b.H., 1959); and A. B. Jackson, *La Revue blanche (1889–1903): Origine, influence, bibliographie* (Paris: Lettres Modernes, 1960).

33. See Newman, "Nudes and Landscapes," in *Pierre Bonnard: The Graphic Art*; and Deborah Silverman, *Art Nouveau in Fin-de-Siècle France: Politics, Psychology, and Style* (Berkeley: University of California Press, 1989) for the relationship between Art Nouveau and eighteenth-century revivals, as the upper-middle class sought to erase the horrors of the Franco-Prussian War with a new decorative style linked to pre-revolutionary monarchic glory and aristocratic traditions. Vallotton himself seems to have been quite aware of the potency of these reinventions of tradition, as reflected in his review of the graphic work of Jules Chéret for the *Gazette de Lausanne*, 18 April 1891: "Here Chéret is celebrated . . . It is the old French tradition that reigns in him, the old and the good, and its constancy gives pleasure. In him all is joy, drawing, color." "*Ici Chéret est célèbre . . . C'est la vieille tradition française qui renait en lui, la vieille et la bonne, et cela fait plaisir à constater. Tout lui est joie, dessin, couleur.*"

34. Cited in Joan Ungersma Halperin, *Félix Fénéon: Aesthete and Anarchist in Fin de Siècle Paris* (New Haven: Yale University Press, 1988), 301. This is by far the most complete and compelling study of Fénéon and his milieu. See also Joan Ungersma Halperin, ed., *Oeuvres plus que complètes*, 2 vols. (Geneva: Droz, 1970).

35. Theater was the most popular and pervasive of the arts. During the 1880s and 1890s half a million Parisians went to the theater once a week, over a million went once a month. See Zeldin, *Taste and Corruption*, 159. Vallotton constantly remarked in his journal and correspondence on plays seen or plays missed, and even wrote eight plays—two were produced, in 1904 and 1907—as a way of reaching a wider audience and bridging the gap between high and popular art. These spare theatrical efforts most often concern the absurdist presentation of types, with particular emphasis on the bourgeoisie; see Unpublished Plays in "Works by Vallotton."

36. See Geneviève Aitkin, "Les Peintres et le théâtre autour de 1900 à Paris, mémoire" (Ecole du Louvre, 1978); Aurélien Lugné-Poe, *La Parade I. Le sot du Tremplin: souvenirs et impressions de théâtre* (Paris: Librairie Gallimard, 1931); and Jacques Robichez, *Le Symbolisme au théâtre: Lugné-Poe et les débuts de L'Oeuvre* (Paris: L'Arche, 1957). At the l'Oeuvre, 1893–94 was the season of Ibsen and Bjornson. Jarry's letter to Lugné-Poe confirms the popularity of Vallotton's Ibsen portrait: "I told Fénéon to reclaim Vallotton's little picture of Ibsen for the cover of *La Revue blanche*, with the list of Ibsen's works presented earlier by the l'Oeuvre" (in Lugné-Poe, *La Parade I*, 169.)

37. *La Revue blanche* played a significant role in the graphic revival at the end of the century, developing and sustaining public interest in the collecting of artists' prints and books. Beginning in 1893, the magazine included an original print in each issue.

38. "*Vallotton . . . nous était arrivé très jeune et très mince, blond, le visage ovale et à peine asymétrique, très peu moustachu mais avec un rien de barbiche. Il marchait de côté, attentif à ses pas. Si son vêtement montrait un peu de corde ce devait être aussi de n'avoir été que trop soigneusement brossé. Il avait l'air constamment sur ses gardes*" (Thadée Natanson, "Le très singulier Vallotton," in *Peints à leur tour* [Paris: Albin Michel, 1948], 304–5).

39. See Félix Vallotton, "Réponse" [à Charles Morice, "Enquête sur les tendances actuelles des arts plastiques"], *Le Mercure de France* (1905); republished in Philippe Dagen, *La peinture en 1905* (Paris: Lettres Modernes, 1986), 64–65.

40. Despite the presence of such notable anarchists as Bernard Lazarc, Zo d'Axa, and Fénéon himself, such early articles on anarchism as Ludovic Malaquais, "Anarchie," *La Revue blanche* (November 1890), were more worldly than committed.

41. In 1894, Alfred Dreyfus, a Jewish army staff captain, was arrested, tried, and found guilty of treason; see Norman L. Kleeblatt, ed., *The Dreyfus Affair, Art, Truth & Justice*. The question

of Dreyfus' guilt or innocence became a fulcrum for all of the schisms and anxieties fomenting in French society and released the anti-Semitism (which was often conflated with anti-bourgeois attitudes: socialism, for example, was initially anti-Semitic) that had been brewing since the Panama Canal scandal of 1892–93 when, in the minds of the public, France had been ripped off by a bunch of greedy Jewish bankers. Dreyfus was retried but again found guilty in a kangaroo court, despite the fact that it was well known that Esterhazy had forged documents. He was ultimately pardoned in 1906.

42. In a letter to Vallotton dated 12 October 1898, Vuillard noted the established positions of the popular press vis-à-vis Dreyfus: "I told him how saddened I had been to see the Libre Parole and the little Journal the only things people around me read, excuse me, there is one who gets the Gaulois." "*Je lui ai dit combien j'avais été attristé de voir la Libre Parole et le petit Journal la seule lecture des gens qui m'entourent, pardon, il y en a un qui reçoit le Gaulois*" (in *Documents 1*, 181). *La Libre Parole* was a violently anti-Semitic journal, *Le Gaulois* was reactionary and monarchist, *Le Petit Journal* was a rather gossipy daily.

43. Such graphic works as *La Débâcle* and later murals produced during and after World War I are connected to Ferdinand Hodler's own response to the Dreyfus court-martial, particularly his *Truth I* of 1902 and *Truth II* of 1903, both in the Kunsthaus Zürich; see *Ferdinand Hodler*, 304–5.

44. See Vallotton-Grave Correspondence, no. 4, in "Selected Unpublished Correspondence."

45. "*Je ne crois pas que l'art prenne des directions nouvelles, ses fins étant immuables, perpétuelles, et depuis toujours*" (Vallotton, "Réponse," 64).

46. Vallotton described Gabrielle in an 1899 letter to his brother: "As for my fiancée, here it is; she is a widow as I told you, her name is Rodrigues she is the daughter of Mr Bernheim a great picture dealer. I have known her for four years, she is surely a good woman with whom I will get along easily. She has three children, the oldest is fifteen, the youngest seven, thus they are grown, they like me and I will love them.—We expect to live together without changing our habits or almost, me at my work, she in her interior, it will be very reasonable." "*Quant à ma fiancée, voilà; elle est veuve comme je te l'ai dit, son nom est Rodrigues elle est fille de Mr Bernheim un grand marchand de tableaux. Je la connais depuis 4 ans, c'est une femme surtout bonne, avec qui je m'entendrai sans peine. Elle a trois enfants, l'aîné a 15 ans, la cadette sept, ils sont donc élevés, ils me sont très sympathiques, et je les aimerai.—Nous pensons vivre tous deux sans rien changer à nos habitudes ou presque, moi à mon travail, elle à son intérieur, ce sera très raisonnable*" (in *Documents 1*, 187).

47. "*Il me semble qu'il y a eu une révolution*" (13 September 1899, in *Documents 1*, 190).

48. Chatenay was the model for *The Sick Girl* and *The Kitchen*. She often traveled to Switzerland with Vallotton, who called her "la petite" (the little one).

49. "*Ce qui me touche le plus c'est ce qui concerne la petite. J'ai pour elle depuis que je la connais, et lui conserverai malgré tout une affection totale et complète; en agissant comme je le fais, je lui fais un chagrin, que je ressens plus qu'elle peut-être, elle le sait, elle connaît mes sentiments.—Je lui ai toujours dit que je me marierais, depuis plusieurs années, nos relations sont purement amicales ce qui me permet de les continuer intégralement; ma fiancée sait tout, elle désire que je reste en relations avec elle, que je l'aide, que je sois son meilleur ami et son conseiller . . . Actuellement je la vois assez peu, nos relations avaient changé quant à la forme du moins, car pour le fond il est intact, je l'aime beaucoup, et elle le sait, ce n'est pas mon mariage qui y changera quelque chose.—Je te dis tout ceci pour calmer l'inquiétude que vous eussiez pu avoir sur ma conduite; je ferai tout ce que je pourrai*" (Félix Vallotton to his brother Paul, 1899, in *Documents 1*, 186).

50. See "Works by Vallotton."

51. "*Je viens d'apprendre une bien triste nouvelle, la mort de la petite Hélène Chatenay dont son ami vient de me faire part. Elle est morte brusquement d'une congestion, et n'a je pense pas eu le temps de souffrir, ni peut-être de se douter de ce qui arrivait. J'en ai bien du chagrin car c'était un coeur d'or et une bonne nature pour qui la vie a souvent été trop dure. Je ne l'avais pas vue depuis longtemps, car elle était fantasque, mais nous recevions des cartes postales d'elle chaque fois qu'elle se déplaçait. Avec elle meurt tout un passé et une grande part de ma jeunesse*" (28 April 1910, in *Documents 2*, 169).

52. See the essay by Margrit Hahnloser-Ingold in the present publication.

53. Bernheim-Jeune, particularly under Fénéon's astute leadership of its "contemporary division," was primarily concerned with the marketing and sale of Impressionist painting and the works of later related artists—such as Bonnard, Vuillard, and lesser lights like Laprade—establishing this aspect of "the great French tradition" as their specific interest, in opposition to either Cubism or cool classicizing trends. For contemporary reinterpretations of this history, see *Bernheim-Jeune, petit résumé historique* (Paris: Éditions Bernheim-Jeune, n.d.); and Henry Dauberville, *La Bataille de l'Impressionnisme* (Paris: Éditions Bernheim-Jeune, 1967).

Exteriors and Interiors:
Vallotton's Printed Oeuvre

1. Meier-Graefe 1898, 49; translated in VG, xiii.

2. On the problem of the revitalization of the woodcut at the end of the nineteenth century, see Jacquelynn Baas and Richard S. Field, *The Revival of the Artistic Woodcut in France, 1880–1900*, exh. cat. (Ann Arbor: University of Michigan Museum of Art, 1984).

3. As has been thoroughly explored elsewhere, the influence of Japanese woodcuts and decorative arts reached its zenith in the late 1880s with Sigfried Bing's publication of *Le Japon Artistique* (1888–1890) and the great exhibition of Japanese prints at the Ecole des Beaux-Arts in 1890. Flatness and decoration were buzzwords just at the time Maurin, Vallotton, and others had opted for the woodcut.

4. Accordingly, this exhibition has intentionally mixed limited-edition prints (woodcuts and lithographs) with mass-editioned reproductions. See Ashley St. James, *Vallotton, dessinateur de presse* (Paris: Chêne, 1979). St. James reproduces 186 illustrations from *L'Escarmouche, Le Courrier français, Le Rire, Jugend, Le Cri de Paris, Le Sifflet, L'Assiette au beurre, Le Canard sauvage, Le Témoin*, and *La Grande Guerre par les artistes*.

5. Gustave Le Bon, *La Psychologie des foules* (Paris: Félix Alcan, 1895; English edition, to which all citations refer, published as *The Crowd: A Study of the Popular Mind*, intro. by Robert K. Merton [London: Penguin, 1977], 50).

6. The closeness of Maurin and Vallotton is amply attested in *Documents 1*. On Maurin see *Charles Maurin (1856–1914)*, exh. cat., with an essay by Phillip Dennis Cate (New York: Lucien Goldschmidt, 1978); Roger Gounot, *Charles Maurin, 1856–1914*, exh. cat. (Le Puy: Musée Crozatier de Puy, 1978); and Baas and Field, 84–85. Maurin's *Head of a Woman* has long been regarded as a portrait of Vallotton's mistress, Hélène Chatenay (see Gounot, no. 72).

7. On Bernard's activity as a woodcutter, see Caroline Boyle-Turner, "Emile Bernard as an Experimental Printmaker," in Mary Anne Stevens, *Emile Bernard 1868–1941, A Pioneer of Modern Art* (Zwolle: Waanders, 1990), 249–307. Among other things, Bernard wished to publish a small woodcut journal, *Le Bois*, for which he had already produced two or three cover cuts by 1890. Bernard's first woodcuts (apparently of 1888) sought rapprochement with the supposed untutored and primitive origins of the medium itself. Yet he almost certainly would *not* have known any fifteenth-century works, though he might have intuited such humble beginnings from the intentionally simple, traditional folk woodcuts of the eighteenth and nineteenth centuries, the so-called *Images d'Epinal*. These largely religious but also historical woodcuts have their own origins in post-Dürer images of the sixteenth century. In their simplified but orderly craft, they have little to do with Bernard's direct attack on the block. Nevertheless, the content of Bernard's work in particular was perceived as bearing close links with the woodcuts of times

past, as was made quite explicit in the publication that began to appear in 1894, *L'Ymagier*.

8. The most easily accessible literature on these artistic undercurrents is contained in the series of catalogues published by The Jane Voorhees Zimmerli Art Museum (New Brunswick, Rutgers, The State University of New Jersey) under the editorship of Phillip Dennis Cate: *Théophile-Alexandre Steinlen* (Salt Lake City: Gibbs M. Smith, 1982), *The Circle of Toulouse-Lautrec* (1986), *The Graphic Arts and French Society, 1871–1914* (1988), and Patricia Eckert Boyer, *The Nabis and the Parisian Avant-Garde* (1988). On the *théâtre de l'ombres* see Boyer, "The Nabis, the Parisian Vanguard Humorous Illustrators and the Circle of Le Chat Noir" (Master's thesis, University of California at Santa Barbara, 1982).

9. While the café opened in 1881, it was in 1885 that the *théâtre de l'ombres* initiated its performances there under Rivière. In his art, Rivière adhered very closely to the formats, colors, subjects, and techniques of the Japanese Ukiyo-e masters; but in the theater, he combined these characteristics with a striking penchant for "astonishing perspective effects, unusual deformations and a range of tones from black through gray" (William Rubin, "Shadows, Pantomimes and the Art of the 'Fin de Siècle'," *Magazine of Art* 21 [March 1953]: 115). By 1885, according to Rubin, there were up to seventeen shadow theaters in operation in Paris; he distinguishes between Rivière's "nuanced" form of the shadow theater and the far more popular style of Louis Morin, who emphasized pure contrasts of white and black (though Morin's work may well have been influenced by Vallotton, Beardsley, and Lautrec, rather than vice versa). It is worth noting that the first performance at Le Chat Noir featured a parade of police officers. On Rivière's printmaking, see Armond Fields, *Henri Rivière* (Salt Lake City: Gibbs M. Smith, 1983); and Baas and Field, 73–79.

10. Ursula Perucchi-Petri has pointed out this particular relationship between nineteenth-century Japanese woodcuts and the shadow theater. She specifically cites a print by Utagawa Kuniyoshi reproduced in Bing's *Le Japon Artistique*. See Perucchi-Petri, *Die Nabis und Japan* (Munich: Prestel, 1976), 88–89. See also Boyer, "The Nabis, the Parisian Vanguard Humorous Illustrators and the Circle of Le Chat Noir," 22–23, for a broad range of parallels to Vallotton's subjects and forms in the productions and publications associated with the Cabaret du Chat Noir. Boyer goes so far as to compare Fernand Fau's *Le Secret du manifestant* (The Demonstrator's Secret), produced at the Chat Noir in 1893, with Vallotton's woodcut *La Manifestation* (The Demonstration; plate 56), published at the end of March 1893; it might be that the influence was exerted in the opposite direction.

11. It is not so much the form of Steinlen's work that may have provided ideas for Vallotton's, but its subjects and their treatments. A few parallels are noted here, but a thorough study of the popular press of the day would surely reveal that

Vallotton benefitted considerably from available imagery. Lise Marie Holst, "Félix Vallotton's *Intimités*: Le Cauchemar d'un Erudit" (Master's thesis, Oberlin College, 1979) and Ashley St. James (see note 4) have provided numerous suggestions in their studies of Vallotton. For example *The Execution* (VG 142) was surely inspired by Lautrec's *At the Foot of the Scaffold* (Adhémar 14), as was Vallotton's lithograph, *The Green Hat* (VG 54) by Lautrec's *The Milliner* (Adhémar 17). In the case of Steinlen, one might compare the following: *Laziness* (VG 169; plate 21) with *The Woman with a Cat*, 1896; and *The Age of Paper* (plate 32) with Steinlen's poster advertising *La Feuille*, 1897. Other works by Steinlen that may have influenced Vallotton include *April Madrigal*, 1895; *Remorse*, 1895; the cover for *Nathalie Madoré*, 1895; *Streetsingers*, 1895; *Two Honest Women*, 1896; *The Lover of Crowds*, 1896; and *My Good Uncle*, 1896. Even Steinlen's illustrations for Aristide Bruant's *Dans la rue* published from 1888 on, must have provided early ideas for Vallotton.

12. See Vuillard's *The Sower*, lithograph for Le Théâtre Libre, 1890.

13. For another sympathetic discussion of these landscapes, see Rudolf Koella, "Den knappsten Ausdruck für den grössten Inhalt: Zum graphischen Werk von Félix Vallotton," in *Félix Vallotton: Bilder, Zeichnungen, Graphik*, exh. cat. (Winterthur: Kunstmuseum, 1978), 27–33.

14. One could easily assemble a long list of works from the past that had set the stage for Vallotton's pictorial inventions: not only Bonnard's remarkable sketches for music programs (especially *Petit Solfège illustré*, of ca. 1891), and Bernard's and Gauguin's zincographs for their 1889 exhibition at the Café Volpini, but also many of the posters by Chéret, the street scenes of Degas and Caillebotte, Manet's transfer lithographs (the "autographies") and, of course, Daumier's and Gavarni's innumerable lithographs of Parisian types and customs.

15. See Baudelaire's essay on Constantin Guys, "The Painter of Modern Life," in *Charles Baudelaire, The Painter of Modern Life and other Essays*, ed. and trans. Jonathan Mayne (New York: Garland, 1978).

16. See Donna M. Stein and Donald H. Karshan, *L'Estampe Originale: A Catalogue Raisonné* (New York: The Museum of Graphic Art, 1970), no. 87. This first issue, of January–March 1893, also contained works by Anquetin, Bonnard, Denis, Ibels, Maurin, Ranson, Roussel, Toulouse-Lautrec, and Vuillard. Vallotton contributed one further woodcut, *The Bath* (VG 148; Stein/Karshan 88) to a subsequent number. Of all ninety-five works published in *L'Estampe originale*, only six others were woodcuts: one each by Henri-Charles Guérard, Emile Bernard, Lucien Pissarro, Georges H. Pissarro, Charles Ricketts, and Georges Auriol.

17. See for example Daumier's lithograph of 1864, *A Literary Discussion in the Second Balcony* (Delteil 3264). A few of Daumier's theater crowds are totally homogenized, suppressing all appearances of individual personalities, as in *The*

Spectators in the Orchestra of 1864 (Delteil 3262), but they are not nearly as focused as is the audience of Vallotton's *The Patriotic Ditty*.

18. Four of Vallotton's woodcuts are directly concerned with funerary affairs (VG 84, 106, 130, 146); one with execution (VG 142); one with assassination (VG 113); one with suicide (VG 143); and in three others, death is both implicit or explicit to the image (VG 99, 102, 103).

19. As our editor, Lesley Baier, has pointed out, this particular woodcut was commissioned; its relatively civilized and less satiric content certainly reflects its patron's needs and sensibilities.

20. Vallotton may have been inspired by a woodcut of Hokusai that was reproduced in *Le Japon Artistique*, no. 34 (1890), pl. CCH.

21. Eugene Glynn, "The Violence within: The Woodcuts of Félix Vallotton," *Artnews* 74 (March 1975): 36–39. See also Reinhold Heller, "Edvard Munch's Vision and the Symbolist Swan," *Art Quarterly* 36 (Autumn 1973): 203–49. While elaborating at great length the long history of the swan's symbolic representation of both life and death, Heller not only failed to include Vallotton's several swan images, but totally overlooked the well-known aggressive characteristics of the swan that were central to Vallotton's meanings.

22. "Vallotton regales himself with bitterness; he feasts on recitals of the unhappy like a gourmand. And yet Vallotton was held vice-like by the things he despised: women, money, society, vulgar life. Devastating honesty, in his life as in his work, was as much a sign of helplessness as an act of revenge" (Jules Renard as paraphrased in Glynn, "The Violence within," 36–37). The relevant passages that appear in Jules Renard, *Journal 1887–1910*, ed. and annotated by Henry Bouillier (Paris: Robert Laffont, 1990) are: "Vallotton, an affable, simple, distinguished air, straight hair distinctly parted on the right, sober gestures, not very complicated theories, and something very egoistic in everything he says" (6 April 1894); "On the wall, sketches of Barrès as a monkey, as hideous birds: crow or screech-owl. Enthusiasm for Willette. Lautrec draws wonderfully. Vallotton, limited, lacks the unexpected" (6 March 1895); "Vallotton has the insignificant dreariness of an upholsterer" (21 October 1904); "Vallotton only regales himself with bitterness. If he knows a woman is getting divorced, he draws her into a corner and delights in hearing her life's story, like a gourmand who drinks alone. It's hard to imagine to what degree this man, who walks with an absorbed air, could think of anything" (16 December 1904). "*Vallotton, un air doux, simple, distingué, des cheveux plats nettement separés par une raie bien droite, des gestes sobres, des théories peu compliquées, et je ne sais quoi de très égoïste dans tout ce qu'il dit*"; "*Au mur, des croquis de Barrès en singe, en hideux oiseaux: corbeau ou chouette. Emballement sur Willette. Lautrec dessine admirablement. Vallotton, borné, manque d'imprévu*"; "*Vallotton, d'une insignifiante tristesse de tapissier*"; "*Vallotton ne se régale que*

d'amertume. Sait-il une femme doit divorcer, il l'attire dans un coin et se délecte de son histoire, comme un gourmand qui ferait suisse. Il est difficile d'imaginer à quel point cet homme, qui se promène l'air absorbé, peut ne penser à rien."

23. Upon the recommendation of Toulouse-Lautrec, Vallotton had executed two lithographs which were reproduced in *L'Escarmouche* in 1893: *The Bores* (VG 42) and *The Latest Fashion* (VG 44).

24. See Ursula Perucchi-Petri, 50.

25. *Badauderies Parisiennes: Les Rassemblements, Physiologies de la Rue* (Paris: Henri Floury, 1896). With contributions by Paul Adam, Alfred Athys, Victor Barrucand, Tristan Bernard, Léon Blum, Romain Coolus, Félix Fénéon, Gustave Kahn, Ernest La Jeunesse, Lucien Muhlfeld, Thadée Natanson, Edmond Pilon, Jules Renard, Pierre Veber, and Eugène Veek; and a prologue by Octave Uzanne. Illustrated with 30 *hors-texte* "gravures" by Félix Vallotton, and woodengraved vignettes in the text by François Courboin.

26. Of the eight surviving preparatory drawings, three are in the present exhibition. It is not beyond the realm of possibility—and it has been recently suggested—that the illustrations in *Les Rassemblements* were actually woodcuts, not reproductions. Certainly if they *were* woodcuts the artist must have transformed the drawings during the execution of the blocks. But I would rather explain the differences between the eight drawings and their respective illustrations by the existence of a second entire set of originals from which reproductions were made; perhaps the eight drawings that survive represent first ideas, which were revised, while the remaining images only required a single assay.

Frankly, there is ample evidence against the woodcut hypothesis. I have no doubts that the illustrations as published are *relief* prints, but I also believe they were printed from zinc linecuts, that is, photomechanically made relief surfaces called *Gillotypes*, rather than from woodblocks. Internal evidence—in the pen-and-ink *ductus* of so many lines—clearly indicates that the illustrations were drawings; this is especially noticeable in the textured passages where the black lines clearly were *not* executed by the removal of the white shapes, as they would be in a woodcut.

There is as well the overwhelming testimony of the artist's own account books and journals, which speak only of drawings, never of woodcuts, and also the fact that not one (signed or unsigned) separate print has been cited in the Vallotton-Goerg catalogue raisonné of the prints. Furthermore, Vallotton's first biographer and expert on prints, Julius Meier-Graefe, explicitly stated in 1898 that these plates were not "*gravures*" (as Uzanne had called them), but reproductions after drawings: "*30 Reproduktionen—nicht Gravüres, wie die Titel sagt!—nach Zeichnungen von Vallotton*" (60).

Thus the use of the word "*Gravures*" on the title page of *Les Rassemblements* was either a deliberate attempt to mislead or just a careless reference to the zinc linecut. I suspect a certain amount of equivocation, because Uzanne lionizes Vallotton's original woodcuts in the introduction to the very publication where he had to employ reproductions of both woodcuts and drawings. The impossible task is to decide whether Uzanne is condemning all reproductive processes with the implication that Vallotton's illustrations were in fact woodcuts, or whether he is in some way legitimizing the Gillotype process and his reproductions of Vallotton's drawings. What follows is a reasonable translation of the appropriate passages.

> I am convinced—as I once wrote—that, in order to win back their lost influence, in order to recover the trust of the connoisseurs of art, in order to proclaim above all a talent now rendered aggressive by the force of personality, those young wood engravers who no longer wish to slavishly interpret the fashionable *genre joli*, must boldly diverge from the gray manners of their predecessors. It is not—as I added—by working fastidiously with their wood that they will find again the brilliance and success of a vanished craftsmanship, it is rather by using rough means, by returning to primitive workmanship, by exercising a temperament that rebels against the rules of the schools—it is ultimately by seeking independence in execution while vigorously opposing the dull precision of a chemical process on zinc. [So far Uzanne is simply praising Vallotton's originality.]
>
> The heliogravure [photomechanical etching] which enables reproduction of drawings as accurately, as simply, and as stupidly as possible may remove from the original the vivacity of its execution, but certainly adds no interpretive seasoning, except for the refinements of the reduction. The process used by zincographers will always be accepted as a marriage of convenience between a drawing properly sketched and its reproduction in relief as required for typographic printing. [Uzanne uses the wrong word here, for "zincograph" is a planographic process that substitutes zinc for limestone. He must be speaking of the Gillotype process, which uses zinc for a relief printing surface.] Undoubtedly all the expedients of popularization come together at this point. However, this marriage, based on both logic and inclination, is usually legitimized only by contingencies stemming from one and the same personality; and it is the artistic bisexuality of the painter-engraver that makes the match finally perfect.
>
> Consequently, it pleased me greatly to see M. Félix Vallotton put into practice theories that should have never lost currency in the world of arts. This newcomer . . . valiantly tried his hand at conveying his inspirations in wood; and using knife and penknife instead of burin, he engraved on blocks of maple or soft pear-tree various scenes of contemporary life, with the cunning candor of a sixteenth-century xylographer.
>
> . . . They [his woocuts] are but silhouettes that seem cut out almost like a shadow show; yet, does one not see in them a burst of life and reality cheered up by a humor peculiar to engraving? Is that not closer to us, more artistic than these hideous, faultless half-tone engravings made via pneumatic photography which for more than ten years have afflicted our eyes in newspapers and illustrated works?

27. Indifference and cynicism seemed everywhere. Quoting Georges Brandimbourg, Charles Rearick remarked that it had "become 'chic' not to laugh but 'to gaze on the greatest farce impassively'" (Charles Rearick, *Pleasures of the Belle Epoque* [New Haven: Yale University Press, 1985], especially chapter 7, "The Spectacles of Modern Life," 48).

28. Gabriel Tarde, "Les Crimes des foules," *Archives de l'anthropologie criminelle* 7 (1892): 353–86; Scipio Sighele, *La Foule criminelle, essai de psychologie collective* (Paris: Félix Alcan, 1892); and Gustave Le Bon, *La Psychologie des foules* (Paris: Félix Alcan, 1895, as cited in note 5). On the whole issue of the psychology of crowds in French studies, see Susanna Barrows, *Distorting Mirrors: Visions of the Crowd in Late Nineteenth-Century France* (New Haven: Yale University Press, 1981). Beginning with Taine's descriptions of the will of the crowds during the French Revolution, Barrows traces the implicit nationalistic and class feelings that underlay virtually all "psychologies" of the crowd, especially Le Bon's.

29. " . . . *la mystérieuse influence du Nombre*" (Guy de Maupassant, "Les Foules," *Le Gaulois* [23 March 1882]; reprinted in Guy de Maupassant, *Chroniques* 2 [Paris: Union Générale d'Editions, 1980], 15–19).

30. See Barrows, *Distorting Mirrors*, chapter 7, for a biting analysis of Le Bon's politics.

31. Le Bon, 5.

32. Le Bon, 27, writes about the "mental unity" of crowds: "The most striking peculiarity presented by a psychological crowd is the following: Whoever be the individuals that compose it, however like or unlike be their mode of life, their occupations, their character, or their intelligence, the fact that they have been transformed into a crowd puts them in possession of a sort of collective mind which makes them feel, think, and act in a manner quite different from that in which each individual of them would feel, think, and act were he in a state of isolation." He further argued that "Men the most unlike in the matter of their intelligence possess instincts, passion, and feelings that are very similar" (28).

33. Le Bon's word was "contagion." The notion of the suggestibility of crowds derived from nineteenth-century ideas about hypnosis, just as the root of the collective behavior of crowds lay in the plentiful models that depicted society as an organism. See Le Bon, 30; Robert A. Nye, *The Origins of Crowd Psychology* (London and Beverly Hills: Sage Publications, 1975), 60ff; and Barrows, chapter 5, for a lengthy discussion of the impact of current theories of hypnosis.

34. Le Bon, 32 and 35–36. Further: "A crowd is not merely impulsive and mobile. Like a savage, it is not prepared to admit that anything can come between its desire and the realization of its desire" (38); "Crowds are everywhere distinguished by feminine characteristics, but Latin crowds are the most feminine of all" (39).

35. Le Bon, 62 and 70.

36. See Vallotton-Grave Correspondence in "Selected Unpublished Correspondence" for six letters from Vallotton to the publisher of *Le Temps nouveaux*, Jean Grave. Dating between 1899 and 1905, they are published here for the first time. It is not clear what kinds of illustrations were requested, although one was surely a portrait. Eugenia W. Herbert reports that in

1898 Vallotton was a member of Le Ligue des Droits de l'Homme; and that in 1899 he contributed to a portfolio of prints published in support of an officer who had been persecuted for defending Dreyfus, *Hommages des Artistes à Picquart*. See *The Artist and Social Reform: France and Belgium, 1885–1898* (New Haven: Yale University Press, 1961), 203.

37. Georges Sorel, "G. Le Bon *Psychologie des foules*," *Le Devenir Social* 1 (November 1895): 765–70.

38. Maurice Spronck, "La Psychologie des foules," *Revue bleue* 8 (26 August 1897): 271–77.

39. Ibid., 276: "*suivre les maîtres*"; "*imiter les modèles*".

40. It would seem likely that Vallotton's reputation was first established on the basis of his widely reproduced portrait vignettes. They appeared as original prints in two portfolios, the lithographs of *Immortels passés, présents ou futurs* (Immortals Past, Present or Future, 1892–94; VG 24–41) and the woodcuts of *Portraits choisis* (Selected Portraits, 1894–95; VG 150–160), as well as in the single woodcuts of Verlaine, Wagner, Berlioz, Jasinski, Uzanne, Baudelaire, Schuck, Schumann, Coolus, Ibsen, Poe, Dostoyevsky, Queen Victoria, William II, Faure, Menzel, Napoleon, Stendhal, Puvis de Chavannes, and Mogens Ballin and his Wife (VG 80–81, 83, 95–97, 108, 131–32, 136, 147, 163, 177–82, 200, and 202). The most famous collections, however, are the two publications edited by Remy de Gourmont, *Le Livre des Masques* of 1896 and 1898 (most of which had already appeared in the pages of *La Revue des revues* and *Le Mercure de France*).

41. ". . . *qu'est-ce que l'homme a donc fait de si grave qu'il lui faille subir cette terrifiante 'associée' qu'est la femme. Il semble parfois, à voir des pensées si violemment contradictoires et des élans si nettement contraires qu'il n'y doive y avoir de possibilité entre les sexes que comme vainqueur et vaincu*" (9 January 1918, in *Journal*, 187).

42. Christian Brinton, "Félix Vallotton," *The Critic* (Spring 1903): 332–33.

43. The association with Maurice Maeterlinck's poems, *Serres Chaudes* (Hothouses), is inevitable. An edition with woodcuts by George Minne was published in Paris in 1889.

44. One possible inspiration for this woodcut might have been Bonnard's *Suite for Piano*, a pen and wash drawing of ca. 1891 (reproduced in Perucchi-Petri, 64).

45. Identified in VG, p. 187.

46. For this kind of interpretation, however, see Hahnloser 1936, 150. The one exception is *The Flute*'s aroused cat, whose arched back and straightened tail might well "correspond" to the notes of the shrill upper registers of the flute.

47. See Holst, "Félix Vallotton's *Intimités*: Le Cauchemar d'un Erudit" (cited in note 11), of which a brief summary was published as "Félix Vallotton's *Intimités*: Le Cauchemar d'un Erudit," *Allen Memorial Art Museum Bulletin* 37 (1979–80): 96–98. Much of what follows, though it may

not be entirely in accord with Ms. Holst, has drawn upon and benefitted from her penetrating analysis of these uncannily moving images.

48. *La Maîtresse* first appeared in serial form in *Le Rire* from 16 November 1895 until 4 January 1896. It was accompanied by very small vignettes by Vallotton, several of which depict a man and a woman (Maurice and Blanche) opposing one another. See also the essay on nudes and interiors by Sasha M. Newman in the present publication.

49. *The Outburst* may very well be read as depicting the financial rule of the husband, and thus, as will soon be suggested, as being directly counter to the power-of-women undercurrent of the *Intimités*. The financial hegemony of the man, so firmly established in France by the Napoleonic Code of 1804, actually gave the husband control over his wife's assets. Only in 1886 were such arrangements opened to court challenge, and only in 1893 were single and separated women legally permitted to manage their own material affairs. For a quick and often devastating overview of the status of women in France, see Eugen Weber, *France: Fin de Siècle* (Cambridge: Harvard University Press, 1986), chapter 4.

50. Aside from the many posters by Chéret, Lautrec, and Bonnard, the obvious prototype for the self-conscious inclusion of a title as part of an image occurs in Gauguin's zincographs of 1889 with their French inscriptions, and in his Tahitian paintings with their Polynesian titles of 1891 and later; Gauguin claimed that they augmented the mysterious aura of his works.

51. For example, Munch's *Ashes* of 1894, National Gallery, Oslo, reproduced in *Edvard Munch: Symbols and Images*, exh. cat. (Washington: National Gallery of Art, 1978), no. 47; the lithograph of the same subject printed in 1896 (Schiefler 69; also National Gallery of Art, 226); *Vampire*, lithograph of 1895 (Schiefler 34); *Man's Head in Woman's Hair*, woodcut of 1896 (Schiefler 80); and *Jealousy*, lithograph of 1896 (Schiefler 58). The reciprocal relationship between Munch and Vallotton has been discussed by Holst, and by Elizabeth Prelinger, *Edvard Munch, Master Printmaker* (New York: W. W. Norton, 1983), 37, among others. One might summarize that what Munch took in form, Vallotton borrowed in content.

52. On the power of women see, for example, entries 33–39 in Ellen S. Jacobowitz and Stephanie L. Stepanek, *The Prints of Lucas van Leyden and His Contemporaries*, exh. cat. (Washington: National Gallery of Art, 1983). Strikingly similar to Vallotton's own words, which are quoted here as the epigraph for the "Interiors" section, are these from a source exactly contemporary with Lucas van Leyden: "What else is woman but a foe to friendship, an inescapable punishment, a necessary evil, a natural temptation, a desirable calamity, a domestic danger, a delectable detriment, an evil of nature, painted with fair colors!" (Heinrich Kramer and Jacob Springer, *Malleus Maleficarum* [Hammer of the Witches], first published in 1486; quoted in James Snyder, *Northern Renaissance Art* [New York: Abrams, 1985], 368).

53. It does seem possible that the well-read Swiss would have been familiar with such popular Protestant themes as the Power of Women and the Unequal Lovers (again the older man who purchases affection from a younger woman). See Alison Stewart, *Unequal Lovers: A Study of Unequal Lovers in Northern Art* (New York: Abaris Books, 1976).

54. Holst, "Félix Vallotton's *Intimités*: Le Cauchemar d'un Erudit," 26.

55. Ibid., 54–58; Louis Godefroy, *L'Oeuvre gravé de Félix Vallotton* (Paris: Chez L'Auteur; Lausanne: Chez Paul Vallotton, 1932), 12; André Thérive, "Félix Vallotton," *L'Amour de l'art* (1921): 169–72.

56. Note further how, in *The Bath*, the servant woman's head almost merges with the wallpaper; similarly, in *Five O'Clock*, the woman's face is featureless. The prototype for Vallotton's lovers, of course, is located in Edvard Munch's many images of *The Kiss*, in which the lovers are fused into one form (plate 171).

57. Holst, 67, also quotes this exchange from Strindberg's *The Father*:

> *Wife*: Power, yes! What has this whole life and death struggle been for but power?
>
> *Husband*: This is like race hatred. If it is true that we are descended from monkeys, at least it must be from separate species. We are certainly not like one another, are we? . . . I feel that one of us must go under in this struggle.
>
> *Wife*: Which?
>
> *Husband*: The weaker, of course.

In 1894, Vallotton had created a lithograph for the program cover for this play's performance at the Théâtre de l'Oeuvre (VG 53; plate 23). See the introductory essay by Sasha M. Newman in the present publication.

Portraiture and Assimilation of the "very singular Vallotton"

1. These categories should be understood as neither polarized nor definitive, and the alliance of artists with one or the other is fluid. In my examples, the works of Cézanne and Gauguin seem especially open to shifting categorization.

2. The protagonist in Vallotton's semi-autobiographical novel *La Vie meurtrière* (The Murderous Life), begun in 1907, declared his instinctive preference for the "*écoles sévères et de grand goût*" and stated that to his mind the greatest painters were Holbein and Leonardo (55). On Vallotton's view of Holbein as "above all a portraitist and the most impeccable there has ever been" "*avant tout, Holbein fut portraitiste, et le plus impeccable qui fut jamais*," see Hahnloser 1936, 180–83. He did cast his net more widely, also copying portraits by the more expressive Hals and Rembrandt in these early years.

3. "*Le Nabi étranger*" (see Ducrey 1989, 10).

4. "*Le très singulier Vallotton*" was the title Thadée Natanson gave to the chapter on Vallotton in *Peints à leur tour* (Paris: Albin Michel, 1948), 304–11.

5. It has recently been suggested that Vallotton began the account book at a later date. See Ducrey 1989, 13 n. 2.

6. Only eight of these self-portrait paintings are known today; they are conveniently reproduced in Erika Billeter, ed., *L'Autoportrait à l'âge de la photographie*, exh. cat. (Lausanne: Musée cantonal des Beaux-Arts, 1985), 342–43. In comparison, Vuillard was far more prolific in this genre, as were such other contemporaries as Ferdinand Hodler, Lovis Corinth, Käthe Kollwitz, and Henri Matisse.

7. "*Portrait de largeur honnête et intéressant, quoique un peu sec*" (Louis de Fourcaud, *Le Gaulois*, supplement to 30 April 1885, in *Journal*, 364–65).

8. See Catherine Fehrer, "History of the Julian Academy," in *The Julian Academy, Paris, 1868–1939*, exh. cat. (New York: Shepherd Gallery, 1989), 2.

9. Rudolf Koella, *Félix Vallotton im Kunsthaus Zürich* (Zurich: Kunsthaus Zürich, 1969), 68.

10. Moreover, Vallotton continued to accept material support from his family, a sacrifice that caused him some guilt. See Hahnloser 1936, 22.

11. I have in mind Degas' psychologically more complex portraits of the Bellelli family and the Morbillis, as well as his portrait of his own father Hilaire, all situated in a domestic setting.

12. Patricia Berman has remarked on a "typology of bohemianism centering on the cigarette" in the work of the Norwegian Edvard Munch, exemplified by his *Self-Portrait with Cigarette* of 1895. This seems a pertinent conceptual context for the portrait of Paul Vallotton, though he was hardly a bohemian. See her discussion in Kirk Varnedoe, ed., *Northern Light: Realism and Symbolism in Scandinavian Painting, 1880–1910*, exh. cat. (Brooklyn: The Brooklyn Museum, 1982), 194.

13. See, for example, the letter of 4 May 1885 to his brother, in which Vallotton emphasized his pursuit of portrait commissions (*Journal*, 365).

14. Conversely, he may have welcomed the state of personal disengagement ensured by the photograph. In his *Livre de raison* Vallotton specifically noted three portraits he painted "*d'après photo*" in 1885 and 1888 (LRZ 5, 9, and 68); and in 1888 and 1889 he mentioned several others in letters to his parents (see *Documents 1*, 46, 63); in later years he painted more portraits in this way.

15. On these specific exchanges see Hahnloser 1936, 32, 157; and *Documents 1*, 63–64. In his *Livre de raison* Vallotton recorded three portrait replicas painted in 1888 and 1889 (LRZ 54, 63, and 71). On Vallotton's commodification of the portrait in general, see Ducrey 1989, 15.

16. On Jasinski and his unhappy end in suicide, see Hahnloser 1936, 55–58.

17. Bernard Wyder, "Preface," in *Félix Vallotton: Portraits de contemporains célèbres* (Lausanne: L'Imprimerie Bron S.A., 1983), 5–11.

18. In 1894, for example, Jules Renard said to Vallotton of his woodcut portrait of Edgar Allan Poe: "I don't know what he looks like, but intellectually it's he, it can only be he." "*Je ne connais pas son image, mais c'est intellectuellement lui, ce ne peut être que lui*" (*Documents 1*, 116). And in 1896 Stéphane Mallarmé wrote to Vallotton to request a portrait of Rimbaud, saying that only Vallotton "could, with the portrait as we know it, do something original." "*Vous seul pouvez, avec le portrait connu, faire quelque chose d'original*" (*Documents 1*, 146).

19. For a detailed discussion of Vallotton's sources for this portrait, see Ashley St. James, "The Vallotton Portrait of Poe," *The Poe Messenger* 8 (Spring 1978): 1–4.

20. See LRZ 407. The issue of Vallotton's adherence to a traditional style and presentation points up the contradictions that sometimes arise between the identity of an artist who belongs to an avant-garde group and the style of his or her art when it is not easily reconciled with the group style. In this respect the relationship of Berthe Morisot and Edouard Manet to the Impressionists produces a similar tension.

21. *Portrait of Lugné-Poe* (Rochester, Memorial Art Gallery); *At the Revue Blanche (Portrait of Félix Fénéon)* (New York, Solomon R. Guggenheim Museum). Around 1910 Bonnard also showed Fénéon at work in his amusing autobiographical sketches, *La Vie du peintre* (The Life of the Painter).

22. On the question of primitivism in connection to Denis and Cézanne, see Richard Shiff, *Cézanne and the End of Impressionism: A Study of Theory, Technique, and Critical Evaluation of Modern Art* (Chicago: University of Chicago Press, 1984), 171–72, 194.

23. See *Le Douanier Rousseau*, exh. cat. (Paris: Grand Palais, 1984), 102.

24. *La Revue blanche* (15 June 1897); cited in Ibid., 38. Vallotton painted Natanson's portrait during the month of July; see *Etudes de lettres*, 9, 11.

25. "*Eh bien, Vallotton, marchons ensemble*" (quoted in Hahnloser 1936, 103). Within a few decades many writers, Guillaume Apollinaire among them, wrote of the affinities between the work of Rousseau and Vallotton.

26. "*Mon petit Vallo*." On the eventful life of this brimming figure see Arthur Gold and Robert Fizdale, *Misia: The Life of Misia Sert* (New York: Alfred A. Knopf, 1980).

27. On Vallotton's *Intimités* and related paintings see the essays by Sasha M. Newman and Richard S. Field in the present publication. On the erosion of strict genre categories in French painting beginning in the mid-nineteenth century, see Steven Z. Levine, "The Crisis of Resemblance: Portraits and Paintings During the Second Empire," *Arts Magazine* 53 (December 1978): 90–93; and Leila W. Kinney, "Genre: A Social Contract?" *Art Journal* 46 (Winter 1987): 267–77.

28. See Hahnloser 1936, 88 and *Portrait of Edouard Vuillard* of 1897 (LRZ 350; pl. 7).

29. This emphasis on human relationships in the portraiture of the Nabis is most prominent in the work of Vuillard. For the most complete study of his portraits see Patricia Ciaffa, "The Portraits of Edouard Vuillard" (Ph.D. diss., Columbia University, 1985).

30. The work of Munch in Norway, Hodler in Switzerland, Fernand Khnopff in Belgium, and Anselm Feuerbach and Lovis Corinth in Germany exemplifies this melodramatic strain. The seventeenth-century corporation portraits of Rembrandt represent one of its earlier manifestations.

31. On Hammershøi, see the catalogue entry by Emily Braun, who also notes the connections between Hammershøi's work and Rembrandt's, in Varnedoe, ed., *Northern Light*, 126. Scandinavian arts were the rage in Vallotton's circle in the 1890s. Lugné-Poe's Théâtre de l'Oeuvre staged the plays of Strindberg and Ibsen in Paris (for which Vallotton designed programs; see plate 23); and the Danish painter Mogens Ballin, another *Revue blanche* adherent, may have contributed to Vallotton's awareness of developments in his country. I owe this last suggestion to Sasha Newman.

32. Marina Ducrey has, however, noted the differences in treatment of these personages; see Ducrey 1989, 94, where four of these paintings are also illustrated. But such individualized variations may also be found in the portrait prints in the various series of "masques."

33. All but Zola, who died in September 1902, were deceased.

34. Hahnloser 1936, 113.

35. See, for example, his efforts from 1902 to 1904 to get prominent theatrical and literary figures to read his work, usually with disappointing results, in *Documents 2*, 70–77.

36. Letter to Paul Vallotton, spring 1899, in *Documents 1*, 186.

37. "*Nous pensons vivre tous deux sans rien changer à nos habitudes ou presque, moi à mon travail, elle à son intérieur, ce sera très raisonnable*" (*Documents 1*, 187).

38. See *The Kitchen* (plate 6) and *Young Woman Sewing (Hélène Chatenay)* of 1891, illustrated in Hahnloser 1936, pl. 12.

39. Even when Vallotton depicted his wife in an activity that might be construed as work, such as her knitting in *Portrait of Gabrielle Vallotton Sitting in a Rocking Chair* (plate 182), the casual atmosphere and her pose in a grand rocking chair indicate pastime more than labor. Conversely, in *The Sick Girl* (plate 8), Vallotton had depicted Hélène Chatenay abed while a maid brings a hot drink, which seems to be a fantasy of this lower-class woman being served by domestic help.

40. There were early indications that Vallotton felt uncomfortable among his new extended family; see letter from Vuillard to Vallotton, 26 July 1899, in *Etudes de lettres*, 15–16; and on the disagreeable pre-nuptial contract the Bernheims imposed on the artist, see Hahnloser 1936, 106–7.

41. Ducrey 1989, 82.

42. Vallotton's fascination extended to several paintings depicting rooms in the Bernheim house, including two showing the bedrooms of Josse and Gaston Bernheim, which he exhibited in the Salon d'Automne of 1903 (LRZ 526, 529a, 529b).

43. "The family will be a great help to my career; they are important art dealers." "*La famille . . . me sera, j'y compte, d'un puissant secours de ma carrière: ce sont de gros marchands de tableaux*" (letter of 1899 [to his parents?], quoted in Hahnloser 1936, 105).

44. Vallotton usually expressed his unease in terms of difference. In a letter of February 1906 to Paul Vallotton, he indicated that at times he felt like he was walking on eggs within his family and finally declared: "They are so different." "*Ils sont si différents*" (*Documents 2*, 102; quoted and elaborated by Ducrey 1989, 32–33). See also Hahnloser 1936, 105–7; 211: "I live amidst strangers." "*Je vis au milieu d'étrangers*" (undated letter); and 191 for the link she suggests between the Bernheims and Vallotton's satiric novel about an ambitious Jewish family, *Les Soupirs de Cyprien Morus* (The Sighs of Cyprien Morus). But the possibility must be noted that Hahnloser may herself have had biases that intervened in this and other assessments of Vallotton's relationship with the Bernheims.

45. On the social mobility of French Jews in the 1890s, see Paula E. Hyman, "The French Jewish Community from Emancipation to the Dreyfus Affair," in Norman L. Kleeblatt, ed., *The Dreyfus Affair: Art, Truth & Justice*, exh. cat. (Berkeley: University of California Press in cooperation with the Jewish Museum, 1987), 29–30.

46. LRZ 487.

47. See *Documents 2*, 95; and Hahnloser 1936, pl. 2, 3. In 1908 Vallotton painted a forceful portrait of Gabrielle that largely liberated her from the need for circumstantial identity, but it too expresses Vallotton's alienation; see Ducrey 1989, 92.

48. Gertrude Stein, *The Autobiography of Alice B. Toklas* (New York: Harcourt, Brace and Company, 1933), 61–62.

49. Lest Vallotton's procedure seem circumstantial, we also have the account of the painter Charles Guérin, whose portrait he painted in 1906 in a similarly precise, finely calculated fashion, moving down the face from one part to the next; see the letter from Guérin to Hahnloser, 22 January 1932, in *Documents 2*, 91–92. Vallotton did not record Guérin's portrait in his *Livre de raison* (nor did he record Stein's), and its location today is unknown.

50. The two paintings are precisely the same size, and Vallotton made his initiative soon after he would have been able to see Picasso's painting in Stein's rue de Fleurus apartment. Photos of Stein's apartment taken in 1906 or 1907 show Picasso's portrait, not yet framed, on her studio wall; see Margaret Potter, ed., *Four Americans in Paris: The Collections of Gertrude Stein and Her Family* (New York: The Museum of Modern Art, 1970), 91. By exhibiting Stein's portrait in the Salon d'Automne, Vallotton apparently intended to make public his part in this dialogue between the avant-garde and tradition; by contrast, Picasso did not exhibit his portrait of Stein.

51. John Richardson has recently proposed that Picasso derived his abstract conception for Stein's face from the head of the Empress Livia in Ingres' *Virgil Reciting from the Aeneid* of 1819; see his *A Life of Picasso* 1: 1881–1906 (New York: Random House, 1991), 456. If this is true, then Vallotton would have been making a double response to Ingres.

52. "*Ça, c'est Madame Bertin!*" (Hahnloser 1936, 210); see also reviews by Louis Vauxcelles and Thiébault-Sisson in *Documents 2*, 257.

53. See, for example, reviews by Fagus and Louis Vauxcelles in *Documents 2*, 246 (1903); 252 (1905); and 253–54 (1906).

54. Guillaume Apollinaire, *Apollinaire on Art: Essays and Reviews, 1902–1918*, ed. Leroy C. Breunig, trans. Susan Suleiman (New York: Viking Press, 1972), 194.

55. On the Hahnlosers as collectors of Vallotton's work, see Rudolf Koella et al., *Künstlerfreunde um Arthur und Hedy Hahnloser-Bühler*, exh. cat. (Winterthur: Kunstmuseum Winterthur, 1973).

56. "*La statue du Commandeur*" (letter from Félix Vallotton to Paul Vallotton [no date cited], quoted in Ducrey 1989, 74).

57. "*Mon portrait fini, robe de chambre et lunettes de corne, j'ai l'air d'un bon rond de cuir enrhumé— pas mal d'ailleurs*" (4 November 1914, in *Journal*, 42).

58. Entry for 13 November 1921, in *Journal*, 293.

59. See *The Black Velvet Hat with a Plume* of 1913, illustrated in Hahnloser 1936, pl. 68.

"Stages of Sentimental Life":
The Nudes and the Interiors

1. The full citation reads: "*En bas, ma femme, sa fille et Mlle Oulmann palabrent sur le prochain mariage de Mlle Aghion. Je n'ai pu y tenir; qu'est-ce que l'homme a donc fait de si grave qu'il lui faille subir cette terrifiante 'associée' qu'est la femme? Il semble parfois à voir des pensées si violemment contradictoires, et des élans si nettement contraires qu'il n'y doive y avoir de possibilité entre les sexes que comme vainqueur et vaincu*" (9 January 1918, in *Journal*, 187).

2. See the letter of 19 February 1909 from A. Vallette at the *Mercure de France* to Vallotton; and "*Je suis souffrant, je vieillis, je voudrais bien laisser cette trace-là aussi*" (in *Documents 2*, 146, 146n). Vallotton's literary aspirations were well known. Between 1890 and 1920, he involved himself in nearly all of the literary genres including the completion of poetic essays (probably destroyed), nine plays and a tenth left unfinished, three novels, a series of novellas and stories, and of course the essays in art criticism which he began in 1890. *La Vie meurtrière* was first published in *Le Mercure de France* in 1927, two years after Vallotton's death. See Doris Jakubec, "Félix Vallotton, écrivain," in *Félix Vallotton*, exh. cat. (Paris: Musée du Petit Palais, 1979), n.p.

3. "*Je fais un peu de peinture, natures mortes innocentes, quelques dessins pour un roman de ma manière*, Un Meurtre *fait il y a quatorze ans et qu'on se décide à mettre au jour. Je l'ai revu aussi et épluché. Ca vaudra ce que ca vaudra, ni plus ni moins qu'un autre, peut-être même un peu mieux que pas mal d'autres*" (in *Journal*, 285).

4. "*Un front égal, un oeil pâle, bien placé, mais sans éclat sous des paupières maladives, un nez court et busqué, une lèvre supérieure proéminente, où pointent les prémices d'une moustache retardataire, une bouche aux lèvres épaisses, volontiers entr'ouvertes sur des dents assez belles, mais écartées, et, subitement, la fuite d'un tout petit menton raté, d'un mauvais petit menton de hasard, qui entache l'ensemble et le tare de sa défaillance*" (La Vie meurtrière, 49).

5. Many of the descriptions of personages in the novel, not simply the description of Jacques Verdier but those of his parents and his colleagues, can be related to specific paintings by Vallotton. Moreover, the lingering death of Vallotton's mistress Hélène Chatenay (as well as the tremendous guilt he felt and noted in his journal) can be related to the tragedy that caused the death of the model Jeanne.

6. The "discovery" of the unconscious at the turn of the century became a significant aspect of literary and artistic self-description and was central to Vallotton's own attitudes toward aesthetic creativity. Freud's essay on literary creativity, "Creative Writers and Daydreaming," published in 1908, marked an important contribution to psychoanalytic aesthetics and was also one of the first sustained attempts to apply psychoanalytic ideas to cultural expression. Its emphasis on the centrality of childhood memory

and experience, mediated by unconscious fantasies and wish fulfillment, to literary construction parallels the semi-autobiographical structure of *La Vie meurtrière*. The outpouring of this and other such confessional novels at the turn of the century anticipates Freud's summation. See also Peter Gay, *Freud: A Life of Our Time* (New York: W. W. Norton, 1988), 307–24.

7. A resounding example is Verdier's description of the death of Hubertin, in which the victim's frantic cries, hands beating the air, and distended eyes are portrayed with an overwhelming vividness. His eyes fix themselves on Verdier, actually petrifying him on the spot. See *La Vie meurtrière*, 30–31.

8. This essay is not intended as an in-depth analysis of the function of the gaze in Vallotton's work. However, it is important to note both Vallotton's implicit acknowledgment of the gaze and the way in which this acknowledgment distinguishes him from his contemporaries. For a clear synopsis of the decentering of the subject in Sartre and Lacan and the meaning of the terror of the gaze, see Norman Bryson, "The Gaze in the Expanded Field," in *Vision and Visuality: Discussions in Contemporary Culture* 2, ed. Hal Foster (Seattle: DIA Art Foundation, 1988), 87–114.

9. "*Déjà, par la fente du corsage, ma main fouillait, brisant les défenses, quand un cri m'échappa, un cri de dégoût et d'horreur.*
 Au lieu de la douce chose espérée, mes doigts avaient senti je ne sais quel déchet grumeleux et desséché! . . . D'un bond, je fus sur pied, loin d'elle.
 La pauvrette, presque jetée à terre, eut peine à retrouver son équilibre." And the passage continues, "As a result of the movement, a sort of small cushion, a ridiculous and touching thing, fell from her open blouse and rolled toward me. I repulsed it as one does a slimy animal, feeling my look flame with hate. Jeanne, at first disconcerted did not understand, then her large dilated eyes enlarged even further, and her pallor became mortuary." "*Dans le mouvement, une sorte de petit coussin—ridicule et touchant postiche—tomba de sa blouse entr'ouverte et roula jusqu'à moi. Je le repoussai comme on chasse un animal visqueux, je sentis que mon regard flambait de haine. Jeanne, interloquée d'abord, ne comprit pas, puis ses grands yeux dilatés s'élargirent encore, sa pâleur devint mortuaire*" (*La Vie meurtrière*, 162).

10. "*Morte! . . . la douce Jeanne au rire clair était morte! . . . Mort son sourire! . . . morts ses cheveux! . . . mort son parfum! . . .*" (Ibid., 190).

11. Zola's unforgettable final description of Nana dead from smallpox is one of the most powerful examples of the male fascination with the dirt of female sexuality: "what lay on the pillow was a charnel house, a heap of pus and blood, a shovelful of putrid flesh" (*Nana*, trans. with an intro. by George Holden [Harmondsworth, Eng. and Baltimore: Penguin, 1972], 470). Prescient of Georges Bataille's later Surrealist fascination with the erotic object as excrement as well as his analysis of *Olympia*'s body as corpse, such texts illuminate the interrelationship between the literary convention of realism/symbolism/surrealism, a relationship also manifest in Vallotton's peculiarly pre-surrealistic work; see Georges Bataille, *Eroticism*, trans. Mary Dalwood (London and New York: Boyars, 1987) and *Manet* (Geneva: Skira, 1983). My thinking about this is indebted to Charles Bernheimer, *Figures of Ill Repute: Representing Prostitution in Nineteenth-Century France* (Cambridge: Harvard University Press, 1988); see also his "Huysmans: Against (Female) Nature," in *The Female Body in Western Culture*, ed. Susan Rubin Suleiman (Cambridge: Harvard University Press, 1985), 373–85.

12. Described in the prologue as the "*confessions de l'homme intérieur*," *La Vie meurtrière* is part of a developing tradition of confessional novels in the later nineteenth century—from the ingratiating and superficial, as in the case of Paul Bourget's tremendously popular *Physiologies de l'amour moderne* (Paris, 1891) to the opulently phantasmic as in Huysmans' *A Rebours*. Bourget's *Physiologies*, actually a collection of articles that had appeared throughout 1888–89 in *La Vie parisienne*, is closest to Vallotton's own endeavor in the genre, employing as it does the descriptive technique of the naturalist to describe psychological conflict. Such novels are related to the contemporary fascination with detailed case studies of sexual perversion, pairing this confessional mode with the discourse of science. See Michel Foucault, *The History of Sexuality, Volume I: An Introduction*, trans. Robert Hurley (New York: Vintage Books, 1980). See also Emily Apter, "Cabinet Secrets: Fetishism, Prostitution and the Fin de Siècle Interior," *Assemblage* (June 1989): 7–19, for a discussion of the profusion of literature cataloguing sexual perversion.

13. Only *Bathers* truly distinguishes itself from this generalization, imbricating the concerns of the 1890s with those of Vallotton's post-1905 work. On psychological positivism and its relationship to Symbolism in general, and the Nabis in particular, see Feliz Burhan, *Vision and Visionaries: Nineteenth-Century Psychological Theory, the Occult Sciences and the Formation of the Symbolist Aesthetic* (Ph.D. diss., Princeton University, 1979).

14. The male gaze is preoccupied with sexual difference and the fear of castration; according to Freudian theory the male voyeur is attempting to eradicate his anxiety by scopically reenacting the imagined perception of female castration, his "original trauma." Similarly, the mythological Medusa's gaze, the woman's look back, is concomitant with a fear of castration. However, this look might also be considered the lethal reflection of the male viewer's own initial gaze, which petrifies and objectifies the woman. See Sigmund Freud, *Three Essays on the Theory of Sexuality*, ed. James Strachey with an intro. by Steven Marcus (New York: Basic Books, 1975); and Freud, "Medusa's Head," in *Sexuality and the Psychology of Love*, ed. Philip Rieff (New York: Collier, 1972).

15. Rudolf Koella's essay on the *Bathers* in *Félix Vallotton im Kunsthaus Zürich* (Zurich: Kunsthaus Zürich, 1969) remains the best analysis of this painting, and I am indebted to Dr. Koella's perceptive commentary.

16. For a discussion of the decorative impulse as it preoccupied not only the Nabis but the official limner of Third Republic France, Pierre Puvis de Chavannes, as well as official artistic policies of the Third Republic itself, see *Le Triomphe des Mairies: Grands Décors républicains à Paris, 1870–1914*, exh. cat. (Paris: Musée du Petit Palais, 1986); and Marie Aquilino, "Decoration by Design: The Development of the Mural Aesthetic in Nineteenth-Century French Painting" (Ph.D. diss., Brown University, 1989).

17. "*Un qui s'est payé la trombine des visiteurs, c'est Vallotton: il nous montre une tripotée de femmes, des jeunes et des vieilles à la baignade, y en a à poil, d'autres en chemise; c'est tout plein gondolant!*" (Félix Fénéon, "Balade chez les artistes indépendants," *Le Père peinard* [16 April 1893]; cited in *Documents 1*, 236).

18. See Marcia R. Pointon, "Allegory and the Body in Manet's *Dejeuner sur l'herbe*: Guess Who's Coming to Lunch," in *Naked Authority: The Body in Western Painting, 1830–1908* (Cambridge: Cambridge University Press, 1990), 150. Pointon analyzes the increasingly problematic relationship of allegory to contemporary painting in the depiction of the naked, not nude, body. Allegory regularly requires the body and commonly requires nudity. Moreover, to be allegorical is not to be real. Clothes disrupt nudity as they disrupt allegory and prevent the woman from assuming her historical role, a role that masks the immediacy of her body. See also John Berger, *Ways of Seeing* (London: Penguin, 1972).

19. See Bernheimer, *Figures of Ill Repute*.

20. Maurice Denis writes in his journal that Vallotton copied this work but no such copy is extant, nor is it listed in Vallotton's *Livre de raison* (see Koella, n. 22). Koella does not think it possible that Vallotton actually saw this work—nor that he had made a copy from a reproduction; he hypothesizes that Denis meant simply that *Bathers* was a modern version of Cranach's well-known painting. Vallotton did study Cranach at the Louvre, as well as at the art dealer's Henri Harot, where he worked as a restorer and copyist.

21. In *Bathers*, Vallotton fluctuated between allegorical and pragmatic description. His contemporary Francis Jourdain reported that in 1893–94, Vallotton showed him his work-in-progress on a corollary panel to *Bathers*, entitled *Spring*, which would have continued the decorative tradition of serialized allegory so popular with Vallotton's contemporaries, and would have mitigated to some degree the shocking disruption of the solo panel. But despite the fact that Jourdain went so far as to describe the work as representing a young girl picking flowers in a park, executed in a divisionist style, there remains no trace of this spring allegory, which is not noted in Vallotton's *Livre de raison*; see Francis Jourdain, *Félix Vallotton* (Geneva: Editions de Pierre Cailler, 1953), 19. The small

oil sketches of nudes in the grass (plate 147) might be related to it, but this cannot be confirmed. While the woodcut *Three Bathers* of 1894 is close to *Bathers* in style and treatment, a series of ten vignettes from this same period that shows a more tranquil idyll of harmony between man and nature was possibly related to the more traditional decorative treatment Vallotton most likely was going to apply to *Spring*.

22. One is also reminded of the tradition of morphological play in contemporary caricature. See Phillip Dennis Cate, "Between Nature and Symbol: French Prints and Illustrations at the Turn of the Century," in *The Graphic Arts and French Society 1871–1914* (New Brunswick and London: Rutgers University Press and The Jane Voorhees Zimmerli Art Museum, 1988), 108–10.

23. The hard-edged (masculine) silhouettes and the process of displacements and substitutions evident in Vallotton's *Bathers* clearly manifest the depiction of woman and her attributes as fetish. According to Freud, the fetish should offer "a token of triumph over the threat of castration and a safeguard against it" (Sigmund Freud, "Fetishism," in *Sexuality and the Psychology of Love*, 216. The denial of the female form and the reduction of woman to man's fetish does not subvert the gender of the gaze but confirms it.

24. As well as being a moment of tremendous intensification of the fetishism of woman's body this is also one of inexorable expansion of consumer culture causing a subsequent imbrication of fetishism and commodification. See such contemporary works as Max Klinger's graphic series *The Glove* (1881); John Grand-Carteret's *L'Histoire, la vie, les moeurs et la curiosité par l'image 1830–1900* (Paris: Librairie de la curiosité et des Beaux-Arts, 1928), 5:192; or Octave Uzanne's *The Sunshade—The Glove—The Muff* (London: J. C. Nimmo and Bain, 1883) for examples of the fetishism of woman's apparel. See also Luce Irigary, *This Sex Which is Not One* (Ithaca: Cornell University Press, 1985) and Apter, "Cabinet Secrets," for discussions of the conflation of Marxist and Freudian interpretations of the fetish (both collectible and feminine talisman invested with erotomania) at the end of the nineteenth century. The proliferation and dissemination of pornographic photography—the camera which fragments and abstracts the living subject—also contributed to this inorganic view of woman's body. See Abigail Solomon Godeau, "The Legs of the Countess," *October* 39 (Winter 1986): 65–108; and Graham Knight and Berkeley Kaite, "Fetishism and Pornography: Some Thoughts on the Pornographic Eye I," *Canadian Journal of Political and Social Theory* (Fall 1985).

25. See Carol M. Armstrong, "Edgar Degas and the Representation of the Female Body," in *The Female Body in Western Culture*, 233–42; and T. J. Clark, *The Painting of Modern Life: Paris in the Art of Manet and his Followers* (Princeton: Princeton University Press, 1986).

26. Meier-Graefe 1898, 35.

27. New pictorial conventions—both high and low—obsessively depicted contemporary women

at home bathing or dressing, or out in public spaces shopping. See Octave Uzanne, *The Modern Parisienne*, with an intro. by the Baroness von Hutten (New York: G. P. Putnam's Sons, 1912; first published in French in 1894), 18. See also Camille Mauclair, "La Femme devant les peintres modernes," *La Nouvelle Revue*, n.s. 1 (1899): 190–213; and Marins-Avry Le Blond, "Les Peintres de la femme nouvelle," *La Revue* 39 (1901): 275–90.

28. Vallotton often included "portraits" of other paintings in his interiors of the 1890s; one of the most striking examples of this practice is *Woman in a Purple Dress by Lamplight* (plate 27), in which Vuillard's *Large Interior with Six Figures* of 1897 (a gift to Vallotton from Vuillard; now in the Kunsthaus Zürich) appears, albeit subtly transformed to meet the needs of Vallotton's painting.

29. Grand-Carteret, 293.

30. Writers were equally obsessed with the possibility that all women were potential whores and that one could no longer tell the difference between a venal woman and an "honest" one. Octave Uzanne, for example, warns of the perpetual threat of prostitution and the ambiguity of all women's status: "Many do not see it even when it is at their elbows, for one's power of observation must be sharpened by long residence in Paris, and by an innate curiosity in these matters before one can be certain, so deceptive are the appearances which this culpable trade assumes" (*The Modern Parisienne*, 199–200).

 The widespread preoccupation with prostitution during the last half of the nineteenth century has been well and frequently discussed. See Alain Corbin, *Les filles de noce: Misère sexuelle et prostitution aux 19e et 20e siècles* (Paris: Ambier Montaigne, 1978); in art see Hollis Clayson, "Representations of Prostitution in Early Third Republic France" (Ph.D. diss., UCLA, 1984), and Bernheimer, *Figures of Ill Repute*. Of course the iconography of bathing in *Bathers* can be related to the tremendous currency of this discourse of the prostitute.

31. Rouart to Jourdain in Francis Jourdain, *Félix Vallotton*, 22.

32. See A. B. Jackson, *La Revue blanche (1889–1903): Origine, influence, bibliographie* (Paris: Lettres Modernes, 1960), 152–305.

33. See the essay by Richard S. Field in the present publication. The series *Intimités* was also reviewed extensively. See particularly Thadée Natanson, "De M. Félix Vallotton," *La Revue blanche* 18 (1 January 1899); Raymond Bouyer, "Les graveurs sur bois de fil au canif," *L'Estampe et l'affiche* (15 December 1899); *Le Cri de Paris* (18 December 1899); and Gabriel Mourey, "Correspondance de Paris," *The Studio* (15 March 1899).

34. The contemporary literature on this subject is so extensive as to be overwhelming; the examples listed in the text are simply intended to give a sense of the proliferation of these topics in all parts of the social and literary milieus of Third Republic Paris. For contemporary examples see Alexandre Laya, *Canses célèbres du mariage ou les*

infortunes conjugales (Paris, 1883); Leopold Lacour, "La question de la femme," *Revue franco-américaine* (July 1895): 33–37; Paolo Lombroso, "Le Bonheur des Femmes," *La Revue des revues* (1897): 301; Octave Uzanne, *Son Altesse la Femme* (Paris: A. Quantin, 1885); and Jules Bois, *La Femme Inquiète* (Paris, 1897). Recent analyses of this phenomenon include Anne Martin-Fugier, *La Bourgeoise: Femme au Temps de Paul Bourget* (Paris: B. Grasset, 1983); James McMillan, "Marriage and Motherhood in the Bourgeoisie: House or Harlot," in *The Place of Women in French Society, 1870–1940* (New York: St. Martin's Press, 1981); and Jean-Paul Aron, ed., *Misérable et glorieuse: La Femme du XIXe siècle* (Paris: Fayard, 1980); for a revelatory early study of this subject and its presentation in contemporary French theater see C. E. Young, *The Marriage Question in the Modern French Drama (1850–1911)* (Ph.D. diss., University of Wisconsin), published in *Bulletin of the University of Wisconsin* 5, no. 771 (Madison, 1915).

35. Women were subject to both psychological and legal repression directly related to the laws concerning marriage and adultery. Required to obey their husbands, they could actually be imprisoned from three to twenty-four months for adultery, although a husband could behave with impunity and retain power over the money, children, and property. Although punishment for adultery became less certain in the latter quarter of the century, it remained a punishable crime. The laws of 1884 made divorce by consent impossible, although reasons of cruelty or injury could be and increasingly were invoked; only in 1904 could the guilty partner marry the person with whom he or she had committed adultery. See Theodore Zeldin, *Ambition and Love* (Oxford: Oxford University Press, 1979), 356–58. Paul Bourget's plays and novels were one of the most popular forums for concerns about marriage, divorce, and adultery. After the great success of his early *Essais de psychologie contemporaine* of 1883, Bourget determined to write a novel that would describe the "state of soul" of his generation. Interestingly enough, some of the titles of his long and short novels of the late 1880s and early 1890s, for example, *The Irreparable* (a collection of short stories of 1884) and *Lies* of 1887, are those that Vallotton used to title the plates of his *Intimités*; and Bourget's first-person confessional novels—both psychological and voluptuous—had much in common with Vallotton's later *La Vie meurtrière*. On Bourget, including a complete list of his works, see Armand E. Singer, *Paul Bourget* (Boston: Twayne Publishers, 1976); Rita Raffetto, *L'Evolution du roman de Paul Bourget* (doctorat, l'Université de Toulouse, 1938); and Walter Todd Secor, *Paul Bourget and the Nouvelle* (New York: King's Crown Press, Columbia University, 1948).

36. A. Strindberg, "Sur l'infériorité de la femme," *La Revue blanche* 8 (1895): 1–20. This article can be considered a seminal one of its type, invoking as it does Darwinian theory to "prove" the logic of woman's predetermined and immutable inferiority.

37. "*Il la choisit entre les plus chastes et les plus jolies petites Eves qui fussent à la disposition des aquéreurs*" ("Le Chasseur de chevelures: Legendes actuelles," *La Revue blanche* (February 1894): 101–2.

38. Such a description was a spoof on the honeymoon—the *voyage de noces*—which had become so conventional a part of bourgeois marriage by the turn of the century that doctors had even begun to proscribe against its more exotic manifestations as being too debilitating for a new wife. See Martin-Fugier, *La Bourgeoise: Femme au Temps de Paul Bourget*, 73–76.

39. Bourgeois woman's prescribed position was mistress of the interior; often called the *gardienne du foyer* (guardian of the hearth), she was the guardian of the "traditions" of the bourgeoisie: traditions described in such reactionary language that they imply a re-feudalization of France—a return to a non-urban regionalism that one also sees expressed in such key texts of the epoch as Maurice Barrès' *Les Déracines* (Paris, 1897). See also Aron, ed., *Misérable et glorieuse: La Femme du XIXe siècle*; and Zev Sternhall, *Maurice Barrès et le nationalisme français* (Paris: Editions Complèxe, 1985).

40. "*Ah, si j'étais en Europe ou même Australie, je serais déjà quelque chose, outre mesure. Ici, c'est défendu, ma femme ne peut me tromper qu'avec moi*" (*La Revue blanche*, 102).

41. Fear of the sexual or the animal in woman was continually expressed at this moment. See for example Dumas fils, *L'Homme-Femme*, his celebrated pamphlet against the female adulterer which also warns against unregulated sexual behavior in marriage as "setting bad examples." Good women have sex for procreation; bad women have sex for pleasure.

42. "*. . . d'un idéal renversé, d'une dignité faible, d'une morale élastique, d'une imagination troublée par les mauvaises exemples, de la curiosité de la sensation déguisée sous le nom du sentiment, de la soif du danger, du plaisir de la ruse, du besoin de la chute, du vertige d'en bas et de toutes les duplicités*" (Alexandre Dumas fils, *Une visite de noces* [Paris, 1871]; cited in Martin-Fugier, 101). Woman is a vampire; she always has need of new sensations to "feed" her and, of course, adultery is the most common result of a woman's "natural" susceptibility to deceitful and immoral behavior —in this case even to the extent of copulating with a baboon.

43. Vallotton's ambivalent attitude to the bourgeoisie had its roots in the novels of Zola and the Naturalists; in both, sexual and social themes intersect; in both sexual hypocrisy is exposed as a prominent bourgeois trait.

44. Jean Schopfer, "The Woodcuts of Félix Vallotton," *The Book Buyer* 20 (May 1900).

45. The inextricable relationship between man's inner being and his outer shell was an essential philosophical aspect of Vallotton's milieu, reflecting the appearances to which the bourgeoisie were so vigorously attached.

46. "*Dix fois un homme et une femme se rencontrent dans toutes les attitudes où les peuvent arrêter les accidents, les stations de la vie sentimentale. Elles en expriment tous les aspects imaginables, la naïveté et le ridicule, l'hypocrisie et le mensonge, la cruauté et jusqu'à ce goût de mort qui est dans notre conception de l'amour. On rit, on frémit, on s'attendrit, on s'indigne, on frissonne. Le délicieux, l'inquiétant spectacle*" (Thadée Natanson, "De M. Félix Vallotton," *La Revue blanche* [1 January 1899]; cited in *Documents 1*, 255).

47. Munch was omnipresent in the *Revue blanche* circle; Thadée Natanson reviewed Munch's exhibition in Oslo in *La Revue blanche* in September 1895. Munch's lithograph *The Scream* (*L'Anxiété*) appeared in the December 1895 issue of the magazine prior to its publication in Vollard's *Album des peintres-graveurs*; and a Munch exhibition at Bing's Maison de L'Art Nouveau in June 1896 was reviewed by August Strindberg (*La Revue blanche* 10: 72 (1896): 525). In 1897 the paintings from Munch's *Frieze of Life* cycle were shown at the Salon des Indépendants. Munch designed the sets and program covers for Ibsen's *Peer Gynt* and *John Borkman* (plate 25), staged at the Théâtre de l'Oeuvre in 1896 and 1897 respectively.

48. As previously mentioned, many of Vallotton's titles from the *Intimités* series refer to Paul Bourget's novels, in particular *The Lie* (Le Mensonge), which can be related to Bourget's *Mensonges* (1887) the story of René Vincy, a young aspiring writer who is introduced to decadent society, and to a certain Suzanne Moraines, by Claude Larcher, a cool, analytical and infinitely more sophisticated writer. Vincy and Moraines have a disastrous relationship defined by Moraine's inability to tell her the truth. It is the old story of youth corrupted by a demi-mondaine: "These women whom you dream of being so delicate, so fine, so aristocratic . . . if you only knew them. Vain women dressed by Worth or Lafernière. But there aren't ten who are capable of a true emotion. The few honest ones are those who take a lover because they find it pleasurable; if you dissect them you'll find in place of their heart a dressmaker's bill and a half-dozen prejudices which hold them instead of principles." "*Ces femmes que vous revez si delicates, si fines, si aristocratiques . . . si vous les connaissiez! Des vanités habillées par Worth ou Lafernière. Mais il y en a pas dix qui soient capables d'une émotion vraie. Les peus honnêtes sont celles qui prennent un amant parce qu'elles y trouvent du plaisir si vous les disséquiez, vous trouveriez à la place du coeur, la note de la couturière, une demi-douzaine de préjugés qui leur tiennent lieu de principes . . .*" (Claude Larcher to René Vincy in *Mensonges* [Paris, 1887], 43).

Like Vallotton, Bourget emphasizes the unhappy pessimistic side of love and the corrosive effects of lies and dissembling upon true human feeling. Bourget, however, also plays to his bourgeois readers' desire for titillation and aristocratic pretense. *Le Mensonge* also refers to Henrik Ibsen's "mensonge vital"—his essential message that only if released from the oppression of bourgeois hypocrisy and social conventions

(the mensonge vital) could the individual develop his free forces and fullest potential; hence the revelation of truth was an act of liberation, the lie was a perpetuation of the stultifying status quo. For a good idea of the interpretation of Ibsen that predominated in the circle of *La Revue blanche* see Henry Bourdeaux, "Les Idées morales de Henri [sic] Ibsen," *La Revue blanche* 7: 193–210.

49. "*. . . sa culture approfondie des maîtres français, d'Ingres en particulier, le nationalisaient français*" (Thadée Natanson, "De M. Félix Vallotton," in *Documents 1*, 253). So while Vallotton had previously done a good deal of illustrative work for the *Revue blanche*, and while he had participated in its literary and artistic events, he had never before been completely assimilated. With the publication of *Intimités* Natanson welcomed him as one of the family and baptized him a Frenchman.

50. In 1899 Vallotton exhibited six of these paintings at the Galerie Durand-Ruel in an exhibition with Bonnard, Denis, Hermann-Paul, Ibels, Ranson, Redon, Roussel, Sérusier, and Vuillard. See *Documents 1*, 257–62 for a list of reviews. I would like to thank Lesley Baier for her thoughtful contributions to my analysis of these paintings.

51. Each detail included in these paintings confirms the sordid atmosphere implied, particularly Vallotton's emphasis on the drapery superimposed on the furnishings: a detail which to a late-nineteenth-century audience was a not too subtle indication of extramarital sexual behavior. Women involved in amorous rendezvous generally brought drapery to feminize the male apartments they were illicitly visiting, as revealed in the novels of Paul Bourget.

52. See Lise Marie Holst, "Félix Vallotton's *Intimités*: Le Cauchemar d'un Erudit" (Master's thesis, Oberlin College, 1979) for a discussion of the Renard influence on and parallels with Vallotton's graphic work. Renard's earlier book, *L'Ecornifleur*, in which the author elaborates his coolly ironic view of the current state of the relations between the sexes, must have also helped focus Vallotton's vision. He undertook the illustrations for *L'Ecornifleur* in 1894, although the project was not republished until 1904.

53. *La Caricature* (13 May 1882); reproduced in Emile Zola, *Oeuvres complètes* (Paris: François Bernouard, n.d.).

54. "*Non seulement les personnages jouent merveilleusement leurs roles, mais aussi les meubles, comique d'un facon si singulière par leur étoffe, leur emplacement, la simplification d'existence qu'ils prennent*" (Octave Mirbeau, *Le Journal* [15 March 1899]).

55. Emile Zola, *Au Bonheur des Dames* (Paris, 1891). This crossroad of commerce and culture was one of the central ingredients of naturalist literature. For discussions of the bourgeois spectacle of shopping and commerce and its relationship to attitudes about women, see Rémy G. Saisselin, *The Bourgeois and the Bibelot* (New Brunswick: Rutgers University Press, 1984);

Rachel Bowlby, *Just Looking: Consumer Culture in Dreiser, Gissing and Zola* (New York: Methuen, 1985). See also Thorstein Veblen, *The Theory of the Leisure Class; An Economic Study of Institutions* (New York: The Modern Library, 1934); Walter Benjamin, *Illuminations*, ed. with an intro. by Hannah Arendt, trans. Harry Zohn (New York: Schocken Books, 1969); and Roland Barthes, *Mythologies* (Paris: Le Seuil, 1957). For a history of the Bon Marché see Michael B. Miller, *The Bon Marché: Bourgeois Culture and the Department Store 1869–1920* (Princeton: Princeton University Press, 1981) and Bernard Marrey, *Les grands magasins des origines à 1939* (Paris: Picard, 1979).

56. "*Cossu et de mauvauis gout, aux fauteuils gonflés de crin, mirotait de leur épaisse petuche, lieu de banales amours, simplifié et synthétique*" (Henri Gheon, *L'Hermitage* [April 1899]).

57. Contemporary critics made insistent distinctions between the work of Vallotton and that of his closest Nabi colleagues Bonnard and Vuillard, although the three were nonetheless often reviewed together. See, for example, reviews of the 1899 exhibition at the Galerie Durand-Ruel, which included Vallotton's interiors alongside works by Bonnard and Vuillard. Gustave Geffroy remarked on Vuillard's "refinement, where color embellishes form so softly and delicately." "*. . . délicatesse . . . où la couleur fleurit si doucement et si finement la forme*" (*Le Journal* [15 March 1899], in *Documents 1*, 258); versus André Fontainas' description of Vallotton's "vile coloring [that] is almost as regrettable as the heavy drawing, which is simpler but as repugnant." "*. . . coloriages ignobles feraient presque regretter les épais dessins, plus simples, aussi répugnants*" (*Mercure de France* [April 1899], in *Documents 1*, 261).

58. "*La passion de l'objet d'art et de l'objet d'art industriel a tué chez moi la séduction de la femme*" (Edmond de Goncourt, *Journal* 4:373 (15 March 1893). See also Saisselin, *The Bourgeois and the Bibelot* and Apter, "Cabinets Secrets," which discuss the fetishistic concept of showing and telling through bibelots and collectibles at the end of the century—a bourgeois idolatry of art that revealed the "hidden" commodity value of sex.

59. For an account of these issues in relationship to the genesis of Art Nouveau but with no mention of the Nabis, see Deborah L. Silverman, "Nature, Nobility, and Neurology: The Ideological Origins of Art Nouveau in France, 1889–1900" (Ph.D. diss., Princeton University, 1983). See also Sasha M. Newman, "Nudes and Landscapes," in Colta Ives et al., *Pierre Bonnard: The Graphic Art* (New York: The Metropolitan Museum of Art, 1989), 145–92.

60. Obsessed by the contrast between the opaque solidity of appearances and the hidden motivations or emotions beneath, Vallotton, like many of his generation, sought quite simply the truth beneath these appearances. "*Il cherche en toutes choses, de bonne foi, la verité. Ce n'est pas de sa faute si il ne la rencontre point souvent, rayonnante, dans sa nudité legendaire, mais presque toujours habillée de mensonges*" (Octave Mirbeau,

L'Exposition de peintures de Félix Vallotton [Paris: Durand-Ruel, 1910], n.p.).

61. Henri Bergson's essay on the data of consciousness, *Essai sur les données immédiates de la conscience* was published in 1889 and read avidly by the Nabis who also attended the lectures upon which the later and equally influential *Matière et mémoire* (1896) was based. Bergson's ideas, which were more synthetic than original—and which so captured the spirit of his age—emphasized subjectivity and intuition in perception, maintaining that consciousness is always fluid and always in a state of becoming largely because of the transformation function of memory. Any concrete "truth" of experience is too fluid to be grasped, as it is constantly being modified by memory. Bergsonian ideas were fundamental to the *intimiste* vision of Bonnard and Vuillard but antithetical to Vallotton's attitude. While *La Vie meurtrière* addresses the persistence of memory in shaping one's life, it has the insistent predetermination of naturalist literature. Vallotton's paintings also eschew the personal, the intuitive, and the fluid, insisting as they do in their cold and frontal formalism on the inert heaviness of matter. While not seeking insignificant experiences, they are revelatory nonetheless in their willful refutation of psychological investigation.

62. Raymond Cogniat, interview with Bonnard, quoted in his *Bonnard*, trans. Anne Ross (New York, 1968), 30.

63. In the late-nineteenth-century apartment, each room and each piece of furniture had a specific function, and also delineated the boundaries between private space and public space. The interior of a good bourgeois woman's home necessarily expressed sweetness and tenderness, as do these room interiors; if the interior is cold, then it is a worrying sign about the woman. Such different states of "woman" signaled by the interior decoration of course are central to an understanding of all Vallotton's interiors. See Anne Martin-Fugier, "La Maîtresse de la Maison," in Aron, ed., *Misérable et glorieuse*; and Martin-Fugier, *La Bourgeoise*, 158–61 (cited in note 34 above). See also the various novels of Paul Bourget where all of the women embarking on assignations carry draperies with them in order to transform the spaces.

64. The maid (*la bonne*) was an essential aspect of a bourgeois woman's entourage and had a real symbolic function in assuring her status. Moreover, the maid herself (her cleanliness, demeanor, ethics) was a direct reflection of her mistress' spiritual state in much the same way as was the interior. See Bonnie G. Smith, *Ladies of the Leisure Class: The Bourgeoises of Northern France* (Princeton: Princeton University Press, 1981); and Martin-Fugier, "La Maîtresse de la Maison," in Aron, ed., *Misérable et glorieuse*, 32. See also Octave Uzanne, *Parisiennes de ce temps* (Paris, 1910).

65. He did paint still lifes and landscapes during the spring and summer while on vacation out of Paris, but with some exceptions these seem almost to be a distraction from or perhaps sublimation of his real focus.

66. Previous literature has already addressed at some length the mythological paintings; see for example Koella, *Félix Vallotton im Kunsthaus Zürich;* and especially Charles Goerg and Antoinette Wakker, *A propos des mythologies et des allégories de Félix Vallotton*, exh. cat. (Geneva: Musée d'Art et d'Histoire, 1979). This latter work gives a thorough history of the presentation of the large-format oils at the Salons d'Automne between 1908 and 1915, which is most useful in terms of Vallotton's shifting critical reception: 1908: *Rape of Europa*; 1909: *Hatred*; 1910: *Perseus Killing the Dragon* and *Summer*; 1912: *Landscape with Figures*; 1913: *The Rape*; 1919: *Orpheus Torn Apart*, and *Hope, Crime Punished, Mourning* (triptych) (both of these works were painted in 1913–14).

67. See Rosalind Krauss and Jane Livingston, *L'Amour fou: Photography and Surrealism* (New York: Abbeville, 1985), and Hal Foster, "L'Amour fou," *Art in America* (January 1986): 117–28.

68. See, for example, Bonnard's *The Red Garters*, ca. 1905 (Dauberville 300; Private Collection, Switzerland).

69. References to Ingres proliferate in Vallotton's critical literature beginning with both Meier-Graefe 1898: "In Ingres Vallotton sees his master." "*En Ingres, Vallotton voit son maître*" (9); and an early review in *L'Estampe et l'affiche* (15 December 1898), which invokes the lineage of Ingres. Ingres is also cited profusely in the criticism following Vallotton's first Salon des Indépendants submission in 1905 (not so coincidentally since a large Ingres retrospective was installed at the same time).

70. For more on Ingres' influence on Vallotton, see *Documents 1*, 256, 258, 274, 280; *Documents 2*, 177, 180, 190, 203, 242, 246, 252, 257, 259, 262–63, 266, 270–71, 279, 297–98, 300; and *Journal*, 125, 186, 337, 341–43.

71. Selected criticisms from Fonds Vauxcelles, Carton 121, Bibliothèque Jacques Doucet, Paris.

72. Clearly the painting also references Manet's *Olympia* as well as Gauguin's own brand of exoticism. See Peter Brooks, "Gauguin's Tahitian Body," *Yale Journal of Criticism* 3 (1990).

73. In *Olympia*, for example, the maid is both stand-in for the spectator (the male viewer) as she rather than he offers flowers and, as is also typical, the revealer of her mistress' charms. See Bernheimer, *Figures of Ill Repute*, 100–102.

74. See Sander Gillman, *Difference and Pathology: Stereotypes of Sexuality, Race and Madness* (Ithaca: Cornell University Press, 1985) on the negress as the purveyor of libidinous drives and lascivious sexuality. See also Gillman, "Black Bodies, White Bodies: Towards an Iconography of Female Sexuality in Late-Nineteenth-Century Art, Medicine, and Literature," *Critical Inquiry* 12 (Autumn 1985): 204–42. On continued black and colonial stereotyoing in post-World War I Paris, see James Clifford, *The Predicament of Culture* (Cambridge: Harvard University Press, 1988).

75. On the history of colonialism in the early twentieth century, see Patricia Leighton, "The

White Peril and L'Art Nègre: Picasso, Primitivism, and Anti-Colonialism," *The Art Bulletin* 72, no. 4 (December 1990): 609–30.

76. The photograph disrupts the propriety of the nude. What the painter represses the photographer reveals: pubic hair and dirty feet as well as the face of the real woman with her direct gaze, all incorporated into Vallotton's later nudes. On the photographic nude and its disruptions of convention (and creation of new ones) see Abigail Solomon-Godeau, "The Legs of the Countess," *October*, no. 39 (Winter 1986): 65–108.

77. "*Si Vallotton, comme Ingres, s'efforce de jeter autour de la forme une ligne simple et continue comme un lasso, c'est pour la rendre immobile sans violence, en apaisant son mouvement, c'est pour représenter son repos.—Mais ce dessin, trop serré, étrangle le mouvement au lieu de l'arrêter, et enferme le modèle dans une attitude si stricte et si définie qu'elle apparaît tout transitoire. Toutes les figures de Vallotton ont quelque chose de mal déployé; elles sont comme un animal pris au piège et qui reste raide, maladroit, malheureux, avec les pattes cassés et plein du désir de s'échapper. Trop fidèlement cernées, trop étroitement surveillées par le trait, elles ne parviennent pas à prendre l'aisance qui les pourrait mettre en repos. Il est significatif de constater qu'alors que presque toutes les déformations d'Ingres sont les allongements, presque toutes celles de Vallotton sont des raccourcis. Le trait retient le bras, les jambes du modèle; au lieu de les accompagner, il les empêche de se développer et de s'étirer jusqu'au calme. Il les ramène durement et les oblige à demeurer dans une sorte de repliement anguleux, si pénible qu'on ne peut le sentir durable*" (Jacques Rivière, "Félix Vallotton," *Nouvelles études* [Paris, 1947]: 25–26; cited in Koella, *Félix Vallotton im Kunsthaus Zürich*, 93).

78. See Linda Nochlin's review, "Return to Order," *Art in America* 69 (September 1981): 74–83 of *Les Réalismes*, exh. cat. (Paris: Centre Georges Pompidou, 1981). This exhibition also sheds much light on a larger context for Vallotton's development despite its concentration on post-World War I issues. See also the catalogue of the recent exhibition at the Tate Gallery, "*On Classic Ground.*" *Picasso, Léger, de Chirico and the New Classicism 1910–1930*, ed. Elizabeth Cowling and Jennifer Mundy (London: Tate Gallery Publications, 1990).

Vallotton's Rediscovery of the Classical Landscape

The above text is based in part on my unpublished dissertation, "Das Bild der Landschaft im Schaffen von Félix Vallotton: Wesen, Bedeutung, Entwicklung," Universität Zürich, 1969. One chapter was published as "Le Retour au paysage historique. Zur Entstehung und Bedeutung von Félix Vallottons später Landschaftsmalerei," in *Jahrbuch des Schweizerischen Instituts für Kunstwissenschaft, 1968–69.*

Essay and notes translated from the German by Celene Abramson.

1. Rudolf Koella, "Den knappsten Ausdruck für den grössten Inhalt. Zum graphischen Werk von Félix Vallotton," in *Félix Vallotton: Bilder, Zeichnungen, Graphik*, exh. cat. (Winterthur: Kunstmuseum, 1978), 27–34.

2. Pierre Cabanne, *Entretiens avec Marcel Duchamp* (Paris: Belfond, 1967), 33.

3. Hahnloser 1936, 204.

4. *Neue Sachlichkeit und Surrealismus in der Schweiz, 1915–1940*, ed. Rudolf Koella, exh. cat. (Winterthur: Kunstmuseum, 1979).

5. See LRZ 428 and 445.

6. See LRZ 433–35, described as "after studies done at Naz" (*d'après études faites à la Naz*).

7. For a study of the very possible influence of Vallotton on Hopper, see Giorgio Pellegrini, "Edward Hopper tra Realismo e Metafisica," *Bolletino d'Arte* 14 (April–June 1982): 145–58.

8. See LRZ 508. As this entry is precisely registered in the middle of all entries for 1903, one can assume that the landscapes were painted in the summer. Vallotton was probably staying in Dieppe, from which he visited Arques-la-Bataille, a small city that lies about ten kilometers further inland, at the confluence of the Varenne and Béthune rivers.

9. The preparatory sketches for three of the landscapes painted at Arques-la-Bataille have been preserved. In addition to a fourth sketch that was apparently never transposed into paint, they were executed on a single sheet, folded horizontally. Later, Vallotton began to do his landscape sketches in small sketchbooks that he bought at the Bazar Laffitte for a sou (according to Francis Jourdain, *Félix Vallotton* [Geneva: Pierre Cailler, 1953], 70). These sketchbooks, as well as a number of loose sheets of sketches, are largely owned by the artist's descendants.

10. The term *paysage composé* first appears in Vallotton's *Livre de raison* in 1918, where it applies to fantasy landscapes. See LRZ 1173, 1175–77, 1179, and 1181.

11. "*Oubli après l'étude*" (Guillaume Apollinaire, *Méditations esthétiques* [Geneva: Pierre Cailler, 1954], 8).

12. "*Les Paysages de Vallotton ne sont pas des interprétations, mais des équivalences*" (Antonin Artaud, "La figure du Salon d'Automne," *Demain* 82 [October/December 1920]; reprinted in *Oeuvres complètes* 2 [Paris: Gallimard, 1961], 197–200).

13. See Robert Rey, *La Renaissance de sentiment classique. La peinture française à la fin du XIXe siècle. Degas—Renoir—Gauguin—Cézanne—Seurat* (Paris: Les Beaux-Arts, 1931).

14. "*Dans la notion d'art classique, ce que domine donc c'est l'idée de synthèse. Pas de classique qui ne soit économe de ses moyens, qui ne subordonne toutes les grâces de détail à la beauté de l'ensemble, qui n'atteigne la grandeur par la concision. Mais l'art classique implique encore la croyance à des rapports nécessaires, à des proportions mathématiques, à une norme de beauté—soit dans le sujet de l'oeuvre d'art (canon humaine), soit dans l'économie de l'oeuvre elle-même (lois de composition). Il compose aussi un juste équilibre entre la nature et le style, entre l'expression et l'harmonie. Le classique synthétise, stylise ou, comme on voudra, invente la beauté, non seulement lorsqu'il sculpte ou lorsqu'il peint, mais encore lorsqu'il use des yeux, lorsqu'il regarde la nature. Tout objet qu'il considère, il le récrée en tant qu'objet, il lui conserve sa logique essentielle en le transformant selon son propre génie*" (Maurice Denis, *Du Symbolise au Classicisme. Théories*, ed. Olivier Revault d'Allones [Paris: Hermann, 1964], 96 and 140). That it was André Gide who gave rise to this new confrontation with the classical is surely not a coincidence, since he was among the most important leaders of literary symbolism, whose 1891 manifesto had proclaimed the founding of an "Ecole romane" honoring the Greco-roman ideal.

15. For these references to Cézanne as "*quelque maître sévère*" and "*le Poussin de la nature morte et du paysage vert*," see Ibid., 160.

16. Cf. Kurt Bauch, "Klassik—Klassizität—Klassizismus," in *Das Werk des Künstler* 1 (1939–40), 429–40; reprinted in *Studien zur Kunstgeschichte* (Berlin, 1967), 40ff.

17. "*Imaginez Poussin refait entièrement sur nature, voilà le classicisme que j'entends. Ce que je n'admets pas, c'est le classicisme qui vous borne. Je veux que la fréquentation d'un maître me rend à moi-même; toutes les fois que je sors de chez Poussin, je sais mieux qui je suis*" (J. Gasquet, *Paul Cézanne* [Paris: Bernheim-Jeune, 1921], 192). Bernard reports the same statement in his contemporaneous work, *Souvenirs sur Paul Cézanne. Une conversation avec Cézanne* (Paris: Mercure de France, 1907).

18. See Hahnloser 1936, 99. Identified in Lionello Venturi, *Cézanne, son art, son oeuvre* (Paris, 1936), as *Départ sur l'eau* (Departure by Water) of ca. 1879–82, and exhibited as a loan in the Vienna Secession in 1903, it appears on the wall in Vallotton's *The Toilette* of 1912. While the memorial he composed in 1907, on the occasion of the Cézanne retrospective at the Salon d'Automne, leaves no doubt as to his honest appreciation of the master, it also seems strangely cool and distanced. See Félix Vallotton, "Au Salon d'Automne," *La Grande Revue* 9 (1907): 916–24. Two years earlier, he had written: "As for Cézanne, I hold him in the highest esteem. I avoid him respectfully." "*Quant à Cézanne, j'en fais en état capital. Je l'évite, respectueusement*" (cited in Charles Morice, "Enquête sur les

tendances actuelles des arts plastiques," *Le Mercure de France* 56 [1905], 358–59).

19. Describing Poussin's *Coriolanus* in his journal entry for 7 September 1916, for example, Vallotton wrote: "It is splendid, it is like a magnificent song played on the organ; colors transcribed into delimited shapes ring like a peal of bells and everything comes in harmony within a powerful, large and gentle whole." And four years later on 28 October 1920, he further noted: "Yesterday I went to see the Poussin paintings which the Louvre has finally decided to show again. What a wonderful artist and what a man! That room is a radiating source of energy. Next to him, the Italians are artificial and the French 18th century seems but a sickly prolongation of his incomparable force. I have much reflected on the topic and I came out stronger and more determined." "*Il est splendide, c'est un chant d'orgue magnifique, les couleurs écrites dans des formes délimitées y sonnent comme des cloches, à pleine volée, et le tout s'harmonise, dans un ensemble puissant, large et doux*"; "*Hier au Louvre voir les Poussin enfin remis au jour. Quel admirable artiste, et quel homme; cette salle est un foyer rayonnant, à côté les Italiens sont artificiex, et le XVIIIe français n'a l'air que d'un prolongement maladif de cette force incomparable. Beaucoup réfléchi là-dessus et sorti réconforté et agissant*" (*Journal*, 126 and 281).

20. "*Je rêve d'une peinture dégagée de tout respect littéral de la nature; je voudrais reconstituer des paysages sur le seul secours de l'émotion qu'ils m'ont causée, quelques grandes lignes évocatrices, un ou deux détails choisis sans superstition d'heure ou d'éclairage. Au fond, ce serait une sorte de retour au fameux Paysage historique. Pourquoi pas? Et peut-être, qui sait si du paysage je ne remonterais pas à la figure? Il me semble voir là des voies ouvertes indéfinies*" (quoted in Edmond Jaloux, "Félix Vallotton," in Jourdain, 88).

21. "*Je récite mon tableau car volontairement je néglige l'imprévu, non pas dans la rue, ni chez les autres, mais dans les choses du métier*" (quoted in Jacques de Laprade, "Vallotton, ou la passion de l'impassible. Avec quelques lettres inédites de Vallotton," *Beaux arts* 73 [1931]: l). The words are reminiscent of a sentence in Ingres' "Pensées," which Vallotton, as we know from his journal, read with great enthusiasm: "When one knows one's trade well and once one has carefully learned how to imitate nature, the hardest thing for a painter to do is to think of his painting as a whole, to have it all in his mind so that it can be executed with one warm endeavor. Only then do I think that all appears to have been simultaneously understood." "*Lorsqu'on sait bien son métier et que l'on a bien appris à imiter la nature, le plus long pour un bon peintre est de penser en tout son tableau, de l'avoir pour ainsi dire tout dans sa tête, afin de l'exécuter ensuite avec chaleur et comme d'une seule venue. Alors, je crois, tout paraît senti ensemble*" (cited in *Ingres raconté par lui-même et par ses amis, pensées et écrits du peintre*, ed. Pierre Courthion with the collab. of Pierre Cailler [Vesenaz and Geneva: Pierre Cailler Editeur, 1947], 19).

22. Denis, 109.

23. Paul Gauguin, *La Vague* (The Wave), 1888 (Wildenstein 286). Similar works, also attributed to 1888, include 264, 281, and 284–86. Inspired by the example of Gauguin, fellow artists Georges Lacombe, Paul Sérusier, Maurice Denis, Paul Ranson, and Aristide Maillol also painted related water pictures. It is conceivable that Vallotton's interest in Gauguin was renewed by the memorial exhibition in the Salon d'Automne of 1903.

24. "*En travail, une méthode—de contradiction, si l'on veut. S'attaquer aux plus fortes abstractions, faire tout ce qui était défendu, et reconstruire plus ou moins heureusement, sans crainte d'exagération, avec exagération même. Apprendre à nouveau, puis, une fois su, apprendre encore. Vaincre toutes les timidités, quelque soit le ridicule qui en rejaillit.— Devant son chevalet, le peintre n'est esclave, ni du présent, ni de la nature, ni de son voisin. Lui, encore lui, toujours lui*" (cited in Charles Morice, *Paul Gauguin* [Paris: Floury, 1920], 244).

25. Cited in Hans H. Hofstätter, *Jugendstil. Der Weg ins zwanzigste Jahrhundert* (Heidelberg and Munich: Helmut Seling, 1959), 105ff. Translated from the German by Celene Abramson.

26. See Jean and Henry Dauberville, eds., *Bonnard* (Paris: J. et H. Bernheim-Jeune, 1968), for example nos. 199, 221, and 329.

27. In 1905, the two paintings were exhibited in the Salon d'Automne in Paris as *Penthée* (no. 1534) and *Soir antique* (no. 1535). A charcoal preparatory drawing for the former presents the motif in a picturesque manner and was probably inspired by the drawings of Böcklin, of whom both theme and method are reminiscent.

28. See the essay by Charles Goerg and Antoinette Wakker, *A propos des mythologies et des allégories de Félix Vallotton*, exh. cat. (Geneva: Musée d'Art et d'Histoire, 1979).

29. See Georg Schmidt, "Böcklin heute," in *Schriften aus 22 Jahren Museumstätigkeit* (Basel: Selbstverlag, 1964): 55.

30. "*C'est là le côté intéressant de ce peintre amer, tourmenté de rêves baudelairiens et de réalisations hors de ses moyens*" (Félix Vallotton, "Sur la grande exposition Böcklin à Bâle," *La Revue blanche* 107 [15 November 1897]: 280ff; reprinted in Fritz Hermann, *Die Revue blanche und die Nabis* [Munich: Mikrokopie G.m.b.H., 1959], 2:407–10).

31. Anthony Blunt, "The Heroic and Ideal Landscape in the Work of Nicolas Poussin," *Journal of the Warburg and Courtauld Institutes* 7 (1944): 167.

32. The word *historique*, derived from the Italian *istoriare*, is synonymous with the term *héroique* in French literature on art. Even in German, the terms *historisch* and *heroisch* are used synonymously in this regard. Cf. Geese, *Dine heroische Landschaft von Koch bis Böcklin* (Studien zur deutschen Kunstgeschichte 271, Strasbourg 1930), 149 n. 27.

33. When it appears for the first time in Roger de Piles' *Cours de peinture par principes*, the term heroic is already understood in this extended sense. It is there defined as "a composition of objects which draws from nature and art all that both can produce which is extraordinary and grand; . . . and if Nature is not expressed in the way that chance shows it to us every day, it is however represented as it should be." " . . . *une composition d'objets qui dans leur genre tirent de l'Art et de la Nature tout ce que l'un et l'autre peuvent produire de grand et d'extraordinaire; . . . et si la Nature n'y est pas exprimée comme le hazard nous le fait voir tous les jours, elle y est du moins représentée comme elle devroit être*" (Paris, 1708, 202ff). See also Walter Friedländer, *Nicolas Poussin* (Paris: Cercle d'art, 1965), 72.

34. "*Certes, mes préférences vont à des peintres plus ambitieux, qui s'efforcent vers le sublime de la plastique, qui, en faveur d'un art si élevé, ne redoutent même pas le trébuchement*" (Guillaume Apollinaire, "Exposition Bonnard" [1910], in *Chroniques d'art, 1902–1918* [Paris: Gallimard, 1960], 88).

35. "*Il faudra . . . qu'il laisse apparaître la pureté d'un Vallotton*" (Guillaume Apollinare, "Georges Braque," in *Catalogue de l'Exposition Braque* [1908], in Ibid., 76). Apollinaire was not always so generous in his appraisal of Vallotton's art, however. For additional examples of his criticism, see the essay by Margrit Hahnloser-Ingold in the present publication.

Vallotton and the Great War

This essay grew out of my participation in a seminar taught at Yale University in the spring of 1990 by Kenneth Silver. Many of the ideas developed here were first explored in his book *Esprit de Corps: The Art of the Parisian Avant-Garde and the First World War, 1914–1925* (Princeton: Princeton University Press, 1989). I would like to thank him for his guidance as I worked on this essay. I would also like to extend my thanks to Sasha Newman for her encouragement and direction, Alvin Clark for his input on French classicism, Lesley Baier for her careful editing, and Peter Zegers, who first encouraged me to pursue issues of the First World War. Thanks go as well to Maria Watroba and Yasmina Mobarek for their assistance with the translations.

1. "*La guerre! . . . Le mot est magnifique, il est évocateur, et sonne en clair toutes ses plus redoutables significations; aucun qualificatif ne saurait l'augmenter ou l'attiédir, et le jour où je le vis surgir en caractères gras le long des murs, je crois bien avoir ressenti la plus forte émotion de ma vie*" (from "Art et Guerre," *Les Ecrits nouveaux* [December 1917]: 31; reprinted in *Journal*, 301–7).

2. "*Ordre de mobilisation générale! Tout est donc fini et la France va jouer son grand jeu*" (1 August 1914, in *Journal*, 24). From the opening of his one-man exhibition at the Galerie Druet in Paris on the eve of the war (5 May 1914) through 31 December 1919, Vallotton kept a private, almost daily journal detailing his feelings and personal relationships as well as current events—the war in particular. Although not solely intended as a record of that conflict, it clearly reveals the artist's obsession with it.

3. The question of how the civilian could best serve his country was a major topic of concern on the homefront. See the series of articles, "Troisième année de guerre: comment les civils peuvent-ils le mieux servir le pays?"; in particular Paul Bourget, "Par les lettres," *Revue hebdomadaire*, no. 8 (24 February 1917): 437–51, in which he asserted that the role of writers was to maintain French spirit during the war and that they could best serve their country by creating superior works of art. The same themes are stressed in the introduction to the 1916 "Triennale" exhibition catalogue (see note 11 below).

4. World War I was the largest war ever staged, with sixty-five million mobilized forces. The unprecedented carnage of eight and a half million deaths on both sides resulted from new artillery used for the first time in a major war: the machine gun, developed in the 1880s and 1890s, was a deadly weapon in trench warfare. Other new and equally deadly inventions included poison mustard gas, first used by the Germans in the battle of Yprès; tanks—a British invention—could rip through barbed wire and crawl across the trenches; the improved airplane, which by the end of the war could drop bombs in place of the zeppelin; and the submarine.

5. Although Vallotton—with Bonnard, Vuillard, and Roussel—refused the *Légion d'honneur* in 1912, judging it a reactionary honor inappropriate to his artistic aspirations, his patriotism was unquestioned; see Elie Faure, "Pour remercier Bonnard, Vuilard [sic], Valloton [sic], Roussel, d'avoir refusé la croix," *Les Cahiers d'aujourd'hui* 2 (December 1912): 78–81. And he took some pride in the fact that his native Switzerland's official neutrality did not govern the hearts of its inhabitants. Following a 1915 trip with Gabrielle to his hometown of Lausanne in the French-speaking Vaudois region of Switzerland, for instance, he wrote: "The francophile fervor of the people of Vaud is incredible. They literally stamp with impatience waiting to see the day when France humbles its enemy which is also theirs. Over there the Boches are in a tight corner and keep a low profile; what a difference!" "*L'ardeur francophile des Vaudois est inimaginable, littéralement ces gens piétinent d'impatience de voir la France abaisser son ennemi, qui est aussi le leur; là-bas les Boches n'en mènent pas large, et rasent plutôt les murs; quelle différence!*" (10 April 1915, in *Journal*, 63).

6. "Here we tend to the wounded; I am a stretcher-bearer and can in this way use the forces that may have been worth more elsewhere." "*Ici on attend les blessés, je suis brancardier, et pourrai utiliser ainsi des forces qui peut-être auraient valu plus ailleurs*" (30 August 1914, in *Journal*, 31). Vallotton spent the majority of the war years in Paris, although he continued to summer in Honfleur. His stepsons, however, served at the front, Jacques in the fall of 1914, Max in 1915. With Jacques a prisoner-of-war at the beginning of 1915 and Max wounded in combat in June in Aparges, the reality of the war entered the Vallotton household on a personal level.

7. Vallotton's Nabi colleagues seem to have been less deeply immobilized by such frustrations. Bonnard distanced himself from the war—his lack of patriotism was a great disappointment to Vallotton. Vuillard worked as a highway guard at Conflans near Paris. Although Roussel suffered a severe depression and spent a good part of the war hospitalized in Switzerland, he nevertheless made contacts there that would provide him with commissions in the coming decade.

8. This experience was shared by foreigners, Picasso and Matisse, and by older artists who did not enlist; see Silver, 5; and Patricia Leighten, *Re-Ordering the Universe: Picasso and Anarchism 1897–1914* (Princeton: Princeton University Press, 1989), 143–46. For an analysis of the public's perception of cowardly artists who sat comfortably in their studios while others went to war, see Elizabeth Kahn Baldewicz, "Les Camoufleurs: The Mobilization of Art and the Artist in Wartime France, 1914–1918" (Ph.D. diss., UCLA, 1980), 149–51; and, by the same author, Elizabeth Louise Kahn, *The Neglected Majority: "Les Camoufleurs," Art History, and World War I* (New York and London: University Press of America, 1984); and "Art from the Front, Death Imagined and the Neglected Majority," *Art History* 8 (June 1985): 192–208.

9. "*Je puis presque dire que je ne souffre plus de mon inaction, disons de mon inutilité; j'en prends mon parti; puisqu'il est admis que cette guerre ne regarde que ceux qui la font, les gens en place, et les malins, je suis donc sans emploi. Les hommes d'affaires trouvent moyen de gagner de l'argent, les roublards se tirent des pieds et ramassent des honneurs, les braves gens se font tuer. Moi je reste là, désargenté, donc inutile aux pauvres; pratiquant un métier, dont l'énoncé seul prête à rire dans les circonstances; hors d'âge pour le service et si parfaitement dénué de toute ambition que l'idée de me mettre en spectacle et de tenter les manoeuvres indispensables me fait froid dans le dos. Je suis l'inutile parfait, c'est amer car je me croyais tout de même quelque valeur*" (19 December 1914, in *Journal*, 47).

Vallotton did propose the production of a type of grenade derived from the Chinese in a letter of May 1915 to Paul Painlevé, the Minister of War.

10. "I consider as wasted an important part of the work I have produced in the last two years. I lack self-discipline and support. I wonder whether it is worth the effort. Every day I promise myself to react and day after day nothing changes." "*Depuis deux ans j'ai dans ma production un déchet sensible; un peu de laisser-aller, pas d'encouragements, et constat de là quoi bon. Tous les jours je me promets de réagir, et les jours se suivent sans rien qui en ressorte*" (23 January 1917, in *Journal*, 148). Vallotton's artistic deadlock followed a period of extreme productivity prior to the war. According to his *Livre de raison*, in 1911 he made seventy-one paintings; in 1912 sixty-one; in 1913 sixty-nine; in 1914 forty-four; in 1915 thirty-nine; in 1916 thirty-four; in 1917 forty-four; and in 1918 sixty-one. The death of his dealer, Eugène Druet, in January 1916 presented an additional source of stress, though the gallery was taken over by Druet's wife. As far as can be determined, Vallotton sold seven paintings during the war: two through the Galerie Druet (June 1915 and June 1917); one to the State (October 1917) *The Gruerie Forest and the Meurissons Ravine* (LRZ 1113); and four to a private collector (February 1918). He also sold three paintings to the Musée de la guerre in January 1919: *Military Cemetery, Châlons-sur-Marne* (LRZ 1138); *The Souain Crater* (LRZ 1139); and *Firing on the German Front Lines* (LRZ 1114).

11. Some galleries were actually forced into exile, as were two important German-born dealers of cubist art, Daniel-Henry Kahnweiler and Wilhelm Uhde. Yet after the initial shock of the war faded, more gallery shows took place. See Malcolm Gee, *Dealers, Critics, and Collectors of Modern Painting: Aspects of the Parisian Art Market Between 1910 and 1930* (New York: Garland Publishing Inc., 1981). Some private galleries donated the proceeds of special exhibitions to support such patriotic causes as the plight of disabled soldiers: for example, Galerie Georges Bernheim, "Exposition de tableaux de maîtres contemporains," 25 November–30 December 1916—sale on behalf of the work of wounded or ill soldiers [*vente au profit de l'oeuvre*

du soldat blessé ou malade]. See Kahn 1984, 5 n.10; and Kahn Baldewicz, 167–81.

Major government-sponsored exhibitions defended the *patrie*: nationalistic shows like the "Triennale," held at the Jeu de Paume in the spring of 1916, promoted the superiority of French art; see introduction to the catalogue by Clément Janin, *La Triennale, Exposition de l'art français* (Paris, 1916), 14; and Silver, 31–32. The government also found a military role for over 3000 French artists who were ultimately employed in the camouflage corps, painting trucks, airplanes, trains, and trompe l'oeil blinds. The technique of painted camouflage was considered a French invention; see Kahn Baldewicz, 29–35, and Theda Shapiro, *Painters and Politics: The European Avant-Garde and Society, 1900–1925* (New York: Elsevier Scientific Publishing Company, 1976), 139–40. Typical works sent back from the front depicted the daily life of the *poilu*, or the French soldier— a theme avoided by non-combatants; see Silver, 78–79.

12. Vallotton exhibited five paintings at a group show at the Galerie Druet in May 1917, and in October of the same year participated in the exhibition "Les Peintres en mission aux armées" in Paris.

13. The artists were given a mandate to "seize the atmosphere of the front, viewing what takes place with sensitivity, with emotion, and presenting no vulgar postcards to the commission. What must be made are documents that can serve to continue the history of the war and can later be used to compose works on the modern war for the Museum of Versailles." " . . . *saisir l'atmosphère du front, qui prennant des vues de ce qui se passe avec sensibilité, avec émotions, et que ce ne soit pas des vulgaires cartes postales que l'on vienne présenter à la commission. Ce qu'il faut prendre, ce sont les documents qui puissent servir à continuer l'histoire de la guerre et à composer plus tard les oeuvres de la Guerre Moderne pour le Musée de Versailles*" (Statement by Léonce Bénédite at the procès verbaux of the commission on the "Missions Artistiques aux Armées," Paris, quoted in Kahn Baldewicz, 151 n.3). Bonnard, Vuillard, and Denis also visited the front as *peintres aux armées*. Vuillard, sent to Gérardmer in Les Voges, received both government and private commissions for several war paintings, the most interesting for the munitions factory in Lyon, run by the former *Revue blanche* owner, Thadée Natanson—four decorative panels depicting the interior of the factory (Musée des Beaux-Arts de Troyes).

14. One thinks, for example, of Callot's *The Great Miseries of War*, Charles Lebrun's paintings of the exploits of Louis XIV, and Baron Gros' glorifications of Napolean's conquests. Vallotton for one particularly admired the war paintings of Jean-Louis Meissonier (1815–1891).

15. Robert de la Sizeranne, *L'Art pendant la Guerre, 1914–1918* (Paris: Librairie Hachette, 1919), 224.

16. "There is no longer a single battle. The Marne is ten uncertain battles and Verdun is thirty, of which not one is picturesque." "*Or, en 1914–1918, il n'y a plus de bataille. La Marne c'est dix batailles incertaines et Verdun c'en est trente, dont aucune n'est pittoresque*" (André Salmon, *L'Art Vivant* [Paris: Les Editions G. Crès et Cie, 1920], 181).

17. See Kahn 1984, 61–64.

18. Vallotton issued the album in a series of 100: ten deluxe large editions on Japan paper, and ninety of a smaller format which he tried to sell on his own for 85 francs each. He wrote in his journal, "I am redoing a series of woodcuts on the war, this pleases me and is a change from the eternal standard 25 cm canvas or the 40 cm to which I seemed dedicated." "*Je refais une série de bois sur la guerre, ça me plaît et me change de l'éternelle toile de 25, ou de 40 à quoi je semblais voué*" (26 December 1915, in *Journal*, 103).

19. On popular art for a popular war see Silver, 38–43. The first war-related *Image d'Epinal* is said to have been made by E. G. Benito in August 1914. Raoul Dufy among many others was engaged in this revival. See also Clément Janin, "Les Estampes et la guerre," *Gazette des Beaux-Arts* (October–December 1917): 483–508.

20. See Phillip Dennis Cate and Patricia Eckert Boyer, *The Circle of Toulouse-Lautrec: An Exhibition of the Work of the Artist and his Close Associates* (New Brunswick: The Jane Voorhees Zimmerli Art Museum, Rutgers, The State University of New Jersey, 1985); and Phillip Dennis Cate, "The Paris Cry: Graphic Artists and the Dreyfus Affair," in *The Dreyfus Affair: Art, Truth & Justice*, ed. Norman L. Kleeblatt (Berkeley: University of California Press in cooperation with the Jewish Museum, 1987), 62–95.

21. VG 134.

22. "*Il est vrai que c'est la guerre! . . . et que les poches ne sont pas facilement ouvertes pour ce qui n'est pas oeuvre de solidarité.—Et pourtant c'en est une*" (18 February 1916, in *Journal*, 108).

23. Although dated 1915, the drawing was probably made in October of 1914; see Vallottton's entry for 21 October 1914, in *Journal*, 39. Vallotton used the same model who had figured in *Dark Woman in a Black Scarf against a Red Background* of 1912 (LRZ 845; Private Collection, Switzerland).

24. "*La France et l'art français, exaltés par la victoire, brilleront de nouveau d'un radieux et splendide éclat*" (Léon Bonnat, "A nos amis," *Album nationale de la guerre*, n.p.).

25. " . . . *l'Art témoignera en faveur de la Justice, de la Beauté et de la Bonté de notre cause*" (Introduction, *La Grande guerre par les artistes*, 1915).

26. See Silver, 89–145.

27. Kahn 1984, 5 n.8. The First World War unleashed an obsession with its documentation. In France, the Musée de la grande guerre, devoted to the history of World War I, was established at the outbreak of the war by the inspector general of libraries and archives and his wife. In 1914, having found a site for it on the rue de Colisée, they began to collect everything printed about the war (in various languages), including periodicals, documents, and posters. This museum would eventually house the paintings made by the *peintres aux armées*.

28. Vallotton tended to display this darker side in his graphic art of the 1890s—for instance *The Execution* (1894; VG 142), *The Assassination* (1893; VG 114); *A Tight Corner* (1893; VG 130), *The Suicide* (1894; VG 143)—and in the morbid experiences of Jacques Verdier in Vallotton's semi-autobiographical novel *La Vie meurtrière* (The Murderous Life).

29. Vallotton wrote on 9 May 1917: "I may go to the front on a mission, this will be a change and will remove the absurdity 'of having seen nothing' but I cannot say that I am impassioned by it"; and on 15 or 16 May 1917 he added: "I hope to leave at the beginning of June on a mission to the front, and I am impatiently awaiting the answer from the minister. It will mean expressing ideas concretely using seen details, and I hope to draw a lot of fodder from all this for the summer." "*Peut-être vais-je aller au front, en mission, ce me sera un changement, cela m'ôtera le ridicule 'de n'avoir rien vu' mais je ne puis pas dire que celà me passionne*"; "*J'espère partir au début de juin pour le front en mission, et j'attends la réponse du ministère non sans impatience. Il s'agira de fixer quelques idées par des détails vus, et j'ai bon espoir de tirer de tout celà une pâture pour cet été*" (in *Journal*, 160).

30. The trio visited Châlons, Suippes, Bussy, St. Rémy, Laval, Hurlus, the camp in Mailly which housed Senegalese soldiers, Souain, Vienne-la-Ville, Vienne-le-Chateau, Harazée, and Florent. Lebasque (1865–1937), who was originally from the Champagne region, painted Impressionist-style women in landscapes, strongly influenced by Matisse and Bonnard. In poor health and too old to enlist in active service, he spent the war in the Midi where he helped the injured. His wartime paintings of desolate landscapes, ruins without grandeur, mutilated walls, and skeletal trees are now in the Musée de la guerre. Piot (1866–1934), who had studied with Gustave Moreau, was sociétaire of the Salon d'Automne. His oeuvre included landscapes, portraits, flower studies, fresco paintings in the manner of Denis, and theater decors.

31. On 8 June 1917, Vallotton noted: "The spectacle becomes increasingly intense, the tombs of soldiers everywhere, soldiers stand gaping at the gates, ruins and factory installations, water posts, barracks etc. that make this disinherited land resemble some place in America. The officers anticipate our wishes, but still this sadness from feeling this world weary and aspiring only to peace." Four days later he added: "The entire country is under boche fire, and the appearance is sinister, ruins bleed of the previous day, and the rare soldiers give it an air of life, even though they trail alone along the highways . . . A very strong impression of this corner of modern war, and of the actors, much more solid than the paltry specimens behind the lines." "*Le spectacle se tend, des tombes partout, des soldats bayant aux portes, des ruines et des installations usinières, postes*

d'eau, baraquements etc. qui font ressembler ce pays déshérité à quelque place d'Amérique. Les officiers vont au-devant de nos désirs, mais toujours cette tristesse de sentir ce monde las et n'aspirant qu'à la paix" (Journal, 163–64); "Tout le pays est sous le feu boche, et l'aspect est sinistre, la ruine est saignante de la veille, et de rares soldats y donnent un air de vie, encore qu'isolés et traînant le long des routes . . . Très forte impression de ce coin de guerre moderne, et des acteurs, autrement solides que les piètres échantillons de l'arrière" (12 June 1917, in Journal, 165).

32. "Les Peintres en mission aux armées." The state purchased one painting from this show (LRZ 1113), but to Vallotton's dismay he had to accept a meager "prix de famine" of 500 francs; see letter to Paul Vallotton, 31 October 1917, in Journal, 177.

I have found three reviews of this show, none of which mention Vallotton's contributions: Le Rousseur, "Les Peintres aux armées," Le Crapouillot, no. 6 (November 1917): 2—a negative review, asserting that works are only truly representative of the war when the artist is not a mere spectator but an actor, a participant in the events depicted; Léonce Bénédite, Curator at the Musée du Luxembourg, "Peintres en mission aux armées," Les Arts 14 (1917): 20–24—a laudatory review; and Péladan, "Le Salon des armées," Revue hebdomadaire (January 1917): 378–90—the critic complains that the paintings lack color. See also Kahn Baldewicz, vol. 2, for photographs of this exhibition, plates 87, 88, 89, 90 [Coll. Archives nationales, carton F21 4079].

33. "Journée entière à Souain dans cet amas de ruines antiques feuillées de roses . . . De tous côtés les fusées boches ou françaises se répondent mettant un air de fête dans ce paysage désolé" (15 June 1917, in Journal, 166). Just over a month later he noted, "At last this series of paintings of the war is finished, basically more or less devasted landscapes." "Enfin fini cette série de toiles de guerre, au fond, des paysages plus ou moins délabrés" (20 July 1917, in Journal, 171).

34. "Certes, ce n'est pas la première guerre qui ait fait des ruines—elles en ont toutes fait—mais c'est la première, du moins dans les temps modernes, qui en ait fait de si complètes et de si précieuses. Depuis des siècles, on n'avait pas rasé une ville, ni détruit un chef-d'oeuvre. Sur les champs de bataille, on voyait, çà et là, une ruine: maintenant, ce sont des paysages de ruines . . . L'horreur de ces destructions est telle qu'elle finit par paraître grandiose, presque à l'égal des grandes convulsions du globe" (La Sizeranne, 233–34). La Sizeranne first expressed these ideas in his article, "Ce que la guerre enseigne aux peintres: A propos du salon du 1918," Revue des deux mondes 84 (1 June 1918): 610–34.

35. "On comprend que ces Ruines nous soient doublement chères. Aussi, est-ce la première fois qu'on a eu l'idée de faire des tableaux entiers et pour ainsi dire des 'portraits de ruines' " (La Sizeranne, 235).

36. See Silver for a discussion of the equation of French civilization and its ruins with those of antiquity.

37. See Album de la guerre (August 1915– December 1915), a bi-monthly with photographs of the war. An image of a ruined city might be captioned with "la ville Martyr" (no. 9 [1 December 1915], pl. 127). Other preferred subjects included the poilus in the trenches, prisoners of war, and important leaders. For an example of a wartime postcard see Christopher Green, Léger and the Avant-Garde (New Haven: Yale University Press, 1961), 110.

38. Although anti-clerical struggles were frequent during the war, French churches were instrumental in promoting patriotism. The war temporarily served to unite the nation and restore the church to its "rightful" place. See Jean-Jacques Becker, The Great War and the French People, trans. Arnold Pomerans (Leamington Spa: Berg, 1985), 161–77.

39. Countless articles in newspapers and journals focused on this particular assault. Two photographs of the ravaged cathedral appeared in the Album de la guerre of 1915; and Remy de Gourmont devoted a chapter to Reims in Pendant l'orage (Paris: Mercure de France, 1925).

40. See Apollinaire's review of Vallotton's one-man show at the Galerie Druet in 1912, in which he notes the influence of the Douanier Rousseau: "The imitation is undeniable. M. Félix Vallotton has taken to the school of Rousseau and he has done well." "L'imitation n'est pas niable. M. Félix Vallotton s'est mis résolument à l'école de Rousseau et il a bien fait" (Guillaume Apollinaire, "Les Pompiers, Vallotton et le douanier Rousseau," Le Petit bleu [3 February 1912]).

41. See "L'Exposition des artistes Indépendants," Gazette de Lausanne (25 March 1891) and Francis Jourdain, Felix Vallotton (Geneva: Editions Pierre Cailler, 1953), 100.

42. "En effet, pour déformés qu'ils soient, les objets atteints retombent à l'instant même qui suit le choc dans une nouvelle fixité. Ce qui était une maison n'est plus qu'une ruine branlante, mais sur cette ruine le soleil joue et distribue ses rayons; les modelés sont autres, la matière diffère, les surfaces et les angles sont modifiés; un caillou est là qui n'y était pas, un mur a disparu, soudain remplacé par un balancement d'arbres; le décor s'est transformé, mais c'est encore et toujours un décor" ("Art et guerre," 32). The exaggerated simplicity of these ruins not only recalls Vallotton's stylized interior paintings of the late 1890s but also the chilling metaphysical paintings of Giorgio de Chirico, whose often figureless images focused on the architecture of Italy.

43. "Interpreted in this spirit . . . one will have good paintings, true, but purely charming and fragmentary. One will not have 'The War.'" "Interprété dans cet esprit . . . on aura de bons tableaux, c'est certain, mais d'agrément pûr, et fragmentaires. On n'aura pas 'La Guerre' " ("Art et Guerre," 32).

44. "L'église, située au centre, semble avoir été, dès le début, leur but de prédilection. Ce n'est que trop tard que l'on songea à en sauver le mobilier: dès les premiers jours, la sacristie avait été démolie par un obus. Le reste de l'église suivit peu à peu le même

sort, surtout en mai, lorsqu'un soldat crut faire un beau coup en remplaçant le coq par un drapeau français. Celui-ci n'y resta pas longtemps: les obus démolirent bientôt le clocher dont les débris supportant encore les cloches gisent en ce moment dans la rue, devant le grand portail. Il n'y a plus un mètre carré de toitures intact, et sur les dalles humides, au milieu des bancs démolis, commencent à pousser les herbes folles. Seules quelques statues épargnées par la mitraille et ramenées par des officiers ou des soldats bienveillants à Suippes sont les pierres d'attente de la résurrection future" (Monseigneur Tissier, La Guerre en Champagne, 3rd ed. [Paris: Pierre Tequi, Libraire-Editeur, 1916], 441).

45. Félix Vallotton to Paul Vallotton, n.d. (ca. 1906), in Documents 2, 106.

46. 1913; LRZ 964.

47. Vallotton had recently seen Poussin's Coriolanus—itself a painting about war and personal morality—at the Hôtel de Ville in les Andelys; see entry for 7 September 1916, in Journal, 126. Coriolanus, a Roman general exiled from his native city in 491 B.C. joined the neighboring Volsci, against whom he had once campaigned. Soon in command of their forces, he returned to attack Rome. His wife and children successfully pleaded with him to call off his offensive, and upon his return to the Volsci he was condemned to death as a traitor.

48. Perhaps encouraged by having sold a painting to the state, he made several works in 1917 based on the material he had gathered on his trip to the front. In November, for example, he painted a reminiscence of the military cemetery in Châlons, in which he hoped to emphasize "the perfect expression of calculated carnage that had become commonplace in the three years of the war." " . . . cette expression parfaite du carnage mathématique qui est notre ordinaire depuis trois ans" (28 November 1917, in Journal, 181).

For an indication of critical reaction to Vallotton's text, see Pierre-Albert Birot, who had not read "Art et guerre" but had seen part of it excerpted in a trench newspaper, L'Horizon, and had been very impressed (in Sic, no. 3 [June 1918]: 232).

49. "Beaucoup d'artistes ayant vu, revinrent des lignes, les poches bourrées de croquis pris sur place, dans la tranchée, au repos, ou, à la chandelle, dans le sombre ennui des guitournes; leur succès fut grand et justifié, mais pour intéressantes que furent ces notations, et leur abondance point encore tarie, leur sens ne dépassa pas celui d'heureuses illustrations. On s'y complut faute de mieux. Mais, pour tous ceux qu'emplissait 'le mot,' la prébende était maigre et 'la guerre' cherchait toujours son expression plastique" ("Art et Guerre," 32).

50. "L'idée de la guerre est une idée intérieure; le spectacle des images qu'elle comporte satisfera ma curiosité, mais n'augmentera pas l'ampleur du drame que je sens" (9 May 1917, in Journal, 160).

51. " 'War' is strictly an internal phenomenon, perceptible to the insides, and all of its visible manifestations, whether grandiose or horrific, are

but picturesque or documentary episodes." "*La 'guerre' est un phénomène strictement intérieur, sensible au dedans, et dont toutes les manifestations apparentes, quel qu'en puisse être le grandiose ou l'horreur, sont et restent épisodes, pittoresque ou document*" ("Art et Guerre," 32).

Vallotton was undoubtedly attracted to the idea of an abstracted projection of a war in which he could not overtly fight. He never portrayed the French soldier in his paintings—the most popular subject for the mobilized artist—though he did portray the German and French soldiers in his prints. Oddly enough, Vallotton painted a reminiscence of troops resting on the highway in Champagne (LRZ 1206) for his own amusement after the war. See his entry for 22 January 1919 in *Journal*, 230.

52. "*Que représenter dans tout cela? Pas l'objet, bien sûr, ce serait primaire, encore qu'on n'y manquera pas, et cependant un Art sans représentation déterminée d'objet est-il possible? Qui sait! . . . Peut-être les théories encore embryonnaires du cubisme s'y pourront-elles appliquer avec fruit? Dessiner ou peindre des 'forces' serait bien plus profondément vrai qu'en reproduire les effets matériels, mais ces 'forces' n'ont pas de forme, et de couleur encore moins*" ("Art et Guerre," 36).

53. See Silver, 78–85. *Verdun* was purchased by the Musée de l'Armée in 1976 from a private collection.

54. See Marc Ferro, *The Great War 1914–1918* (London, New York: Ark Paperbacks, 1969).

55. "*De toute cette horreur s'exhale une noblesse parfaite; on devient vraiment fier d'être de ce côté-là d'humanité, et quoi qu'il arrive, le nom Français se rajeunit d'un lustre inconnu jusqu'ici*" (10 March 1916, in *Journal*, 111). Two days later a more reactionary Vallotton would write: "We on the other hand keep it up, and if Verdun is taken one day, which I don't believe will happen, it will have cost them [the Germans] so dearly that they will lose more than they gain. Furthermore one must think of after the war, when only the living will count. Therefore our tactic appears perfect to me. We must kill the boches, without a truce, without pity, non-stop; the dead do not make children." "*Nous d'autre part nous tenons le coup, et si Verdun est pris un jour, ce que je ne crois pas, il leur aura coûté si cher qu'ils perdront à l'affaire. —Puis il faut songer à l'après-guerre, et à ce moment-là, seuls les vivants compteront. Donc notre tactique me paraît parfaite, il faut tuer les Boches, sans trêve, sans pitié, sans arrêt, les morts ne font pas d'enfants*" (12 March 1916, in *Journal*, 111).

56. Moreau's paintings of Verdun are in the Musée d'histoire contemporaine, Paris.

57. There is no evidence to suggest that Vallotton ever visited the area.

58. "*Un obus qui explose sur un talus et dont les éclats portent la mort aux alentours ne présente à voir rien de tragique. Abstraction faite du bruit on ne constate qu'un gros bouillonnement de fumée et de poussières diversement nuancées dont les volutes se lient avec grâce, se déroulent puis se dissipent selon les lois habituelles. Après comme avant le ciel reste bleu, et si le terrain subit quelque modification, elle est immédiatement acquise au paysage qui*

picturalement change, mais ne perd pas toujours" ("Art et guerre," 32).

59. *1ère Exposition Futuriste d'Art Plastique de la Guerre et d'autres oeuvres antérieures* (solo exhibition), 15 January–1 February 1916. These paintings relate to Severini's declaration in his 1916 article published in the *Mercure de France*: "For example, I tried to express the idea war, by plastic means composed of these realities: Cannon, Factory, Flag, Order for Mobilization, Airplane, Anchor. According to our notion of *conceptual realism* no more or less naturalist description of the battlefield or the carnage could give us the synthesis of the idea: war better than these objects, that are themselves the living symbol." "*Par exemple, j'ai tâché d'exprimé l'idée:* Guerre, *par exemple plastique composé de ces réalités: Canon, Usine, Drapeau, Ordre de mobilisation, Aéroplane, Ancre. Selon notre* conception de réalisme *idéiste aucune carnage ne pourra nous donner la synthèse de l'idée: guerre mieux que ces objets, qui en sont le symbole vivant*" (Gino Severini, "Symbolisme plastique et symbolisme littéraire," *Le Mercure de France* [1 February 1916]: 446–76).

60. See Filippo Tommaso Marinetti to Gino Severini, 20 November 1914: "We urge you to interest yourself pictorially in the war and its repercussions in Paris. Try to live the war pictorially, studying it in all its marvelous mechanical forms (military trains, fortifications, wounded men, ambulances, hospitals, parades, etc" (quoted in Caroline Tisdall and Angelo Bozzolla, *Futurism* [New York: Oxford University Press, 1978], 177). See also Louis Roman, "Les projecteurs électriques et la guerre moderne," *Je sais tout* 124 (15 March 1916): 251–56; and on the theme of Vallotton's war art and mechanization, Konrad Tobler, "Ein neues Modell," *Kulturmagazin* (Bern) (September 1984): 42–49.

61. Vallotton described such a scene in his journal: "Two zeppelins flew over Paris, in a sky of perfect purity where the long pencils of light from the projectors put on a spectacle. They passed not far from the house, high above but perfectly clear in the electric jet that accompanied them. The shells exploding nearby resembled fireworks.—We were tempted to applaud. Unfortunately the bombs must have hit their target and there must be casualties." "*Deux Zeppelins ont survolé Paris, dans un ciel d'une pureté parfaite où les longs pinceaux des projecteurs mettaient une féerie. Ils ont passé non loin de la maison très haut, mais parfaitement nets dans le jet électrique qui les accompagnait.—Les obus éclatant autour semblaient des fusées d'artifice.—On était tenté d'applaudir. Malheureusement des bombes ont dû porter et il doit y avoir des victimes*" (21 March 1915 in *Journal*, 63; see also 30 and 31 January 1916, 106). And see Joseph Stella's *Brooklyn Bridge* of 1918–20 (Yale University Art Gallery, New Haven) and Kurt Schwitters *The Great Ich Picture (Merz Picture 9B)* of 1919 (Museum Ludwig, Cologne).

62. Paul Klee, *The Diaries of Paul Klee 1898–1918*, ed. Felix Klee (London: Peter Owen, 1965;

orig. ed. 1957), 350. Fourteen years Vallotton's junior, Klee was born and raised in the German-speaking Bern area of Switzerland to a Swiss mother and German father. Married to a German woman and living in Munich, he was drafted and put to work in the German infantry reserves for nearly two years. He too recorded his impressions of the war years in a journal.

63. During the war Valensi (1883–1960) was a "*peintre de l'Etat majeur de général Gourand*." He exhibited the paintings and drawings made on this expedition at the Galerie Druet in 1917; some were bought by the State and are now in the Musée de l'histoire contemporaine. Valensi had participated in the Section d'or Exhibition in 1912 and invented a type of cubism which he coined *musicalisme*. He also associated with the Futurists. See his "Rome à travers le temps et l'espace," and "Le musicalisme," in *Poésia*, Marinetti Archives, Beinecke Rare Book and Manuscript Library, Yale University.

64. Vallotton described these drawings as "concise and rigorous documents drawn from nature. War, as it is thus portrayed is not dramatic. The whole horror vanished amidst the great calm of nature. I made some remarks about this topic so that such documents may say something. I am lacking the *sounds*; otherwise it is lifeless and just good enough for military museums." " . . . *documents précis et rigoureux pris sur nature, la guerre vue ainsi n'a rien de dramatique, toute l'horreur disparaît dans l'immensité du calme naturel. Fait des réflexions à ce sujet pour que des documents de cet ordre puissent parler, il y manque* les sons; *autrement c'est inerte, et bon juste pour les musées militaires*" (23 August 1916, in *Journal*, 124).

65. "*Voilà bien la guerre de machine et de science sans les éléments de pittoresque chers à la peinture militaire d'autrefois*." The review continued: "By volumes knowingly juxtaposed and a highly colored ground, Vallotton fixes the infernal aspects of modern combat: dark volutes, giant flames, tragic rockets, bubbling yellowish gas, such is the work which is suggested to him by the legendary name of *Verdun*. Here also is *Yser* and its flooded plains; several skeletal trees emerge from the liquid immensity; only the burst of a large velvety missile of smoke reveals the bombardment; then there is the *Marne*, or rather a corner of a vast battlefield with the desolation of the campaign under a sky stabbed by fires." "*Par des volumes savamment juxtaposés et de grands plans colorés, Vallotton fixe les aspects infernaux du combat moderne: sombres volutes, flammes géantes, fusées tragiques, bouillonnements de gaz jaunâtres, telle est l'ouevre que lui suggère le nom légendaire de* Verdun. *Voici d'autre part l'* Yser *et ses plaines inondées; quelques arbres squelettiques émergent de l'immensité liquide; seul, l'éclatement d'un gros projectile ouaté de fumée révèle le bombardement; puis c'est la* Marne *ou plutôt un coin du vaste champ de bataille avec la désolation des campagnes sous un ciel que poignardent les incendies*" (Le Demi-Solde, "Galerie Druet: Félix Vallotton," *Le Crapouillot* [1 April 1919], in *Journal*, 325).

Vallotton's Secret Garden:
Observations on the Artist as Draftsman

Essay and notes translated from the French by Philippe Hunt.

1. "*Le dessin, c'est la probité de l'art*" (*Ingres raconté par lui-même et par ses amis, pensées et écrits du peintre*, ed. Pierre Courthion with the collab. of Pierre Cailler [Vesenaz and Geneva: Pierre Cailler Editeur, 1947], 56). Vallotton further avers his admiration for Ingres through his protagonist in *La Vie meurtrière* (The Murderous Life): "Nothing has made me undergo the warmth of a woman's body and the weight of a breast more than the way in which Ingres confines the shape of his line." " . . . *rien, plus que la façon dont Ingres enserre la forme de son trait, ne m'a fait subir la tiédeur d'un corps de femme et le poids d'un sein*" (56).

2. "*M. Boulanger a été satisfait de mon travail la semaine passée, par contre celle-ci va des plus mal, pas moyen de faire un dessin convenable, j'en ai recommencé 6 de suite*" (in *Journal*, 361).

3. Vallotton so described his ambition to Hahnloser in a letter of May 1909: "*Je pense cependant que la caractéristique chez moi est le désir d'exprimer par la forme, la silhouette, la ligne et les volumes; la couleur n'étant qu'adjuvant, destiné surtout à mettre en valeur l'objet principal, mais lui restant toujours subordonnée*" (in *Documents 2*, 151). The exhibition in question was at the Künstlerhaus, Zurich, 2–26 May 1909.

4. " . . . *suivez-vous le précepte du Vinci, le petit calpin attaché à une ficelle et battant la hanche?*" (in *Documents 1*, 71). Not all of Vallotton's sketchbooks have been found, and it is known that some were sold as separate leaves. I wish to thank the Galerie Paul Vallotton in Lausanne, and various sketchbook owners, for having allowed me to consult and photograph them.

5. The presence of this portrait of Vallotton's grandfather (Roseng) suggests that the artist started the sketchbook in Switzerland, prior to his departure for Paris.

6. See Hahnloser 1936, 30.

7. LRZ 43. Ibid., 33.

8. Jos Hessel, cousin of Josse and Gaston Bernheim-Jeune, was a dealer and collector. His wife Lucy was Vuillard's intimate friend, confidante, model, and muse from approximately 1905 until his death on 21 June 1940.

9. See Charles Guérin to Hedy Hahnloser, 22 January 1932, in *Documents 2*, 91; and Hahnloser 1936, 209.

10. Vallotton's *Portrait of Juliette Lacour* (LRZ 13) is reproduced in color in Ducrey 1989, 57.

11. See Ashley St. James, "Félix Vallotton: The Nabi Years" (Ph.D. diss., Courtauld Institute, London, 1982), 234; and Rudolf Koella, "Le Retour au paysage historique. Zur Entstehung und Bedeutung von Félix Vallottons später Landschaftsmalerei," in *Jahrbuch des Schweizerischen Institutes für Kunstwissenschaft, 1968–69*, Zurich (1970): 36, 41–42.

12. See Hahnloser 1936, 209.

13. Both the artist's *Livre de raison* (Ledger) and *Livre de comptes* (Account book) indicate that the portrait of Vollard was painted in 1901. For a reproduction of the Meier-Graefe drawing, see Ducrey 1989, 20.

14. See Ursula Perucchi-Petri, *Bonnard und Vuillard im Kunsthaus Zürich* (Zurich: Kunsthaus, 1972), 24.

15. Although Vallotton's 1904 paintings of the bedrooms of Josse and Gaston Bernheim-Jeune are the most accomplished of the series in their precise detailing of the richness of the furnishings, no preparatory documents have as yet been identified.

16. This "Sketchbook with detachable perforated leaves for drawing, pen, and watercolor" (*Livret d'esquisses à feuillets pointillés détachables pour le dessin, la plume, l'aquarelle*), from G. Sennelier, 3 quai Voltaire, measures 8.1 x 12.1 cm. In addition to three pen sketches done at Puteaux in 1900, it contains sketches executed in the forest of Fontainebleau in 1901, several interiors, some seashore sketches (Honfleur, 1901?), and two or three country landscapes resembling certain views of the valley of Arques-la-Bataille (1903?).

17. Although this painting has often been set at the rue Richepanse (see for example *Félix Vallotton*, exh. cat. [Paris: Musée national d'art moderne, 1966], no. 48), its 1901 date precludes that address, as the Galerie Bernheim-Jeune only moved from the rue Laffitte to the rue Richepanse in 1906; see *Bernheim-Jeune, petit résumé historique* (Paris: Edition Bernheim-Jeune, n.d.).

18. Ibid., 5.

19. "*Sisley église ciel bleu léger toits gr[is] roux.*" It is easy to recognize the church of Moret-sur-Loing, which Sisley painted in numerous works between 1893 and 1894. See François Daulte, *Alfred Sisley: Catalogue raisonné de l'oeuvre peint* (Paris: Ed. Durand-Ruel, 1959), nos. 819ff.

20. Hahnloser 1936, 122.

21. See his entry for 17 November 1916, in *Journal*, 134; and *Félix Vallotton*, exh. cat. (Winterthur: Kunstmuseum, 1978), 67.

22. See reproductions in *Nabis und Fauves. Zeichnungen, Aquarelle, Pastelle aus Schweizer Privatbesitz*, exh. cat. (Zurich: Kunsthaus, 1982), 152–53.

23. LRZ 1001. See reproduction in *A propos des mythologies et des allégories de Félix Vallotton*, exh. cat. (Geneva: Musée d'Art et d'Histoire, 1979), 27.

24. Vallotton executed only a very small number of painted sketches. These are known to exist for an 1893 portrait, for *Bathers on a Summer Evening* (plate 149), for three war landscapes, and for a mountain landscape entitled *The High Alps, Glaciers and Snow-Covered Peaks*.

25. See, for example, *The Rape of Europa* or *Perseus Slaying the Dragon* (plates 38, 195).

26. See reproductions in Winterthur, 67 (cited in note 21), and Charles Fegdal, *Félix Vallotton* (Paris: Les Editions Rieder, 1931), pl. 33,

respectively. A landscape as starting point also distinguishes *Twilight* and *Pantheus*, two landscapes with figures painted in 1904, the first from an oil study, the second from a drawing (plates 223, 222). In neither painting, however, do the nudes seem to have been the subject of preparatory drawings. See the essay by Rudolf Koella in the present publication.

27. The painting measures 22 x 26 cm and bears the stamp of the studio with the date "12." It should however probably be identified with LRZ 759, "Ten small pochades landscape at Honfleur" (*Dix petites pochades paysage Honfleur*), painted in 1910, all the more so in that its size corresponds exactly to that given in the LRZ for that series of *pochades*.

28. See Ducrey 1989, 38–40.

29. Vallotton's *Livre de raison* is most useful for works after 1906, as his descriptions of earlier paintings were none too explicit. The *Livre de comptes* is unpublished and kept in manuscript form by the artist's descendants.

30. Vallotton rarely signed or dated his works before selling or exhibiting them. On 23 October 1919, he wrote to Louis Valtat, who was in charge of the hanging at the Salon d'Automne: "The way you are proposing to place my work seems very good to me . . . in a few days' time, when everything is in place, I'll go and sign my second consignment, which isn't signed yet." "*La façon dont vous me proposez de placer mon affaire me semble très bien . . . d'ici quelques jours, quand tout sera en place, j'irai signer mon second envoi, qui ne l'est pas*" (Louis-André Valtat Archives). And according to Claude Vallotton, his uncle once signed but refused to date a painting he had just given him because he did not have his *Livre de raison* with him.

31. See note 16 for a full reference to this recently discovered sketchbook. And see LRZ 477.

32. See Aargauer, Kunsthaus, *Sammlungskatalog 1* (1979), 135.

33. According to an unpublished letter from Jos Hessel to Vallotton, dated 19 November 1920, Hessel bought *Passersby (Street Scene)* from the artist in exchange for a still life by van Gogh. At the foot of this letter, Vallotton noted: "The above mentioned painting was painted and exchanged by me against the van Gogh in 1897." "*Le tableau ci-dessus a été peint et échangé par moi contre le Van Gogh en 1897*" (letter owned by the artist's descendants.)

34. These belong to the series indicated by LRZ 430: "About thirty landscape paintings, done at La Naz, Switzerland" (*Une trentaine de paysages, peintures, faites à La Naz, Suisse*).

35. LRZ 493, 494; 485. Coquelin was a character in Molière's play, *Le Bourgeois Gentilhomme*.

36. See Koella, cited in note 11.

37. "*Félix dessine sans arrêt.*" Undated, this letter was probably written in Cagnes in the winter of 1921 or 1922.

38. Very few drawings are mentioned in his *Livre de raison*, and that mostly before 1900. Hence,

the fact that Vallotton recorded his "Four synthetic drawings" (LRZ 1087: *Quatre dessins synthétiques*) in 1916, attests to the importance he attached to them as very unusual experiments (plate 254). See the essay by Deborah L. Goodman in the present publication.

39. "*Bon petit succès, d'estime et de ventes*" (30 April 1921, in *Journal*, 284).

40. "*Ma peinture est peut-être mauvaise; mais, je le sais, mes dessins sont bons*" (quoted in Fegdal, 27).

41. Ibid.

Affirmation and Debate:
Vallotton's Critics and Collectors

Essay and notes translated from the German by Celene Abramson, with translations from the French by Yasmina Mobarek.

1. "*Une oeuvre si originale se défend et se défendra d'elle-même*" (René Auberjonois, "Félix Vallotton," *Das Werk* 10 [October 1931]: 313). The Swiss painter Auberjonois (1872–1957) was born in Lausanne and worked in Paris from 1897 to 1914, when he returned to his native country. He was an eager defender of Vallotton's work.

2. Vallotton ascribed this admission to the protagonist, Jacques Verdier, in his novel *La Vie meurtrière*: "*une répulsion pour tout ce qui sent la bohème et le débraillé*" (52).

3. The use of such terms as "*sec*," "*froid*," "*volontairement réduit*," "*sans poésie*," and "*lourd*" was endemic to reviews of Vallotton's work.

4. "... *la mâle vigueur de ses études espagnoles; le sobre réalisme de ses nus, la virtuosité de pratique des accessoires, fleurs, étoffes, écharpes . . . la splendeur décorative de ses vastes et silencieux paysages*" (Louis Vauxcelles, *Gil Blas* [18 January 1910], in *Documents 2*, 266). See also note 20, below.

5. "*Le très singulier Vallotton*" was the title of Natanson's chapter on the Swiss artist in *Peints à leur tour* (Paris: Albin Michel, 1948). See Ibid., 309: "*d'aucune plus que de la chair féminine.*"

6. François Fosca referred to the significance of "*son hérédité calviniste*" in a review of the 1906 Salon des Indépendants (see *Documents 2*, 275).

7. By comparison, the Swiss saw the large and figural works of Vallotton's contemporary, Ferdinand Hodler, as symbolic of the primordial Swiss character. Hodler's mountain pictures in particular won their hearts.

8. "*Chez nous, en Suisse française, une certaine prudence paysanne, une auto-analyse desséchante, avec un goût marqué à la flânerie, le passage sous un ciel bleu déjà aimable, mais qui n'a ni la lumière d'argent de l'Ile de France, ni l'emportement des ciels d'Italie ou d'Espagne*" (Auberjonois, "Félix Vallotton," 315).

9. Hahnloser had personally known the artist since 1908, experienced the heights and depths of his life, and left us with a valuable correspondence. Unfortunately, Vallotton must have destroyed her letters to him before his death, for they remain untraceable. A few appear in fragmentary form in a copybook. Did they contain so many personal revelations that the artist deliberately kept them from becoming public?

10. "*La salle où l'on a réuni les grands nus ne manque pas d'intérêt: c'est encore très ferme, très bien peint, mais, même lorsque le niveau d'exécution est très élevé* (La Blanche et la Noire), *le sentiment paraît bien morose et lourdement équivoque. Ce n'est plus une manière troublante d'être simple, mais une manière trop simple de vouloir nous troubler*" (André Fermigier, *Le Monde* [26 April 1979]).

11. In 1898, Julius Meier-Graefe, a frequent visitor to Paris, authored a monograph on the "maître-graveur," which was co-published by the Parisian print dealer Edmond Sagot. Six years earlier, Vallotton—commissioned by Sagot—created the woodcut *The Print Fanciers* as an address card for the dealer's firm (plate 58). Claiming that "Vallotton made so much of the woodcut, he could easily give up the ambition to count as a painter as well," Meier-Graefe nevertheless offered a promising judgment on the artist's paintings: "In his artistic reaction, Vallotton coincides with the youngest of the painters, Maurice Denis, Vuillard, Bonnard, who wish to return from the excessive light of the plein-airs to more intimate colors. But it seems to me that he forges his path more decisively than any of the others" (Meier-Graefe 1898, 11, 7).

12. "*Mais songez mon cher Vallo aux bons amis que vous avez ici, qui vous attendent avec tant de plaisir que nous vous en redonnerons si vous voulez m'écouter et venez passer votre été ici. Allons terminez vite ce qui vous retient à Paris, ne faites pas l'enfant*"; "*J'ai besoin de vous*" (Misia Natanson and Thadée Natanson to Vallotton, Villeneuve, 1 July 1897, in *Etudes de lettres*, 9).

13. "*J'aurais bien aimé vous causer un peu. Pouvez-vous m'écrire un mot au moins? Ce serait charité, ici on a des tendances à croire le monde limité aux coteaux qui nous entourent et aux idées qu'on y agite. C'est peu prudent et pourquoi je vous demande de me secouer un peu en attendant de vous avoir en personne*" (Vuillard to Vallotton, Villeneuve, Fall 1899, in Ibid., 18).

14. Largely, though, the evidence points to a happy marriage, as one can gather from letters and the series of interiors he painted after the turn of the century, using his wife as a model. Even Gertrude Stein insisted: "He was very happy with his wife and she was a very charming woman" (*The Autobiography of Alice B. Toklas* [New York: Harcourt, Brace and Company, 1933], 61).

15. "*M. Vallotton affronte le redoutable parallèle de la* Maja desnuda *et de l'*Olympia. *Sa* Femme nue, *couchée, une main à plat sur son gagne-pain est d'un dessinateur savant et probe; la tête est vraie et curieuse, toute la passivité des filles dites de joie est exprimée*" (Louis Vauxcelles, *Gil Blas* [23 March 1905]).

16. Stein, 61.

17. See Vallotton-Stein Correspondence, no. 1, in "Selected Unpublished Correspondence" for Vallotton's letter to Leo Stein, spring/early summer 1907: "*ce sera le plat de résistance*" (Gertrude Stein Archive, Beinecke Rare Book and Manuscript Library, Yale University).

18. "*J'ai convenu avec Druet, car il me faut à Paris quelqu'un, et c'est le mieux . . . Il a payé très convenablement, ou du moins payera je l'espère, mais n'a pas beaucoup marchandé. Il voulait prendre tout l'atelier . . . et il va pousser les prix. Je lui donne la première vue pour trois ans, mais les commandes, portraits, décorations etc. sont en dehors de lui bien entendu, et je reste libre de garder des choses si ça me plaît.—Je compte bien d'ailleurs, ne lui revendre qu'une fois payé sinon entièrement au moins en grande partie, et tout ce qui est chez moi jusqu'à cette date (1er novembre) m'appartient sans*"

qu'il n'y ait rien a voir. Il en reste pas mal!"
(Vallotton to Hedy Hahnloser, November 1909,
Hahnloser Archives).

19. "*Quand je regarde cette exposition magnifique
où, entre les poèmes de chair et d'âme, j'aperçois des
paysages qui sont là, comme un repos pour nos
émotions, et pour affirmer encore, la grandeur de la
vision de ce rare artiste, j'admire cette violence de
passion, dont il est animé, et dont frémit son art tout
entier. Et j'aime cet absolu dont aucun mécompte,
aucune déception n'ont pu faire fléchir, jamais, le
tranquille courage. Je connais des peintres différents
de M. Vallotton, j'en connais de plus séduisants,
peut-être, je n'en connais pas de plus forts*" (Octave
Mirbeau, "Sur M. Félix Vallotton," *Félix Vallotton*
[Paris: Galerie Druet, 1910], 11).

20. "*Quoi qu'en dise Mirbeau . . . cet art-là est
d'une austérité qui glace*" (in *Documents 2*, 265).
See also note 4, above.

21. "*J'ai le plaisir de vous annoncer que mon
exposition chez Druet est un gros succès, il a vendu
trois toiles sur six, et ce n'est pas fini, mais c'est
surtout un succès d'artiste, ce qui pour moi est bien
plus important*" (Vallotton to Hedy Hahnloser,
n.d., ca. 1910, Hahnloser Archives).

22. "*Il est presque toujours un puissant peintre du
nu féminin. C'est là que sa vision semble avoir son
champ naturel et qu'elle devient réellement créatrice.
Un peu à la façon d'Ingres—toutes proportions
gardées, cette comparaison, qui a déjà été faite,
s'impose—il jette sur le corps de la femme ce regard
aigu, obstiné et dénué de préjugés, qui va saisir la
forme à sa source la plus primitive et la plus
naturelle; et de cette observation tenace, minutieuse
et impartiale d'un modèle individuel, parfois
vulgaire ou ingrat, il tire précisément des images de
grande allure et de beauté générale. C'est par sa
soumission même au réel, contemplé sans autre
préoccupation, qu'il arrive à la grande ligne
typique, au galbe, au style. Sa manière, pour n'être
justement ni conventionelle, ni académique, en
acquiert quelque chose de classique*" ("A travers les
expositions," *Art décoratif* [5 February 1912]).

23. " *. . . la palette est plus riche, plus variée; les
corps palpitent, la sève circule; les fleurs brillent
d'un éclat plus chatoyant. On respire plus
largement. On sent dans la salle comme une joie de
vivre . . . Pourquoi n'acquerrait-il point, pour le
Musée du Luxembourg, un tableau de M.
Vallotton?*" (*Gil Blas* [24 January 1912], in
Documents 2, 270).

24. "*Il se trouve que les véritables maîtres de M.
Félix Vallotton ce sont les Pompiers*" (in *Petites
flâneries d'art par Guillaume Apollinaire*, ed.
Pierre Caizergues [Montpellier: Bibliothèque
artistique et littéraire, 1980], 38). In 1914,
Apollinaire stated this criticism more sharply yet:
"Félix Vallotton, who expected to approach
Ingres, has not gotten beyond photography's
mechanical ideal, which replicates nature
according to a machinist's mold, so to speak. He
has not gotten beyond this, and M. Vallotton
adds to this ideal a thoroughly conventional
concern that renders his work utterly insipid."
"*Félix Vallotton qui pensait s'approcher d'Ingres n'a
pas dépassé cet idéal mécanique de la photographie
où la nature est reproduite pour ainsi dire à*

*l'emporte-pièce. Il ne l'a pas dépassé et M. Vallotton
ajoute à cet idéal toute une part conventionnelle qui
affadit ce qu'il peint*" (Ibid., 47). In 1908,
however, Apollinaire had expressed a far more
positive view of Vallotton's work; see the essay by
Rudolf Koella in the present publication.

25. "*Le satanisme de cet artiste s'accroît chaque
année; naguère, il épiait la laideur pour la saisir au
passage; aujourd'hui il la crée arbitrairement,
instaurant le plus faux et le plus fâcheux
académisme*" (*Paris-Journal* [30 September 1910],
in *Documents 2*, 277).

26. "*Chaque artiste, enflammé d'un sain désir tend
à la poursuite d'un idéal neuf, qui lui soit
personnel, strictement, et n'ait avec celui du voisin
que les rapports—de plus en plus vagues d'ailleurs
—du métier*" ("Notes d'auteur," *La Grande Revue*
[10 October 1907], in *Documents 2*, 24).

27. "*Figurez-vous que le premier tableau de moi
vendu par Druet (des derniers achats), c'est le nu
que vous trouvez si mauvais que vous m'avez
empêché de l'exposer (la demoiselle nue au ruban
vert dans les cheveux qui vous faisait rire) et c'est
acheté par un poete! . . . comme c'est comique les
goûts*" (Vallotton to Hedy Hahnloser, 19
December 1909, Hahnloser Archives).

28. *Rest* is now in the collection of the Art
Institute of Chicago. Also sold were *Aïcha* of
1922 (LRZ 1392) and *The Yellow Scarf* of 1909
(LRZ 689). According to the records of the Druet
Gallery, Pacquement still owned quite a
representative selection of Vallotton's paintings.

29. The work fetched a high price when it was
resold in 1987.

30. "*Chez Druet exposition de groupe, j'ai trois
paysages et deux natures mortes, j'en suis satisfait,
mais rien n'est vendu. Ca ne marche pas très fort en
ce moment et chacun resserre un peu les cordons de
sa bourse, ceci est général et pour tout le monde*";
and "*L'exposition est un gros succès et qui avancera
beaucoup mes affaires, au point de vue situation
surtout. A ce jour il y a 14 vendus, et à des prix
sérieux, car les Vallottons montent!!!*" (Vallotton to
Hedy Hahnloser: presumably December 1910,
and ca. January 1910, Hahnloser Archives).

31. "*La manière de M. Vallotton a pour nous le
charme de ce qui est vivant, robuste et hardi. Ses
planches, si primitives d'aspect, annoncent l'oeil
d'un peintre qui voit juste et qui voit grand*"
("Chronique Suisse" [May 1892], in *Documents 1*,
235).

32. Wilhelm Wartmann, "Preface," *Félix
Vallotton*, Paris, exh. cat. (Zurich: Künstlerhaus,
1909).

33. "*Je reçois aujourd'hui de Kissling [sic] une lettre
bien étonnante; il me propose d'ajourner mon
exposition, soit à l'automne, soit l'année prochaine!
. . . Et ses raisons sont, la crainte que mes nus ne
semblent au public zuricois une provocation; surtout
après ceux de Hodler, qui ont paru-il révolutionné
l'opinion.—Un délai de quelque mois lui paraîtrait
nécessaire pour amener le repos.—. . . J'avoue que
me voilà bien embarrassé, aussi vais-je encore vous
demander ce service de vous mettre en rapport avec
ces Messieurs,—de suite et de voir au juste ce dont il
s'agit.—Je ne vous cache pas que tant d'histoires*

*pour soumettre des oeuvres à l'opinion me lassent un
peu*" (Vallotton to Hedy Hahnloser, March 1909,
Hahnloser Archives). Only a short time before,
the representation of *Love* in an exhibition of
Ferdinand Hodler's work had led to polemical
reactions.

34. "*Personnellement, il me semble qu'il vaut mieux
marcher de l'avant et donner son opinion complète
et sans réserve, mais si j'ai affaire avec un comité
mal disposé et un public hostile, cela vaut-il tant de
tracas, de soucis et de dépenses? En tout cas telle que
je la combine, cette exposition serait considérable,
unique même (76 numéros), nus, paysages, et
quelques intérieurs.—Je ne la recommencerai
certainement jamais nulle part*" (Vallotton to Hedy
Hahnloser, n.d., Hahnloser Archives).

35. *Tages-Anzeiger* (9 May 1909).

36. In 1908, for example, he was included in an
exhibition of French Impressionist art in Zurich.
But 1913, in a far more comprehensive survey
of French art, which included his friends Maillol,
Cottet, Bonnard, Denis, Marquet, and Vuillard
among others, Vallotton's work was omitted.
Such selectivity, however, was inconsistent. An
exhibition of French art in Zurich in 1917, for
example, included one Vallotton. It must be
noted, however, that the loans for this exhibition
came directly from the Parisian art trade and
hence bypassed the artist's involvement.
According to Vallotton, "Someone told me about
a French exhibition in Zurich where I was
represented by one of my small landscapes
purchased at Mme. Druet's and by two other
canvases lent by her. I only have a vague
recollection of these two. All these business deals
occur without the painters knowing about them.
They concern only art dealers." "*Il paraît qu'il y a
à Zurich une exposition française, on me dit même
que j'y suis représenté par un petit paysage à moi,
pris chez Mme Druet et par deux autres toiles
fournies par elle. Je n'ai de ces dernières qu'un
souvenir confus. Toutes ces affaires-là se passent en
dehors des peintres, ce sont des histoires de
marchands*" (Vallotton to Hedy Hahnloser, 19
October 1917, Hahnloser Archives). After the
war, artists rarely continued to determine which
works to present in an exhibition. Rather, dealers
and exhibition organizers assumed this function.

37. "*Il nous faudrait à présent une chose un peu
fraîche, gaie, pour mettre un peu de couleurs aux
murs. Car nous aurons en perspective: La femme au
perroquet, Le paysage aux baigneuses, notre toile
noire de la mort, Le portrait de la vieille femme, que
nous donnerons aussi, un des petits paysages gris
anciens, du temps des bois (que notre beau-frère va
donner), il y aura assez de choses lourdes de
couleurs et sombres*" (letter to Vallotton, from
Hedy Hahnloser's Copybook, 25 February 1914,
Hahnloser Archives).

38. On deposition were: *Woman with a Rose*
(1905; LRZ 551), *Portrait of the Artist* (1908; LRZ
642), *The Rape of Europa, Woman with a Parrot,
Old Woman* (1909; LRZ 681), *At the Seaside*
(1912), and *Anemones* (1914; LRZ 985). The
museum already owned *View of Honfleur,
Summer Morning* (1910; LRZ 729), purchased
from the Sulzer-Grossman legacy in 1911;

Landscape with Bathers (1913; LRZ 962), purchased at the "Exposition nationale suisse" in Bern in 1914; and *The Pont Neuf* (1901; plate 210), a gift from Emil Hahnloser in 1915.

39. *Neue Zürcher Zeitung* (26 January 1913).

40. "*Je n'aurais jamais cru que ma peinture put déchaîner tant d'agitation, et il m'a fallu arriver à mon âge pour courir cette chance d'être refusé en Suisse! Cela n'eût pas manqué d'un certain piquant pour l'histoire*" (Vallotton to Hedy Hahnloser, 27 April 1914, Hahnloser Archives).

41. "*Evidemment j'aurais peut-etre mieux fait de rester chez moi et de ne rien y envoyer, mais il est bien certain aussi que combattant comme vous le faites en ne ménageant personne, vous risquiez d'attraper des coups.—Prenez donc la chose avec philosophie et dans tout ça ne vous souciez pas de moi, mais de vous seule et de vos intérêts.—En ce qui me concerne rien au monde ne me fera varier du but que je me suis choisi et je suivrai ma vie inlassablement. Les discussions, les débinages et les criailleries de qui que ce soit n'y feront rien. Vous ne sauriez même concevoir à quel point cela me laisse indifférent, cela ne m'excite même plus, et vraiment j'ai pour mes ardeurs d'autres idéals et des directions plus certaines que perdre mon temps à polémiquer*" (Vallotton to Hedy Hahnloser, 19 May 1914, Hahnloser Archives).

42. "*Uebrigens ist näturlich grosses Aufsehen erregt worden im Club bei Ankunft der Baigneuse, auch herzlich wenig Begeisterung*" (Hedy Hahnloser to Charles Montag, 23 May 1908, Hahnloser Archives).

43. " . . . *une femme bouillonnante, et je suis un homme un peu désabusé, et qui ne croit pas beaucoup à tant de choses qui vous passionnent encore*" (Vallotton to Hedy Hahnloser, May 1909, Hahnloser Archives).

44. "*Vous voyez donc, très cher ami, que c'est toujours la même chose qui fait que ma vie me soit précieuse, c'est de me sentir unie à vous et à vos intentions de travail et de vie*"; and "*vous me devez encore bien des réponses sur bien des questions . . . je suis heureuse d'être au moins un petit peu la confidente de vos détresses*" (letters to Vallotton, from Hedy Hahnloser's Copybook, ca. 1912, Hahnloser Archives).

45. "*Il faut maintenant reprendre le poids de la vie et se refaire aux contacts pénibles auxquels je suis obligé. Ça n'est pas drôle, et il m'y faut tout mon courage, souvent bien entamé. A y réfléchir, je vis une existence affreusement solitaire et désenchantée; sans doute de cela provient l'âpreté de ma peinture et son manque de joie, ce sera là ma marque*" (Vallotton to Hedy Hahnloser, 14 March 1911, Hahnloser Archives).

46. "*Le plaisir de parler et de m'ouvrir un peu à des gens de mon espèce passe tout autre*"; "*N'oubliez pas que je suis le plus ancien de vos amis d'ici et le plus fidèle, et écrivez—n'est-ce pas*"; and "*Donnez-moi quelque nouvelles et dites ce que vous devenez*" (Vallotton to Hedy Hahnloser: 3 May 1913, n.d., and 23 December 1924, Hahnloser Archives).

47. The exact number of paintings they purchased by Vallotton is unknown, as they gave many away to friends and fellow collectors. Their collection in general centered around the Nabis and the Fauves, with many of whom they also established personal friendships.

48. "*Je m'intéresse à beaucoup de choses ici, mais pas tant au point de vue art que vie et moeurs. Le Kremlin est une chose bien étonnante, sauvage, barbare et un peu comique. Là-dedans une dévotion pouilleuse mais touchante; la boue, de jolies femmes, des théâtres merveilleux, voici le plus clair de tout*" (Vallotton to Hedy Hahnloser, March 1913, Hahnloser Archives).

49. A genuine affection developed between the sisters and the artist's family in Lausanne, and Claribel's letters to Etta are filled with amusing anecdotes concerning the deceased artist: "By the way—Mrs. V. yesterday evening told me a spicy but proper—quite proper—story of a flirtation Felix [sic] Vallotton had with a beautiful American girl of about 26 shortly before his death . . . It was at the dinner table and frankly this harmless (?) little flirtation made him (Felix) more interesting than—'than ever' I was about to say—'his pictures do' is better.—'Oh,' I put in 'all artists have their flirtations'—but I must confess I was surprised at 'Felix' who seems to have had many" (Claribel Cone to Etta Cone, 20 August 1927, Cone Archives, The Baltimore Museum of Art).

50. "*Merci pour votre bonne pensée, mais je suis absolument décidé à ne plus envoyer des toiles en dépôt à l'étranger*" (Vallotton to Hedy Hahnloser, 8 November 1925, Hahnloser Archives).

51. "*Voulez-vous avoir l'obligéance de mettre très au net mes affaires à Winterthur de façon qu'aucune difficulté ne puisse jamais survenir en aucun cas prévisible . . . On se plaint ici des affaires; je suis très soucieux étant donné mes charges croissantes que ne suit pas une augmentation d'affaires. La vie est bien difficile, et l'avenir inquiétant surtout lorsque la vieillesse s'approche et que les illusions disparaissent*" (Vallotton to Hedy Hahnloser, n.d., presumably 25 July 1925, Hahnloser Archives).

52. " *En Suisse, on n'avait pas compris l'importance des recherches de Vallotton*" (Hahnloser 1936, 207).

53. In anticipation of the exhibition, Vallotton had written to Hahnloser: "Thirty-five canvases left yesterday for Munich. Most are landscapes, some of which you know, then the Breton series, all little things. The woman on the sand and two or three rather important canvases make up the lot . . . Perhaps you will have a chance to go to Munich while my exhibition is there, I think it opens around 15 April. The person who made the selections claims it will go well. Let's hope so." "*Pour Munich sont parties hier trente cinq toiles. La plupart paysages vous connaissez en partie, plus la série bretonne, tout ça petites choses. La femme sur le sable et deux ou trois toiles un peu importantes feront le lot . . . Peut-être aurez-vous l'occasion d'aller à Munich lors de mon exposition, ça ouvre je crois vers le 15 avril. La personne qui a choisi chez moi prétend que ça fera très bien, espérons-le*" (Vallotton to Hedy Hahnloser, n.d., Hahnloser Archives).

54. "Kleine Chronik," *Neue Zürcher Zeitung* (23 March 1910).

55. *Basler Zeitung* (3 April 1910). Approval was hardly unanimous, however. One German critic, for example, compared Vallotton's art negatively to the works of Camoin, with whom he shared the exhibition space: "Vallotton . . . paints like a policeman, like someone whose job it is to catch forms and colors. Everything creaks with an intolerable dryness; all things, especially the nudes, are represented with such indelicate corporeality and with a bureaucratic pedantry that is sharpened rather than ameliorated by a dry sarcasm. All shadows are drawn with charcoal; the colors lack all joyfulness. What Camoin possesses perhaps in excess, Vallotton possesses too little of, namely—well, let us this time call it poetry" ("Kleine Chronik," *Neue Zürcher Zeitung* [23 March 1910]).

56. "*Il prodigue de nombreux conseils sur les peintres à exposer, sur les prix à fixer et signale à son frère les offres intéressantes qui se présentent. Il fait bénéficier Paul de sa longue fréquentation des milieux du commerce d'art*" (Marina Ducrey and Guy Ducrey, *La Galerie Paul Vallotton Depuis 1913* . . . [Lausanne: Edition Galerie Vallotton, 1988], 30). For much of the information concerning purchase dates, I am indebted to the Galerie Paul Vallotton, especially to Marina Ducrey.

57. "*Entre toutes les manières d'être marchand de tableaux, dont la plus sûre est de flatter la médiocrité, il choisit, je crois la plus périlleuse et la plus désintéressée, en prétendant former un goût nouveau, imposer des van Dongen et des Félix Vallotton à une bourgeoisie qui laisse mourir son musée de peinture, et ne voit pas plus loin, pour l'art ancien, qu'une estampe de Lory, pour le moderne, que la Gazette du Bon Ton*"; "*Pour qui a vu sur ces parois les images de Renoir, Guérin, van Dongen, Vuillard, l'aigre méthodisme de Vallotton scandalise. Il ne nous propose pas moins que d'abjurer notre impressionnisme, il y insulte, il est agressif*" (P. B., "Opinions et Rubriques," *2e Cahier Vaudois* [Lausanne 1914], 49 and 51).

58. "*Paris est tonique et vivifiant; c'est un fond dispensateur d'énergie, je le sens par moi-même*" (Vallotton to Hedy Hahnloser, 17 January 1919, Hahnloser Archives).

59. "*Le Salon a très bien marché avec résultat parfait. Mad. Druet qui avait vendu presque toutes mes toiles est venue en rechercher un lot, cela va extrêmement bien, on pourrait presque dire qu'on se les arrache. Il est bien temps, et j'aurai attendu mon heure. Tout ceci me fait plaisir pour vous qui avez été d'un tel encouragement, et dont l'obligeance ne s'est jamais démenti*" (Vallotton to Hedy Hahnloser, 3 November 1920, Hahnloser Archives).

60. "*Déjà autour de moi s'accumulent des poussières, je suis d'un passé dont la survie démodée luit pauvrement parmi les fanfares et la grosse caisse des actuels. Je considère celà sans mélancolie, à de certains jours même je voudrais pousser à la roue et hâter la fin*" (26 February 1920, in *Journal*, 268).

61. Besset's assessment was written for the 1979 Vallotton retrospective: "*figuration froide*," "*poétique de l'écart, de la distance*" (Maurice

Besset, "Une poétique de l'écart," *Félix Vallotton* [Paris: Musée du Petit Palais, 1979], n.p.).

62. "*Il dédaigne l'artifice, la ruse; mieux même: il ignore les moyens qu'utilisent tant de ses confrères. Ses nus sont d'un modelé sévère; la sensualité en est fortement cachée; elle ne se livre qu'après une longue méditation; le premier venu ne la découvre pas. La couleur générale, elle aussi, est volontairement assourdie; elle ne veut pas 'raccrocher'; elle ne veut pas plaire; elle veut faire penser. Cependant, l'art de M. Félix Vallotton n'est pas un art de prédicateur; il veut seulement être considéré avec réflexion, avec une lente gourmandise. Il ne s'adresse pas aux esprits superficiels, que l'on captive si aisément avec des rouges, des bleus et des jaunes; il s'adresse aux sages.*

C'est un art protestant, peut-être; mais c'est surtout un art protestant qui a cessé d'être bourru et revêche au contact de Paris et des autres pays enviables que M. Félix Vallotton a visités" (Gustave Coquiot, *Cubistes, Futuristes, Passéistes: Essai sur la Jeune Peinture et la Jeune Sculpture* [Paris: Librairie Ollendorff, 1914], 194–95).

Chronology

1. "*Liste de mes oeuvres, peintures et gravures faite dans l'ordre chronologique, à partir de 1885.*"

2. "*Je découvre aussitôt de M. Lautrec un cadre notable. C'est du Degas canaille, mais la force, ou plutôt la compréhension du dessin est telle que cela saisit*" ("L'Exposition des artistes Indépendants à Paris," *Gazette de Lausanne* [11 April 1890]). The painting to which he refers is *Dortu* P361.

3. "L'Exposition des artistes Indépendants," *Gazette de Lausanne* (25 March 1891); trans. in *Henri Rousseau*, exh. cat. (New York: The Museum of Modern Art, 1985), 92 and 109. The painting to which he refers is *Surprise!*

4. "*Mes bois font paraît il leur petit chemin dans le monde, et me font beaucoup connaître, il est vrai qu'il ne me rentre rien, les dépositaires refusant de m'en donner reçu je suis à leur merci*" (Vallotton to Paul Vallotton, June 1892, in *Documents 1*, 79).

5. "*Leur auteur a été un des artisans de cet affranchissement de la xylographie dont nous nous réjouissons aujourd'hui; son rôle décisif au cours de l'évolution émancipatrice méritait d'être mis en lumière; on l'a exclu sans considération pour sa science profonde, sans prendre garde à l'exquise qualité de son ironie, et ceci à l'instant où le Salon du Champ-de-Mars se targue d'accueillir les humoristes et les satiristes*" (*Le Voltaire* [25 April 1896], in *Documents 1*, 247). Marx's article also appeared on the same day in the *Revue encyclopédique*: 277–86.

6. "*En revenant à Ingres Vallotton cherche à reconquérir les mêmes éléments de la peinture. Mais il ne revient pas au temps d'Ingres, il cherche, au contraire, à refondre ces éléments pour leur donner une forme et une expression moderne, afin d'en faire les moteurs des sentiments artistiques qui maintenant s'agitent en nous*" (Meier-Graefe 1898).

7. " . . . *un poète subtil et gai, amer et voluptueux*" (Thadée Natanson, "De M. Félix Vallotton," *La Revue blanche* [1 January 1899], in *Documents 1*, 254).

8. "*Ils sont des plus honorables, et riches. Les deux frères continuent la maison installée rue Laffitte, l'autre soeur est mariée avec un monsieur Aghion qui est très riche et sans importance autre. Elle n'a pas de grosse fortune, mais une rente qui lui assure l'existence ainsi que celle des enfants. L'avenir de ceux-ci est garanti par la famille. J'aurai à y joindre l'apport de mon travail qui va redoubler, et je serai fortement soutenu tu le penses par sa famille dont c'est le métier et qui me sont très sympathiques . . . Je l'aime beaucoup, ce qui est la raison capitale de ce mariage et elle me le rend; nous nous connaissons à fond, et avons réciproquement pleine confiance*" (1899, in *Documents 1*, 188). See also the introductory essay by Sasha M. Newman in the present publication.

9. "*De tous ces nus, le seul qui soit riant est celui d'une belle créature allongée dans une pose immortalisée par le Titien et l'auteur de la* Maja desnuda" (Louis Vauxcelles, *Gil Blas*, 17 October 1905).

10. "*M. Vallotton procède d'Ingres . . . Il n'y a pas de hardiesse qu'elle ne puisse se permettre, tant sa science est grande; elle paraît se complaire aux raccourcis les plus redoutables; cependant elle ne fait étalage d'aucune virtuosité. Au contraire elle garde toujours cette apparence de gaucherie, je ne sais pas si j'oserais dire classique, qui vient de la subordination de la main à l'esprit, ennemi des effets faciles*" ("A propos d'une exposition à la galerie Bernheim-Jeune," *La Semaine littéraire*, Geneva [9 June 1906]; in Dorival, 209).

11. Guillaume Apollinaire in *Je Dis Tout* (12 October 1907); trans. in *Apollinaire on Art: Essays and Reviews 1902–1918*, ed. Leroy C. Breunig (New York: Da Capo Press, 1972), 29.

12. "*Il est clair que M. Vallotton obéit à une sourde fatalité interne et que son intelligence ne dispose pas à sa guise des aptitudes qui lui furent octroyées au berceau. Il ne peut avancer qu'entre les rudes brancards de son implacable volonté. D'où la conviction, d'où la morne audace que respirent les ouvrages de son cru. L'Enlèvement d'Europe est une affirmation si tranchante qu'elle tient du défi*" (Pierre Hepp, *Gazette des Beaux-Arts* [1 November 1908], in *Documents 2*, 261–62).

13. "*M. Vallotton est un esprit clair, précis, très averti, très cultivé, très passionné. Observateur aigu, parfois un peu amer, parce que extrêmement sensible des êtres et des choses, il aime à se jouer parmi les idées, et il met à ce jeu de la grâce, de la force, de la verve et de la profondeur*" (Octave Mirbeau, in *Félix Vallotton* [Paris: Galerie Druet, 1910]).

14. Apollinaire, *L'Intransigeant* (27 January 1912), in *Apollinaire on Art*, 194–95.

15. "*Je sens mon art en défaveur complète auprès des amateurs, mais j'ai certains appuis sentimentaux de jeunes qui consolent un peu de cet ostracisme brutal. Néanmoins j'ai la gorge un peu serrée et des appréhensions. Si je ne vends rien c'est une catastrophe. Pourquoi toutes ces hostilités?*" (2 March 1919, in *Journal*, 232).

16. Henri Régnier, in *L'Art moderne et quelques aspects de l'art d'autrefois 2* (Paris: Bernheim-Jeune, 1919), 79.

17. "*Crise de dépression et de noir; je me sens las comme je ne me suis jamais senti tel, et de tout. La peinture m'indiffère, les gens m'obsèdent et je fuis l'une et l'autre, sans réconfort nulle part*" (15 September 1920, in *Journal*, 279).

18. "*Ce qui rend vraiment dramatique l'aventure de ce peintre c'est ceci: artiste particulièrement sensible, au lyrisme sans spontanéité—parfait illustrateur de Jules Renard—il en arriva à se défier du pittoresque. L'inquiétude de Félix Vallotton fut le fruit d'une sagesse lentement acquise*" ([Paris: G. Crès et Cie, 1920], 27).

19. "*La vie est une fumée, on se débat, on s'illusionne, on s'accroche à des fantômes qui cèdent sous la main, et la mort est là*" (22 December 1921, in *Journal*, 294).

Lenders to the Exhibition

Anonymous Lenders

Aargauer Kunsthaus, Aarau (on long-term loan from the Gottfried Keller-Stiftung)

Allen Memorial Art Museum, Oberlin College

Mr. and Mrs. Arthur G. Altschul

The Art Institute of Chicago

The Baltimore Museum of Art

Bayerische Staatsgemäldesammlungen, Neue Pinakothek, Munich

The Walter F. Brown Collection, Texas

The Detroit Institute of Arts

Marianne Feilchenfeldt, Zurich

Galerie Vallotton, Lausanne

Hahnloser-Jäggli Foundation

Sabine Helms, Munich

Mr. and Mrs. Michal Hornstein, Montreal

Josefowitz Collection

Kirov Art Museum, Kirov, USSR

Kunsthaus Zürich

Kunstmuseum Bern

Kunstmuseum Solothurn, Dübi-Müller-Stiftung

Kunstmuseum Winterthur

Ellen Melas Kyriazi

The Robert Lehman Collection, The Metropolitan Museum of Art, New York

The Library of Congress, Washington

The Metropolitan Museum of Art, New York

Musée cantonal des Beaux-Arts, Lausanne

Musée d'Art et d'Histoire, Geneva

Musée d'Art moderne de Troyes

Musée de l'Armée, Paris

Musée de Grenoble

Musée des Beaux-Arts, Rouen

Musée d'Orsay, Paris

Musée du Louvre, Paris

Musée du Petit Palais, Geneva

Museum Folkwang, Essen

The Museum of Modern Art, New York

National Gallery of Art, Washington

National Gallery of Canada, Ottawa

The New York Public Library

Oeffentliche Kunstsammlung, Kunstmuseum, Basel

State Hermitage Museum, Leningrad

Virginia Museum of Fine Arts, Richmond

Yale University Art Gallery

The Jane Voorhees Zimmerli Art Museum, Rutgers, The State University of New Jersey

Checklist of the Exhibition

Works are listed chronologically; when several within one year are included, we have followed the order of Vallotton's *Livre de raison* (LRZ), the ledger in which he detailed his production from 1885 until his death. Prints are identified as well by their catalogue number in Maxime Vallotton and Charles Goerg, *Félix Vallotton: Catalogue raisonné de l'œuvre gravé et lithographié* (VG). Exhibition histories include all known solo exhibitions, identified by location. Group exhibitions, distinguished by the addition of short titles, are complete through 1925 and elective thereafter. For full references to all cited exhibitions, see "Exhibition History, 1885–1991." The provenance and exhibition histories of individual paintings have been compiled by Marina Ducrey and the Galerie Paul Vallotton. We would like to thank Mme Ducrey for so generously sharing with us the results of her research for the forthcoming catalogue raisonné of Vallotton's painted oeuvre.

Paintings

The Painter at 20 (*Le Peintre à 20 ans*), 1885
LRZ 10: Mon portrait buste (Salon 1886)
Oil on canvas, 70 x 55.2 cm
Musée cantonal des Beaux-Arts, Lausanne
(*plate 115*)

PROVENANCE: Musée cantonal des Beaux-Arts, Lausanne (1896)
EXHIBITIONS: 1886 Paris, *Salon des Artistes français*, no. 2344 ("Portrait de jeune homme"; honorable mention); 1886 Geneva, *Salon suisse des Beaux-Arts*, no. 191 ("Portrait de jeune homme"); 1887 Geneva, *Exposition municipale des Beaux-Arts* ("Portrait de jeune homme"); 1938 Zurich, no. 5; 1942 Basel, no. 181; 1954 Brussels/ Rotterdam, no. 2; 1957 Basel, no. 2; 1957

Dusseldorf, no. 1; 1957 London, Lefevre Gall., no. 1; 1965 Zurich, no. 3; 1966–67 Paris/ Charleroi, no. 2; 1967–68 St. Gallen/Berlin, *Fünf Waadtländer Künstler*, no. 140 (no. 107, Berlin); 1985 Lausanne, no. 543; 1988 Mesola/Milan/ Bellinzona, no. 1; 1991 Tampere, no. 1

Paul Vallotton, the Artist's Brother
(*Paul Vallotton, frère de l'artiste*), 1886
LRZ 18: Portrait de mon frère
Oil on canvas, 76 x 61 cm
Galerie Vallotton, Lausanne, Private Collection
(*plate 117*)

PROVENANCE: Paul Vallotton; Gal. Vallotton, Lausanne, Private Collection
EXHIBITIONS: 1886 Geneva, *Salon suisse des Beaux-Arts*, no. 192 ("Portrait de M. X"); 1942 Basel, no. 186; 1973 Lausanne, Gal. Vallotton, *60e anniversaire*, no. 1; 1978–79 Winterthur et al., no. 5

The Artist's Parents
(*Les Parents de l'artiste*), 1886
LRZ 22: Portraits réunis de mes parents assis sur canapé (Salon 1887)
Oil on canvas, 102 x 126 cm
Musée cantonal des Beaux-Arts, Lausanne
(*plate 116*)

PROVENANCE: Paul Vallotton; Gal. Vallotton, Lausanne; Gottfried Keller-Stiftung, deposited at Musée cantonal des Beaux-Arts, Lausanne
EXHIBITIONS: 1887 Paris, *Salon des Artistes français*, no. 2349; 1891 Paris, *Salon des Indépendants*, no. 1175 ("Portrait de famille"); 1926 Winterthur, no. 27; 1927 Lausanne, no. 1a; 1927 Bern, no. 3; 1928 Zurich, no. 4; 1938

Lucerne, no. 2; 1938 Zurich, no. 8; 1957 Basel/ Dusseldorf, no. 5 (no. 4, Duss.); 1965 Zurich, no. 5; 1967 St. Gallen, no. 141; 1988 Mesola/Milan/ Bellinzona, no. 2

Félix Jasinski in his Printmaking Studio
(*Félix Jasinski dans son atelier de graveur*), 1887
LRZ 24: Portrait de Mr. F. Jasinski, dans atelier de graveur
Oil on canvas, 26 x 37.5 cm
Sabine Helms, Munich
(*plate 119*)

PROVENANCE: Ambroise Vollard, Paris; Max Rodrigues-Henriques, Paris; Alfred Vallotton, Paris; Gal. Vallotton, Lausanne (1949); Gal. Fabiani, Paris (1951); Mrs. M. F. Albenq, New York; Gal. Meissner, Zurich; Sabine Helms, Munich
EXHIBITIONS: ?1926 Paris, Gal. Druet, no. 1; 1928 Zurich, no. 6; 1954 Brussels/Rotterdam, no. 3; 1978–79 Winterthur et al., no. 8

The Sick Girl (*La Malade*), 1892
LRZ 111: Intérieur, jeune fille couchée, une autre entre portant un plateau
Oil on canvas, 74 x 100 cm
Galerie Vallotton, Lausanne, Private Collection
(*plate 8*)

PROVENANCE: Adrien Vallotton, Lausanne; Paul Vallotton; Gal. Vallotton, Lausanne, Private Collection
EXHIBITIONS: 1927 Lausanne, no. 4; 1927 Bern, no. 6; 1928 Zurich, no. 14; 1929 Paris, Gal. Druet, no. 17; 1932 Geneva, Gal. Moos, no. 10; 1937 Paris, *Les Maîtres de l'art indépendant*, no. 5; 1938 Zurich, no. 13; 1942 Basel, no. 184; 1953 Lausanne, no. 6; 1957 Basel, no. 11; 1965 Zurich, no. 10; 1978–79 Winterthur et al., no. 13; 1983

New York, Wildenstein, *La Revue blanche*; 1984 Rochester, *Artists of La Revue blanche*, no. 14

Study for "Bathers on a Summer Evening"
(*Etude pour "Le Bain au soir d'été"*), 1892
LRZ not cited
Oil on board, 24.8 x 32.5 cm
Private Collection
(*plate 149*)

PROVENANCE: Bernheim-Jeune (1907); Private Collection

The Crowd (*La Foule*), 1894
LRZ 223: Une pochade foule
Oil on panel, 26.8 x 34.9 cm
Allen Memorial Art Museum, Oberlin College, Elisabeth Lotte Franzos Bequest, 1958
(*plate 44*)

PROVENANCE: Elisabeth Lotte Franzos; Allen Memorial Art Museum, Oberlin College, Oberlin, Ohio
EXHIBITIONS: 1984 Rochester, *Artists of La Revue blanche*, no. 48

The Bistro (*Le Bistro*), ca. 1895
LRZ 251(?): Diverses pochades peinture
Oil on canvas, 22 x 27 cm
Mr. and Mrs. Arthur G. Altschul
(*plate 14*)

PROVENANCE: Mme L. Godet-Druet, Paris; Gal. Vallotton, Lausanne (1964); Mr. and Mrs. Arthur G. Altschul
EXHIBITIONS: 1938 Zurich, no. 18; 1957 Basel, no. 17; 1965 Zurich, no. 17; 1965 Vevey, *De Vallotton à Desnos*, no. 22 (dated 1898); 1966–67 Paris/Charleroi, no. 15; 1970 New York, Hirschl & Adler, no. 27

A Street (Street Corner)
(*Une Rue [Coin de rue]*), 1895
LRZ 258: Une rue. peinture
Gouache on board, 35.9 x 29.9 cm
The Metropolitan Museum of Art, New York, The Robert Lehman Collection, 1975, 1975.1.736
(*plate 60*)

PROVENANCE: Druet, Paris; Auction, Gal. Charpentier, Paris, no. 276 (4/6/60); Marianne Feilchenfeldt, Zurich; Robert Lehman, New York; Metropolitan Museum of Art, New York (1975)
EXHIBITIONS: ?1896 Paris, Gal. L'Art Nouveau (Bing), *2e Exposition*, no. 694 ("Coin de rue à Paris"); 1929 Paris, Gal. Druet, no. 25; 1987–88 Paris/Tokyo, *Le Japonisme*, no. 286

The Luxembourg Gardens
(*Jardin du Luxembourg*), 1895
LRZ 259: Le Luxembourg. peinture
Oil on canvas, 54 x 73 cm
Private Collection
(*plate 86*)

PROVENANCE: Gal. Vallotton, Lausanne; Druet, Paris; H. Adam, Paris (1929); Private Collection
EXHIBITIONS: ?1896 Paris, Gal. L'Art Nouveau (Bing), *2e Exposition*, no. 696 ("Jardin public le soir"); 1926 Basel, *Auberjonois . . . Vallotton*, no.

154; 1927 Lausanne, no. 8; 1927 Bern, no. 12; 1928 Zurich, no. 18; 1929 Paris, Gal. Druet, no. 28

Woman with a Plumed Hat
(*Femme au chapeau à plumes*), 1895
LRZ 280: Diverses petites peintures femmes dans la rue.
Oil on board, 48 x 29 cm
Private Collection, Zurich
(*plate 168*)

PROVENANCE: Alexandre Bernheim, Paris (1897); Marguerite Aghion-Bernheim, Paris; Gal. Vallotton—Marianne Feilchenfeldt (1983); Private Collection, Zurich
EXHIBITIONS: 1983 Lausanne, Gal. Vallotton

The Laundress (*La Blanchisseuse*), 1895
LRZ 280: Diverses petites peintures femmes dans la rue.
Oil on board, 36 x 21 cm
Private Collection
(*plate 167*)

PROVENANCE: Alexandre Bernheim, Paris (1897); Marguerite Aghion-Bernheim, Paris; Private Collection
EXHIBITIONS: 1955 Paris, no. 3

Street Scene (*Scène de rue*), 1895
LRZ 284(?): La rue. peinture
Oil on board, 26 x 34 cm
Private Collection
(*plate 65*)

PROVENANCE: Mrs. Paul Vallotton; Gal. Vallotton, Lausanne; Irving Horace Vogel, Philadelphia (3/31/50); Auction, Hammer Gall., New York (3/12/56); Private Collection
EXHIBITIONS: 1938 Zurich, no. 22; 1942 Basel, no. 213; 1949 Paris, Gal. André Weil

Félix Fénéon at the Revue blanche
(*Félix Fénéon à la Revue blanche*), 1896
LRZ not cited
Oil on board, 52 x 65 cm
Josefowitz Collection
(*plate 261*)

PROVENANCE: Gal. Marlborough, London; Josefowitz Collection
EXHIBITIONS: 1962 Minneapolis, *The Nabis and their circle*; 1966–67 Paris/Charleroi, no. 18; 1978–79 Winterthur et al., no. 21; 1979–80 Washington/London, *Post-Impressionism*, no. 273

The Mistress and the Servant
(*La Maîtresse et la servante*), 1896
LRZ 309(?): Petites peintures. paysages et nus
Oil on board, 52 x 66 cm
Private Collection, Switzerland
(*plate 157*)

PROVENANCE: Paul Vallotton; Gal. Vallotton, Lausanne; Private Collection, Geneva (1973); Gal. Vallotton, Lausanne; Private Collection
EXHIBITIONS: ?1897 Paris, Gal. Vollard, *Les Dix*, no. 61 ("Baigneuses"); 1928 Zurich, no. 22; 1929 Paris, Gal. Druet, no. 29; 1955 Paris, *Nabis*, no. 161; 1957 Basel, no. 20; 1963 Milan, Gal. del

Levante, no. 2; 1965 Vevey, *De Vallotton à Desnos*, no. 21; 1970 Bologna, Gal. Forni, no. 1; 1978–79 Winterthur et al., no. 20

Passersby (Street Scene)
(*Les Passants [Scène de rue]*), 1897
LRZ 323: Scène de rue. peinture
Tempera on board, 33.2 x 46 cm
Private Collection
(*plate 59*)

PROVENANCE: Druet, Paris, no. 8261; Jos Hessel, Paris; Roger Marx, Paris; Auction, Coll. Roger Marx, Paris, no. 79 (5/12/14); Armand Dorville, Paris; Private Collection
EXHIBITIONS: 1926 Paris, Gal. Druet, no. 3 (dated 1895)

Nudes Playing Checkers
(*Femmes nues jouant aux dames*), 1897
LRZ 324(?): Femmes nues jouant aux dames (peinture)
Oil on panel, 25.5 x 52.5 cm
Musée d'Art et d'Histoire, Geneva
(*plate 191*)

PROVENANCE: Bernheim-Jeune (1907)?; Musée d'Art et d'Histoire, Geneva

Portrait of Stéphane Natanson
(*Portrait de Stéphane Natanson*), 1897
LRZ 326: Portrait de M. S. Natanson [incorrectly transcribed as M. J. in Hahnloser 1936 and Zurich 1938]
Oil on canvas, 46 x 55 cm
National Gallery of Canada, Ottawa
(*plate 123*)

PROVENANCE: Stéphane Natanson, Paris?; Auction, Champin-Lombrail, Enghien, no. 140 (6/13/82); Gal. Ile de France, Paris; Gal. Clos de Sierne, Geneva; Marianne Feilchenfeldt, Zurich (1982); National Gallery of Canada, Ottawa (1983)

Self-Portrait (*Autoportrait*), 1897
LRZ 336: Mon portrait. peinture
Oil on board, 58 x 47 cm
Private Collection
(*plate 4*)

PROVENANCE: Gabrielle Vallotton, Paris; J. Rodrigues-Henriques, Paris; Private Collection
EXHIBITIONS: 1923 Paris, Gal. Druet, no. 19; 1935 Paris, Gal. Druet, no. 1; 1936 London, Arthur Tooth Gall., no. 24; 1951 Bern, *Die Maler der Revue blanche*, no. 137; 1954 Brussels/Rotterdam, no. 10; 1955 Paris, no. 4; 1963 Paris, no. 1; 1978–79 Winterthur et al., no. 22; 1985 Lausanne, no. 545

Woman Reclining on Cushions
(*Femme aux coussins*), 1897
LRZ 340(?): Peintures femmes nues, effet de nuit etc.
Oil on board, 23 x 40 cm
Josefowitz Collection
(*plate 163*)

PROVENANCE: Gal. Vallotton, Lausanne; Gal. Arts plastiques modernes, Paris (1950); Dr. W.

Raeber, Basel (1952); Private Collection, Basel; Auction, Gal. Motte, Geneva, no. 514 (6/27/69); Private Collection, USA; Marianne Feilchenfeldt, Zurich; Josefowitz Collection
EXHIBITIONS: 1897 Paris, Gal. Vollard, *Les Dix*, no. 92 ("Femme nue"); 1923 Paris, Gal. Druet, no. 18; 1929 Paris, Gal. Druet, no. 31; 1957 Basel, no. 25; 1965 Zurich, no. 35

Women at their Toilette
(*Femmes à leur toilette*), 1897
LRZ 340(?): Peintures femmes nues, effet de nuit etc.
Oil on board, 48 x 58 cm
Private Collection, Switzerland
(*plate 161*)

PROVENANCE: Bernheim-Jeune, "Femmes dans intérieur" (1907); Druet, "Le Gynécée"; Max Moos?; Dr. E. Troester, Geneva; Musée de l'Athénée, Geneva; Private Collection
EXHIBITIONS: ?1897 Paris, Gal. Vollard, *Les Dix*, no. 63 ("Femmes nues"); 1910 Paris, Gal. Bernheim-Jeune, *Nus*, no. 120 ("Femmes dans un intérieur"); 1910–11 London, Grafton Gall., *Manet and the Post-Impressionists*, no. 102 ("Femmes [Le Tub] [Lent by Bernheim]"); 1951 Bern, *Die Maler der Revue blanche*, no. 147; 1953 Lausanne, no. 10; 1954 Brussels/Rotterdam, no. 13; 1957 Basel, no. 22; 1966–67 Paris/Charleroi, no. 22; 1978–79 Winterthur et al., no. 23

Portrait of Thadée Natanson
(*Portrait de Thadée Natanson*), 1897
LRZ 346: Portrait de M. Th. Natanson (peinture)
Oil on board, 66.5 x 48 cm
Musée du Petit Palais, Geneva
(*plate 125*)

PROVENANCE: Thadée Natanson, Paris; Auction, Coll. Thadée Natanson, Paris, no. 36 (6/13/08); Octave Mirbeau, Paris; Auction, Coll. O. Mirbeau, Paris, no. 55 (2/24/19); Druet; Romain Coolus, Paris; Auction, La Peau de l'ours (1938?); Pierre Cailler, Geneva; Oscar Ghez, Geneva; Musée du Petit Palais, Geneva
EXHIBITIONS: ?1898 Paris, Gal. Vollard, [Nabis]; 1926 Gal. Druet, no. 4; 1938 Zurich, no. 26; 1954 Brussels/Rotterdam, no. 11; 1955 Paris, *Nabis*, no. 31; 1957 Basel, no. 26; 1964 Turin/Tel Aviv, *80 Pittori da Renoir a Kisling*, no. 42 (no. 23, Tel Aviv); 1965 Zurich, no. 32; 1966–67 Paris/Charleroi, no. 20; 1970 New York, Hirschl & Adler, no. 13; 1978–79 Winterthur et al., no. 24; 1983 New York, Wildenstein, *La Revue blanche*; 1984 Rochester, *Artists of La Revue blanche*, no. 50

Nude Lying in the Grass
(*Femme nue étendue dans l'herbe*), 1897(?)
LRZ not cited
Oil on board, 26 x 28 cm
Josefowitz Collection
(*plate 147*)

PROVENANCE: Gabrielle Vallotton, Paris; J. Rodrigues-Henriques, Paris; Private Collection, Paris; René Steiner, Pully (1978); Josefowitz Collection (1979)

EXHIBITIONS: 1928 Paris, Gal. J. Rodrigues-Henriques, no. 13 (dated 1899); 1965 Zurich, no. 33

Nude Seated in a Red Armchair
(*Femme nue assise dans un fauteuil rouge*), 1897
LRZ 355: Peinture, femme nue dans fauteuil rouge
Oil on canvas, 30 x 29 cm
Musée de Grenoble
(*frontispiece*)

PROVENANCE: Marcel Guérin, Paris; Huguette Bérès, Paris; Musée de Grenoble (1975)
EXHIBITIONS: ?1898 Paris, Gal. Vollard, [Nabis]; 1938 Zurich, no. 25; 1955 Paris, *Nabis*, no. 163

Nude in the Red Room
(*Nu dans la chambre rouge*), 1897
LRZ 356: Peinture, femme nue dans intérieur
Oil on board, 43 x 60 cm
Private Collection
(*plate 162*)

PROVENANCE: Dr. A. Hahnloser, Winterthur (1910); Private Collection
EXHIBITIONS: ?1898 Paris, Gal. Vollard, [Nabis]; 1926 Winterthur, no. 41; 1928 Zurich, no. 23; 1938 Zurich, no. 27; 1938 Lucerne, no. 1; 1940 Lucerne, *Die Hauptwerke der Sammlung Hahnloser*, no. 141; 1942 Basel, no. 196; 1951 Bern, *Die Maler der Revue blanche*, no. 154; 1953 Lausanne, no. 11; 1957 Basel, no. 21; 1965 Zurich, no. 34; 1973 Winterthur, *Künstlerfreunde um Arthur und Hedy Hahnloser-Bühler*, no. 231; 1978–79 Winterthur et al., no. 25

Portrait of Marthe Mellot
(*Portrait de Marthe Mellot*), 1898
LRZ 366: Portrait de Mlle M. Mellot. peinture
Oil on canvas, 73 x 60 cm
Kunsthaus Zürich, Vereinigung Zürcher Kunstfreunde
(*plate 124*)

PROVENANCE: Gal. Vallotton; Vereinigung Zürcher Kunstfreunde (1938); Kunsthaus Zürich
EXHIBITIONS: 1898 Paris, Gal. Vollard, [Nabis]; 1926 Winterthur, no. 32; 1927 Lausanne, no. 10; 1927 Bern, no. 13; 1928 Zurich, no. 25; 1929 Paris, Gal. Druet, no. 34; 1938 Zurich, no. 29; 1942 Basel, no. 190; 1943–44 La Chaux-de-Fonds, no. 3; 1951 Bern, *Die Maler der Revue blanche*, no. 149; 1956 Zofingen, *Meisterwerke der Schweizer Kunst*, no. 133; 1957 Basel, no. 32; 1957 Dusseldorf, no. 19; 1963–64 Mannheim, *Nabis*, no. 276; 1978–79 Winterthur et al., no. 26

Nude Standing in front of Bed with Little Dog (*Femme nue debout devant un lit avec petit chien*), 1898
LRZ 386: Femmes nues dans intérieur. peintures
Oil on canvas, 33 x 22 cm
Private Collection
(*plate 160*)

PROVENANCE: Josef Müller, Solothurn; Private Collection
EXHIBITIONS: 1938 Zurich, no. 31; 1953 Lausanne, no. 14

Nudes with Cats (*Femmes nues aux chats*), 1898(?)
LRZ 386: Femmes nues dans intérieur. peintures
Oil on board, 41 x 52 cm
Galerie Vallotton, Lausanne, Private Collection
(*plate 190*)

PROVENANCE: Paul Vallotton; Gal. Vallotton, Lausanne, Private Collection
EXHIBITIONS: 1938 Zurich, no. 24; 1938 Lucerne, no. 50; 1942 Basel, no. 191; 1949 Paris, Gal. André Weil; 1953 Lausanne, no. 15; 1957 Basel, no. 36; 1963 Milan, Gal. del Levante, no. 198; 1965 Vevey, *De Vallotton à Desnos*, no. 116; 1966–67 Paris/Charleroi, no. 24; 1978–79 Winterthur et al., no. 28; 1982 Bremen, Graphisches Kabinett, no. 2; 1983 New York, Wildenstein, *La Revue blanche*; 1984 Rochester, *Artists of La Revue blanche*, no. 51

The Lie (*Le Mensonge*), 1898
LRZ 387: Trois petits sujets amoureux. peintures
Oil on board, 23.5 x 33 cm
The Baltimore Museum of Art, The Cone Collection, formed by Dr. Claribel Cone and Miss Etta Cone of Baltimore, Maryland, BMA 1950.298
(*plate 170*)

PROVENANCE: Gal. Vallotton; Etta Cone, Baltimore; The Baltimore Museum of Art (1950)
EXHIBITIONS: ?1899 Paris, Gal. Durand-Ruel, [Nabis]; 1972 Los Angeles, no. 2; 1984 Rochester, *Artists of La Revue blanche*, no. 49

Intimacy (Interior with couple and screen)
(*Intimité [Couple dans un intérieur avec paravent]*), 1898
LRZ 387: Trois petits sujets amoureux. peintures
Tempera on board, 35 x 57 cm
Josefowitz Collection
(*plate 173*)

PROVENANCE: Gal. Vallotton, Lausanne; Richard Bühler, Winterthur (1926); Auction Richard Bühler, Lucerne, no. 12 (9/2/35); Gal. Moos, Geneva; Gal. Vallotton, Lausanne (1951); Dr. M. Gilbert, Paris (3/29/52); Gal. Vallotton, Lausanne (1968); Josefowitz Collection (1970)
EXHIBITIONS: ?1899 Paris, Gal. Durand-Ruel, [Nabis]; 1923 Paris, Gal. Druet, no. 21; 1926 Winterthur, no. 39; 1928 Zurich, no. 26?; 1951 Bern, *Die Maler der Revue blanche*, no. 153; 1953 Lausanne, no. 17; 1954 Brussels/Rotterdam, no. 15; 1957 Basel, no. 31; 1965 Zurich, no. 41; 1966–67 Paris/Charleroi, no. 23; 1978–79 Winterthur et al., no. 30; 1979–80 Washington/London, *Post-Impressionism*, no. 274

The Kiss (*Le Baiser*), 1898
LRZ 387: Trois petits sujets amoureux. peintures
Tempera on board, 30 x 37.5 cm
Private Collection
(*plate 172*)

PROVENANCE: Gal. Vallotton, Lausanne; Louis Noyer, Paris (1929); Private Collection

The Hand Kiss (The Lovers) (Thadée and Misia) *(Le Baisemain [Les Amoureux] [Thadée et Misia])*, 1898
LRZ 387(?): Trois petits sujets amoureux. peintures
Tempera on board, 36 x 29 cm
Private Collection
(plate 129)

PROVENANCE: Gal. Vallotton, Lausanne; Marcel Guérin, Paris (10/17/30); Lily Goujon, Paris ("Tendresse") (1931); Private Collection
EXHIBITIONS: 1929 Paris, Gal. Druet, no. 36; 1938 Zurich, no. 32; 1965 Zurich, no. 45; 1966–67 Paris/Charleroi, no. 25, 1957 Basel, no. 27

Mother and Child *(Mère et enfant)*, 1898
LRZ 390(?): Trois études, peintures et pastels. intérieurs.
Gouache on board, 27 x 34 cm
Private Collection
(plate 294)

PROVENANCE: Gal. Vallotton, Lausanne (1924); Richard Bühler, Winterthur (6/16/24); Private Collection
EXHIBITIONS: 1926 Winterthur, no. 47; 1965 Zurich, no. 43; 1978–79 Winterthur et al., no. 27

Woman in a Purple Dress by Lamplight *(Femme en robe violette sous la lampe)*, 1898
LRZ 390(?): Trois études, peintures et pastels. intérieurs.
Gouache on board, 29.5 x 36 cm
Private Collection
(plate 27)

PROVENANCE: Gal. Vallotton; Dr. A. Hahnloser, Winterthur (12/6/26); Private Collection
EXHIBITIONS: 1926 Winterthur, no. 43; 1938 Zurich, no. 37; 1965 Zurich, no. 73; 1973 Winterthur, *Künstlerfreunde um Arthur und Hedy Hahnloser-Bühler*, no. 232; 1957 Basel, no. 35; 1966–67 Paris/Charleroi, no. 42

Misia at her Dressing Table *(Misia à sa coiffeuse)*, 1898
LRZ 390: Trois études, peintures et pastels. intérieurs.
Tempera on board, 35 x 27 cm
Private Collection
(plate 127)

PROVENANCE: Thadée Natanson, Paris; J. Rodrigues-Henriques; Private Collection
EXHIBITIONS: 1955 Paris, no. 5; 1978–79 Winterthur et al., no. 32

Misia Godebska *(Misia Godebska)*, 1898
LRZ not cited
Gouache on board, 35.9 x 29 cm
Neue Pinakothek, Bayerische Staatsgemäldesammlungen, Munich
(plate 128)

PROVENANCE: J. Rodrigues-Henriques, Paris; Marcel Guérin, Paris (1932); Marianne Feilchenfeldt, Zurich; Neue Pinakothek, Bayerische Staatsgemäldesammlungen, Munich
EXHIBITIONS: 1928 Paris, Gal. J. Rodrigues-

Henriques, no. 8; 1938 Zurich, no. 30; 1965 Zurich, no. 44; 1966–67 Paris/Charleroi, no. 28

Private Conversation *(Colloque sentimental)*, 1898
LRZ 394: Chambre gris et bleu peinture et pastel
Pastel and gouache on paper reinforced with board, 45.5 x 64.5 cm
Musée d'Art et d'Histoire, Geneva
(plate 176)

PROVENANCE: Charles Guérin, Paris; Auction, Gal. Charpentier, Paris, no. 127 (3/22/55); Dr. W. Raeber, Basel; Dr. W. Hahnhart, Basel; Musée d'Art et d'Histoire, Geneva (1967)
EXHIBITIONS: ?1899 Paris, Gal. Durand-Ruel, [Nabis]; 1957 Basel, no. 28; 1978–79 Winterthur et al., no. 29

The Visit *(La Visite)*, 1899
LRZ 395: Intérieur canapé bleu. peinture et pastel
Gouache on board, 55 x 87 cm
Kunsthaus Zürich
(plate 177)

PROVENANCE: Vereinigung Zürcher Kunstfreunde (1909); Kunsthaus Zürich
EXHIBITIONS: 1899 Gal. Durand-Ruel, [Nabis]; 1909 Zurich, Künstlerhaus, no. 4; 1938 Zurich, no. 40; 1942 Basel, no. 194; 1943–44 La Chaux-de-Fonds, no. 5; 1954 Brussels/Rotterdam, no. 17; 1957 Basel, no. 37; 1963–64 Mannheim, *Nabis*, no. 277; 1965 Zurich, no. 47; 1966–67 Paris/Charleroi, no. 29; 1978–79 Winterthur et al., no. 33; 1991 Tampere, no. 7

Interior, Red Room with Woman and Young Child (Mme. Vallotton and her Niece Germaine Aghion) *(Intérieur, chambre rouge avec femme et petit enfant [Madame Vallotton et sa nièce Germaine Aghion])*, 1899
LRZ 408: Divers sujets bain de mer. Etretat
Oil on board, 49.2 x 51.3 cm
The Art Institute of Chicago, Bequest from the Estate of Mary Runnells, 1977.606
(plate 35)

PROVENANCE: Druet (1907); Pierre Goujon, Paris; Etienne Goujon, Paris; Auction, Etienne Goujon, Paris, no. 71a (3/28/19); Auction, Sotheby's, London, no. 57 (11/29/67); Marianne Feilchenfeldt, Zurich; Mary Runnells; The Art Institute of Chicago (1977)
EXHIBITIONS: 1921 London, The Goupil Gallery, *Salon 1921*, no. 83; ?1923 Paris, Gal. Druet, no. 23 ("Le Bébé")

The Boardwalk at Etretat *(Les Planches à Etretat)*, 1899
LRZ 408: Divers sujets bain de mer. Etretat
Oil on board, 33 x 53 cm
Private Collection
(plate 295)

PROVENANCE: J. Rodrigues-Henriques, Paris (1924); Jean-Arthur Fontaine, Paris; Auction, J.-A. Fontaine, Paris, no. 51 (12/2/36); Emile Laffargue, Paris; Private Collection
EXHIBITIONS: ?1900 Paris, Gal. Bernheim-Jeune, *Exposition des dix*, no. 10 ("Au bord de la mer");

1918 Paris, Gal. Druet, *1er Groupe* ("Les Planches"); 1957 Basel, no. 47; 1965 Zurich, no. 54

Washerwomen at Etretat (Women Drying Laundry on the Beach) *(Laveuses à Etretat [Femmes mettant du linge à sécher sur la plage])*, 1899
LRZ 408: Divers sujets bain de mer. Etretat
Oil on board, 39 x 50.5 cm
Marianne Feilchenfeldt, Zurich
(plate 297)

PROVENANCE: J. Rodrigues-Henriques; Marcel Guérin, Paris; Dr. Feilchenfeldt, Zurich; Marianne Feilchenfeldt, Zurich
EXHIBITIONS: 1900 Berlin, *Secession II*, no. 332 ("Die Wäscherinnen"); 1928 Paris, Gal. J. Rodrigues-Henriques, no. 12; 1957 Basel, no. 46; 1957 London, Lefevre Gall., no. 6; 1964 Munich, *Secession*, no. 598; 1965 Zurich, no. 53; 1966–67 Paris/Charleroi, no. 32; 1978–79 Winterthur et al., no. 35

Sleeping Woman *(Femme couchée dormant)*, 1899
LRZ 411: Femme couchée dormant. peinture
Oil on board, 56.5 x 76 cm
Private Collection
(plate 19)

PROVENANCE: M. Rosenberg, Paris (1900); Auction, "M. Rosenberg, Père," Paris, no. 43 (5/21/09); Bernheim-Jeune, Paris; Pierre Goujon, Paris; Etienne Goujon?; Gall. Wildenstein, New York; Private Collection
EXHIBITIONS: 1900 Paris, Gal. Bernheim-Jeune, *Exposition des dix*, no. 7 ("Le Sommeil")

The Ball *(Le Ballon)*, 1899
LRZ 415: Coin de parc avec enfant jouant au ballon. peinture
Oil on board on wood, 48 x 61 cm
Musée d'Orsay, Paris, Legs. Carle Dreyfus
(plate 9)

PROVENANCE: J. Rodrigues-Henriques, Paris; Carle Dreyfus, Paris (1938); Musée national d'Art moderne, Paris; Musée d'Orsay, Paris (legacy of Carle Dreyfus, 1953)
EXHIBITIONS: ?1902 Halle Saale, *Kunstsalon Ammann*; 1903 Paris, Gal. Bernheim-Jeune, *Vallotton-Vuillard*, no. 8 ("Le Ballon"); 1909 Zurich, Künstlerhaus, no. 5; 1923 Paris, Gal. Druet, no. 28; 1938 Zurich, no. 35; 1978–79 Winterthur et al., no. 37; 1984 Rome, *Debussy e il simbolismo*, no. 184; 1988 Paris/Tokyo, *Le Japonisme*, no. 290

The Visit *(La Visite)*, 1899
LRZ 419: La Visite, effet de lampe dans intérieur
Oil on board on wood, 81 x 111.5 cm
Kunstmuseum Winterthur
(plate 26)

PROVENANCE: Ed. Vuillard; K.-X. Roussel; Coll. Salomon, Paris; Marianne Feilchenfeldt, Zurich; Kunstmuseum Winterthur (1973)
EXHIBITIONS: 1900 Paris, Gal. Bernheim-Jeune, *Exposition des dix*, no. 2

Dinner by Lamplight
(*Le Dîner, effet de lampe*), 1900
Copy of LRZ 417: Le Dîner, effet de lampe
(peinture) [in the collection of the Musée
d'Orsay, Paris]
Oil on board, 55.3 x 87 cm
Kirov Art Museum, Kirov, USSR
(*plate 136*)

PROVENANCE: S. A. Poliakov, editor of the
magazine *Vesy* (1908); sold by Poliakov to the
town of Viatka (now Kirov; 1919); Kirov Art
Museum, Kirov, USSR
EXHIBITIONS: 1903 Vienna, *Secession*, no. 229
("Das Dîner"); 1908 Moscow, *Zolotoe Rouno*, no.
178

Woman Hemming (*Femme ourlant*), 1900
LRZ 422: Femme ourlant une serviette. peinture
Oil on board, 26.5 x 24.5 cm
Private Collection
(*plate 184*)

PROVENANCE: Alexandre Bernheim, Paris;
Marguerite Aghion-Bernheim, Paris; Private
Collection

Nude at the Stove
(*Femme nue à la salamandre*), 1900
LRZ 423: Femme nue de dos accroupie devant
une salamandre. peinture
Gouache on board, 80 x 110 cm
Private Collection
(*plate 187*)

PROVENANCE: Gal. Vallotton, Lausanne; Josef
Müller, Solothurn; Private Collection
EXHIBITIONS: 1900 Paris, Gal. Bernheim-Jeune,
Exposition des dix, no. 3 ("Le Feu"); 1909 Vienna,
Internationale Kunstschau, no. 21 ("Der Kamin");
1910 Prague, *Les Indépendants*, no. 108
("Fireplace"); 1926 Basel, *Auberjonois . . .
Vallotton*, no. 159; 1953 Lausanne, no. 20; 1957
Basel, no. 53; 1978–79 Winterthur et al., no. 45

Cloud at Romanel (*Nuage à Romanel*), 1900
LRZ 430: Une trentaine de paysages peintures
faites à la Naz, Suisse
Oil on board, 35 x 46 cm
Musée cantonal des Beaux-Arts, Lausanne
(*plate 296*)

PROVENANCE: J. Rodrigues-Henriques, Paris
(1924); Musée cantonal des Beaux-Arts,
Lausanne (1952)
EXHIBITIONS: 1903 Paris, Gal. Bernheim-Jeune,
Vallotton-Vuillard, no. 23 ("Le Grand Nuage");
1909 Zurich, Künstlerhaus, no. 20; 1910 Munich,
Gal. Tannhauser; 1923 Paris, Gal. Druet, no. 33;
1928 Paris, Gal. J. Rodrigues-Henriques, no. 14;
1938 Zurich, no. 55; 1963–64 Mannheim, *Nabis*,
no. 281; 1965 Zurich, no. 66; 1967–68 Berlin,
Fünf Waadtländer Künstler, no. 109; 1978–79
Winterthur et al., no. 43; 1988 Mesola/Milan/
Bellinzona, no. 9

Autumn Crocuses (*Les Colchiques*), 1900
LRZ 430: Une trentaine de paysages peintures
faites à la Naz, Suisse
Oil on board, 33.5 x 55 cm

Musée cantonal des Beaux-Arts, Lausanne
(*plate 206*)

PROVENANCE: J. Rodrigues-Henriques, Paris
(1924); Musée cantonal des Beaux-Arts,
Lausanne (1952)
EXHIBITIONS: ?1902 Halle Saale, *Kunstsalon
Ammann*; 1903 Paris, Gal. Bernheim-Jeune,
Vallotton-Vuillard, no. 24 ("Les Saules"); 1909
Zurich, Künstlerhaus, no. 10 ("Les Saules"); 1928
Paris, Gal. J. Rodrigues-Henriques (not in cat.);
1938 Zurich, no. 47; 1951 Bern, *Die Maler der
Revue blanche*, no. 136; 1954 Brussels/
Rotterdam, no. 21; 1957 Basel, no. 56; 1963–64
Mannheim, *Nabis*, no. 280; 1965 Zurich, no. 64;
1966–67 Paris/Charleroi, no. 37; 1967 St. Gallen,
Fünf Waadtländer Künstler, no. 146; 1988
Mesola/Milan/Bellinzona, no. 10; 1991 Tampere,
no. 9

The Balloons (*Les Ballons*), 1900–02
LRZ not cited
Oil on board, 39 x 57 cm
Aargauer Kunsthaus, Aarau (on long-term loan
from the Gottfried Keller-Stiftung)
(*plate 282*)

PROVENANCE: Gal. Vallotton, Lausanne; Marcel
Guérin, Paris (1937); Musée de l'Athénée,
Geneva (1975); Gottfried Keller-Stiftung
(1977), on long-term loan to the Aargauer
Kunsthaus, Aarau
EXHIBITIONS: 1926 Winterthur, no. 48; 1928
Zurich, no. 31; 1929 Paris, Gal. Druet, no. 32;
1938 Zurich, no. 58; 1991 Tampere, no. 12

Woman Searching through a Cupboard
(*Femme fouillant dans un placard*), 1900–01
LRZ 449: Femme fouillant dans un placard, effet
de lampe. peinture
Oil on canvas, 78 x 49.5 cm
Private Collection, Basel, Switzerland
(*plate 181*)

PROVENANCE: Gaston Bernheim-Jeune, Paris;
Edouard Herriot, Paris; Gal. Lorenceau, Paris;
Coll. Staub, Männedorf; Dr. F. and P. Nathan,
Zurich; Dr. W. Raeber, Basel; Private Collection
EXHIBITIONS: 1963–64 Mannheim, *Nabis*, no.
282; 1964 Munich, *Secession*, no. 599; 1965
Zurich, no. 76; 1966–67 Paris/Charleroi, no. 43;
1975 Zurich, Gal. Nathan, no. 3

Seine Embankment with Red Sand
(*Quai de Seine au sable rouge*), 1901
LRZ 454: Sable rouge et neige (bords de Seine)
peinture
Oil on board, 46 x 65 cm
Museum Folkwang, Essen
(*plate 207*)

PROVENANCE: Gal. Vallotton, Lausanne; Alfred
Scherz, Bern (1951); Dr. F. and P. Nathan,
Zurich (1966); Museum Folkwang, Essen (1969)
EXHIBITIONS: 1901 Paris, *Salon des Indépendants*,
no. 969 or 970 ("Quai de Seine"); ?1926
Winterthur, no. 56; 1951 Bern, *Die Maler der
Revue blanche*, no. 144; 1965 Zurich, no. 81;
1966–67 Paris/Charleroi, no. 45

Place Clichy (*Place Clichy*), 1901
LRZ 458: Place Clichy peinture
Oil on board, 43.5 x 57 cm
Private Collection
(*plate 208*)

PROVENANCE: Dr. Arthur Hahnloser, Winterthur
(1909); Private Collection
EXHIBITIONS: 1903 Paris, Gal. Bernheim-Jeune,
Vallotton-Vuillard, no. 33; 1938 Zurich, no. 64;
1938 Lucerne, no. 11; 1940 Lucerne, *Die
Hauptwerke der Sammlung Hahnloser*, no. 142;
1942 Basel, no. 210; 1949 Winterthur,
Winterthurer Privatbesitz II, no. 20; 1951 Bern,
Die Maler der Revue blanche, no. 143; 1954
Brussels/Rotterdam, no. 25; 1955 Paris, *Nabis*,
no. 175; 1957 Basel/Dusseldorf, no. 63; 1965
Zurich, no. 83; 1966–67 Paris/Charleroi, no. 46;
1973 Winterthur, *Künstlerfreunde um Arthur und
Hedy Hahnloser-Bühler*, no. 238; 1978–79
Winterthur et al., no. 53

The Pont Neuf (*Le Pont Neuf*), 1901
LRZ 459: Le Pont neuf peinture
Oil on board, 39 x 58 cm
Kunstmuseum Winterthur
(*plate 210*)

PROVENANCE: Dr. Emil Hahnloser, Paris (1909);
Kunstmuseum Winterthur (1915)
EXHIBITIONS: ?1903 Paris, Gal. Bernheim-Jeune,
Vallotton-Vuillard, no. 32; 1905 Berlin/Hamburg,
Gal. Cassirer, *VII. Ausstellung*; 1926 Winterthur,
no. 57; 1938 Zurich, no. 66; 1938 Lucerne, no.
13; 1942 Basel, no. 208; 1953 Lausanne, no. 25;
1957 Basel, no. 64; 1965 Zurich, no. 84; 1966–67
Paris/Charleroi, no. 47; 1967 St. Gallen, *Fünf
Waadtländer Künstler*, no. 148; 1978–79
Winterthur et al., no. 50

The Poker Game (*Le Poker*), 1902
LRZ 475: Le Poker peinture
Oil on board, 52.5 x 67.5 cm
Musée d'Orsay, Paris, Gift of David Weill
(*plate 138*)

PROVENANCE: J. Rodrigues-Henriques, Paris;
David Weill, Paris; Musée du Luxembourg, Paris
(gift of David Weill, 1953); Musée national d'Art
moderne, Paris; Musée d'Orsay, Paris
EXHIBITIONS: 1918 Paris, Gal. Druet, *1er Groupe*;
1938 Zurich, no. 69; 1945–46 Paris, *Maurice
Denis, ses maîtres, ses amis, ses élèves*, no. 66; 1965
Zurich, no. 93; 1965 Vevey, *De Vallotton à
Desnos*, no. 29; 1966–67 Paris/Charleroi, no. 51;
1978–79 Winterthur et al., no. 60

Gossip (*Papotage*), 1902
LRZ 477: Intérieur 3 femmes peinture
Gouache on board, 38 x 51 cm
Mr. and Mrs. Arthur G. Altschul
(*plate 280*)

PROVENANCE: J. Rodrigues-Henriques, Paris; Mr.
and Mrs. Arthur G. Altschul
EXHIBITIONS: 1952 Paris, Gal. Bernheim-Jeune,
Peintres de portraits, no. 61; 1955 Paris, no. 7;
1962 Minneapolis, *The Nabis and their circle*, no.
2; 1965 New Haven, *Neo-Impressionists and Nabis*

in the Collection of Arthur G. Altschul, no. 45; 1970 New York, Hirschl & Adler, no. 32; 1972 Los Angeles, no. 4

Portrait of Gabrielle Vallotton Sitting in a Rocking Chair (*Portrait de Gabrielle Vallotton assise dans un rocking*), 1902
LRZ 495: Portrait de ma femme assise dans un rocking
Oil on board, laid on panel, 45 x 65 cm
Josefowitz Collection
(*plate 182*)

PROVENANCE: Alexandre Bernheim, Paris (1902); ?Gal. Beyeler, Basel; ?Gal. Moos, Geneva (1954); Silvan Kocher, Solothurn; Auction, Christie's, London, no. 122 (6/24/86); Josefowitz Collection
EXHIBITIONS: ?1904 Berlin, *Secession,* no. 220 ("Dame mit Strickstrumpf")

The Five Painters (*Les Cinq Peintres [Vallotton, Bonnard, Vuillard, Cottet et Roussel]*), 1902–03
LRZ 502: Une grande toile représentant groupés Roussel, Cottet, Vuillard, Bonnard et moi (Salon Société Nationale 1903)
Oil on canvas, 115 x 187 cm
Kunstmuseum Winterthur
(*plate 130*)

PROVENANCE: Gal. Druet (1909); Dr. Emil Hahnloser, Paris; Dr. Arthur Hahnloser, Winterthur; Kunstmuseum Winterthur (gift of Prof. Hans Hahnloser and Lisa Jäggli-Hahnloser, 1946)
EXHIBITIONS: 1903 Paris, *Salon de la Société nationale,* no. 1279; 1906 Paris, Gal. Bernheim-Jeune, no. 1 ("Groupe de peintres"); 1913 San Francisco, *Salon des Indépendants and Exposition universelle* ("Groupe de portraits"); 1915 San Francisco, *Panama-Pacific International Exposition,* no. 512 ("The Painters"); 1926 Winterthur, no. 9; 1927 Lausanne, no. 14; 1928 Zurich, no. 38; 1938 Zurich, no. 71; 1942 Basel, no. 274; 1943–44 La Chaux-de-Fonds, no. 11; 1946 La Chaux-de-Fonds, *Bonnard . . . Vallotton,* no. 49; 1951 Bern, *Die Maler der Revue blanche,* no. 141; 1954 Brussels/Rotterdam, no. 30; 1955 Paris, *Nabis,* no. 18; 1957 Basel/Dusseldorf, no. 32; 1963–64 Mannheim, *Nabis,* no. 285; 1965 Zurich, no. 103; 1973 Winterthur, *Künstlerfreunde um Arthur und Hedy Hahnloser-Bühler,* no. 239

Landscape at Arques-la-Bataille
(*Paysage d'Arques-la-Bataille*), 1903
LRZ 508: 17 Paysages faits à Arques-la-Bataille
Oil on board, 67 x 103.5 cm
State Hermitage Museum, Leningrad
(*plate 216*)

PROVENANCE: Georges Hasen, St. Petersburg (1910); State Hermitage Museum, Leningrad (1921)
EXHIBITIONS: ?1904 Paris, *Salon des Indépendants,* no. 2260 ("Les Saules, Arques-la-Bataille"); 1909–10 Odessa et al., *Exposition internationale d'art,* no. 89/76 ("Paysage à Aigues" [sic])

Interior with Woman in Red Seen from Behind
(*Intérieur avec femme en rouge de dos*), 1903
LRZ 511: Intérieur avec femme en rouge de dos. peinture
Oil on canvas, 92.5 x 70.5 cm
Private Collection
(*plate 36*)

PROVENANCE: Gal. Vallotton, Lausanne; Marianne Feilchenfeldt, Zurich (1965); Private Collection
EXHIBITIONS: ?1903 Paris, *Salon d'Automne,* no. 558 ("Intérieur"); ?1909–10 Odessa et al., *Exposition internationale d'art,* no. 91/78 ("Intérieur"); 1926 Basel, *Auberjonois . . . Vallotton,* no. 163; 1929 Paris, Gal. Druet, no. 53 or 54; 1953 Lausanne, no. 33; 1954 Brussels/ Rotterdam, no. 32; 1963 Milan, Gal. del Levante, no. 12; 1964 Turin, Gal. del Narciso, *E. Bernard– F. Vallotton,* no. 2; 1965 Zurich, no. 108; 1966–67 Paris/Charleroi, no. 60; 1978–79 Winterthur et al., no. 65

Gabrielle Vallotton Sewing
(*Gabrielle Vallotton cousant*), 1903
LRZ not cited
Oil on board, 25.1 x 25.2 cm
Private Collection
(*plate 135*)

PROVENANCE: J. Rodrigues-Henriques, Paris; Private Collection (gift of J. Rodrigues-Henriques)

Interior with Woman in Pink
(*Intérieur avec figure en rose*), 1903–04
LRZ 514: Intérieur avec figure en rose dans le fond. au Dr. Vacquez
Oil on canvas, 67 x 54 cm
Private Collection
(*plate 185*)

PROVENANCE: Dr. Vacquez, Paris (1904); A. Fasciani, Locarno; Gal. Beyeler, Basel; Gal. Blendiger, Agno; Günter Scharnowski, Munich; K. Meissner, Zurich; Private Collection
EXHIBITIONS: 1964 Munich, *Secession,* no. 601; 1978–79 Winterthur et al., no. 66

The Black Stocking (*Le Bas noir*), 1904
LRZ not cited
Oil on canvas, 62 x 71 cm
Private Collection
(*plate 189*)

PROVENANCE: J. Rodrigues-Henriques, Paris; Dr. Arthur Hahnloser, Winterthur (1927); Private Collection
EXHIBITIONS: 1928 Zurich, no. 39 ("Modell beim Ankleiden"); 1938 Zurich, no. 73; 1938 Lucerne, no. 27; 1942 Basel, no. 212; 1949 Winterthur, *Winterthurer Privatbesitz II,* no. 212; 1953 Lausanne, no. 35; 1957 Basel, no. 72; 1965 Zurich, no. 118; 1973 Winterthur, *Künstlerfreunde um Arthur und Hedy Hahnloser-Bühler,* no. 242

Interior, Vestibule by Lamplight
(*Intérieur vestibule, effet de lampe*), 1904
LRZ 522: Intérieur vestibule, effet de lampe
Oil on board, 61.5 x 63 cm

Virginia Museum of Fine Arts, Richmond; The Collection of Mr. and Mrs. Paul Mellon, 83.57
(*plate 186*)

PROVENANCE: J. Rodrigues-Henriques, Paris; Jacques Laroche, Paris ("Le Salon d'attente"); Gal. Vallotton, Lausanne (1965); Marianne Feilchenfeldt, Zurich; Mr. and Mrs. Paul Mellon (1966); Virginia Museum of Fine Arts, Richmond
EXHIBITIONS: 1904 Paris, Gal. Bernheim-Jeune, [Nabis], no. 23 ("Intérieur soir"); 1905 Berlin/ Hamburg, Gal. Cassirer, *VII Ausstellung,* no. 57 ("Interieur Flur"); 1908 Moscow, *Zolotoe Rouno,* no. 179; 1954 Brussels/Rotterdam, no. 33; 1955 Paris, no. 21

Interior, Bedroom with Two Women (*Intérieur chambre à coucher avec deux femmes*), 1904
LRZ 523: Intérieur chambre à coucher avec deux femmes dont une cousant
Oil on board, 61.5 x 56 cm
State Hermitage Museum, Leningrad
(*plate 183*)

PROVENANCE: Georges Hasen, St. Petersburg (1908); State Hermitage Museum, Leningrad (1921)
EXHIBITIONS: 1904 Paris, Gal. Bernheim-Jeune, [Nabis], no. 20 ("Intérieur"); ?1912, St. Petersburg, *Centennale de l'Art français,* no. 72 ("Intérieur [coll. Hasen]")

Gabrielle Vallotton at the Piano
(*Gabrielle Vallotton au piano*), 1904
LRZ not cited
Oil on canvas, 77 x 49 cm
Private Collection, Geneva, Switzerland
(*plate 134*)

PROVENANCE: Gabrielle Vallotton, Paris; Auction, Palais Galliera, Paris, no. 64 (3/19/73); Gal. Vallotton, Lausanne; Private Collection
EXHIBITIONS: 1979 Geneva, Gal. Engelberts; 1981 Munich, Gal. Thomas; 1982 Bremen, Graphisches Kabinett, no. 5; 1983 Munich, Sabine Helms/Bremen, Wolfgang Werner, *Edouard Vuillard und die Nabis,* no. 79

Twilight (*Crépuscule [Soir antique]*), 1904
LRZ not cited
Oil on canvas, 92 x 142 cm
Private Collection
(*plate 223*)

PROVENANCE: Dr. Arthur Hahnloser, Winterthur (1909); Private Collection
EXHIBITIONS: 1905 Paris, *Salon d'Automne,* no. 1535; 1906 Christiania [Oslo], [Group show]; 1909 Zurich, Künstlerhaus, no. 35; 1926 Winterthur, no. 29; 1957 Basel, no. 75; 1960–61 Paris, *Les Sources du XXe siècle,* no. 724; 1965 Zurich, no. 114; 1973 Winterthur, *Künstlerfreunde um Arthur und Hedy Hahnloser-Bühler,* no. 241; 1978–79 Winterthur et al., no. 69

Standing Nude Holding her Gown at her Knee
(*Femme nue debout, retenant sa chemise sur le genou*), 1904
LRZ 538: Figure femme nue debout retenant sa chemise sur le genou. (profil)

Oil on canvas, 134 x 101.3 cm
The Detroit Institute of Arts, Founders Society
Purchase, Robert H. Tannahill Foundation Fund
(plate 192)

PROVENANCE: Paul Vallotton; Gal. Vallotton,
Lausanne; Dr. M. Gilbert, Paris; Auction, Mme
Loudmer, Paris, no. 71 (12/10/66); Gal. Vallotton,
Lausanne (1968); Gal. Kovler, Chicago; Detroit
Institute of Arts (1975)
EXHIBITIONS: 1954 Brussels/Rotterdam, no. 36;
1957 Basel, no. 73; 1965 Zurich, no. 116; 1970
Chicago/Iowa City, *The Graphic Art of Vallotton
& the Nabis*

Nude Reclining on a Yellow Cushion
(*Grand Nu allongé au coussin jaune*), 1904
LRZ 540a: Femme nue couchée sur un drap
blanc, coussin jaune (Indépendants) Me Stein
Oil on canvas, 98 x 146 cm
Private Collection
(plate 287)

PROVENANCE: Bernheim-Jeune, Paris; Gertrude
Stein, Paris (1905); Bernheim-Jeune (1924); Josse
Bernheim-Jeune (1931); Paris, Auction Drouot,
no. 11 (11/23/87); Private Collection
EXHIBITIONS: 1905 Paris, *Salon des Indépendants*,
no. 23917; 1926 Paris, Gal. Druet, no. 8; 1930
Paris, Gal. Bernheim-Jeune, *La Femme 1800–
1930*, no. 93; 1953 Lausanne, no. 36; 1965
Zurich, no. 117; 1978–79 Winterthur et al., no. 67

The Toilette (*La Toilette*), 1905
LRZ 544: Figure femme nue tenant sa chemise
dans intérieur avec toilette, tapis rouge
Oil on board, 87 x 65 cm
Collection Ellen Melas Kyriazi
(plate 188)

PROVENANCE: J. Rodrigues-Henriques, Paris;
Jacques Laroche, Paris; Dr. M. Gilbert, Paris;
Auction, Kornfeld, Bern, no. 1224 (6/13–15/74);
Gal. Vallotton, Lausanne; Ellen Melas Kyriazi
(1988)
EXHIBITIONS: ?1905 Paris, *Salon d'Automne*, no.
1536 or 1537 ("Jeune fille nue"); ?1923 Paris,
Gal. Druet, no. 124 ("Intérieur"); 1976 Lausanne,
Gal. Vallotton, no. 7; 1982 Bremen, Graphisches
Kabinett, no. 6; 1983 Lausanne, Gal. Vallotton

The Beautiful Florence (*La Belle Florence*), 1906
LRZ 596: Femme nue assise et accoudée sur le
dossier de sa chaise, fond gris d'atelier. (belle
Florence)
Oil on canvas, 81 x 65 cm
Private Collection, Basel, Switzerland
(plate 307)

PROVENANCE: Bernheim-Jeune, Paris (sold 1907);
Gal. Vallotton, Lausanne; Dr. W. Raeber, Basel
(1942); Private Collection
EXHIBITIONS: 1907 Paris, Gal. Bernheim-Jeune,
Groupe des dix, no. 77; 1909 Zurich, no. 46
("Torse de femme"); 1910 Zurich, Kunsthaus
[Inaugural exhibition], no. 416; 1915 Basel,
Märzausstellung, no. 177; 1922 Montreux,
Exposition des Beaux-Arts; 1929 Paris, Gal. Druet,
no. 58; 1932 Geneva, Gal. Moos, no. 49; 1938
Lucerne, no. 10; 1938 Zurich, no. 88; 1942 Basel,

no. 279; 1957 Basel, no. 81; 1975 Zurich, Gal.
Nathan, no. 5

Portrait of Gertrude Stein
(*Portrait de Gertrude Stein*), 1907
LRZ not cited
Oil on canvas, 100.3 x 81.2 cm
Baltimore Museum of Art, The Cone Collection,
formed by Dr. Claribel Cone and Miss Etta Cone
of Baltimore, Maryland, BMA 1950.300
(plate 139)

PROVENANCE: Leo Stein, Paris; Dr. Claribel Cone,
Baltimore; The Baltimore Museum of Art (1950)
EXHIBITIONS: 1907 Paris, *Salon d'Automne*, no.
1666; 1908 Munich, *Secession*, no. 206; 1970 New
York, Hirschl & Adler, no. 3; 1972 Los Angeles,
no. 7

**Three Women and a Young Girl Playing in the
Water** (*Trois Femmes et une petite fille jouant dans
l'eau*), 1907
LRZ 601: Trois femmes et une petite fille jouant
dans l'eau (Indépendants)
Oil on canvas, 130.5 x 195.5 cm
Oeffentliche Kunstsammlung, Kunstmuseum,
Basel
(plate 37)

PROVENANCE: Paul Vallotton, Lausanne (1910);
Richard Bühler, Winterthur; Oeffentliche
Kunstsammlung, Kunstmuseum, Basel (1957)
EXHIBITIONS: 1907 Paris, *Salon des Indépendants*,
no. 4853 ("Baigneuses"); 1908 Munich, *Secession*,
no. 207 ("Badende Frauen"); 1909 Zurich, no.
59; 1913 Lausanne, Gal. Bernheim-Jeune-
Vallotton, [Swiss and French Art]; 1915 Basel,
Märzausstellung, no. 178; 1926 Winterthur, no.
69; 1938 Zurich, no. 92; 1938 Lucerne, no. 36;
1942 Basel, no. 308; 1943–44 La Chaux-de-
Fonds, no. 15; 1946 La Chaux-de-Fonds,
Bonnard . . . Vallotton, no. 53; 1957 Basel, no.
88; 1965 Zurich, no. 132; 1966–67 Paris/
Charleroi, no. 67

The Purple Hat (*Le Chapeau violet*), 1907
LRZ 629: Femme corset rose, chapeau violet,
fond vert buste
Oil on canvas, 80 x 65 cm
Private Collection
(plate 143)

PROVENANCE: Russian Private Collection?; Dr.
Arthur Hahnloser, Winterthur (through Paul
Vallotton, 1911); Private Collection
EXHIBITIONS: 1928 Zurich, no. 50; 1942 Basel,
no. 280; 1953 Lausanne, no. 39; 1973
Winterthur, *Künstlerfreunde um Arthur und Hedy
Hahnloser-Bühler*, no. 250

Sleep (*Le Sommeil*), 1908
LRZ 645: Femme nue dormant sur un canapé
recouvert d'une couverture bleue, coussins
rouges, livre jaune à terre
Oil on canvas, 113.5 x 162.5 cm
Musée d'Art et d'Histoire, Geneva
(plate 201)

PROVENANCE: Gal. Vallotton, Lausanne; Musée
d'Art et d'Histoire, Geneva (1967)

EXHIBITIONS: 1909 Zurich, no. 73; 1927
Lausanne, no. 17; 1928 Zurich, no. 59
("Schlummernde"); 1942 Basel, no. 175 (dated
1918); 1953 Lausanne, no. 41; 1957 Basel, no.
92; 1965 Zurich, no. 141; 1978–79 Winterthur et
al., no. 81; 1985 Lausanne, Gal. Vallotton

The Rape of Europa
(*L'Enlèvement d'Europe*), 1908
LRZ 647: Enlèvement d'Europe. ciel bleu et rose
mer bleu noir écumante (Salon d'Automne)
Oil on canvas, 130 x 162 cm
Kunstmuseum Bern
(plate 38)

PROVENANCE: Druet (1908–09); Joachim Gasquet,
Paris (1908); Dr. Arthur Hahnloser, Winterthur;
Kunstmuseum, Bern (gift of Arthur Hahnloser,
1946)
EXHIBITIONS: 1908 Paris, *Salon d'Automne*, no.
2024; 1910 Paris, Gal. Druet, no. 34; 1913 Ghent,
Exposition universelle, no. 396; 1915 Basel,
Märzausstellung, no. 183; 1926 Winterthur, no.
87; 1927 Lausanne, no. 18; 1927 Bern, no. 22;
1928 Zurich, no. 63; 1938 Zurich, no. 96; 1940
Lucerne, *Die Hauptwerke der Sammlung
Hahnloser*, no. 145; 1943–44 La Chaux-de-
Fonds, no. 16; 1957 Basel/Dusseldorf, no. 93;
1965 Zurich, no. 142; 1973 Winterthur,
*Künstlerfreunde um Arthur und Hedy Hahnloser-
Bühler*, no. 255; 1978–79 Winterthur et al.,
no. 80

The Pond, Landscape at Honfleur
(*La Mare, paysage Honfleur*), 1909
LRZ 680: La mare. paysage Honfleur
Oil on canvas, 73 x 100 cm
Private Collection, Switzerland
(plate 290)

PROVENANCE: Druet (1909); Marcel Noréro, Paris
(1917); Auction, Marcel Noréro, Paris, no. 100
(2/14/27); J. Rodrigues-Henriques; Private
Collection, Switzerland
EXHIBITIONS: 1910 Paris, Gal. Druet, no. 8; 1926
Paris, Gal. Druet, no. 14 (coll. Noréro); 1936
London, Arthur Tooth Gall., no. 19; 1955 Paris,
no. 27; 1978–79 Winterthur et al., no. 83

At the Café (The Provincial)
(*Au Café [Le Provincial]*), 1909
LRZ 694: Au Café. impression de café à deux (le
provincial)
Oil on canvas, 50 x 53 cm
Private Collection
(plate 40)

PROVENANCE: Druet; F. Sulzer, Winterthur
(1919); Dr. Arthur Hahnloser, Winterthur;
Private Collection
EXHIBITIONS: 1918 Paris, Gal. Druet, *1er Groupe;*
1928 Zurich, no. 68; 1938 Zurich, no. 106; 1938
Lucerne, no. 14; 1940 Lucerne, *Die Hauptwerke
der Sammlung Hahnloser*, no. 148; 1943–44 La
Chaux-de-Fonds, no. 20; 1949 Paris, *Eugène
Carrière et le Symbolisme*, no. 254; 1951 Bern, *Die
Maler der Revue blanche*, no. 156; 1953
Lausanne, no. 42; 1954 Brussels/Rotterdam, no.
40; 1955 Paris, *Nabis*, no. 177; 1957 Basel/
Dusseldorf, no. 95 (no. 40, Duss.); 1964 Munich,

Secession, no. 602; 1965 Zurich, no. 151; 1966–67 Paris/Charleroi, no. 69; 1973 Winterthur, *Künstlerfreunde um Arthur und Hedy Hahnloser-Bühler*, no. 260; 1978–79 Winterthur et al., no. 86

Box Seats at the Theater, The Gentleman and the Lady (*La Loge de théâtre, le Monsieur et la Dame*), 1909
LRZ 695: figures homme et femme
Oil on canvas, 46 x 38 cm
Private Collection, Switzerland
(*plate 28*)

PROVENANCE: J. Rodrigues-Henriques, Paris (1924); Private Collection, Switzerland
EXHIBITIONS: 1918 Paris, Gal. Druet, *1er Groupe* ("Le Monsieur et la Dame")

At the Français, 3rd Gallery, Theater Impression (*Au Français, 3e galerie, impression de théâtre*), 1909
LRZ 700: Au Français, 3e galerie impression de théâtre
Oil on canvas, 45.7 x 37.9 cm
Musée des Beaux-Arts, Rouen
(*plate 29*)

PROVENANCE: Raymonde Heudebert, Paris (wedding present from the artist); Musée des Beaux-Arts, Rouen (gift of Henri Baderou, 1982)
EXHIBITIONS: 1918 Paris, Gal. Druet, *1er Groupe* ("Troisième Galerie"); 1923 Paris, Gal. Druet, no. 46 ("Au Théâtre")

The Wind (*Le Vent*), 1910
LRZ 730: Le Vent. Verger avec fond de gros arbres sous un coup de vent. Honfleur
Oil on canvas, 89 x 116.2 cm
National Gallery of Art, Washington, Collection of Mr. and Mrs. Paul Mellon
(*plate 230*)

PROVENANCE: Gal. Bernheim-Jeune-Vallotton, Lausanne; Richard Bühler, Winterthur (1914); Gal. Vallotton, Lausanne (1939); Paul Mellon, Washington, DC (1968); National Gallery of Art, Washington, Collection of Mr. and Mrs. Paul Mellon
EXHIBITIONS: 1914 Lausanne, Gal. Bernheim-Jeune-Vallotton; 1915 Zurich, [French and Swiss Art], no. 14; 1957 Basel, no. 98; 1965 Zurich, no. 157; 1965 Vevey, *De Vallotton à Desnos*, no. 30; 1966–67 Paris/Charleroi, no. 71

Sunset (*Coucher de soleil*), 1910
LRZ 739: Coucher de soleil sur la mer, coteau dans l'ombre à gauche, à droite le Havre, nuage rouge
Oil on canvas, 78 x 100 cm
Private Collection
(*plate 227*)

PROVENANCE: Private Collection, France; Gal. Vallotton, Lausanne (1979); Private Collection

African Woman (*Africaine*), 1910
LRZ 768: Torse de négresse assise, de face nue jusqu'à la taille, le bas du corps drapé dans satin jaune, madras à raies sur la tête. fond atelier gris uni
Oil on canvas, 100 x 81 cm
Musée d'Art moderne de Troyes
(*plate 197*)

PROVENANCE: Druet, Paris (1910); Mlle A. Dièterle, Paris; Auction, Drouot, Paris, no. 24 (6/7/68); Pierre Lévy, Troyes; Musée d'Art moderne de Troyes (gift of Pierre Lévy, 1977)
EXHIBITIONS: 1912 Paris, Gal. Druet, no. 3 ("Négresse")

Seated Black Woman, Front View (*Négresse assise de face*), 1911
LRZ 781: Négresse assise de face, les épaules nues, le torse ceint d'une étoffe rouge, fond jaune.
Oil on canvas, 81 x 65 cm
Private Collection, Switzerland
(*plate 293*)

PROVENANCE: Druet, Paris (1911); Gaston Duché, Paris; Auction, Mme Bellier, Paris, Drouot, no. 112 (2/24/26); Gal. Vallotton, Lausanne; Private Collection, Switzerland
EXHIBITIONS: 1912 Paris, Gal. Druet, no. 14 ("Negresse"); 1927 Lausanne, no. 29; 1928 Zurich, no. 82; 1978–79 Winterthur et al., no. 97

Rest (*Le Repos*), 1911
LRZ 788: Femme nue couchée dans un lit, à mi-corps, blonde, la tête appuyée sur la main droite le bras gauche replié. fond uni brun
Oil on canvas, 88.9 x 116.9 cm
The Art Institute of Chicago, Gift of Mr. and Mrs. Chester Dale, 1945.18
(*plate 292*)

PROVENANCE: Druet, Paris (1911); Charles Pacquement, Paris; Auction, Charles Pacquement, Paris, Gal. G. Petit, no. 6 (12/12/32); Chester Dale; The Art Institute of Chicago (1945)
EXHIBITIONS: 1912 Paris, Gal. Druet, no. 6 ("Femme couchée"); 1926 Paris, Gal. Druet, no. 19; 1928 Zurich, no. 85

Sunset, Gray-Blue High Tide (*Coucher de soleil mer haute gris bleu*), 1911
LRZ 825: Coucher de soleil, mer haute gris bleu, à l'horizon petits nuages en rangs d'oignon, ciel jaune doré
Oil on canvas, 54 x 81 cm
Private Collection
(*plate 228*)

PROVENANCE: J. Rodrigues-Henriques, Paris; Private Collection
EXHIBITIONS: 1978–79 Winterthur et al., no. 105

Solitaire (Nude Playing Cards) (*La Réussite*), 1912
LRZ 902: Femme nue accroupie, de dos. la tête à droite. faisant une réussite sur un coussin rouge. tapis et fond bleu
Oil on canvas, 89.5 x 117 cm
Kunsthaus Zürich
(*plate 198*)

PROVENANCE: Druet, Paris (1913); Auction, Hôtel Drouot, Paris, no. 63 (12/8/37); J. Rodrigues-

Henriques, Paris; Zürcher Kunstgesellschaft (1938); Kunsthaus Zürich
EXHIBITIONS: 1928 Zurich, no. 96; 1938 Zurich, no. 118; 1943–44 La Chaux-de-Fonds, no. 34; 1965 Zurich, no. 184; 1978–79 Winterthur et al., no. 112; 1988 Atlanta, *From Liotard to Le Corbusier*, no. 48

Nude Blonde Woman with Tangerines (*Femme blonde nue aux mandarines*), 1913
LRZ 905: Femme blonde. nue. couchée de face sur le côte, sur tapis lie-de-vin, fond id. rosé, un plat avec 3 mandarines.
Oil on canvas, 89.5 x 116.5 cm
The Walter F. Brown Collection, Texas
(*plate 202*)

PROVENANCE: J. Rodrigues-Henriques, Paris; Auction, Sotheby's, London, no. 90 (7/8/71); Auction, Sotheby's, Zurich, no. 165 (3/29/73); Auction, Gal. Motte, Geneva, no. 540 (7/1/73); Gal. Coray, Zurich; Private Collection, Zurich; Auction, Gal. Kornfeld, Bern, no. 891 (6/22–24/83); Gal. Fischer, Lucerne; Gal. Richard, Lausanne; Auction, Cornette-de-St.-Cyr, Paris, Drouot (11/25/87); The Walter F. Brown Collection, Texas
EXHIBITIONS: 1914 Paris, Gal. Druet, no. 12

Portrait of Mr. Hasen (*Portrait de Mr. Hasen*), 1913
LRZ 910: Portrait de Mr. Hasen assis de face, le bras droit appuyé sur une table recouverte d'une étoffe à fleurs, fond appartement avec rideaux de tons divers. à St. Petersbourg
Oil on canvas, 81.5 x 100 cm
State Hermitage Museum, Leningrad
(*plate 302*)

PROVENANCE: Georges Hasen, St. Petersburg (1913); State Hermitage Museum, Leningrad (1921)

The White and the Black (*La Blanche et la Noire*), 1913
LRZ 924: Femme nue couchée sur canapé recouvert d'un drap blanc, à droite une négresse assise. madras orange, pagne bleu. fond vert d'atelier
Oil on canvas, 114 x 147 cm
Private Collection
(*plate 196*)

PROVENANCE: Druet, Paris (1913); Dr. Arthur Hahnloser, Winterthur (1914); Private Collection
EXHIBITIONS: 1913 Paris, *Salon d'Automne*, no. 2025; 1915 Basel, *Märzausstellung*, no. 200; 1926 Winterthur, no. 78; 1938 Lucerne, no. 32; 1938 Zurich, no. 123; 1940 Lucerne, *Die Hauptwerke der Sammlung Hahnloser*, no. 153; 1942 Basel, no. 309; 1949 Winterthur, *Winterthurer Privatbesitz II*, no. 218; 1953 Lausanne, no. 50; 1954 Brussels/Rotterdam, no. 48; 1957 Basel/Dusseldorf, no. 116 (no. 53, Duss.); 1965 Zurich, no. 194; 1966–67 Paris/Charleroi, no. 79; 1975 Zurich, Gal. Nathan, no. 13; 1978–79 Winterthur et al., no. 118; 1988–89 Basel, *Exotische Welten, Europäische Phantasien*; 1991 Winterthur, *Das Gloriose Jahrzehnt*

Cliff and White Shore
(*La Falaise et la grève blanche*), 1913
LRZ 947a: La grève blanche, Vasony [sic; the site
is Vasouy, a beach near Honfleur]
Oil on canvas, 73 x 54 cm
Private Collection
(*plate 289*)

PROVENANCE: Dr. Arthur Hahnloser, Winterthur
(1914); Private Collection
EXHIBITIONS: 1927 Lausanne, no. 37; 1927 Bern,
no. 41; 1928 Zurich, no. 105; 1938 Lucerne, no.
23; 1938 Zurich, no. 128; 1942 Basel, no. 299;
1943–44 La Chaux-de-Fonds, no. 36; 1953
Lausanne, no. 52; 1957 Basel/Dusseldorf, no. 112
(no. 49, Duss.); 1965 Zurich, no. 189; 1973
Winterthur, *Künstlerfreunde um Arthur und Hedy
Hahnloser-Bühler*, no. 274; 1978–79 Winterthur
et al., no. 116; 1991 Winterthur, *Das Gloriose
Jahrzehnt*

Mulatto in a Red Shawl
(*Mulâtresse drapée dans un châle rouge*), 1913
LRZ 972: Mulâtresse, drapée dans châle rouge
sombre, et tenant une rose, collier bleu, fond vert
Oil on canvas, 100 x 81 cm
Kunstmuseum Winterthur
(*plate 144*)

PROVENANCE: Druet, Paris (1914); Gal. Vallotton,
Lausanne; Richard Bühler (1916); Private
Collection; Kunstmuseum Winterthur
EXHIBITIONS: 1914 Paris, Gal. Druet, no. 15; 1916
Winterthur, *Ausstellung Französischer Malerei*,
no. 185; 1917 Basel, *Januar Ausstellung*, no. 119;
1927 Lausanne, no. 39; 1928 Zurich, no. 104;
1932 Geneva, Gal. Moos, no. 33; 1938 Lucerne,
no. 21; 1938 Zurich, no. 120; 1942 Basel, no.
285; 1957 Basel, no. 115; 1965 Zurich, no. 207;
1978–79 Winterthur et al., no. 120; 1988–89
Basel, *Exotische Welten, Europäische Phantasien*;
1991 Winterthur, *Das Gloriose Jahrzehnt*

Landscape: Beets, Wheat, and Cabbage (*Paysage:
betteraves, blés et choux*), 1914 [atelier stamp 1909]
LRZ 1005: Paysage betteraves, blés et choux, au
fond silhouettes d'arbres, au 1er plan longues
ombres
Oil on canvas, 56 x 96 cm
Private Collection, Switzerland
(*plate 284*)

PROVENANCE: J. Rodrigues-Henriques, Paris;
Private Collection
EXHIBITIONS: 1955 Paris, no. 26; 1973 Honfleur,
no. 7; 1978–79 Winterthur et al., no. 124

Still Life, Pears in a Japanese Bowl
(*Nature morte, poires dans un pot japonais*), 1914
LRZ 1012: Nature morte, des poires dans un pot
japonais blanc à dessins bleus posé sur une
serviette, ainsi qu'un couteau
Oil on canvas, 46 x 55 cm
Private Collection
(*plate 305*)

PROVENANCE: Pierre Bonnard (1919); Auction,
Coll. Pierre Bonnard, Gal. Charpentier, Paris, no.
26 (2/23/54); J. Rodrigues-Henriques, Paris;
Private Collection
EXHIBITIONS: 1955 Paris, no. 33

Still Life, Red Peppers on a White Table
(*Nature morte, piments rouges sur une table lacquée
blanc*), 1915
LRZ 1057: Nature morte, cinq gros piments
rouges sur une table ronde laqué blanc avec
couteau manche noir
Oil on canvas, 46 x 55 cm
Kunstmuseum Solothurn, Dübi-Müller-Stiftung
(*plate 303*)

PROVENANCE: J. Rodrigues-Henriques, Paris
(1924); Josef Müller, Solothurn; Kunstmuseum
Solothurn, Dübi-Müller-Stiftung
EXHIBITIONS: 1978–79 Winterthur et al., no. 130

Ruins at Souain (*Ruines à Souain*), 1917
LRZ 1112: Ruines à Souain. au 1er plan des
gabions pleins de pierre et des déblais
Oil on canvas, 82 x 88 cm
Collection Ellen Melas Kyriazi
(*plate 243*)

PROVENANCE: Gabrielle Vallotton, Paris; Private
Collection, France; Gal. Vallotton, Lausanne
(1987); Ellen Melas Kyriazi (1987)
EXHIBITIONS: 1917 Paris, Musée du Luxembourg,
Les Peintres en mission aux armées; 1965 Zurich,
no. 218; 1987 Lausanne, Gal. Vallotton, no. 17

The Church of Souain in Silhouette
(*L'Eglise de Souain en silhouette*), 1917
LRZ 1115: Eglise de Souain, en silhouette sur ciel
doré au 1er plan ruines et déblais
Oil on canvas, 96 x 130 cm
National Gallery of Art, Washington, The
Chester Dale Fund
(*plate 246*)

PROVENANCE: Paul Vallotton; Gal. Vallotton,
Lausanne; Ellen Melas Kyriazi (1987); National
Gallery of Art, Washington
EXHIBITIONS: 1917 Paris, Musée du Luxembourg,
Les Peintres en mission aux armées; 1983
Lausanne, Gal. Vallotton; 1985 Lausanne, Gal.
Vallotton, no. 7

Verdun (*Verdun*), 1917
LRZ 1141: Verdun. Tableau de guerre interprêté
projections colorées noires bleues et rouges
terrains dévastés, nuées de gaz
Oil on canvas, 115 x 146 cm
Musée de l'Armée, Paris
(*plate 250*)

PROVENANCE: Gabrielle Vallotton, Paris; Private
Collection, France; J. Rodrigues-Henriques,
Paris; Musée de l'Armée, Paris (1976)
EXHIBITIONS: 1919 Paris, Gal. Druet, no. 3; 1928
Paris, Gal. J. Rodrigues-Henriques, no. 36; 1938
Zurich, no. 139; 1965 Zurich, no. 224; 1966–67
Paris/Charleroi, no. 81; 1978–79 Winterthur et
al., no. 136

Sunset (*Coucher de soleil*), 1918
LRZ 1167: Coucher de soleil à Grâce, ciel orangé
et violet, à droit gros tronc noir 1er plan
Oil on canvas, 54 x 73 cm
Private Collection, Switzerland
(*plate 229*)

PROVENANCE: J. Rodrigues-Henriques, Paris;
Private Collection
EXHIBITIONS: 1978–79 Winterthur et al., no. 142

A Corner of the Lake in the Bois de Boulogne
(*Un coin du lac au Bois de Boulogne*), 1920
LRZ 1269: Un coin du lac au Bois de Boulogne. à
gauche, 1er plan arbre décharné. le haut
jaunissant, à droite arbre jaune, effet soleil voilé
Oil on canvas, 81 x 65 cm
Private Collection, Zollikon
(*plate 226*)

PROVENANCE: Gal. Vallotton, Lausanne; The
Baltimore Museum of Art (gift of Paul Vallotton,
1928); Marianne Feilchenfeldt (1965); Private
Collection
EXHIBITIONS: 1927 Lausanne, no. 63? (dated
1921); 1965 Zurich, no. 237; 1966–67 Paris/
Charleroi, no. 44; 1978–79 Winterthur et al., no.
149

Jug and Hydrangea (*Cruche et hortensia*), 1921
LRZ 1348: nature morte, une grosse jarre de
terre, un hortensia avec feuilles, un verre d'eau
sur un linge blanc
Oil on canvas, 81 x 65 cm
Private Collection
(*plate 304*)

PROVENANCE: Druet, Paris (1921); Dr. Arthur
Hahnloser, Winterthur (1927); Private Collection
EXHIBITIONS: 1922 Paris, Gal. Druet, no. 16; 1965
Zurich, no. 249; 1973 Winterthur,
*Künstlerfreunde um Arthur und Hedy Hahnloser-
Bühler*, no. 277; 1978–79 Winterthur et al., no.
157

**Nude Young Woman on Yellow-Orange Velvet
Background** (*Jeune Femme nue fond velours jaune
orange*), 1921
LRZ 1369: Jeune femme nue tenant sa chemise à
hauteur du sexe. la main droite posant sur
l'épaule, tête inclinée fond velours jaune orange.
Oil on canvas, 100 x 81 cm
Mr. and Mrs. Michal Hornstein, Montreal
(*plate 42*)

PROVENANCE: Druet, Paris; J. Rodrigues-
Henriques, Paris; Jacques Laroche, Paris; Gal.
Vallotton, Lausanne (1965); Bruno Meissner,
Zurich (1984); Mr. and Mrs. Michal Hornstein,
Montreal
EXHIBITIONS: 1924 Paris, *Salon d'Automne*, no.
2078 or 2079; ?1928 Zurich, no. 153; 1955 Paris,
no. 50; 1965 Lausanne, Gal. Vallotton, no. 8;
1967 London, Mercury Gall., no. 7; 1978–79
Winterthur et al., no. 159; 1980–81 Paris/Berlin,
Les Réalismes

Chaste Suzanne (*La Chaste Suzanne*), 1922
LRZ 1418: La chaste Suzanne. Deux crânes
chauves de vieillards encadrant une tête de jeune
femme. large divan rose, fond sombre
Oil on canvas, 54 x 73 cm
Private Collection
(*plate 39*)

PROVENANCE: J. Rodrigues-Henriques, Paris;
Private Collection
EXHIBITIONS: 1955 Paris, no. 57

Evening on the Loire
(*Un soir au bord de la Loire*), 1923
LRZ 1453: Paysage soir. Un bras perdu de rivière
reflète des arbres éclairés par un soleil bas, au
fond une côte violacée, 1er plan herbe, dans le
fond deux moissonneurs
Oil on canvas, 72 x 93 cm
Private Collection, Switzerland
(*plate 218*)

PROVENANCE: Gal. Vallotton (1925); Private
Collection, Switzerland
EXHIBITIONS: 1927 Lausanne, no. 74 or 77; 1928
Zurich, no. 170; 1938 Lucerne, no. 48; 1938
Zurich, no. 173; 1943–44 La Chaux-de-Fonds,
no. 59; 1953 Lausanne, no. 74; 1954 Brussels/
Rotterdam, no. 63; 1965 Zurich, no. 258; 1978–
79 Winterthur et al., no. 165

Sandbanks on the Loire
(*Des Sables au bord de la Loire*), 1923
LRZ 1456: Des sables au bord de la Loire, au
centre un bouquet de saules reflétés dans une
petite anse. fond côte bleu-noir.
Oil on canvas, 73 x 100 cm
Kunsthaus Zürich
(*plate 220*)

PROVENANCE: Gal. Vallotton, Lausanne; Zürcher
Kunstgesellschaft (1938); Kunsthaus Zürich
EXHIBITIONS: 1927 Lausanne, no. 74 or 77; 1928
Zurich, no. 168; 1938 Lucerne, no. 46; 1938
Zurich, no. 172; 1942 Basel, no. 304; 1943–44 La
Chaux-de-Fonds, no. 58; 1954 Brussels/
Rotterdam, no. 64; 1978–79 Winterthur et al.,
no. 166; 1988 Atlanta, *From Liotard to Le
Corbusier*, no. 51

Still Life with Large Jug
(*Nature morte à la grande jarre de terre*), 1923
LRZ 1462: nature morte, une grande jarre de
terre, un grand verre d'eau, un melon, des
aubergines, tomates et oeufs sur une serviette
posée sur le parquet.
Oil on canvas, 81 x 65 cm
Galerie Vallotton, Lausanne, Private Collection
(*plate 306*)

PROVENANCE: Gal. Vallotton, Lausanne, Private
Collection
EXHIBITIONS: 1927 Lausanne, no. 73; 1979
Winterthur, *Neue Sachlichkeit und Realismus in
der Schweiz*, no. 306

Drawings

The Demonstration (*La Manifestation*), 1893
Study for "The Demonstration"
See VG 110
India ink, lead pencil, and scraping on cream
wove paper, 20.3 x 32.5 cm (image)
Galerie Vallotton, Lausanne
(*plate 18*)

Study for "Paris Intense," frontispiece from
Paris Intense, 1894
See VG 45
India ink, charcoal, and graphite on cream wove
paper, 21.3 x 31.2 cm (image)
Galerie Vallotton, Lausanne
(*plate 67*)

The Milliners (*Les Modistes*), 1894
Study for "The Milliner"
See VG 138, no. 1
India ink, charcoal, and lead pencil on glazed
cream wove paper, 18.1 x 22.6 cm (image)
Galerie Vallotton, Lausanne
(*plate 62*)

The Milliners (*Les Modistes*), 1894
Study for "The Milliner"
See VG 138, no. 2
India ink, charcoal, and scraping on glazed
cream wove paper, 18.2 x 22.7 cm (image)
Galerie Vallotton, Lausanne
(*plate 63*)

Study for "The Shower" (*L'Averse*), 1894
See VG 149
India ink, charcoal, and scraping on white wove
paper, 18.3 x 22.6 cm (image)
Galerie Vallotton, Lausanne
(*plate 75*)

The Exit (*La Sortie*), 1894
LRZ 200: la Sortie, dessin
India ink, pencil, and crayon on paper, 31.7 x
22.9 cm (sheet)
Published in *Le Courrier français*, 13 May 1894
Mr. and Mrs. Arthur G. Altschul
(*plate 30*)

The Drunk (*L'Ivrogne*), for *Les Rassemblements*,
1895
LRZ 275, 277a, 279: dessins pour les
Rassemblements (Uzanne)
India ink and blue pencil on cream paper, 26.5 x
20.3 cm (sheet)
Galerie Vallotton, Lausanne, inv. 966863
(*plate 78*)

Military Music (*La Musique militaire*), for *Les
Rassemblements*, 1895
LRZ 275, 277a, 279: dessins pour les
Rassemblements (Uzanne)
India ink and blue pencil on cream paper, 25.5 x
20.3 cm (sheet)
Galerie Vallotton, Lausanne, inv. 966862
(*plate 80*)

The Wedding (*Le Mariage*), for *Les
Rassemblements*, 1895
LRZ 275, 277a, 279: dessins pour les
Rassemblements (Uzanne)
India ink and graphite on cream paper, 25.8 x
20.4 cm (sheet)
Galerie Vallotton, Lausanne, inv. 966864
(*plate 82*)

The Flute (*La Flûte: Instruments de Musique*),
1896
Study for "The Flute," from *Musical Instruments*
See VG 172
India ink and blue crayon on white wove paper,
22.6 x 18.3 cm (image)
Cabinet des estampes, Musée d'Art et d'Histoire,
Geneva
(*plate 90*)

The Guitar (*La Guitare: Instruments de
Musique*), 1897
Study for "The Guitar," from *Musical Instruments*
See VG 175
India ink and lead pencil on white laid paper,
22.7 x 18 cm (image)
Cabinet des estampes, Musée d'Art et d'Histoire,
Geneva
(*plate 92*)

The Lie (*Le Mensonge*), 1897
Study for "The Lie," from *Intimités*
See VG 188
India ink, lead pencil, and white gouache on
white laid paper with watermark, 18.2 x 22.8 cm
(image)
Musée du Louvre, Département des Arts
Graphiques (Fonds Musée d'Orsay), Paris
(*plate 94*)

The Triumph (*Le Triomphe*), 1898
Study for "The Triumph," from *Intimités*
See VG 189
India ink, lead pencil, sepia, white gouache, and
scraping on white laid paper with watermark,
18.1 x 22.7 cm (image)
Musée du Louvre, Département des Arts
Graphiques (Fonds Musée d'Orsay), Paris
(*plate 96*)

The Pressing Errand (*La Course Pressée*), 1898
Study for "The Cogent Reason," from *Intimités*
See VG 191
India ink on white laid paper watermarked
Hallines, 17.7 x 22.3 cm (image)
Musée du Louvre, Département des Arts
Graphiques (Fonds Musée d'Orsay), Paris
(*plate 100*)

The Temptation (*La Tentation*), 1898
Study for "Money," from *Intimités*
See VG 192
India ink, lead pencil, white gouache, and sepia
on white laid paper watermarked Hallines,
18.3 x 24.7 cm (image)
Musée du Louvre, Département des Arts
Graphiques (Fonds Musée d'Orsay), Paris
(*plate 101*)

Dressing Up to Go Out (*Toilette de sortie*), 1898
Study for "Getting Ready for a Visit," from *Intimités*
See VG 195
India ink, lead pencil, sepia, and white gouache on white laid paper watermarked Hallines, 18.1 x 22.7 cm (image)
Musée du Louvre, Département des Arts Graphiques (Fonds Musée d'Orsay), Paris
(*plate 107*)

The Irreparable (*L'Irréparable*), 1898
Study for "The Irreparable," from *Intimités*
See VG 197
India ink, lead pencil, sepia, and white gouache on white laid paper watermarked Hallines, 18.1 x 22.8 cm (image)
Musée du Louvre, Département des Arts Graphiques (Fonds Musée d'Orsay), Paris
(*plate 110*)

At Home (*En Famille*), 1898
India ink on paper, 23 x 19 cm (sheet)
Published in *Le Cri de Paris*, 18 December 1898
Private Collection, Zurich
(*plate 31*)

Prints

The Funeral (*L'Enterrement*), 1891
LRZ 109: Enterrement. gravure sur bois; VG 84a
Woodcut, 26 x 35.3 cm (block)
Reproduced in *L'Art et l'idée*, 20 February 1892, p. 117
Collection, The Museum of Modern Art, New York, Gift of William S. Rubin, 389.62
(*plate 51*)

The Paris Crowd (*La Foule à Paris*), 1892
VG 91
Woodcut, 13.9 x 19.5 cm (block)
Reproduced in *L'Art et l'idée*, 20 February 1892, p. 116; and in *Les Rassemblements*, 1896
The Metropolitan Museum of Art, New York, Gift of Mary Turley Robinson, 1950, 50.522.2
(*plate 54*)

The Brawl (*La Rixe*), 1892
LRZ 119: la rixe. gravure sur bois; VG 101
Woodcut, 17 x 25 cm (block)
Print Collection, Miriam and Ira D. Wallach Division of Art, Prints and Photographs, The New York Public Library; Astor, Lenox and Tilden Foundations
(*plate 55*)

The Print Fanciers
(*Les Amateurs d'estampes*), 1892
LRZ 133c: Couverture de Catalogue pour Sagot; VG 107
Woodcut, 18.5 x 25.3 cm (block)
Yale University Art Gallery, Everett V. Meeks, B.A. 1901, Fund, 1984.16
(*plate 58*)

The Demonstration (*La Manifestation*), 1893
LRZ 137: Manifestation. gravure sur bois; VG 110
Woodcut, 20.3 x 32 cm (block)
Published in *L'Estampe originale*, January–March 1893
The Metropolitan Museum of Art, New York, Rogers Fund, 1922, 1922.82.1–9
(*plate 56*)

The Milliner (*La Modiste*), 1894
VG 138
Woodcut, 18 x 22.6 cm (block)
National Gallery of Art, Washington, Ailsa Mellon Bruce Fund, 1983.90.1
(*plate 61*)

The Singers (*Les Chanteurs*), from *Paris Intense*, 1893
LRZ 142: les chanteurs. litho; VG 46
Zincograph, 21.5 x 31.5 cm (image)
The Baltimore Museum of Art, Unknown donor, BMA 1956.162.3
(*plate 72*)

Off to the Jug (*Au violon*), from *Paris Intense*, 1893
LRZ 144: Au Violon; VG 47
Zincograph, 21.8 x 31.4 cm
The Baltimore Museum of Art, Unknown donor, BMA 1956.162.4
(*plate 69*)

Box Office (*Deuxième bureau*), from *Paris Intense*, 1893
LRZ 146: Deuxième bureau. litho; VG 48
Zincograph, 21.7 x 31.2 cm
The Baltimore Museum of Art, Unknown donor, BMA 1956.162.2
(*plate 68*)

Parading through the Streets in Single File
(*Le Monôme*), from *Paris Intense*, 1893
LRZ 153: Le monôme. litho; VG 49
Zincograph on saffron yellow paper, 22.2 x 31.1 cm (image)
National Gallery of Art, Washington, Rosenwald Collection, 1952.8.483
(*plate 70*)

The Patriotic Ditty (*Le Couplet patriotique*), 1893
LRZ 160: le couplet patriotique. gravure sur bois; VG 127
Woodcut, 17.6 x 27.3 cm (block)
The Metropolitan Museum of Art, Gift of Mary Turley Robinson, 1950, 1950.522.1
(*plate 57*)

The Charge (*La Charge*), 1893
LRZ 161: la charge. gravure sur bois; VG 128
Woodcut, 20 x 26 cm (block)
Print Collection, The Miriam and Ira D. Wallach Division of Art, Prints and Photographs, The New York Public Library; Astor, Lenox and Tilden Foundations
(*plate 17*)

The Accident (*L'Accident*), from *Paris Intense*, 1893
LRZ 166: l'accident. litho; VG 50
Zincograph, 22.4 x 31.2 cm (image)
National Gallery of Art, Washington, Rosenwald Collection, 1952.8.485
(*plate 71*)

Three Bathers (*Les Trois baigneuses*), 1894
LRZ 176: Baigneuses. gravure sur bois; VG 133d
Woodcut, 18.2 x 11.2 cm (block)
Published in *La Revue blanche*, February 1894
Collection, The Museum of Modern Art, New York, Gift of Heinz Berggruen, 163.51
(*plate 158*)

The Shower (*L'Averse*), from *Paris Intense*, 1894
LRZ 180: l'Averse. litho; VG 51
Zincograph, 22.7 x 31.3 cm (image)
National Gallery of Art, Washington, Rosenwald Collection, 1952.8.484
(*plate 73*)

Paris Intense, frontispiece from *Paris Intense*, 1894
LRZ 182: Paris Intense. titre litho; VG 45
Zincograph, 22 x 31.5 cm (image)
The Baltimore Museum of Art, Unknown donor, BMA 1956.162.1
(*plate 66*)

The Gust of Wind (*Le Coup de vent*), 1894
LRZ 213: Coup de Vent. gravure sur bois; VG 145
Woodcut, 18 x 22.4 cm (block)
Collection, The Museum of Modern Art, New York, Gift of Mrs. Bertha M. Slattery, 184.51
(*plate 76*)

The Shower (*L'Averse*), 1894
LRZ 233: l'Averse. gravure sur bois; VG 149
Woodcut, 18.2 x 22.5 cm (block)
The Metropolitan Museum of Art, New York, Mary Martin Fund and The Elisha Whittelsey Collection, The Elisha Whittelsey Fund, 1984, 1984.1071.1
(*plate 74*)

Laziness (*La Paresse*), 1896
LRZ 290: la paresse. gravure sur bois; VG 169
Woodcut, 17.9 x 22.4 cm (block)
Josefowitz Collection
(*plate 21*)

The Flute (*La Flûte: Instruments de Musique*), from *Musical Instruments*, 1896
LRZ 312: la flûte. gravure sur bois; VG 172c
Woodcut, 22.4 x 17.7 cm (block)
Collection, The Museum of Modern Art, New York, Gift of Victor S. Riesenfeld, 371.48
(*plate 89*)

The Violin (*Le Violon: Instruments de Musique*), from *Musical Instruments*, 1896
LRZ 313: le violon. gravure sur bois; VG 173
Woodcut, 22.5 x 17.9 cm (block)
Josefowitz Collection
(*plate 88*)

The Guitar (*La Guitare: Instruments de Musique*), from *Musical Instruments*, 1897
LRZ 329: la guitare. gravure sur bois; VG 175a
Woodcut, 22.5 x 17.9 cm (block)
Collection, The Museum of Modern Art, New York, Gift of Ludwig Charell, 131.55
(*plate 91*)

The Lie (*Le Mensonge*), from *Intimités*, 1897
LRZ 339: le mensonge. gravure sur bois; VG 188
Woodcut, 18 x 22.5 cm (block)
The Art Institute of Chicago, Gift of the Print and Drawing Club, 1948.3.1
(*plate 93*)

The Symphony (*La Symphonie*), 1897
LRZ 348: la Symphonie. gravure sur bois; VG 186
Woodcut, 21.8 x 26.8 cm (block)
Josefowitz Collection
(*plate 87*)

The Triumph (*Le Triomphe*), from *Intimités*, 1898
LRZ 374: le triomphe. gravure sur bois; VG 189
Woodcut, 17.8 x 22.5 cm (block)
The Art Institute of Chicago, Gift of the Print and Drawing Club, 1948.3.2
(*plate 95*)

The Fine Pin (*La Belle épingle*), from *Intimités*, 1898
LRZ 375: la belle épingle. gravure sur bois; VG 190
Woodcut, 17.9 x 22.5 cm (block)
The Art Institute of Chicago, Gift of the Print and Drawing Club, 1948.3.3
(*plate 98*)

The Cogent Reason (*La Raison probante*), from *Intimités*, 1898
LRZ 377: la raison probante. gravure sur bois; VG 191
Woodcut, 17.8 x 22.3 cm (block)
The Art Institute of Chicago, Gift of the Print and Drawing Club, 1948.3.4
(*plate 99*)

Money (*L'Argent*), from *Intimités*, 1898
LRZ 378: l'argent. gravure sur bois; VG 192
Woodcut, 17.9 x 22.5 cm (block)
The Art Institute of Chicago, Gift of the Print and Drawing Club, 1948.3.5
(*plate 102*)

Extreme Measure (*Le Grand Moyen*), from *Intimités*, 1898
LRZ 379: le grand moyen. gravure sur bois; VG 193
Woodcut, 17.7 x 22.3 cm (block)
The Art Institute of Chicago, Gift of the Print and Drawing Club, 1948.3.6
(*plate 103*)

Five O'Clock (*Cinq heures*), from *Intimités*, 1898
LRZ 380: cinq heures. gravure sur bois; VG 194
Woodcut, 17.7 x 22.3 cm (block)
The Art Institute of Chicago, Gift of the Print and Drawing Club, 1948.3.7
(*plate 105*)

Getting Ready for a Visit (*Apprêts de visite*), from *Intimités*, 1898
LRZ 381: Apprêts de visite. gravure sur bois; VG 195
Woodcut, 17.7 x 22.3 cm (block)
The Art Institute of Chicago, Gift of the Print and Drawing Club, 1948.3.8
(*plate 106*)

The Other's Health (*La Santé de l'autre*), from *Intimités*, 1898
LRZ not cited; VG 196
Woodcut, 17.7 x 22.3 cm (block)
The Art Institute of Chicago, Gift of the Print and Drawing Club, 1948.3.9
(*plate 108*)

The Irreparable (*L'Irréparable*), from *Intimités*, 1898
LRZ 383: l'Irréparable. gravure sur bois; VG 197
Woodcut, 17.8 x 22.3 cm (block)
The Art Institute of Chicago, Gift of the Print and Drawing Club, 1948.3.10
(*plate 109*)

Books

Parisian Curiosities: Gatherings, Physiologies of the Street, Paris (*Badauderies parisiennes: Les Rassemblements, Physiologies de la rue, Paris*), Ed. Octave Uzanne, 1896
See LRZ 275: 8 dessins pour les Rassemblements (Uzanne); LRZ 277a: 8 dessins pour les Rassemblements; LRZ 279: 9 dessins pour les Rassemblements; LRZ 283: Dessin Couverture pour les Rassemblements
The Library of Congress, Washington, Rosenwald Collection
(*See plates 77, 79, 81, 83*)

Parisian Curiosities: Gatherings, Physiologies of the Street, Paris (*Badauderies parisiennes: Les Rassemblements, Physiologies de la rue, Paris*), Ed. Octave Uzanne, 1896
See LRZ 275: 8 dessins pour les Rassemblements (Uzanne); LRZ 277a: 8 dessins pour les Rassemblements; LRZ 279: 9 dessins pour les Rassemblements; LRZ 283: Dessin Couverture pour les Rassemblements
Josefowitz Collection
(*See plates 77, 79, 81, 83*)

Periodicals

Cover, *Le Rire*
1 December 1894
See LRZ 234 and 236: Dessins pour le Rire
The Jane Voorhees Zimmerli Art Museum, Rutgers, The State University of New Jersey, Museum Purchase
(*plate 85*)

Cover, *Le Rire*
8 January 1898
See LRZ 364: Dessins Rire et Cri de Paris
The Jane Voorhees Zimmerli Art Museum, Rutgers, The State University of New Jersey, Museum Purchase
(*plate 84*)

Exhibition History, 1885–1991

Solo Exhibitions and Reviews

All known solo exhibitions are cited; within a given year they are ordered chronologically when possible. After 1925, only selected reviews are cited.

1898
Paris, Offices of *La Revue blanche. Intimités.*

Natanson, Thadée. "De M. Félix Vallotton." *La Revue blanche* 18 (1 January 1899): 73–75.

Mourey, Gabriel. *The Studio* (London) (15 March 1899).

Bouyer, Raymond. "Les graveurs sur bois de fil au canif." *L'Estampe et l'affiche* (15 December 1899).

Le Cri de Paris (18 December 1899).

1906
Paris, Galerie Bernheim-Jeune. *Félix Vallotton.* 4–17 May.

Guillemot, Maurice. *L'Art et les Artistes* 3 (June 1906): 134.

Monod, François. *Art et décoration* 19 (June 1906): supplement, 1–2.

Ramuz, C.-F. *La Semaine Littéraire* (9 June 1906).

1909
Zurich, Künstlerhaus. *Félix Vallotton.* 2–26 May.

H. T. *Berner Rundschau* (15 May 1909).

T. *Neue Zürcher Zeitung* (2, 13, 14, and 17 May 1909).

Tages-Anzeiger (9 May 1909).

1910
Paris, Galerie Druet. *Félix Vallotton.* 10–22 January. [Catalogue: preface by Octave Mirbeau]

Chantre, Ami. *L'Art décoratif* 23 (1 February 1910): supplement, 1–5.

Chervet, Henri. *La Nouvelle Revue* (1 February 1910).

Le Gaulois (11 January 1910).

Hepp, Pierre. *La Grande Revue* 59 (25 January 1910): 392–93.

Monod, François. *Art et décoration* 27 (February 1910): supplement, 2.

Mourey, Gabriel. *L'Opinion* (15 January 1910).

Paris-Journal (15 January 1910).

S[chlumberger], J[ean]. *La Nouvelle Revue Française* 3 (1 March 1910): 421.

Vauxcelles, Louis. *Gil Blas* (18 January 1910): 3.

Werth, Léon. *La Phalange* (20 February 1910).

1912
Paris, Galerie Druet. *Félix Vallotton.* 22 January–3 February.

A. S. *Paris Journal* (20 January 1912).

Alexandre, Arsène. *Le Figaro* (30 January 1912): 5.

Apollinaire, Guillaume. *L'Intransigeant* (27 January 1912).

L'Art décoratif 27 (5 February 1912): supplement, 2–6.

Kahn, Gustave. *Mercure de France* 95 (16 February 1912): 866.

Martin, Georges. *La Renaissance Contemporaine* (24 February 1912).

Paris Midi (2 February 1912).

Petite Gazette des Arts (2 February 1912).

R[ivière], J[ean]. *La Nouvelle Revue Française* (March 1912).

S. N. *L'Action Nationale* (10 March 1912).

Sarradin, Edouard. *Journal des débats* (21 February 1912).

Vauxcelles, Louis. *Gil Blas* (24 January 1912): 4.

1913
Lausanne, Galerie Paul Vallotton.

Perret, Paul. *Gazette de Lausanne* (15 November 1913).

1914
Lausanne, Galerie Bernheim-Jeune-Vallotton. 16–31 March.

Florentin, Lucienne. *La Suisse* (19 March 1914).

Perret, Paul. *Gazette de Lausanne* (16 March 1914).

Paris, Galerie Druet. *Félix Vallotton.* 4–16 May.

Monod, François. *Art et décoration* (June 1914).

Paris, Galerie Bernheim-Jeune. *Félix Vallotton.* 8–16 June.

1919
Paris, Galerie Druet. *Félix Vallotton.*

Kahn, Gustave. *Mercure de France* 133 (1 May 1919): 135.

Le Demi-Solde. *Le Crapouillot* (1 April 1919): 7.

Le Temps (28 March 1919): 5.

Zurich, Galerie Bernheim-Jeune. *Félix Vallotton.*

1920
Lausanne, Galerie Paul Vallotton. 15 May–15 June.

Zurich and Lausanne, Galerie Bernheim-Jeune.

1922
New York, Weyhe Galleries. *Fifty-six Woodcuts by Félix Vallotton.*

Paris, Galerie Druet. *Félix Vallotton.*

1923
Paris, Galerie Druet. *Félix Vallotton.*

Fosca, François. *Revue Hebdomadaire* 7 (21 July 1923): 416–18.

George, Waldemar. *1Ere Nouvelle* (10 June 1923).

Jaloux, Edmond. *Nouvelles Littéraires* (9 June 1923).

Thiébault-Sisson. *Le Temps* (2 June 1923): 3.

Paris, Galerie Rodrigues-Henriques.

1925
Lausanne, Galerie Paul Vallotton. *Félix Vallotton: 50 dessins.* 11 April–11 May.

Lausanne, Musée Arlaud.

1926
Paris, Galerie Druet. *Cinquante tableaux de Félix Vallotton.*

Winterthur, Kunstmuseum. *Félix Vallotton: Gedächtnisausstellung.*

1927
Lausanne, Musée Arlaud. *Félix Vallotton.* Exposition organisée par les artistes vaudois. 17 September–8 October. [Catalogue]

Bern, Kunsthalle. *Félix Vallotton.* 23 October– 20 November.

1928
Zurich, Kunsthaus Zürich. *Félix Vallotton.* 20 January–26 February.

Paris, Galerie Jacques Rodrigues-Henriques. *Exposition rétrospective d'oeuvres inédites de Félix Vallotton.* 9–30 March. [Catalogue]

1929
Paris, Galerie Druet. *Vallotton inconnu.* 22 April– 3 May.

1931
Paris, Galerie Druet. *Dessins et petites peintures de Félix Vallotton.*

1932
Lausanne, Galerie Paul Vallotton. *Félix Vallotton: Rétrospective de l'oeuvre gravé.* 5–26 March.

Geneva, Galerie Moos. *Félix Vallotton.*

1933
Paris, Galerie Bernheim-Jeune.

1935
Paris, Galerie Druet. *Félix Vallotton.* 14–25 September.

Lausanne, Galerie Paul Vallotton. *Félix Vallotton: Dessins.* Opened 30 November.

1936
London, Arthur Tooth Gallery.

Winterthur, Kunstmuseum.

1938
Lucerne, Kunstmuseum. *Félix Vallotton.* 28 August–25 September.

Zurich, Kunsthaus Zürich. *Félix Vallotton.* 11 November–14 December. [Catalogue: see Bibliography, under "Monographic"]

1942
Basel, Kunsthalle. *Félix Vallotton.* 7 February– 8 March.

1943–44
La Chaux-de-Fonds, Musée de La Chaux-de-Fonds. *Félix Vallotton.* 28 December– 30 January 1944.

1944
Geneva, Athénée Genève. *Félix Vallotton.* 14 October–2 November.

1949
Paris, Galerie André Weil. *Rétrospective Vallotton.* April.

1952
Geneva, Cabinet des estampes. *L'Oeuvre gravé de Félix Vallotton.*

Paris, Galerie Colette Vallotton.

1953
Lausanne, Musée cantonal des Beaux-Arts, Palais de Rumine. *Peintures de Félix Vallotton 1865– 1925.* 18 June–13 September. [Catalogue: preface by René Berger]

1954
Brussels, Palais des Beaux-Arts. *Félix Vallotton.* June; traveled to Rotterdam, Museum Boymans. [Catalogue: preface by J. C. Ebbinge Wubben; essay by E. Manganel]

Lausanne, Musée cantonal des Beaux-Arts. *Dessins et gravures de Félix Vallotton.*

1955
Paris, Maison de la Pensée française. *Félix Vallotton, 1865–1925.* [Catalogue: essay by Francis Jourdain]

1957
Basel, Kunsthalle. *Félix Vallotton.* 23 January– 24 February; traveled to Dusseldorf, Kunsthalle, 8 March–3 April.

London, The Lefevre Gallery. *Paintings by Félix Vallotton.* 14 November–14 December.

Lausanne, Musée cantonal des Beaux-Arts.

1958
Toulouse, Musée Paul Dupuy.

1963
Milan, Galleria del Levante. *Félix Vallotton.*

Paris. *Salon d'Automne. Rétrospective Félix Vallotton.*

1964
Pisa, Università degli Studi, Istituto di Storia dell'Arte.

1965
Zurich, Kunsthaus Zürich. *Félix Vallotton.* 10 April–30 May. [Catalogue: see Bibliography, under "Monographic"]

Jedlicka, Gotthard. "Félix Vallotton: Zur Ausstellung im Kunsthaus Zürich." *Neue Zürcher Zeitung,* no. 1625 (18 April 1965): 1–2.

Lausanne, Galerie Paul Vallotton. *Hommage à Félix Vallotton (1865–1925).* 15 July–20 October. [Catalogue]

Milan, Galleria del Levante.

1966
Baden-Baden, Galerie Elfried Wirnitzer.

1966–67
Paris, Musée national d'Art moderne. *Vallotton.* 15 October–20 November; traveled to Charleroi, Palais des Beaux-Arts, 1966–67. [Catalogue: see Bibliography, under "Monographic"]

Vaillant, Annette. "L'Ami Vallotton." *L'Oeil* (13 October 1966): 8.

1967
London, Mercury Gallery. *Félix Vallotton.* 8 February–11 March.

1969
Bielefeld, Kunststudio.

1970
Lausanne, Galerie Paul Vallotton. *Félix Vallotton peintre et écrivain.* 26 February–14 March.

New York, Hirschl and Adler Galleries, Inc. *Félix Vallotton.* 7–25 April. [Catalogue: essay by François Daulte]

Artforum 8 (June 1970): 85.

Arts 44 (April 1970): 21.

Bologna, Galleria Forni.

1971
Geneva, Cabinet des estampes, Musée d'Art et d'Histoire. *Félix Vallotton, oeuvre gravé.*

Lausanne, Musée des Arts Décoratifs.

Milan, Galleria dei Lanzi.

Zurich, Galerie Intérieur. *Félix Vallotton: Zeichnungen.* 9 September–30 October. [Catalogue: forward by Rudolf Koella]

1971–73
Smithsonian Institution. *An Exhibition of Prints and Drawings by Félix Vallotton.* Traveling. [Catalogue: preface by Maxime Vallotton]

1972
Frankfurt am Main, Galerie Herbert-Helliger.

Los Angeles, University of California, The Grunwald Graphic Arts Foundation. *The Graphic Art of Félix Vallotton.*

1973
Honfleur, Grenier à Sel. *Félix Vallotton.*

1974
New York, Associated American Artists Gallery. *Félix Vallotton, etchings and drypoints, lithographs, woodcuts.*

New York, The Museum of Modern Art. *Félix Vallotton's Woodcuts.*

1975
Zurich, Galerie Nathan. *Félix Vallotton: Gemälde und Zeichnungen.* 26 September–13 December. [Catalogue: forward by Günter Busch]

1975–76
Lausanne, Galerie Paul Vallotton. *Oeuvre gravé et dessins préparatoires.* 4 December–3 January 1976. [Catalogue]

1976
London and Zurich, Arts Council and Pro Helvetia Foundation. *The Graphic Work of Félix Vallotton 1865–1925.* Traveling. [Catalogue: introduction by Mary Anne Stevens]

Lausanne, Galerie Paul Vallotton. *Félix Vallotton: Peintures.* 24 June–4 September. [Catalogue: preface by Georges Borgeaud]

1977
Milan, Studio d'arte grafica.

1978–79
Brescia, Galleria Schrieber.

Winterthur, Kunstmuseum. *Félix Vallotton: Bilder, Zeichnungen, Graphik.* 1 October–12 November 1978; traveled to Bremen, Kunsthalle; Dusseldorf, Kunsthalle; Paris, Musée du Petit Palais; Geneva, Musée Rath. [Catalogues: see Bibliography, under "Monographic"]

"Félix Vallotton." *L'Oeil*, no. 286 (May 1979): 97.

Fermigier, André. "Vallotton au Petit Palais: Une manière troublante d'être simple." *Le Monde* (26 April 1979): 21.

Hammer, Ethel Joyce. "Félix Vallotton at the Petit Palais and Galerie Documents." *Art in America* 79 (January 1980): 117.

Kupper, Hans Jürg. "Fleisch auf Eis." *Basler Zeitung*, no. 256 (4 October 1978).

Mazars, Pierre. "Vallotton rouge et noir." *Le Figaro* (24 April 1979).

Micha, René. "Vallotton." *Art International* 23 (May 1979): 24–25.

Monnier-Raball, Jacques. "Félix Vallotton en trois lieux genevois." *Construire*, no. 35 (29 August 1979).

Muratova, Xenia. *Burlington Magazine* 121 (June 1979): 401–2.

St. James, Ashley. "Vallotton." *Arts Review* (24 November 1978): 638.

1979
Buenos Aires, Centro de arte y Comunicación. *Félix Vallotton, el nabi suizo.* [Catalogue: essay by Jorge Glusberg]

Geneva, Musée d'Art et d'Histoire. *A propos des mythologies et des allégories de Félix Vallotton.* [Catalogue: essay by Charles Goerg and Antoinette Wakker]

Geneva, Galerie Engelberts. July–September. [Mainly graphics]

1980
Pully-Lausanne, Maison Pulliérane. *L'Oeuvre gravé de Félix Vallotton.*

Rome, Galleria Nazionale d'Arte Moderna. *Félix Vallotton: le incisioni su legno,* 20 February–30 March. [Catalogue: forward by Giovanna De Feo]

1981
Bremen, Kunsthalle. *Félix Vallotton: Das druckgraphische Werk.* 3 May–14 June; traveled to Berlin, Kupferstichkabinett der Staatliche Museen; Kassel, Neue Galerie der Staatliche Kunstsammlungen. [Catalogue: see Bibliography, under "Monographic"]

Winter, Peter. "Félix Vallotton: Das druckgraphische Werk." *Das Kunstwerk* 34 (1981): 73–74.

Munich, Galerie Thomas. *Félix Vallotton.*

1982
Bremen, Graphisches Kabinett Kunsthandel Wolfgang Werner. *Félix Vallotton 1865–1925: Intérieurs, Paysages, Nus et Gravures sur Bois.* 19 May–26 June. [Catalogue: no texts]

1983
Lausanne, Galerie Paul Vallotton. *Félix Vallotton —Huiles.* 30 June–17 September. [Catalogue]

Gravelines, Musée du dessin et de l'estampe originale en l'Arsenal de Gravelines. *Félix Vallotton, L'Oeuvre gravé et quelques dessins préparatoires.* 1 October–27 November. [Catalogue: introduction by Donald Vallotton]

1984
Ixelles, Liège. *Félix Vallotton graveur.*

1985
Lausanne, Galerie Paul Vallotton. *Félix Vallotton: Huiles et bois.* 2–25 May. [Catalogue]

Dorival, Bernard. "Lausanne: Félix Vallotton." *L'Oeil*, no. 359 (June 1985): 86–87.

1986
Lausanne, Galerie Paul Vallotton. 27 April–24 May.

1987
Lausanne, Galerie Paul Vallotton. *Félix Vallotton et la Russie.* 12 February–7 March. [Catalogue: preface by Marina Ducrey; see also Bibliography, under "Monographic," Brodskaïa]

1988
Mesola, Castello Estense. *Félix Vallotton: Opere dal Museo di Losanna.* 19 June–4 September; traveled to Bellinzona, Villa del Cedri; Milan, Palazzo della Permanente. [Catalogue: see Bibliography, under "Monographic"]

1989
London, JPL Fine Arts. *Félix Vallotton: Paintings, Watercolors, Drawings, and Woodcuts.* 1 March–14 April. [Catalogue: no texts]

Lausanne, Galerie Vallotton. *Félix Vallotton.*

1991
Tampere, Taide Museo [Finland]. *Félix Vallotton.* 3 March–5 May; traveled to Stockholm, Prins Eugens Waldemarsudde, 26 June–31 August.

Lausanne, Galerie Paul Vallotton. *Félix Vallotton. Dessins et xylographies.* 30 May–22 June. [Catalogue: text by Marina Ducrey]

Group Exhibitions and Reviews

Within a given year, group exhibitions are ordered chronologically when possible. After 1925, only selected group exhibitions and reviews are cited. When page numbers of a review are known, the specific page(s) of Vallotton's mention are indicated in brackets.

1885
Paris. *Salon des Artistes français.*

Boucher, Paul. *Moniteur des Arts* (15 May 1885).

deFourcaud, Louis. *Le Gaulois* (supplement to 30 April 1885).

Maurice-Albert. *Journal de Genève* (14 May 1885).

Geneva. *Salon suisse des Beaux-Arts.*

X. *Journal de Genève* (1 September 1885).

1886
Paris. *Salon des Artistes français.*

"Les artistes suisses au Salon." *Gazette de Lausanne* (25 May 1886).

Geneva. *Salon suisse des Beaux-Arts.*

W. S. *Journal de Genève* (13 October 1886).

1887
Paris. *Salon des Artistes français.*

S. "Les peintres suisses au Salon." *Gazette de Lausanne* (24 May 1887).

Seippel, Paul. "Les peintres suisses au Salon." *Journal de Genève* (6 July 1887).

Geneva. *Exposition municipale des Beaux-Arts.*

Spectator. *Journal de Genève* (7 September 1887).

1888
Paris. *Salon des Artistes français.*

Lausanne. *Exposition fédérale des Beaux-Arts.*

X. *Gazette de Lausanne* (19 July 1888).

1889
Paris, "Pavillon de la Suisse," *Exposition universelle.*

"Lettre de Paris." *Gazette de Lausanne* (21 May 1889).

Paris. *Salon des Artistes français.*

"Lettre de Paris." *Gazette de Lausanne* (11 June 1889).

1890
Paris. *Salon des Artistes français.*

"Lettre de Paris." *Gazette de Lausanne* (16 May 1890).

Bern. *Première Exposition Nationale d'Art Suisse.*

Godet, Philippe. *Gazette de Lausanne* (3 June 1890).

1891
Paris. *Salon des Indépendants.*

Marx, Roger. "Les petits Salons." *Le Voltaire* (23 April 1891).

Lausanne. *Exposition vaudoise des Beaux-Arts.*

Koella, Charles. *Gazette de Lausanne* (8 October 1891).

Paris. *Salon des Champs-Elysées.*

1892

Paris. *Premier Salon de la Rose + Croix.*

> R. G. *Mercure de France* 5 (May 1892): 62–64.

Bern. *Exposition fédérale des Beaux-Arts.*

> "Chronique Suisse." *Bibliothèque Universelle* (May 1892).

Paris. *Salon des Indépendants.*

Paris. *Salon du Champ-de-Mars.*

1893

Paris. *Salon des Indépendants.*

> Marx, Roger. *Le Voltaire* (28 March 1893).

> Natanson, Thadée. *La Revue blanche* 4 (15 April 1893): 271–76 [272–73].

> Fénéon, Félix. "Balade chez les artistes indépendants." *Le Père peinard* (16 April 1893).

> Christophe, Jules. *Journal des Artistes* (23 April 1893).

> Rambosson, Yvanhoé. *Mercure de France* 8 (May 1893): 76–77.

Lausanne. *Exposition vaudoise des Beaux-Arts.*

> Godet, Philippe. *Gazette de Lausanne* (26 September 1893).

Paris, Le Barc de Boutteville. *Exposition des Artistes Impressionnistes et Symbolistes.*

> Fargue, Léon-Paul. "Peinture (chez Le Barc de Boutteville)." *L'Art Littéraire* (December 1893).

1894

Geneva, Salle de l'Institut.

> Vallette, Gaspard. *Gazette de Lausanne* (22 February 1894).

> Chanteclair. *La Semaine Littéraire* (24 February 1894).

Brussels. *Salon de la Libre Esthétique.* [2 prints]

Paris, Offices of *La Dépêche de Toulouse.* *Exposition des Nabis.*

> Homodei. *La Dépêche de Toulouse* (21 May 1894).

Yverdon. *Exposition d'Yverdon.*

> de Felice, S. *Gazette de Lausanne* (24 September 1894).

1895

Brussels. *Salon de la Libre Esthétique.*

> Mauclair, Camille. *Mercure de France* 14 (April 1895): 100–101.

Neuchâtel. *Salon neuchâtelois.*

> Godet, Philippe. *La Suisse Libérale* (17 May 1895).

> [Godet, Philippe]. *Gazette de Lausanne* (20 May 1895).

Paris, Galerie Laffitte. *Exposition.*

> Natanson, Thadée. *La Revue blanche* 8 (1 June 1895): 523–24.

Paris. *Salon du Champ-de-Mars.*

> Couvreu, Emile. "Les Artistes suisses à Paris." *Gazette de Lausanne* (7 June 1895).

Paris, Galerie L'Art Nouveau (Bing). *Premier Exposition.* December.

Paris. *Salle de l'Union au Bois-Colombes.*

1896

Paris, Galerie L'Art Nouveau (Bing). *Deuxième Exposition.* February.

Paris. Refused at *Salon du Champ-de-Mars.* [for his woodcuts]

> Marx, Roger. *Le Voltaire* (25 April 1896).

> Natanson, Thadée. *La Revue blanche* 10 (1 June 1896): 520–24 [524].

1897

Brussels. *Salon de la Libre Esthétique.*

Paris, Galerie Vollard. *Les Dix.*

> Méry, Maurice. "Les Dix." *Moniteur des Arts* (9 April 1897).

> Natanson, Thadée. *La Revue blanche* 12 (15 April 1897): 484–87 [486].

> *L'Estampe et L'Affiche* (15 April 1897).

> C. J. "Quelques-uns." *Paris* (17 April 1897).

> Chanel, Léopold. *Journal des Artistes* (18 April 1897).

> *Le Voltaire* (20 April 1897).

Paris. *Salon du Champ-de-Mars.*

> *Gazette de Lausanne* (31 May 1897).

Lausanne. *Exposition vaudoise des Beaux-Arts.*

> Wirz, Maurice. *Gazette de Lausanne* (20 October 1897).

1898

Paris, Galerie Vollard. Nabis group exhibition/*La Revue blanche, Intimités.*

> Natanson, Thadée. *La Revue blanche* 15 (15 April 1898): 615–19 [616–18].

> Hoffmann, Eugène. *Journal des Artistes* (24 April 1898).

Basel. *Exposition nationale des Beaux-Arts.*

> Godet, Philippe. *Gazette de Lausanne* (14 October 1898).

1899

Paris, Galerie Durand-Ruel. Nabis group exhibition.

> Geffroy, Gustave. *Le Journal* (15 March 1899).

> M. G. *L'Art décoratif* (March 1899).

> Lesaulx, Gaston-E. *Journal des Artistes* (26 March 1899).

> *Le Cri de Paris* (26 March 1899).

> A. B. *La Justice* (27 March 1899).

> "Choses d'Art: Un Salon d'avant-garde." *Le Temps* (29 March 1899): 2.

> Natanson, Thadée. "Une date de l'histoire de la peinture française." *La Revue blanche* 18 (1 April 1899): 504–21 [510].

> H. G. [Henri Ghéon]. *L'Ermitage* (April 1899).

> Fontainas, André. *Mercure de France* 30 (April 1899): 247–52 [248].

> Rambosson, Yvanhoé. "Les Symbolistes et les Néo-impressionnistes chez Durand-Ruel." *La Plume*, no. 243 (1 June 1899): 343.

Paris. *Salon des Indépendants.*

Vienna. *Secession* (in "Studies and Products of Modern Drawing").

1900

Paris, Galerie Bernheim-Jeune. *Exposition des dix* (Bonnard, Denis, Hermann-Paul, Ibels, Maillol, Ranson, Roussel, Sérusier, Vallotton, Vuillard). 2–22 April. [10 paintings]

> Alexandre, Arsène. *Le Figaro* (3 April 1900): 5.

> Thiébault-Sisson. *Le Temps* (19 April 1900).

Natanson, Thadée. "Félix Vallotton, peintre." *L'Art décoratif* (April 1900).

Natanson, Thadée. "Des Peintres intelligents." *La Revue blanche* 22 (1 May 1900): 53–56 [53–55].

Fontainas, André. *Mercure de France* 34 (May 1900): 542–45 [544].

Berlin. *Secession II.* Spring.

Paris. *Exposition universelle* (in *Exposition centennale de l'Art français*).

> Thiébault-Sisson. *Le Temps* (1 May 1900).

> Bouyer, Raymond. *La Nouvelle Revue* (15 June 1900).

> Klingsor, Tristan. *La Vogue* 7 (15 July 1900): 53–64 [55].

1901

Paris. *Salon des Indépendants.*

> Alexandre, Arsène. *Le Figaro* (2 May 1901): 5.

> Coquiot, Gustave. *Gil Blas* (20 April 1901): 1–2 [2].

> Fontainas, André. *La Plume*, no. 290 (15 May 1901): 352–55 [354].

> Marx, Roger. *Revue Universelle* (13 July 1901).

> Natanson, Thadée. *La Revue blanche* 25 (1 May 1901): 52–57.

> Pascal, Jean. *La Vogue* 10 (15 May 1901): 114.

Zurich, Künstlerhaus. *Schweizer Künstler in Paris.* 22 September–23 October.

1902

Brussels. *Salon de la Libre Esthétique.* 27 February–31 March.

Paris. *Salon des Indépendants.*

> Alexandre, Arsène. *Le Figaro* (1 April 1902): 5.

> Bidou, Henry. *L'Occident* 1 (April 1902): 253–64 [263–64].

> Dervaux, Adolphe. *La Plume*, no. 316 (15 June 1902): 740–42 [741].

> Fagus, Félicien. *La Revue blanche* 27 (15 April 1902): 623–26 [626].

> Fontainas, André. *Mercure de France* 42 (May 1902): 526–31.

Paris, Galerie Bernheim-Jeune. Nabis group exhibition.

> Bidou, Henry. *L'Occident* 1 (June 1902): 397.

> Fagus, Félicien. *La Revue blanche* 28 (1 June 1902): 215–17 [216].

> Fontainas, André. *Mercure de France* 42 (June 1902): 815–16 [815].

> Klingsor, Tristan. *La Plume*, no. 317 (1 July 1902): 811.

Halle Saale [Germany]. *Kunstsalon Ammann.* [20 paintings, 36 woodcuts]

1902–03

Berlin. *Secession* (in exhibition for the graphic arts). Winter.

1903

Vienna. *Secession* (in *Die Entwicklung des Impressionismus in Malerei und Plastik*). January–February. [10 paintings]

Paris. *Salon des Indépendants.* 20 March–25 April.

> Alexandre, Arsène. *Le Figaro* (30 March 1903): 5.

> Dervaux, Adolphe. *La Plume*, no. 340 (15 June 1903): 651–54 [653].

Fagus, Félicien. *La Revue blanche* 30 (1 April 1903): 541–46 [546].

Morice, Charles. *Mercure de France* 46 (May 1903): 389–405 [402].

Valbranche, Pierre. *L'Occident* 3 (May 1903): 315–21 [320].

Paris. *Salon du Champ-de-Mars.*

Alexandre, Arsène. *Le Figaro* (15 April 1903).

Dayot, Armand. *Gil Blas* (15 April 1903): 5–6 [6].

Lorrain, Jean. *Le Journal* (15 April 1903): 3.

Rolland, Romain. *Revue de Paris* (1 June 1903).

Berlin. *Secession.* Spring. [1 painting]

Paris. *Salon de la Société nationale des Beaux-Arts.* 16 April–30 June.

Paris, Galerie Bernheim-Jeune. *Exposition Vallotton et Vuillard.* [75 paintings]

Leclère, Tristan [Tristan Klingsor]. *La Plume,* no. 339 (1 June 1903): 638.

Saunier, Charles. *Revue Universelle* (May 1903).

Paris. *Salon d'Automne.* 31 October–6 December. [2 paintings]

Alexandre, Arsène. *Le Figaro* (31 October 1903): 3.

Ayraud-Degeorge, H. *L'Intransigeant* (1 November 1903): 2.

Bouyer, Raymond. *La Revue bleue* 40 (14 November 1903): 618–23 [621].

Dayot, Armand. *Gil Blas* (30 October 1903).

Leblond, Marius-Ary. *La Grande Revue* 28 (15 December 1903): 683–89 [686].

Morice, Charles. *Mercure de France* 48 (December 1903): 683–97 [694].

Vogt, Felix. *Neue Zürcher Zeitung* (2 December 1903).

1903–04

Paris, Galerie B. Weill. 10 December–10 January. [1 drawing]

1904

Paris. *Salon des Indépendants.* [6 paintings]

Alexandre, Arsène. *Le Figaro* (22 February 1904): 5.

Leblond, Marius-Ary. *La Grande Revue* 29 (15 March 1904): 698–705 [698].

Leclère, Tristan [Tristan Klingsor]. *La Plume,* no. 358 (15 March 1904): 348–52 [350].

Nanteuil, Maurice. *L'Occident* 5 (April 1904): 189–95 [195].

Saunier, Charles. *Revue Universelle* 108 (1904).

Vauxcelles, Louis. *Gil Blas* (24 February 1904).

Paris, Galerie Bernheim-Jeune. Nabis group exhibition. 8–18 April. [11 paintings]

Berlin. *Secession.* Spring. [1 painting]

Paris. *Salon d'Automne.* 15 October–15 November. [3 paintings]

Alexandre, Arsène. *Le Figaro* (14 October 1904).

Cordonnier, Emile. *La Grande Revue* 32 (15 November 1904): 435–42 [438].

Marx, Roger. *Revue Universelle* (October 1904).

Monod, François. *Art et décoration* 16 (December 1904): supplement, 2.

Vauxcelles, Louis. *Gil Blas* (14 October 1904).

1905

Paris. *Salon des Indépendants.* 24 March–30 April.

Alexandre, Arsène. *Le Figaro* (25 March 1905): 5.

Holl, J. C. *Cahiers d'Art et de Littérature* (May 1905).

Morice, Charles. *Mercure de France* 54 (15 April 1905): 536–56 [545].

Ramuz, C.-F. *Gazette de Lausanne* (23 and 25 May 1905).

Saunier, Charles. *La Plume,* no. 370 (15 April 1905): 328–34 [332].

Thiébault-Sisson. *Le Temps* (24 March 1905): 3.

Vauxcelles, Louis. *Gil Blas* (23 March 1905).

Venice. *Esposizione d'Arte.* 22 April–31 October. [1 painting, woodcuts]

Paris. *Salon d'Automne.* 18 October–25 November. [7 paintings]

Alexandre, Arsène. *Le Figaro* (17 October 1905): 3.

Denis, Maurice. *L'Ermitage* (15 November 1905)

Fagus. *L'Occident* 8 (November 1905): 250–59 [254–55].

Guillemot, Maurice. *L'Art et les Artistes* 2 (October 1905): 49–59 [51, 57].

Holl, J. C. *Cahiers d'Art et de Littérature* (November 1905).

Mauclair, Camille. *La Revue bleue* 43 (21 October 1905): 521–25 [523].

Morice, Charles. *Mercure de France* 58 (1 December 1905): 376–93 [381].

Paris (19 October 1905).

Ramuz, C.-F. *La Voile Latine* (Winter 1906).

Vauxcelles, Louis. *Gil Blas* (17 October 1905): supplement, 1–2 [1].

Berlin, Paul Cassirer Gallery. *VII. Ausstellung.* Traveled to Hamburg. [34 paintings: 17 at each venue] [Catalogue]

Munich, Palais Vetro. *Internationale Kunstausstellung.*

1906

Paris. *Salon des Indépendants.* 20 March–30 April.

Fosca, François. *Les Essais* (April 1906).

Guillemot, Maurice. *L'Art et les Artistes* 3 (April 1906): 70–76 [76].

Holl, J. C. *Cahiers d'Art et de Littérature* (May 1906).

Morice, Charles. *Mercure de France* 60 (15 April 1906): 534–44 [540].

Vauxcelles, Louis. *Gil Blas* (20 March 1906).

Christiania [Oslo]. May or June. [4 paintings]

Paris. *Salon d'Automne.* 6 October–15 November.

Alexandre, Arsène. *Le Figaro* (5 October 1906): 2–3 [3].

Chervet, Henri. *La Nouvelle Revue* 43 (1 November 1906): 97–102 [98–99].

Guillemot, Maurice. *L'Art et les Artistes* 4 (October 1906): 296–308 [305].

Holl, J. C. *Cahiers d'Art et de Littérature* (November 1906).

Jamot, Paul. *Gazette des Beaux-Arts* 36 (1 December 1906): 456–84 [482].

Leclère, Tristan. *La Phalange* (15 October 1906).

Mauclair, Camille. *La Revue bleue* 44 (13 October 1906): 456–58 [456].

Morice, Charles. *Mercure de France* 64 (1 November 1906): 34–48 [41].

Vauxcelles, Louis. *Gil Blas* (5 October 1906).

1907

Paris. *Salon des Indépendants.* 20 March–30 April.

Alexandre, Arsène. *Le Figaro* (21 March 1907): 5.

Guillemot, Maurice. *L'Art et les Artistes* 5 (May 1907): 87–88 [88].

Klingsor, Tristan. *La Phalange* (15 April 1907).

M., Pierre L. *L'Occident* 11 (April 1907): 195–200 [195–96].

Morice, Charles. *Mercure de France* 66 (15 April 1907): 752–57 [754].

Pératé, André. *Gazette des Beaux-Arts* 37 (1 May 1907): 355–63 [356].

Thiébault-Sisson. *Le Petit Temps* (supplement to *Le Temps,* 23 March 1907).

Vauxcelles, Louis. *Gil Blas* (20 March 1907).

Strasbourg, Château des Rohan. Contemporary French Art. 2 March–2 April. [1 painting]

Stuttgart, Museum der Bildenden Künste. French Art. 1–31 May. [1 painting]

Paris, Galerie Bernheim-Jeune. *Groupe des dix.* 3–15 June.

Paris. *Salon d'Automne.* 1–22 October.

Alexandre, Arsène. *Le Figaro* (30 September 1907).

Apollinaire, Guillaume. *Je Dis Tout* (12 October 1907).

Chervet, Henri. *La Nouvelle Revue* 49 (1 November 1907): 122–27 [125].

Desvallières, Georges. *La Grande Revue* 44 (10 October 1907): 740–42 [742].

Guillemot, Maurice. *L'Art et les Artistes* 6 (November 1907): 394–400 [399–400].

Klingsor, Tristan. *La Phalange* (15 October 1907).

Pératé, André. *Gazette des Beaux-Arts* 38 (1 November 1907): 385–407 [402].

Rouart, Louis. *L'Occident* 12 (November 1907): 230–41 [239].

Segard, Achille. *Le Studio* (December 1907).

Thiébault-Sisson. *Le Petit Temps* (supplement to *Le Temps,* 1 October 1907).

Vauxcelles, Louis. *Gil Blas* (30 September 1907): 1–3 [2].

1907–08

Paris, Galerie Bernheim-Jeune. *Portraits d'hommes.* 16 December–4 January.

1908

Paris. *Salon des Indépendants.* 20 March–2 May. [1 painting]

Alexandre, Arsène. *Le Figaro* (21 March 1908): 5.

Apollinaire, Guillaume. *Revue des Lettres et des Arts* (1 May 1908).

L'Art et les Artistes 7 (April 1908): 35–36.

Chervet, Henri. *La Nouvelle Revue* 2 (15 April 1908): 427–29 [429].

Denis, Maurice. *La Grande Revue* 48 (10 April 1908): 545–53 [549, 553].

Monod, François. *Art et décoration* 23 (April 1908): supplement, 2.

Vauxcelles, Louis. *Gil Blas* (20 March 1908): 1–2 [2].

Munich. *Secession.*

Brussels. *Salon de la Libre Esthétique.* 1 March–5 April. [1 painting, 2 statuettes]

Moscow. *Zolotoe Rouno* (The Golden Fleece). 18 April–24 May. [6 paintings]

Paris, Galerie Druet. 3–20 July. [3 paintings]

Paris. *Salon d'Automne.* [1 painting]

Alexandre, Arsène. *Le Figaro* (30 September 1908): 2–3 [3].

Bovy, Adrien. *La Grande Revue* (10 October 1908).

Chervet, Henri. *La Nouvelle Revue* 5 (15 October 1908): 559–68 [567].

Hepp, Pierre. *Gazette des Beaux-Arts* 40 (1 Novembre 1908): 381–401 [395–96].

Mauclair, Camille. *L'Art décoratif* 19 (1 December 1908): 193–211 [202].

Morice, Charles. *Mercure de France* 76 (1 November 1908): 155–66 [162].

Morot, F. G. *L'Intransigeant* (6 October 1908).

Péladan. *La Revue hebdomadaire* 8 (17 October 1908): 360–404 [373–74].

Schultz, Emil. *Neue Zürcher Zeitung* (13 October 1908).

Thiébault-Sisson. *Le Petit Temps* (30 September 1908).

Vaudoyer, Jean-Louis. *Art et décoration* 24 (November 1908): 147–58 [151].

Vauxcelles, Louis. *Gil Blas* (30 September 1908).

Zurich, Künstlerhaus. French Impressionism. [2 works]

1909

Paris. *Salon des Indépendants.* 25 March–2 May.

Alexandre, Arsène. *Le Figaro* (25 March 1909): 5.

Chervet, Henri. *La Nouvelle Revue* 8 (15 April 1909): 569–71 [571].

Goujon, Pierre. *Gazette des Beaux-Arts* 1 (1 May 1909): 388–99 [389–91].

Monod, François. *Art et décoration* 25 (May 1909): supplement, 1–3 [2].

Morice, Charles. *Mercure de France* 78 (16 April 1909): 725–31 [728–29].

Vauxcelles, Louis. *Gil Blas* (25 March 1909): 1–2 [2].

Vienna. *Secession.* May–October. [3 paintings]

Hagen, Folkwang Museum. *Sonderausstellung.* 4 August–16 September. [27 woodcuts, 4 drawings]

Paris. *Salon d'Automne.* 1 October–8 November.

Alexandre, Arsène. *Le Figaro* (30 September 1909): 5.

Bovy, Adrien. *La Voile Latine* (November–December 1909).

Chervet, Henri. *La Nouvelle Revue* 11 (15 October 1909): 556–63 [559–60].

Goujon, Pierre. *Gazette des Beaux-Arts* 2 (1 November 1909): 371–88 [384].

Hepp, Pierre. *La Grande Revue* 58 (25 November 1909): 376–81 [379].

Martial, M. *Le Gaulois* (30 September 1909): 1–2 [2].

Miomandre, Francis de. *L'Art et les Artistes* 10 (November 1909): 78–86 [83].

Rambosson, Yvanhoé. *L'Art décoratif* 21 (October 1909): 97–114 [106–7].

Salmon, André. *L'Intransigeant* (1 October 1909): 1–2 [2].

Schultz, Emil. *Neue Zürcher Zeitung* (16 October 1909).

Thiébault-Sisson. *Le Temps* (30 September 1909).

Vauxcelles, Louis. *Gil Blas* (30 September 1909): 1–2 [2].

Paris, Galerie Eugène Blot. *Natures mortes et fleurs.* 13 November–4 December. [1 painting]

Zurich, Polytechnikum. [Prints]

1909–10

Odessa. *Exposition internationale d'Art.* Traveled to Kiev and St. Petersburg. [2 paintings]

1910

Prague, Manes. *Les Indépendants.* February–March. [4 paintings]

St. Petersburg. *Exposition d'oeuvres graphiques d'artistes français.* 2 May–7 June; traveled to Odessa, Kiev, and Riga. [4 paintings]

Tugendhold, Iakov, and Serge Makovski. "Cinquième exposition de la revue Apollon," *Apollon* 6 (March 1910): 8–9.

Munich, Galerie Tannhauser. [40 paintings]

Basler Zeitung (3 April 1910).

Hannoverscher Courier (8 April 1910).

"Kleine Chronik." *Neue Zürcher Zeitung* (23 March 1910).

Paris, Galerie Bernheim-Jeune. *Nus.* 17–28 May. [5 paintings]

Stockholm, Sveriges Allmänna Konstförening. *Modern Graphic Art from Herr Thorsten Laurins Collection.* September. [4 woodcuts, 1 lithograph]

Paris. *Salon d'Automne.* 1 October–8 November.

Alexandre, Arsène. *Le Figaro* (30 September 1910): 1–2 [2].

Apollinaire, Guillaume. *L'Intransigeant* (1 October 1910): 1–2 [1].

Loustalot. *Le Gaulois* (30 September 1910).

Morice, Charles. *Mercure de France* 88 (1 November 1910).

Morice, Charles, and André Salmon. *Paris-Journal* (30 September 1910).

Rude, Léopold. *Gil Blas* (30 September 1910): 1–2 [1–2].

Salmon, André. *Paris-Journal* (30 September 1910).

Schultz, Emil. *Neue Zürcher Zeitung* (21 October 1910).

Thiébault-Sisson. *Le Petit Temps* (supplement to *Le Temps*, 30 September 1910).

Vauxcelles, Louis. *L'Art décoratif* 24 (1 October 1910): 113–76 [165–66].

Paris, Galerie Druet. "Premier Groupe" exhibition. 4–17 December. [5 paintings]

Paris, Galerie Bernheim-Jeune. *La Faune.* 19–30 December. [2 paintings]

Zurich, Kunsthaus Zürich. Inaugural exhibition.

1910–11

London, Grafton Gallery. *Manet and the Post-Impressionists.* [4 paintings]

1911

Munich. *Secession.* 16 May–31 October. [1 painting]

Winterthur, Kunstverein. 11 June–2 July. [14 paintings]

Paris, Galerie Bernheim-Jeune. *La Montagne.* 26 June–13 July. [1 painting]

Paris, Galerie Bernheim-Jeune. *L'Eau.* 20 July–5 August. [6 paintings]

Paris. *Salon d'Automne.* 1 October–8 November.

Alexandre, Arsène. *Le Figaro* (30 September 1911): 3–4 [4].

Hamel, Maurice. *Les Arts* (November 1911).

Kahn, Gustave. *Mercure de France* 93 (16 October 1911): 868–74 [873].

Meurville, Louis de. *Le Gaulois* (30 September 1911).

Miomandre, Francis de. *L'Art et les Artistes* 14 (November 1911): 86–90 [88].

Puy, Michel. *La Grande Revue* 69 (25 October 1911): 852–59 [859].

Salmon, André. *Paris-Journal* (30 September 1911).

Schultz, Emil. *Neue Zürcher Zeitung* (19 October 1911).

Thiébault-Sisson. *Le Temps* (1 October 1911): 4.

Vauxcelles, Louis. *L'Art décoratif* 26 (5 November 1911): 177–83 [182].

Paris, Galerie Druet. "Premier Groupe" exhibition. 27 November–9 December. [5 paintings]

Apollinaire, Guillaume. *L'Intransigeant* (13 December 1911): 2.

L'Art décoratif 26 (20 December 1911): supplement, 2.

Kahn, Gustave. *Mercure de France* 95 (1 January 1912): 194.

Rome. International Exhibition.

1912

St. Petersburg. *Centennale de l'Art.* [6 paintings]

Amsterdam, Stedelijk Museum. *International Exhibition of Art.* 13 April–July. [2 paintings]

Paris. *Salon de Mai.* 1–15 May. [2 paintings]

Berlin. *Der Sturm.* May. [1 woodcut]

Hagen, Museum Folkwang. Modern Art. Opened 2 July. [1 woodcut]

Paris. *Salon d'Automne.* 1 October–8 November.

Alexandre, Arsène. *Le Figaro* (30 September 1912): 4.

Apollinaire, Guillaume. *L'Intransigeant* (30 September 1912).

Fargue, Léon-Paul. *Nouvelle Revue Française* 8 (December 1912): 1087–93 [1089].

Kahn, Gustave. *Mercure de France* 99 (16 October 1912): 879–884 [880].

M., F. [Francis de Miomandre]. *L'Art et les Artistes* 16 (November 1912): 86–89 [87].

Olivier-Hourcade. *Paris-Journal* (19 October 1912).

Rosenthal, Léon. *Gazette des Beaux-Arts* 8 (November 1912): 405–17 [409].

Vauxcelles, Louis. *Gil Blas* (20 September 1912).

Paris, Galerie Druet. "Premier Groupe" exhibition. 25 November–7 December.

Kahn, Gustave. *Mercure de France* 100 (16 December 1912): 846.

Thalasso, Adolphe. *L'Art et les Artistes* 16 (January 1913): 137–39 [138].

Vauxcelles, Louis. *Gil Blas* (29 November 1912).

1913
Zurich, Kunsthaus Zürich. *Januar Ausstellung.* [43 paintings]

Neue Zürcher Zeitung (26 January 1913).

New York, Chicago. *Armory Show.* 17 February–15 April. [3 paintings in NY; 2 in Chicago]

San Francisco. *Salon des Indépendants and Exposition universelle.* [1 painting]

Rome. *Secession.* March–June. [2 paintings]

Ghent. *Exposition universelle.* Summer. [represents France with 3 paintings]

Lausanne, Galerie Bernheim-Jeune-Vallotton. *Exposition inaugurale.* Opened August.

Paris, Galerie Druet. "Premier Groupe" exhibition. 17–29 November.

Kahn, Gustave. *Mercure de France* 106 (16 December 1913): 822–23.

Turnus. *Schweizer Kunstverein.* [3 paintings]

1913–14
Paris. *Salon d'Automne.* 15 November–5 January.

Alexandre, Arsène. *Le Figaro* (14 November 1913): 2.

Apollinaire, Guillaume. *L'Intransigeant* (14 November 1913).

Bouyer, Raymond. *Art et décoration* 34 (2nd semester 1913).

Dervaux, Adolphe. *La Plume* (15 December 1913).

Fargue, Léon-Paul. *Nouvelle Revue Française* (January 1914).

Hautecoeur, Louis. *Gazette des Beaux-Arts* 10 (1 December 1913): 499–511 [504].

Péladan. *La Revue Hebdomadaire* 12 (13 December 1913): 261–79 [275].

Revers, Henry. *Paris-Journal* (14 November 1913).

Thalasso, Adolphe. *L'Art et les Artistes* 18 (January 1914): 191–94 [192].

1914
Paris. *Salon d'Automne.*

Paris, Galerie Bernheim-Jeune. [1 painting]

Bern. *Exposition nationale suisse.*

1915
Basel, Kunsthalle. *Märzausstellung: Alfred Heinrich Pellegrini, Gustava Iselin-Haeger, Julie Haeger, Félix Vallotton.* 6–28 March. [70 works]

Zurich, Kunsthaus Zürich. *French and Swiss Art.*

Neue Zürcher Zeitung (2 November 1915).

San Francisco. *Panama-Pacific International Exposition.* [2 paintings]

1916
Winterthur, Kunstverein. *Ausstellung Französischer Malerei.* 29 October–26 November. [3 paintings]

1917
Basel, Kunsthalle. *Januar Ausstellung. Exposition de peinture française organisée au profit de la Fraternité des artistes de Paris.* 10 January–4 February. [6 works]

Paris, Musée du Luxembourg. *Les Peintres en mission aux armées.* Opened October.

Paris, Galerie Druet. [5 paintings]

Zurich, Kunsthaus Zürich. *French Art.* [3 paintings lent by Druet]

1918
Paris, Galerie Druet. "Premier Groupe" exhibition.

1919
Paris. *Salon d'Automne.*

Alexandre, Arsène. *Le Figaro* (1 November 1919): 1.

George, Waldemar. *Le Crapouillot* (15 November 1919): 6–10 [7].

Michel, André. *Revue hebdomadaire* 12 (December 1919): 79–102 [89–90].

Polyphile. *Feuillets d'Art* 3 (1919).

Rey, Robert. *L'Opinion* 12 (8 November 1919): 487–88 [487].

Roger-Milès, L. *Le Gaulois* (31 October 1919).

Vauxcelles, Louis. *L'Eclair* (31 October 1919).

Paris, Galerie Druet.

1920
Paris, Pavillon de Marsan.

René-Jean. "Le Musée de la Guerre." *Le Bulletin de la vie artistique* 1 (1 January 1920): 557–60.

Paris. *Salon d'Automne.*

Allard, Roger. *Revue Universelle* 3 (15 November 1920): 495–501 [501].

du Colombier, Pierre. *Revue Critique des Idées et des Livres* (10 November 1920).

Léon-Martin, Louis. *Le Crapouillot* (16 October 1920).

Mercereau, Alexandre. *Les Hommes du Jour* (October–November 1920).

Vaudoyer, Jean-Louis. *L'Opinion* 13 (16 October 1920): 438–40 [439].

Brussels, Salle Eolian. *Ceux d'aujourd'hui: Groupe Franco-Belge pour la Défense de la peinture moderne.*

Zurich and Lausanne, Galerie Bernheim-Jeune.

Venice. *XII Biennale.*

London, Independent Gallery. [32 works]

1921
Paris, *Salon d'Automne.*

Bricon, Etienne. *Le Gaulois* (5 November 1921).

Brillant, Maurice. *Le Correspondant* (25 November 1921).

Gillet, Louis. *Gazette des Beaux-Arts* 4 (November 1921): 303–16 [312–13].

Thiébault-Sisson. *Le Temps* (9 November 1921): 3.

Vaudoyer, Jean-Louis. *L'Opinion* 14 (19 November 1921): 572–74 [574].

Lausanne, Galerie Vallotton. *Lithographies et gravures sur bois modernes: Daumier, Bonnard, Vuillard, Lautrec, Vallotton, Steinlen, Delacroix.* Opened 11 September.

Paris, Galerie Druet.

London, The Goupil Gallery. *Salon 1921.*

1922
Paris. *Salon d'Automne.*

Escholier, Raymond. *Art et décoration* (December 1922).

Fegdal, Charles. *Revue Contemporaine* (November–December 1922).

Rey, Robert. *Le Crapouillot* (1 November 1922).

Paris, Galerie Druet.

Montreux. *Exposition des Beaux-Arts.*

1923
Paris. *Salon d'Automne.*

Blanchard, Claude, and Michel-Gabriel Vaucaire. *Le Crapouillot* (1 November 1923).

du Colombier, Pierre. *L'Opinion* (9 November 1923).

Jaloux, Edmond. *Nouvelles Littéraires* (3 November 1923).

Paris, Galerie Druet.

Paris, Galerie Druet. Félix Vallotton and René Piot.

Paris, Galerie Rodrigues-Henriques. Félix Vallotton and Hermann-Paul.

Paris. *Salon des Tuileries.*

1924
Paris. *Salon d'Automne.*

du Colombier, Pierre. *L'Opinion* 18 (7 November 1924): 13.

Hautecoeur, Louis. *Gazette des Beaux-Arts* 10 (December 1924): 333–52 [336].

Pératé, André. *La Revue bleue* 62 (6 December 1924): 820–22 [821].

Vaudoyer, Jean-Louis. "Le Salon d'Automne: La Peinture et la Sculpture." *Art et décoration* (December 1924): 161–72 [167].

Paris. *Salon des Tuileries.*

Venice. *XIV Biennale.*

1925
Paris. *Salon d'Automne.*

du Colombier, Pierre. *L'Opinion* 19 (5 October 1925): 21–22 [22].

George, Waldemar. *L'Amour de l'Art* (September 1925).

Paris, Galerie Druet.

Paris. *Salon des Tuileries.*

Lausanne, Musée Arlaud.

1926
Paris, Société des Artistes Indépendants. *30 Ans d'Art Indépendant.*

Fosca, François. "Trente ans d'art indépendant." *Art et décoration* (April 1926): 97–110.

Basel, Kunsthalle. *René Auberjonois, Albert Kohler, Alexander Soldenhoff, Félix Vallotton.* 9–30 May. [Organized by Paul Signac]

1928

Paris, La Renaissance. *Portraits et figures de femmes: Ingres à Picasso.* 1–30 June. [Catalogue: preface by Albert Flament, essay by Arsène Alexandre]

1930

Paris, Galerie Druet. *Seven Contemporary Artists: Bonnard, Denis, Maillol, Roussel, Sérusier, Vallotton, Vuillard.*

Paris, Galerie Bernheim-Jeune. *La Femme: 1800–1930.*

1934

Paris, Galerie des Beaux-Arts. *Gauguin, ses amis, l'Ecole de Pont Aven et l'Académie Julian.*

1936

Paris, Bibliothèque Nationale. *Cinquantenaire du Symbolisme.*

1937

Paris, Petit Palais. *Les Maîtres de l'art indépendant, 1895–1937.*

1940

Lucerne, Kunstmuseum. *Die Hauptwerke der Sammlung Hahnloser.*

1943

Paris, Parvillée. *L'Ecole de Pont Aven et les Nabis, 1888–1908.*

1945–46

Paris, Musée national d'Art moderne. *Maurice Denis, ses maîtres, ses amis, ses élèves.*

1946

Milan, Casa d'artisti. *Mostra di bianco e nero.*

La Chaux-de-Fonds, Musée de La Chaux-de-Fonds. *Bonnard, Vuillard, Cottet, Roussel, Vallotton.*

1949

Vienna, Palazzo Lobkewitz. *Französische Meister um 1900.*

Paris, Musée de l'Orangerie. *Eugène Carrière et le Symbolisme.*

Winterthur, Kunstmuseum. *Winterthurer Privatbesitz II: Werke des 20. Jahrhundert.*

1951

Bern, Kunsthalle. *Die Maler der Revue blanche. Toulouse-Lautrec und die Nabis.* 21 March–22 April.

Albi, Musée Toulouse-Lautrec. *Lautrec et ses amis.*

1952

Paris, Galerie Bernheim-Jeune. *Peintres de portraits.*

1955

Paris, Musée national d'Art moderne. *Bonnard, Vuillard, et les Nabis.* 18 June–2 October.

1956

Zofingen, Staadtsaal. *Meisterwerke der Schweizer Kunst 1850–1950.*

1960

Paris, Galerie Guiot. *Bonnard et son époque, 1890–1910.*

1960–61

Paris, Musée national d'Art moderne. *Les Sources du XXe siècle, Les Arts en Europe de 1884 à 1914.*

1962

Minneapolis, Institute of Art. *The Nabis and their circle.*

1963–64

Mannheim, Kunsthalle. *Die Nabis und ihre Freunde.* 23 October–6 January.

1964

Munich, Haus der Kunst. *Secession: Europäische Kunst um die Jahrhundertwende.* 14 March–10 May. [Catalogue: see Bibliography, under "General"]

Turin, Galleria Civica d'Arte Moderna. *80 Pittori da Renoir a Kisling.* Traveled to Tel Aviv.

Rome, Galleria del Levante. Exhibition of Vallotton and Bernard.

Turin, Galleria del Narciso. *E. Bernard–F. Vallotton.*

1965

Vevey, Musée des Beaux-Arts. *De Vallotton à Desnos.* 24 July–3 October.

New Haven, Yale University Art Gallery. *Neo-Impressionists and Nabis in the Collection of Arthur G. Altschul.* 20 January–14 March.

1965–66

Milan, Rome, Munich, Galleria del Levante. *Pont Aven e i Nabis.*

1967–68

St. Gallen, Kunstmuseum. *Fünf Waadtländer Künstler.* 7 October–19 November; traveled to Berlin.

1968

Winterthur, Kunstmuseum. *Da Toepffer a Hodler, il disegno svizzero nell'Ottocento.* Traveled to Coira, Kunsthaus; Lucerne, Kunstmuseum; Basel, Kunstmuseum; Lugano, Museo di Belle Arti; Lausanne, Musée cantonal des Beaux-Arts; Bern, Kunstmuseum.

Paris, Grand Palais. *79e Exposition, Société des Artistes Indépendants, Rétrospective 1905–1909.*

1969

Bremen, Kunsthalle. *Von Delacroix bis Maillol: Handzeichnungen französischer Meister des 19. Jahrhundert.* 9 March–13 April. [Catalogue: see Bibliography, under "General"]

Geneva, Galerie Krugier. *Les Nabis.*

1970

Chicago, Kovler Gallery. *The Graphic Art of Vallotton & The Nabis.* May–July; traveled to Iowa City, Museum of the University of Iowa. [Catalogue: forward by Maxime Vallotton]

1971–72

Munich, Staatliche Graphische Sammlung. *Schweizer Zeichnungen im 20. Jahrhundert.* Traveled to Winterthur, Kunstmuseum; Bern, Kunstmuseum; Geneva, Musée d'Art et d'Histoire.

1973

Lausanne, Galerie Paul Vallotton. *Exposition jubilaire du 60e anniversaire de la fondation de la Galerie Paul Vallotton.* 5 July–8 September.

Winterthur, Kunstmuseum. *Künstlerfreunde um Arthur und Hedy Hahnloser-Bühler: Französische und Schweizer Kunst, 1890 bis 1940.* 23 September–11 November. [Catalogue: essays by Rudolf Koella, Margrit Hahnloser-Ingold, Hans R. Hahnloser, and Robert Steiner-Jäggli]

1974

Milan, Palazzo Reale. *Boccioni e il suo tempo.*

1975–76

Rotterdam, Museum Boymans van Beuningen. *Le Symbolisme en Europe.* Traveled to Brussels, Musées Royaux des Beaux-Arts; Baden-Baden, Staatliche Kunsthalle; Paris, Grand Palais.

1977

New York, The Museum of Modern Art. *Ambroise Vollard, Editeur, prints, books, bronzes.*

Paris, Musée du Louvre, Cabinet des dessins. *De Burne-Jones à Bonnard, dessins provenant du Musée National d'Art Moderne.*

Troyes, Hôtel de Ville. *Donation Pierre Lévy, 2e Exposition.*

1978–79

New Brunswick, Rutgers University Art Gallery. *The Color Revolution 1890–1900.* Traveled to Baltimore, The Baltimore Museum of Art; Boston, The Boston Public Library.

1979

Winterthur, Kunstmuseum. *Neue Sachlichkeit und Surrealismus in der Schweiz, 1915–1940.* 17 September–11 November. [Catalogue: see Bibliography, under "General"]

Lawrence, The University of Kansas, Spencer Museum of Art. *Ritual and reality: prints of the Nabis.*

1979–80

Washington, National Gallery of Art. *Post-Impressionism: Cross-Currents in European and American Painting 1880–1906.* Traveled to London, Royal Academy. [Catalogue: see Bibliography, under "General"]

1980–81

Paris, Centre Georges Pompidou. *Les Réalismes 1919–1939.* 17 December–20 April; traveled to Berlin, Staatliche Kunsthalle. [Catalogue: see Bibliography, under "General"]

1983

New York, Wildenstein. *La Revue blanche: Paris in the Days of Post-Impressionism and Symbolism.* 17 November–December. [Catalogue: essay by Georges Bernier]

1983–84

Ann Arbor, The University of Michigan Museum of Art. *The Artistic Revival of the Woodcut in France 1850–1900.* 4 November–8 January; traveled to New Haven, Yale University Art Gallery; The Baltimore Museum of Art. [Catalogue: essays by Jacquelynn Baas and Richard S. Field]

1984

Rochester, Memorial Art Gallery of the University of Rochester. *Artists of La Revue blanche: Bonnard, Toulouse-Lautrec, Vallotton, Vuillard.* 22 January–15 April. [Catalogue: essays by Bret Walker and Grace Seiberling]

Rome, Villa Medici. *Debussy e il simbolismo.*
April–June. [Catalogue: preface by Jean
Leymarie; introduction by François Lesure]

1985–86
New Brunswick, The Jane Voorhees Zimmerli
Art Museum, Rutgers, The State University of
New Jersey. *The Circle of Toulouse-Lautrec: An
Exhibition of the Work of the Artist and of His
Close Associates.* 17 November–2 February.
[Catalogue: see Bibliography, under "General"]

1986
Smithsonian Institution. *Art Nouveau Bing.*
Organized by the Smithsonian Institution
Traveling Exhibition Service. [Catalogue: text by
Gabriel Weisberg]

1987–88
New York, The Jewish Museum. *The Dreyfus
Affair: Art, Truth & Justice.* 13 September–15
January. [Catalogue: see Bibliography, under
"General," Cate]

1988
Atlanta, High Museum of Art. *From Liotard to Le
Corbusier: 200 Years of Swiss Painting, 1730–
1930.* 9 February–10 April. [Catalogue: preface
by Hans A. Lüthy and Gudmund Vigtel]

Paris, Galeries nationales du Grand Palais. *Le
Japonisme.* 17 May–15 August; traveled to
Tokyo, National Museum of Western Art.
[Catalogue: essay by G. L.]

New Brunswick, The Jane Voorhees Zimmerli
Art Museum, Rutgers, The State University of
New Jersey. *The Nabis and the Parisian Avant-
Garde.* [Catalogue: see Bibliography, under
"General"]

1988–89
Basel, Gewerbe Museum. *Exotische Welten,
Europäische Phantasien.* November–February.
[Catalogue]

1991
Winterthur, Kunstmuseum. *Das Gloriose
Jahrzehnt: Französische Kunst 1910–1920 aus
Winterthur Besitz.* 22 January–1 April.
[Catalogue: essays by Rudolf Koella, Lukas
Gloor, Margit Weinberg Staber]

316. Galerie Bernheim-Jeune, ca. 1910, Bernheim-Jeune Archives

317. Catalogue cover, *Exposition Vallotton et Vuillard*, Galerie
Bernheim-Jeune, Paris, 1903

Selected Unpublished Correspondence

Vallotton–Grave Correspondence, 1899–1905
Institut français d'histoire sociale, Paris

1.
[Letter from Félix Vallotton to Jean Grave, publisher of *Les Temps nouveaux*, summer 1899; written on letter paper]

Château d'Etretat
Etretat

Cher Monsieur
Je viens de recevoir ici votre lettre, et ne demande pas mieux que d'y satisfaire.
Il faudrait que vous me fassiez tenir les dimensions de votre album, et son objet que je m'y conforme autant que possible.
Je serais heureux également d'avoir les divers ouvrages de Kropotkine que les temps nouveaux ont publiés, j'en ai vu la liste au verso des couvertures échantillons.
Dites-moi également dans quel délai devrait être fait le dessin, et croyez je vous prie à mes meilleurs sentiments

fVallotton

Dear Sir
I have just received your letter, and would be delighted to comply with it.
I will need you to send me the measurements of your album, and its subject so that I can conform to it as much as possible.
I would also like to receive the various works by Kropotkine which the *Temps nouveaux* has published, I have seen the list on the back of the sample covers.
Let me know also by what deadline the drawing should be ready, and pray believe in my best feelings

2.
[Letter from Félix Vallotton to Jean Grave, summer 1899; written on letter paper]

Château d'Etretat
Etretat

Cher Monsieur
Merci de votre lettre et des lithographies. Sitôt qu'il me poussera une idée je ferai le dessin et vous l'enverrai.
—J'habite maintenant 6 rue de Milan et je suis étonné que le journal ne m'y ait pas suivi.
—Je rentrerai à Paris à la fin du mois, et d'ici là suis à l'adresse ci-dessus.
—J'espère donc bientôt pouvoir vous envoyer mon dessin, et vous prie de croire à mes meilleurs sentiments.

fVallotton

Dear Sir,
Thank you for your letter and for the lithographs. As soon as an idea moves me I will do the drawing and send it to you.
—I am now living at *6 rue de Milan*, and I am surprised that the journal did not follow me there.
—I will be back in Paris at the end of the month, and until then I will be staying at the above address.
—I hope that I will soon be able to send you the drawing, and I am asking you to believe in my best feelings

3.
[Letter from Félix Vallotton to Jean Grave, September 1899; written on letter paper]

Monsieur Jean Grave
les Temps Nouveaux
140 rue Mouffetard
Paris

Cher Monsieur, Je vous envoie ce jour un dessin pour votre série; vous pourrez soit le faire graver comme vous m'en aviez parlé soit le reproduire directement; mais le graver serait mieux, et plus artistique
—Merci pour vos brochures, je suis en train de les lire, et je place après lecture, le journal au casino, où il est lu.—Une institutrice de mes amies souhaiterait en recevoir je lui ai dit de s'adresser à vous pour cela.
Croyez cher Monsieur, à mes bons sentiments

fVallotton
Etretat. Château d'Etretat.

Dear Sir, I am sending you today a drawing for your series; you could either have it engraved as you had mentioned or reproduce it as it is; but it would be better, and more artistic, to engrave it
—Thank you for your pamphlets, I am reading them, and after I have read the journal, I put it at the casino, where it is being read.—One of my friends, a schoolmistress, would like to receive some I have told her to get in touch with you about this.
Pray believe, dear Sir, in my good feelings

4.

[Letter from Félix Vallotton to Jean Grave, ca. 1890; written on letter paper]

Mon cher Grave
Je vous remercie de votre rouleau. Il me semble que le graveur n'a pas lieu d'être mécontent, je n'ai plus mon dessin très présent à l'esprit, mais tel que reproduit il me paraît bien et d'un bon effet. Vous pourrez lui dire toute ma satisfaction.
Croyez moi toujours bien vôtre

fVallotton

My dear Grave,
Thank you for your printer's roll. It seems to me that the engraver has no cause to feel dissatisfied, I can't quite bring my drawing to mind at this stage, but as it is reproduced it seems fine and of good effect to me. Please tell him that I am quite satisfied.
Pray believe that I am always yours

5.

[Postcard from Félix Vallotton to Jean Grave, postmarked 13 April 1905]

Impossible mon cher Collègue de me rendre à votre rendez-vous vendredi.—Décidez donc sans moi, mais je vous serais [sic] gré de ne pas trop faire fond sur ma collaboration, au moins actuelle, je suis très pris, et me dispose a quitter la France pour environ 6 mois, conditions peu propices à un travail effectif. Cordialement avec vous quand même

fVallotton

Impossible my dear Colleague to come to your appointment on Friday.—Make decisions without me, but I would be grateful if you didn't depend too much on my collaboration, at least for the time being, I am very busy, and am preparing to leave France for about 6 months, hardly favorable conditions for effective work.
Cordially with you in spite of this

6.

[Letter from Félix Vallotton to Jean Grave, ca. 1905; written on letter paper]

Monsieur J. Grave
4 rue Broca
Paris

Cher Monsieur
Il y a des temps infinis que je ne fais plus de dessins, pour personne. Je serais bien embarassé [sic] de m'y remettre.
Pardonnez moi donc de ne pouvoir vous satisfaire et croyez je vous prie à mes sentiments les meilleurs.

fVallotton

Dear Sir
I haven't done any drawings, for anyone, in ages. I would be hard put to start again.
Forgive me then for being unable to satisfy you and pray believe in my best feelings.

Vallotton–Stein Correspondence, 1907–1909

Gertrude Stein Archive, Yale Collection of American Literature, Beinecke Rare Book and Manuscript Library, Yale University

1.

[Letter from Félix Vallotton to Leo Stein, spring/early summer 1907; written on stationery: 59, Rue des Belles-Feuilles. XVIe]

Mon cher ami.
Que Devenez-vous, car voici bientôt deux mois que nous n'avons de vos nouvelles.—Je vous écris à Fiesole car je pense bien que vous y êtes encore et à ce propos vous annonce que j'exposerais volontiers au salon d'Automne le portrait de votre soeur. Je suppose qu'il est encadré:—Il est possible que je m'absente à nouveau pour tout le mois d'Août et peut-être un peu de Septembre, par conséquent il faut s'en occuper à l'avance.
Pourriez-vous donc aviser votre concierge de tenir ce portrait à la disposition de mon encadreur: je le ferais prendre en son temps; (les envois sont le 6.7.8.9.10 Septembre) et transporter directement au palais. Rien ne presse encore vous le voyez et nous avons du temps.—Un mot n'est ce pas que je sache. Je ne sais trop ce que je mettrais autour, j'ai si peu travaillé! en tout cas ce sera le plat de résistance, je tâcherai de déniché[r][sic] deux ou trois bribes pour l'accompagner.
Faites je vous prie nos bons compliments à tous les vôtres et croyez-moi bien tout dévoué.

fVallotton

My dear friend
What has become of you as it is almost two months that we have had no news from you. I am writing to you in Fiesole since I think you are still there and in this connection I want to tell you that I would gladly exhibit the portrait of your sister at the Salon d'Automne. I suppose it is framed. It is possible that I will be away the entire month of August and possibly a bit of September, consequently this must be taken care of in advance.
Could you therefore advise your doorman to make this portrait available to my framer, I would have someone pick it up in due course; (the shipments are the 6,7,8,9,10 of September) and bring it directly to the Palais [Grand Palais]. There is no hurry as you see we have plenty of time. Just send the word so I know.
I am not sure what I would put around it, I have worked so little! and in any case this will be the pièce de résistance, I will try to unearth two or three scraps to accompany it.
Please send my best regards to all of yours and consider me devoted.

2.

[Postcard from Gabrielle Vallotton to Gertrude Stein, postmarked 2/5/07 from Rome (2 May 1907); postcard: Roma—Piazza dei Cinquecento Staz. Fer. Monumento per i caduti de Dogali]

Mademoiselle Stein
27 rue de Fleurus
Paris
France

76 via Sistina
Nous sommes bien installés à Rome d'où nous vous envoyons nos meilleurs souvenirs—

GVallotton

We are well settled in Rome from where we send you our fondest memories—

3.

[Letter from Félix Vallotton to Leo Stein, postmarked 2/12/07 from Paris (2 December 1907); written on blue stationery: 59, rue des Belles-Feuilles, XVIe]

Monsieur Leo D. Stein
27 rue de Fleurus
Paris

Mon cher ami
Voici longtemps que je voudrais vous voir et que sans cesse quelque imprévu m'empêche. J'irai demain soir mardi vous voir, mais si vous avez quelque empêchement un petit bleu m'avertirait à temps.
Je serais très heureux de passer une heure avec vous.
Bien vôtre

fVallotton

My dear friend
It has been a while that I have wanted to see you and that without fail something unexpected prevents me. Tomorrow, Tuesday evening, I will come and see you, but if this is inconvenient for you please send me a telegram to warn me in time.
I would be delighted to spend an hour with you.
Yours

4.

[Letter from Félix Vallotton to Leo Stein, postmarked 16/3/09 from Paris (16 March 1909); written on blue stationery]

Monsieur L. Stein
27 rue de Fleurus
Paris
59 rue Beles [sic] Feuilles

Cher ami
Voulez vous de nous ce soir mardi? . . . Nous sommes libres—Si oui pas de réponse, ce sera convenu.
Bien vôtre

fVallotton

Dear friend
Would you like to come over this evening, Tuesday?—If yes, do not answer, it will be agreed.
Yours

319. Claribel Cone, Gertrude Stein, and Etta Cone, Settignano/Fiesole, 26 June 1903

320. Letter from Félix Vallotton to Leo Stein, 2 December 1907, Gertrude Stein Archive, Beinecke Rare Book and Manuscript Library, Yale University

Works by Vallotton

Novels

Corbehaut. Lausanne: Editions Le Livre du Mois, 1970; manuscript dated 1920

Les Soupirs de Cyprien Morus. Geneva and Paris: Editions des Trois Collines, 1944; manuscript undated, ca. 1899–1900

La Vie meurtrière. Serialized in *Le Mercure de France* (15 January–15 March 1927); published with 7 drawings by the author and a preface by André Thérive, Editions des Lettres de Lausanne, 1930; 2nd edition, Geneva and Paris: Editions des Trois Collines, 1946; manuscript (*Le Meurtre*) undated, ca. 1907

Unpublished Plays

Une Femme de tête, 3 acts

La Part du feu, 3 acts

Le Sein de la famille, 3 acts

Célérité et Discrétion, 3 acts

Soliman tondeur, 1 act

Un Homme très fort, 1 act; produced at the Théâtre de Grand Guignol, 1 February 1904; manuscript lost

Un Rien, 1 act; produced at the Théâtre de l'Oeuvre, 18 May 1907; manuscript lost

Justice immanente, in collaboration with Xanrof; manuscript lost

Art Criticism, *Gazette de Lausanne*

"L'Exposition des Artistes indépendants à Paris" (11 April 1890).

"Une Exposition internationale" (29 January 1891).

"Meissonier" (6 February 1891).

"Les Femmes artistes" (28 February 1891).

"L'Exposition des Artistes indépendants" (25 March 1891).

"Chéret" (18 April 1891).

"Le Salon I" (16 May 1891).

"Le Salon II" (22 May 1891).

"Le Salon III" (25 May 1891).

"Au Champ-de-Mars" (4 June 1891).

"Les Envois de Rome" (3 November 1891).

"Le Salon de la Rose + Croix" (4 December 1891).

"Les Petits Salons" (8 February 1892).

"L'Exposition Pissarro" (7 March 1892).

"Le Salon de la Rose + Croix I" (18 March 1892).

"Le Salon de la Rose + Croix II" (22 March 1892).

"Les Petits Salons" (6 May 1892).

"Le Salon du Champ-de-Mars" (8 June 1892).

"Au Musée de Bâle I" (17 November 1892).

"Au Musée de Bâle II" (18 November 1892).

"Meissonier" (23 March 1893).

"Le Salon" (4 May 1893).

"Le Salon du Champ-de-Mars I" (25 May 1893).

"Le Salon du Champ-de-Mars II" (26 May 1893).

"Impressions de voyage, Rembrandt" (5 May 1894).

"Le Salon du Champ-de-Mars" (2 May 1895).

"Le Salon des Champs-Elysées" (16 May 1895).

"Exposition Holbein à Bâle" (30 October 1897).

Art Criticism, Other

"Sur la grande exposition Boecklin à Bâle." *La Revue blanche* 14 (15 November 1897): 280–81.

"Note d'Auteur (au Salon d'Automne)." *La Grande Revue* 44 (7 October 1907): 742–43.

"Au Salon d'Automne." *La Grande Revue* 44 (25 October 1907): 916–24.

"Artistes, critiques, amateurs et marchands." *Bibliothèque universelle et Revue suisse* (February 1917): 288–310.

"Art et Guerre." *Les Ecrits nouveaux* 1 (December 1917): 30–37.

"A propos de Hodler." In *La Suisse et les Français*, 242–54. Paris: Alexandre Castell, 1920.

Illustrated Books

1892

Droz, Henri Edouard. *10 août 1892. Centenaire de la défense des Tuileries par les Suisses* (poem). Neuchâtel: Attinger. [2 woodcuts: chapterhead and tailpiece]

1894

Morhardt, Matthias. *Le Livre de Marguerite*. Geneva: Eggimann. [2 woodcuts: decorative frames for poems]

1895

Adam, Paul. *L'Essai de Vivre*. Serialized novel, in *Revue franco-américaine* (July and August 1895). [12 drawings]

d'Axa, Zo. *De Mazas à Jérusalem*. Paris: Chamuel. Co-illustrators: Lucien Pissarro and Steinlen. [3 drawings: 2 frontispieces (parts 3 and 5) and a tailpiece]

_____. *Le Grand Trimard*. Brussels: Kistemaekers. Co-illustrators: Anquetin and Lucien Pissarro. [6 chapterheads]

1896

Bierbaum, Otto Julius. *Der Bunte Vogel von 1897 (ein Kalenderbuch)*. Berlin: Schuster and Loeffler. [Numerous drawings: portraits, chapterheads, tailpieces, vignettes, as well as covers]

_____. *Die Schlangendame*. Berlin: Schuster und Loeffler. [38 drawings: cover, chapterheads, tailpieces, and decorative borders]

Catalogue de l'Exposition internationale du livre moderne à l'Art nouveau. Paris: June 1896. [Designed by Vallotton, with vignettes, endpieces, and ornaments]

de Gourmont, Remy. *Le Livre des Masques*. Paris: Mercure de France. [30 portrait heads]

Badauderies parisiennes: Les Rassemblements, Physiologies de la rue, Paris. Ed with a prologue by Octave Uzanne, and 30 essays by 15 authors: Paul Adam, Alfred Athys, Victor Barrucaud, Tristan Bernard, Léon Blum, Romain Coolus, Félix Fénéon, Gustave Kahn, Ernest La Jeunesse, Lucien Muhlfeld, Thadée Natanson, Edmond Pilon, Jules Renard, Pierre Veber, and Eugène Veek. Paris: Henry Floury. [Cover and 30 "hors texte" drawings]

Renard, Jules. *Histoires naturelles*. Paris: Flammarion. [2 vignettes]

_____. *La Maîtresse*. Paris: H. Simonis Empis. [28 vignettes and cover]

Seignobos, D. *Comment on forme une cuisinière*. Paris: Hachette. [Numerous drawings]

1897

Bernard, Tristan. *Contes de Pantruche et d'ailleurs*. Paris: F. Juven. [52 vignettes]

1898

de Gourmont, Remy. *Le IIème Livre des Masques*. Paris: Mercure de France. [23 portrait heads]

Meier-Graefe, Julius. *Félix Vallotton*. Berlin: J.-A. Stargardt; Paris: Edmond Sagot. [Vignettes, decorative borders, and 5 woodcut portraits]

Renard, Jules. *Plaisir de rompre*. Paris: Ollendorff. [Cover and tailpiece]

1899

Hommage des artistes à Picquart. Album of 12 lithographs; preface by Octave Mirbeau. Paris: Société des gens de lettres. [1 lithograph]

1900

Scheerbart, Paul. *Rakkox der Billionaer*. Berlin: Schuster und Loeffler; Leipzig: Weihnachlen. Ornamentation by Jassot. [5 drawings]

1901

Athys, Alfred [Alfred Natanson]. *Grasse Matinée*. Paris: Editions de la Revue blanche. [Cover]

Documents sur l'Art industriel au XXe siècle. Paris: La Maison moderne. [9 drawings]

1902

Léonard. *L'élection du Maire de la commune par le nouveau conseil municipal*. Paris: "Temps nouveaux," no. 23. [Cover]

Renard, Jules. *Poil de Carotte*. Paris: Flammarion. [50 drawings and cover]

1904

Renard, Jules. *L'Ecornifleur*. Paris. [Drawings executed in 1894]

1915

Album national de la guerre. Published by the Comité de la "Fraternité des artistes." Paris: Bernheim-Jeune, Editeur. [1 drawing: "Renouveau"]

1924

Flaubert, Gustave. *Oeuvres complètes* 14. Paris: Librairie de France. [3 illustrations for "Un Coeur simple"]

Hervieu, Louise. *L'Ame du cirque*. Paris. [1 drawing by Vallotton; additional drawings by Bonnard, Cocteau, Denis, Dunoyer de Segonzac, Gernez, Laprade, Lhote, Picasso, et al.]

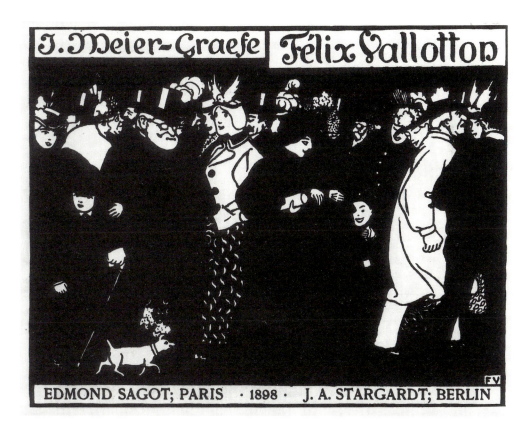

321. Frontispiece for Meier-Graefe's monograph on Vallotton, 1898

Bibliography

Monographic

A. K. "Félix Vallotton Inconnu." *Gazette de Lausanne* (12/13 October 1963): 19.

Apollinaire, Guillaume. "Les 'Pompiers'—Félix Vallotton." *L'Intransigeant* (27 January 1912).

_____. "Les Pompiers, Vallotton et le douanier Rousseau." *Le Petit bleu* (3 February 1912).

Auberjonois, René. "Vallotton—Hommages et opinions." *Aujourd'hui* (Lausanne), no. 11 (13 February 1930): 1.

_____. "Un grand artiste vaudois." *Gazette de Lausanne* (30/31 December 1950): 7–8.

_____. "Félix Vallotton et son salon." *Gazette de Lausanne* (27/28 June 1953): 5.

Barilli, Renato. "Ai Margini della Surrealtà: Vallotton e Maillol." *L'Arte Moderna* 2 (1967): 161–200.

Berger, René. "Félix Vallotton: ou le discours de la méthode pour bien conduire sa pensée et son pinceau." *Pour l'art* (March–April 1953): 9–11.

_____. "Félix Vallotton 1865–1925." *Du* 14 (March 1954): 16–29.

Bianconi, Piero. "Félix Vallotton." *I Maestri del Colore*, no. 126. Milan: Fratelli Febbri, 1966.

Bouret, Jean. "Félix Vallotton ou le climat suisse en France." *Les Arts* (15 April 1949).

_____. "Le civilisé Vallotton." *Les Nouvelles Littéraires*, no. 2682 (12–19 April 1979): 14.

Bouyer, Raymond. "L'Estampe murale." *Art et décoration* 4 (July–December 1898): 185–91.

Bremen, Kunsthalle. *Félix Vallotton: Das druckgraphische Werk*. Essays by Jürgen Schultze, Annette Meyer zu Eissen, and Annemarie Winther. Exh. cat., 1981. [Same catalogue also published for Neue Galerie, Kassel]

Brinton, Christian. "Félix Vallotton." *The Critic* (April 1903): 324–41.

Brodskaïa, Natalia Valentinova. *Félix Vallotton et la Russie*. Trans. Antoine Baudin. Preface by Marina Ducrey. Lausanne: Galerie Paul Vallotton, 1987.

Budry, Paul. "Félix Vallotton ou le retour de l'impassible." *Les Cahiers Vaudois* 2 (20 April 1914): 48–57.

_____. "Félix Vallotton." *Pages d'art* (April 1917): 143–86.

_____. "Inquiétude de Félix Vallotton." *Aujourd'hui* (Lausanne), no. 11 (13 February 1930): 2–3.

_____. "Félix Vallotton." *Chroniques du Jour* (4 May 1930): 13–15.

Le Bulletin de la vie artistique (1 January 1921): 2:47; 3:71; 12:584; 23:603, 607.

Busch, Günter, Bernard Dorival, and Doris Jakubec. *Félix Vallotton, Leben und Werk*. Frauenfeld: Verlag Huber, 1982.

Busch, Günter, Bernard Dorival, Patrick Grainville, and Doris Jakubec. *Vallotton*. Lausanne: La Bibliothèque des Arts, 1985.

du Colombier, Pierre. "Félix Vallotton." *Art et décoration* (March 1926): 65–74.

Ducrey, Marina. *Félix Vallotton: La Vie, la technique, l'oeuvre peint*. Lausanne: Edita, 1989.

Ducrey, Marina, and the Vallotton Family. *Félix Vallotton. Catalogue raisonné de l'oeuvre peint*. Forthcoming.

Fegdal, Charles. *Félix Vallotton*. Paris: Les Editions Rieder, 1931.

_____. "Félix Vallotton." *L'Amour de l'art* (April 1933): 94–96.

"Félix Vallotton." *Dekorative Kunst* 6 (1900): 290–94.

"Félix Vallotton et l'Institut Carnegie." *Le Bulletin de la vie artistique*, no. 3 (1 January 1920): 460–62.

Friedrich, Anton, ed. *Félix Vallotton*. Introduction and appendix by Rudolf Koella. Zurich: Diogenes Verlag AG, 1979.

Gernez, J. "Paysages de Vallotton." *Les Ecrits Nouveaux* 3 (1920): 68–72.

Glynn, Eugene. "The Violence within: The Woodcuts of Félix Vallotton." *Art News* 74 (March 1975): 36–39.

Godefroy, Louis. *L'Oeuvre gravé de Félix Vallotton*. Paris: Chez l'Auteur; Lausanne: Chez Paul Vallotton, 1932.

Günther, Werner. "Internationales Kolloquium Félix Vallotton." *Neue Zürcher Zeitung* (25 May 1965): 1.

Guiffré, Guido. "A Note on Vallotton's Woodcuts." *Print Collector* 50 (1981): 10–21.

Guisan, Gilbert, and Doris Jakubec, eds. "Félix Vallotton, Edouard Vuillard et leurs amis de La Revue blanche." *Etudes de lettres* (Lausanne), 3d ser., vol. 8 (October–December 1975).

_____, eds. *Félix Vallotton: Documents pour une biographie et pour l'histoire d'une oeuvre*, 3 vols. (1, 1884–1899; 2, 1900–1914; 3, 1914–1921). Paris-Lausanne: La Bibliothèque des Arts, 1973–75.

Hahnloser, Hans R. "Félix Vallotton: 'Les cinq peintres.'" *Hauptwerke des Kunstmuseums Winterthur* (1949): 121–37.

Hahnloser, Hedy. "Félix Vallotton: I. Der Graphiker." *Neujahrsblatt der Zürcher Kunstgesellschaft* (1927): 3–23.

_____. "Félix Vallotton: II. Der Maler." *Neujahrsblatt der Zürcher Kunstgesellschaft* (1928): 3–41.

_____. "Um Félix Vallotton." *Werk* (Zurich) 18 (October 1931): 311–15.

Hahnloser-Bühler, Hedy. *Félix Vallotton et ses amis.* Paris: Editions A. Sedrowski, 1936. [Includes Vallotton's *Livre de raison*]

Henne, Nicolas. "Félix Vallotton." *L'Oeil,* no. 232 (November 1974): 12–17.

Hervieu, Louise. "Vallotton." *Aujourd'hui,* no. 11 (13 February 1930): 4.

Heyligers, J. C. "Het Portret van Ambroise Vollard Door Félix Vallotton." *Bulletin Museum Boymans Rotterdam* 5 (November 1954): 70–74.

Holst, Lise Marie. "Félix Vallotton's *Intimités*: Le Cauchemar d'un Erudit." Master's thesis, Oberlin College, 1980.

_____. "Félix Vallotton's *Intimités*: Le Cauchemar d'un Erudit" [Master's thesis abstract]. *Allen Memorial Art Museum Bulletin* 37, no. 2 (1979–80): 96–98.

Huber, Meinrad. "Félix Vallotton: Le Bain au Soir d'été," Ph.D. diss., Universität Zürich, 1977–78.

Jakubec, Doris. "Vallotton à Honfleur." *L'Oeil,* no. 299 (June 1980): 42–49.

_____. "Félix Vallotton ou 'Le goût des synthèses.'" *L'Oeil,* no. 338 (September 1983): 88–89.

Jaloux, Edmond. "Félix Vallotton." *Formes et couleurs* (1940): 66–100.

Jedlicka, Gotthard. "Félix Vallotton." *Neue Schweizer Rundschau* (August 1937): 220–40.

Jourdain, Francis. *Félix Vallotton.* Geneva: Editions Pierre Cailler, 1953.

Karasek, Jiri. "Félix Vallotton." *Moderni Revue* (Prague) (1 August 1898): 130–35.

Killer, Peter. "Die Abende sind schön—Félix Vallotton in Honfleur." *Du* 46 (November 1986): 56–71.

Koella, Rudolf. "Das Bild der Landschaft im Schaffen von Félix Vallotton: Wesen, Bedeutung, Entwicklung." Ph.D. diss., Universität Zürich, 1969.

_____. *Félix Vallotton im Kunsthaus Zürich.* Zurich: Kunsthaus Zürich, 1969.

_____. "Le Retour au paysage historique. Zur Entstehung und Bedeutung von Félix Vallottons später Landschaftsmalerei." *Jahrbuch des Schweizerischen Instituts für Kunstwissenschaft, 1968–69* (Zurich) (1970): 33–52.

LaFarge, Henry A. "Félix the Nabi." *Art News* 69 (April 1970): 48–49.

Laprade, Jacques de. "Vallotton, ou la passion de l'impassible. Avec quelques lettres inédites de Vallotton." *Beaux arts* 73 (1931).

Leblond, Marius-Ary. "Painting, Sculpture and Decorative Art." *Apollon* 3, no. 6 (1910): 71–92.

"Le cas Vallotton et Henri Matisse." *Le Bulletin de la vie artistique,* no. 3 (1 January 1920): 511–12.

Martini, Alberto. "Félix Vallotton: Classicist manqué." Trans. Anthony Rhodes. *Apollo* 78 (November 1963): 416–17.

Meier-Graefe, Julius. *Félix Vallotton: Biographie de cet artiste avec la partie la plus importante de son oeuvre editée et différentes gravures originales & nouvelles.* Berlin: J.-A. Stargardt; Paris: Sagot, 1898.

Mesola, Castello Estense. *Félix Vallotton: Opere dal Museo di Losanna.* Essays by Matteo Bianchi, Vittorio Sgarbi, and Bernard Wyder. Exh. cat., 1988. [Same catalogue also published for Palazzo della Permanente, Milan]

Monnier, Jacques. *Félix Vallotton.* Lausanne: Editions Rencontre, 1970.

Morhardt, M. "Les Artistes vaudois à Paris: M. Félix Vallotton." *Gazette de Lausanne* (24 March 1893).

Natanson, Thadée. "Le très singulier Vallotton." In *Peints à leur tour,* 304–11. Paris: Albin Michel, 1948.

Neff, John H. "Félix Vallotton: A Forgotten Master Painter." *Bulletin of the Detroit Institute of Art* 54, no. 4 (1976): 165–73.

Nicollier, Jean. "L'écrivain." *Gazette de Lausanne* (30/31 December 1950): 7.

Paris, Musée du Petit Palais. *Félix Vallotton: 1865–1925.* Preface by Luc Boissonnas; essays by Maurice Besset, Margrit Hahnloser-Ingold, Doris Jakubec, and Rudolf Koella. Exh. cat., 1979. [See also Winterthur, Kunstmuseum. *Félix Vallotton: Bilder, Zeichnungen, Graphik*]

Paris, Musée national d'Art moderne. *Vallotton.* Preface by Bernard Dorival. Exh. cat., 1966.

Pica, Vittorio. "I Moderni incisori su legno: Félix Vallotton." *Emporium* (Bergamo) 21 (1905): 310–18.

Puy, Michel. "Vallotton." *Le Carnet des Artistes,* no. 7 (1 May 1917): 3–6.

Reymond, Mouse. "Félix Vallotton: Quelques réflexions sur le peintre et l'écrivain." *Lettres romandes,* 175–91. Lausanne: Editions de l'Aire, 1981.

Roger-Marx, Claude. "Le Nu et la mer." *Le Jardin des Arts* 2 (September 1955): 658–64.

Russoli, Franco. "Vallotton." *Letteratura,* no. 66 (November–December 1963): 59–65.

Sailer, Anton. "Meister der Graphik: Félix Vallotton." *Die Kunst* 9 (September 1970): 553–60.

St. James, Ashley. *Vallotton: Graphics.* London: Ash & Grant Ltd., 1978.

_____. "The Vallotton Portrait of Poe." *The Poe Messenger* 8 (Spring 1978): 1–4.

_____. *Vallotton graveur.* Paris: Editions du Chêne, 1979.

_____, ed. *Vallotton: Dessinateur de Presse.* Paris: Editions du Chêne, 1979.

_____. "Félix Vallotton: The Nabi Years." Ph.D. diss., Courtauld Institute, London, 1982.

Salmon, André. "Survivre." *L'Art Vivant* 2 (January 1926): 59–60.

Schopfer, Jean. "The Woodcuts of Félix Vallotton." *The Book Buyer* 20 (May 1900): 279, 292–97.

Shchekatikhin, N. N. *Félix Vallotton.* Preface by A. A. Sidorov. Moscow: St. Petersburg, 1918.

Sutton, Denys. "The Revue blanche." *Signature: A Quadrimestrial of Typography and Graphic Arts,* no. 18 (1954): 23–43.

T. "Félix Vallotton." *Le Bulletin de la vie artistique* (1 February 1926): 38–39.

Teall, Gardner C. "The Unusual Woodcuts of M. Félix Vallotton." *The Craftsman* 12, ed. Gustave Stickley, New York (May 1907): 160–64.

Thérive, André. "Félix Vallotton." *L'Amour de l'art* (1921): 169–72.

Tobler, Konrad. "Ein neues Modell: Zu Félix Vallottons Krieglandschaften." *Kulturmagazin* (September 1984): 42–49.

Uzanne, Octave. "La Renaissance de la gravure sur bois: un néo-xylographe, M. Félix Vallotton." *L'Art et l'idée* (20 February 1892): 113–19.

"Vallotton." *Mir Iskousstva* 2 (1904): 223–26.

Vallotton, Félix. "Félix Vallotton." *Apollon* 4 (1910): 37–46. [9 woodcuts, no text]

Vallotton, Maxime. "Félix Vallotton vu par son neveu." *Annali* 3 (March–August 1954): 26–27, 84, 96–98.

Vallotton, Maxime, and Charles Goerg. *Félix Vallotton: Catalogue raisonné de l'oeuvre gravé et lithographié.* Geneva: Editions de Bonvent, 1972.

Vauxcelles, Louis. "Félix Vallotton." *Le figaro artistique* (February 1926): 259–61.

Weisberg, Gabriel P. "Félix Vallotton, Siegfried Bing, and l'Art Nouveau." *Arts Magazine* 60 (February 1986): 33–37.

Wilhelm, Jacques. "Deux vues de Paris par Jongkind et Vallotton." *Bulletin du Musée Carnavalet,* no. 2 (October 1966): 14–17.

Winterthur, Kunstmuseum. *Félix Vallotton: Bilder, Zeichnungen, Graphik.* Essays by Maurice Besset, Margrit Hahnloser-Ingold, Doris Jakubec, and Rudolf Koella. Exh. cat., 1978. [See also Paris, Musée du Petit Palais. *Félix Vallotton: 1865–1925*]

Wyder, Bernard, ed. *Félix Vallotton: Portraits de contemporains célèbres.* Lausanne: L'Imprimerie Bron S.A., 1983.

Zevaco, Michel. "Félix Vallotton." *Le Courrier français* (March 1894): 8–9.

Zurich, Kunsthaus. *Félix Vallotton. 1865–1925.* Introduction by Wilhelm Wartmann; essay by C. Montag. Exh. cat., 1938. [Includes Vallotton's *Livre de raison*]

_____. *Félix Vallotton.* Essays by René Auberjonois, Edouard Hüttinger, A. Dunoyer de Segonzac, and R. Wehrli. Exh. cat., 1965.

General

Achilles, Rolf. "The Chap-Book and Posters of Stone & Kimball at the Newberry Library." *The Journal of Decorative and Propaganda Arts*, no. 14 (Fall 1989): 64–77.

Basler, Adolphe, and Charles Kunstler. *Le dessin et la gravure modernes en France*. Paris: Les Editions G. Crès & Cie., 1930.

Bernheim-Jeune, Josse, ed. *L'art moderne et quelques aspects de l'art d'autrefois* 2. Paris: Bernheim-Jeune, Editeur, 1919.

Bierbaum, Julius Otto. "Modernen Holzschnitte." *Ver Sacrum* 1 (October 1898): unpaginated.

Bloch, Camille, and René Jean. "Le musée de la grande guerre et l'art contemporain." *Bulletin des musées de France* 4 (March 1932): 43–46.

Cate, Phillip Dennis. "The Paris Cry: Graphic Artists and the Dreyfus Affair." In *The Dreyfus Affair: Art, Truth & Justice*. Ed. Norman L. Kleeblatt. Berkeley: University of California Press in cooperation with the Jewish Museum, 1987.

―――. "Japonisme and the Revival of Printmaking at the End of the Century." In *Japonisme in Art: An International Symposium*. Tokyo: Committee for the Year 2001, 1980.

Chassé, Charles. *The Nabis & their Period*. Trans. Michael Bullock. New York: Frederick A. Praeger, 1969.

Coquiot, Gustave. *Cubistes, Futuristes, Passéistes: Essai sur la Jeune Peinture et la Jeune Sculpture*. Paris: Librairie Ollendorff, 1914.

Courthion, Pierre. "La Collection Arthur Hahnloser." *L'Amour de l'art*, no. 2 (1926): 62–69.

―――. *L'Art Indépendant: Panorama International de 1900 à nos jours*. Paris: Editions Albin Michel, 1958.

Denney, Colleen. "English Book Designers and the Role of the Modern Book at l'Art Nouveau; Part Two: Relations Between England and the Continent." *Arts Magazine* 61 (Summer 1987): 49–57.

Dorival, Bernard. *Les peintres du vingtième siècle: Nabis—Fauves—Cubistes*. Paris: P. Tirné, 1957.

Ducrey, Marina, and Guy Ducrey. *La Galerie Paul Vallotton Depuis 1913. . .* Lausanne: Edition Galerie Vallotton, 1988.

Faure, Elie. "Pour remercier Bonnard, Vuilard [sic], Valloton [sic], Roussel, d'avoir refusé la croix." *Les Cahiers d'aujourd'hui* 2 (December 1912): 78–81.

Fels, Florent. *L'Art vivant de 1900 à nos jours*. Geneva: Pierre Cailler, 1950.

Gauthier, E. Paul. "Lithographs of the 'Revue blanche' 1893–95." *Magazine of Art* 45 (October 1952): 273–78.

Gil, René. "Contemporary Directions of Literature, Art and Philosophy in France." *Apollon* 3, no. 6 (1910): 19.

Gordon, Donald E. *Modern Art Exhibitions 1900–1916*. 2 vols. Munich: Prestel-Verlag, 1974.

Guichard, Léon. *L'Interprétation graphique, cinématographique, et musicale des Oeuvres de Jules Renard*. Paris: A. Nizet & M. Bastard, 1936.

Halperin, Joan Ungersma. *Félix Fénéon: Aesthete and Anarchist in Fin de Siècle Paris*. New Haven: Yale University Press, 1988.

Heller, Steven, and Ralph E. Shikes. "The Art of Satire: Painters as Caricaturists and Cartoonists from Delacroix to Picasso." *Print Review* 19 (1984).

Hermann, Fritz. *Die Revue blanche und die Nabis*. 2 vols. Munich: Mikrokopie G.m.b.H., 1959.

Jackson, A. B. *La Revue blanche (1889–1903): Origine, influence, bibliographie*. Paris: Lettres Modernes, 1960.

Levin, Gail. "The Office Image in the Visual Arts." *Arts Magazine* 59 (September 1984): 98–103.

Mahé, Raymond. *Les artistes illustrateurs: répertoire des éditions de luxe de 1900 à 1928 inclus*. Paris: René Kieffer, 1943.

Mauner, George L. *The Nabis: their History and their Art, 1888–1896*. New York: Garland, 1978.

Munich, Haus der Kunst. *Secession: Europäische Kunst um die Jahrhundertwende*. Text by Siegfried Wichmann. Exh. cat., 1964.

New Brunswick, The Jane Voorhees Zimmerli Art Museum, Rutgers, The State University of New Jersey. *The Circle of Toulouse-Lautrec: An Exhibition of the Work of the Artist and of His Close Associates*. Text by Phillip Dennis Cate and Patricia Eckert Boyer. Exh. cat., 1985.

―――. *The Nabis and the Parisian Avant-Garde*. Essays by Patricia Eckert Boyer and Elizabeth Prelinger. Exh. cat., 1988.

Pellegrini, Giorgio. "Edward Hopper tra Realismo e Metafisica." *Bolletino d'Arte* 14 (April–June 1982): 145–58.

Perucchi-Petri, Ursula. *Die Nabis und Japan: Das Frühwerk von Bonnard, Vuillard und Denis*. Munich: Prestel-Verlag, 1976.

Pouterman, J. E. "Les livres d'Ambroise Vollard." *Art et métiers graphiques*, no. 64 (15 September 1938): 45–46.

Rome, Villa Medici. *Debussy e il Simbolismo*. Preface by Jean Leymarie; introduction by François Lesure. Exh. cat., 1984.

Salmon, André. *L'Art Vivant*. Paris: Editions G. Crès et Cie., 1920.

Sprinchorn, Evert. "The Transition from Naturalism to Symbolism in the Theater from 1880 to 1900." *Art Journal* 45 (Summer 1985): 113–19.

Stein, Gertrude. *The Autobiography of Alice B. Toklas*. New York: Harcourt, Brace and Company, 1933.

Tuchman, Maurice S. *The New Woodcut of the 1890s: Gauguin, Munch and Vallotton*. Master's thesis, Columbia University, 1959.

Tugendhold, R. "Nude in French Art." *Apollon*, no. 11 (1910): 17–29.

Vollard, Ambroise. *Recollections of a Picture Dealer*. Trans. Violet M. Macdonald. New York: Dover Publications, Inc., 1978.

Washington, National Gallery of Art. *Post-Impressionism: Cross-Currents in European and American Painting, 1880–1906*. Introduction by Alan Bowness; essays by John House, Gillian Perry, Anna Gruetzner, Sandra Bemesford, Maryanne Stevens, Wanda Corn, and John Wilmerding. Exh. cat., 1980.

Weinberg-Staber, Margrit. "Die Welt des guten Geschmackes: Interieurs in der Schweizer Malerei des 19. Jahrhunderts." *Du* 6 (1986): 30–40.

Weisberg, Gabriel P. "Paris Cafés: Their Role in the Birth of Modern Art." *Arts Magazine* 60 (January 1986): 90–91.

Werth, Léon. *Quelques peintres*. Paris: Les Editions G. Crès et Cie., 1923.

Winterthur, Kunstmuseum. *Neue Sachlichkeit und Surrealismus in der Schweiz, 1915–1940*. Essays by Dorothea Christ, Hans-Jörg Heusser, Rheinhold Hohl, Peter Killer, Rudolf Koella, Dieter Koepplin, Guido Magnaguagno, and Willy Rotzler. Exh. cat., 1979.

Index